Robert Rosenblum

PAINTINGS IN THE MUSEE D'ORSAY

Foreword by Françoise Cachin

DIRECTOR, MUSEE D'ORSAY

Stewart, Tabori & Chang

NEW YORK

Published in 1989 by Stewart, Tabori & Chang, Inc.
740 Broadway, New York, New York 10003

Library of Congress Cataloging-in-Publication Data

Rosenblum, Robert.
 Paintings in the Musée d'Orsay.

 Includes index.
 1. Painting, French. 2. Painting, Modern—19th century—France.
3. Painting, Modern—20th century—France. 4. Painting—France—
Paris. 5. Musée d'Orsay.
I. Musée d'Orsay. II. Title
ND547.R78 1989 759'.05'074'44361 89-11338
ISBN 1-55670-099-7

Distributed in the U.S. by Workman Publishing,
708 Broadway, New York, New York 10003
Distributed in Canada by Canadian Manda Group,
P.O. Box 920 Station U, Toronto, Ontario M8Z 5P9
Distributed in all other territories by
Little, Brown and Company, International Division,
34 Beacon Street, Boston, Massachusetts 02108

Printed in Italy

10 9 8 7 6 5 4 3 2 1
First Edition

Page 1: Edouard Manet, *Olympia*, detail
Frontispiece: Henri Martin, *Self-Portrait*, detail

Photographs of artwork in this book were supplied by the Service
Photographique de la Réunion des Musées Nationaux, Paris.

In captions, height precedes width. The code number at the end of the
caption is the museum's catalogue number for the work.

The publisher would like to extend special thanks to the following
organizations, whose staffs provided invaluable cooperation and
assistance throughout this project: the Service Photographique de la
Réunion des Musées Nationaux in Paris, Graphic Arts Composition
in Philadelphia, and Arnoldo Mondadori Editore in New York
and Verona.

CONTENTS

ACKNOWLEDGMENTS

*H*aving spent a good part of my professional life trying to reestablish connections between the great painters of the nineteenth century and their lesser and frequently maligned contemporaries, I felt, when the Musée d'Orsay opened its doors in December 1986, that my art-historical dreams had miraculously come true. I was no less excited when, soon after, Andrew Stewart offered me the chance to anthologize the paintings at Orsay in one volume and to provide them with commentaries that might serve as guides to these new maps of nineteenth-century art. Geniuses and masterpieces, I believe, should retain their lustrous places, but countless secondary works of art should also be reconsidered fairly through the multiple new vantage points of history and aesthetics that have burgeoned in the last decades.

In facing the problem of transforming the vast holdings of a great museum into a very large book, I have been fortunate in having the fullest and most professional support on both sides of the task. As for the Musée d'Orsay, its hospitality to a prowling foreign scholar could not have been warmer. Thanks to Françoise Cachin, Geneviève Lacambre, Anne Roquebert, and the most open-shelved of libraries, I had what seemed instant and total access to everything from the files on individual paintings to the run of the store rooms, including even the chance to see canvases so mammoth that a team of workers had to be called in to unearth them for proper view (and later, to be photographed for this book). No scholar could have asked for more efficient, smiling, and erudite assistance. On the publishing end of things, I was equally lucky. Whether dealing with picture groupings, sequences, translations, muddy sentences, or the many other stumbling blocks, large and small, that confronted me at every turn, I had the unfailingly focused and clear-minded advice of my editor Maureen Graney. Her role in organizing this volume and bringing it to fruition is so great that I might almost consider her a co-author. Without her constant and close surveillance of the parts and the whole, the book would surely have been the poorer and, in terms of publication date, the tardier. Since the bulk of this book is to be looked at rather than read, I want also to express my pleasure in the layout of the more than eight hundred illustrations, which at first seemed so overwhelming in number and diversity that I wondered who on earth could make visual sense of them all. The answer turned out to be J.C. Suarès and Paul Zakris, to whose unusual skills and perseverance I offer both respect and gratitude. As for the illustrations themselves, their quality and their fidelity to the originals were supervised, on both sides of the Atlantic, by Kathy Rosenbloom, with an unusually sharp eye.

A word, too, about the captions. As often as possible, I tried to preserve the original form of the titles, although later variations are sometimes included. I am responsible as well for the translations of the titles or, in some cases when it seemed appropriate, the non-translations (as in *Déjeuner sur l'herbe* or *Luxe, calme, et volupté*). As for the dates, I have usually tried to give, between parentheses, the date of a work's first public exhibition. As for the date of its execution, this follows the title, and is based on the confirmation of an inscription or some secure external evidence. When the date is left more vague (ca. 1875 or 1885-1890), I am relying on the putative dates provided in the most recent catalogues.

Robert Rosenblum
New York, NY
April 1989

✲

Paintings in the
Musée d'Orsay

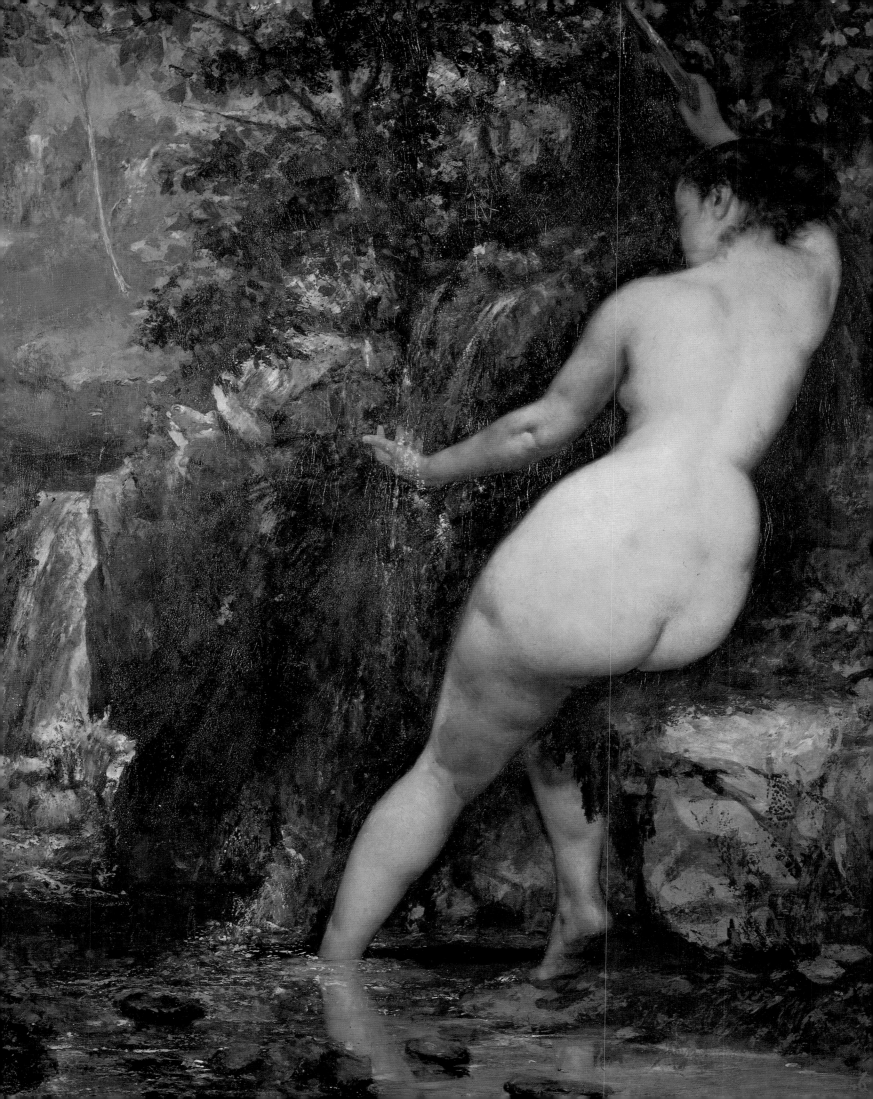

FOREWORD

*L*uck and fate seem to have taken turns ruling the conversion of the Gare d'Orsay, built in 1900, into the Musée d'Orsay, repository of late nineteenth-century art. First came the good luck of timing, for it was largely due to the destruction of Les Halles that the press was moved to mount an ultimately successful campaign to save the old railway station and hotel. In 1973, Les Halles (the markets) of Victor Baltard, one of Paris's most beautiful mid-century cast-iron buildings, had been demolished, and, ironically, this loss worked to the benefit of the Gare d'Orsay's subsequent survival. The station was a bold structure by the architect Victor Laloux that had been partially covered over with an eclectic and academic stone façade, giving it a very different look from the building that was originally intended to bring travelers visiting the 1900 Exposition Universelle, or world's fair, into the heart of Paris. In another ironic stroke, this centennial featured a retrospective exhibition of French art of the nineteenth century.

Geographical luck also came to play a role: among the station's prestigious neighbors just across the Seine were the Louvre, the Grand-Palais (site of the Exposition Universelle), and the Orangerie, containing Monet's grand Water Lily series. What more natural place to house the collections that followed chronologically those of the Louvre and, especially, the Jeu de Paume, whose Impressionist collection was growing beyond the building's exhibition capacity with each passing year!

And then, going beyond the factors of location and timing, there is the question of fate to consider: Orsay was destined to become a museum! From the very beginning, the railway station was itself a symbol of advanced technology, of a new worldly openness, of faith in material progress and innovation—a cathedral for the worship of all that was modern. Courbet himself had had the idea, according to the critic Castagnary, "to make out of huge railway stations new churches for painting, to cover their vast walls with a thousand subjects of decorous suitability, depicting the views of the very places through which one was about to travel; with portraits of great men whose names were synonymous with the cities passengers were visiting; with subjects that were picturesque, edifying, industrial, metallurgical—in short, with the saints and miracles of modern society."

The space was symbolic of a new industrial poetry as depicted by Monet in his *Gare Saint-Lazare*. At the same time, it was able to welcome and accommodate a growing public eager to learn about or simply to enjoy the paintings of this epoch.

The decision, in 1978, to transform the station into a museum came a little after the installation of the national collection of modern art at the Georges Pompidou Center (1977), which deliberately emphasized the innovations of Modernism, beginning with Fauvism. What took place between the innovations of Impressionism and those of Modern Art—the Post-Impressionism of the Pont-Aven school, Neo-Impressionism, Nabis, Symbolism, the traditionalists, foreign painting, et cetera—was not, or was very poorly, represented. In Paris, to find the paintings of these schools, one had to go to the Louvre for Corot and Courbet, to the Jeu de Paume for Impressionism from Renoir to Cézanne, then to the Musée d'Art Moderne to discover Matisse and Picasso. It was a search that could only end with the vague recollection of chapter headings and the names of kings and great battles.

Regrouping the paintings of this era at the Musée d'Orsay did not so much involve reevaluating, establishing standards, abolishing hierarchies: the storage rooms of Orsay are today still full of secondary works and paintings by minor artists. It was time to reconsider the case of the "bad boys" of Modernism, to show the best of the forgotten and second-best painters, not to mention the teaching masters. Manet was, after all, the student of Couture; Lautrec, of Cormon; and Matisse, of Gustave Moreau.

Many paintings came from the Louvre—from the walls and from storage. Paintings by the Impressionists and their immediate followers came from the Jeu de Paume. We also wanted to gather together numerous works on deposit in the state-run, or national, museums throughout the country that were originally in the old Museum of Modern Art at the Palais de Tokyo (emptied when the Pompidou Center came into being), and from its predecessor, the Musée du Luxembourg (which from 1818 to 1939 had contained the work of living artists only). Paintings by foreign artists came from the storage rooms of the old Jeu de Paume, which, before being converted in 1947 into the Museum of Impressionism, had been, from 1922 to 1940, the Museum of Foreign Schools. One museum after another was

GUSTAVE COURBET
The Source, 1868
4' 2½" x 3' 2¼" (128 x 97 cm) RF 2240

born, only to be "born again" in some new guise, dependent on the vagaries of taste. In the first third of the nineteenth century, the emphasis was on so-called academic, or eclectic, art. Then came a complete about-face relegating academic art to the darkest corners of the storerooms while glorifying the avant-garde!

Nevertheless, we have not sought systematically to restore the reputations of those against whom the followers of Manet rebelled. We have, however, attempted to give a second chance to numerous artists who were often rightly—and sometimes, but not always, wrongly—praised in their own time. We wanted to rid the debate of emotionalism and approach it instead as historians, in order to understand and illuminate. Some artists do not pass the test of time, but others are worthy of being looked at again, if only because they were the artistic companions of the great innovators—and even if they were not, they were not necessarily dummies.

It is worth mentioning, too, that in general it was the museum directors during the time of Impressionism who bought the works of those artists forgotten or condemned by the "Modern tradition": more state purchases are crated in our storerooms than are hung on our walls, and the best of what is on display comes by way of gifts. In fact, the great majority of key works from a contemporary point of view have entered the national collections directly from collector-donors. It is, for example, to the generosity of Chauchard that we owe the most beautiful Millets, Corots, and Barbizon School paintings. Etienne Moreau-Nélaton gave us Manet's *Déjeuner sur l'herbe* and other early Impressionist work. And we are indebted to Antonin Personnaz—and especially to the painter Gustave Caillebotte and banker Isaac de Camondo—for the core of the museum's Impressionist masterpieces, from Manet's *The Balcony, The Fifer,* and *Lola de Valence* to Renoir's *Ball at the Moulin de la Galette,* Degas's *Absinthe,* to Monet's cathedral series. Jacques Doucet should be remembered for his gift of Le Douanier Rousseau's *Snake Charmer,* Dr. Gachet for Van Gogh's *Self-Portrait* and *The Church of Auvers-sur-Oise,* the Pellerin family for our most beautiful Cézannes, and John Quinn for our finest Seurat! And then the families of the artists themselves have had the graciousness to allow us to represent worthily Courbet, Bazille, Monet, Lautrec, Renoir, Signac, Sérusier, Redon, Vuillard, not to men-

tion—and we do so with gratitude—the heirs of the sitters of Manet's *Emile Zola* and Van Gogh's *Eugène Boch,* among others. What would the Musée d'Orsay be today without this admirable group of donors? A provincial, dated, forgotten museum.

Analysis of such riches by our small group of curators, spirited on by Michel Laclotte, has led us to recognize clearly the deficiencies of our collection and inspired our desire to overcome them. This became a major direction in the course of action undertaken during the preparatory period (1978–1986) and the years immediately following the museum's opening (1986–1989). Consequently, a large number of the works reproduced here are recent acquisitions. These acquisitions were made with two considerations in mind: to fill in the gaps in the area of foreign painting and to represent certain developments within France that were heretofore inadequately covered by existing collections. Among the non-French, European artists we now include in our collection, I will cite (in chronological order) just a few who were completely absent from it just ten years ago: Makart, Burne-Jones, Stuck, Klimt, Khnopff, Strindberg, Mašek, Rusinol, Munch, Hodler. The Musée d'Orsay finally can now offer a panorama of European art up to the turn of the century.

We have also been able, thanks to generous donations and some purchases, to strengthen our holdings of paintings representing key developments in French art, whether realist, historical, decorative, or symbolist: Gustave Doré's *The Enigma,* Puvis de Chavannes's *The Balloon* and *The Pigeon,* Devambez's *The Police Charge,* Clairin's *The Burning of the Tuileries.* But it is thanks to the French system of *dation* (donations of works of art taking the place of inheritance taxes) that we have been able in only a few years to dramatically enrich the museum's holdings of important works with Manet's *Escape of Rochefort,* Pissarro's *Hill of the Hermitage,* Monet's *Rue Montorgueil* and *Déjeuner sur l'herbe,* a series of Cézanne's *Bathers,* and Renoir's *A Dance in the Country.*

We have made particularly distinguished acquisitions of Nabis and Pont-Aven School painting. Among the latter is, for example, a group of pictures by Sérusier, including *The Gateway, The Washerwomen at la Laïta, Breton Eve (Melancholy), Grammar (Study),* and the famous *Talisman,* painted

under the guidance of Gauguin. From Lacombe we now have *The Violet Wave;* from Emile Bernard, *Bathers with Red Cow* and *The Harvest (Breton Landscape).* From the Nabis, or those affiliated with them, we have acquired works by Maurice Denis (*Motherhood*), Charles Lacoste (*The Shadow Hand*), and Félix Vallotton (*Moonlight*). Pierre Bonnard's youthful period is now represented in a spectacular manner, for, in addition to *The Composer Claude Terrasse and Two of His Sons, The White Cat, The Large Garden, Women in the Garden, By Lamplight, Child with Sand Castle,* and *Twilight (The Croquet Party),* ten important pictures by this artist have arrived at Orsay in recent years, mainly by *dation* and gifts.

The French-Belgian Neo-Impressionist School has also been developing quickly and respectably, as witness the accessions of Seurat (*The Little Peasant in Blue*), Signac (*Young Provençal Women at the Well, Woman by Lamplight, Port of La Rochelle*), Luce (*The Quai Saint-Michel and Notre Dame, Félix Fénéon*), Henri Edmond Cross (*The Evening Breeze*), Van Rysselberghe (*Sailboats and Estuaries, Man at the Helm*), and Lemmen (*Portrait of Mme. Lemmen, Beach at Heist*).

Finally, after Bonnard, the French artist who has found unexpected acclaim at the Musée d'Orsay is Odilon Redon: we have received a generous bequest of landscapes and portraits, and, thanks to the aforementioned policy of *dation*, a large decorative series of eleven panels, which are now deployed in a circle around a room otherwise devoted to Art Nouveau furniture.

Although painting reigns throughout the exhibition space, and indeed its celebration is the reason for this book, the museum is not devoted solely to painting. The organizational plan alternates rooms of sculpture, objets d'art and furniture, and graphic arts (pastels, drawings, photographs) in more or less chronological sequence down the length of the exhibition concourse. The architecture of the nineteenth-century is evoked not only by the various elements of the former railway station itself but also by restoration of the restaurant and the ballroom of the hotel and by many models and drawings of the period.

The museum's rotational layout and immense variety are its novelties. Paintings are installed not in rooms with contemporaneous décor (we decided not to create "period rooms" at Orsay) but within chronological groupings, not far from works in other media of the same time. In only four cases are the sculptures and paintings of the same artist exhibited side by side in the same space, and they are those of Daumier, Carpeaux, Degas, and Gauguin.

In addition to reestablishing harmony among the diverse directions followed within a single period, it has seemed important to the programming staff not to isolate the masters in a kind of timeless tabernacle, but to establish their ties to the past and their roles vis-à-vis succeeding generations. In this way, we have tried to make palpable the "hereditary" ties, for example, between the Impressionists and the landscape artists of the Barbizon School, between Ingres and Degas, Gauguin and the Nabis, and to demonstrate the roles of Van Gogh and the Neo-Impressionists in the first bursts of Fauvism, to which the last room of the exhibition course is dedicated.

Robert Rosenblum, in his introduction and in his learned and lively analyses of the pictures, shows that he has completely understood—with subtlety and sympathy—our undertaking: to present an artistic reality that is manifold and complex and that provokes discussions that have not been engaged in for a long time. He himself was one of the first to defend the painters cast aside by the dogmas of an intolerant Modernism and to consider that they merited at the very least a purgatory rather than the inferno of storage. It is now hard to imagine that just fifteen years ago it seemed revisionist to exhibit the works of Puvis de Chavannes, as was done in Paris, even if art historians knew he played an important role in the lives of Seurat and Gauguin. But the sympathy and, at times, the fascination of Robert Rosenblum for the disinherited of yesterday, the "minor" artists, and the "weirdos," do not lead him to neglect the fundamentals. His goodwill is clearheaded, and, if one should ever doubt his admiration for and profound understanding of the masterpieces of Modernism exhibited at the Musée d'Orsay, one has only to read him to be disabused of that notion.

Françoise Cachin
translated by Harriet Zinnes
and Lorraine Alexander Veach

INTRODUCTION

*T*he story of the Musée d'Orsay and the resurrection of nineteenth-century art is like a parable about a fiercely feuding family that, once rent asunder, has at last been reunited. The family in question comprises all those artists who lived and worked from the middle of the nineteenth century to the dawn of the twentieth. The feud has to do with the civil war between avant-garde and conservative factions that was fought and won by the partisans of modernism.

As for the feud, it was one of the great nurturing beliefs of the first half of our century that the history of genuinely modern art had a painful birth, like that of a conquering hero, whose origins could be traced back to the works of Manet in the mid-nineteenth century. Manet, in turn,

spawned no less heroic progeny who would create a noble dynastic table that, with various mutations via Impressionism, and the next generation of Post-Impressionists—Seurat, Cézanne, Gauguin, and Van Gogh—could at last produce the pure breeds that might be isolated, protected, and venerated in such sanctuaries as New York's Museum of Modern Art. There, in 1936, on the occasion of the epoch-making exhibition "Cubism and Abstract Art," organized by the museum's first director, Alfred H. Barr, Jr., a genealogical chart was published that would help intelligent converts work their way through the jungles of the past century. Singled out were those landmark artists and "isms" that would lead, with Darwinian inevitability, to the cutting edge of modern art, just as proponents of the modern

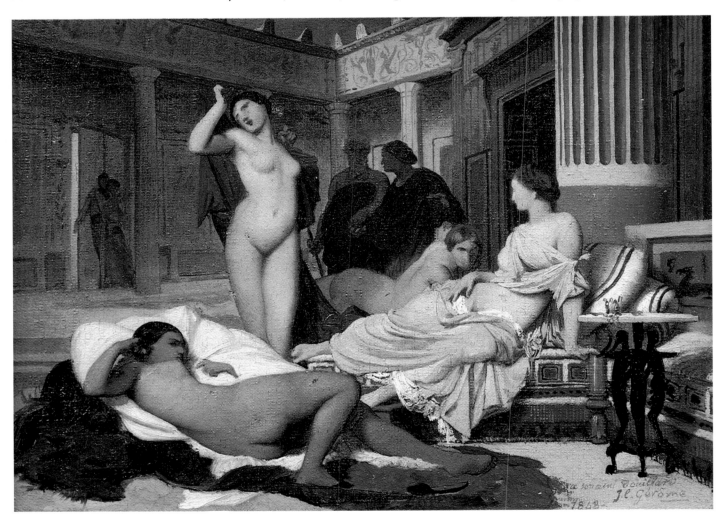

JEAN-LÉON GÉRÔME
Greek Interior, sketch, 1848
6″ x 8¼″ (15.5 x 21 cm) RF 1981-46

movement in architecture were seeking out their nineteenth-century roots in buildings that eschewed historical ornament and exposed structural bones. In creating historical foundations for what they thought to be the only vital and authentic art of the twentieth century, the leaders of modernism necessarily wore blinders in viewing the past. They vigorously rejected and often maligned, as most fervent reformers are apt to do, what appeared irrelevant to their cause. Having selected their ancestors, these crusaders for modern art, essential for their time but not for ours, left behind them a scorched-earth policy in nineteenth-century territory. They reduced to nearly invisible rubble the infinite acres and tons of art that, at its best, presumably led nowhere and was therefore inconsequential and, at its worst, in the hands of powerful establishment figures like Bouguereau, actively impeded the triumphal course of modernism.

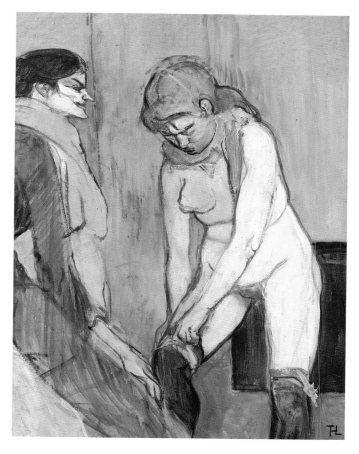

But in the late twentieth century, such a clear-minded linear vision of the ultimate conquest of truth over falsehood, beauty over ugliness, has gradually begun to recede into history—a moral fable from the ever more distant decades when the battle for modern art was still heated. Now that it has been won, as amply demonstrated by the international fame and public acceptance of all the giants of modern art, from Cézanne and Picasso to Mondrian and Pollock, the nineteenth century has begun to look quite different, too. For anybody born after the Second World War, such ancestral strife is a thing of the past, a parental or grandparental conflict as remote as the antipathy felt toward Rococo art and culture by the revolutionary generation of David. These days, younger spectators, confronted with a nude by Cabanel or a Victorian town hall, tend to be neutral: gone are the knee-jerk responses of aesthetic revulsion or smug hilarity that used to indicate a discomforting closeness to alien values still threatening the present. Their reactions to this once forbidden art are more refined and informed, both visually and historically. Today anyone interested can quickly learn to distinguish a nude by Cabanel from one by Gérôme (though they were once thought to be interchangeable in terms of badness), just as any museumgoer exploring for the first time, say, the little Dutch masters can learn to tell a ter Borch from a de Hooch. Once eyes are opened to differences, no longer seeing everything as a communal whole, endless new vistas can be explored, including hierarchies of good, better, best. The respective virtues and weaknesses of, for example, two photo-realist portrait painters, Bonnat and Benjamin-Constant (pages 398 and 399), might then be argued just as fervently as the qualities of two nineteenth-century portrait photographers. As usual, ignorance breeds indifference or contempt; knowledge, open-minded inquiry and pleasure.

The Musée d'Orsay is now the grandest international statement of what might be called a Postmodernist view of nineteenth-century art. In this view the Modernist belief in a century aesthetically polarized into the blacks and whites of left-wing/right-wing, hero/villain, genius/daub has dissolved into infinite shades of gray. Instead of a battlefield, we have a huge family of artists whose connections with one another are far more subtle and binding, for they shared the experience of living together through some or all of the same decades in Western history. It was the mandate of the Musée d'Orsay to fill a chronological void between, on the one hand, the Louvre and, on the other, the Musée d'Art

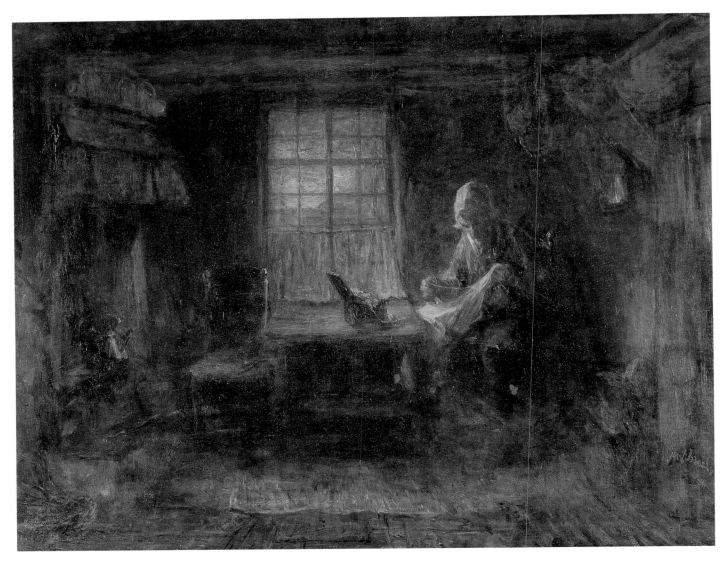

Moderne. In terms of date, this meant that its collections were to begin officially around 1848, the year of many revolutions throughout Europe. It was also the year that became a springboard for the rebellious careers of Millet and Courbet in their role as proponents of what would be called "Realism"—artists who would drastically undermine prevailing hierarchies of style and subject. And in visual terms, the collections were to end, with less precision of date, before the shattering revolution of Cubism that, on the eve of the First World War, seemed to inaugurate another historical era. We are taken to the first tremors of Fauvism and Expressionism, but not beyond, even though long-lived survivors of earlier generations—a Monet, a

Renoir, a Bonnard—are represented in their twentieth-century entirety, and in some cases, such as that of Vuillard, well into the 1930s.

Between approximately 1848 and 1914, artists, like other people of their age, not only lived through the same traumatic and joyous events but shared or challenged the same assumptions and doubts. If they were old enough, they witnessed the revolutions of 1848; and if they were French, there were few who, as children or adults, were not touched by the Franco-Prussian War of 1870–1871. Indeed, many of them, from Meissonier (page 252) to Henri Rousseau (page 659), responded directly or obliquely to these communal tragedies. Moreover, every artist repre-

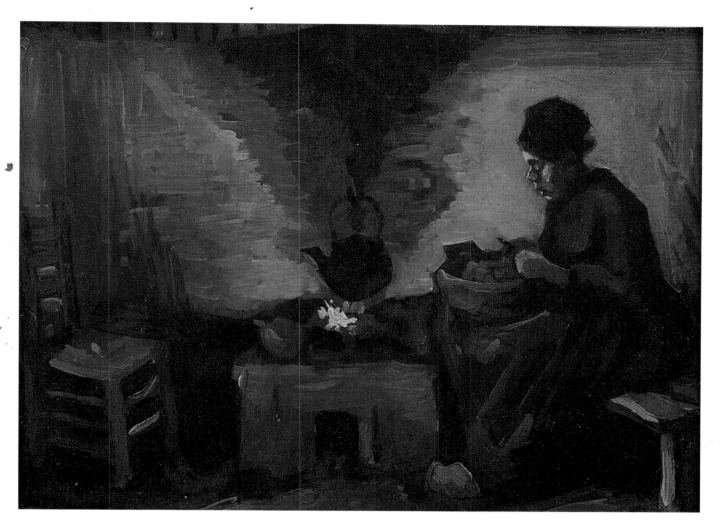

sented at the Musée d'Orsay must have experienced first-hand or from hearsay and publications one or many of the Expositions Universelles, or world's fairs, in 1855, 1867, 1878, 1889, and 1900, that punctuated Parisian life with such thrilling and diverse roundups of the latest in art, commodities, and technology. Among these were Courbet's "Pavilion of Realism" in 1855 and Gustave Eiffel's tower in 1889. How did these exhibitions alter the ambitions of artists the world over, whether in Paris, New York, or Stockholm?

But on a level loftier than a chronicle, there were also the ongoing questions of the nineteenth century that must have colored, directly or subliminally, the thinking and hence the work of the countless artists, both geniuses and hacks, who populated the six decades represented at the Musée d'Orsay. Was Christ a real historical personage like Julius Caesar, earthbound and in period costume, or a supernatural being who could levitate and glow with radiant light? Were women inevitably to be pigeonholed in such categories as nurturing mother, chaste virgin, or wanton temptress, or could they be granted the intellectual and social liberties assumed for men? Were peasants a happy, endangered species from a more innocent world of faith and simplicity or a miserable, downtrodden population that might at any moment revolt and threaten cultivated proprieties? Was the art, not to mention the life, of tribal or exotic

cultures, whether Polynesian or Japanese, innately inferior or superior to contemporary Western civilization? Were the official advent of photography in 1839 and its instant burgeoning a death blow to the belief that painting ought to record the visible world, or was the new medium a friendly ally to painters concerned with documenting things seen? Was the rapid expansion of suburban factories and railroad networks an invigorating symbol of technological utopias to come or a blight on the timeless harmonies of landscape? Should art join the ongoing rebellions of the working classes against their economic slave masters or remain locked in the ivory towers of remote history and legend? Was the great art of the past to be eternally venerated, or had it become so removed from modern experience that it could only be parodied or ignored? Could art itself, with its potential powers of transcendence, usurp the already threatened faith in religion and make philosophical statements about human destiny or even create new cults of beauty that might lead to the divine?

Such resonant issues, which may sound like lofty topics in a study of nineteenth-century cultural history, have nevertheless very concrete translations in the immense diversity of paintings housed at the Musée d'Orsay. To confront the lascivious reconstruction of a would-be ancient Greek interior by Gérôme (page 40) or to peek into the bordellos frequented by Toulouse-Lautrec (page 463) is to reveal some of the facts and fictions of nineteenth-century sexuality and prostitution. To pause before the pious peasants of Legros (page 133) or Gauguin is to learn how the intellectually sophisticated could view the rituals of Christianity with the eye of an anthropologist observing a remote tribe. To see the floor-scrapers of Caillebotte (page 323) or the laundresses of Degas (page 328) is to see not only a documentary, quasi-photographic study of human motion or an abstract invention of regularized rhythmic beats but also to understand something of the attitude of a well-heeled Parisian artist toward the working classes. To see Ingres' *Virgin of the Host* (page 25) and Carrière's *Crucifixion* (page 543) is to realize how the nineteenth century could alternate between the preservation and destruction of traditional ways to conceive and depict the supernatural themes of Christianity.

Such broad issues, and countless others, haunted the thinking and the art of the painters who are represented at the Musée d'Orsay, uniting in one family not only geniuses as unlike as Manet, Cézanne, and Redon but also their lesser contemporaries. These could range from pedestrian professionals with hardly a distinguishing contour—a Baudry or a Lenepveu—to what might be called major minor masters of acutely refined and personal flavor: a

Tissot or a Puvis de Chavannes. But names like these are only the tip of the Orsay iceberg, for the sheer number of paintings and painters bequeathed by the nineteenth century is daunting. At the Salon of 1848, for example, 4,598 canvases were exhibited; and even though this was an unusually high count, every annual Salon that followed could boast a tally of at least several thousand paintings. Even in more exclusive exhibition spaces, the numbers were high. When, in 1863, the Salon des Refusés was created to accommodate those rejected by an increasingly conservative jury, Manet's then notorious, and now classic, *Déjeuner sur l'herbe* (page 202) shared the walls with 679 other officially unworthy canvases, many by artists whose names still conceal unknown quantities and qualities even to today's most specialized art historians. And in 1874, at the first group exhibition of what quickly came to be called "Impressionism," thirty artists were represented; unlike Degas, Monet, Renoir, and Cézanne, not all of them have become today's household words. How many of us have seen paintings by their fellow "Impressionist" exhibitors, for example, Levert, Latouche, Bureau, or Attendu? And if we found them, shouldn't we at least give them the courtesy of looking at them, perhaps for the first time since 1874 when they hung on the same walls with artists whose every scrap now awes us?

But it is not only the history of French painting that the Musée d'Orsay is obliging us to reconstruct. It is nothing less than the global history of Western painting. For as all roads once led to Rome, in the nineteenth century all roads, especially those sighted by artists, led to Paris. There, at the world's fairs, at the annual official Salons, or at the more independent, refractory shows that proliferated from the 1870s on, artists from Turkey and Peru, from Canada and Madagascar were exhibited to international audiences in Paris. If they were lucky, their works were acquired by the Louvre or by the Musée du Luxembourg, the world's first museum dedicated to collecting contemporary art. Small wonder, then, that the geographical scope of artists housed today in the Musée d'Orsay is so vast, boasting not only such foreign classics as the painting familiarly known as Whistler's *Mother* (page 155) but cutting an international swath that anthologizes a veritable United Nations of artists from, among other places, Australia, Puerto Rico, Russia, Portugal, and Finland. Moreover, in keeping with the current expansion of interest in nineteenth-century painting outside France, the Musée d'Orsay's new acquisitions actively embrace a wide range of international masters, especially from the turn of the century. Among these are Hodler, a Swiss; Klimt, an Austrian; Corinth, a German;

Munch, a Norwegian; Burne-Jones, an Englishman; and even a remarkable painting by the great playwright Strindberg, a Swede (page 568).

As gathered together now at the Musée d'Orsay, the painting of the second half of the nineteenth century is like an old archaeological site that has been freshly excavated. Familiar monuments jostle alongside unfamiliar works that, at the least, may be no more than revealing artifacts of a lost culture or, at the most, precious discoveries that will unsettle our ways of seeing and even add new dimensions to works we know by heart. Looking at them is, of course, the first thing to do, especially since so many are by obscure artists whose names, unlike Monet's or Cézanne's, may be so new to us that there is no Pavlovian reflex of tradition to tell us whether we should like them or not. To see them often involves shedding prejudices that, for younger generations in particular, may never have been there to shed. For instance, the twentieth century's evangelism on behalf of an art that transcends mere imitation of things seen invalidated in one grand sweep that huge domain of nineteenth-century painting that looked, so it was thought, like unselective, handmade and hand-tinted photographs. All of this was lumped together in the category of the stillborn. But in the later twentieth century the rampant growth of interest in nineteenth-century photography and the rapid establishment of visual hierarchies that would sort out photographers into great or mediocre, innovator or disciple, have resurrected the possibility of looking at the painted counterparts of this materialist view of the world with fresh sympathy. Now one can distinguish the infinite variations of descriptive precision, of dramatic staging, of sensibility to particular colors or tones that may be savored in individual masters working within this pictorial milieu. Although only a few decades ago, artists like Meissonier, Gérôme, Tissot, and Bonnat would have been discarded in the same pile with worthless artists who chose brushless, glossy, mechanical truth to appearances over personal facture and significant form, the experience of photography itself, not to mention the Photo-Realist painting of the 1970s, has now made such a wholesale condemnation look naive and blind. As anyone who looks at them knows, the best of these artists are utterly distinctive, no more alike than, say, the best of those artists who work within the pointillist technique developed by Seurat. In such domains alone, the Musée d'Orsay is sure to make new reputations and to open our eyes to new values that we could not begin to discern until the paintings were at last hanging in easily accessible abundance. After all, neither connoisseurs nor the public could learn to sort out the multiple styles, the relation of master to pupil, of genius to competence in the once maligned painting of the Italian primitives until the works themselves were finally studied and exhibited in quantities large enough to permit extended familiarity and discrimination.

Of course, given the awesome quantity of paintings produced in the nineteenth century, the probability is that most of them follow dull, workmanlike formulas for popular consumption. But should they therefore be burned or forever hidden? At least now, after decades of censorship, the public has the right to see for itself what had been concealed because of prejudices that may now appear as remote as the seventeenth-century battle between the ancients and the moderns—the partisans of Poussin versus those of Rubens—or the conflict that began in the 1820s between upholders of the classical tradition espousing the doctrine of Ingres and the young Romantic rebels rallying under the banner of Delacroix. (This polarity, in fact, begins the Musée d'Orsay collection, with its juxtaposition of late mature works by these two great masters who forever locked horns.)

Many purists, of course, have feared that the unlocking of the prison gates of history would release such an avalanche of terrible art that the familiar deities would be sullied and insulted by the presence of such mediocrity. There are, however, other ways to look at this. As unique a genius as Van Gogh was deeply indebted to the work of presumably inferior artists, such as the Dutchman Jozef Israëls; if they were good enough for him, perhaps we should pause before them a moment, too. And even if the context is one of repulsion rather than admiration, can it hurt us to see the visual rub? Here the example of the official nudes of Bouguereau and his colleagues comes to mind, for surely the copious inventions of ideal nudes by Cézanne and Renoir cannot be fully understood without reference to the academic standards they hoped to rival and to surpass in their own more private universes.

Often the context of lesser artists permits us better to savor the more familiar lofty achievement. Can we fully judge the singularity of Redon's imagination without seeing the more common coin of mystic themes and ethereal mood shared by such fin de siècle contemporaries of his as Osbert and Séon? Can we fully experience the quantum leap of Manet's innovations without measuring them against the broadly comparable motifs and styles of such contemporaries of his as Bonvin, Ribot, and Régamey? Can we begin to imagine Courbet's epic ambitions for *A Burial at Ornans* without actually seeing the giant symbol of pictorial success that preceded it at the Salon by three years, Couture's

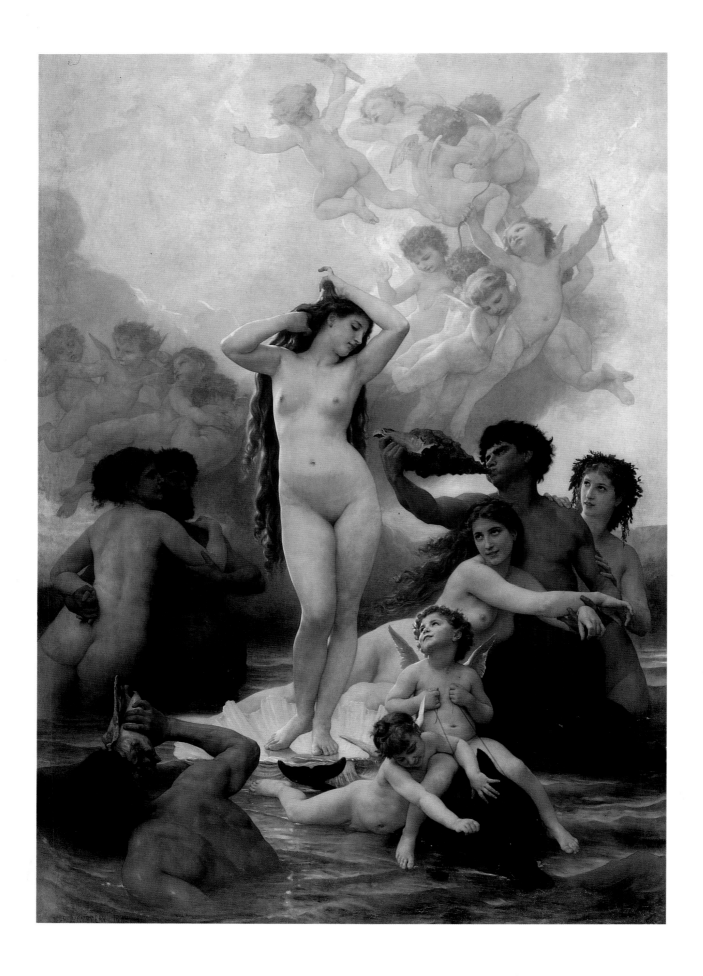

Romans of the Decadence? By exploring the foothills, whether of public pomposity or quiet integrity, that lead up to the Olympian heights on which the time-honored deities of nineteenth-century painting reside, we may find not only that their supernatural glow is all the more intense by contrast with the more mortal artists who live beneath them but that some of these lesser mortals, too, are worthy of attention.

An art museum, after all, can be more than a pantheon of eternal beauty. Housing some of the supreme masterpieces of Western painting—Courbet's *The Painter's Studio*, Manet's *Olympia*, Degas's *Bellelli Family*, Monet's "Rouen Cathedral" series, Cézanne's *Woman with Coffee Pot*, and dozens of others—the Musée d'Orsay is, of course, a world shrine; but it is also a world encyclopedia of rejuvenating ferment. Its huge repository of nineteenth-century art not only gives us at last the visual data with which we can begin to exercise fresh judgments about the way the past looks in our present, but it also ensures that future generations, way beyond the year 2000, will be able to construct new systems of visual value, new ways of fusing nineteenth-century art and history that remain undreamed of today.

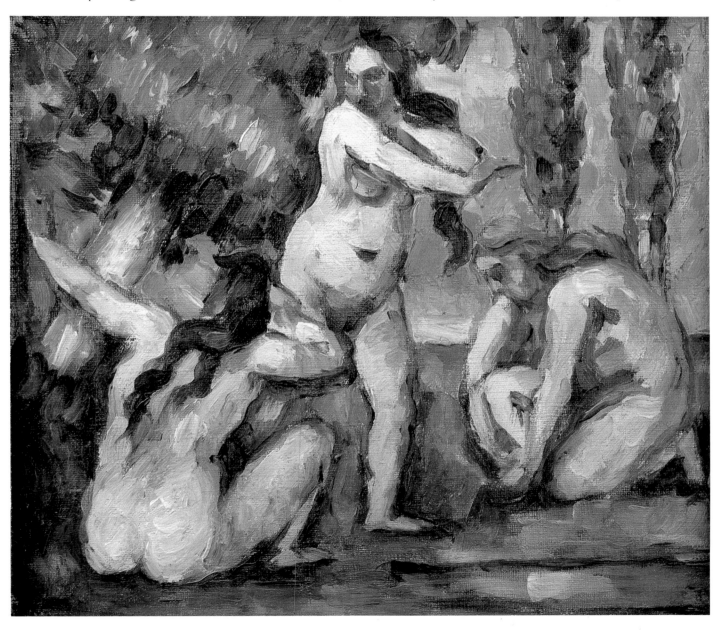

facing page
WILLIAM BOUGUEREAU
The Birth of Venus, 1879 (Salon of 1879)
9′ 10″ x 7′ 1¾″ (300 x 218 cm) RF 253

PAUL CÉZANNE
Three Bathers, ca. 1875–1877
8¾″ x 7½″ (22 x 19 cm) RF 1982-40

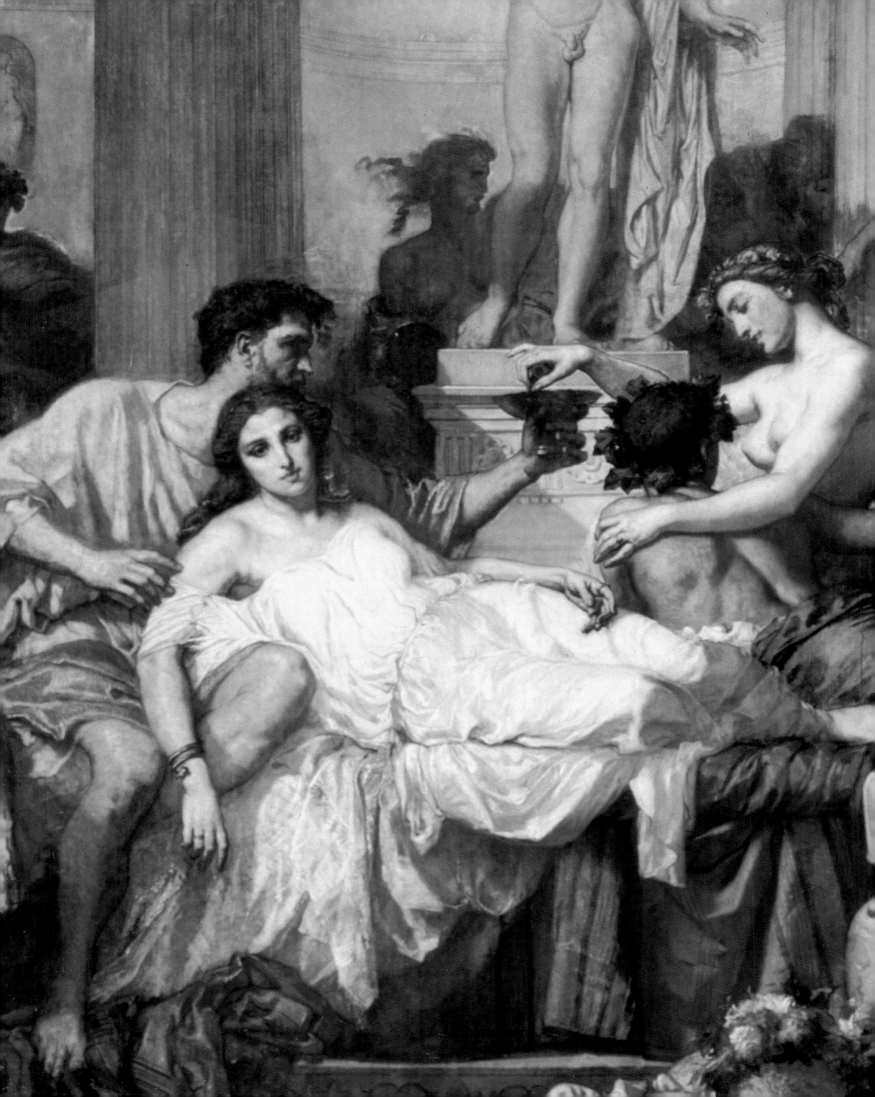

The Establishment in France, 1848–1880

ROMANS OF THE DECADENCE

Thomas Couture
Romans of the Decadence

*T*homas Couture's huge painting—it is over 25 feet wide and over 15 feet high—is the ringmaster of the Musée d'Orsay. Dominating the vast sweep of the museum's main concourse, and framed in countless views from neighboring galleries, it resonates throughout the collection as a touchstone of academic authority, a painting to be both respected and rejected. And its date, 1847—the year of its exhibition at the Paris Salon—also launches chronologically the museum's own collections, which officially, if only approximately, begin in the revolutionary year, 1848.

Couture's theme offers, too, that sense of lofty historical overview, high-minded but nostalgic, that characterizes so many mid-nineteenth-century responses to the growing collision between the venerable past and the shockingly rapid changes of the present. Supported by a quotation from Juvenal about how the Roman Empire lost its power not through its earlier exertions of war but through its later cultivation of vice during years of peace, Couture's grandiose spectacle is at once sobering and voluptuous, pitting a civilization's virtuous past against a corrupted present. Within the upright, regular beat of a columned atrium, a gallery of forefathers in the guise of marble statues (dominated in the center by Germanicus) recalls earlier, more moral times, a startling contrast to the orgy of alcohol and flesh that sinks below this austere classical backdrop. The statue at the right even seems to be rejecting, with outstretched hand, the cup of wine his living descendant would offer him in a fit of drunken confusion. And in the extreme right foreground, two foreign visitors, members of the remote Germanic tribes that will eventually put an end to this last chapter of ancient history, ponder thoughtfully the familiar nineteenth-century question of the rise and fall of great civilizations. So abstract and epic a theme could be interpreted in countless ways, perhaps even couching messages about the decline of France since the heroic days of the Revolution or about the threat to classical ideals posed by artists of the 1830s and 1840s more interested in wallowing in exotic vice than in upholding ancient virtue.

Couture's homage to the glory of the past is matched by his willful art-historical borrowings from the pantheon of time-honored Renaissance styles. If we recognize, on the one hand, the authority of Raphael in the ideal clarity of space and the fluent harmony of figure groupings, we also sense the sensual countertradition of Venetian painting, especially as exemplified in the Louvre by Veronese's immense painted pageants. This eclectic mixture of opposing sixteenth-century styles—that of Venice, with its pursuit of chromatic warmth and atmosphere, versus the more cerebral character of Raphael's Rome, with its ideal geometries and lucid contours and modeling—reflected the warfare between Delacroix and Ingres that dominated mid-century aesthetics. It also typified the encyclopedic inventory of old-master allusions that would give academic art the respectable pedigree to scare off such coarse young upstarts as Courbet, who would challenge officialdom. Indeed, just around the corner in the Musée d'Orsay, and visible from Couture's roadblocking statement of faith in tradition, are Courbet's two major masterpieces of the next decade, *A Burial at Ornans* and *The Painter's Studio* (pages 139 and 152). Both works offer full-scale revolutionary responses to Couture not only in their dimensions but in their epic themes of life and death, past and present. And as yet another link between Couture and the rebellious young generations soon to come, it should be recalled that in 1850 Manet himself would enter the master's studio, where he would learn fresh ways to juggle the demands of tradition with the excitement of contemporary life that Couture could never have imagined.

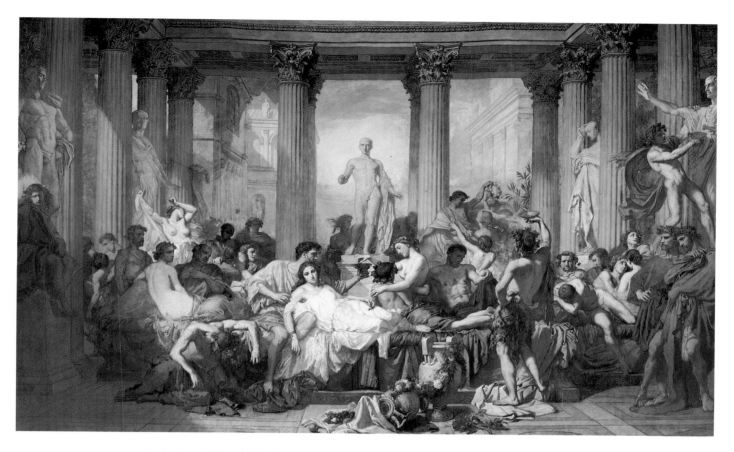

THOMAS COUTURE, Senlis 1815–Villiers-le-Bel 1879
Romans of the Decadence, 1847 (Salon of 1847)
15′ 5¾″ x 25′ 4″ (472 x 772 cm) INV 3451

INGRES, DELACROIX, AND CHASSÉRIAU

Jean-Auguste-Dominique Ingres
The Virgin of the Host

Whether praised or maligned, Ingres's painted tributes to the absolute authority of Catholicism can at the very least pinpoint the problems of mid-nineteenth-century religious art. In a century introduced by the atheism of the French Revolution and then set in turmoil by Darwin's and Marx's full-scale attacks on religion, how on earth could artists continue to maintain belief in miracle-working irrelevant to the history of medicine, in halos and flying angels exempt from the laws of gravity, in a purity of flesh and spirit unknown to dwellers in modern cities? Nevertheless they tried, and none harder than Ingres, who, from his youth under the First Empire of Napoleon I to his old age under the Second Empire of Napoleon III, continued to paint traditional images of Christian piety and truth as if they had never been doubted. Indeed this painting repeats an earlier invention of 1841.

Ingres's stubborn faith in this tradition shows, for in *The Virgin of the Host*, we are meant to kneel almost literally before an unchallenged shrine of past beliefs, both artistic and religious. Once again he has invoked the ghost of Raphael, whose multiple variations on the Virgin's faultless clarity and serenity provided Ingres with a sacred canon of perfection that could only be worshiped, not bettered. Here the ideally lucid geometries of the Renaissance master are emphatically restated with almost textbook-like diagrams; the central motif of the host, the eucharistic wafer with the Crucifixion faintly incised on its whiteness, floats over the equally circular shape of the chalice like a lesson in plane geometry. This theme of perfect circularity is then reiterated in both the whole—the Raphaelesque tondo shape of the entire canvas—as well as in the parts, from the perfect arcs of the garlands in front of the parted curtains and the three halos seen in complex changing perspective to, above all, the ideal roundness, approaching the ovoid, of the Virgin's head, reflected in her crowning hairline and the lids of her downcast eyes. Confirming this abstract perfection is the image's insistent symmetry, the structural counterpart of faith in inflexible truth. For this exercise in the plane and solid geometry of circular beauty is ordered on the simplest but most unyielding crossing of a vertical and horizontal axis that freezes the image in timeless permanence—an icon impervious to nineteenth-century change.

Yet to us and to many of his contemporaries, Ingres's attempts at timelessness look timebound and even eccentrically personal. The Virgin's holy but red-cheeked and fleshy-mouthed countenance, which would reign far above our mortal eye level, has an imperious and even sensual cast that, together with the softly attenuated fingers of her hands folded in prayer, would not be out of place in one of Ingres's harems; and the pair of angels, oddly cropped in the lower quadrants, seem to wriggle with an almost puckish animation. No less disconcerting, this would-be supernatural world has the look of earthbound reality, of palpable things more likely observed in a modern church than in heaven. The chalice and oil lamps are as graspable and brassily metallic as polished Victorian liturgical objects that reflect natural light; the flames might burn our fingers; and the trio of transparent but gold-rimmed halos have the glint of stage props. As for the delicately wayward golden fringe that crosses the Virgin's blue robe, it might be excerpted from one of Ingres's contemporary portraits in which elaborate details of luxurious clothing are seen in sharpest focus.

Included in Ingres's major retrospective at the 1855 Exposition Universelle, or world's fair, where visitors would also be confronted by Courbet's counterfaith in material, here-and-now truths, *The Virgin of the Host* was meant to be a cool avowal of belief in venerable ideals of art and religion. But the subliminal contradictions that undermine Ingres's belief now tend to fascinate us more—the supernatural warring with the empirical, the petrified with the animated, the pious with the sensual. In the hands of artists of considerably lesser genius—Bouguereau, Lefebvre, Cabanel (pages 39 to 45)—such contradictions would continue to dominate and finally to undo the official religious and mythological painting that later nineteenth-century artists created under the long shadow of Ingres.

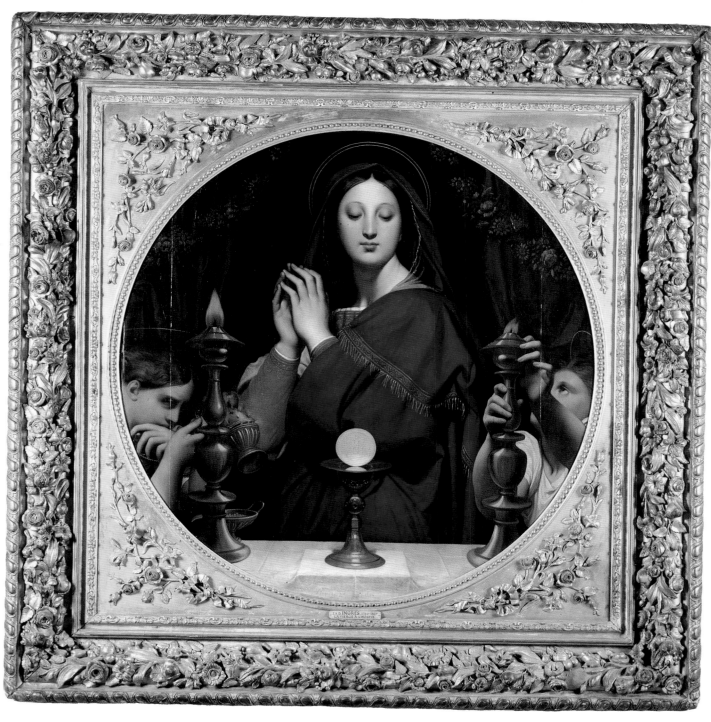

JEAN-AUGUSTE-DOMINIQUE INGRES
Montauban 1780–Paris 1867
The Virgin of the Host, 1854 (1855 Exposition Universelle)
3′ 8½″ x 3′ 8½″ (113 x 113 cm) Deposit from the Louvre. INV 20088

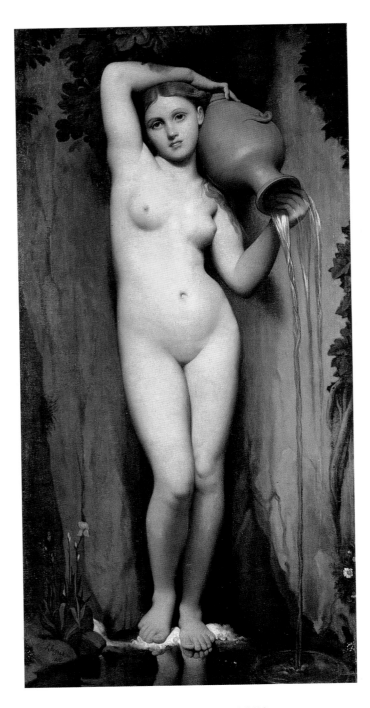

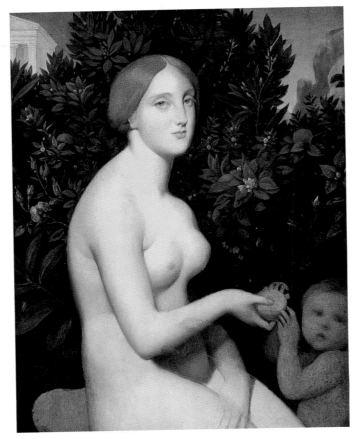

JEAN-AUGUSTE-DOMINIQUE INGRES
Venus at Paphos, 1852–1853
3′ x 2′ 3¾″ (91.5 x 70.5 cm) RF 1981-39

JEAN-AUGUSTE-DOMINIQUE INGRES
The Source, 1856
5′ 4¼″ x 2′ 7½″ (163 x 80 cm) Bequest of Countess Duchâtel, 1878.
Deposit from the Louvre. RF 219

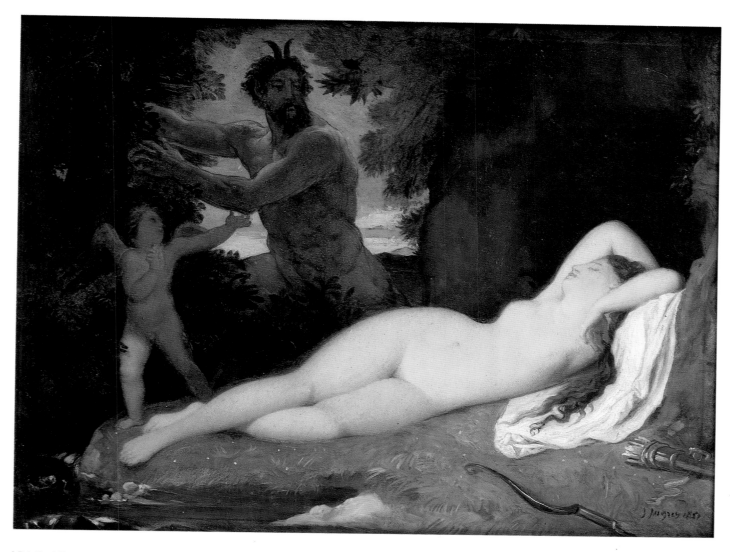

JEAN-AUGUSTE-DOMINIQUE INGRES
Jupiter and Antiope, 1851 (1855 Exposition Universelle)
1′ 1″ x 1′ 5¼″ (32.5 x 43.5 cm) Bequest of Paul Cosson, 1926.
Deposit from the Louvre. RF 2521

Eugène Delacroix
Lion Hunt, sketch

For eyes like ours, accustomed to a long tradition of abstract painting, Delacroix's large oil sketch seems a voice in the wilderness, a prophecy of the way molten brushwork and volcanic energy might convey by themselves the kind of urgent drama traditionally associated with legible narrative. With what seems an explosion of disembodied color, this sketch may easily be seen as an ancestor of Wassily Kandinsky's own dissolutions of landscape into floods of color or, later, of Jackson Pollock's immaterial coils of poured pigment. Delacroix's sketch, however, was not intended as the end product, but as a preliminary means to a finished painting that would depict one of his favorite themes: the eruption of wild animal forces barely held at bay by human intervention, a theme also seen in his later painting of Arab horses fighting in a stable (page 31) but transformed here into an Orientalist setting of savage lions attacking turbaned hunters and their rearing horses.

For us, the sketch may go in or out of focus. It may congeal into the exotic scene of high Romantic drama which, as a large completed canvas, Delacroix would include the following year in his major retrospective at the Paris Exposition Universelle of 1855 (and which would soon after, in 1870, be destroyed by fire). Or it may dissolve into a blurred, imaginative domain where a centrifugal burst of colored pigments seems enough to warrant Charles Baudelaire's comment on the exhibited painting that "never did more beautiful or intense colors pass through the funnel of the eyes to penetrate the soul." It is a remark that again might be misplaced in time as belonging to an early twentieth-century argument that emotionally satisfying painting could be achieved by color alone. Following such clues, and venerating an art that would appear spontaneous and therefore closer to instinct, twentieth-century observers may often feel that in such a sketch Delacroix is truer to himself than in a fully completed canvas destined for public view. We might guess, however, that Delacroix, like another master of vibrant preparatory oil sketches, John Constable, would probably have wanted it both ways: the sketch as a personal exploration and the finished product as a record for posterity.

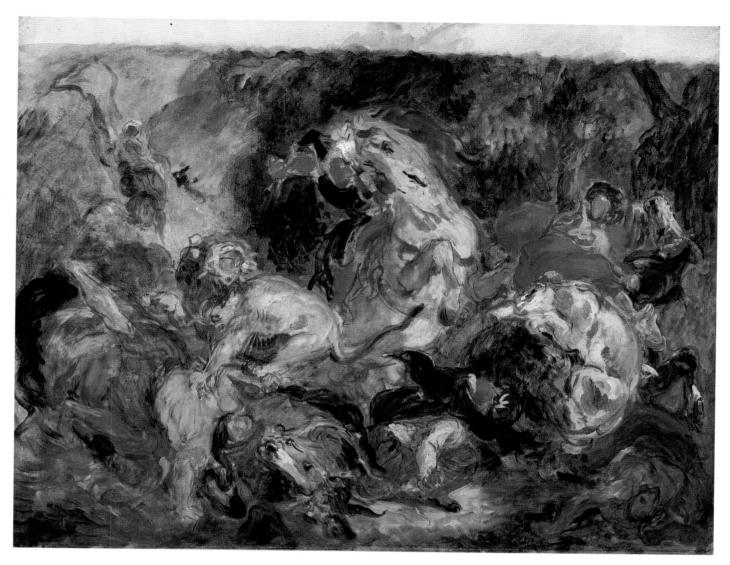

EUGÈNE DELACROIX
Charenton-Saint-Maurice 1798–Paris 1863
Lion Hunt, sketch, 1854
2′ 9¾″ x 3′ 9¼″ (86 x 115 cm) RF 1984-33

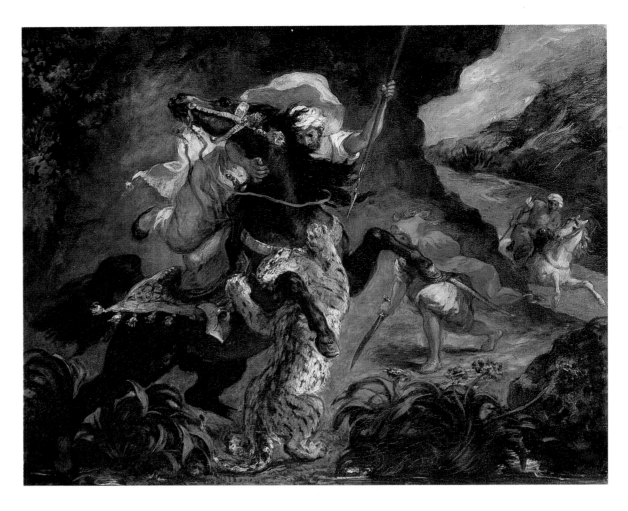

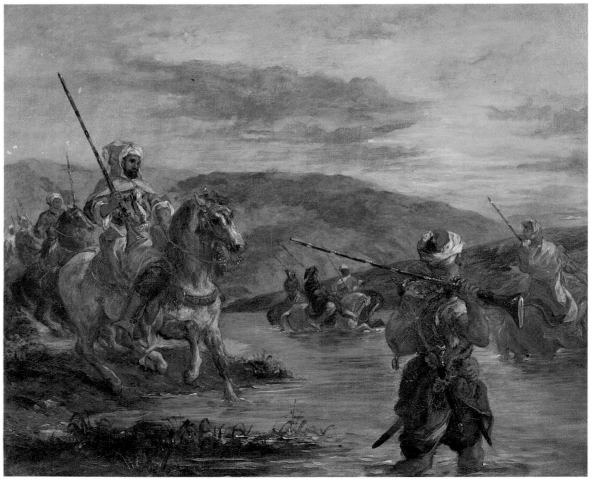

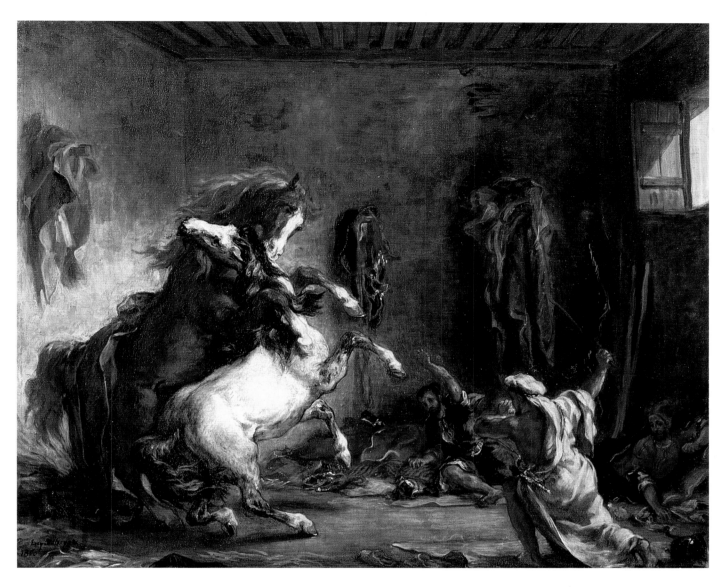

EUGÈNE DELACROIX
Arabian Horses Fighting in a Stable, 1860
2′ 1½″ x 2′ 8″ (64.5 x 81 cm) Bequest of Count Isaac de Camondo,
1911. Deposit from the Louvre. RF 1988

facing page, top
EUGÈNE DELACROIX
Tiger Hunt, 1854
2′ 5″ x 3′ ½″ (73.5 x 92.5 cm) Bequest of
Alfred Chauchard, 1909. RF 1814

facing page, bottom
EUGÈNE DELACROIX
Fording a Stream in Morocco, 1858
1′ 11½″ x 2′ 4¾″ (60 x 73 cm) Bequest of Count Isaac de Camondo,
1911. Deposit from the Louvre. RF 1987

Théodore Chassériau
The Tepidarium

*N*ineteenth-century painters, from Ingres and Delacroix to Renoir, Cézanne, and Bouguereau, could find countless pretexts for presenting an inventory of nude or semi-nude women displaying endless variations on the postures of languor. Often the pretext was that of encyclopedic erudition, providing, say, a travelogue about women's baths in Turkey or a presumably learned reconstruction of an aspect of life in ancient Greece or Rome that would permit both an education in the classics and an excursion to a world of erotic abandon alien to the surface proprieties of the nineteenth-century Parisian society that looked at art. This huge canvas by the short-lived Chassériau, a student of Ingres, is one of these.

Ever since their archaeological resurrection in the mid-eighteenth century, Pompeii and Herculaneum provided a special touchstone for artists and architects to imagine the daily life of the ancient Romans. Here Chassériau has decided to give pictorial flesh to the fantasies that must have been prompted by his visits to classical sites in Rome and the Bay of Naples in 1840 and 1841. In fact, the setting of *The Tepidarium* is a precise reconstruction of the Baths of Venus Genetrix at Pompeii, a point suggested by the painting's explanatory subtitle, *Chamber where the women of Pompeii went to relax and to dry themselves after leaving the bath.* Under the learned sanction of this vast, barrel-vaulted interior, whose roof offers an arced vista of a perfect blue Mediterranean sky, the ancient women of Pompeii, separated from their men, can disport themselves uninhibitedly. The mood is stated fully by the standing figure in the foreground who, like a Near Eastern belly dancer, stretches and writhes with guiltless sensuality in what becomes a theater of the erotic, viewed through an imaginary proscenium. Indeed it is more the ambience of the Levant, or

more precisely North Africa (which Chassériau had visited in 1846), that dominates what resembles a harem, as if the easy voluptuousness of the pagan world had somehow survived into the nineteenth century in the more remote climes of an Arab civilization. Such ideas, in fact, were familiar to French voyagers in Algeria, such as Delacroix himself, who intuited that the world of Homer was somehow still alive there. In *The Tepidarium*, the variety of skin color, from blond and olive to brown, the exotic decor of fans, of incense, of pitchers held on heads, contribute to this mélange of Mediterranean civilizations remote from the buttoned-up decorum of Second Empire Paris.

For all its moderately wanton display, Chassériau's painting also invokes noble artistic pedigrees, of a kind recalled earlier in Couture's *Romans of the Decadence* (page 23). The grandiose symmetry of the architecture, as well as many of the figure groupings, would conjure up ancestral tables that run through Poussin and Raphael. Still, the theme of a totally exclusive women's space, presented, as it were, to male voyeurs, has a peculiarly nineteenth-century flavor, and one that, in Chassériau's hands, combines, as is often said, the opposite, warring poles of Ingres's linear clarity and localized color with Delacroix's molten palette and atmospheric haze. Here this is underscored by the center basin of hot coals, which create a golden glow to warm and dry these freshly bathed bodies.

The painting's almost palpable heat can be even more clearly felt in contrast with Gérôme's preparatory study for a large painting at the Salon of 1850, *Greek Interior* (page 40). Despite its title, the scene is more Pompeian than Greek and counters a brothel-like atmosphere of provocative nudity with the icy chill of Ingres's marmoreal contours and surfaces.

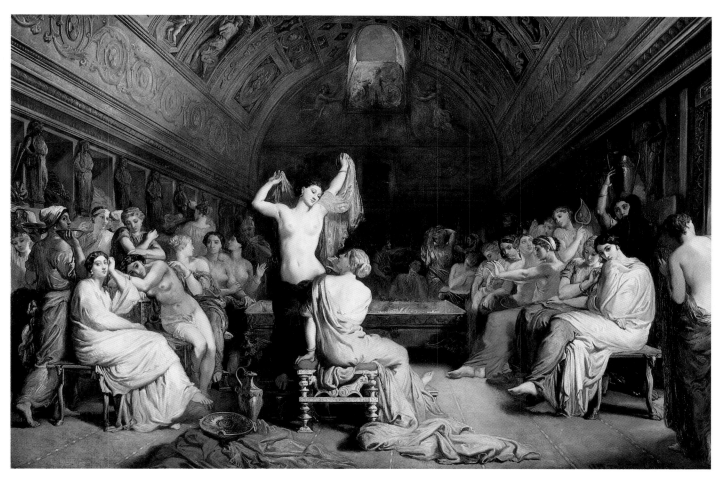

THÉODORE CHASSÉRIAU, Samana 1819–Paris 1856
The Tepidarium, 1853 (Salon of 1853)
5′ 7¼″ x 8′ 5½″ (171 x 258 cm) Deposit from the Louvre. RF 71

pages 34 and 35
THÉODORE CHASSÉRIAU
The Tepidarium, detail

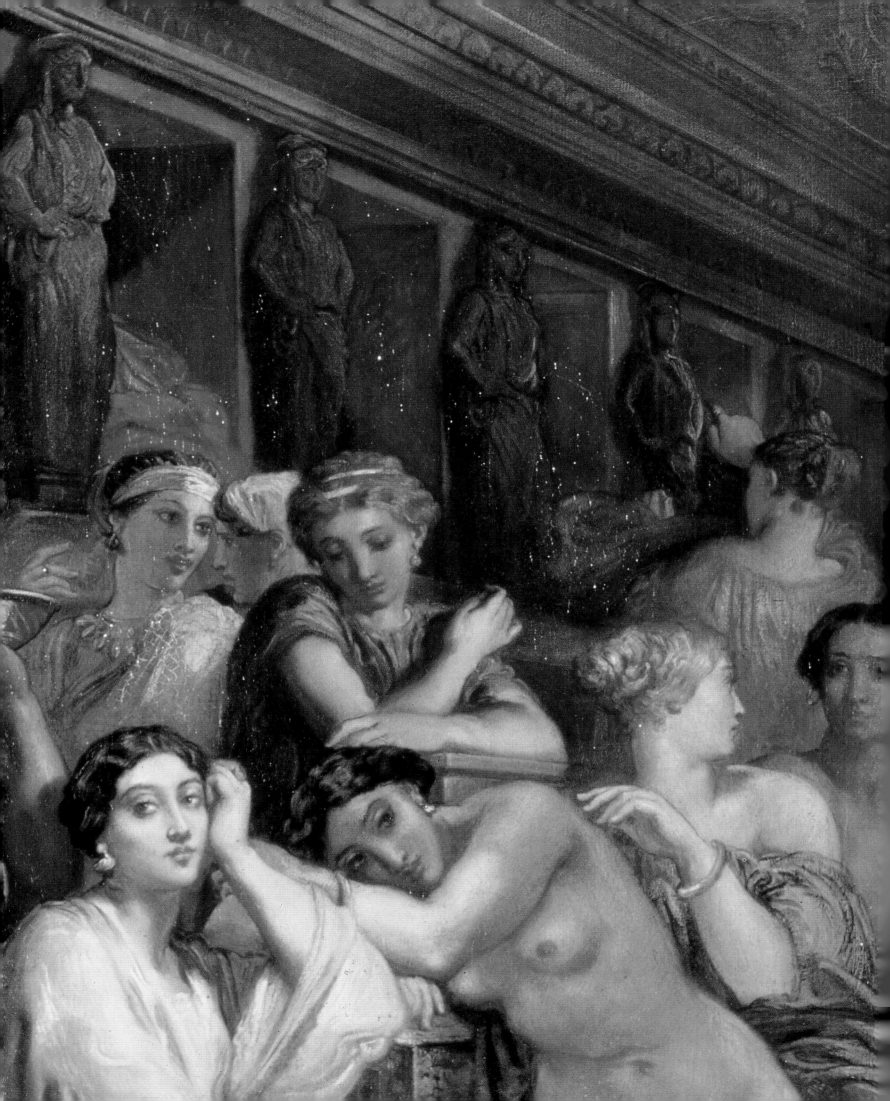

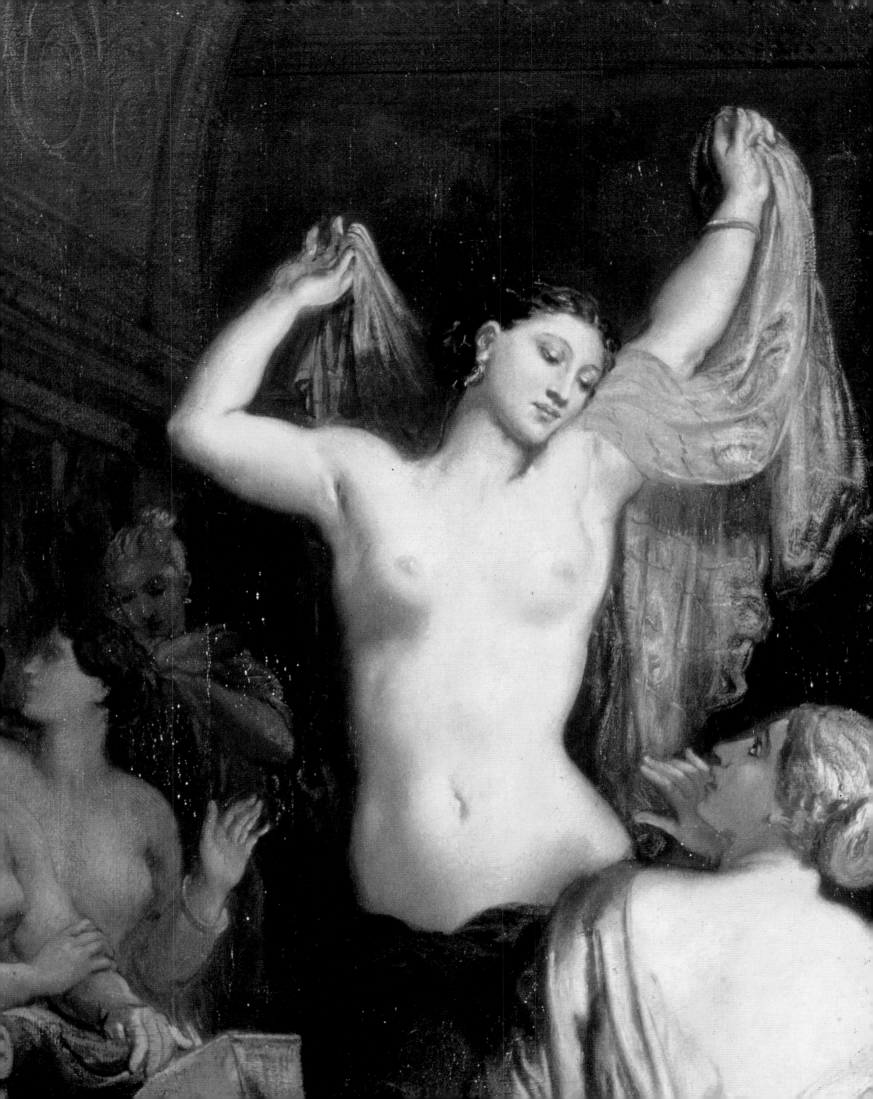

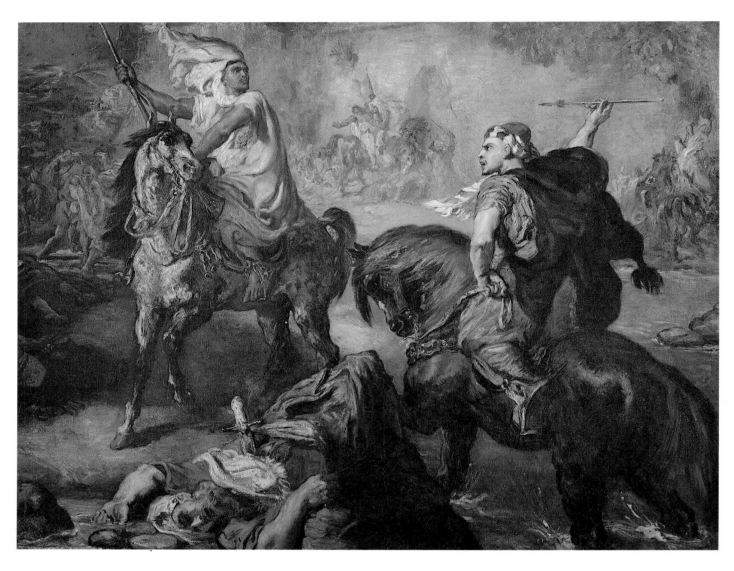

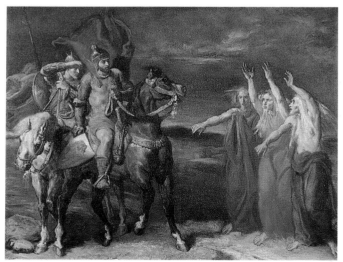

THÉODORE CHASSÉRIAU
Arab Chiefs Challenging to Combat under a City Ramparts, 1852
(Salon of 1852)
2′ 11¾″ x 3′ 10½″ (91 x 118 cm) Deposit from the Louvre. RF 2186

THÉODORE CHASSÉRIAU
Macbeth and the Three Witches, 1855
2′ 4¼″ x 2′ 11½″ (72 x 90 cm) Donated by Baron and Baroness
Arthur Chassériau, 1918. Deposit from the Louvre. RF 2213

facing page
THÉODORE CHASSÉRIAU
Sappho, 1848 (Salon of 1850–1851)
10¼″ x 8½″ (27.5 x 21.5 cm) Bequest of Baron Arthur Chassériau,
1934. Deposit from the Louvre. RF 3886

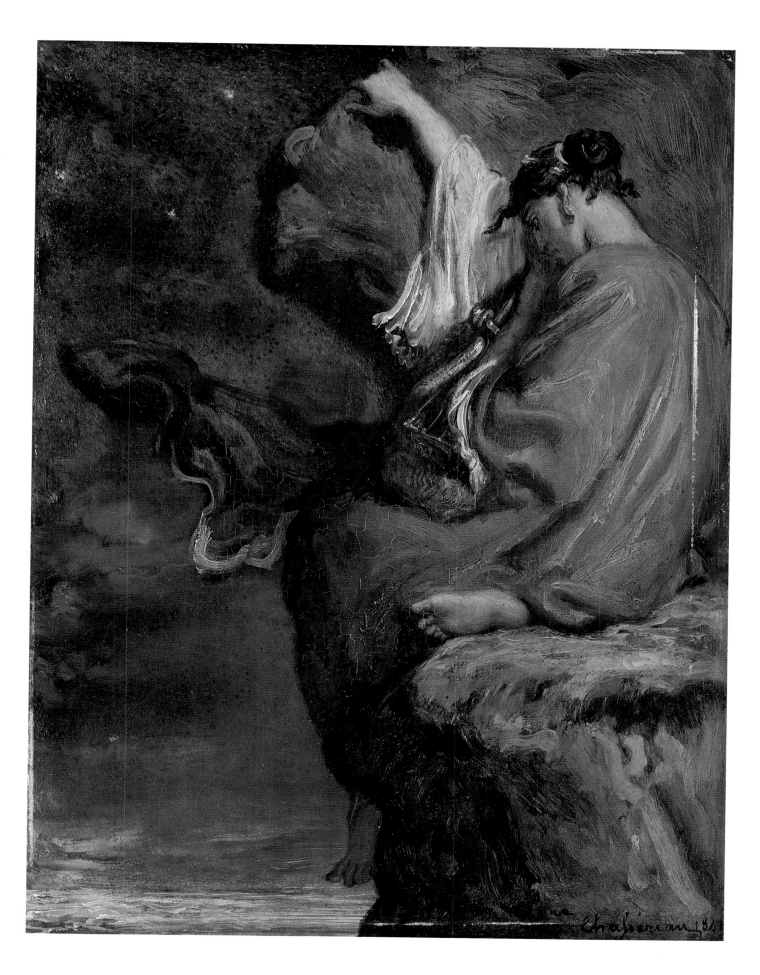

NUDES AND ALLEGORIES

Alexandre Cabanel
The Birth of Venus

*J*ustifiably, Cabanel's *Birth of Venus* has long been the textbook example of official Second Empire taste. A centerpiece of success at the Salon of 1863, it was immediately bought by Napoleon III. Like his establishment colleagues, the emperor could sanction this version of sexual pleasure while cringing in horror at Manet's depiction of the facts of life in contemporary Paris as disclosed in the *Déjeuner sur l'herbe* and *Olympia* (pages 202 and 199), both completed in the same year. Unlike Manet, who pitted his modern themes against traditional references in a parodistic way, Cabanel puts on the longest, most serious face of academic respectability as he wallows, with his spectators, in erotic delight. Here the subject has an impeccable pedigree: the newborn Venus, spewn up on the shore from Neptune's foaming sea; and the art-historical allusions as well—from the winged, conch-blowing putti to the circuitous abstract rhythms of the goddess of love—conjure up ancestral tables as recent as Ingres's idealized harem girls and as remote as Raphael's own marine fantasy, the *Triumph of Galatea*. Within this pantheon of classical tradition, however, Cabanel's Venus exudes a dream of carnal abandon and easy accessibility that corresponded to a fantasy shared by many male spectators of the period. Served up on a shell, cushioned by cascades of unbound russet hair, tilted backward from toes to bedroom eyes in supine acquiescence, this Venus hovers somewhere between an ancient deity and a modern dream of a sexual partner of perfect hygiene and compliance. Her smooth, clean flesh (depilated in groin and armpit to affirm her Greek marmoreal ancestry) is in no way challenged by mind or personality, providing an image of total passivity. Against this communal fantasy of the 1860s, Manet's tough-minded naked women, harshly alert and calculating instead of dreamily remote, must have cut like a knife.

As a vehicle of guiltless pleasure, Cabanel's nude also belongs to another period fantasy that involved, like much of Renoir's painting, the nostalgic revival of Rococo art and life-style. The pearly blues and pinks, the frolicking, airborne cherubs, the roseate sky, and the frothing curls of hair and surf all speak of the Second Empire's infatuation with Boucher and the carefree world of the *ancien régime*. But within this artifice, the palpable realities of anatomy are obtrusive, as they often are in academic nudes. Here the sense of knobby knees, sagging belly, knowingly foreshortened rib cage smacks of Cabanel's academic study of a particular model whose body conformed to the period's erotic ideals, as did the nudes who posed for the quasi-pornographic photographs of the time.

In Manet's art, the mixture of tradition and modernity produces a jolting, tonic collision; in that of Cabanel and his establishment colleagues, this dual allegiance provides a more unctuous fusion of past and present, obedient to elite but moribund ideals, yet pandering to the most commonplace erotic taste of the mid-century. It is telling that this blend of historicism and commercialized lust would be found in the decoration of many of the more expensive brothels of Paris.

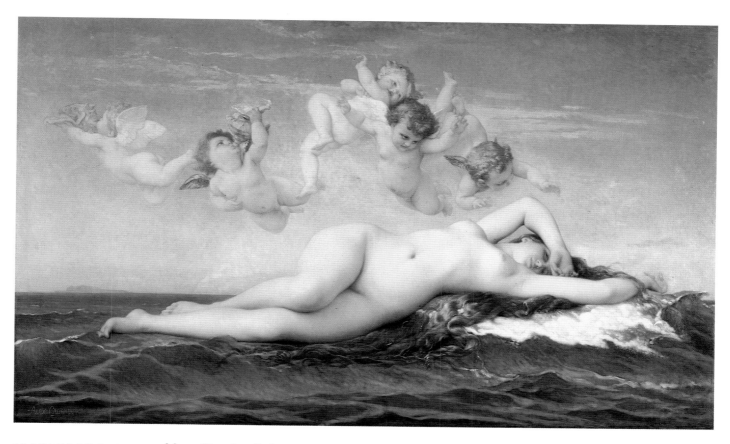

ALEXANDRE CABANEL, Montpellier 1823–Paris 1889
The Birth of Venus (Salon of 1863)
4′ 3¼″ x 7′ 4½″ (130 x 225 cm) RF 273

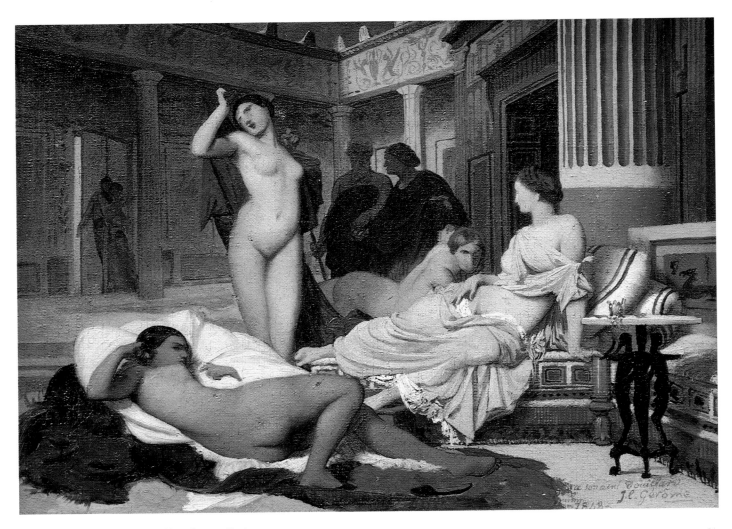

JEAN-LÉON GÉRÔME , Vesoul 1824–Paris 1904
Greek Interior, sketch, 1848
6″ x 8¼″ (15.5 x 21 cm) RF 1981-46

JEAN-LÉON GÉRÔME
The Five Parts of the World, oil study for the decoration of a
commemorative vase for the 1851 Great Exhibition in London, 1852
1′ 4¾″ x 7′ 10½″ (55 x 310 cm) Deposit from the Sèvres factory.
RF 1980

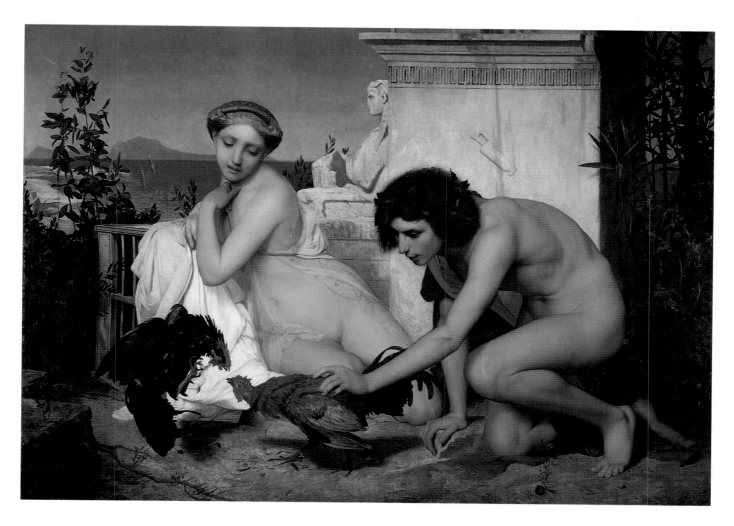

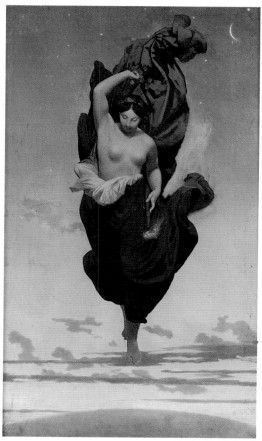

JEAN-LÉON GÉRÔME
Young Greeks at a Cockfight, 1846 (Salon of 1847)
4′ 8¼″ x 6′ 8¼″ (143 x 204 cm) RF 88

JEAN-LÉON GÉRÔME
Night, undated
2′ 6″ x 1′ 6″ (76.5 x 46 cm) RF 1984-27

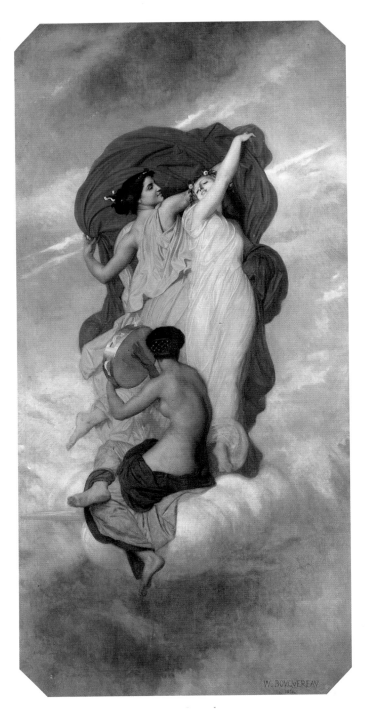

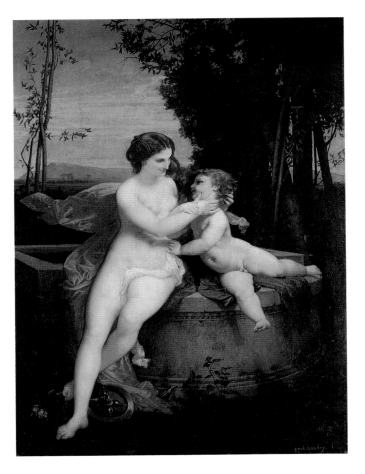

PAUL BAUDRY
Fortune and the Young Child, 1857 (Salon of 1857)
6′ 4¼″ x 4′ 9½″ (193.5 x 146 cm) RF 59

WILLIAM BOUGUEREAU, La Rochelle 1825–La Rochelle 1905
The Dance, 1856 (Salon of 1857; part of decorative ensemble for
Anatole Bartholoni's private residence)
12′ x 6′ 1″ (367 x 185 cm) Gift of Captain Peter Moore, 1981.
RF 1981-33

facing page
WILLIAM BOUGUEREAU
The Birth of Venus, 1879 (Salon of 1879)
9′ 10″ x 7′ 1¾″ (300 x 218 cm) RF 253

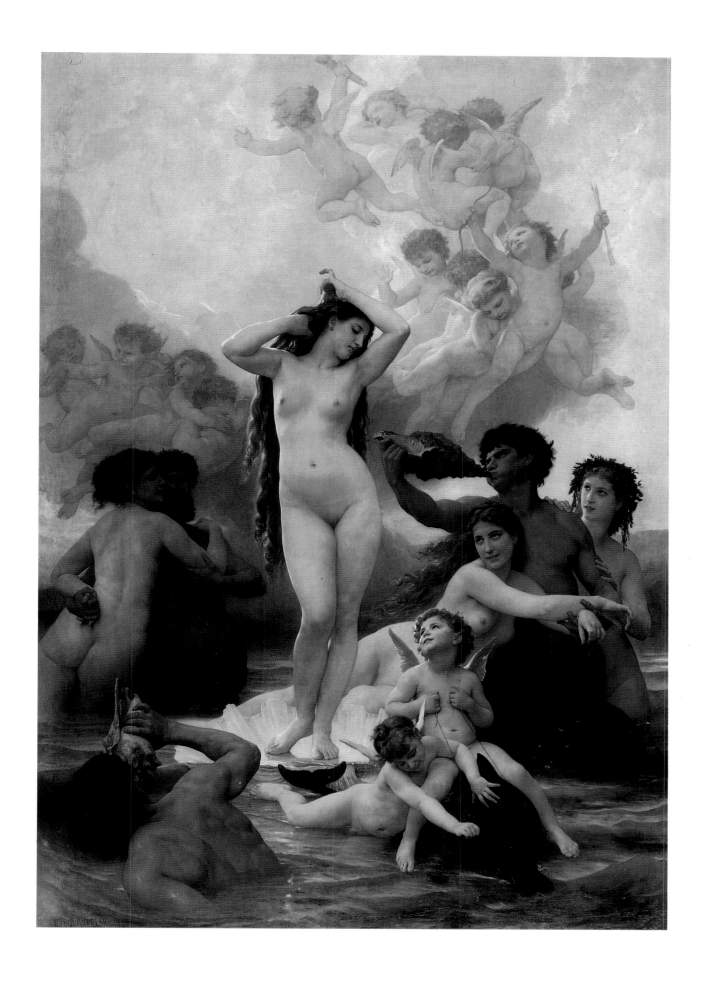

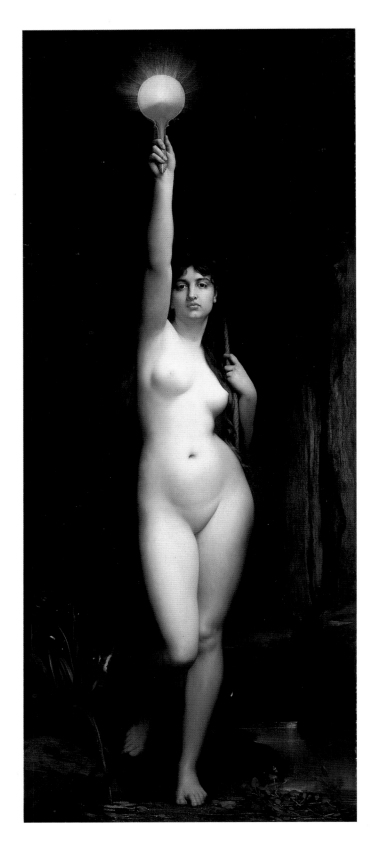

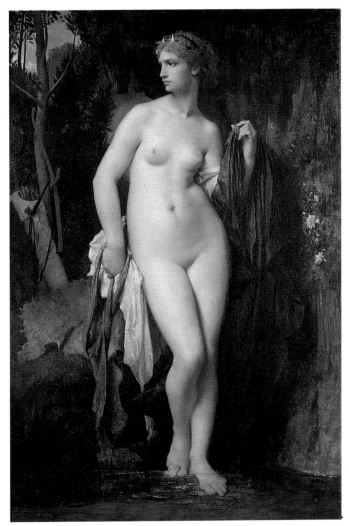

JULES-ÉLIE DELAUNAY, Nantes 1828–Paris 1891
Diana, 1872 (Salon of 1872)
4′ 11¾″ x 3′ 1″ (147 x 94 cm) RF 2712

JULES LEFEBVRE, Tournan-en-Brie 1834–Paris 1912
Truth, 1870 (Salon of 1870)
8′ 8¼″ x 3′ 8″ (265 x 112 cm) RF 1981-29

facing page
JEAN-JACQUES HENNER, Bernwiller 1829–Paris 1905
The Chaste Susannah (Susannah at the Bath) (Salon of 1865)
6′ ¾″ x 4′ 3¼″ (185 x 130 cm) RF 94

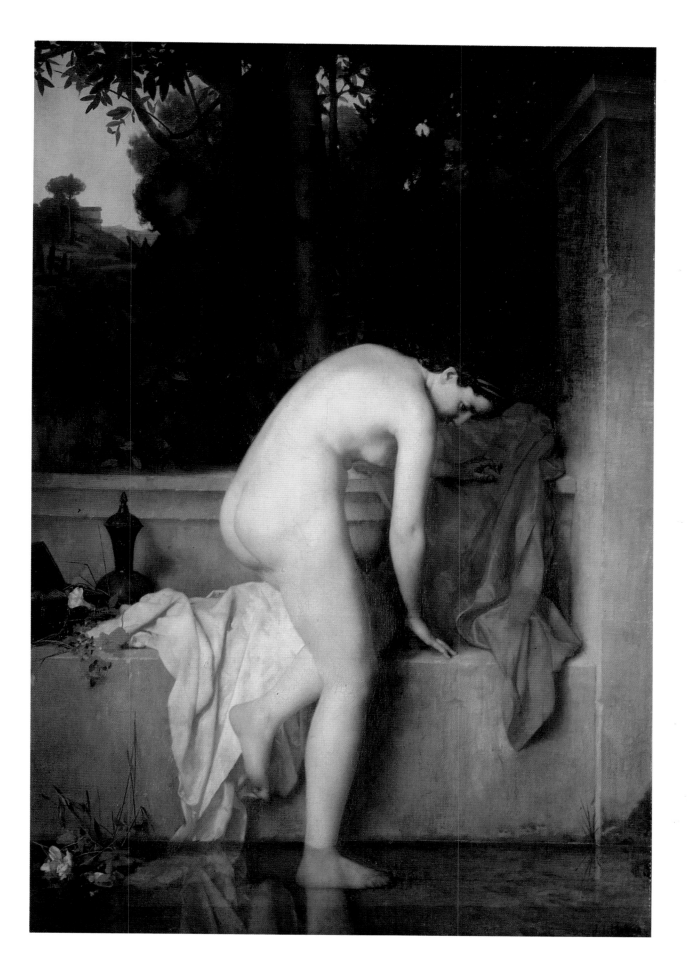

RELIGIOUS PAINTING

Christianity in an Age of Doubt

*I*n an age when religious belief was challenged from every angle—by scientists whose data cast flagrant doubts on the Scriptures, by political theorists who found the Church a force of economic suppression, by biographers who blasphemously considered Christ himself as a man who belonged only to historical time—the painting of traditional Christian subject matter was riddled with new problems. These mixed anxieties, whether displayed by uncertainty or by a passionate revival of faith, were expressed in many ways in the religious painting of the nineteenth century. For some artists—Ingres among them—the safest course was to resurrect the canonic Christian images of tradition, which meant a recycling of the old masters, with the choice of authority depending on the artist's own taste. In the case of Ingres (pages 25 to 27), it was Raphael. For Ribot, however, it was a countertradition of earthy and earthbound realism, that of seventeenth-century Spanish art, which provided secure foundations.

His *St. Sebastian, Martyr*, a huge success at the 1865 Salon, at which Manet himself exhibited the second of his two Spanish-style paintings of Christ's martyrdom, is clearly based on the example of Jusepe Ribera, whose star was high among artists of a Realist bent. Thanks to its obvious reference to this old master, its potentially shocking Realism—the proximity of a coarse, unscrubbed model receiving medical first aid from a no less proletarian St. Irene—looked less offensive; and the halo above the arrow-pierced St. Sebastian, just visible in the murky shadows, must also have helped elevate it to a more exalted level. Another supine martyrdom, that of Christ, was shown by Henner at the 1879 Salon. Here the artist explored the naturalistic component of a supernatural subject with reference to the authority of similar paintings by Holbein and Philippe de Champaigne as well as to a Caravaggesque tradition of such intense lighting that it can help the spectator cross the boundaries between earth and heaven. Still, the sense of a particular, gravity-bound studio model remains, demanding an act of faith or an act of art-historical recognition to make the imaginative leap to a convincing image of the martyred Christ.

For many nineteenth-century painters, Christian subject matter was translated into the depiction of time-bound events in the history of Christianity. Faith was placed in the chronology of Western civilization, blurring the boundaries between history painting and religious painting, as Delaunay had done in his *Plague in Rome* (page 55). At the 1855 Salon, Lenepveu reconstructed the earliest days of Christian worship when martyrs, already endowed with halos, were solemnly and secretly buried in the catacombs (page 49). His choice of a friezelike marmoreal figure style coolly irradiated by light from the natural heavens above was a perfect vehicle for depicting the moment of transition from the classical to the Christian world. And to bring this Catholic chronicle up-to-date, Lenepveu also exhibited at the 1855 Salon a scene of the Sistine Chapel presided over by Pope Pius IX, who a year earlier had declared the dogma of the Immaculate Conception.

At the 1855 Salon, Benouville's success from the 1853 Salon was exhibited again. This reconstruction of thirteenth-century piety shows us the dying St. Francis carried on a litter

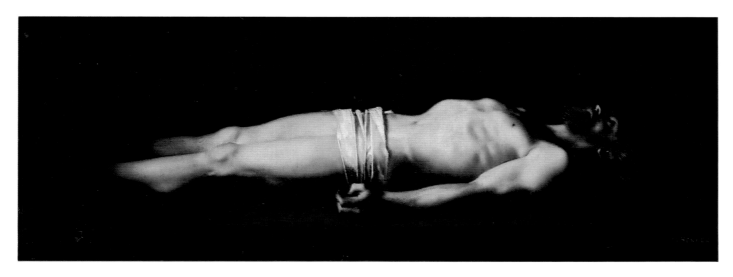

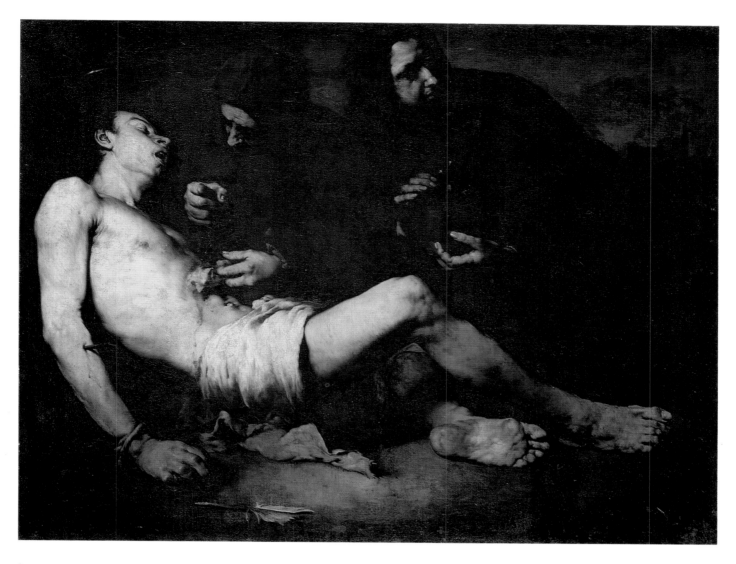

by a group of Franciscan monks to Santa Maria degli Angeli, from which holy spot he blesses the town of Assisi (page 49). The serene simplicity of the painting, with its faraway vista of a shrine of Christendom, produced a fairy-tale ambience perfectly suited to this mix of historical narrative and an implied avowal of faith for the modern world.

For other painters, Christian themes could trigger wilder tangents of the imagination. Isabey's *Temptation of St. Anthony*, seen at the 1869 Salon (page 50), is less the story of a saint's trials than a bombastic, feverish orgy of diabolical temptresses who look like a major Rubens altarpiece seen through a lens that has been warped by nineteenth-century sexual repression. It was the kind of private erotic fantasy in public guise that had a long issue in later painting, from the works of Cézanne, who was also attracted to this theme (page 355), to the countless femmes fatales of the 1890s.

Most astonishing as a gargantuan private construction on a Christian theme is the mammoth *Divina Tragedia* by Chenavard, which was seen at the same Salon as Isabey's *Temptation*. It was, in effect, a philosophical and religious work whose exposition was offered on canvas instead of in a treatise and whose multiple personages include everybody from Adam and Eve and the Virgin Mary to Hercules and Thor. Despite the long explanation in the 1869 Salon catalogue, the audience read the painting in contrary ways. Some saw it as the luminous triumph of Christianity, symbolized by the Holy Trinity, over evil; others considered it a statement about the ultimate collapse of all religions. It was a perfect symbol of the nineteenth century's encyclopedic view of history, religion, and myth as well as of the era's teetering balance between public and private visions of faith.

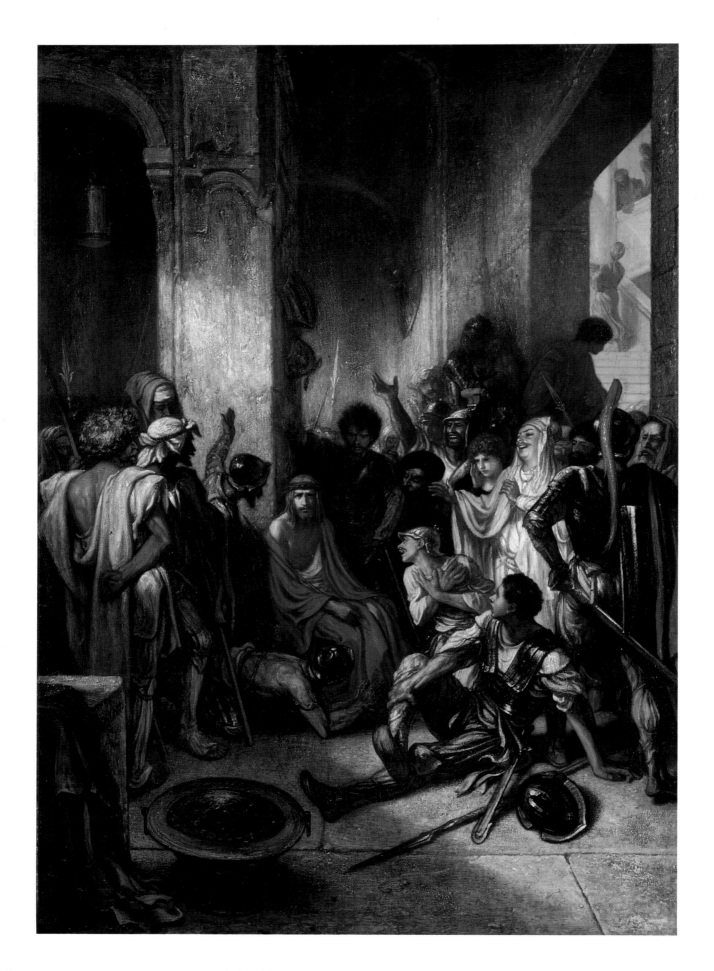

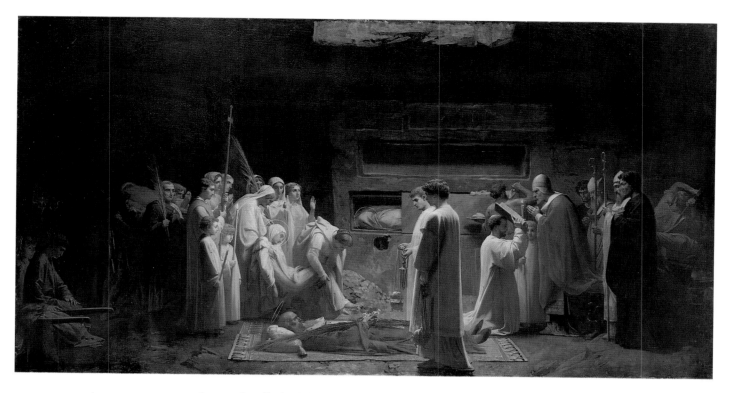

JULES-EUGÈNE LENEPVEU, Angers 1819–Paris 1898
The Martyrs in the Catacombs, 1855 (Exposition Universelle, 1855)
5′ 7″ x 11′ ¼″ (170 x 336 cm) RF 102

facing page
ALEXANDRE-GABRIEL DECAMPS
Christ at the Praetorium, 1847
4′ 8¾″ x 3′ 5¼″ (144 x 104.5 cm) Bequest of Alfred Chauchard, 1909.
RF 1813

LÉON BENOUVILLE, Paris 1821–Paris 1859
St. Francis of Assisi, Carried Dying to Santa Maria degli Angeli,
Blesses the City (1226), 1853 (Salon of 1853)
3′ ½″ x 7′ 10½″ (93 x 240 cm) Deposit from the Louvre. MI 9

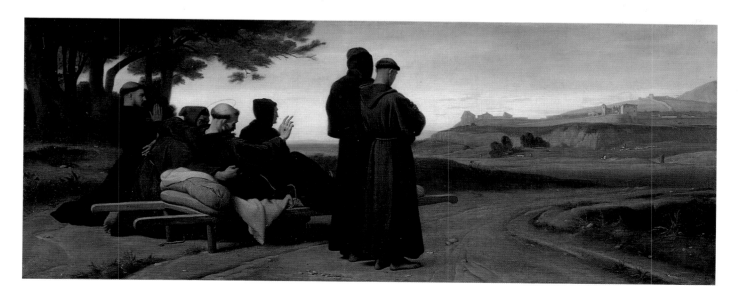

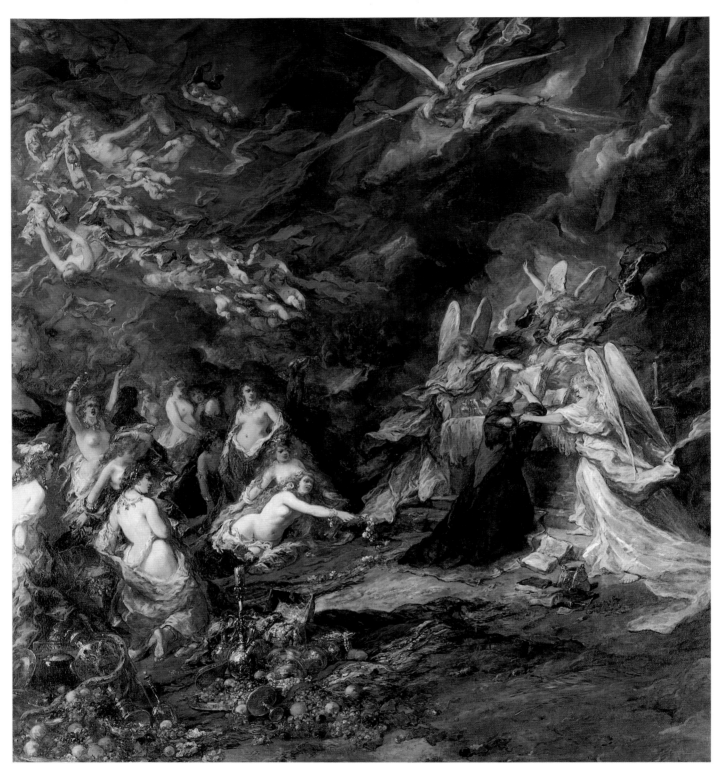

EUGÈNE ISABEY, Paris 1803–Montévrain 1886
The Temptation of St. Anthony (Salon of 1869)
11′ 4½″ x 10′ 2″ (347 x 310 cm) Gift of Société des Amis d'Orsay,
1982. RF 1982-57

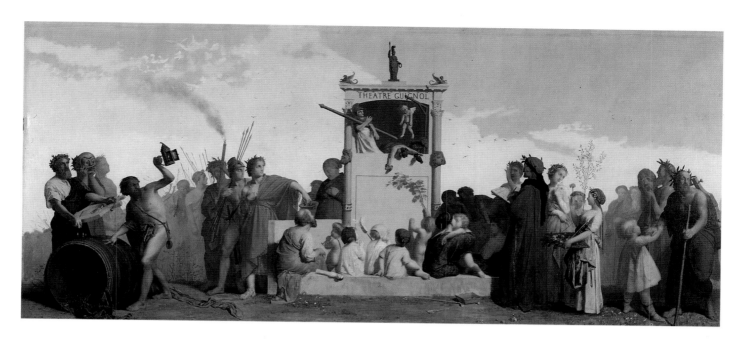

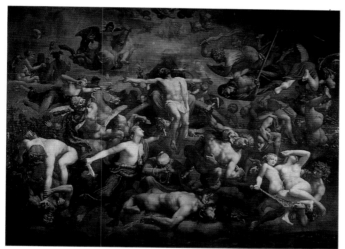

JEAN-LOUIS HAMON, Plouha 1821–Saint-Raphaël 1874
The Human Comedy, 1852 (Salon of 1852)
4′ 7″ x 10′ 4″ (140 x 315 cm) INV 5279 bis

PAUL CHENAVARD, Lyons 1807–Paris 1895
Divina Tragedia (Salon of 1869)
13′ 1½″ x 18′ ½″ (400 x 550 cm) INV 20635

page 52
FRANÇOIS-LOUIS FRANÇAIS, Plombières 1814–Paris 1897
Orpheus, 1863 (Salon of 1863)
6′ 4¾″ x 4′ 3¼″ (195 x 130 cm) RF 85

page 53
ÉMILE LÉVY, Paris 1826–Paris 1890
Death of Orpheus, 1866 (Salon of 1866)
6′ 2½″ x 3′ 10½″ (189 x 118 cm) RF 103

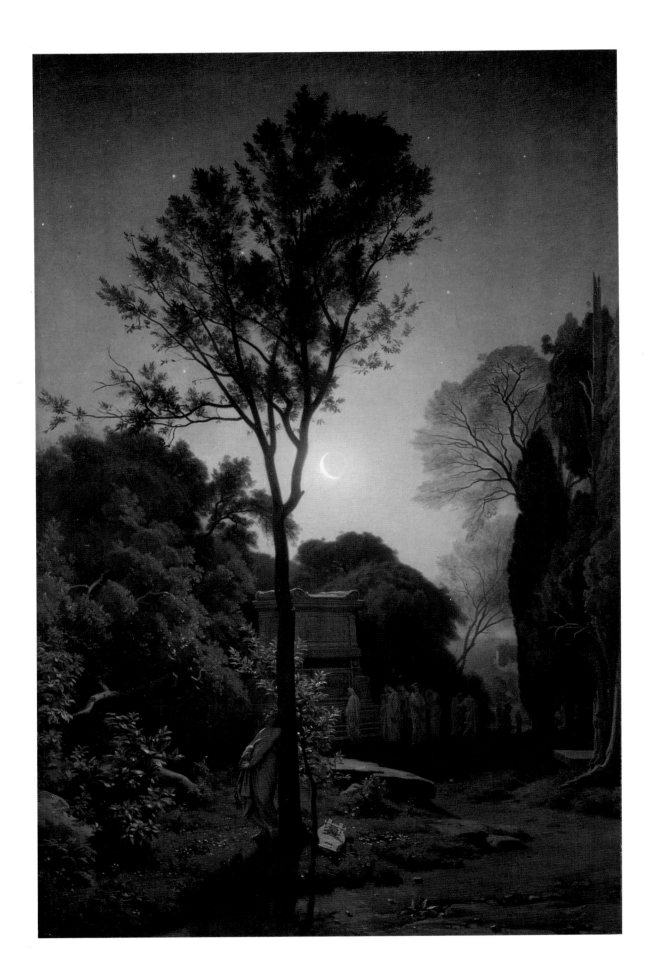

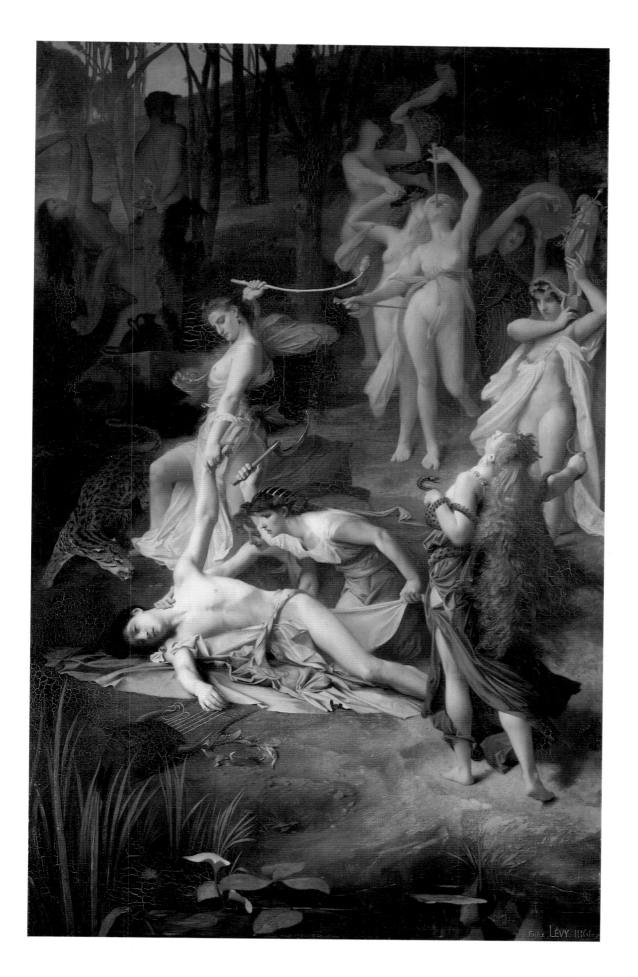

VISIONS OF THE HISTORICAL PAST AND PRESENT

Jules-Elie Delaunay
The Plague in Rome

*T*he traditional concept of history painting—the depiction of noble narratives from the Bible or from classical mythology and history—became ever more encyclopedic by the mid-nineteenth century. Painters, like stage designers, attempted to reconstruct with maximum accuracy almost any epoch, from the prehistoric past to the military present. A typical example of this expanding repertory is Delaunay's *Plague in Rome*, a huge success at the 1869 Salon, where critics praised both its grandiose drama, as if it were an operatic production, and what they called its science, as if it were a scrupulously erudite account of an event in the early Christian era.

As materialized by Delaunay, that event is both historical and supernatural, a merger of hard archaeological fact and fanciful fictions familiar to most official painting of high-minded subjects. The theme here is inspired by both history and art history. It illustrates a narrative from *The Golden Legend* (a thirteenth-century compilation of saints' lives by the Italian Jacobus de Varagine) that tells of how, during the Roman plague of 680, a good angel commanded a bad angel to strike the doors of the godless with a spear, indicating by the number of knocks how many deaths there should be within the home.

During his own sojourn in Rome, as a pensionnaire at the French Academy, Delaunay had come upon a fresco in San Pietro in Vincoli depicting a Renaissance pope praying for the end to a plague. He then set out to dramatize a literary account of another Roman plague with a stage-set pastiche of actual Roman monuments, from the statue of Marcus Aurelius to the stairs of the Ara Coeli. The horror was meant to shock, and it did. We are pressed into the middle of this ancient street of pagans and Christians now littered, left and right, with the agonized bodies of the dead and the dying. Through the murky, insalubrious atmosphere we see minuscule figures fleeing in terror, as the pair of vengeful angels wreak Christian justice. Alien as this may seem to the Paris of 1869, it should be remembered that epidemics, especially cholera, were recurrent in nineteenth-century France, as elsewhere, and that, as with all such human disasters, a religious explanation of sinful transgression could easily be provided. In this way, Delaunay's painting subliminally asserted Christian faith in an age of scientific doubt—the negative counterpart to earlier scenes of Christ and saints miraculously curing the plague-stricken. This image of divine retribution, however, smacks of terrestrial truth, and we almost sense that the good angel, in order to defy gravity, must be suspended by a wire between its stage-prop wings.

It is this feeling of empirical observation that permeates and, for many, adulterates most of these studied resurrections of historical past and present. In Laurens's account of the power of the Church before the millennial year 1000— *The Excommunication of Robert the Pious*, shown at the 1875 Salon (page 56)—we almost feel, as in the paintings by Degas shown at the contemporary Impressionist group shows, that we have wandered obliquely into a private chamber, which, like Delaunay's street scene, creates a space that extends in all directions, embracing the spectator within its fragmented confines. Instead of ballet dancers, we find the heretical king who had rejected his first wife in order to marry the woman who cringes with him here before the large smoking candle on the floor. This symbol of excommunication is presented in as literal and time-bound a way as the smoking cigarettes in a café scene by Renoir or Manet.

All of history was at the command of these official painters. We are not only on-the-spot spectators at the arrival in 1567 of the Duke of Alba at Rotterdam (page 56) but we are also thrust into the Revolutionary streets of Paris in 1793 to watch Charlotte Corday being arrested as she leaves the murdered Marat's rooms (page 57). Even the Napoleonic saga could be frozen in cinematic stills, whether from the world of Napoleon I or of his nephew, Napoleon III, under whose imperial reign these history paintings flourished as never before. The popular Meissonier, whose sharp-focus miniaturist technique would one day earn him the praise of Salvador Dalí, could cover this dynasty in two paintings he showed at the 1864 Salon. In one, we see Napoleon I in the last tragic year of his power, 1814, as he leads his troops in somber but heroic defeat (pages 60–61); in the other, his nephew, Napoleon III, leads his troops at the bloody Battle of Solferino in 1859, which resulted in a peace agreement with the Austrian enemy. Before these meticulously detailed accounts of what looks like photographic truth, it was difficult not to believe the authenticity of Meissonier's reportage of the glories of the battlefield,

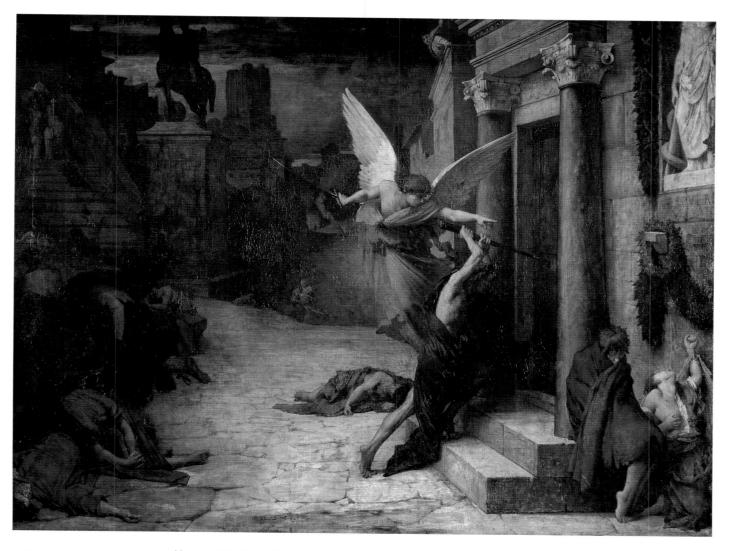

JULES-ELIE DELAUNAY, Nantes 1828–Paris 1891
The Plague in Rome, 1869 (Salon of 1869)
4' 3½" x 5' 9¼" (131 x 176 cm) RF 80

even in defeat. (The rare opposite side of this coin can be seen in the flamboyant painted sketches of contemporary historical events by the sculptor Carpeaux, who depicted headline events of the times—the 1867 attempt to assassinate Czar Alexander II and the 1871 shooting of a Parisian archbishop under the Commune on page 62—with such sputtering, agitated pigment that we experience a heated abstraction of Romantic drama more than a legible document of a particular time and place.)

Art history, too, was susceptible to reconstruction. Meissonier himself, with his penchant for diminutive scale, often re-created the cultivated life of the eighteenth century. In some canvases, connoisseurs, smiling readers, and elegant hunting parties pose with the delicate, casual grace of figures in the newly esteemed painting of the Rococo period (page 59). The results are like frames from a historical

movie, in which we are privy to nostalgic scenes of domestic life in pre-Revolutionary France. And providing an unusual and curious document of this art-historical resurrection of the eighteenth-century past is Philippe Rousseau's homage, from the 1867 Salon, to the bespectacled Chardin (page 58). His grandly framed self-portrait, like a holy but accessibly down-to-earth cult image, is surrounded by a palpable inventory of the very objects—from plums and peaches to copper and porcelain vessels—that are found in the master's still lifes, as if a waxworks tableau had been made of his studio. To be sure, other painters of the period—not the least Manet—would also be inspired to honor Chardin not as an embalmed historical deity but as a living inspiration for rejuvenating the art of still life in a fresh, contemporary language.

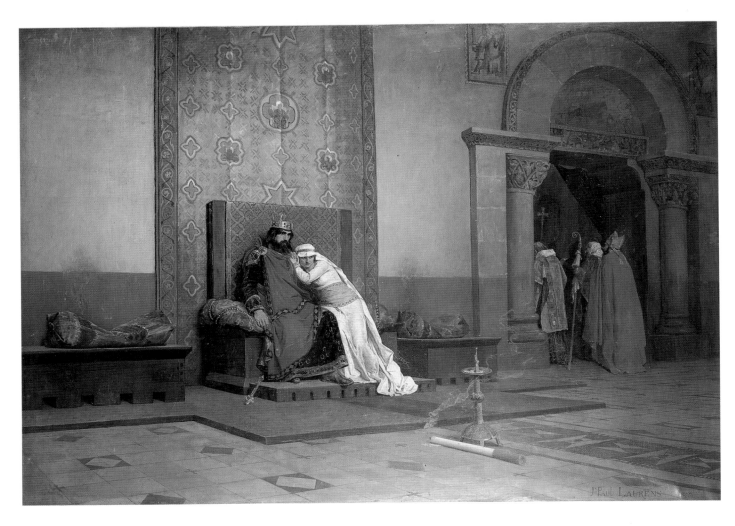

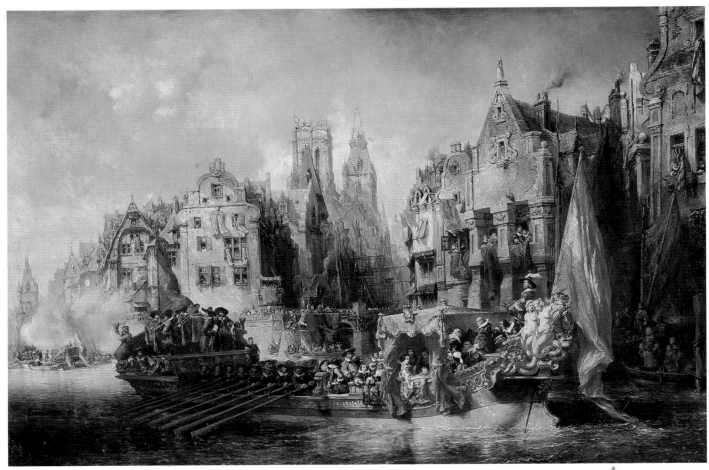

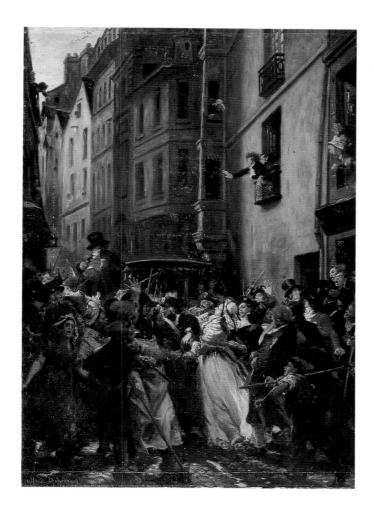

ALFRED DEHODENCQ, Paris 1822–Paris 1882
*The Arrest of Charlotte Corday after the Murder of Marat
(July 13, 1793)*, 1853 (Salon of 1868)
4′ 6″ x 3′ 3¼″ (137 x 100 cm) RF 1508

facing page, top
JEAN-PAUL LAURENS, Fourquevaux 1838–Paris 1921
The Excommunication of Robert the Pious, 1875 (Salon of 1875)
4′ 3¼″ x 7′ 1¾″ (130 x 218 cm) RF 151

facing page, bottom
EUGÈNE ISABEY, Paris 1803–Montévrain 1886
Arrival of the Duke of Alba at Rotterdam (1567), 1844
3′ 1″ x 4′ 8″ (93.5 x 142.5 cm) Bequest of Alfred Chauchard, 1909.
RF 1840

OCTAVE PENGUILLY-L'HARIDON, Paris 1811–Paris 1870
*Roman Villa Built on the Foothills of the Dauphinois Alps Shortly after
the Conquest of the Gauls*, 1870 (Salon of 1870)
4′ 3½″ x 6′ 10″ (131 x 208 cm) INV 20113

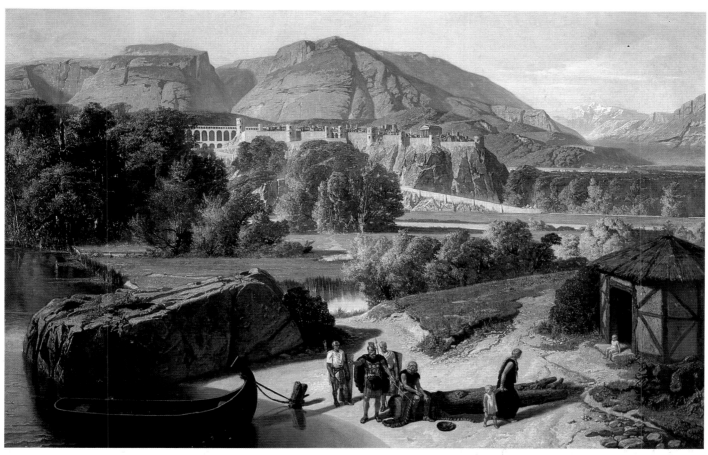

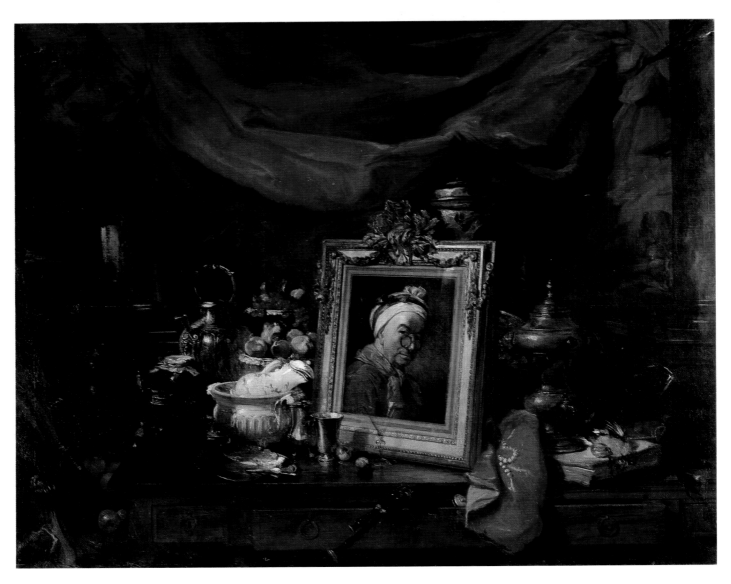

PHILIPPE ROUSSEAU, Paris 1816–Acquigny 1887
Chardin and His Models, 1867 (Salon of 1867)
5′ 10″ x 7′ 5″ (177.5 x 226 cm) RF 1983-97

facing page, top left
ERNEST MEISSONIER, Lyons 1815–Paris 1891
The Reader in White, 1857
8½″ x 6″ (21.5 x 15.5 cm) Bequest of Alfred Chauchard, 1909.
RF 1852

facing page, top right
ERNEST MEISSONIER
The Lovers of Painting, 1860 (Salon of 1861)
1′ 2″ x 11¼″ (35.5 x 28.5 cm) Bequest of Alfred Chauchard, 1909.
RF 1855

facing page, bottom
ERNEST MEISSONIER
At the Relay Station (Relay Station in The Forest of Saint-Germain), 1860
6¾″ x 9″ (17 x 23 cm) Bequest of Alfred Chauchard, 1909. RF 1856

pages 60 and 61
ERNEST MEISSONIER
The Campaign in France, 1814 (Salon of 1864)
1′ 8¼″ x 2′ 6″ (51.5 x 76.5 cm) Bequest of Alfred Chauchard, 1909.
RF 1862

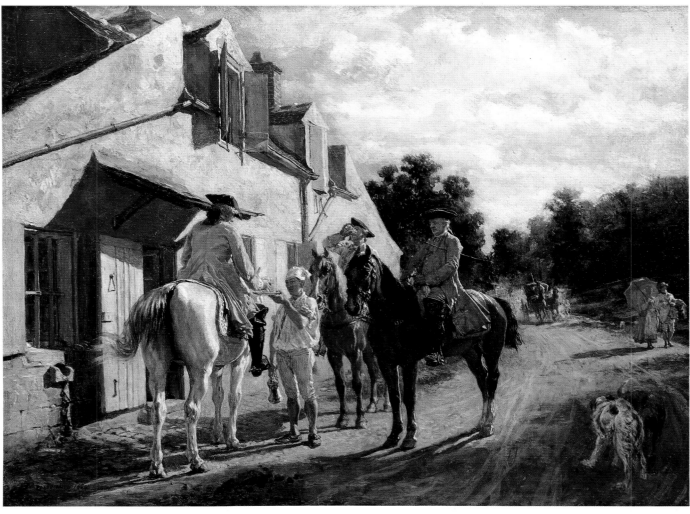

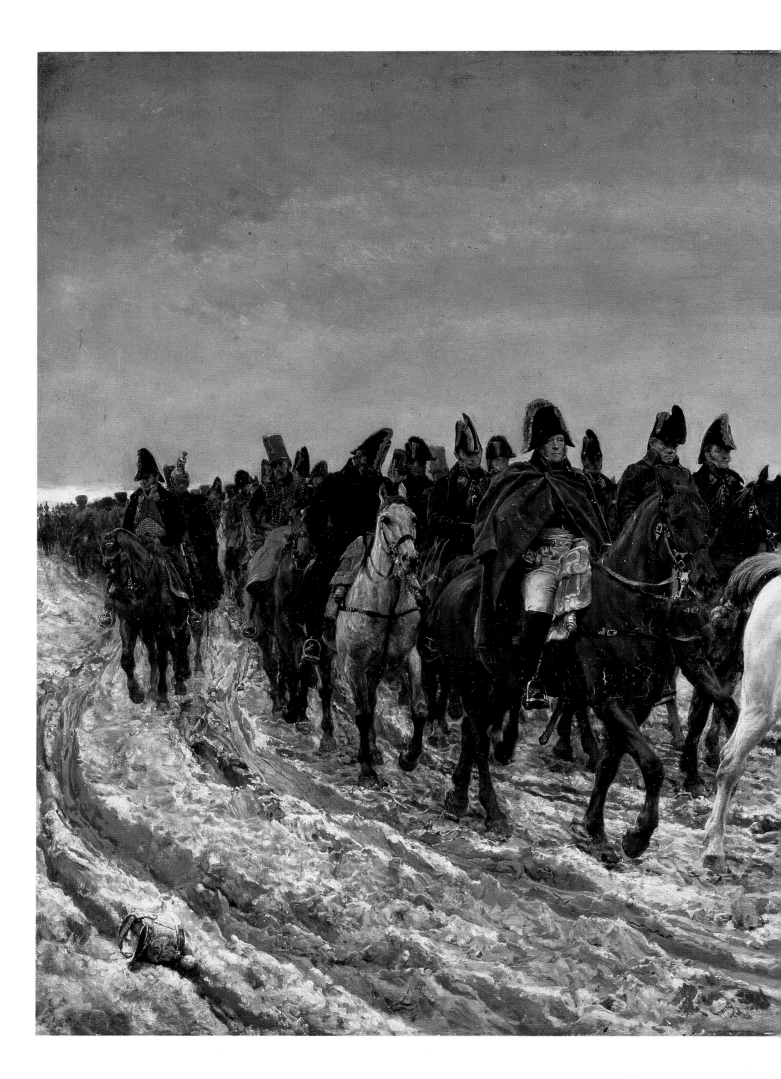

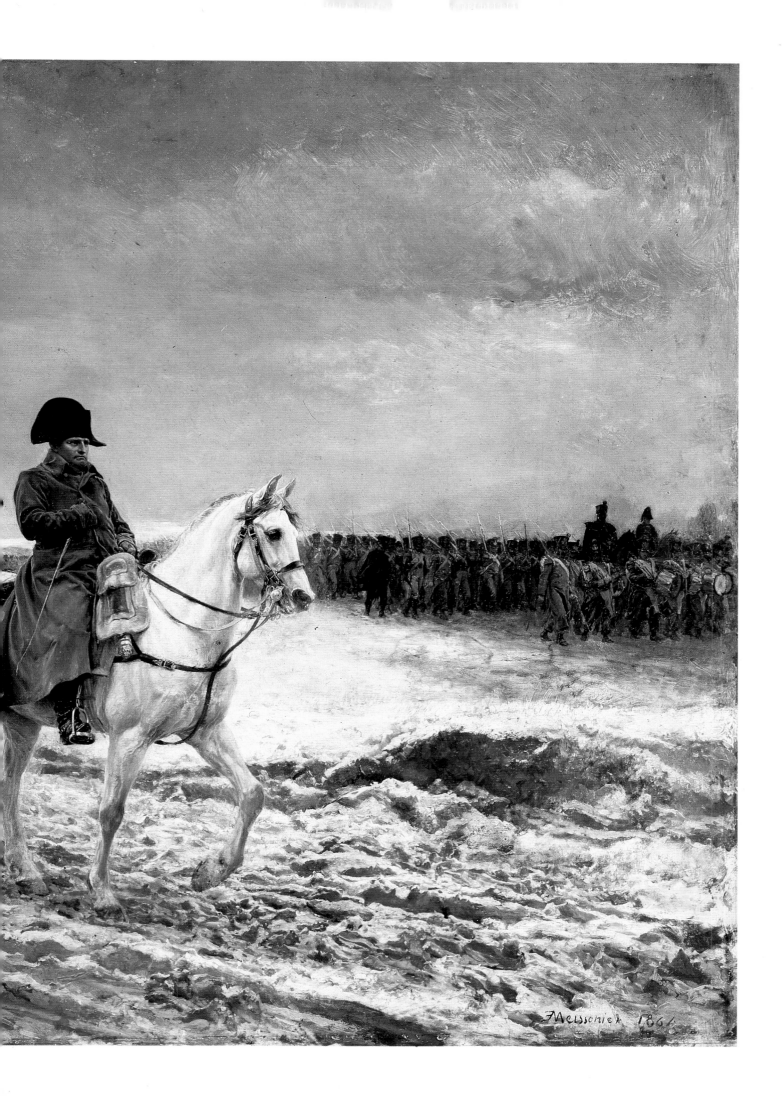

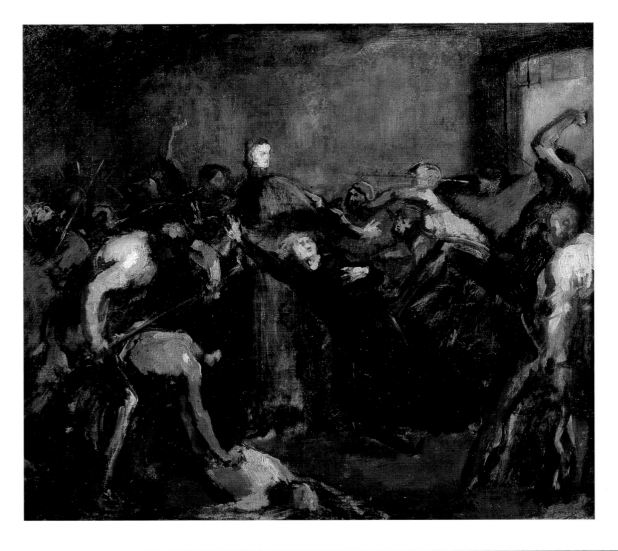

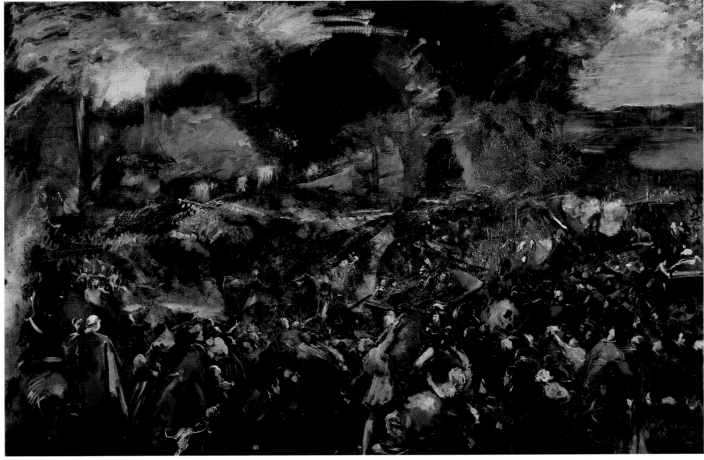

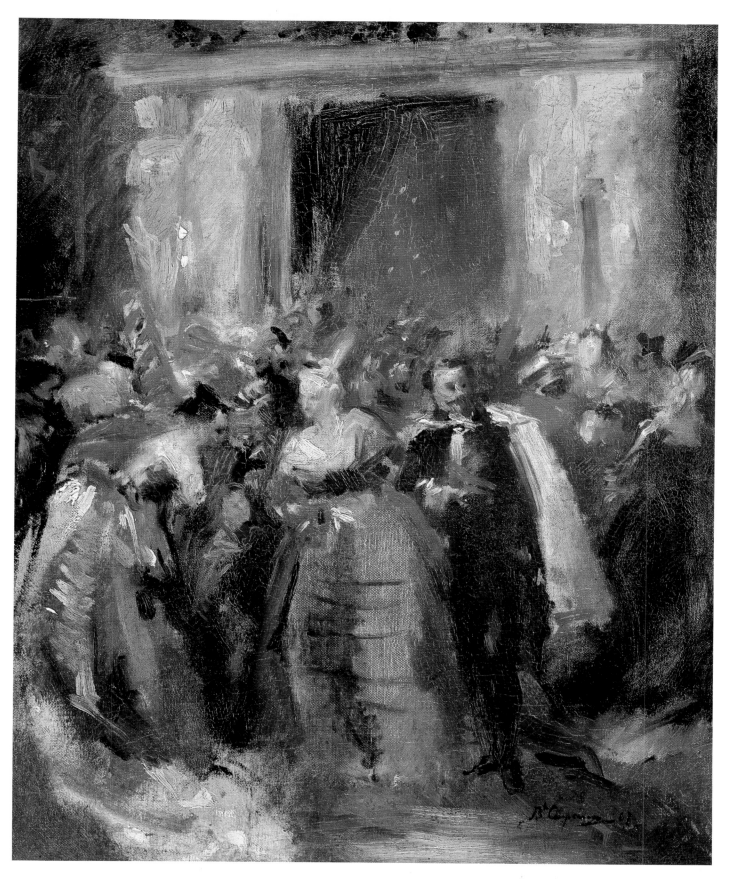

facing page, top
JEAN-BAPTISTE CARPEAUX
Monseigneur Darboy in His Prison (archbishop shot by Commune,
May 24, 1871), 1871
1′ 10½″ x 2′ 2¾″ (57 x 68 cm) RF 1985-19

facing page, bottom
Berezowski's Assault on Czar Alexander II (June 6, 1867), 1867
4′ 3¼″ x 6′ 4¾″ (130 x 195 cm) RF 1598

JEAN-BAPTISTE CARPEAUX
Valenciennes 1827–Courbevoie 1875
Costume Ball at the Tuileries Palace (Napoleon III and the Comtesse de
Castiglione), 1867
1′ 10″ x 1′ 6″ (56 x 46 cm) RF 1600

Portraits

Charles Carolus-Duran
Lady with a Glove
(Mme. Carolus-Duran)

*C*arolus-Duran's elegantly artificial fashion plate of his wife, Pauline, perfectly sums up public ideas of feminine decorum and costume in the official portraiture of the 1860s and 1870s. As many critics observed, the pose and expression are noble, even slightly victorious, though the detail of the glove dropped on the dark green carpet adds a desirable note of female coquetry to this otherwise haughty and imposing figure, soberly dressed in black. And the painting could earn respect, too, for its craftsmanlike solidity and seriousness, upholding traditions of Ingres's portraits that would omit no detail of clothing, jewelry, or setting to produce a glossy mirror of the female pillars of contemporary society. For some, this icon of drawing-room charm and propriety was a bit too austere; and it was exactly the more abstract components—the severe horizontal clarity of the dado and the flat starkness of the wall plane behind—that could offend eyes accustomed to more luxurious and padded settings. But from our distance, *Lady with a Glove*, as it became known, may offer the happy combination of a time-bound period piece—the equivalent of a Second Empire fashion illustration—and a more enduring pictorial achievement that is almost Whistlerian in its restricted range of nearly colorless tonalities and its spare, geometric skeleton.

Such an ideal of elegant, at times unapproachable, womanhood was often repeated in the more formal portraits of the period. These spanned an emotional range that could encompass sphinxlike mystery, as in Amaury-Duval's 1862 portrait of Mme. de Loynes (page 67); sultry, bejeweled temptation, as in Cabanel's 1873 portrait of the Comtesse de Keller (page 70); theatrical grandeur, as in Bonnat's depiction of the actress Mme. Pasca, from the 1875 Salon (page 71); or a dignified public view of private grief, as in Delaunay's portrait of the widow of Georges Bizet, exhibited at the 1878 Salon, three years after the composer's death (page 71). (She would, however, remarry, this time a famous lawyer.)

As a surprising countercurrent to these posturing and meticulously detailed official portraits, the same painters would often perform off duty in more casual, intimate glimpses of the friends and relatives in their immediate

entourage. Carolus-Duran himself looks like an entirely different painter in his more ruffled, snapshot views of the heads of his artist-friends—Fantin-Latour and Oulevay, Zacharie Astruc (page 66); and his fragmentary, cropped record of a convalescent propped up on a pillow, his eyes closed, his shirt wide open (page 66), belongs to the domain of Realist portraiture explored in the same decade, the 1860s, by Renoir and Bazille.

Such intimate glimpses of the ordinary are especially common in depictions of older people who are no longer available for official view. There is Delaunay's somber, inward record of his aged mother's quiet resignation; or, more poignantly, Regnault's straightforward rendering of his great-aunt's expiration on her deathbed, still clinging, with her last strength, to a crucifix (page 68). Without the capital "R" of Courbet's programmatic Realism, or the startling new structures and visual abbreviations of the Impressionists' pursuit of people and things seen, many of these portraits quietly espouse the informal, earthly facts of the here and now that dominated so much of nineteenth-century painting, whether practiced by stalwart academicians or young Turks.

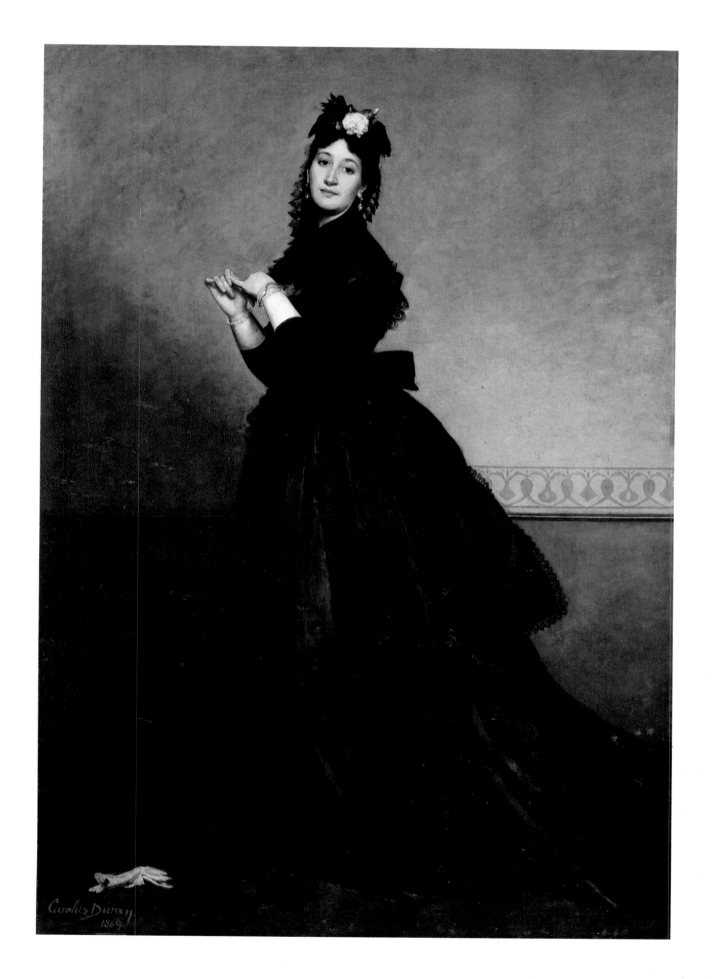

CHARLES CAROLUS-DURAN
Zacharie Astruc, ca. 1860
1′ 4¼″ x 1′ ¼″ (41 x 31 cm) Gift of Countess Doria, 1950.
RF 1950-36

CHARLES CAROLUS-DURAN
The Convalescent (The Wounded Man), ca. 1860 (fragment cut from larger painting, *Visit to the Convalescent*)
3′ 3″ x 4′ 1½″ (99 x 126 cm) RF 251

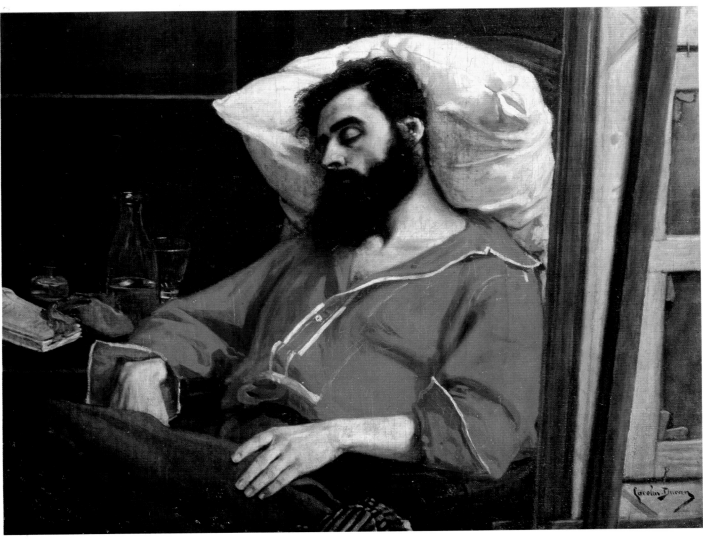

EUGÈNE-EMMANUEL AMAURY-DUVAL
Montrouge 1808–Paris 1885
Mme. de Loynes, 1862 (Salon of 1863)
3′ 3¼″ x 2′ 8¾″ (100 x 83 cm) Bequest of Jules Lemaître, 1914.
Deposit from the Louvre. RF 2168

right, top
LÉON BONNAT, Bayonne 1833–Monchy-Saint-Éloi 1922
Joseph Nicolas Robert-Fleury, 1865
3′ 6¾″ x 2′ 8¼″ (105 x 82 cm) Gift of Mrs. Tony Robert-Fleury,
1912. RF 2723

right, bottom
LÉON BONNAT
Self Portrait, 1855
1′ 6″ x 1′ 2¾″ (46 x 37.5 cm) Bequest of Mrs. Edouard Kann, 1929.
RF 2684

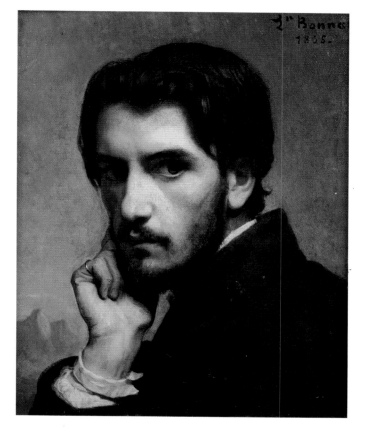

facing page

PIERRE PUVIS DE CHAVANNES
Thomas-Alfred Jones, Member of Stockbrokerage House, 1851
2′ 4¾″ x 1′ 11½″ (73 x 59.5 cm) Gift of Georges Viau, 1930. RF 2841

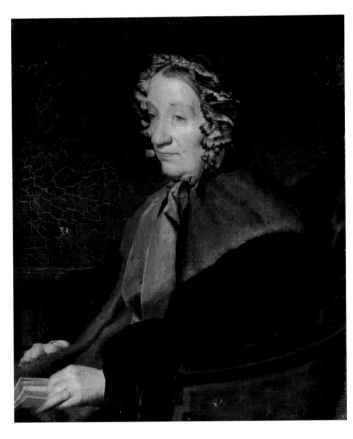

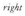

right

JULES-ELIE DELAUNAY, Nantes 1828–Paris 1891
The Artist's Mother, 1863
2′ 5¾″ x 1′ 11½″ (75.5 x 60 cm) Bequest of the artist, 1891. RF 731

right, bottom

PAUL BAUDRY, La Roche-sur-Yon 1828–Paris 1886
Portrait of Charles Garnier, 1868 (Salon of 1869)
3′ 4½″ x 2′ 8″ (103 x 81 cm) RF 2363

HENRI REGNAULT, Paris 1843–Buzenval 1871
Mme. Mazois (The Artist's Great-Aunt on Her Deathbed), 1866
2′ 1¾″ x 2′ 1″ (65.7 x 63 cm) Gift of Victor Regnault, 1875. RF 165

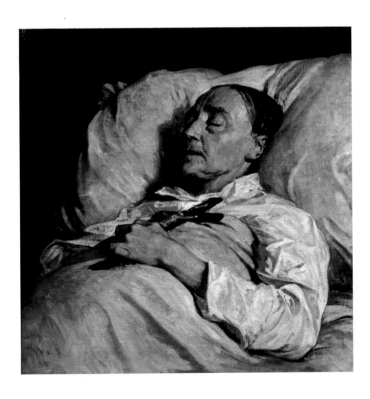

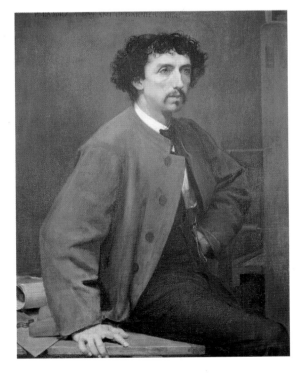

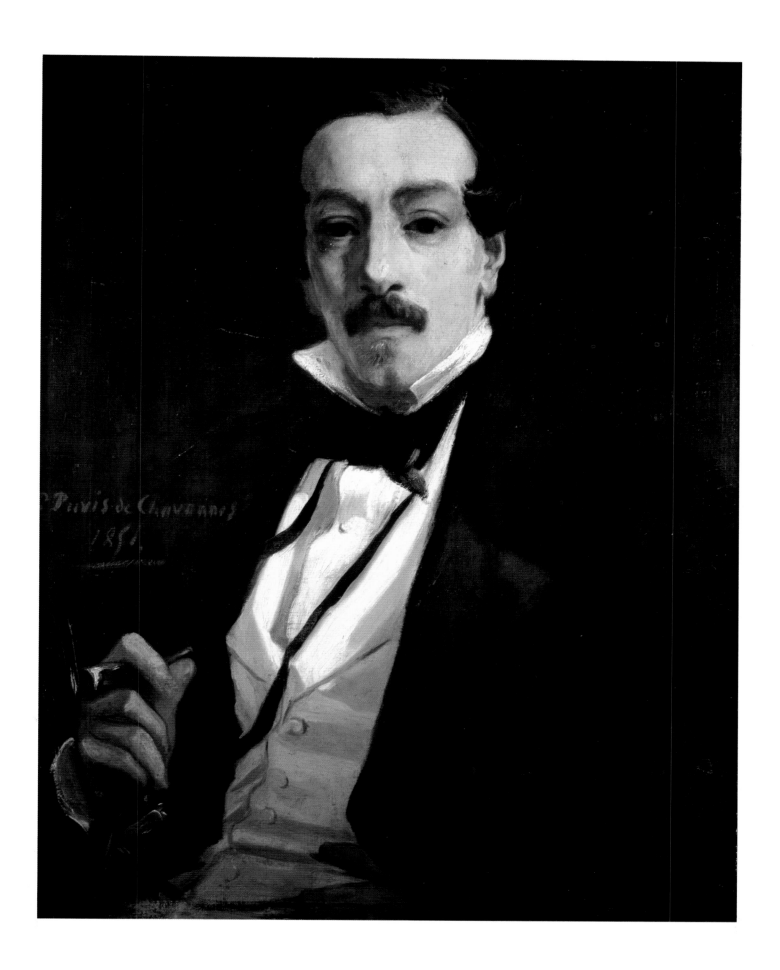

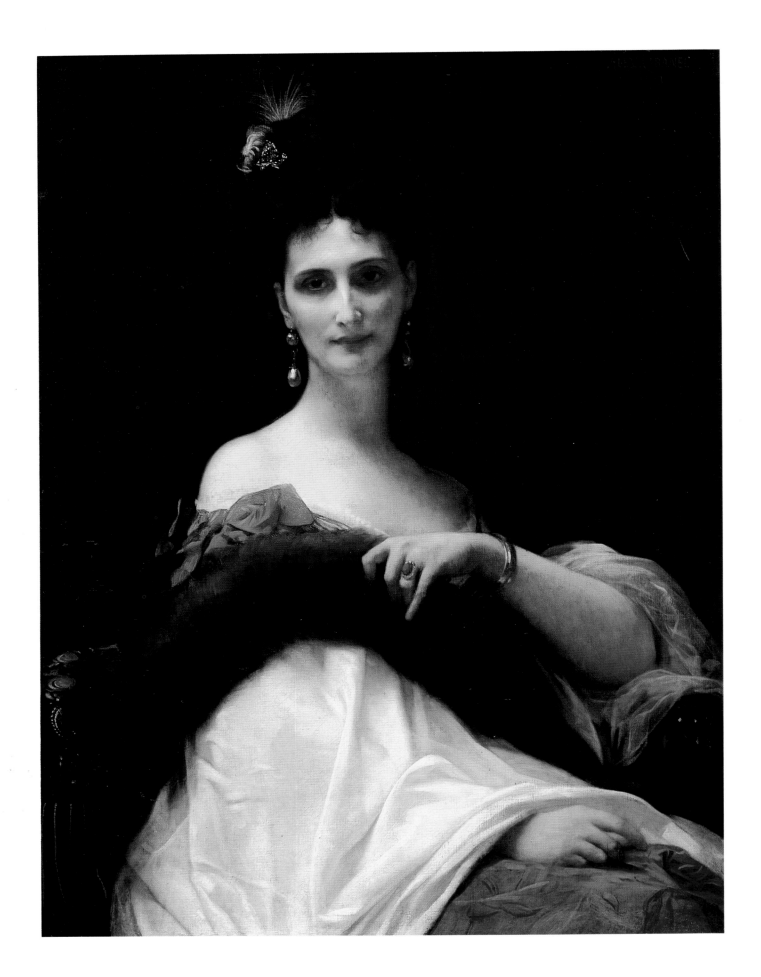

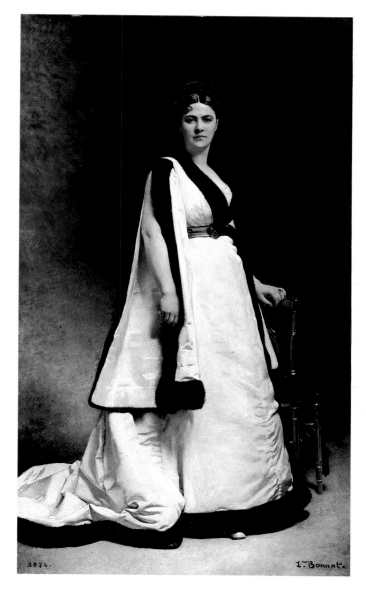

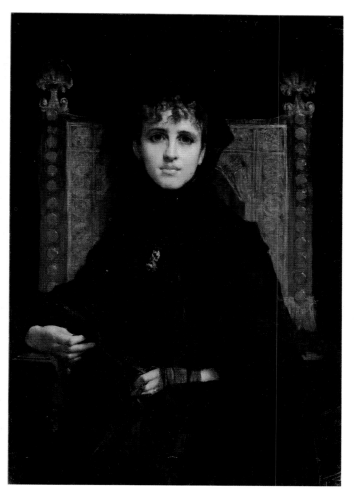

JULES-ÉLIE DELAUNAY, Nantes 1828–Paris 1891
Mme. Georges Bizet (Geneviève Halévy, later Mme. Émile Straus), 1878
(Salon of 1878)
3' 5" x 2' 5½" (104 x 75 cm) Bequest of Mrs. Émile Straus, 1927.
RF 2642

LÉON BONNAT, Bayonne 1833–Monchy-Saint-Éloi 1922
Mme. Pasca, 1874 (Salon of 1875)
7' 3½" x 4' 4" (222.5 x 132 cm) Bequest of Arthur Pernolet, 1915.
RF 2245

facing page
ALEXANDRE CABANEL, Montpellier 1823–Paris 1889
La Comtesse de Keller, 1873
3' 3" x 2' 6" (99 x 76 cm) Gift of Marquis and
Marquise de Saint-Yves d'Alveydre, 1889. RF 2048

PUVIS DE CHAVANNES AND MOREAU

Pierre Puvis de Chavannes
Summer

*I*n libraries, universities, and art museums from Paris to Boston, one is likely to find monumental painted decorations by Pierre Puvis de Chavannes. Generally these internationally acclaimed public murals—the result of three decades of official commissions—depict a mythical, unnaturally serene golden age, a pre-industrial or even prehistoric era where all was milk and honey under balmy skies. At the Salon of 1873, the year before the Impressionists' first group exhibition, Puvis exhibited the huge idyll called *Summer*, first destined for the art museum at Chartres but now at Orsay. A dreamlike counterpart to the intimate scenes of modern summer leisure favored by Manet, Renoir, and Monet in the 1860s and 70s, Puvis's epic panorama of archaic harmony conjures up a mixture of the Bible and remote antiquity in which human society is blessed by what seems eternal peace, bounty, and good weather. A soothing fantasy for the years immediately following the Franco-Prussian War (to which Puvis had responded more directly with a pair of allegories, page 254), this mural sings the praises of simple family life and rudimentary agriculture, offering a gentle and fruitful trinity of babies, lambs, and wheat.

Although these remote fictions of a timeless Garden of Eden were common to the repertory of academic artists, Puvis recreated them with a strongly personal flavor that, oddly enough, was acceptable to both the establishment and to many of the young artistic rebels of later decades. His generalized espousal of ancient beauty legitimized his work in the official world of public prizes and commissions, but his willfully primitive style opened quite different vistas. Inspired by the chalky, pallid surfaces of fresco painting from both the ancient world and that of the Italian primitives, Puvis also resurrected archaic pictorial structures in which simple geometries, flattened silhouettes, and frail columnar rhythms offered an image of almost primordial innocence and clarity. It is no surprise that echoes of Puvis's Arcadia can be found in the works of Seurat and Gauguin and their disciples, whether in their visions of harmonious societies on the banks of the Seine or in the fields of Britanny and the jungles of Tahiti. Nor is it unexpected that the strange hush and stillness familiar to Puvis's art, so often described as anemic, would find more mysterious reverberations in the Symbolist domain of the turn of the century, from works by Maurice Denis and Alexandre Séon (pages 584 and 585; 551) to the Picassos of the Blue Period. In this territory many artists further refined the nuances of Puvis's dreamy silence and introspection.

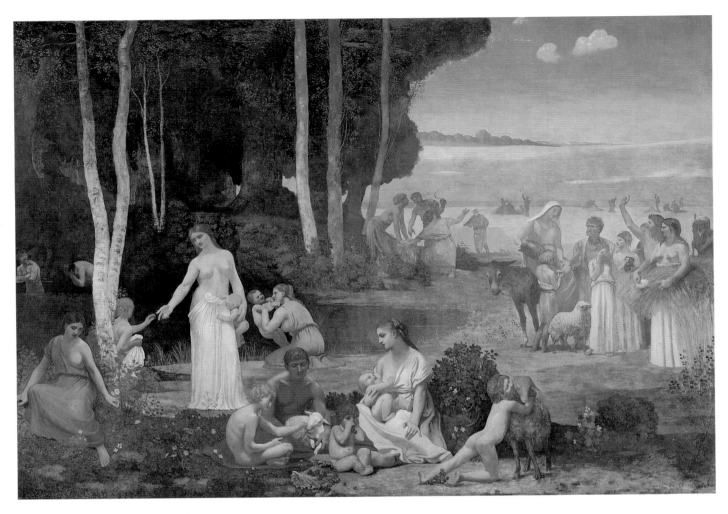

PIERRE PUVIS DE CHAVANNES
Summer, 1873 (Salon of 1873)
11′ x 5¾″ x 16′ 7½″ (350 x 507 cm) RF 1986-20

facing page

PIERRE PUVIS DE CHAVANNES
Young Girls on the Edge of the Sea, 1879 (Salon of 1879)
6′ 8¾″ x 5′ ¾″ (205 x 154 cm) Gift of Robert Gérard, 1970.
RF 1970-34

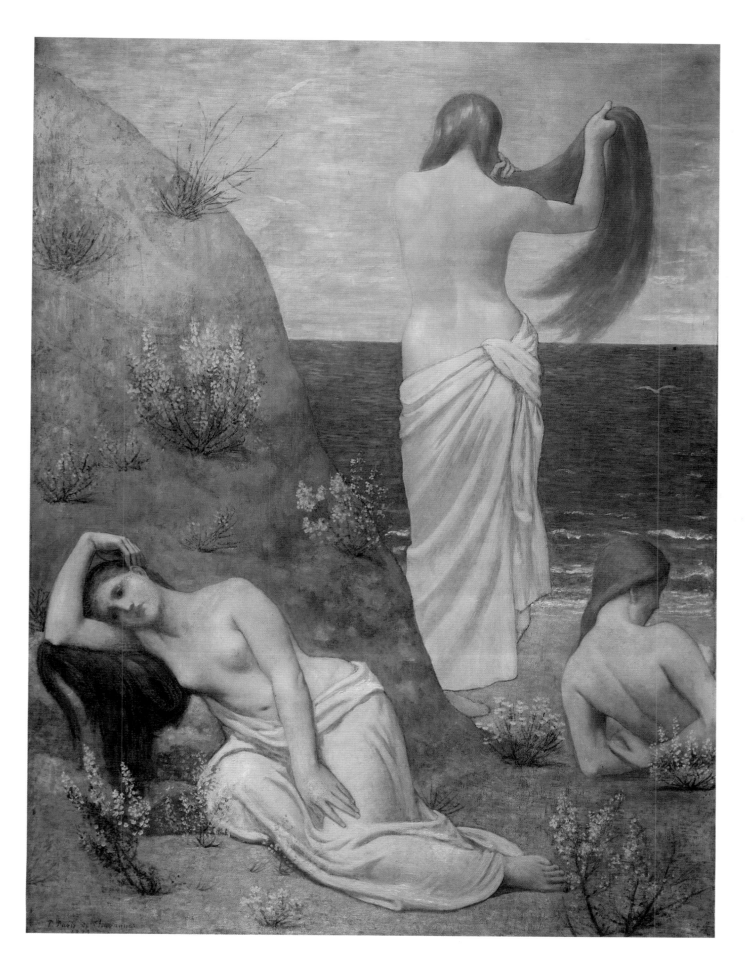

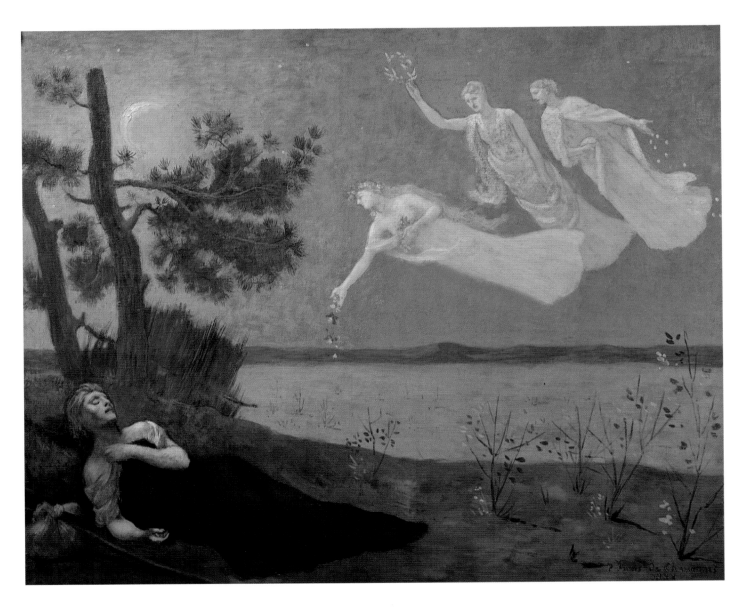

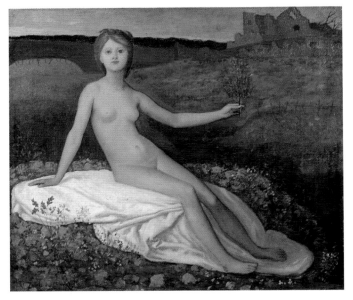

PIERRE PUVIS DE CHAVANNES
The Dream, 1883 (Salon of 1883)
2′ 8¼″ x 3′ 4¼″ (82 x 102 cm) Gift of Étienne Moreau-Nélaton, 1906.
RF 1685

PIERRE PUVIS DE CHAVANNES
Hope, ca. 1872 (larger version at Salon of 1872)
2′ 3¾″ x 2′ 8¼″ (70.5 x 82 cm) INV 20117

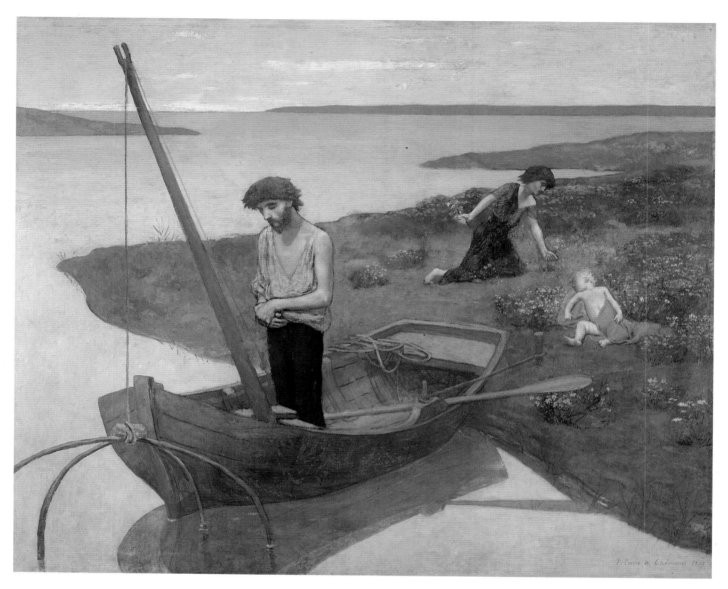

PIERRE PUVIS DE CHAVANNES
The Poor Fisherman, 1881 (Salon of 1881)
5' 1" x 6' 3¾" (155 x 192.5 cm) RF 506

Gustave Moreau
Orpheus

Although threatened by the fleeting truths of modern experience that artists like Manet, Degas, or Monet elected to paint, classical mythology, like a proper education in Greek and Latin, remained a cornerstone of nineteenth-century art and culture, propagated by the academies and illustrated in countless official paintings. It was also subject to intensely personal, even perverse interpretations that could use ancient legends to trigger voyages during which the cold marble facts of ancient sculpture, venerated and slavishly copied in the art schools, would evaporate into the strangest mists. So it was with Gustave Moreau's odd visions of antiquity, opium dreams of his own invention. His *Orpheus* of 1865, when shown at the Salon the following year, needed the artist's own verbal explanation in the catalogue to clarify his deviation from more orthodox depictions of the legend. The inventor of music so beautiful it could charm man and beast, Orpheus had met a gruesome end when he was torn to pieces by the enraged women of Thrace (whose love he had rejected), his head and lyre thrown into a stream. This ferocious group murder could, in fact, be seen at the same Salon of 1866 in a painting by Émile Lévy (page 53). But Moreau imagined instead a later moment of erotic contemplation rather than one of overt physical violence, conjuring up a "young girl who reverently recovers Orpheus's head and lyre." In Moreau's painting, this Thracian maiden now stares as if hypnotized by her strange captive, a disembodied head fused with the musical instrument he played as he sang. Seen through a misty scrim of twilight tones, this morbid vision wafts us off to what the dean of Surrealism, André Breton, would later admire as a "somnambulistic world."

Indeed, Moreau might well be credited as a pioneer in the opening of hazy, disquieting vistas that could begin to plumb the depths of that subconscious fantasy life so prominent in the art and thought of the twentieth century. Supported by a study of Leonardo's otherworldly landscapes of distant waters and strange, almost translucent grottoes, Moreau invented a magical environment where we are not surprised to find bizarre shifts in size (the piping shepherds on the rocks above) or even a pair of what look like prehistoric tortoises in the right foreground, probably an allusion to the myth that their shells were used in the invention of the lyre.

Though partly prophesied by Chassériau and partly shared by such contemporaries as Burne-Jones and Puvis de Chavannes, Moreau's floating world of cultivated inward sensation and fantasy was remarkably precocious, a voice in the wilderness that announced the more concerted explorations of morbid, inward reverie found in the Symbolist domain of the 1890s. By the end of the century, a vast international repertory of drugged silence, introspective mythmaking, decapitated heads, and demonic women could trace its ancestry back to Moreau's first hallucinatory paintings of the 1860s.

facing page
GUSTAVE MOREAU, Paris 1826–Paris 1898
Orpheus, 1865 (Salon of 1866)
5' ¾" x 3' 3¼" (154 x 99.5 cm) RF 104

page 80
GUSTAVE MOREAU
Hesiod and the Muse, 1891
1' 11¼" x 1' 1½" (59 x 34.5 cm) Gift of Étienne Blanc, 1961.
RF 1961-7

page 81
GUSTAVE MOREAU
Jason, 1865 (Salon of 1865)
6' 8¼" x 3' 9½" (204 x 115.5 cm) Gift of Théodore Reinach, 1908.
RF 2780

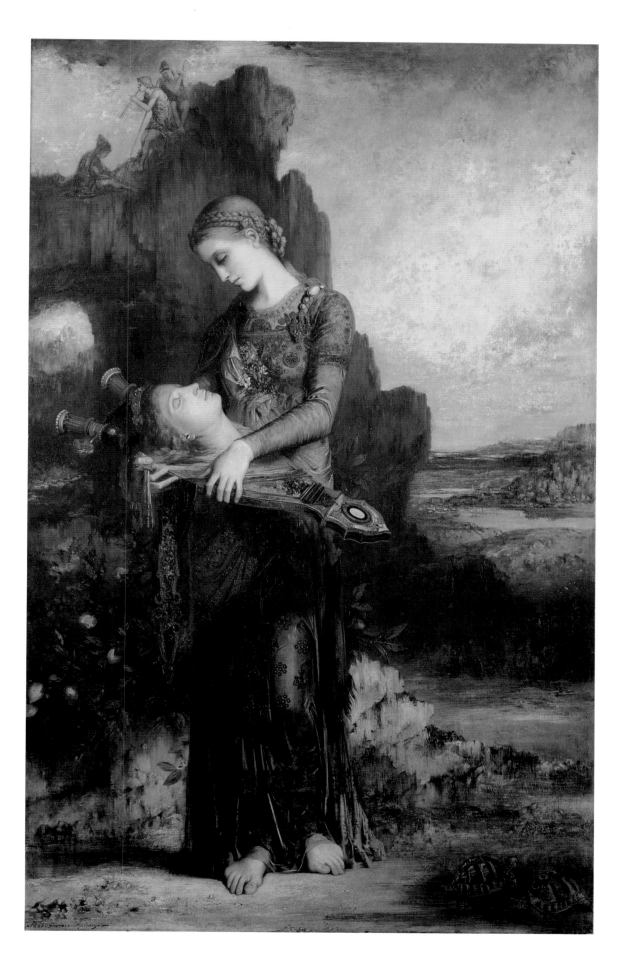

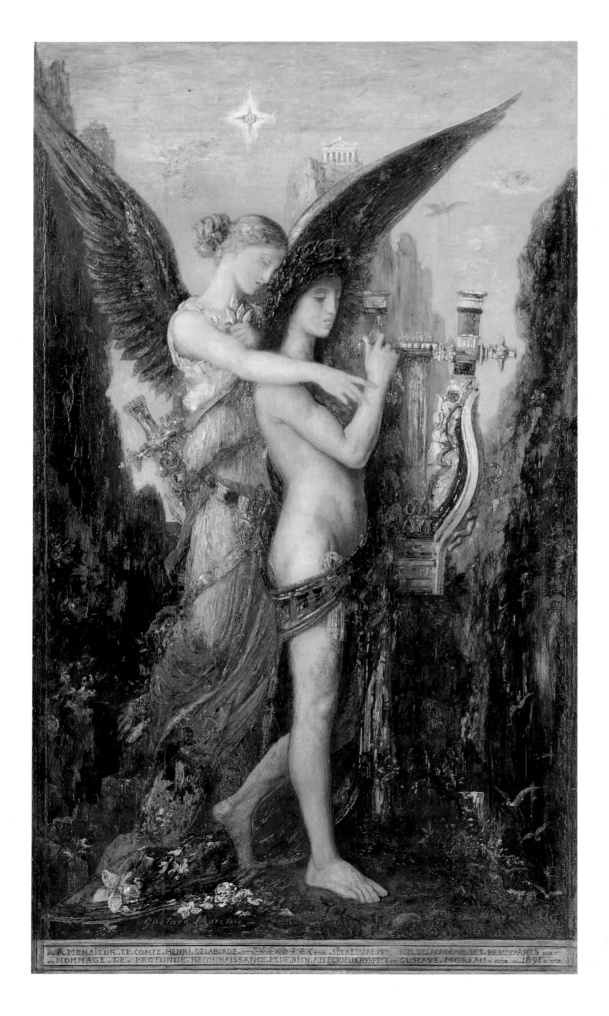

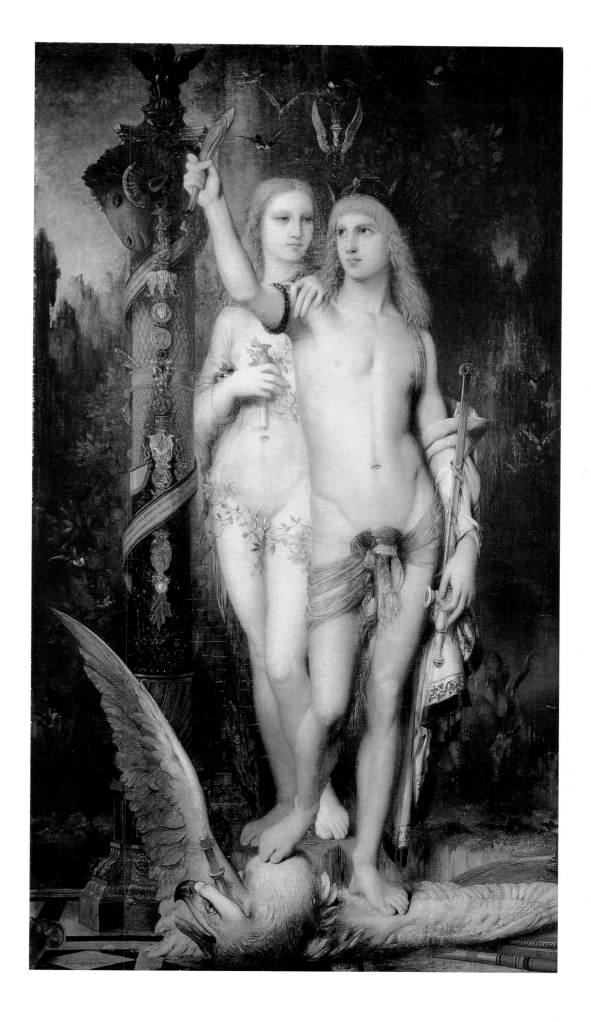

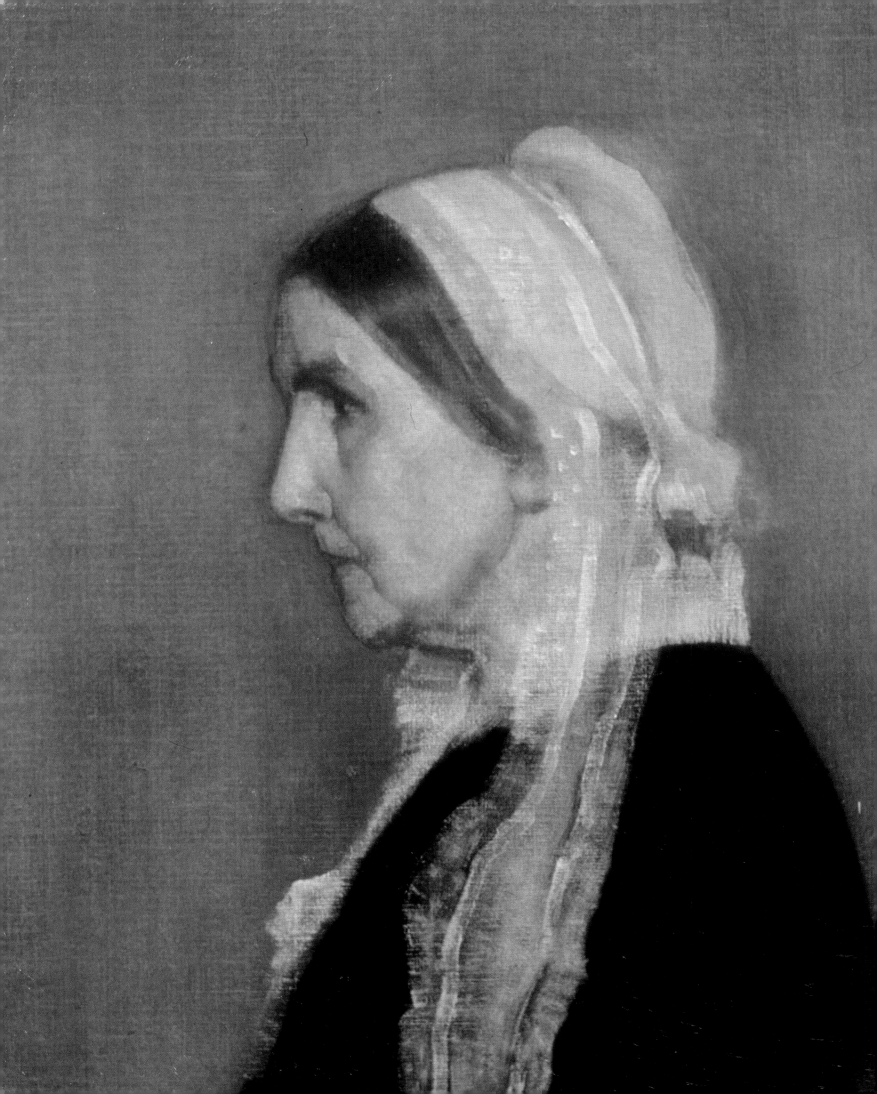

Varieties of Realism

DAUMIER

The Laundress

This is the last of three similar versions of a Parisian washerwoman by Daumier. The first made its debut at the Salon of 1861, one of the rare occasions when the artist showed an ostensibly clumsy, unfinished canvas in the company of paintings that better met the official criteria for being exhibited to the public. What Millet had done for peasants in the 1850s, Daumier does here for the anonymous city workers of the 1860s who day after day toiled at the banks of the Seine. Unlike the Rococo washerwomen of Boucher, Fragonard, or Hubert Robert, who frolicked cheerfully with their linens and water (and who were the subject of new enthusiasm in the 1860s), Daumier's solitary worker bears a surprisingly somber and heroic charge, as if one of the monumental nudes of Michelangelo had been demoted to a symbol, albeit a dignified one, of working-class labor in Second Empire Paris. So generalized are her face, her clothing, her limbs, and even her ponderous burden of wash that she takes on an allegorical character. Indeed, her entire story, and that of multitudes like her, is distilled in one image through Daumier's familiar economy as a graphic artist. Her life, it seems, is lived in simple, rudimentary cycles. Just as she nobly but wearily steps upward from the riverbank at dusk, so, too, will she return the next morning; and just as the child, who for the moment seems to be holding a toy shovel, follows in grave rhythm her mother's footsteps, so, too, will she continue the same grueling labor as an adult.

Daumier's genius at capturing specifics within this vocabulary of broadest generalization is everywhere discernible. The child, we realize, has to exert extra effort to climb these high, steep steps; the mother, with a turn of the head, is both observant and caring; the city view, across the Seine, is momentarily aglow with the light of the setting Paris sun; and the irregular silhouettes of these riverfront buildings, though mirage-like in their vagueness, instantly conjure up a particular, if probably unlocatable, site while evoking a backdrop symbolic of any urban environment.

To be sure, Daumier's painting can be seen in the context of many reportorial images of poverty and social injustice that accelerated in the mid-century; and it could well be construed as an exposé, an indictment. But its uncanny ability to transform specific fact into universal symbol somehow gives the painting a quite different, almost religious, flavor. The pedigree here feels more at home with images of the Virgin and Child, or the Flight into Egypt, than with contemporary reportage about social inequities. Shortly after, in 1869, Degas would begin a series of pastels and paintings treating a similar theme, Parisian laundresses (page 328), but would look at them through such different lenses of psychology and aesthetic order that we might wonder whether both artists were dealing with the same mid-century reality—the commonplace of working women in the city leading lives of unrelieved physical hardship.

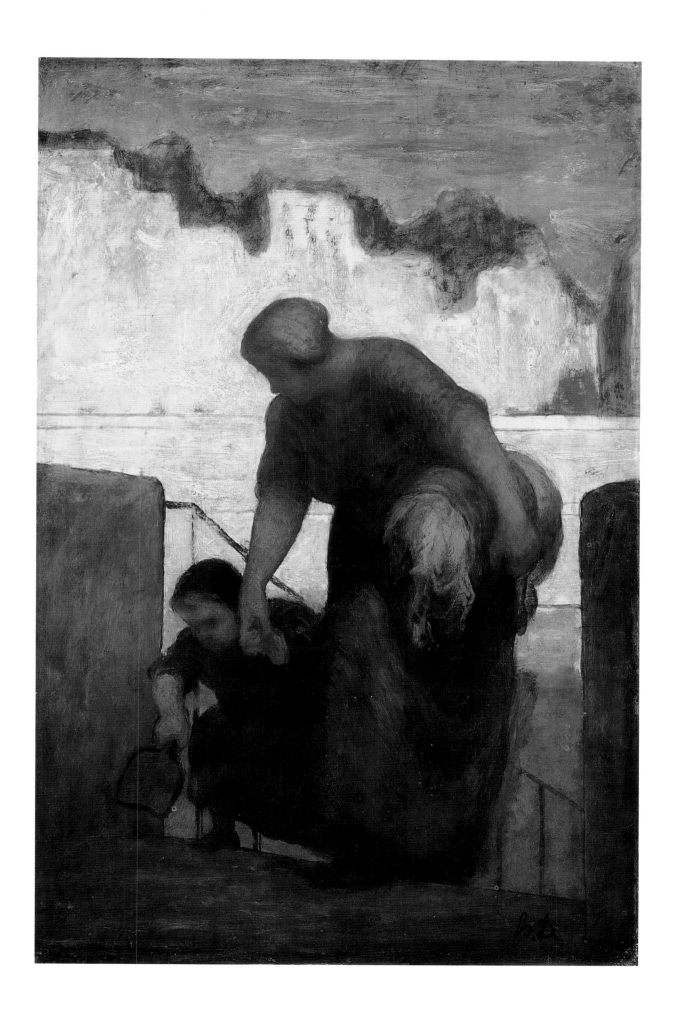

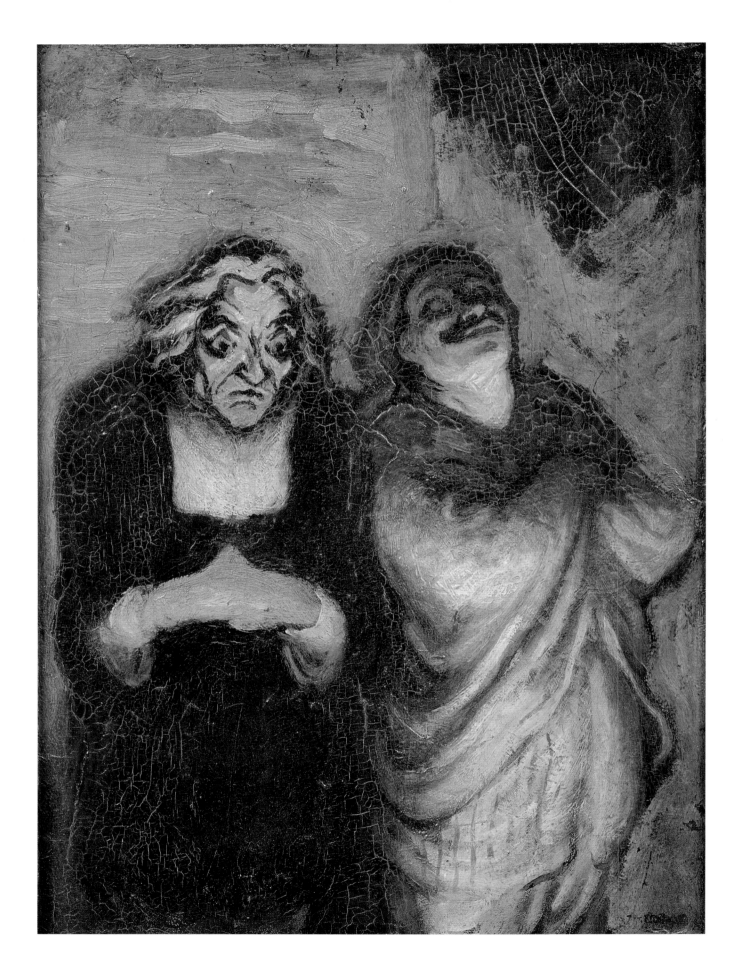

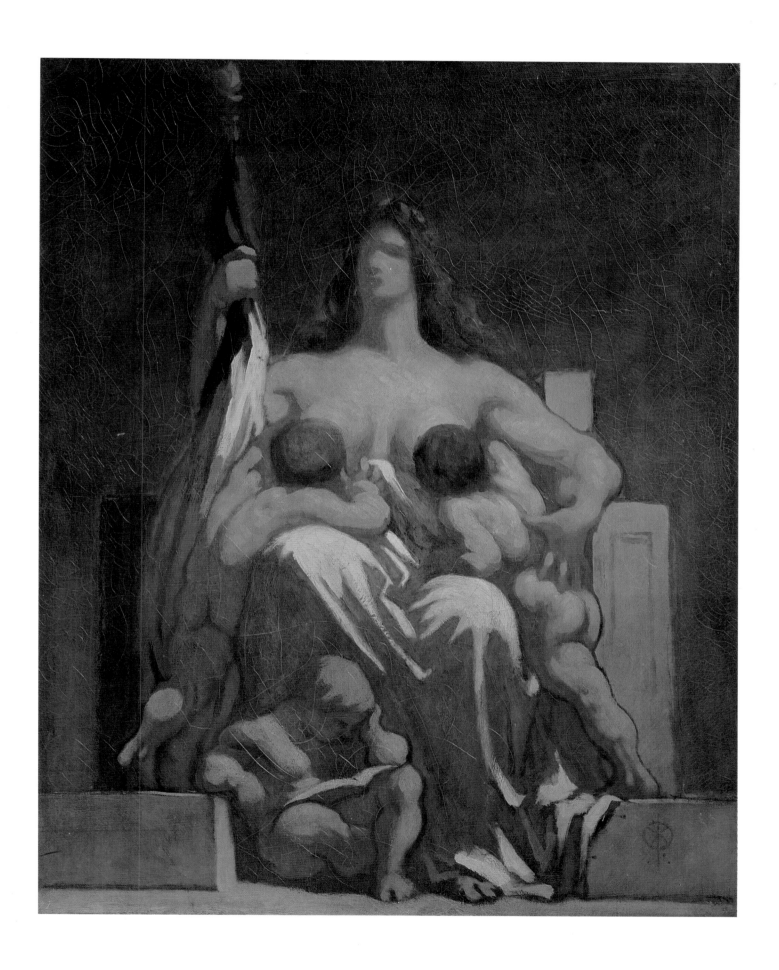

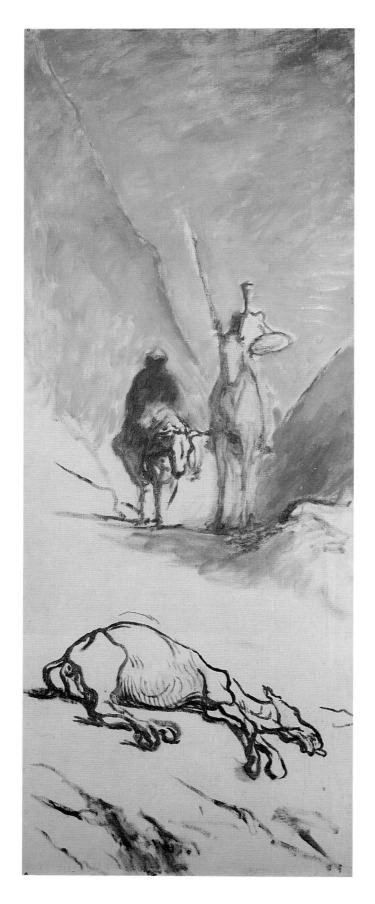

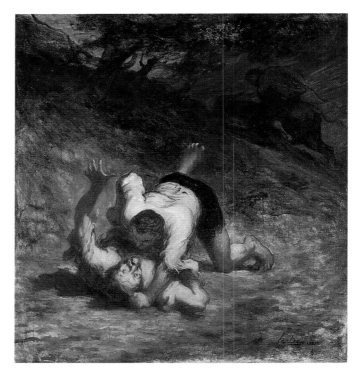

HONORÉ DAUMIER
The Thieves and the Donkey (from La Fontaine)
1′ 11″ x 1′ 10″ (58.5 x 56 cm) RF 844

HONORÉ DAUMIER
Don Quixote and the Dead Mule, 1867
4′ 4¼″ x 1′ 9½″ (132.5 x 54.5 cm) Gift of Baroness
Eva Gebhard-Gourgaud, 1965. RF 1965-7

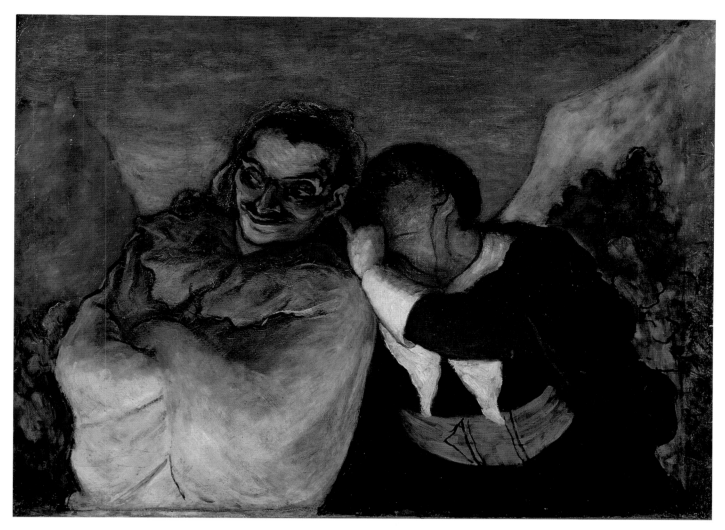

HONORÉ DAUMIER, Marseille 1808–Valmondois 1879
Crispin and Scapin (Scapin and Silvester), ca. 1858–1860
1′ 11 ¾″ x 2′ 8¼″ (60.5 x 82 cm) Gift of Société des Amis du Louvre,
1912. RF 2057

MILLET

The Gleaners

For modern city dwellers, Millet's image of farm life is both literally and figuratively rose-tinted, a dream of rural simplicity and order. But in fact, in 1857, when *The Gleaners* made its debut at the Salon, what now seems a remote poem also had an immediate prose message that reported on the most grueling conditions of mid-century agrarian labor. What we see, among other things, is the absolute bottom rung of an economic ladder that stretched from dirt poverty to new wealth. The three anonymous peasant women who toil in the foreground have a specific role, that of gleaning the spare leavings after the crops have been harvested by rich landowners, whose own abundant gleanings are seen on the more luminous, distant horizon. For this backbreaking work, permission was needed. In Paris the counterparts of these women would be the beggars and ragpickers roaming the streets who were often painted by even so elegant a master as Manet. Here the peasants look for comparable scraps on the cultivated fields of France.

Nevertheless, Millet, a member of Karl Marx's generation, has transformed such grim reportorial facts into an unexpectedly timeless image that resonates as deeply into biblical memories as it does into the grand rhythms of ideal order found in Poussin's classical landscapes. Without belying the physical truths of repetitive, aching labor that numbs mind, body, and soul, Millet has arranged what were mockingly called "the Three Fates of pauperdom" in a trio of emblematic, even heroic clarity. The left-hand pair of laborers rhyme forever in a seesawing balance with their more upright partner, who pauses eternally between rest and work. But all three remain as rooted to the soil as trees. The high and expansive horizon line restricts their movements and defines their role, for their entire bodies are contained below this remote vista of sunlit crops, as if they could never rise to full height above it.

Within this tautly calculated structure, Millet has embraced marvelous details and aesthetic nuances. The oblique glimpses we have of the women's faces reveal a kind of unformed brutishness matched more visibly by the outstretched hands, which have the character of an anatomy blunted by endless labor, like the hooves of beasts of burden. At the same time, Millet offers surprising refinements, such as the Poussinesque trio of primary colors—blue, red, yellow—which, dulled to somber tones that match the earth, individualize the crudely utilitarian clothing of the three workers.

Compared to the diminutive peasants who till the soil in such earlier farm scenes as Daubigny's *Harvest*, from the 1852 Salon (page 117), Millet's trio swells center stage to a scale that can no longer be ignored. Like the rural populations in Courbet's contemporary paintings, they have become imposing new presences in the repertory of mid-century art, with endless progeny in city and country. Daumier's and Degas's laundresses (pages 85 and 328), and even more so Caillebotte's floor-scrapers (page 323), are almost unthinkable without Millet's epic hymn to labor.

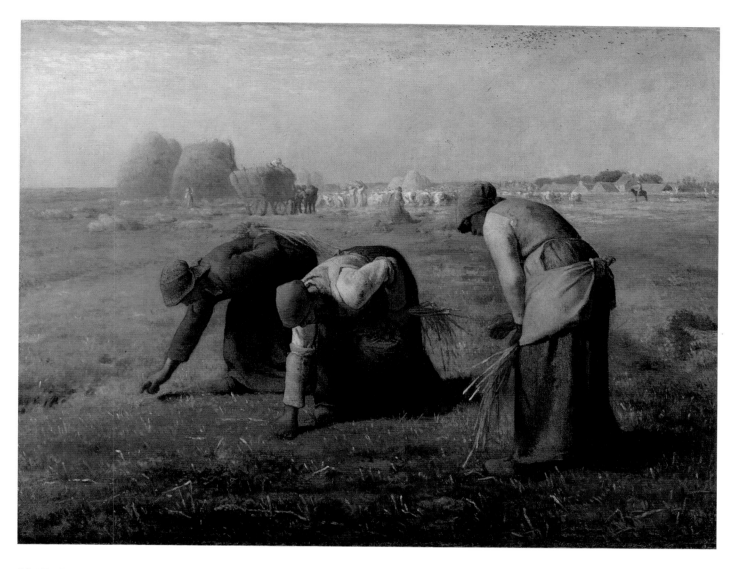

Gruchy, near Gréville 1814– Barbizon 1875
The Gleaners (Salon of 1857)
2′ 8¾″ x 3′ 7¾″ (83.5 x 111 cm) Gift of Mrs. Pommery, 1890.
RF 892

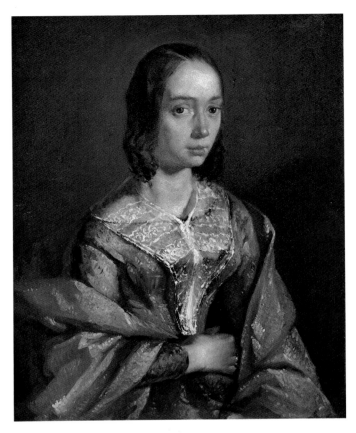

JEAN-FRANÇOIS MILLET
Mme. Eugène-Félix Lecourtois, ca. 1841
2′ 5″ x 1′ 11¼″ (73.5 x 59 cm) RF 1601

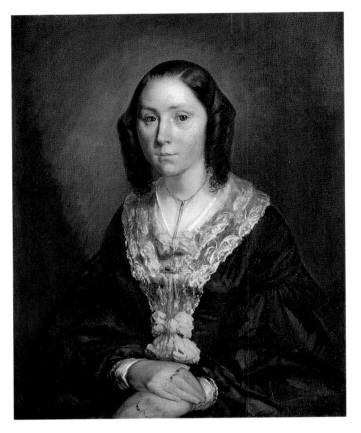

JEAN-FRANÇOIS MILLET
Mme. Eugène Canoville, 1845
2′ 5¼″ x 1′ 11½″ (74.5 x 60 cm) Gift of Dr. Canoville, 1925.
RF 2500

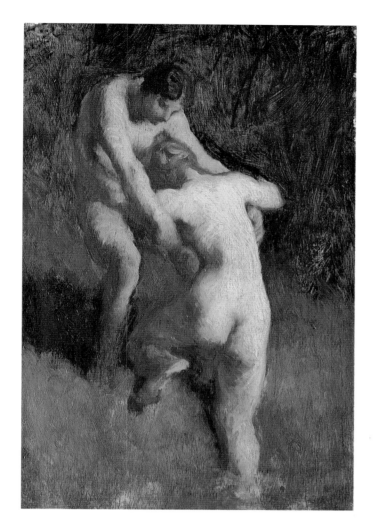

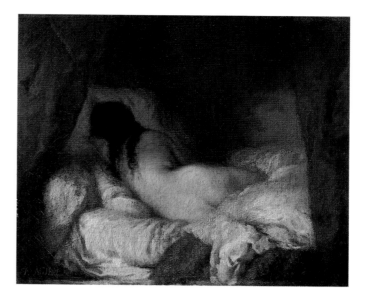

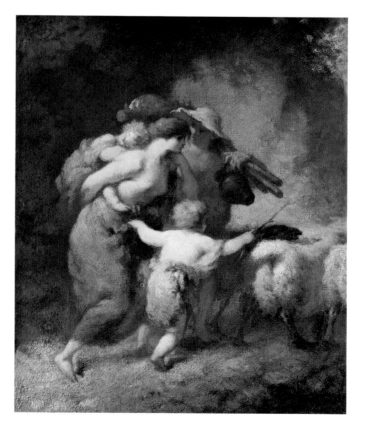

JEAN-FRANÇOIS MILLET
Two Bathers, 1848
11″ x 7½″ (28 x 19 cm) RF 141

right, top
JEAN-FRANÇOIS MILLET
Reclining Nude
1′ 1″ x 1′ 4¼″ (33 x 41 cm) Gift of Henri Ribot, 1923. RF 2409

right, bottom
JEAN-FRANÇOIS MILLET
The Return of the Flock, ca. 1846
1′ 6″ x 1′ 3″ (46 x 38 cm) Gift of Jacques Lenté, 1947. RF 1947-37

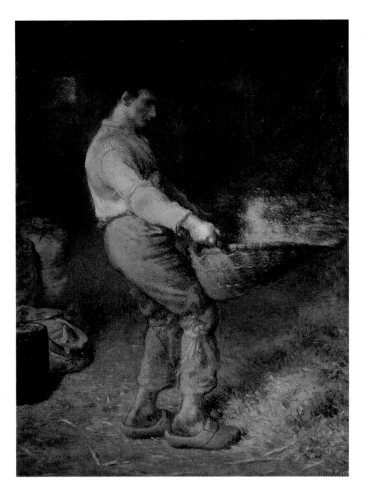

facing page, top

JEAN-FRANÇOIS MILLET
The Winnower, ca. 1866–1868 (replica of 1848 painting)
1' 3¼" x 11½" (38.5 x 29 cm) Bequest of Alfred Chauchard, 1909.
RF 1440

JEAN-FRANÇOIS MILLET
The Haymakers' Rest, 1848 (damaged by fire and reduced in size)
2' 11" x 3' 9¾" (89 x 116 cm) RF 2049

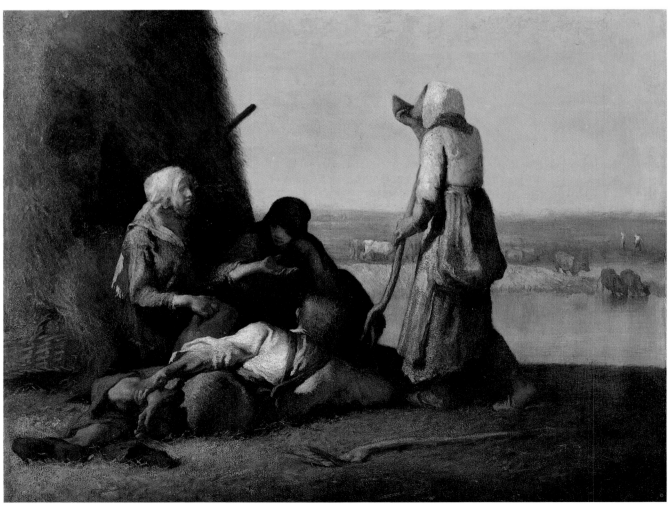

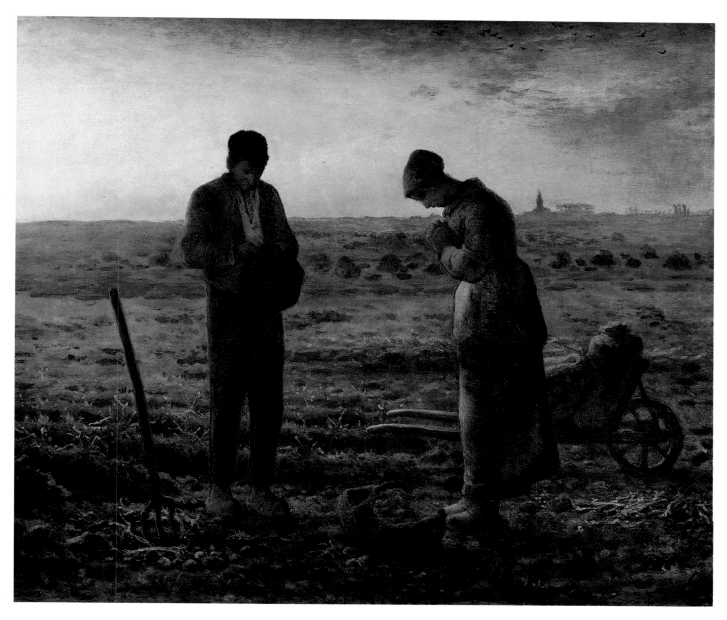

JEAN-FRANÇOIS MILLET
The Angelus, 1857–1859
1′ 9¾″ x 2′ 2″ (55.5 x 66 cm) Bequest of Alfred Chauchard, 1909.
RF 1877

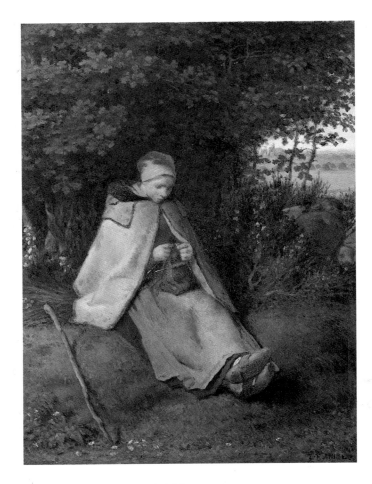

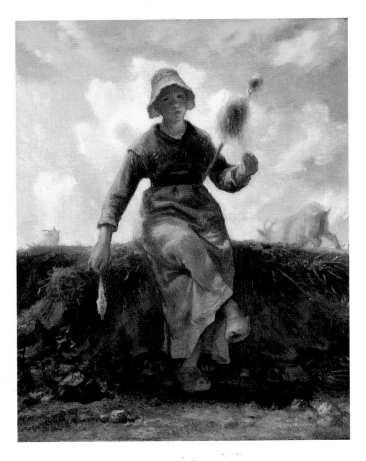

JEAN-FRANÇOIS MILLET
Woman Knitting, 1856
1′ 3¼″ x 11½″ (39 x 29.5 cm) Bequest of Alfred Chauchard, 1909.
RF 1876

JEAN-FRANÇOIS MILLET
The Spinner, Goat-Girl from the Auvergne, 1868–1869
3′ ½″ x 2′ 5″ (92.5 x 73.5 cm) Bequest of Alfred Chauchard, 1909.
RF 1880

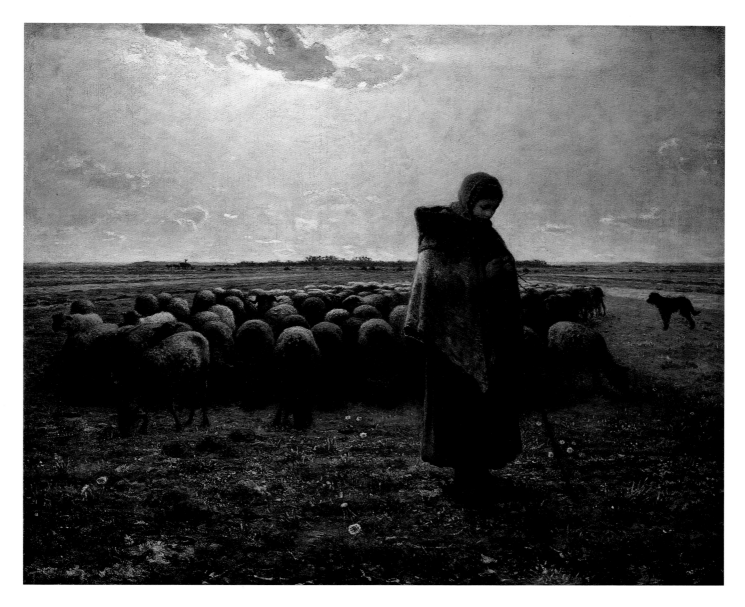

JEAN-FRANÇOIS MILLET
Shepherdess with Her Flock (Salon of 1864)
2′ 8″ x 3′ 3¾″ (81 x 101 cm) Bequest of Alfred Chauchard, 1909.
RF 1879

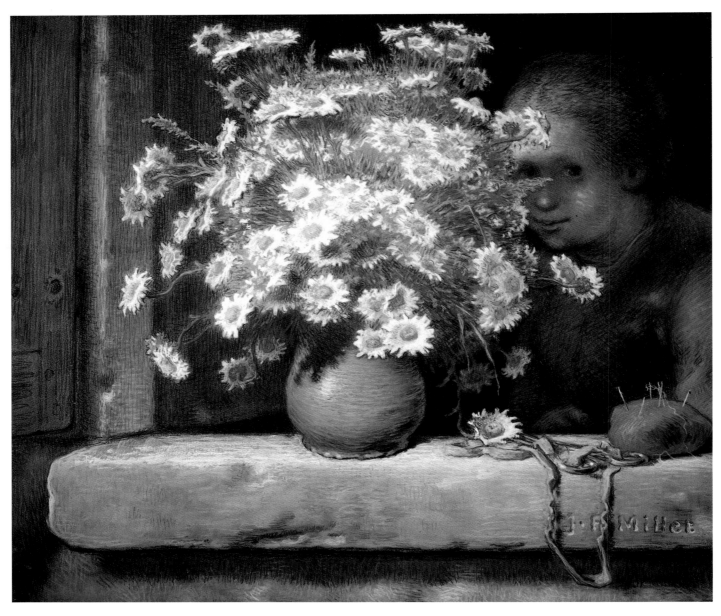

JEAN-FRANÇOIS MILLET
The Bouquet of Daisies, 1871–1874
Pastel on beige paper, 2′ 2¾″ x 2′ 8¾″ (68 x 83 cm)

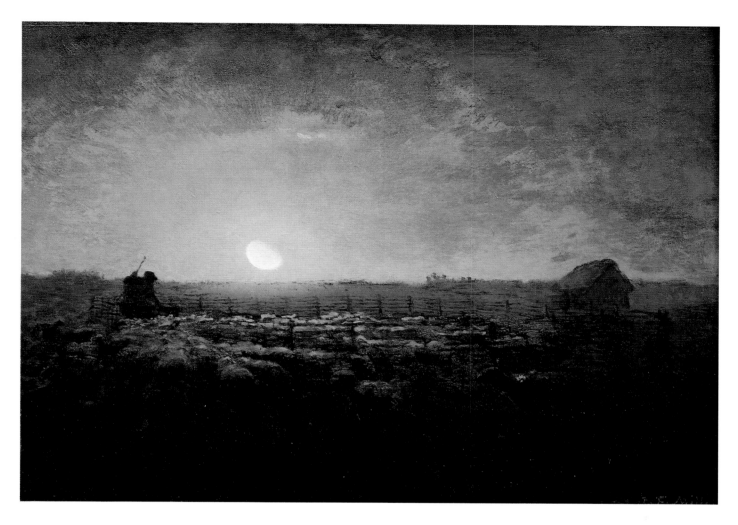

JEAN-FRANÇOIS MILLET
The Sheep Meadow, Moonlight
1′ 3½″ x 1′ 10½″ (39.5 x 57 cm) Bequest of Alfred Chauchard, 1909.
RF 1881

The Church of Gréville

*B*etween 1814, the year of Millet's birth, and 1874, the year he completed this modest painting of the village church at Gréville near his birthplace on the Normandy coast, France and French painting had changed drastically. But in this small canvas, nineteenth-century calendars seem irrelevant. For Millet, this simple rural church, where his family had regularly attended services, remained steadfast and unchanged, even after the events of the Franco-Prussian War and the Commune, whose Artists' Federation the aging painter had refused to join. Visiting Gréville in 1871, only four years before his death, he clearly saw the church of his childhood as an image of permanence and security, a close-up view, as it were, of the many village churches that may be seen on the distant horizon in such earlier paintings by him as *The Angelus* (page 95).

To be sure, many nineteenth-century painters selected as a surrogate religious subject places of Christian worship, whether as famous as the cathedrals of Chartres and Rouen or as obscure as a parish church in a remote province. Their visions of these sturdy survivors of an age of faith range from the touristic and the documentary to the proselytizing and the mystical. Millet's canvas, however, seems saturated mainly with distant autobiographical memory, as if he were trying to resurrect his childhood on a farm and the nostalgic souvenir of the local church, which still glows softly in the sun. To add to this reverie of a timeless, enduring world of repeated cycles, an oddly diminutive peasant on the left walks past the church toward his flock, which grazes just below the cross on the other side of the wall. What results is a place of ancient comfort and refuge, an image that may well have inspired Van Gogh (who venerated Millet) to paint his own sacred haven in the last months of his short life, *The Church of Auvers-sur-Oise* (page 485). But the foursquare strength of Millet's village sanctuary is agitated by Van Gogh into a place of almost desperate asylum for the wanderer, a vision that looms large at the center of a fork in the road, under a fiery blue sky.

In a quiet way, Millet's canvas is more up-to-date than its willfully retrospective theme. The vivid hues and dappled facture of the younger Impressionists, who had their first group show the year this canvas was completed, may well be reflected here in Millet's palette. The patches of an unexpectedly brilliant blue that penetrate the overcast Channel sky and the dabs of high-keyed colors—purple, orange, and green—on the church make this solid, earthbound symbol of a pre-modern world vibrate with a tinge of modernity.

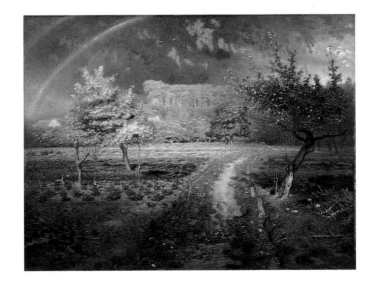

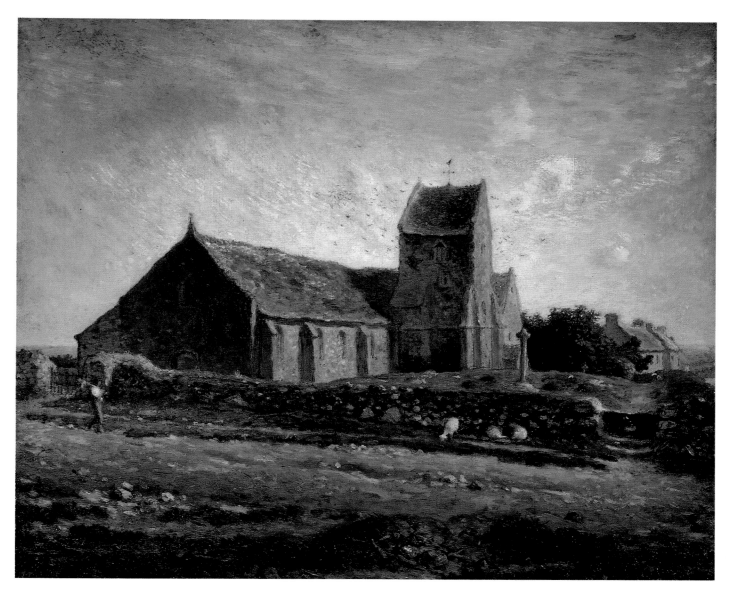

JEAN-FRANÇOIS MILLET
The Church of Gréville, 1871–1874
1′ 11½″ x 2′ 5″ (60 x 73.5 cm) RF 140

COROT

Man in Armor (or Seated Man of Arms)

*C*orot's long career is virtually divided in two by the approximate date, 1848, with which the Musée d'Orsay's collection begins. This division, which puts most of his later work in the company of his rebellious juniors, is not all that arbitrary, since the master's painting, from the 1850s to his death, has the distinctive flavor of a late style of inward melancholy and reflection. It is a mood most fully inaugurated in such twilit, mythological landscapes as *A Morning; Dance of the Nymphs* (page 106), destined for public view at the Salon of 1850–1851; but it can be discerned in more intimate and unexpected ways in such late figure paintings as this matter-of-fact yet wistful record of a seated old man, dressed in a suit of armor and holding a sword.

Everything about this image of an active mind in an inactive body suggests a remembrance of things past, appropriate to the age of the artist (he was in his mid-seventies when he painted it) and to his place in the century (he had become a venerable master in the heyday of Courbet, Manet, and early Impressionism). Out of step with the present, Corot, in the late 1860s, often chose old friends as models and sometimes painted them clad in armor. This association with a long-lost epoch of knights and chivalry may have recalled the work of Delacroix, another great artist, recently dead, of Corot's own Romantic generation; and it may also have reflected the medieval dramas belatedly sustained in official history painting, not to mention theater and opera, of Second Empire Paris. But in these modest costume pieces, Corot quietly lets us know that this world has, in fact, become an outmoded fantasy from earlier, more passionate decades. In this case, the knight is seen without a helmet, his head revealing only a weary mortal (as yet unidentified) in a studio prop. Like a tired old actor seen offstage, he poignantly evokes fact and fiction, with fact winning out. In his monumentally ambitious *The Painter's Studio* of 1855 (page 152), Courbet had symbolized the ascendancy of his Realist credo by including a still life of cloak, dagger, and guitar strewn on the floor, transforming the imaginative trappings of Romanticism into earthbound matter. Corot, without allegorical pretensions, teaches the same lesson.

Nevertheless, as in all of Corot's finest works, especially from his later years, a nostalgic poetry pervades observed fact. For all the casualness of this oblique, cropped glimpse of a studio model, there is also an unforced nobility, almost

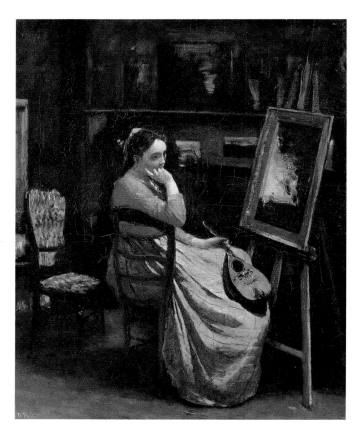

CAMILLE COROT, Paris 1796–Paris 1875
Studio of the Artist, ca. 1865–1879
1' 10" x 1' 6" (56 x 46 cm) Deposit from the Louvre. RF 3745

facing page
CAMILLE COROT
Man in Armor (or Seated Man of Arms), ca. 1868–1870
2' 4¾" x 1' 11¼" (73 x 59 cm) Bequest of Edouard Martell, 1920.
RF 2669

worthy of a knight, in the innate order that Corot extracts from the lucid rhymings of sword and limbs. Together with the posture of tranquil, lonely meditation, the pensive tilt of the shadowed head underlines the aura of introspection. Moreover, the ever more somber nuances of graying tonalities contribute to this darkening mood of silent thought about another kind of world, whether of youth and action or of belief in evaporated dreams.

It is a mood borne out as well in many of Corot's more famous late studio pictures, such as one from the mid-1860s in which the model, seen in total isolation in the artist's studio, emerges from the staged fictions of her picturesque costume and mandolin and ends up lost in a hushed reverie that makes us feel like noisy, embarrassed intruders behind a closed door.

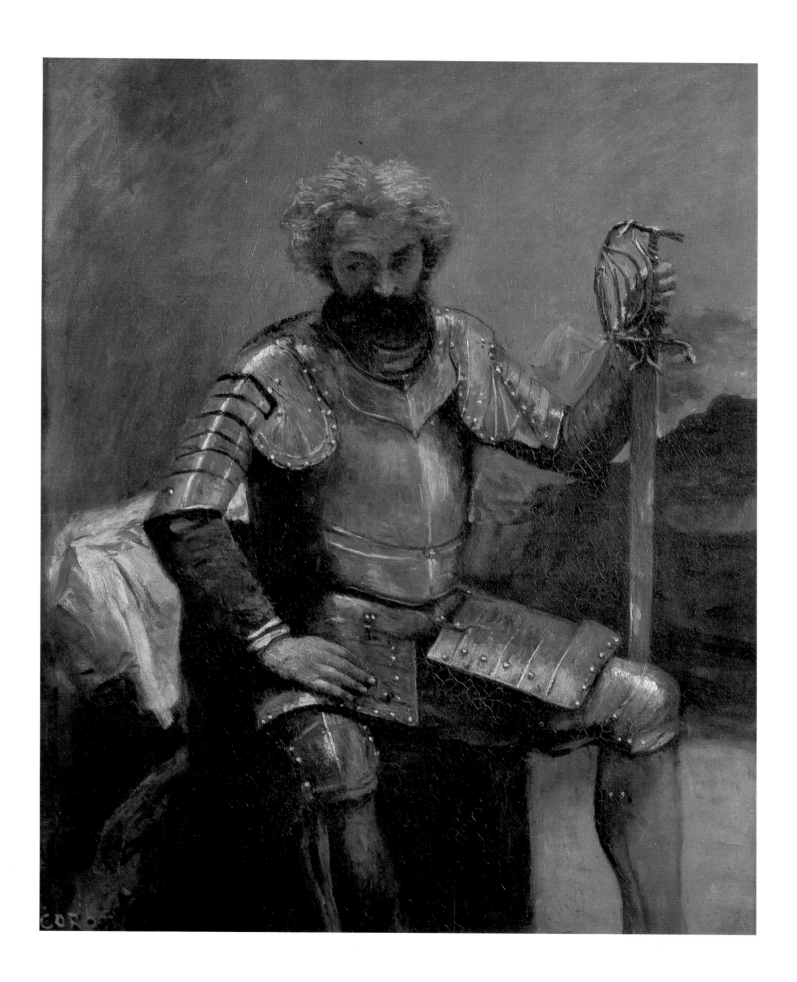

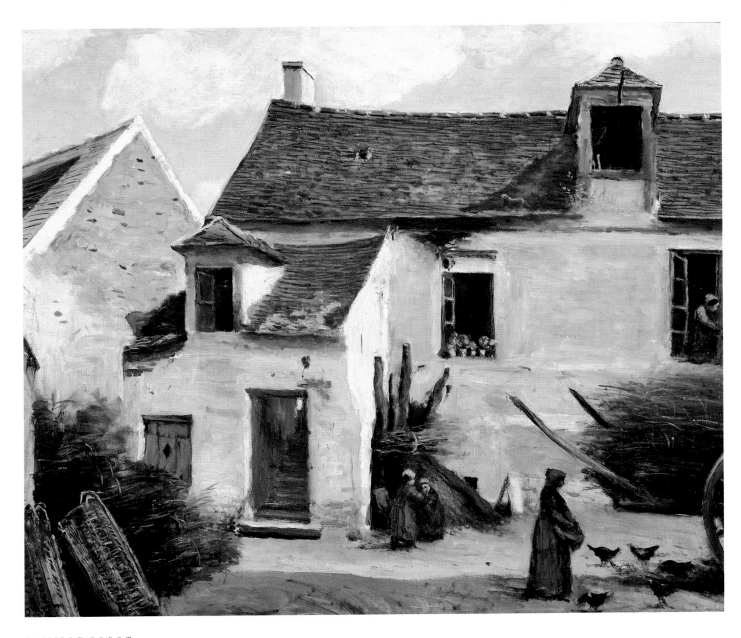

CAMILLE COROT
Courtyard of a Peasant's House near Paris
1′ 6¼″ x 1′ 10″ (46.5 x 56 cm) Deposit from the Louvre; gift of
Ernest May, 1923. RF 2441

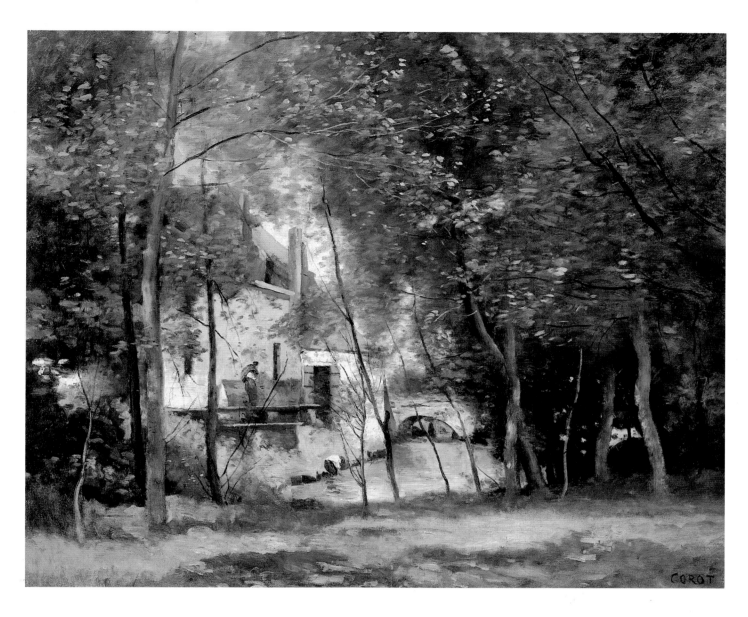

CAMILLE COROT
The Mill of Saint-Nicolas-les-Arraz, July 1874
2′ 1¾″ x 2′ 8″ (65.5 x 81 cm) Bequest of Alfred Chauchard, 1909.
RF 1802

CAMILLE COROT
Trouville; Fishing Boats Stranded in the Channel
8¼″ x 9¼″ (21 x 23.5 cm) Gift of Max and Rosy Kaganovitch, 1973.
RF 1973-13

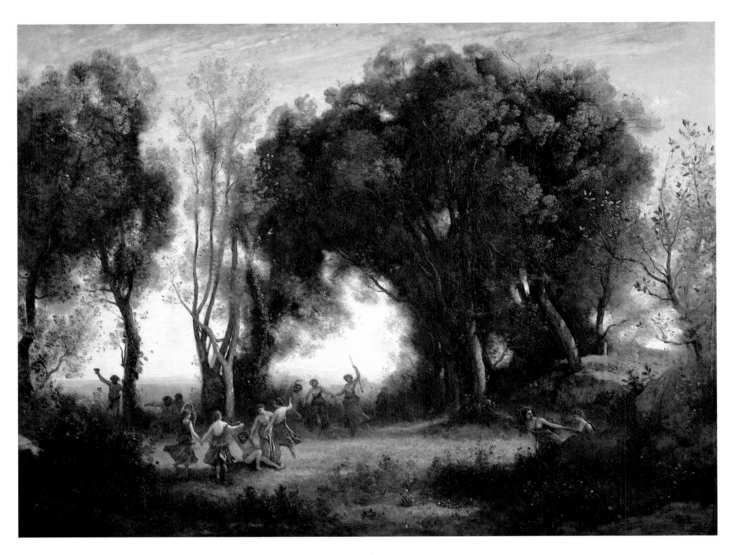

CAMILLE COROT
A Morning; Dance of the Nymphs (Salon of 1850–1851)
3' 2½" x 4' 3½" (98 x 131 cm) Deposit from the Louvre. RF 73

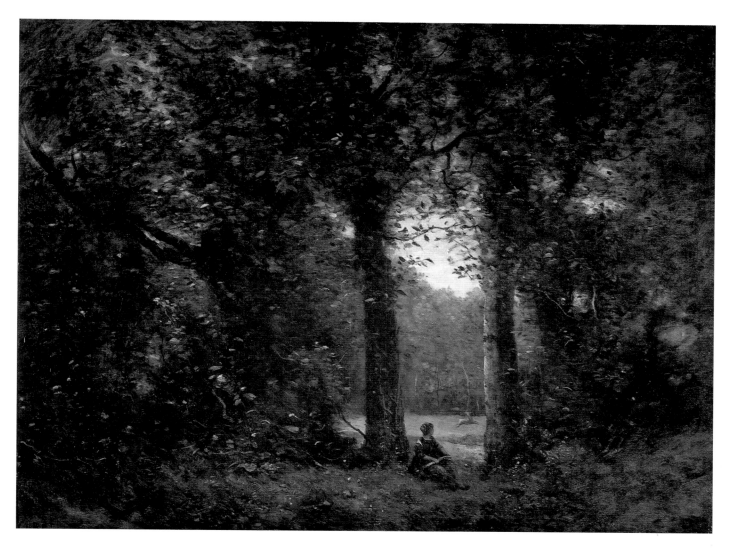

The Clearing; Memory of Ville d'Avray (Salon of 1872)
3′ 3¼″ x 4′ 4¾″ (100 x 134 cm) Bequest of Alfred Chauchard, 1909.
RF 1795

page 108
CAMILLE COROT
A Nymph Playing with Cupid (Salon of 1857)
2′ 7″ x 1′ 10½″ (78.5 x 57 cm) Bequest of Alfred Chauchard, 1909.
RF 1782

page 109
CAMILLE COROT
Young Woman in a Pink Dress
1′ 6″ x 1′ 1″ (46 x 32 cm) Deposit from the Louvre. RF 1967-4

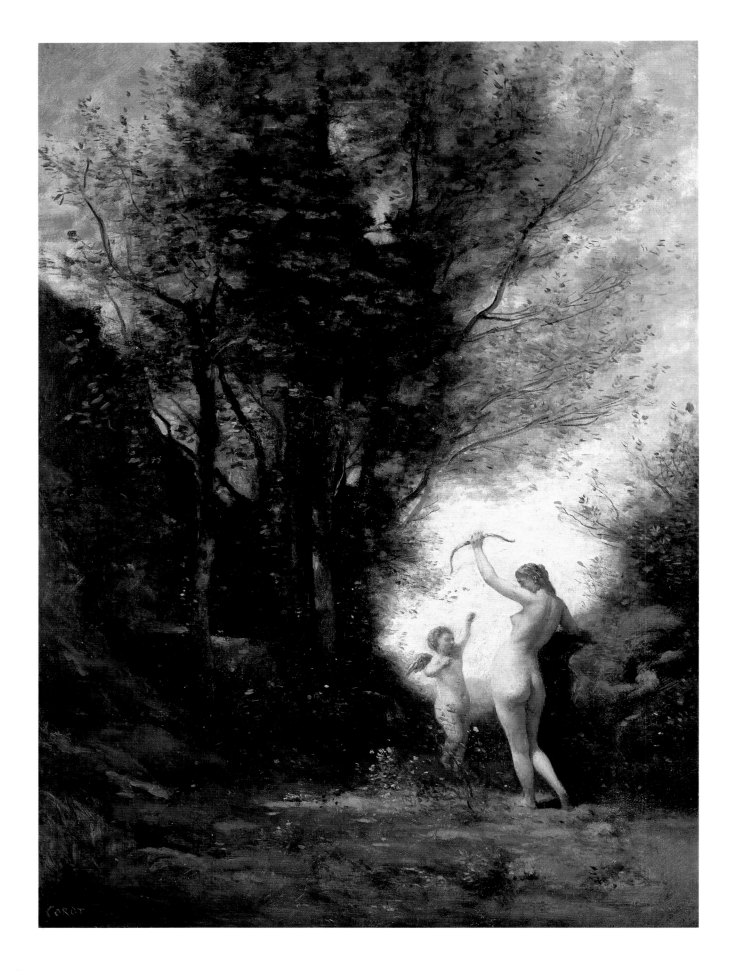

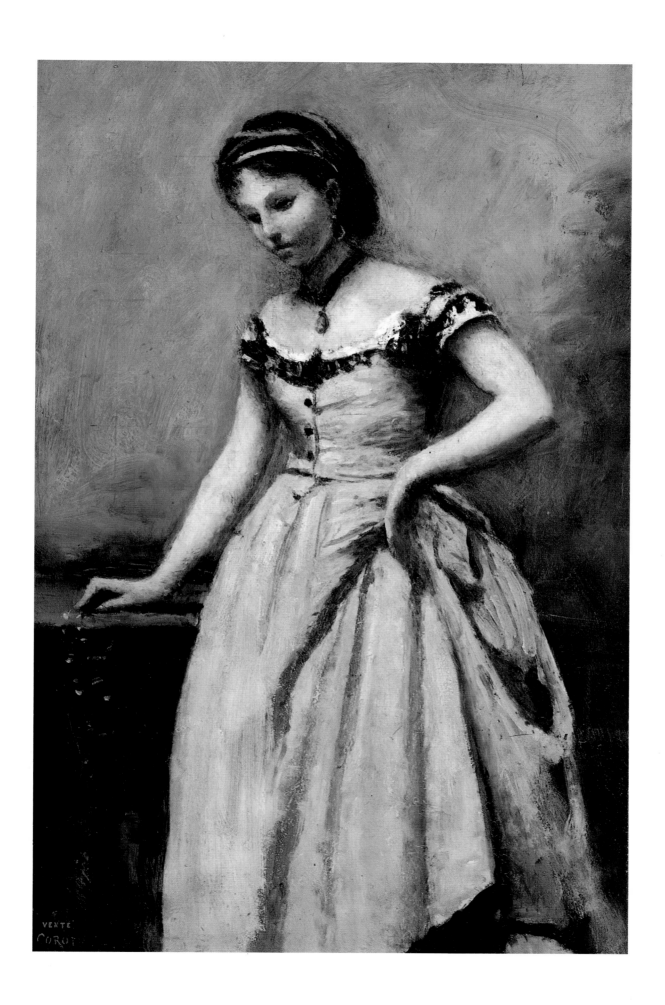

BARBIZON SCHOOL AND RURAL LANDSCAPES

Théodore Rousseau
An Avenue of Trees, Forest of l'Isle-Adam

*F*ew farmers or peasants would recognize rural life as it was depicted in the bountiful harvest of nineteenth-century paintings made by and for city dwellers. The image of pastoral harmony—one of the most deeply rooted in Western culture—was propagated as never before at a time when new forms of grueling factory work began to replace the traditional labors of the fields, and when starving populations from the country invaded cities in the hope of finding jobs and surviving. From a Parisian's point of view, the green land beyond, with its unpolluted forests, its farms and grazing cattle, its tilled fields, could come to represent a vanishing Arcadia.

Of those artists who cherished and cultivated these myths, none were so important as the members of the Barbizon school. This name refers to a little village in the middle of the Fontainebleau forest, easily accessible from Paris. There, beginning in the 1830s, landscape painters would temporarily escape from urban realities and commune with a pre-industrial world of woods, cottages, and shepherdesses. Geographically speaking, Barbizon was only a symbol, since many of these artists traveled far and wide in France to savor variations on this local theme. But the meditative, hushed mood of almost religious respect for an unspoiled countryside remained persistent, whether experienced in the Ile-de-France or the Jura.

The mood is perfectly captured in a forest idyll by the most prominent member of the school, Rousseau, who showed this painting at the Salon of 1849. It was the year after a revolution that covered the streets of Paris with civilian blood and that prompted other artists of rural life, such as Millet and Courbet, to paint more heroic and threatening images of contemporary peasants and landowners. We are set down here in a secluded, peaceful haven in the forest of l'Isle-Adam, in spirit light-years away from Paris though only some twenty miles north of it. In place of the axial boulevards of Paris, we find an irregular avenue of trees that provide a sanctuary of shelter and contempla-

tion in the midst of this benevolent density of bark, leaf, and cooling shade. Time, even work, seems to have stopped as we glimpse through what seems like a distant lens a tiny vignette of a peasant girl seated among cattle that will graze forever. The diminutive scale of the figures, human and bovine, contribute to this mythic evocation of primitive, agrarian peace.

Such pictorial fictions could register as transparently false, were it not for the fact that Rousseau, like the best of the Barbizon group, believed them. With a passionate, on-the-spot intensity that rings true, he attempted to record these vestiges of an endangered, ancient way of life. The unruly profusion of nature, with its thick brambles, tangled leaves, and speckles of light, is presented not as an artificial formula in the Rococo manner, but in loving detail, as if the artist wanted to immerse himself in a primordial landscape remote from the hand of man. The range of perceptions is remarkable, alternating between the chaotic congestion of the underbrush in the foreground and the liberating vista of dappled sunlight that can lead us to the remote horizon. The authenticity of these landscape observations as something particular, animated, and vibrant already approaches the vision of Monet.

Other Barbizon painters could vary this kind of experience in a multitude of ways, as might be seen in two canvases exhibited at the 1855 Exposition Universelle. In one of them, Le Roux's vivid record of the mottled russet profusion of a stand of cherry trees and birches in autumn (page 114), Rousseau's intense perceptions are further refined. In another—Troyon's fantasy of a herd of cattle marching to work across a sunlit plain, directed by a generically noble peasant who might be leading French troops to war (page 113)—Rousseau's quiet veneration of man and beast is expanded in both size and rhetoric. This huge canvas, without a trace of sweat, flies, or manure, translates the personal visions of the Barbizon school into the bombastic language of a patriotic hymn to the glory of French agriculture.

facing page
THÉODORE ROUSSEAU, Paris 1812–Barbizon 1867
An Avenue of Trees, Forest of l'Isle-Adam, 1849 (Salon of 1849)
3' 3¾" x 2' 8¼" (101 x 82 cm) Bequest of Alfred Chauchard, 1909.
RF 1882

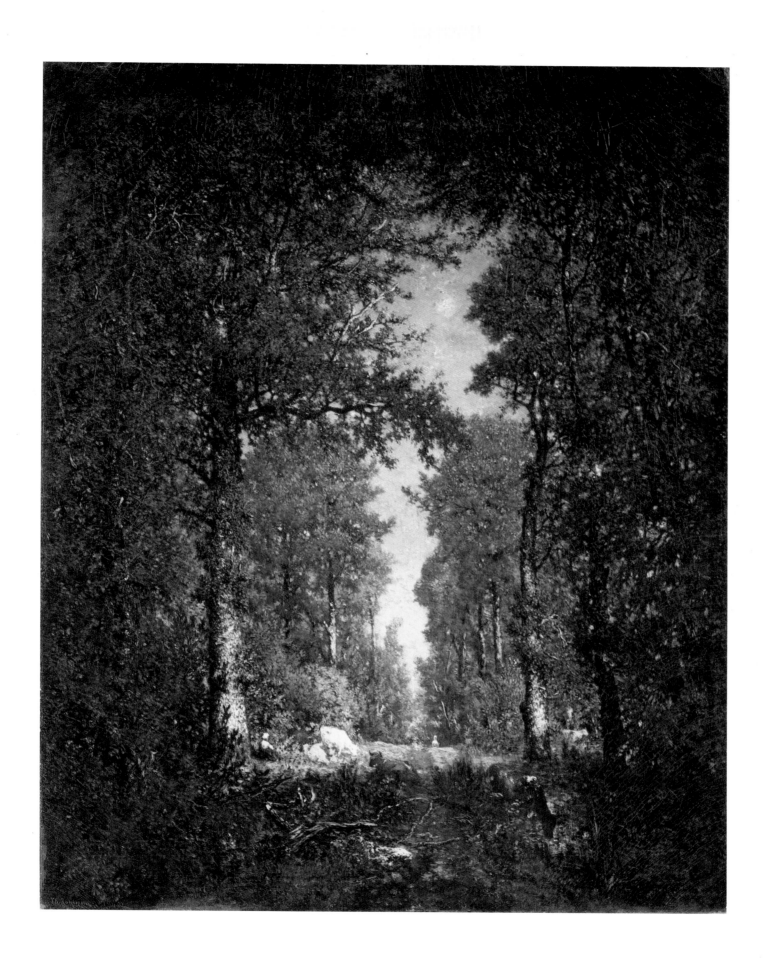

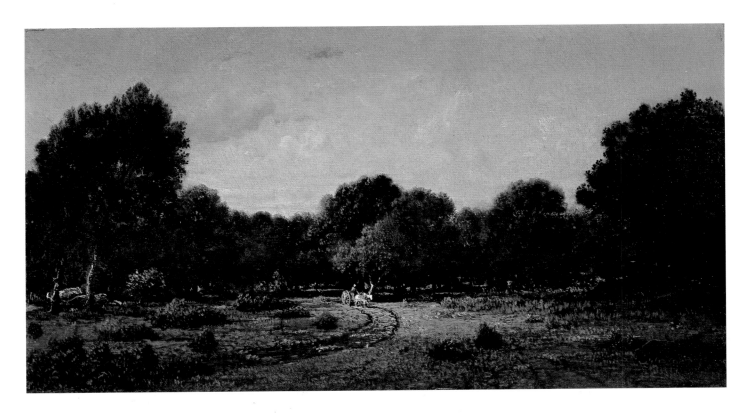

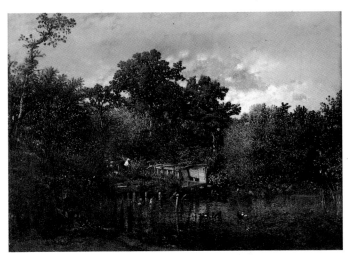

THÉODORE ROUSSEAU
Clearing in a High Forest, Forest of Fontainebleau (The Cart), 1862
(Salon of 1863)
11″ x 1′ 8¾″ (28 x 53 cm) Bequest of Alfred Chauchard, 1909.
RF 1888

JULES DUPRÉ, Nantes 1811–L'Isle-Adam 1889
The Sluice, ca. 1855–1860
1′ 8″ x 2′ 3¼″ (51 x 69 cm) Bequest of Alfred Chauchard, 1909.
RF 1832

facing page, top
CONSTANT TROYON
Cattle Going to Work; Impression of Morning, 1855 (1855 Exposition
Universelle)
8′ 6¼″ x 13′ 1½″ (260 x 400 cm) Deposit from the Louvre. RF 127

facing page, bottom
CHARLES JACQUE
Cattle at the Trough
2′ 3½″ x 2′ 11⅓″ (90 x 116 cm) Deposit from the Louvre. RF 1986

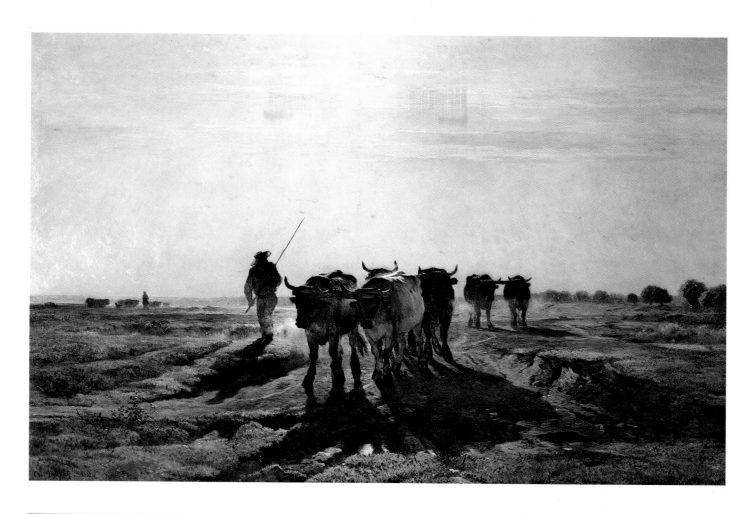

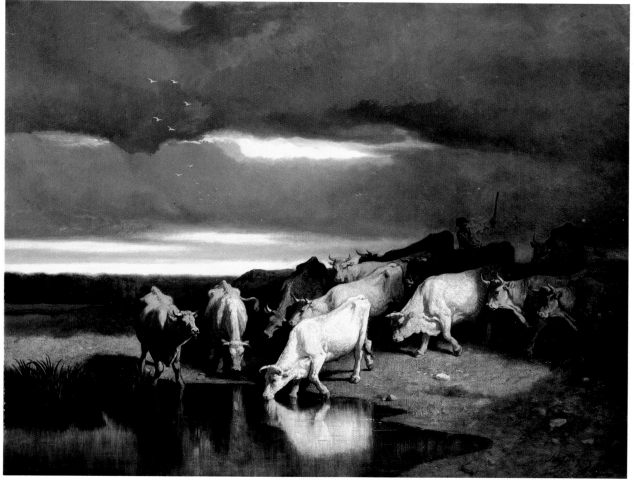

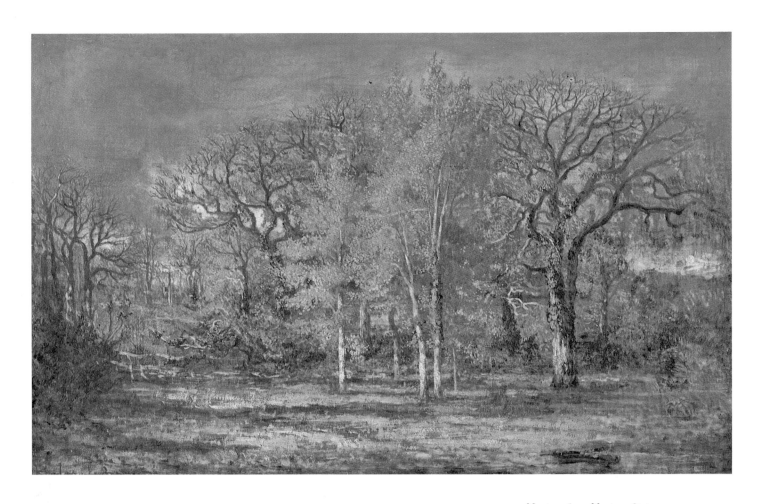

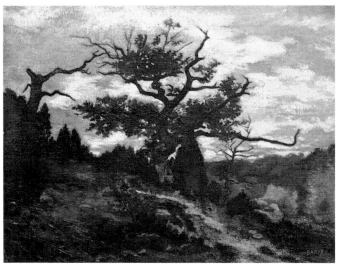

CHARLES LE ROUX, Nantes 1814–Nantes 1895
Edge of the Woods; Cherry Trees in Autumn (1855 Exposition
Universelle)
1′ 6¾″ x 2′ 5½″ (47.5 x 75 cm) Gift of Charles and Joseph Le Roux,
1902. RF 2708

ANTOINE-LOUIS BARYE, Paris 1795–Paris 1875
The "Jean de Paris," Forest of Fontainebleau
1′ x 1′ 3¼″ (30.5 x 38.5 cm) Gift of Jacques Zoubaloff, 1914. Deposit
from the Louvre. RF 2071

facing page
JULES DUPRÉ
The Pond by the Oak Trees, ca. 1850–1855
3′ 4¼″ x 2′ 9″ (102 x 84 cm) Bequest of Alfred Chauchard, 1909.
RF 1831

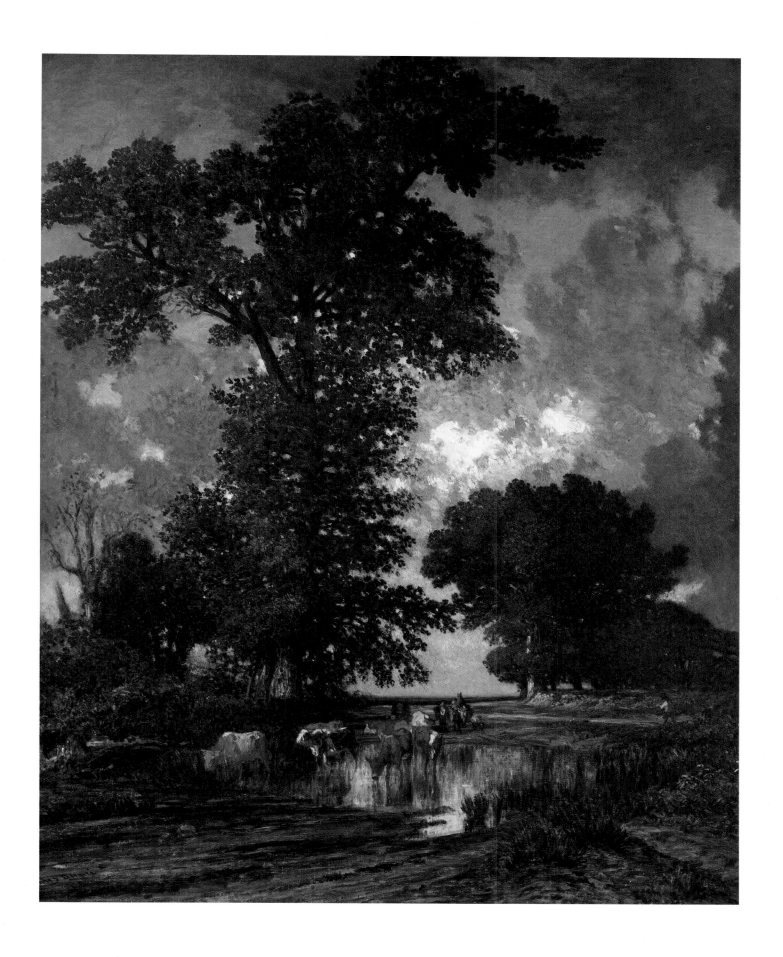

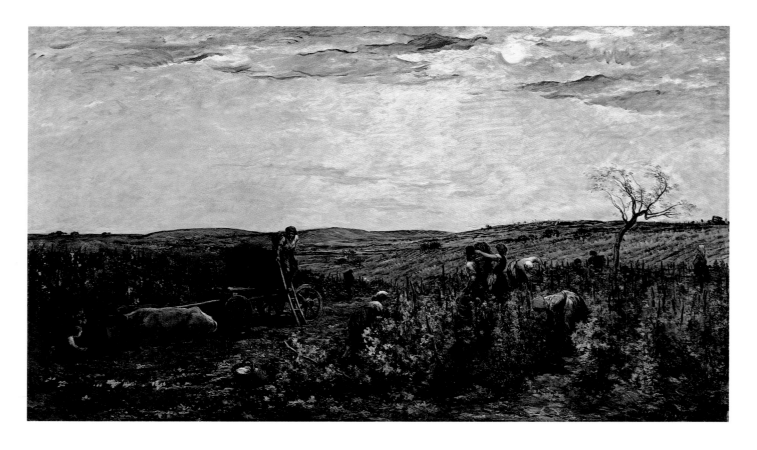

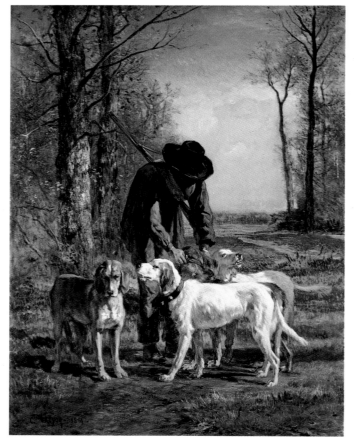

CHARLES-FRANÇOIS DAUBIGNY, Paris 1817–Paris 1878
The Grape Harvest in Burgundy, 1863 (Salon of 1863)
5′ 7¾″ x 9′ 7¾″ (172 x 294 cm) RF 224

CONSTANT TROYON
Gamekeeper Pausing Next to His Dogs, 1854
3′ 10″ x 2′ 11½″ (117 x 90 cm) Bequest of Alfred Chauchard, 1909.
RF 1897

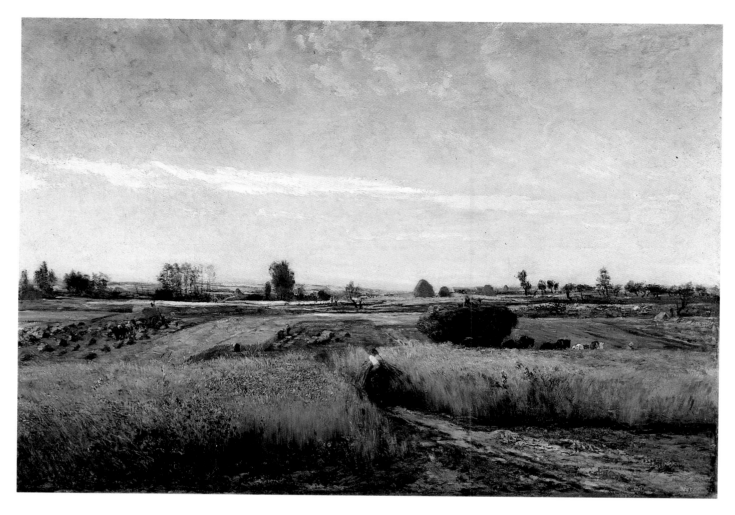

CHARLES-FRANÇOIS DAUBIGNY
Harvest, 1851 (Salon of 1852)
4′ 5¼″ x 6′ 5¼″ (135 x 196 cm) RF 1961

Antoine Chintreuil
Expanse
Paul Huet
The Chasm; Landscape

*A*mong the many pleasures and mysteries summoned up in nineteenth-century landscape, the sense of nature's awesome immensity was often evoked. Few paintings, however, reach such a full-scale orchestration of this theme as *Expanse*, a major canvas by a minor artist that usually makes visitors stop in their tracks. The painter, Antoine Chintreuil, considered himself a disciple of Corot, though the older master would never have depicted a vista so infinite and unbounded. The title in the 1869 Salon brochure was, quite simply, *L'Espace*, a word so abstract and vague in character that it is better translated as *Expanse* than as *Space*. Although the foreground places us in the middle of a country road in the region of La Tournelle-Septeuil—geographically close to Paris but in mood far removed from it—and although we see before us the flock of sheep and farmhouse so common in Barbizon landscape, we are instantly diminished to a mysteriously insignificant scale by the sheer vastness of the horizon and the sky above. Inspired in part by seventeenth-century depictions of the flat, open spaces of Dutch landscape, Chintreuil nevertheless comes closer to the more supernatural mood of such German Romantic artists as Friedrich or, for that matter, of mid-century painters of the American Luminist school. The experience of a radiant infinity of sky, next to which daily life on earth dwindles to nothingness, conjures up a grand meditation on nature's overwhelming power, although the quietly expansive sunrise clearly suggests a benevolent, peaceful deity presiding over the verdant land below.

It was above all the quality of an all-pervasive luminosity that attracted viewers of the 1870s to this painting. Among them was the writer Émile Zola, who probably sensed an affinity between Chintreuil's achievement and the more daring efforts of the Impressionists to dissolve the palpable world in a field of pulsating light. The message of Chintreuil's painting, however, is more consonant with a belated spirit of Romanticism, a resonant hymn of praise and wonder before the varied majesties of nature.

It is a mood that is sustained in another vigorous survivor of Romantic landscape traditions also exhibited in the 1860s, *The Chasm* by Paul Huet, an artist who often depicted nature's potential for eliciting terror in his scenes of crashing waves and stormy skies. Here we are thrust into a landscape of high melodrama, suspended before a rocky chasm whose danger is underscored by the startled huntsmen and the rearing horses at the right and the windswept trees at the left. In contrast to Chintreuil's vision of nature's endlessly expanding benevolence, Huet offers an equally Romantic countercurrent that would make us tremble before the malevolence of a landscape capable of sudden, violent upheaval.

facing page, top
ANTOINE CHINTREUIL, Pont-de-Vaux 1814–Septeuil 1873
Expanse (View near La Queue-en-Yvelines) (Salon of 1869)
3′ 4¼″ x 6′ 7½″ (102 x 202 cm) RF 381

facing page, bottom
PAUL HUET, Paris 1803–Paris 1869
The Chasm; Landscape, 1861 (Salon of 1861)
4′ 1¼″ x 6′ 11½″ (125 x 212 cm) RF 1985-84

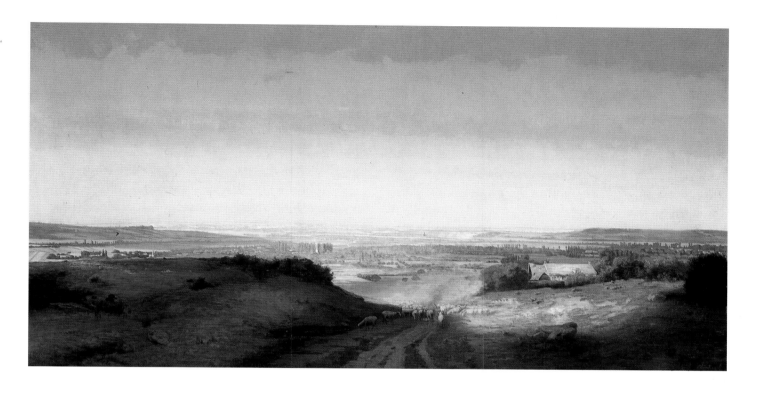

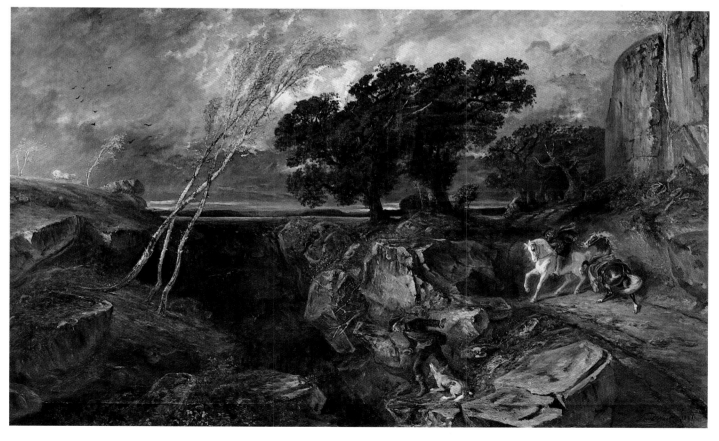

POVERTY AND PIETY IN CITY AND COUNTRY

Alexandre Antigna
The Lightning Bolt

*I*n close synchrony with the three-day revolution of February 1848, French painting seemed quickly to replace the cast of characters from earlier heroic narratives based on literature and Greco-Roman history with anonymous working-class figures from city and country who swelled to dramatic, front-stage presences that demanded serious attention. Along with Millet and Courbet, a far lesser-known master, Antigna, is a fascinating seismograph of these social eruptions. In this new territory, his *Lightning Bolt*, shown in 1848 at the first Salon of the Second Republic, is a precocious triumph.

Like many revolutionary statements, this one molds past elements to unfamiliar purposes. Here the drama is one common in the Romantic repertory of malevolent nature: a blinding flash of lightning that makes earth dwellers quiver with fear. But the scene is not a sublime landscape where remote mythological characters, such as Niobe and her children, might be found under a murderous sky. It is, instead, an attic room in modern Paris where a large fatherless family—a mother and four children—cringe at what almost seems a metaphor of their helplessness before malign, external forces. In reality, like untold thousands of migratory workers who in the late 1840s moved from the provinces to Paris, they are more likely to be destroyed by poverty than by lightning.

Antigna pulls out all dramatic stops. The figures are heroic in scale and grouped in grandly harmonious rhythms that give them an ideal pedigree. And the mother is the very image of uncommon courage in the face of adversity, as she protects her nursing infant and her youngest daughter kneeling in fear. Behind her, the eldest daughter cowers, covering her eyes, while the older son, less fearful than his little sisters, turns in tandem with his mother toward the miserable attic window. The luminary drama—a belated version of Caravaggism—is nobly measured, producing resonant contrasts of light and shadow that elevate this from simple genre to something that can challenge the hierarchies of the past. To be sure, in the mid-eighteenth century Greuze already had translated lofty history painting into life-and-death dramas of well-heeled country folk; but in Antigna's painting of 1848, we sense a new tremor of mid-nineteenth-century truths, of the lives of oppressed families who might well rise to rebel against the destructive forces outside their pitiful doors and windows. Just two years later, in fact, Antigna would paint a similar family terrorized by a raging fire in their city hovel.

The ring of authenticity in Antigna's work is no accident. In the 1840s he had lived in close proximity to working-class tenements on the Ile Saint-Louis. It was not far, one imagines, from the kind of Seine-side view Daumier would use as background for the Parisian washerwoman whose life, unlike that of Antigna's characters, seems sadly unruffled by any vestiges of Romantic melodrama (page 85).

facing page
ALEXANDRE ANTIGNA, Orléans 1817–Paris 1878
The Lightning Bolt (Salon of 1848)
7' 2½" x 5' 7¼" (220 x 170.5 cm) RF 1986-75

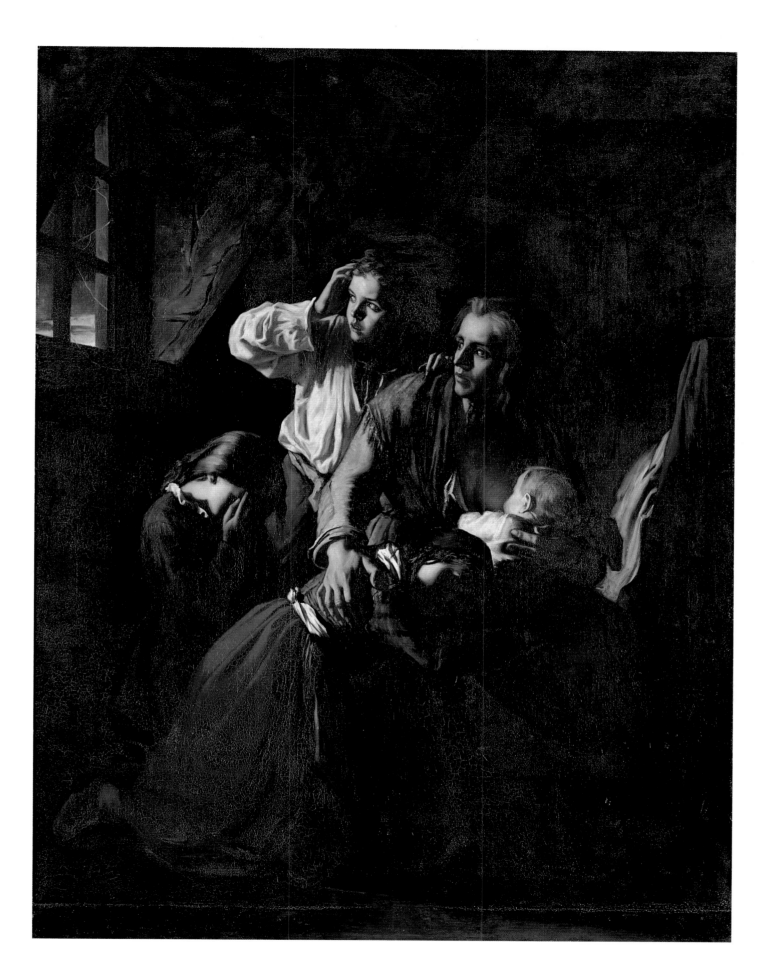

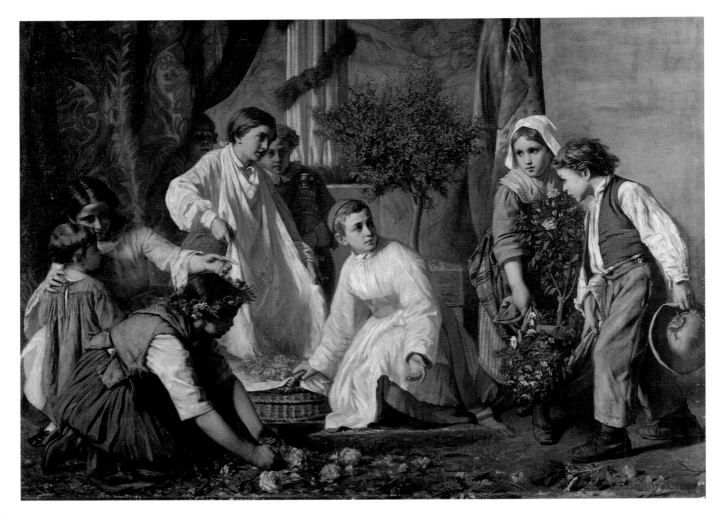

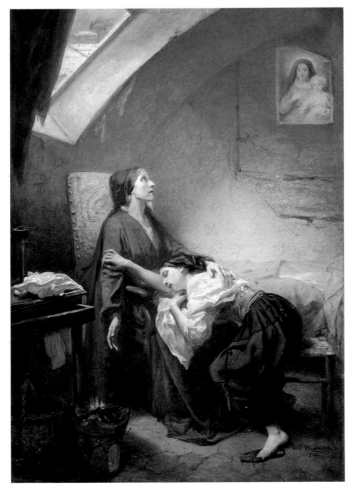

ALEXANDRE ANTIGNA
Corpus Christi Day, 1855 (1855 Exposition Universelle)
4′ 7″ x 6′ 4¾″ (140 x 195 cm) RF 1984-9

OCTAVE TASSAERT, Paris 1800–Paris 1874
An Unhappy Family (or *Suicide*), 1849 (Salon of 1850)
3′ 9¼″ x 2′ 6″ (115 x 76 cm) INV 8114 bis

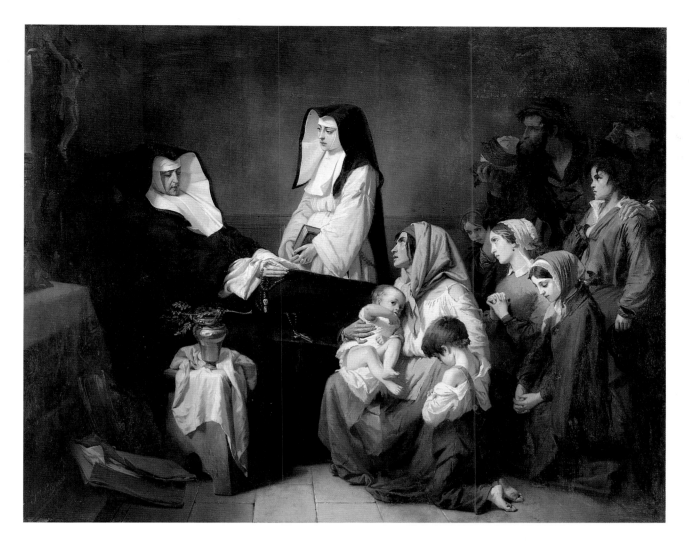

ISIDORE PILS, Paris 1813–Douarnenez 1875
The Death of a Sister of Charity, 1850 (Salon of 1850–1851)
7′ 11″ x 10′ (241 x 305 cm) Salon title is longer. Deposit from the
Louvre. RF 1986-82

HUGUES MERLE, Saint-Marcellin 1823–Paris 1881
A Beggar Woman, 1861 (Salon of 1861)
3′ 7¼″ x 2′ 8″ (110 x 81 cm) RF 554

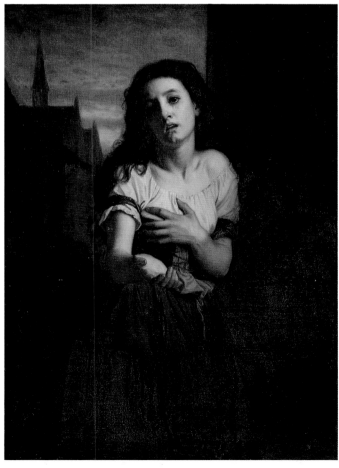

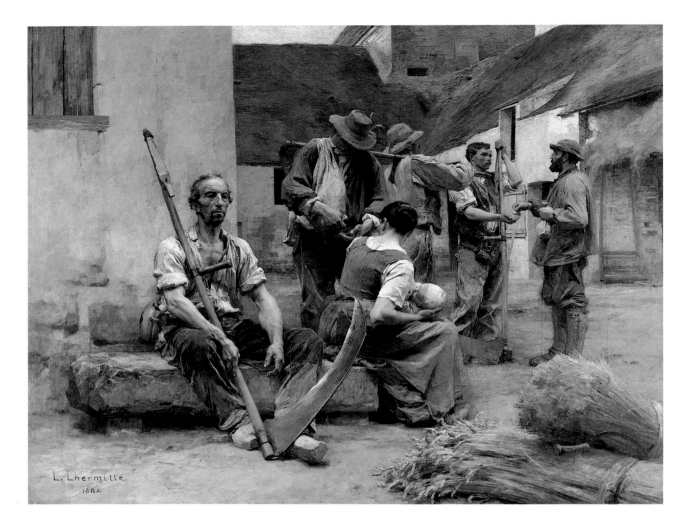

L. Lhermitte
1882

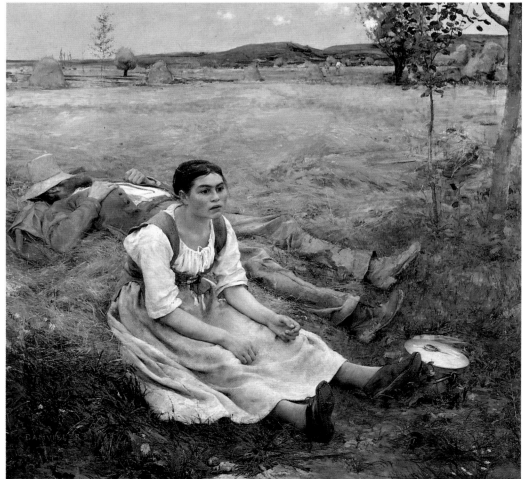

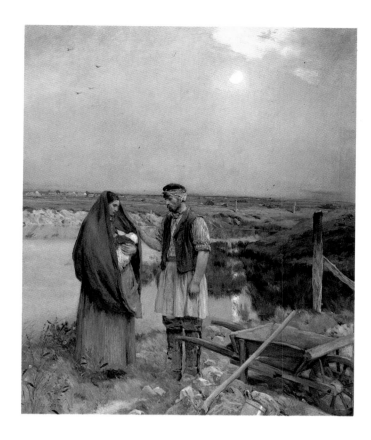

JEAN-CHARLES CAZIN, Samer 1841–Le Lavandou 1901
Day is Done, 1888 (Salon of 1888)
6' 6¼" x 5' 5¼" (199 x 166 cm) RF 1984-114

ROSA BONHEUR, Bordeaux 1822–By 1899
Plowing in the Nivernais; the Dressing of the Vines, 1849 (Salon of 1849)
4' 4¾" x 8' 6¼" (134 x 260 cm) RF 64

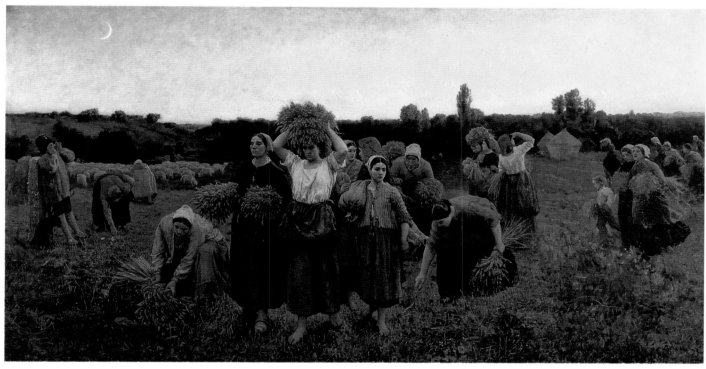

JULES BRETON, Courrières 1827–Paris 1906
The Recall of the Gleaners, 1859 (Salon of 1859)
2' 11½" x 5' 9¼" (90 x 176 cm) MI 289

facing page, top
LÉON LHERMITTE, Mont-Saint-Père 1844–Paris 1925
Harvesters' Country, 1882 (Salon of 1882)
7' ¾" x 8' 11" (215 x 272 cm) RF 333

facing page, bottom
JULES BASTIEN-LEPAGE, Damvillers 1848–Paris 1884
Hay-making, 1877 (Salon of 1878)
5' 10¾" x 6' 4¾" (180 x 195 cm) RF 2748

Ernest Hébert
Mal'aria
Firmin-Girard
The Convalescents

Separated by only a decade, these two paintings offer a head-on collision between old and new mid-century approaches to a common theme: illness and human frailty. In Hébert's belated Romantic fantasy, inspired by something he had actually seen during his Roman sojourn, an Italian peasant family flees from the "mal'aria," the bad air that spreads the disease that may contaminate them as it has others. Such a scene of melancholy terror might almost be a vision of Dante's bark on the river Styx, so gloomy and melodramatic is the voyage through the hazy air of the marshland. Appropriately, this poetic translation of the miserable commonplace of a malaria epidemic in the Roman campagna triggered a favorable response from the art critic and writer Théophile Gautier in the form of a poem, which praised Hébert's metamorphosis of picturesquely costumed Italian peasants—the stock-in-trade of an earlier Romantic generation—into a scene of haunting pallor. What a clash with Courbet's view of a rural burial at the same Salon of 1850–1851 (page 139)!

The clear light of an urban day illuminates the later scene of communal illness, a view by Firmin-Girard, at the 1861 Salon, of what appears to be a courtyard attached to a veterans' hospital. The anonymous convalescents, their heads bandaged, provoke neither tears nor patriotism, but are simply standing and sitting about, enjoying the strong sunshine that casts clear shadows across the open space. The view, as in so many Impressionist paintings to come, is oblique, as if we were just pedestrians who were glimpsing, on the move, an ordinary street scene. If there are individual or collective dramas here—are these men the wounded debris of a recent foreign battle?—they are totally concealed by the casual expressions and postures of the inmates, who offer a matter-of-fact testament to high standards of public hygiene and welfare. In so modest a way, a new viewpoint is quietly announced, that of the urban stroller who, like Manet and Degas, records the constantly shifting scene—hospital or café, beggar or dandy—with an equally cool eye.

facing page, top
ERNEST HEBERT, Grenoble 1817–La Tronche 1908
Mal'aria, 1848–1849 (Salon of 1850–1851)
11′ 3″ x 6′ 4″ (135 x 195 cm) INV 5299

facing page, bottom
MARIE-FRANÇOIS-FIRMIN GIRARD,
called FIRMIN-GIRARD, Poncin 1838–Montluçon 1921
The Convalescents, 1861 (Salon of 1861)
4′ 1¼″ x 6′ 1¼″ (125 x 186 cm) RF 1984-167

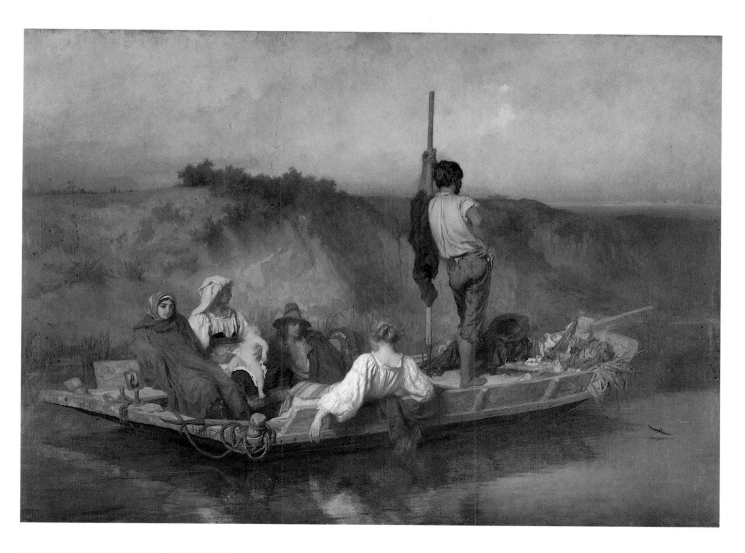

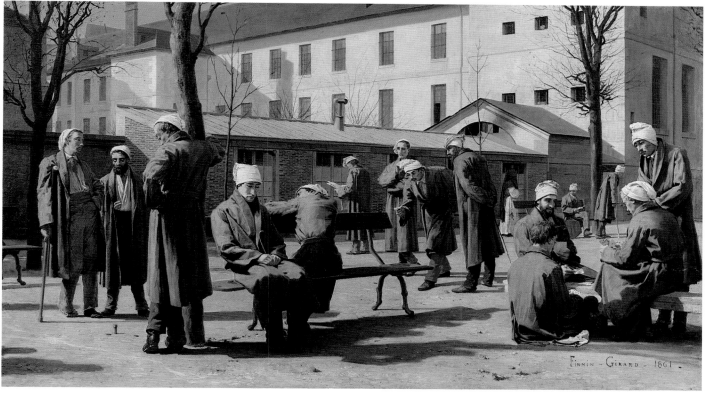

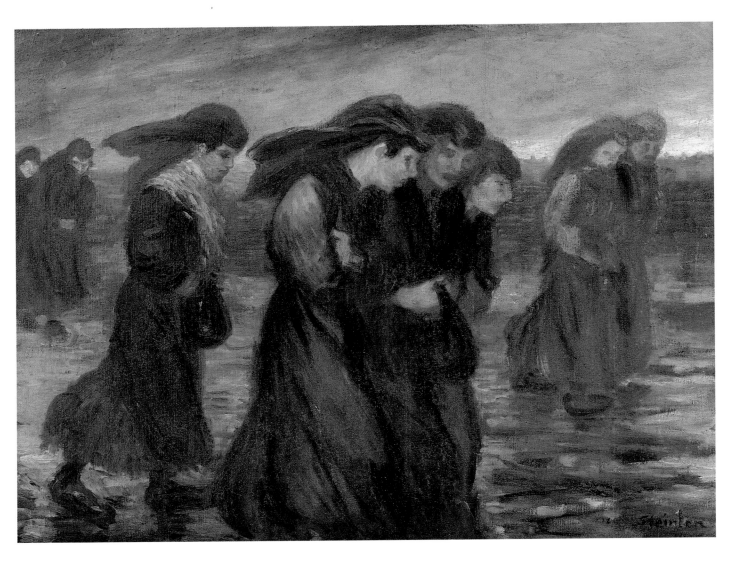

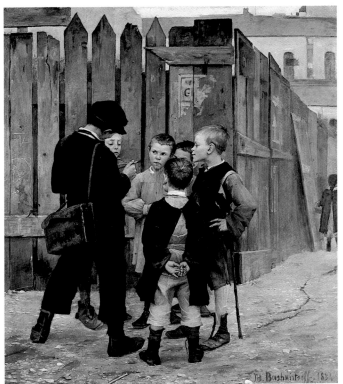

THÉOPHILE-ALEXANDRE STEINLEN
Lausanne 1859–Paris 1923
The Coal Sorters, 1905
2′ x 2′ 8¼″ (61 x 82 cm) Bequest of Mrs. Roger Desormière, 1970.
RF 1970-7

MARIA BASCHKIRTSEVA, Gavrontsy 1860–Paris 1884
A Meeting, 1884 (Salon of 1884)
6′ 4″ x 5′ 9¾″ (193 x 177 cm) RF 442

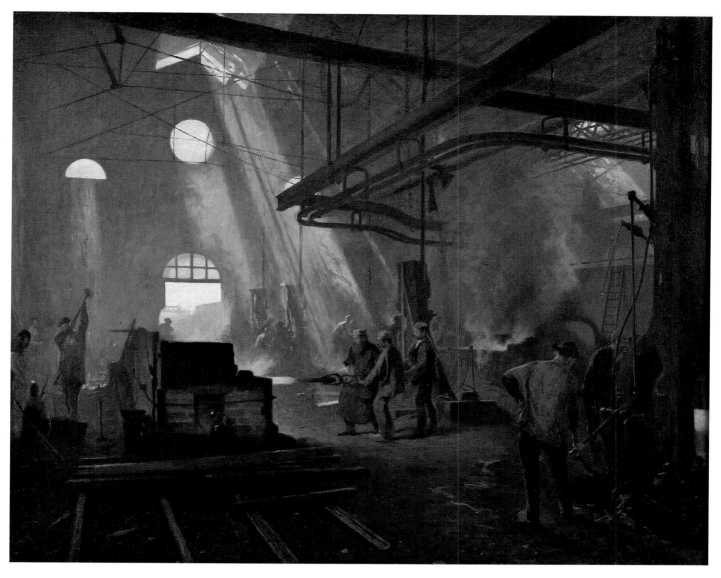

FERNAND CORMON, Paris 1845–Paris 1924
A Forge, 1893 (Salon of 1894)
2′ 4¼″ x 2′ 11½″ (72 x 90 cm) RF 891

Alfred Stevens
What Is Called Vagrancy

*N*obody who had lived through the many revolutions of 1848 could have been unaware of the desperate eruptions of starving workers in city and country. Throughout the 1850s, artists from the widest variety of income groups and aesthetic allegiances paused to consider the lives of the anonymous poor as an urgently topical subject. Both Courbet and Millet had polluted the ideal air of the Salons with such headline truths; and even painters who, like the Belgian-born Alfred Stevens, were later to make their careers mirroring the most fashionable strata of Parisian society often paused to depict the harsh urban realities they would see going to and from their studios and dinner parties.

Such is the case in Stevens's full-size condemnation of police brutality and human misery in Vincennes, on the outskirts of Paris. What we see as victims in this heartbreaking procession are a destitute beggarwoman with her two children: a small baby in her arms and a crying, humiliated little boy tugging at her skirt. Three soldiers armed with rifles are marching them off to prison, while, at the right, members of two divergent social classes, an elegantly dressed woman and a manual laborer, watch this arrest with shock and compassion. The snow-covered ground and leafless trees above the harshly confining wall add their wintry chill to this scene of urban hardship; as a further irony, the posters on the wall proclaim (in partly fragmented, proto-Cubist fashion) BAL and TERRAIN A VENDRE, that is, a ball and property for sale—reminders of a moneyed world painfully remote from this vagrant's wretched life.

The story has it that when Stevens's painting was shown at the Paris Exposition Universelle of 1855, Napoleon III himself professed to be upset that his own armed guard would be reduced to such ugly, brutal chores. He recommended that henceforth such helpless vagrants be taken to prison more discreetly in closed wagons rather than paraded through the street by the military.

The blunt truths of this stark city drama, which might well have provided visual fuel for Marx and Engels's call for a proletarian revolution, are stated in a pictorial language that at first seems related to Courbet's insistence on front-plane, palpable truth, but then looks more allied to the elegant dark-light patterning that Stevens's younger friend Manet would soon make his visual signature. Indeed, the svelte, almost velvety silhouettes of black uniforms and city clothing, whether of the rich or the poor, against gray and white, as well as the emphatic planarity of disjointed figural friezes floating against a flattened ground, are inventions that clearly herald the Manet of the 1860s. He, too, had begun his career by depicting the outcasts of Paris. Nevertheless, both artists were upwardly mobile in art as in life, rapidly shifting by the 1860s to a different kind of social realism: a mirror of that glittering world of Parisian elegance that wore the best and latest fashions and surrounded itself with the newest bibelots from Japan.

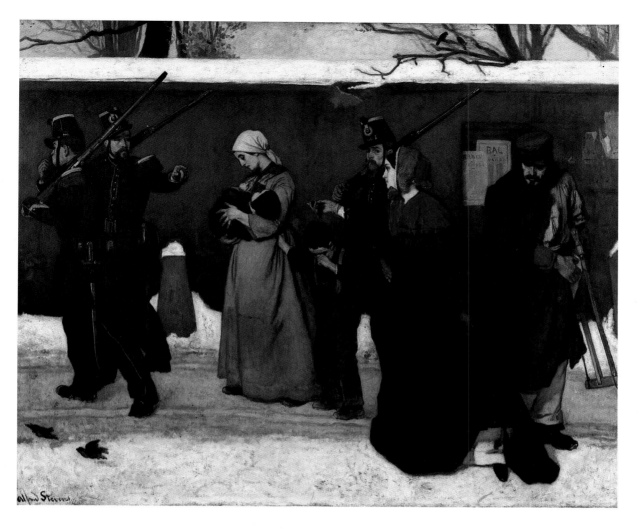

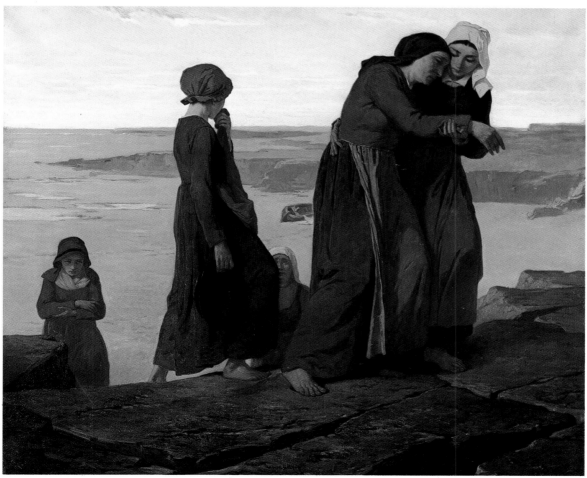

Spectator Christianity

With this modest unfinished painting of 1874 by an old friend of Whistler's, Alphonse Legros, who moved from his native France to England in 1863, we could hardly be more remote in spirit from the pulsating, luminous canvases seen the same year at the first Impressionist group show. Turning his back entirely on the modern world of transient, fragmentary experience, Legros offers solace and permanence with almost an anthropologist's view of the stubborn survival of Christian faith in provincial regions of France. It was a theme whose popularity welled in the mid-century, when sophisticated city dwellers liked to be reminded that, far from the new railway lines, one could still find pockets of archaic simplicity, where workers never went on strike and where Christianity remained as unchallenged as the beliefs of a tribe in French colonial Africa.

Like countless other image makers of the century, Legros painted a vignette of rural piety that is both respectful and condescending. The artist, along with the spectator, is presumably awed by this record of unquestioning faith, in which a sextet of women (traditionally far more religious than the men in rural areas) kneel in solemn prayer before a sculpture of the Crucifixion that seems always to have dominated the somber landscape. Their black capes and white headdresses speak of their ascetic devotion, further underlined by the painting's almost Whistlerian spareness. Clearly, we are to admire this quiet display of spiritual strength; but clearly, too, we are viewing it from the vantage point of an educated modern observer who knows that the Middle Ages have long since passed and that such firm rural faith belongs to a much-endangered species. Such women, we know, wouldn't last a moment in Paris or London, but it is comforting to be reminded that they still exist somewhere in the modern Western world, in the most remote provinces of France.

So deeply ingrained in nineteenth-century art was this theme of spectator Christianity, in which we observe rather than participate in a religious ritual, that it was subject to endless variations. In their matching of primitive faith and would-be primitive style, the most potent are Gauguin's depictions of Breton peasant women worshiping before crudely carved crucifixes. Lesser artists tried other angles of vision. Within the milieu of Brittany, famed for its clinging piety, Dagnan-Bouveret offered a more diluted vision of picturesque church services (page 135), whereas other artists, of a later generation, could invest higher drama into what was known to be the arduous, dangerous lives of peasants and fishermen in these rugged coastal regions of Northwest France. We sense this in such turn-of-the-century works as Lucien Simon's cinematic framing of a religious procession at Penmarch (page 136), in which we can scrutinize every hardened face, young and old, in this community of believers, and in the more ambitious series of paintings by a colleague of Simon's, Charles Cottet, titled *In the Country by the Sea*. Like John Millington Synge's contemporary drama, *Riders to the Sea*, Cottet's work reflects the tragic endurance of a people given strength by ancient faith. In one of his canvases on this theme, the Christian Pietà seems reenacted on the Brittany coast; in another, the triptych form itself echoes the venerable tradition of religious altarpieces, sanctifying the harsh secular realities of Breton life (page 137).

facing page
ALPHONSE LEGROS, Dijon 1837–Watford 1911
The Calvary, 1874
3′ x 2′ 4¾″ (91.5 x 72.8 cm) Gift of Ernest May, 1923. RF 2438

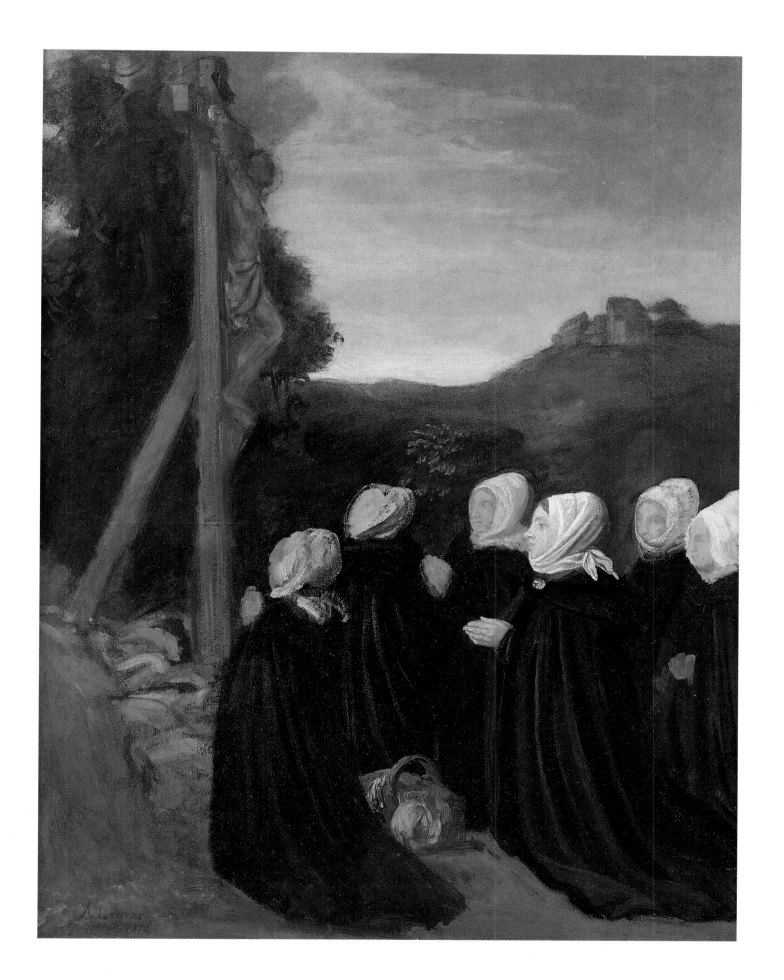

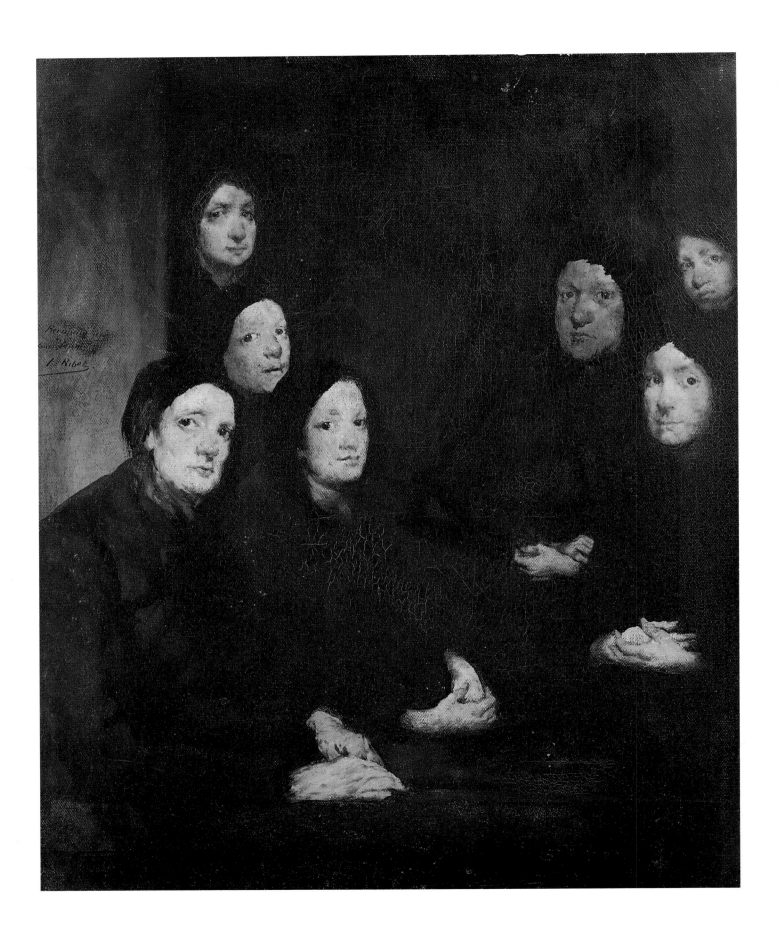

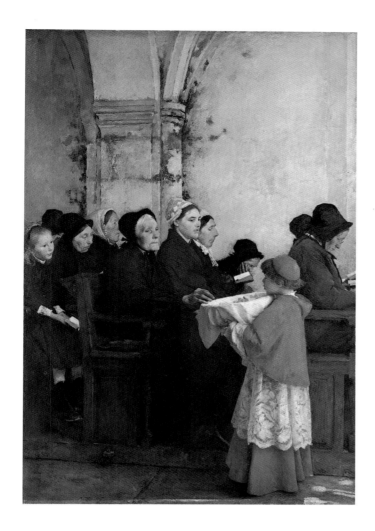

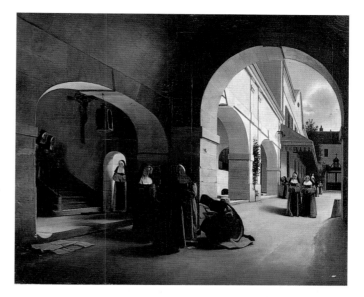

FRANÇOIS BONVIN
The Ave Maria; Interior of a Convent at Aramont, Verberie (Oise), 1870
(Salon of 1870)
2′ 8½″ x 1′ 7¾″ (82.5 x 50 cm) Bequest of Charles-Aimé Vince, 1890.
RF 645

PASCAL DAGNAN-BOUVERET, Paris 1852–Quinay 1929
The Blessed Bread, 1885 (Salon of 1886)
3′ 11¼″ x 2′ 9″ (120 x 84 cm) RF 469

facing page
THÉODULE RIBOT, Saint-Nicolas-d'Attez 1823–Colombes 1891
At the Sermon (Salon of 1890)
1′ 9¾″ x 1′ 6¼″ (55.5 x 46.5 cm) Gift of Josse and
Gaston Bernheim-Jeune, 1917. RF 2187

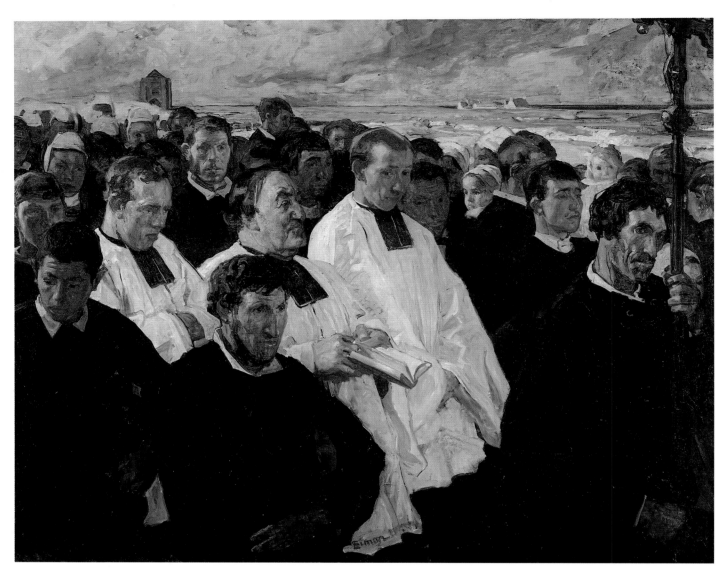

LUCIEN SIMON, Paris 1861–Paris 1945
Procession at Penmarch (Salon de la Société Nationale des Beaux-Arts, 1901)
4′ 5½″ x 5′ 9″ (136 x 175.5 cm) RF 1240

facing page, top
CHARLES COTTET, Le Puy 1863–Paris 1925
In the Country by the Sea, Sorrow, 1908 (Salon of 1908)
8′ 8″ x 11′ 3¾″ (264 x 345 cm)

facing page, bottom
CHARLES COTTET
In the Country by the Sea, 1898 (Salon of 1898)
Triptych: central panel, 5′ 9¼″ x 7′ 9¼″ (176 x 237 cm); left and right panels each 5′ 9¼″ x 3′ (176 x 119 cm) RF 1122

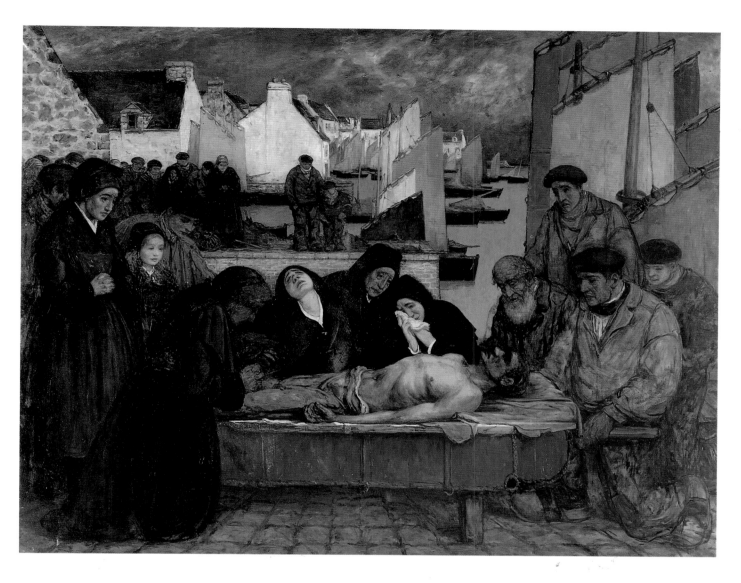

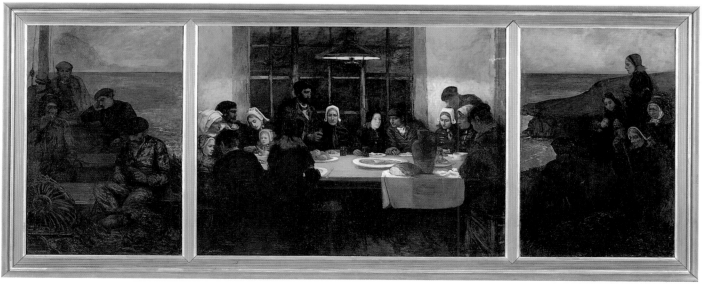

COURBET

A Burial at Ornans

With an irrevocably solid thud, a lofty hierarchy of social and religious fictions falls from sky to earth in Courbet's watershed masterpiece. If only by sheer size—it is almost twenty-two feet wide—it was destined to command at the Salon of 1850–1851 the kind of attention accorded three years earlier to Couture's only slightly larger *Romans of the Decadence* (page 23), whose authority it challenged head-on. For occupying this vast pictorial stage was not a cast of remote players culled from classical legend or the Bible, but a life-size cross section of the actual residents of Courbet's own hometown, Ornans, in the rugged landscape of the Franche-Comté some 270 miles away from the arty sanctuary of the Salon. It was the equivalent of country bumpkins crashing a fancy-dress party in Paris.

What these rural folk were doing was no less upsetting. They are seen performing a Christian ritual, a burial, not within the sacred proximity of a church but far beyond its reach. Belatedly following the French government's efforts to have the nation's dead buried in more hygienic conditions than had earlier been provided in the crowded graveyards of rural churches, Ornans opened its new cemetery in the revolutionary year of 1848. In Courbet's painting, we are in fact attending the burial of its first client, now known to be a certain Claude-Etienne Teste, a local farmer who also happened to be the artist's great-uncle. This identification corrects the traditional legend that it was the burial of Courbet's grandfather that prompted the unfamiliar fusion of an artist's public and personal history. His approach to this civic and clerical ritual is almost that of a combination sociologist and anthropologist who would observe both the gathering of the clan from the little community he knew and loved from his youth and the actual physical facts that pertained to modern Christian burial practice as he witnessed it in the mid-century. It is telling that, before its shocking debut in Paris, Courbet arranged to show his huge canvas to provincial audiences in Ornans, Besançon, and Dijon, who, Courbet felt, would be more receptive to these regional truths.

Attending the burial that inaugurated the wide, open space of the cemetery is a solemn assembly of the pillars of rural society, divided broadly into three groups. The clergy is at the left, clustering around the coffin, which pall bearers carry before our eyes to the grave. The male civic authorities are in the middle, including the justice of the peace (with a widow's peak), a very fat mayor (at his left), and a pair of local veterans, dressed for this church ritual in costumes of 1793. To the right, a large group of grieving townswomen, including the artist's three sisters (two of whom sob into their white handkerchiefs), stand separate from the men, providing a rustic Greek chorus of mourning. Less integrated in this social trinity are the grave digger, kneeling with routine respect as last rites are conducted, and the even more conspicuous white mongrel, who casually turns his head from the open grave to notice perhaps some ongoing movement outside the cropped frame of the processional image.

In accord with Courbet's passionate credo of truth to actual experience—*his* experience—everything has the obdurate ring of documentary fact. It is no surprise to learn that the entire cast of townsfolk was modeled after actual residents of Ornans who posed for the master. Indeed, more than half of the fifty-one members of the community seen here have now been identified by name, including even the grave digger, Antoine Joseph Cassard. For many Parisian spectators, the effect of all these coarse individuals demanding equal visual time with one another and with the figures in adjacent paintings must have been like that of an ugly class photograph from a provincial school. Unsettling, too, was the rejection of conventional hierarchies of major and minor. This was one of Courbet's most heretical innovations, for this community is constructed on what might be called democratic principles, the functions shared equally by individuals rather than controlled by a higher central power.

But still more drastic was the undoing here of Christian authority. Heaven and hell, not to mention the Church, have disappeared. The sacred site where the body will return to earth has now been defined as a freshly dug ditch, a crude and conspicuous hole in center foreground that projects forward into the spectator's space and therefore implies that we are physical witnesses to this event, standing at the foot of the grave and facing the other mourners. As for the trappings of the Church, they have become no less material facts, with the more colorful costumes of the priests, the choir boys, and the beadles (in flamboyant red) equated with the other fancy dress put on for public occasions. Most desanctifying is the only thing to rise above the enclosing horizon that roots this community to the solid earth: a sculptured crucifix held high like a flag in a

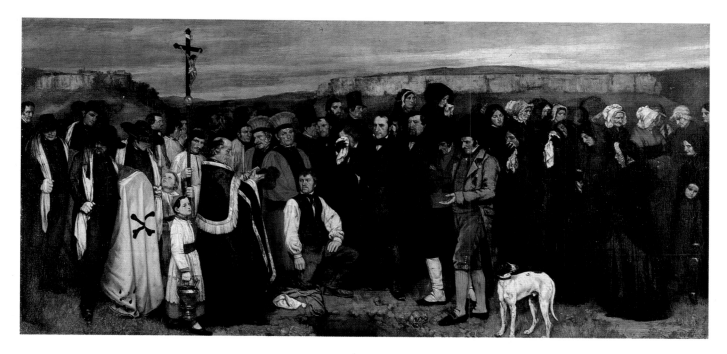

GUSTAVE COURBET
Ornans 1819–La Tour-de-Peilz 1877
A Burial at Ornans, 1849–1850 (Salon of 1850–1851)
10′ 3½″ x 21′ 9″ (314 x 663 cm) Gift of Miss Juliette Courbet, 1881.
RF 325

pages 140 and 141
GUSTAVE COURBET
A Burial at Ornans, detail

patriotic pageant. In Courbet's Realist eye the Crucifixion is no longer a Christian image of universal faith in the supernatural, but a simple, man-made artifact, a stage prop brought out for this would-be sacred occasion for particular people in a particular time and place honoring their dead. Courbet quipped that he could not paint an angel unless he saw one, and the Crucifixion that he painted here was the only kind he could see.

Confronting viewers with this panoramic life-size dose of truth about the Church's role in the passage from life to death, he makes it hard to believe again in the supernatural truths of all those painted Christian heavens to which souls had ascended over the centuries. Courbet, after all, was a contemporary of Darwin and Marx.

He was also a great painter; and if he wanted to tell the awkward, ungainly truths about the provincial experiences he knew firsthand, he could transform them into a canvas that transcends the mere documentation of a typical rural ritual. (The title calls it *A Burial*, not *The* Burial at Ornans.) The ostensible disorder of these earthbound figures, who turn this way and that, stubbornly refusing the interlocking harmonies of Couture's graceful crowd of Romans, is given a new kind of order that Courbet had to

create from the ground up. The long, wide frieze of figures, which at first may seem so unruly, subtly echoes the broad curves of the distant cliffs, yielding a slow, serpentine rhythm that also fuses near and far. And the potential of crowd congestion, always a danger in the way Courbet pushes everything forward in order to make people and objects seem literally available to the spectator's touch, is sidestepped not only by the gross but welcome void of the ditch in dead center but, as contemporary caricatures noted, by the abrupt contrasts of creamy white against the reigning darkness of the costumes. These startling paint passages animate in the most unexpected places—the dog, the shirtsleeves, the handkerchiefs, the bonnets—what might be an unrelieved sea of funereal black.

Finally, the pictorial whole is far more than the sum of its many willfully disjointed parts. Merging into a coherent image of the strong new social and religious realities familiar to the populations of rural France, these modern facts found a genius to depict them with straightforward honesty and dignity. We may recall Mary Cassatt's comment that *A Burial at Ornans* displayed an artistic ancestry that went all the way back to another kind of funerary art, the processional reliefs on classical sarcophagi.

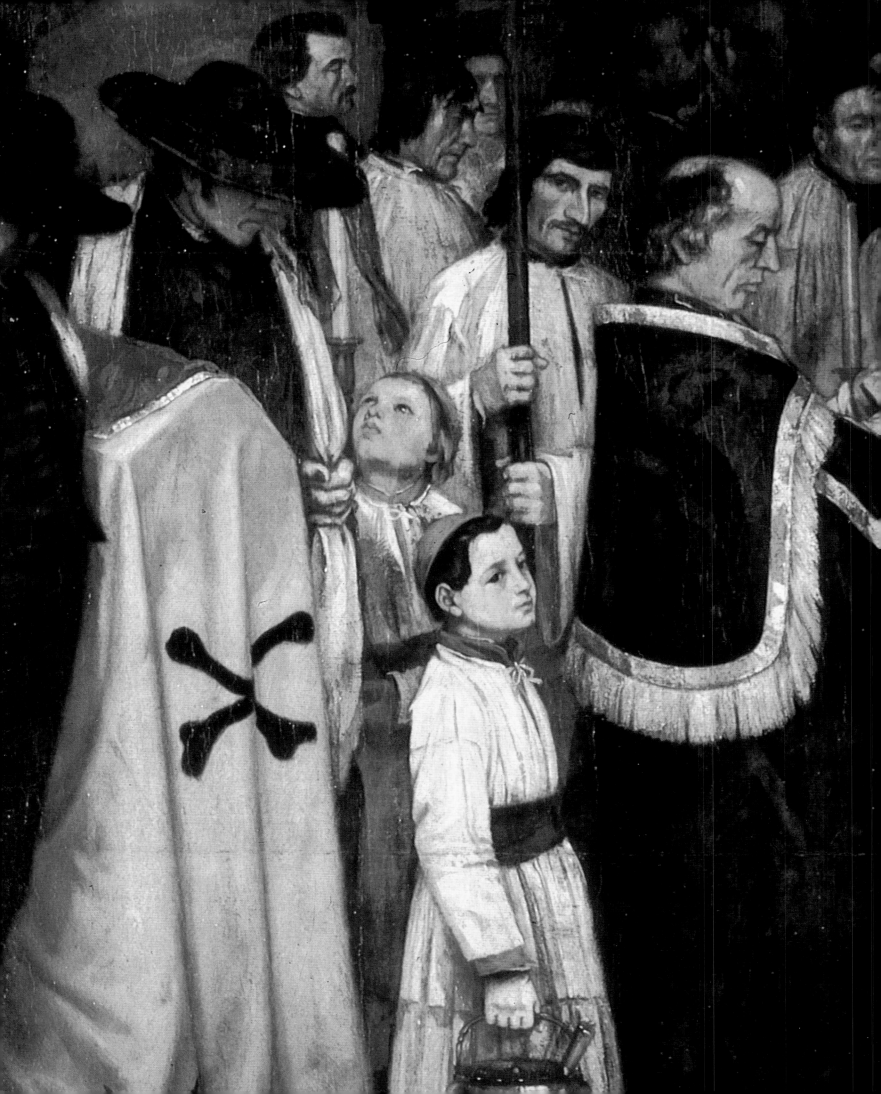

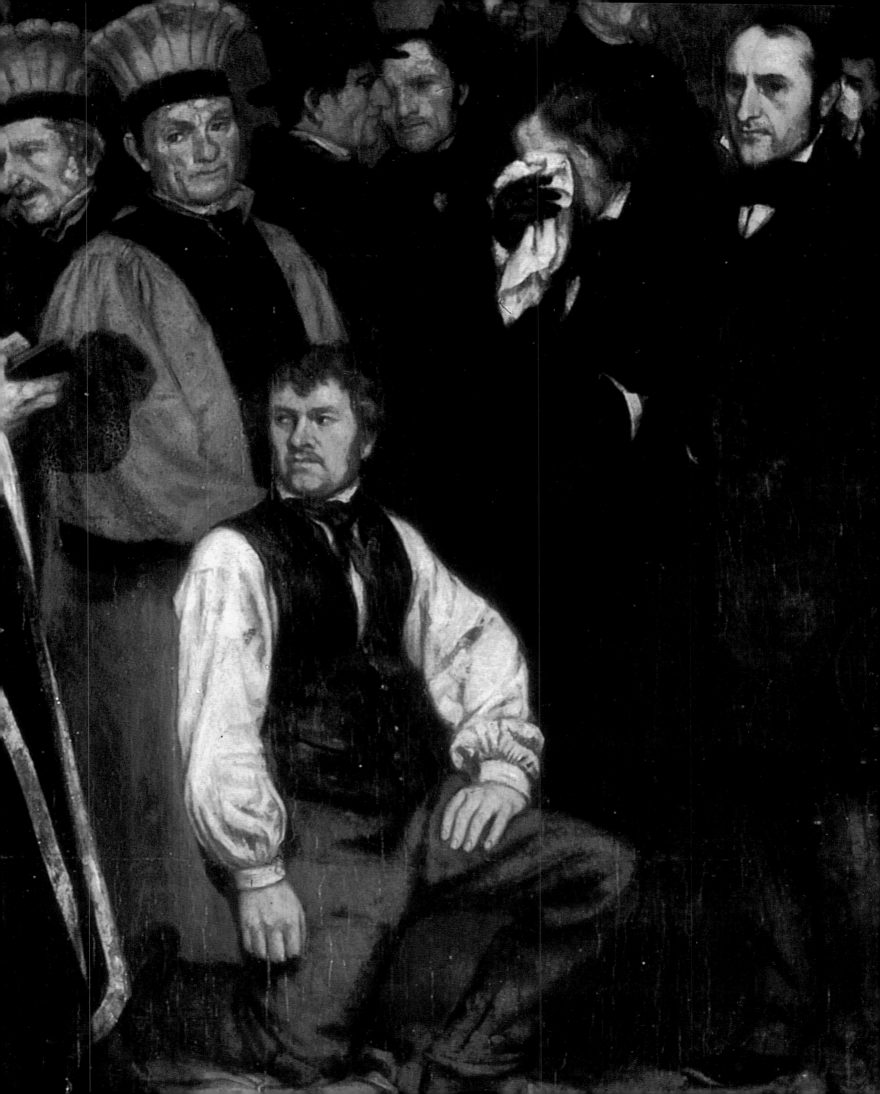

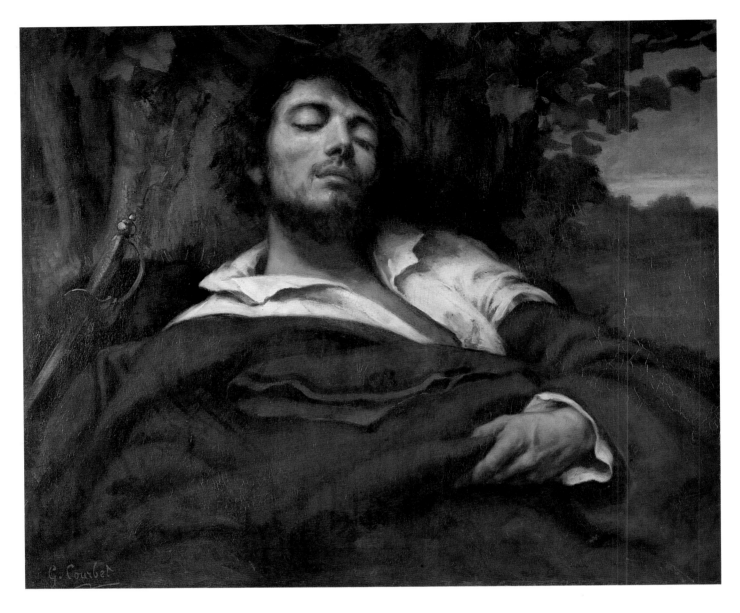

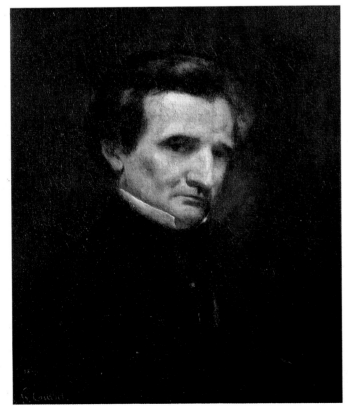

GUSTAVE COURBET
The Wounded Man, 1844
2′ 8″ x 3′ 2½″ (81.5 x 97.5 cm) RF 338

GUSTAVE COURBET
Hector Berlioz, 1850 (Salon of 1850–1851)
2′ x 1′ 7″ (61 x 48 cm) Bequest of Joseph Reinach, 1921. RF 2320

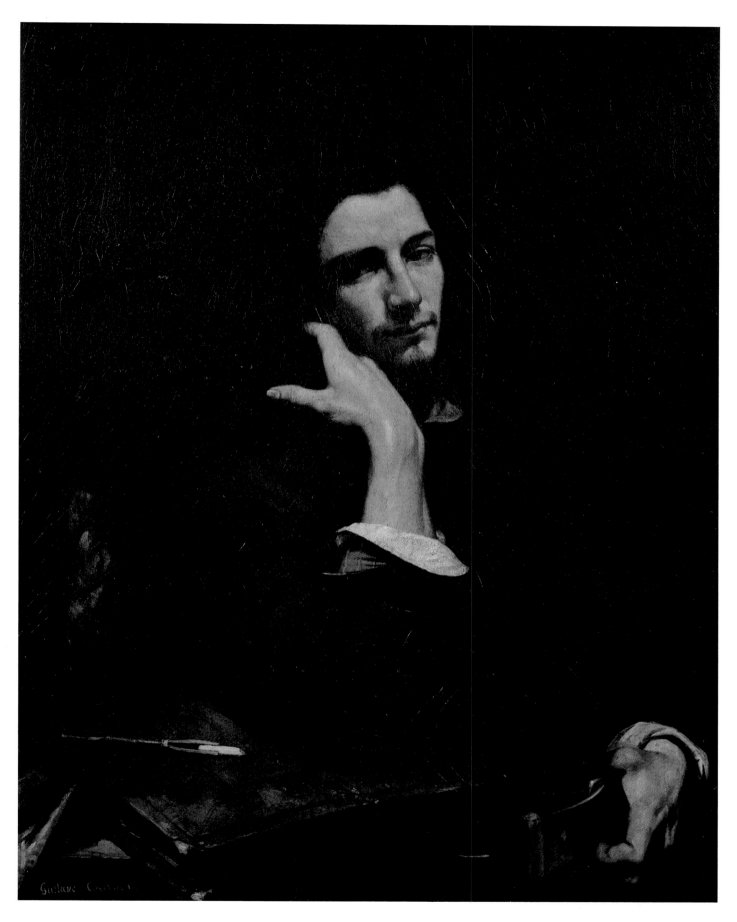

GUSTAVE COURBET
The Man with the Leather Belt (Self-Portrait) (Salon of 1846?)
3' 3¼" x 2' 8¼" (100 x 82 cm) RF 339

Nude with Dog

Part of Courbet's colossal genius was his ability to transform the coarsest subject matter into paintings that demanded full-time attention and a major place in the noblest lineage of Western painting. Even here, with so gross and trivial a theme as a heavy-set nude making mock love to her pet poodle (her left hand around his fluffy little back, her lips pursed for a canine kiss), Courbet conjures up, almost as in an epic parody, a fancy ancestry. The spirit of Titian's heroic female nudes, acting out their love affairs with the gods (who may arrive as eagles, swans, bulls, but never poodles), is awakened here in the monumental scale, the russet tonality, and the idyllic curtained landscape. But closer to home is Courbet's reincarnation of a Rococo theme particularly favored by Fragonard: a young girl in an erotic frolic with a happily compliant lapdog. As such, Courbet's painting may even be thought of in the context of the Rococo Revival that flourished under the Second Empire, which would inspire both Renoir and Monet to translate the sensuous idylls of the *ancien régime* into the language of contemporary French life. But Courbet, typically, controverts his elegant ancestors by insisting on the most vulgar material facts. In reality, the face and naked body here belong not to an old-master Venus but to one of the artist's friends, Léontine Renaud. The auburn hair is disheveled, and the rest of her—dumpy in proportion and dirtied by greasy gray shadows—makes fun of any conventions, old or new, of ideal beauty, usurped now by the robust truths of things freshly seen. As a final insolence, the wiggling big toe and exposed red sole of a large foot transform the establishment nudity of works by Ingres or Cabanel into the earthiest common clay.

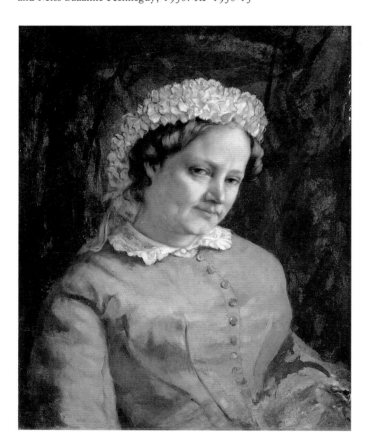

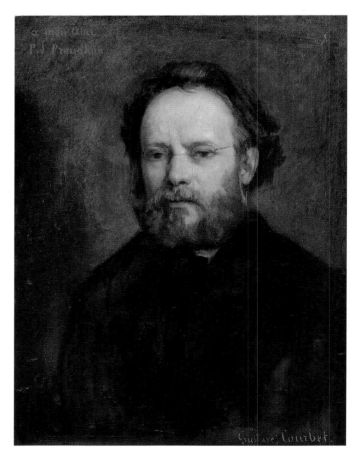

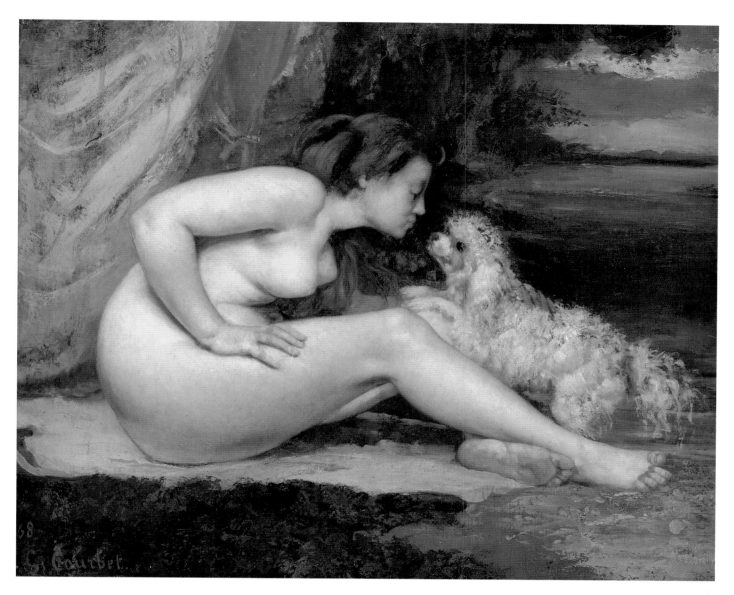

GUSTAVE COURBET
Nude with Dog, 1861–1862 (later dated 1868)
2′ 1½″ x 2′ 8″ (65 x 81 cm) RF 1979-56

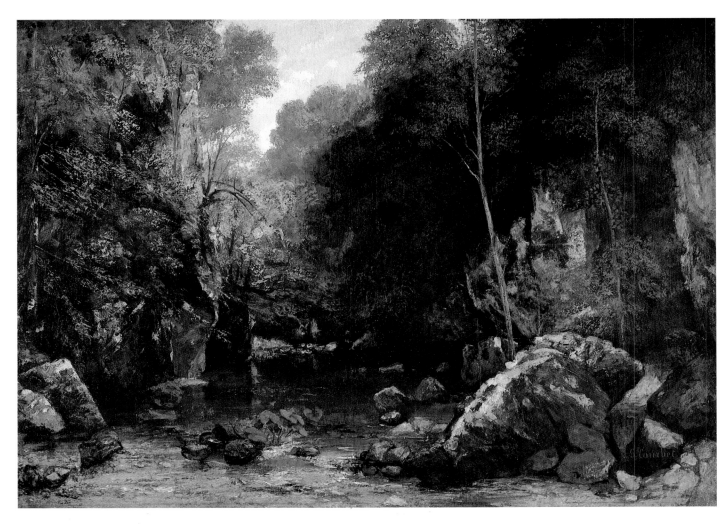

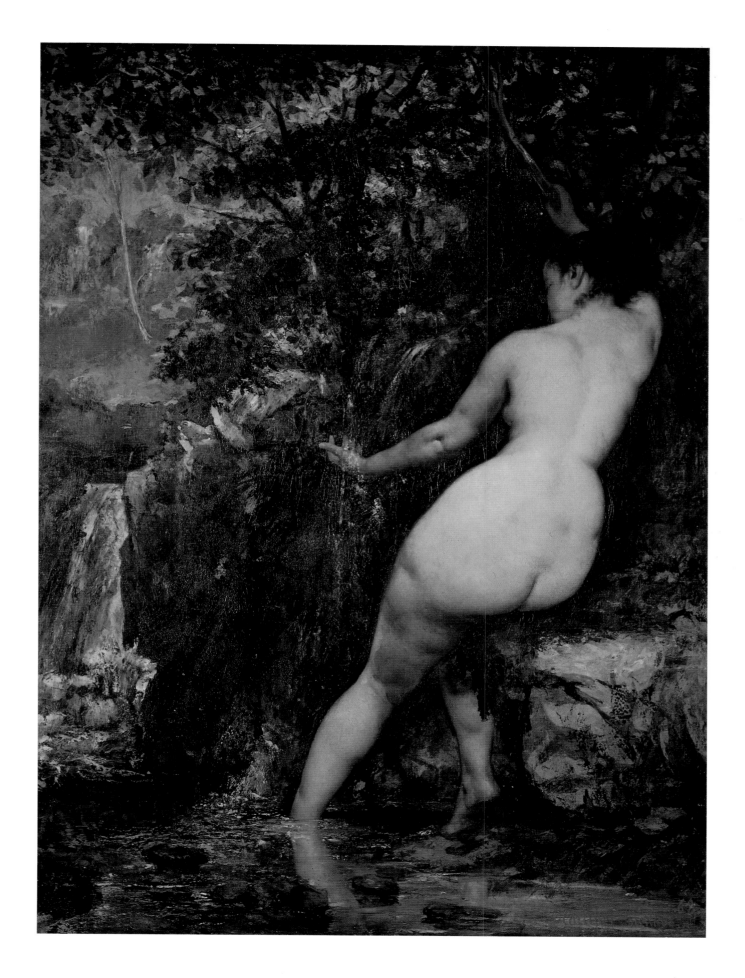

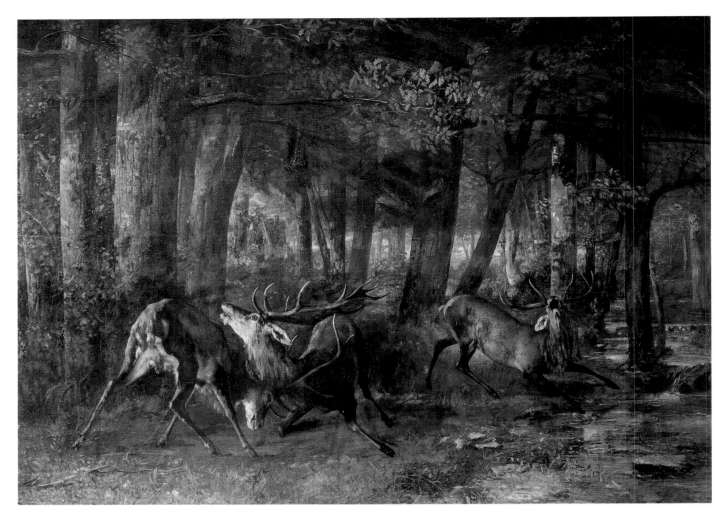

Spring Rutting; Battle of Stags, 1861 (Salon of 1861)
11′ 7¾″ x 16′ 7½″ (355 x 507 cm) RF 326

The Trout, 1873 (variant of 1872 version)
2′ 1¾″ x 3′ 2¾″ (65.5 x 98.5 cm) RF 1978-15

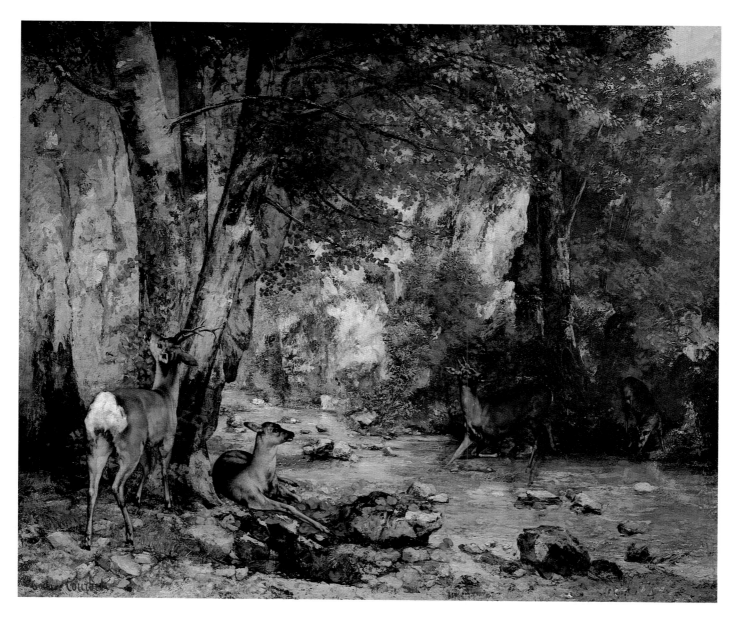

GUSTAVE COURBET
A Thicket of Deer at the Stream of Plaisir-Fontaine, 1866 (Salon of 1866)
5' 8½" x 6' 10¼" (174 x 209 cm) Gift of an amateurs' reunion, 1890.
RF 583

GUSTAVE COURBET
Apple Tree Branch in Flower (Flower of a Cherry Tree), 1872
(predated 1871)
1' 1" x 1' 4" (32 x 40.5 cm) Gift of Max and Rosy Kaganovich, 1973.
RF 1973-14

The Stormy Sea (or The Wave);
The Cliff at Etretat after the Storm

*I*n the summer of 1869, Courbet, like many artists before him, spent some weeks in the picturesque Normandy village of Étretat in a house with a view of the Channel sea. As reported by a most illustrious eyewitness, the young writer Guy de Maupassant, he was seen there one day staring through a window at a wild storm that made the sea splash against the walls and windows of the house while he attempted to record the spectacle on a large canvas, wielding a kitchen knife covered with a slab of white paint. The result was exhibited the following year at the Salon of 1870, together with another coastal scene that records the calm after the storm. The two paintings, almost identical in size, are virtually pendants, distilling in two acts the awesome drama of nature first at war, so to speak, and then at peace, both images of majestic and colossal energy.

Typically for Courbet, even the storm scene, which in the hands of many a Romantic artist would have been all unanchored froth and atmosphere, has a weighty, earthbound solidity. The low-lying Channel clouds and the sweep of whitecaps (which bear testimony to the account of Courbet's applying paint like a workman with a trowel) are almost as densely palpable as the wedge of shore and the two moored, but precariously tilted, fishing boats that, as in Romantic shipwreck scenes, heighten the drama of the tiny sailboat just visible on the horizon.

In the radiant aftermath of the storm, Courbet changes the proportion of earth to sea and sky, now including the best-known geological wonder of Étretat, the so-called Porte d'Aval. This cliff forms a high natural bridge out to the sea, a coastal counterpart to the gigantic rock formations that he often painted in the region of his birthplace so far from the sea, the Franche-Comté. All of nature's fury has

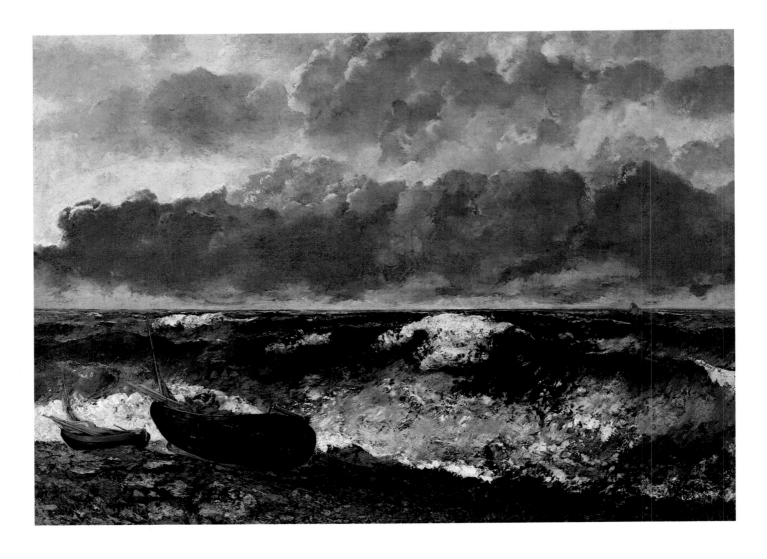

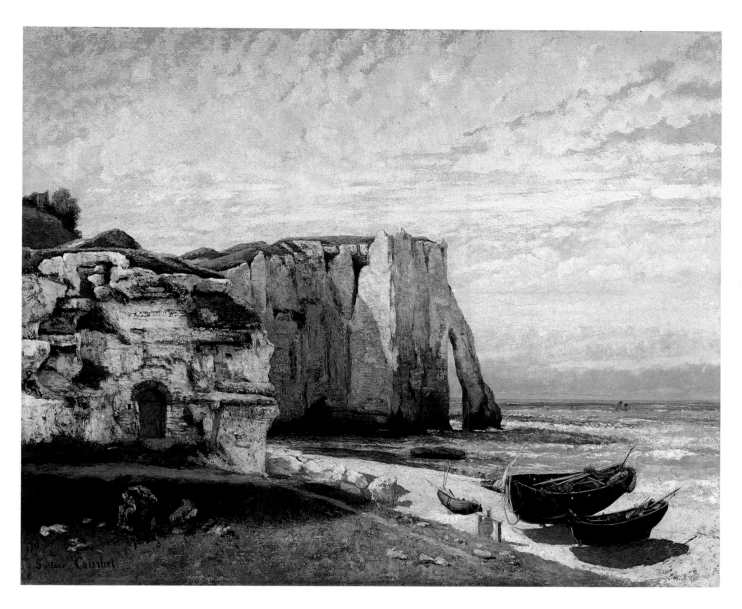

now been assuaged. The two larger fishing boats at the right rest stably on the shore, where minuscule washerwomen have resumed their work; and the threatened sailboat on the horizon has clearly survived the storm. Above, the sky, like the calmed sea below, emanates through the dispersing clouds the luminous warmth of its radiant blueness, which gives even the shadows cast on the beach a bluish tonality. Courbet was perhaps following the practice of Monet, whom he had often encountered on the Normandy coast in the 1860s and who himself painted these cliffs then and in the 1880s. With his refined weave of colored light, however, Monet would thoroughly dissolve the epic way Courbet venerated all of nature—earth, water, air—as something so material that it could almost be kneaded like elemental clay, or, in painter's terms, like the crusty slabs of pigment worked onto this canvas.

GUSTAVE COURBET
The Cliff at Etretat after the Storm, 1869, signed ". . . 70"
(Salon of 1870)
4′ 4¼″ x 5′ 3¾″ (133 x 162 cm) MNR 561

facing page
GUSTAVE COURBET
The Stormy Sea (or *The Wave*), 1869, signed ". . . 70" (Salon of 1870)
3′ 10″ x 5′ 3½″ (117 x 160.5 cm) RF 213

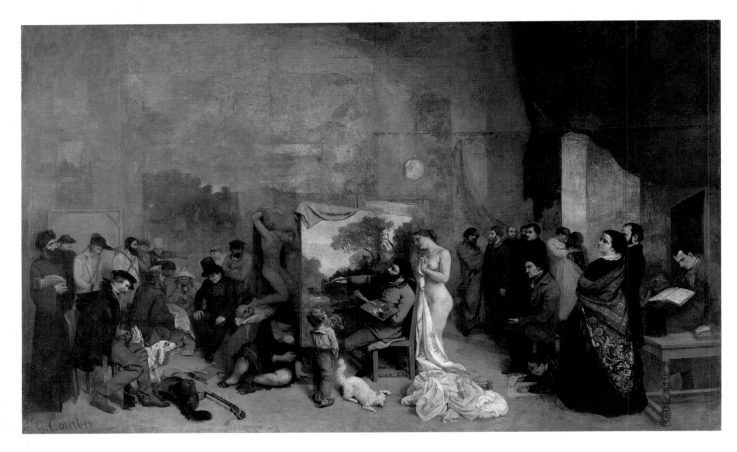

GUSTAVE COURBET
The Painter's Studio; A Real Allegory, 1855
11′ 10¼″ x 19′ 7½″ (361 x 598 cm) RF 2257

facing page
GUSTAVE COURBET
The Painter's Studio, detail

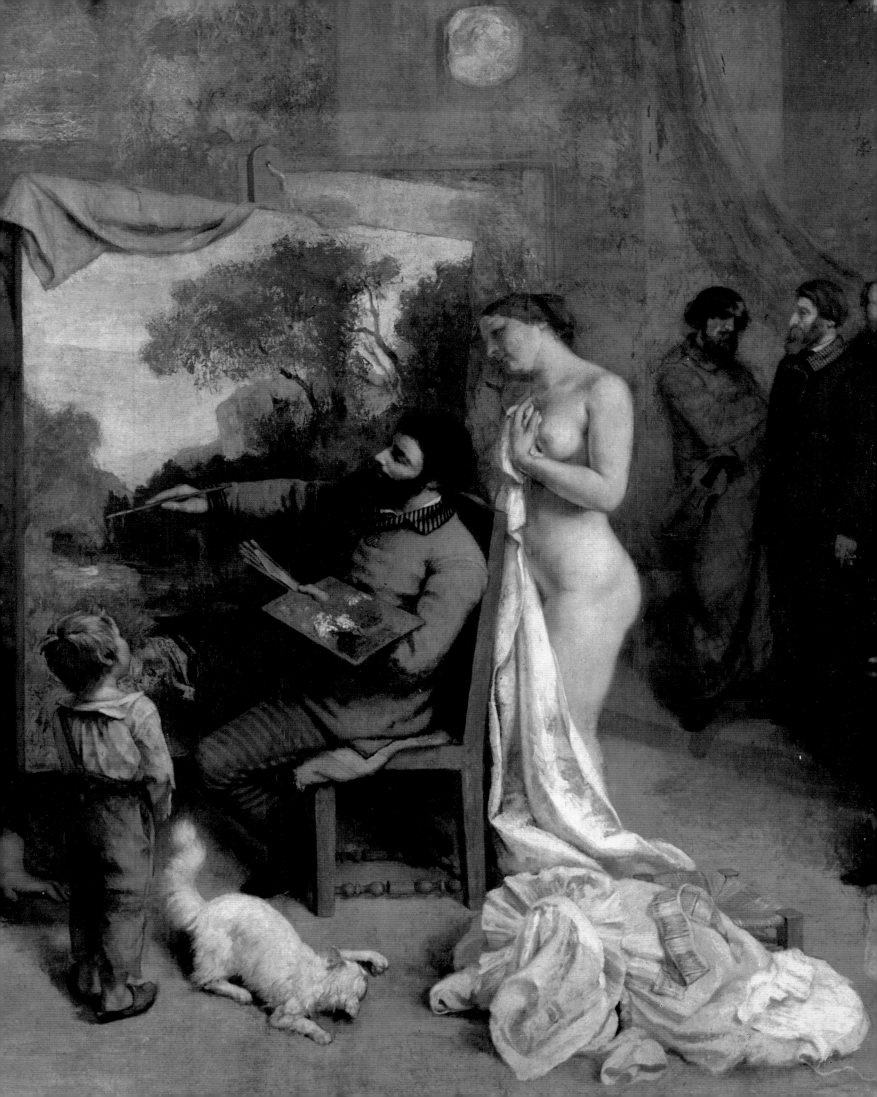

WHISTLER

Whistler's *Mother*

*E*specially to American eyes, Whistler's portrait of his mother is famous to the point of invisibility, a hallowed cultural icon that may at first seem a foreign intruder within the walls of a museum in Paris. But even if the painting's emblematic clarity has become equated with the symbol of the American flag, the realities of its national allegiance and the sanctities of its popular message about American motherhood are far more blurry matters.

As for its nationality, Whistler, like other illustrious American painters represented at Orsay (Cassatt and Sargent, among them), was the very model of an expatriate, leaving his native country forever in 1855, aged twenty-one, and instantly becoming an integral part of the history of adventurous new painting in both France and England. American patriotism may well claim him, as it claims Henry James, but his life and art tell a tale of two foreign cities, Paris and London. In Paris he exhibited regularly, sharing insults with Manet at the notorious Salon des Refusés of 1863 and counting most of the young rebels among his chums. A barely known painting from the late 1850s by Whistler at Orsay, a portrait of an old working-class man, probably a seller of chamber pots, already registers the impact of Courbet in its gritty realism and coarsely troweled paint surface. In Fantin-Latour's *Homage to Delacroix* (page 163), shown at the 1864 Salon, Whistler is the most prominent figure among an otherwise totally French brotherhood of artists and writers who honor the framed portrait of the just-deceased Romantic painter. As much to the point, many of Fantin-Latour's portraits, not to mention such a masterpiece as Degas's *Bellelli Family* (page 215), create a French pictorial environment in which Whistler's singular painting finds compatible company. In particular, Fantin-Latour's seesawing balance between the specific, time-bound facts of individual people and an abiding formal order compiled from the rectilinear patterns of wall planes, doors, dadoes, frames, and curtains casts light on the similar equilibrium achieved by Whistler in his world-famous portrait.

Nevertheless, this painting, executed in London in the summer of 1871 and exhibited to the public the following year at the Royal Academy, remains unique. Compared to Fantin-Latour's work, its flattening reductions of shape and plane appear stark, even ascetic, just as its expulsion of color, leaving only a blush of pink cheek within an austere ambience of nuanced whites, grays, and blacks, pushes the

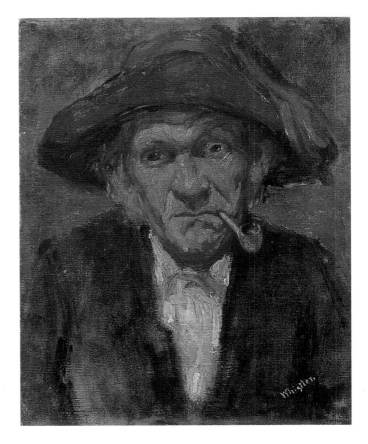

JAMES ABBOTT MCNEILL WHISTLER
Lowell, Massachusetts 1834–London 1903
Man with a Pipe, ca. 1859
1' 4¼" x 1' 1" (41 x 33 cm) Bequest of Charles Drouet, 1909.
INV 20143

facing page
JAMES ABBOTT MCNEILL WHISTLER
Arrangement in Gray and Black No. 1; Portrait of the Artist's Mother
(Anna Matilda McNeill, 1804–1881), 1871 (Royal Academy, London, 1871; Salon of 1883)
4' 8¾" x 5' 3¼" (144 x 162 cm) RF 699

French painter's photographic tonalities to an extreme of chilly austerity. In this image of denial, of visual and tactile chastity, could there perhaps be discerned some throwback to American puritanism? In 1872 a London reviewer had already recognized that the painting grasped the Protestant character.

We know, however, that Whistler was the archetypal aesthete, preaching and practicing the religion of art in which a record of the mundane facts of people, places, and things was to be subordinated to the pure and abstract harmonies of the language of painting. After all, Whistler titled this canvas *Arrangement in Gray and Black No. 1: Portrait of the Artist's Mother*, making it verbally clear, as was usually his custom, that the pattern of shape and tone

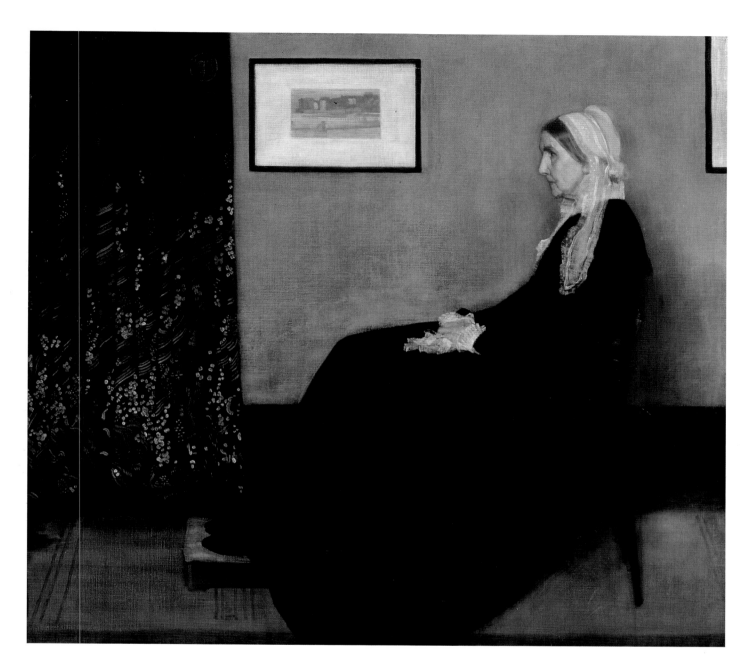

came first, with the thing or person depicted as the necessary evil providing the point of artistic departure. Recent research, however, has offered more complex speculations about the would-be absence of Whistler's mother from a painting whose bare geometric skeleton already points in Mondrian's direction. Anna Mathilda Whistler, who was sixty-seven when her son painted her, turns out to have been an unsmiling, stingy, Bible-reading woman whose fierce goal was the total domination of James's (or Jemie's, as she called him) private and public life. In addition to reigning over his household in London in the 1870s, she had managed to exorcise, back in the 1860s, her son's sexual liaison with a red-haired Irish girl, Joanna Hiffernan, who had often posed naked for Courbet and clothed for Whistler. In

this light, with Freud behind us, Whistler's "arrangement" may turn out to be a curious act of psychological vengeance, eternally immobilizing his meddling mother as if she were a butterfly pinned to a page. Frozen into a profile posture that provides a more rounded contour to counter the lean network of perpendiculars that straightjacket her forever, she becomes a helpless, embalmed effigy of her living self at the service of the higher order of her son's vocation.

Still, her potency remains. Within the decorative equilibrium of subtly gold-flecked vertical curtains against the asymmetrical pattern of black rectangular frames, her face, with its raised eyebrows, pursed lips, and sagging jowls, seems to twitch in a firm, controlling way, even beyond her own grave and that of her son.

RESPECTABLE SOCIETY

James Tissot
The Two Sisters; Portrait of Mlle. L.L.

*F*ew painters can give us so glossy and accurate a mirror image of high society as Tissot. Like his friend and contemporary Whistler, he was at home both in Paris, where he lived and exhibited in the 1860s, and in London, where he spent a professionally successful decade after the fall of the Paris Commune in 1871. And like the well heeled cosmopolitan society he frequented, Tissot's art belongs to an international milieu of high fashion on both sides of the Channel. His ladies pose in costumes and amid decor that reflect the latest modes, whether Spanish or Japanese, and indulge, with their gentlemen companions, in the pleasurable rituals of the country outing, the boating party, or the ballroom. One recalls that Tissot's parents were both in the fashion business in his native Nantes.

His art and social allegiances were clearly announced in the two paintings, both at Orsay, he showed at the 1864 Salon—works we recognize today as ancestors of the most chic fashion photography. Although the Salon catalogue referred to them as portraits, they were probably based on studio models, offering a kind of advertisement for the type of commission Tissot hoped to get.

In *The Two Sisters*, his highly personal stamp is already crystal clear. The color sensibility is willfully precious,

facing page
JAMES TISSOT, Nantes 1836–Chenecey-Buillon 1902
The Two Sisters; Portrait (or *Portraits in a Park*), 1863 (Salon of 1864)
6' 10¾" x 4' 5½" (210 x 136 cm) Gift of Albert Bichet, 1904. RF 2788

JAMES TISSOT
Meeting of Faust and Marguerite, 1860 (Salon of 1861)
2' 6¾" x 3' 10" (78 x 117 cm) RF 1983-93

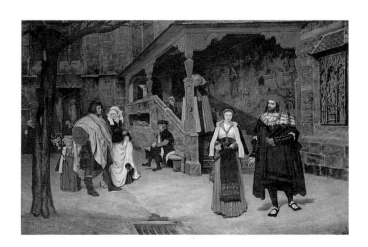

permitting the yellow-green tonalities of the landscape setting to permeate the white summer dresses, with a cooling effect like that of the most rarefied fruit sorbet. Such refinement earned the painting the nickname "The Green Ladies," although, in a more hostile vein, it also inspired analogies to stagnant water. Tissot's nuanced variations on a restricted theme of color and tone are closely related to Whistler's pictorial and Théophile Gautier's poetic efforts to create what could be called "Symphonies in White"— aesthetic exercises in aristocratic discrimination that would elude vulgar taste. Aristocratic, too, is the demeanor of these two young women, who strike poses of casual indifference to the observer, an aloofness borne out by their dour expressions of mild ennui. How often have we seen such models in *Vogue*!

From the beginning, Tissot explored inward psychological subtleties as fragile as his tonalities. They can be seen in 1860 in a painting inspired by Goethe's *Faust*, illustrating the hero's first glimpse of Marguerite as she leaves church and his unsuccessful effort to accompany her. Here Tissot grapples with a way to render through discreet facial expression and posture the kind of intricately mannered etiquette he would quickly transport to scenes of contemporary society. In *The Two Sisters*, these modern personalities have been defined and now belong to the gallery of detached, unsmiling faces we find in Degas's family portraits of the 1860s (page 213). A few years later, in fact, Tissot himself would sit for Degas, his friend from art-school days, creating a perfect match of painter and sitter.

In the other portrait from the 1864 Salon (page 158), Tissot updates Ingres, whose uncannily sharp focus of costume and setting was a constant inspiration. Here Tissot's preference for low visual temperatures—explored in the background's subtly modulated fusion of the palest pinks, greens, and blues in curtain, wallpaper, upholstery, and books—is used as a foil to the startling heat of the red "Zouave" bolero. Such clothing was a fashionable nod to Spain timely in the 1860s (the Empress was of Spanish ancestry), when painters like Manet often chose Spanish dancers, musicians, and bullfighters as subjects. The model's expression, like her posture, is something of a tease, first attracting the viewer's gaze, then rebuffing it as her

continued on page 159

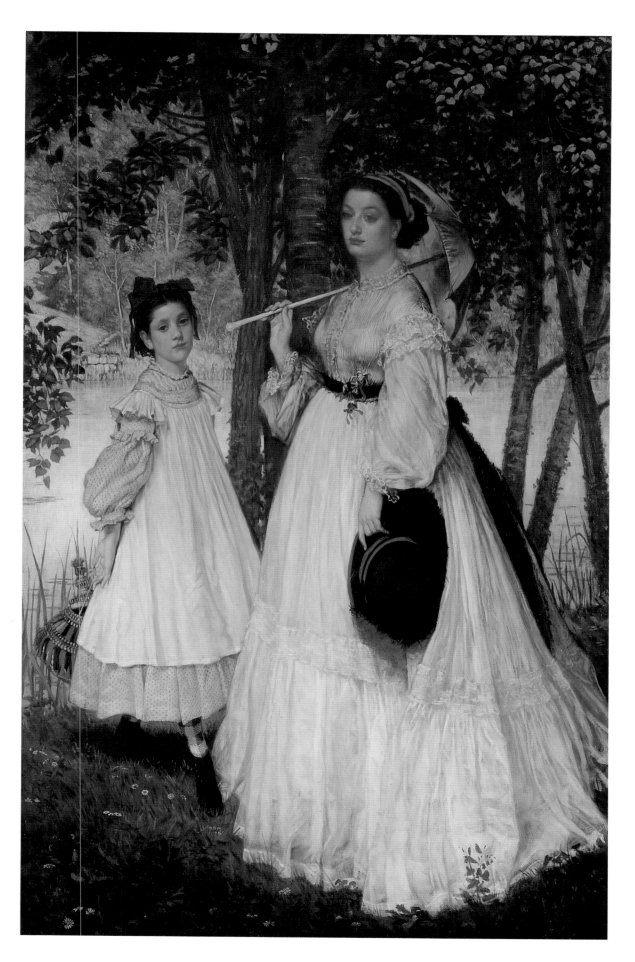

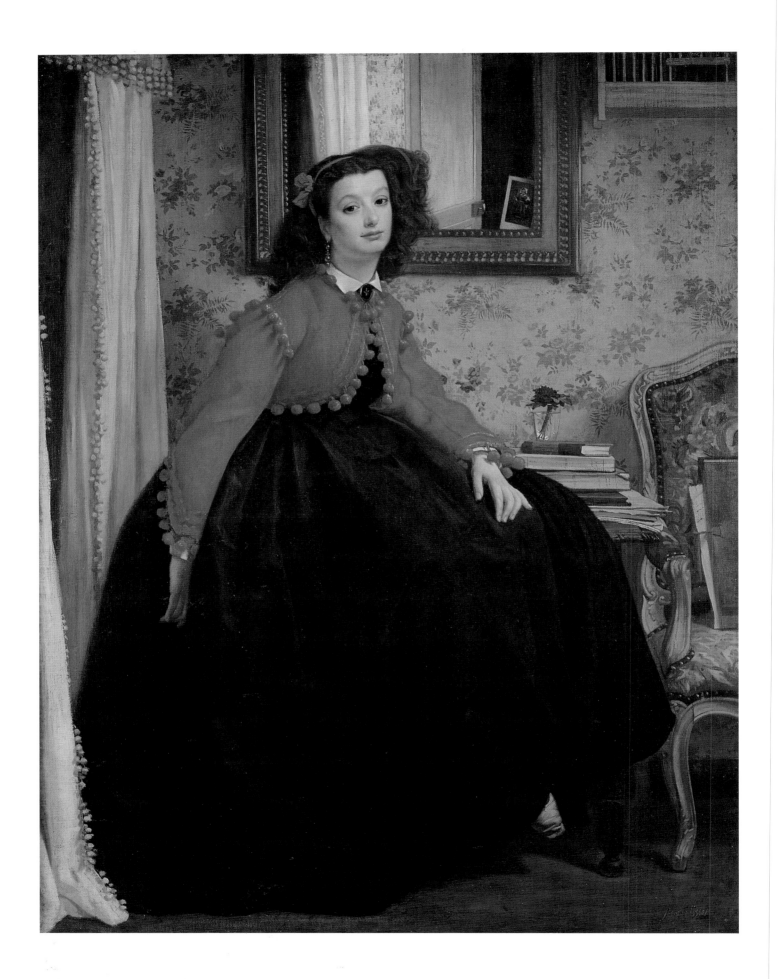

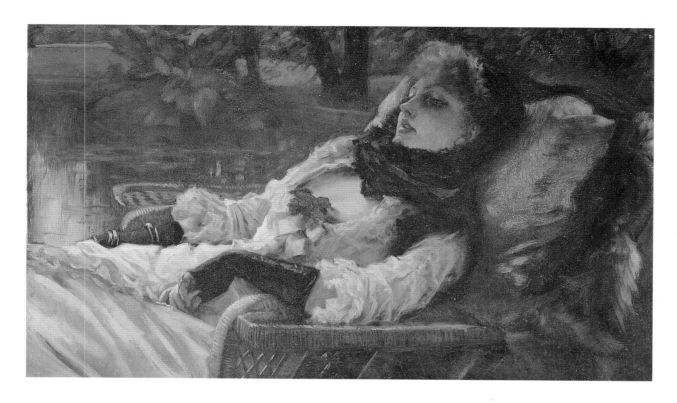

JAMES TISSOT
The Dreamer (Summer Evening), undated
1' 1½" x 1' 11¼" (34 x 59 cm) Bequest of William Vaughan, 1919.
RF 2254

JAMES TISSOT
The Ball, undated
2' 11½" x 1' 7¾" (90 x 50 cm) Bequest of William Vaughan, 1919.
RF 2253

facing page
JAMES TISSOT
Portrait of Mlle. L.L. (or Young Girl in Red Jacket), 1864
(Salon of 1864)
4' 1" x 3' 3" (124 x 99 cm) RF 2698

continued from page 156
head seems to slip away into the more secluded area of the Ingresque mirror reflection behind her, where a door may be glimpsed. The studied casualness, part of the repertory of fashion illustration, pertains even to such witty details as the bird cage, just visible at the upper right, or the photograph tucked into the corner of the mirror frame.

The phrase "Social Realism" is usually applied to art that reveals truths about the oppressed working class, but it would seem no less applicable to Tissot's documentary revelations about high society in the 1860s and 1870s. Like masters of Victorian fiction who dealt with contemporary manners—an Anthony Trollope or a Henry James—Tissot has captured for posterity the facts of life he knew firsthand, creating from them perfect, if minor, works of art, the equivalent of elegantly wrought short stories.

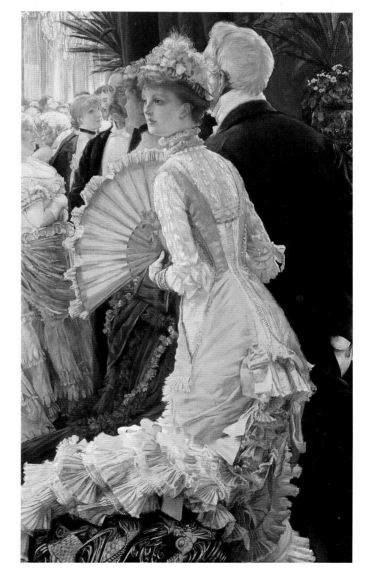

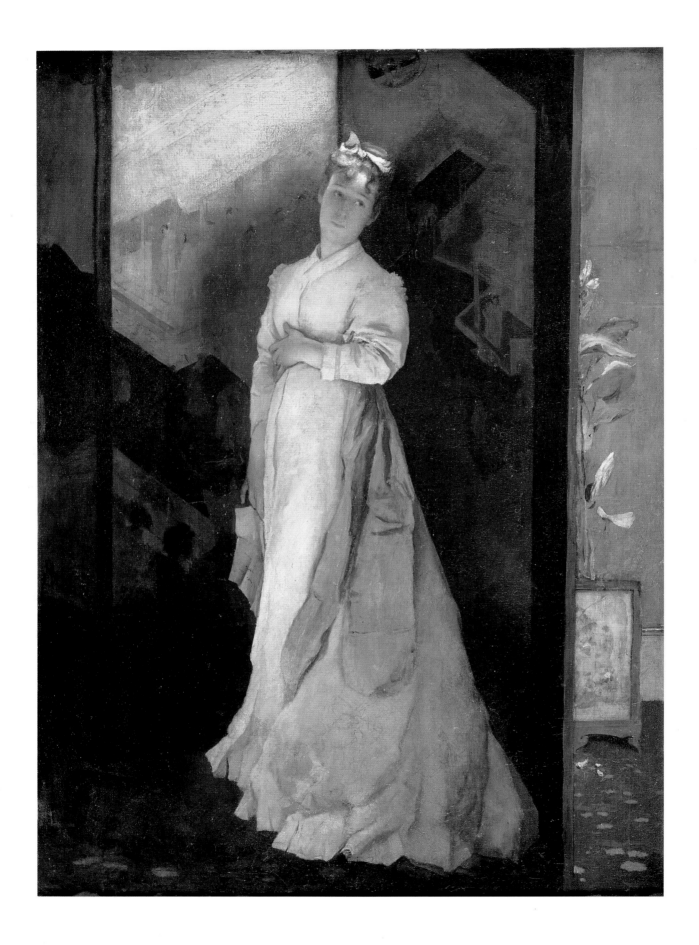

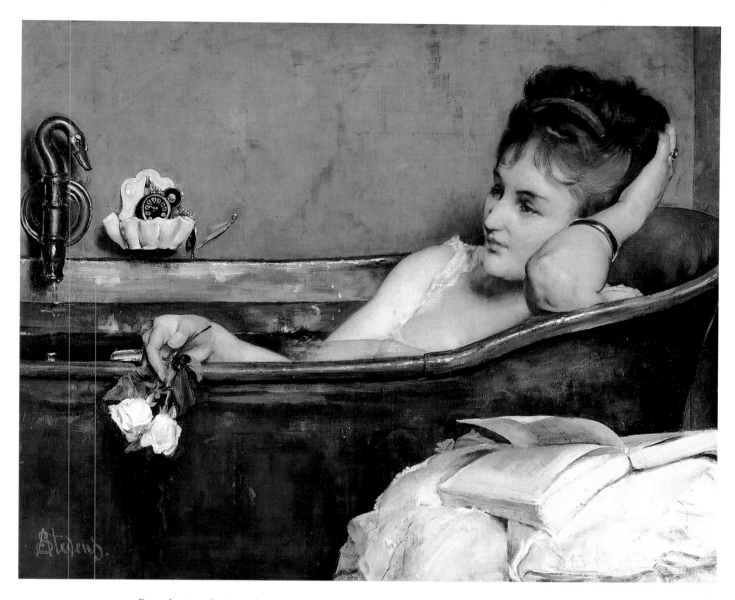

ALFRED STEVENS, Brussels 1823–Paris 1906
The Bath, ca. 1867
2′ 5¼″ x 3′ 1″ (74 x 93 cm) INV 20846

facing page
ALFRED STEVENS
The Farewell Note, ca. 1867
2′ 5¼″ x 1′ 9½″ (74.5 x 54.5 cm) RF 1983-26

FANTIN-LATOUR

Henri Fantin-Latour
Homage to Delacroix

Although Fantin-Latour could be wafted away to aerial heights and submarine depths by the music of Wagner, most of the time he and his art remained firmly planted on earth, existing in the present tense of modern Paris. Famous for his flower paintings that perfectly fuse the extremes of the decorative and the sober, he is equally well known for the probity of his portraiture. He presents people singly, in couples, and, most remarkably, in large groups that resemble photographic commemorations of a special meeting in the history of an elite club.

This particular type of painting was launched in 1863 after the death of Delacroix, whose genius was felt by many to have been insufficiently honored by officialdom. The last survivor of the epic grandeur associated with the Romantic generation of the earlier century, Delacroix was ripe for the kind of historical sanctification symbolized by the burial of great Frenchmen in the Pantheon. After considering several hazy allegorical efforts to pay tribute to the departed giant, Fantin ended up in the domain of contemporary fact, namely, a gathering of ten artists and critics, himself included, who wished to eternalize their veneration of the master. Delacroix is represented not as a cloud-borne vision ascending to Olympus, but as a modern portrait, based on a photograph published only a decade earlier; his face is distinguished from those of his younger admirers only by virtue of its being framed and slightly higher. Such a secular idea of what might be a Christian prayer at a tomb is further underscored by the bouquet of flowers—almost a signature for an artist already known for his floral still lifes—placed before the honored portrait.

Although there are many precedents for Fantin's group, especially in seventeenth-century Dutch painting, a drastically different point of comparison is another homage to a great artist—one who was still living—Courbet's huge *Painter's Studio* of 1855 (page 152). But in place of this grandiose display of narcissism, in which Courbet locates himself as the sun of a solar system that sweeps into its orbit portraits of his worshipful friends and supporters (including Baudelaire, who reappears in *Homage to Delacroix* at the lower right), Fantin's version of hero worship is willfully low-keyed. And he modestly distinguishes himself from his fellow artists only by his shirtsleeves and palette, remaining subsidiary to the standing, dapper Whistler, who towers above him, as well as to Manet, who stands, hand in pocket, on the other side of the venerated image.

What might have been a dreary line-up of famous men is animated, with Fantin's usual understatement, by many subtle shiftings of head and torso that give an unexpectedly natural vitality to an image that recalls the unnatural permanence and immobility of a group photograph long in the arrangement. It is just enough to make us believe that this is a community of living people who share the same space as the spectators who faced the painting at the Salon of 1864. A noble fraternity, these painters and writers who represent the history of modern art communicate directly to their audience a deep respect for another artist who, only a year before, might have been one of their group.

Fantin's invention filled a need. He himself would repeat the formula, offering, in one case, an homage to Manet as the center of a group of young painters and critics who defended this master's cause (page 165); in another, what started as an homage to Charles Baudelaire ended up as a reunion of writers, including the tempestuous Symbolist couple, the poets Paul Verlaine and Arthur Rimbaud, around a dinner table (page 164). Such group portraits of artistic brotherhoods or of homages to older masters had endless variations in nineteenth-century art. The range at Orsay encompasses Bazille's informal studio interior of 1870 (page 226) and, closest to Fantin's prototypes, Denis's official homage to Cézanne (page 585), in which the members of the art establishment of 1900 solemnly take their places around a still life by the master that had once belonged to Gauguin. In such ways do modern artists create their own dynasties.

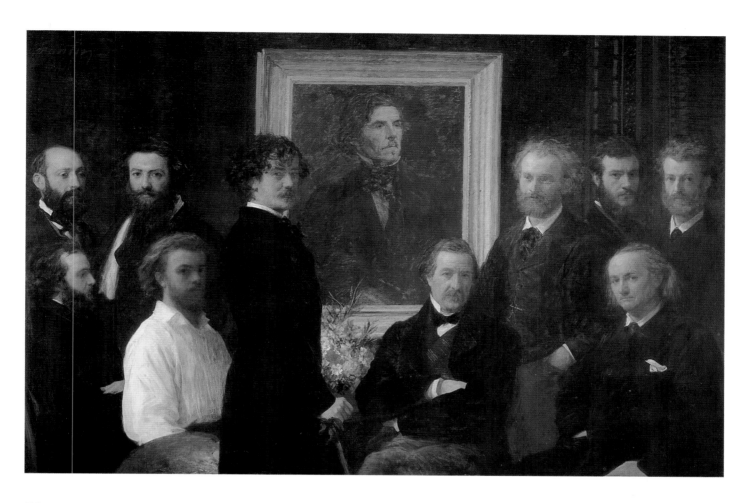

HENRI FANTIN-LATOUR
Homage to Delacroix, 1864 (Salon of 1864)
5' 3" x 8' 2½" (160 x 250 cm) Gift of Étienne Moreau-Nélaton, 1906.
RF 1664

HENRI FANTIN-LATOUR
Flowers and Fruit, 1865
2' 1¼" x 1' 10½" (64 x 57 cm) MNR 227

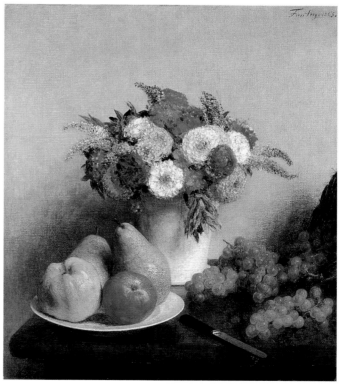

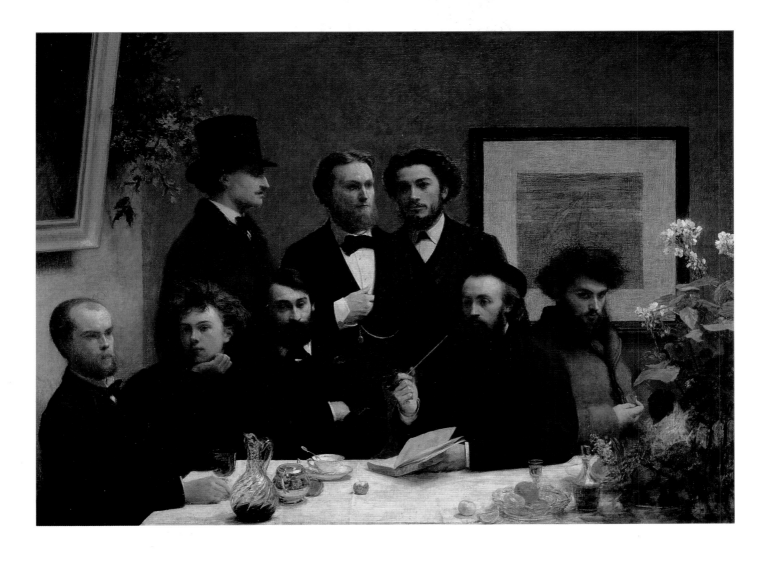

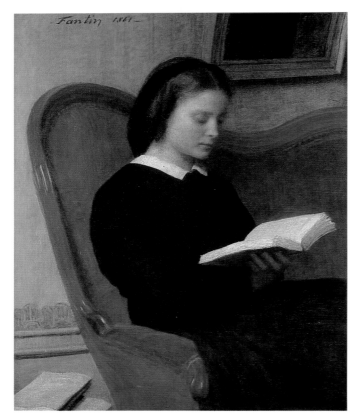

HENRI FANTIN-LATOUR
Around the Table, 1872 (Salon of 1872)
5' 3" x 7' 4½" (160 x 225 cm) Gift of Léon-Émile Petit-Didier and
Mrs. Blémont, 1910. RF 1959

HENRI FANTIN-LATOUR
The Reader (Marie Fantin-Latour, the Artist's Sister), 1861
(Salon of 1861)
3' 3¼" x 2' 8¾" (100 x 83 cm) Bequest of Mr. and Mrs. Raymond
Koechlin, 1931. RF 3702

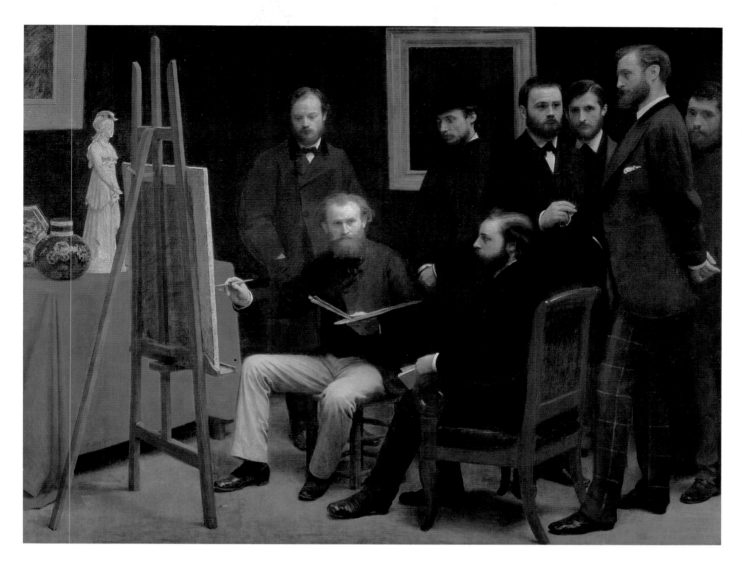

HENRI FANTIN-LATOUR
A Studio in the Batignolles, 1870 (Salon of 1870)
6′ 8¼″ x 8′ 11¾″ (204 x 273.5 cm) RF 729

HENRI FANTIN-LATOUR
Adolphe Jullien, 1887 (Salon of 1887)
5′ 3″ x 4′ 11″ (160 x 150 cm) Gift of Adolphe Jullien, 1915. RF 2174

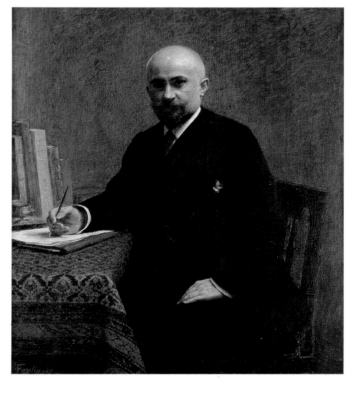

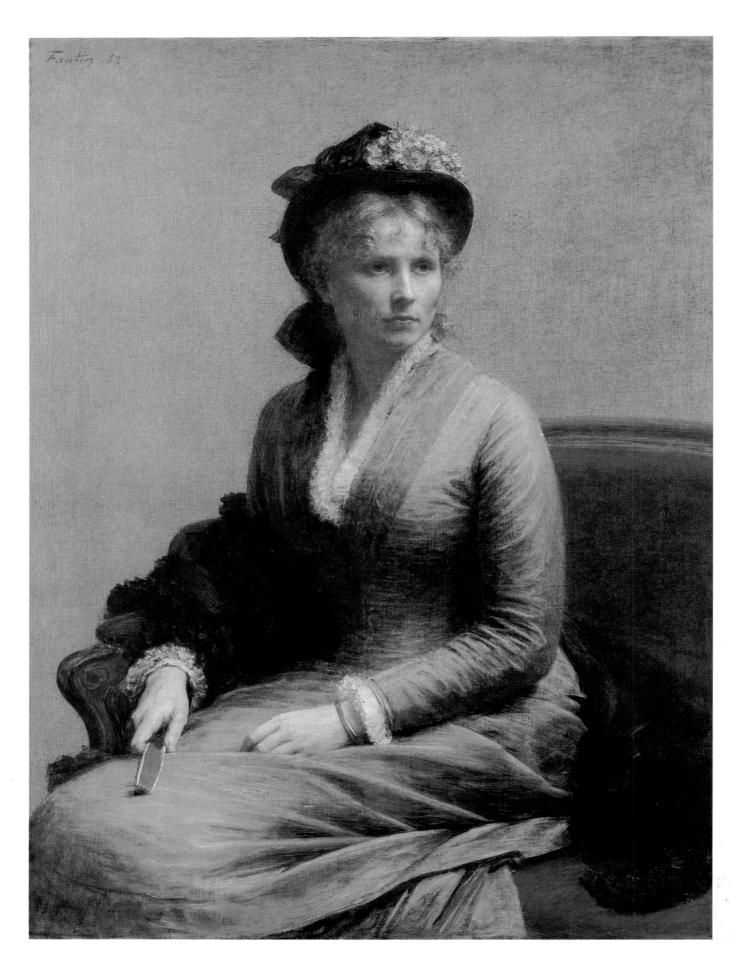

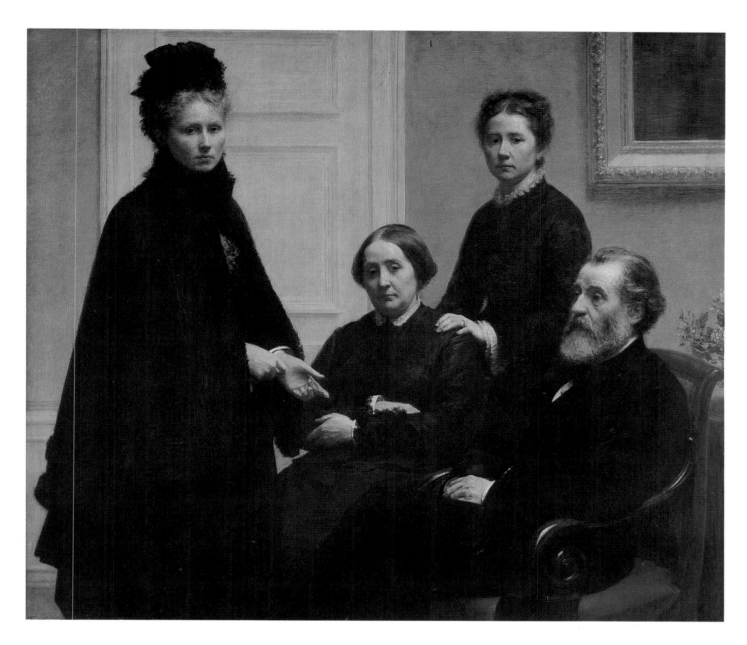

HENRI FANTIN-LATOUR
The Dubourg Family, 1878 (Salon of 1878)
4′ 9¾″ x 5′ 7¼″ (146.5 x 170.5 cm) Gift of Mrs. Fantin-Latour, 1921. RF 2349

HENRI FANTIN-LATOUR
Roses in a Bowl, 1882
1′ 2¼″ x 1′ 6″ (36.5 x 46 cm) Gift of Eduardo Mollard, 1961. RF 1961-25

facing page
HENRI FANTIN-LATOUR
Charlotte Dubourg, 1882 (Salon of 1887)
3′ 10½″ x 3′ (118 x 92.5 cm) Bequest of Charlotte Dubourg, 1921. RF 2348

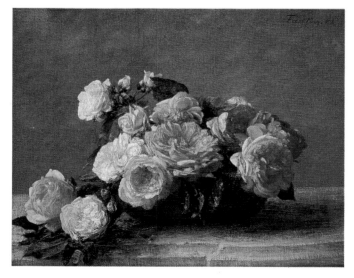

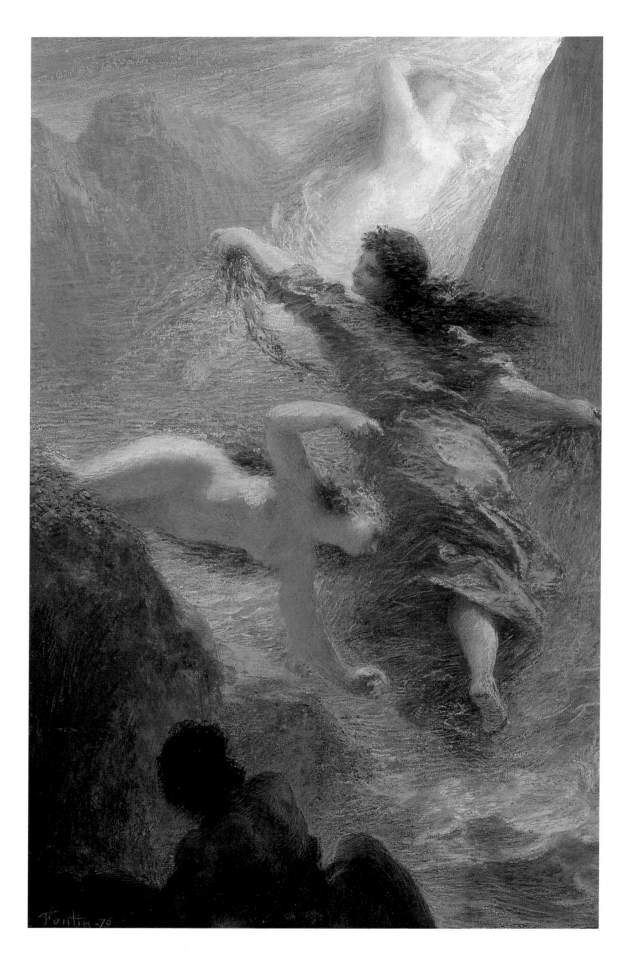

HENRI FANTIN-LATOUR
Golgotha (copy after Veronese)
Oil on paper, 11½″ x 11¾″ (29.5 x 30 cm) RF 1980-51

facing page

HENRI FANTIN-LATOUR
The Three Rhine Maidens, 1876 (Salon of 1877)
Charcoal and pastel, 1′ 8¾″ x 1′ 2″ (52.5 x 35.5 cm) RF 12.249

FRENCH REGIONAL PAINTING

Guigou, Ravier, and Monticelli

*I*n France, all roads, whether of railways or of artists' lives, lead to Paris. This obvious generalization, however, has many exceptions. The history of nineteenth-century painting takes place not only in the capital but also throughout the widely diverse French provinces. Paris-based artists would travel far and wide, from Brittany and the Auvergne to the Alps, in order to paint the local color provided by unspoiled landscape, venerable monuments, and picturesque costume; and there were also many painters, born and raised far from Paris, who were happy to stay at home and cultivate their own gardens. So it is that, just as the glories of French cuisine are enriched by regional styles, flavors, and chefs who never left their parents' kitchens, nineteenth-century painting also has its provincial heroes. Located in such places as Lyons or Marseilles, they worked at their own tempo and under their own skies, even if they were often tempted to visit and exhibit in the center of their national universe.

Conspicuous in this category is the short-lived Guigou, who specialized in the landscape of his native Provence, depicting the countryside around Marseilles. Such paintings instantly convey an authentic experience of this world of deep blue sky and sun-baked earth, a tonic jolt after so many canvases in which all is muted under the overcast skies of northern France. One almost blinks from the intensity of the sunlight, which casts strong shadows and defines a terrain of rugged but benevolent character, where distant mountains frame a scene of harmonious peasant life. In a small canvas, *Washerwoman*, one of these peasants, wearing a wide-brimmed straw hat as protection from the southern sun, is seen at work, transmuting the recurrent theme of laundresses in the country (a motif also favored by Renoir and Pissarro) into a picturesque yet monumental vignette of a world bleached and purified by Mediterranean light. Local as this flavor may be, Guigou's paintings, which were shown at the Paris Salons throughout the 1860s, also intersect with more famous masters of the period. They are often akin to the landscapes of Courbet in their sturdy sense of palpable rock and tree. Their sunny amplitudes and truth to Provençal topography even herald the art of another master from the same region, Cézanne.

A very different kind of local color can be found in the landscapes of Ravier, who specialized in small studies of the terrain around his native Lyons (pages 172 and 173). The weather and the mood change drastically from Guigou's stable vision of Provence. Instead, Ravier offers swift glimpses of vast, unpopulated plains that tremble with windswept rain clouds. His sketchy, vibrant paint surfaces have often been linked to Impressionism, but his sense of gloomy foreboding belongs to earlier, Romantic sensibilities. These canvases register as minor but potent meditations on the awesome power of nature.

Belatedly Romantic in character, too, are the paintings of Monticelli, who, like Guigou, was based in Marseilles. Unlike Guigou, however, he veiled not only the local landscape but all of his imaginative subjects in mottled crusts of paint so dense that we see an image of distant memory more than a specific site or narrative. His illustration—if it can be called that—for *Don Quixote* is like a mirage that vanishes in twilight (page 174). A far cry from Daumier's depiction of the noble knight and Sancho Panza, both clearly isolated in a bleak landscape (page 88), Monticelli's vision dissolves them into a grainy mist at the far end of what may have begun as a specific Provençal landscape setting but was then metamorphosed into a magical garden, where diminutive maidens in Renaissance costume evaporate and congeal as in a pipe dream. The nostalgic mood belongs not only to the reveries that Cervantes's classic inspired in mid-nineteenth-century France but also to the world of French Rococo pleasure gardens, eternalized in the paintings of Watteau and Fragonard. Once scorned by the art and politics of the French Revolution, these mementos of a distant time, where figures moved with graceful leisure in landscapes dedicated to love and enchantment, were newly experienced and admired by mid-century, when painters could re-create their fragile hedonism in widely varied ways. For Monticelli, these pleasures of a lost century were evoked, as in his twilight scene of a walk through a lush park (page 174), within a murky crush of pigment. For others, like Monet in his *Women in the Garden* (page 235), they were translated into the perceived facts of modern life, where elegant Parisians, in the luxuriant costumes of the Second Empire, could stroll about a suburban garden, savoring flowers and the passing sunlight of the Ile-de-France.

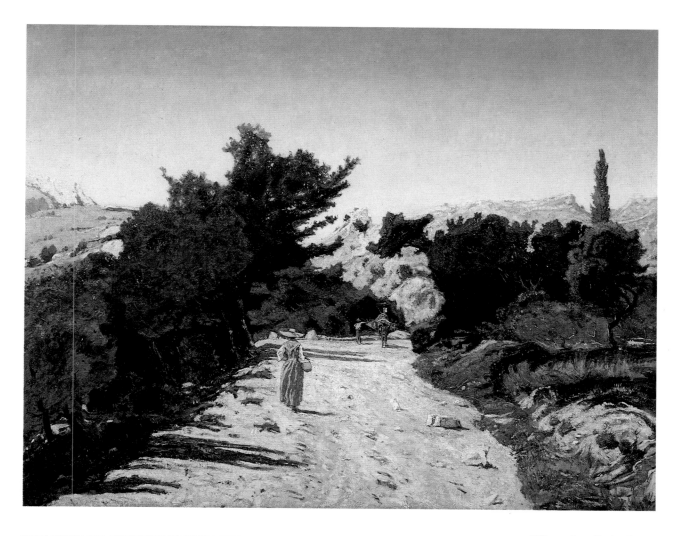

PAUL-CAMILLE GUIGOU, Villars 1834–Paris 1871
La Gineste Road, near Marseille, 1859
2′ 11″ x 3′ 10″ (89 x 117 cm) RF 2028

PAUL-CAMILLE GUIGOU
Washerwoman, 1860
2′ 8″ x 1′ 11¼″ (81 x 59 cm) Gift of Paul Rosenberg, 1912.
RF 2051

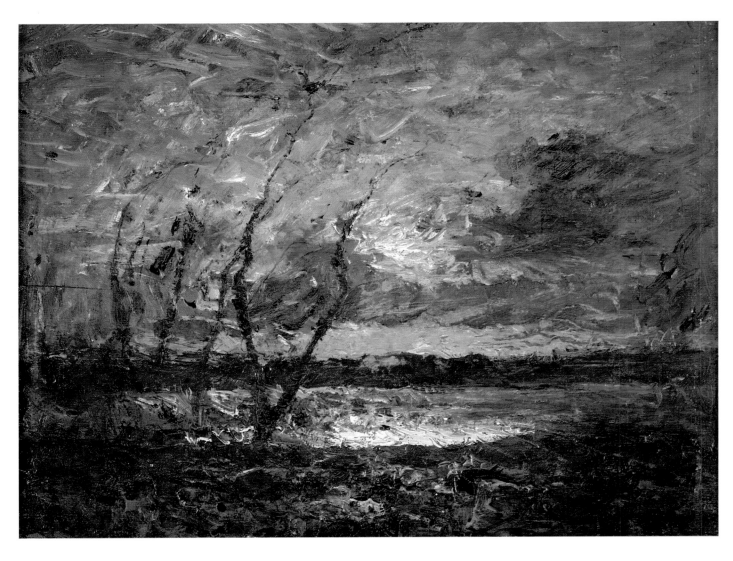

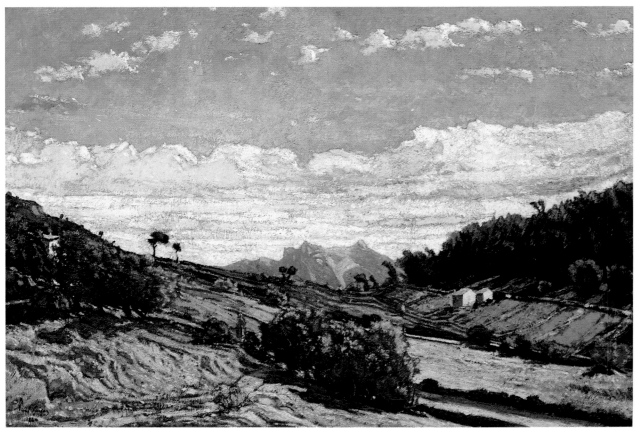

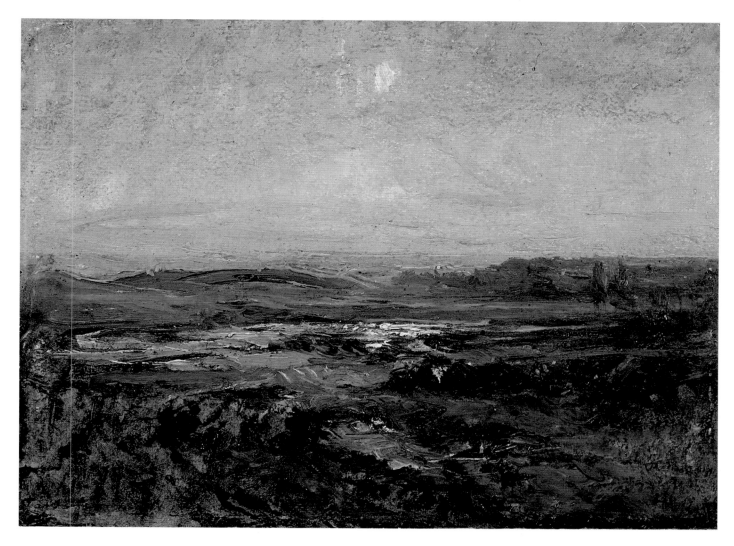

FRANÇOIS-AUGUSTE RAVIER, Lyon 1814–Morestel 1895
The Pond of La Levaz, at Morestel (Isère)
9¾" x 1' 1¼" (25 x 33.5 cm) Gift of Félix Thiollier, 1909. RF 1749

facing page, top
FRANÇOIS-AUGUSTE RAVIER
Landscape near Crémieu
9¾" x 1' 1¼" (25 x 33.5 cm) Gift of Miss Emma Thiollier, 1966.
RF 1966-8

facing page, bottom
PAUL-CAMILLE GUIGOU
Landscape in Provence, 1860
1' 9¼" x 2' 8" (54 x 81 cm) RF 1328

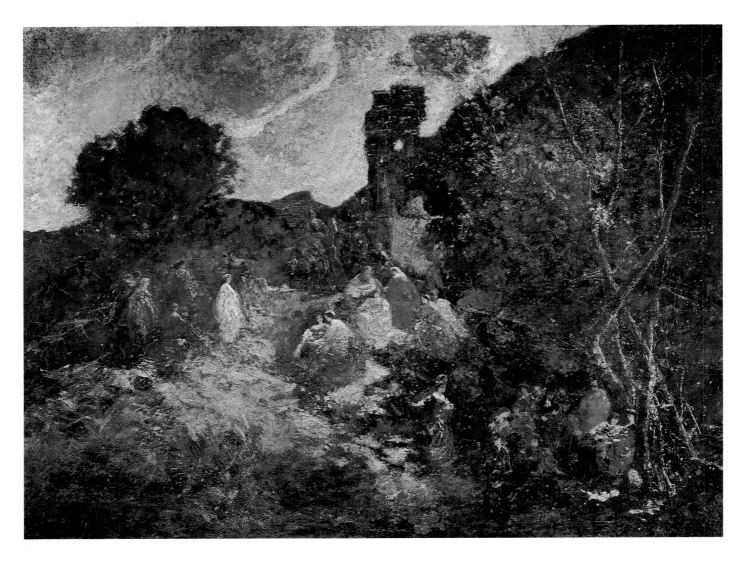

ADOLPHE-JOSEPH MONTICELLI
Marseilles 1824–Marseilles 1886
Don Quixote and Sancho Panza, 1865
3′ 2″ x 4′ 3¼″ (96.5 x 130 cm) Gift from an anonymous Canadian donor, 1953. RF 1953-31

ADOLPHE-JOSEPH MONTICELLI
Twilight Promenade in a Park
1′ 6″ x 2′ 1½″ (46 x 64.5 cm) Gift of Gustave Fayet, 1911. RF 1770

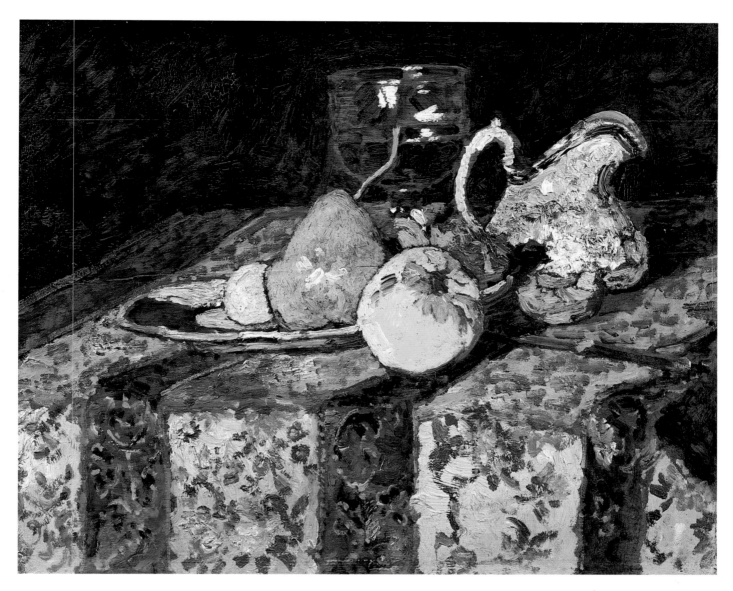

ADOLPHE-JOSEPH MONTICELLI
Still Life with White Pitcher
1′ 7¼″ x 2′ 1″ (49 x 63 cm) RF 1937-5

ADOLPHE-JOSEPH MONTICELLI
Mme. Teissier, 1872
3′ 3¼″ x 2′ 7½″ (99.5 x 80 cm) Gift of Charles Garibaldi, 1950.
RF 1950-30

ORIENTALISM

Guillaumet and Fromentin

*F*or the French, the word "Orientalism" conjured up not the Far East but the Muslim world, which offered both the newspaper reality of overseas wars—Algeria was invaded by the French in 1830 and finally declared a colony in 1848—and an escapist fantasy from the restricting facts of nineteenth-century life. Both real and pictorial voyages to North Africa and the Near East were certain to provide French painters and their audiences back home with the most potent extremes of exotic gorgeousness, mystery, and terror. In geographic terms, the desert itself was a constant challenge to the imagination of painters who wanted to rival an earlier repertory of sublime landscapes that could reach infinite distances, even in the outskirts of Paris, as in Chintreuil's *Expanse* at the 1869 Salon (page 119). At the Salon the year before, Guillaumet, who had made his name in the 1860s with a wide Orientalist repertory, showed a haunting vista of desert sand and eerily luminous sky that seems the terminus for these voyages to awesome immensity. Discarding Western perspective, which would be useless here, he offers total immersion in a cosmic space that belongs to the world of both gazetteer reality and a nightmarish mirage. The documentary aspects of the canvas were assured by the artist's firsthand knowledge of the territory,

but the hallucinatory component is provoked not only by the uncharted vastness of parched sand and heat-laden atmosphere but by the palpable specter of death in the foreground—a camel that has succumbed to heat and thirst and is left to vermin as a bony relic of a once noble beast. With so grotesque a memento mori, of a kind that had also impressed the writer Gustave Flaubert during his travels to Egypt and the Holy Land in 1849–1851, the minuscule vision of living camels and Arab riders on the remote horizon, against the glaring sun, becomes a phantom of dashed hope.

Almost prosaic by contrast is another depiction of bone-dry desert desperation by an even more famous Orientalist, the artist-writer Fromentin, who not only made paintings but wrote travel books inspired by his extended sojourns in Algeria. *The Land of Thirst*, whose title comes from the last phrase in Fromentin's 1857 tourist memoir, *A Summer in the Sahara*, is a new variation on the old Romantic theme of a shipwreck, with sand substituting for water, and a poignant image of anonymous human debris expiring, in rhetorical poses of pain and entreaty, on the burning earth. Such a repertory of living horror could be expanded in the Orient to include more overtly didactic contributions to the

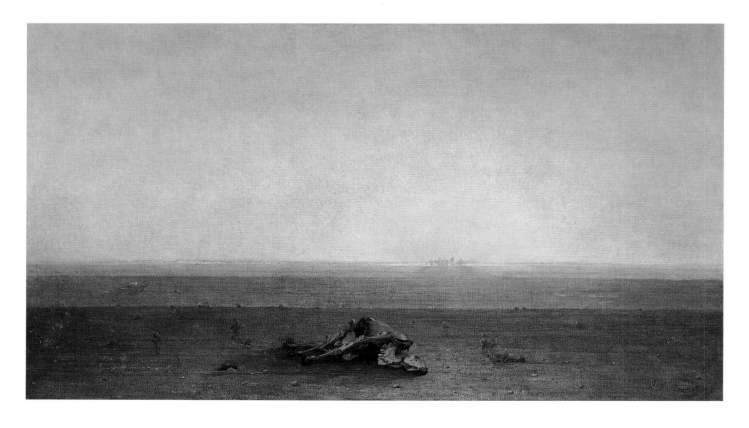

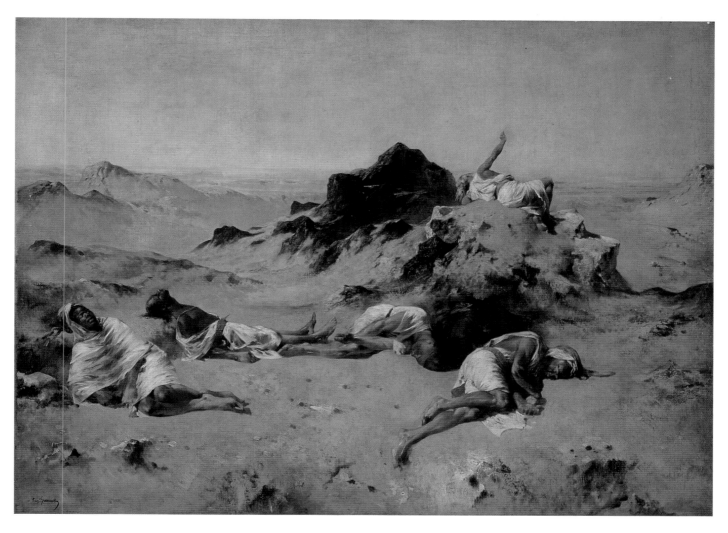

study of local religion and natural history. The range was as wide as Western categories of enquiry, taking us, at times, to scenes of Muslim worship, such as Belly's travelogue souvenir of pilgrims on camels en route to Mecca (page 179) or on tourist safaris to African plains. In Tournemine's canvas, acquired by the emperor himself at the 1867 Salon, elephants can be seen in their natural habitat at a watering place that offers welcome relief from the usual dry-as-dust setting (page 178). Such visions of exotic anthropology and zoology gave French audiences an unpolluted view of what, in fact, were also new domains of cruel imperial exploitation. In Africa, North and South, both humans and animals were expiring under the greedy reign of Western powers, while artists and writers went on documenting what were fast becoming endangered species and vanishing ways of life.

facing page
GUSTAVE GUILLAUMET, Paris 1840–Paris 1887
The Sahara (or *The Desert*), 1867 (Salon of 1868)
3' 7½" x 6' 5" (110 x 200 cm) Gift of the artist's family, 1888.
RF 505

EUGÈNE FROMENTIN
Saint-Maurice 1820–Saint-Maurice 1876
The Land of Thirst, ca. 1869
3' 4½" x 4' 8¼" (103 x 143 cm) Bequest of Edouard Martell, 1920.
RF 2671

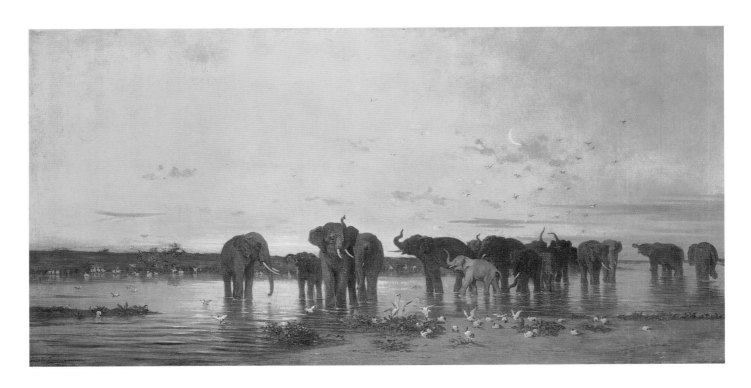

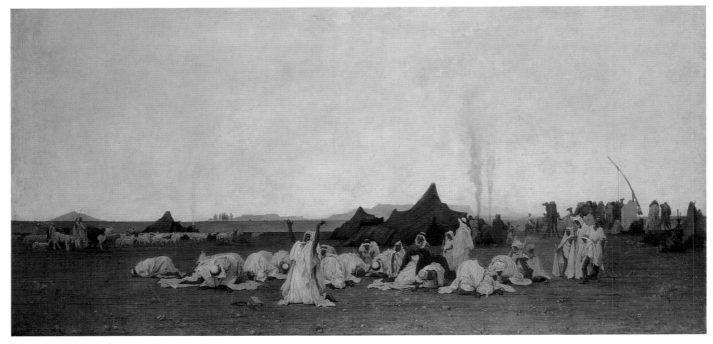

CHARLES TOURNEMINE, Toulon 1812–Toulon 1872
African Elephants (Salon of 1867)
2′ 10¾″ x 5′ 10″ (88 x 178 cm) MI 764

GUSTAVE GUILLAUMET
Evening Prayer in the Sahara, 1863 (Salon of 1863)
4′ 6″ x 9′ 4¼″ (137 x 285 cm) RF 91

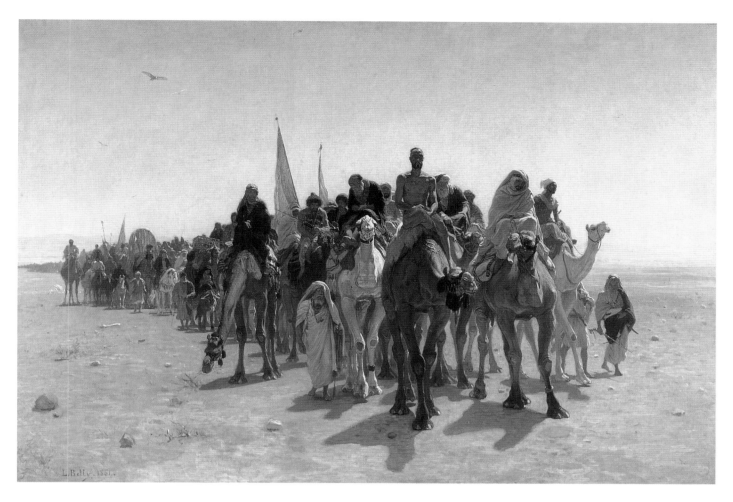

LÉON BELLY, Saint-Omer 1827–Paris 1877
Pilgrims Going to Mecca, 1861 (Salon of 1861)
5′ 3½″ x 7′ 11¼″ (161 x 242 cm) RF 61

Henri Regnault
Execution without Trial under the Moorish Kings of Granada

Still shocking today, Regnault's tall, high canvas forces the viewer to look up at an exotic spectacle that, for both horror and gorgeousness, seems to transcend the dull decorum of Western justice and aesthetics. The repellent, Grand Guignol facts of a just-severed Arab head, a pool of blood dripping down a flight of stairs, and a decapitated but still agonized body are set in a seesawing balance against a vista of exquisite refinement and majesty in which the most precious harmonies of apricot and peach fuse the robes of the coolly indifferent executioner and the breathtaking glimpse of an Arabian Nights interior inspired by the Alhambra. Indeed, Regnault's own itinerary, like that of many nineteenth-century Frenchmen in search of the intense sensuality of the Arab world, took him first to Spain, where he marveled at the Moorish architecture of Granada. Then he moved on to the still more remote Tangiers, where he lived and worked with another academic artist, Georges Clairin, and where, in 1870, he painted this grisly, sharp-focus fantasy, which, he said, tried "to depict the real Moors as they were only in past history, rich and great, terrifying and voluptuous."

Regnault, like his enthusiastically horrified audiences, was clearly attracted to morbid themes set in a remote, exotic world. Anticipating the fascination with bodiless heads and femmes fatales that would proliferate in the 1890s, he had already depicted Judith beheading Holofernes and painted Salome before he completed this Moorish decapitation of 1870. His own death was more prosaic and Western; in January 1871 he was killed in the Franco-Prussian War at the Battle of Buzenval. His more fortunate companion, Clairin, also twenty-eight years old, not only survived the same battle but, several months later, in May, recorded with a rapid oil sketch the burning of the Tuileries Palace in Paris by the Commune (page 253).

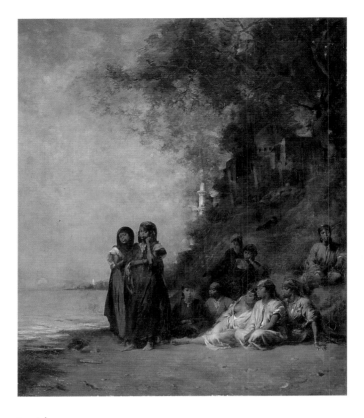

EUGÈNE FROMENTIN
Egyptian Women on the Edge of the Nile, 1876
3′ 11¼″ x 3′ 5¼″ (120 x 105 cm) Bequest of Mrs. Aristide Boucicaut, 1888. RF 515

facing page

HENRI REGNAULT, Paris 1843–Buzenval 1871
Execution without Trial under the Moorish Kings of Granada, 1870
(1878 Exposition Universelle)
9′ 11″ x 4′ 9½″ (302 x 146 cm) RF 22

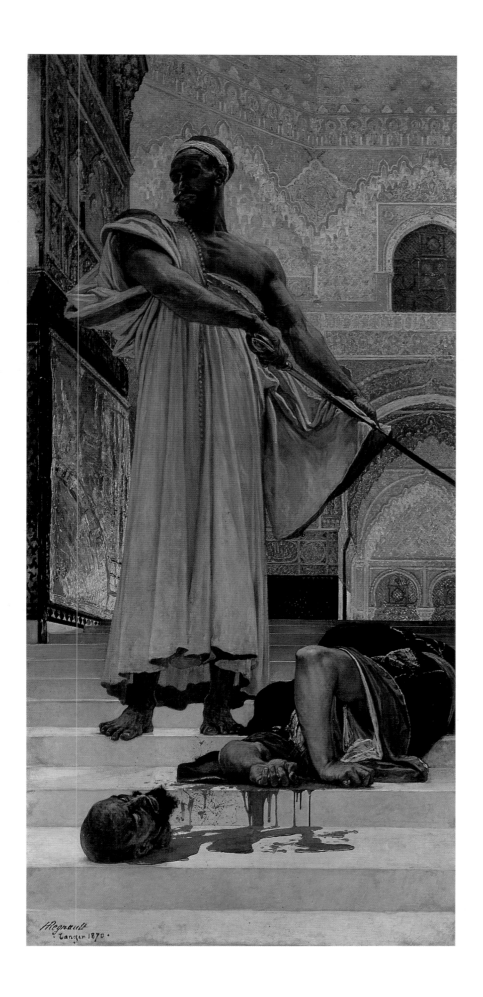

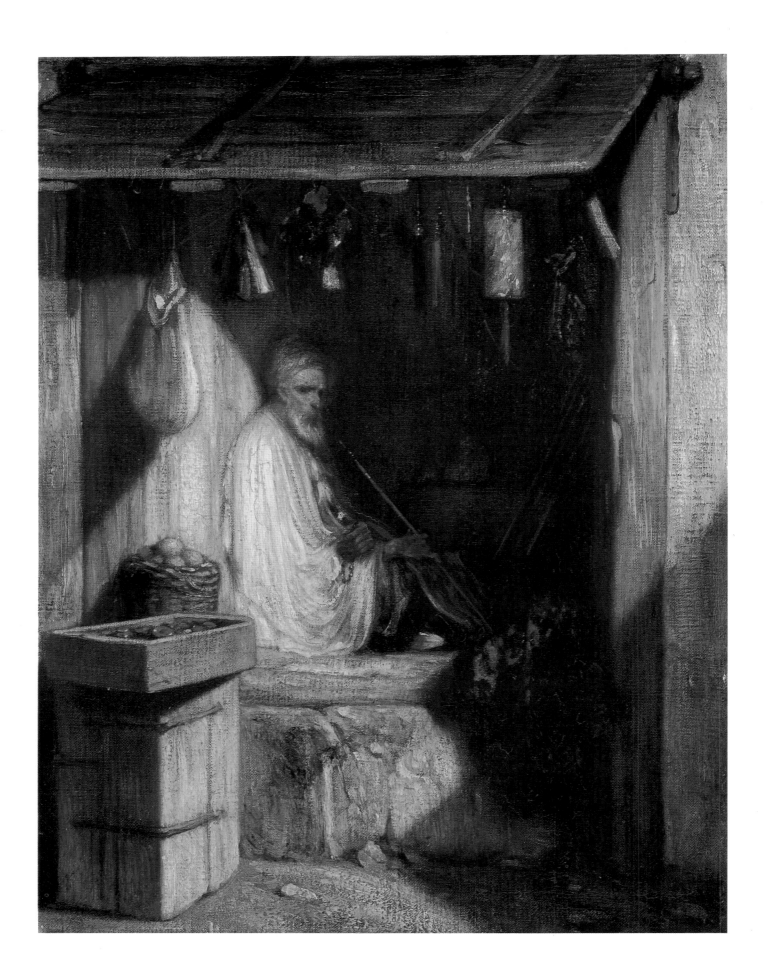

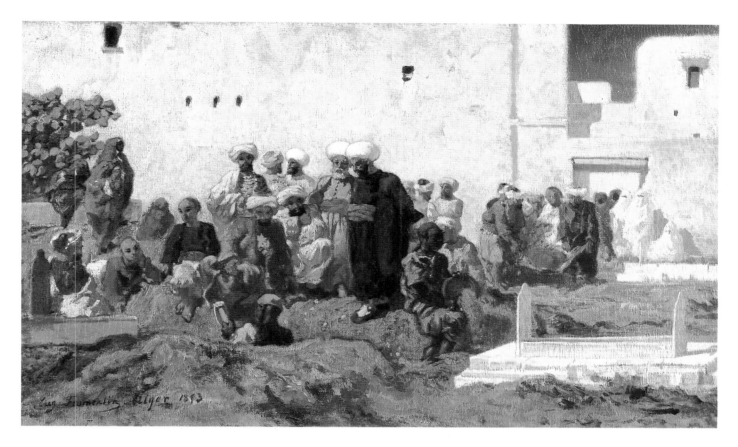

EUGÈNE FROMENTIN
Moorish Burial, 1853 (Salon of 1853)
1′ 1″ x 1′ 10″ (32.5 x 56 cm) Gift of Étienne Moreau-Nélation, 1907.
RF 1700

ALFRED DEHODENCQ, Paris 1822–Paris 1882
Blacks Dancing in Tangiers (Salon of 1874)
4′ 11¾″ x 6′ 7½″ (152 x 202 cm) Bequest of Léon Lhermitte, 1926.
RF 2587

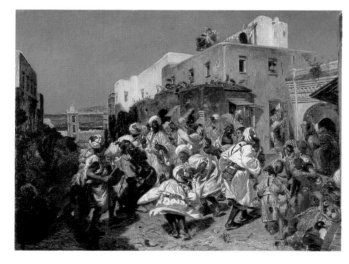

facing page
ALEXANDRE-GABRIEL DECAMPS
Paris 1803–Fontainebleau 1860
Turkish Merchant Smoking in His Shop, 1844
1′ 2¼″ x 11″ (36 x 28 cm) Bequest of Alfred Chauchard, 1909.
RF 1810

page 184
ALFRED DEHODENCQ
The Farewell of King Boabdil at Granada (Salon of 1869)
12′ 4½″ x 9′ (377 x 275 cm) RF 1986-9

page 185
EUGÈNE FROMENTIN
Falcon Hunting in Algeria; The Quarry, 1862 (Salon of 1863)
5′ 4″ x 3′ 10½″ (162.5 x 118 cm) RF 87

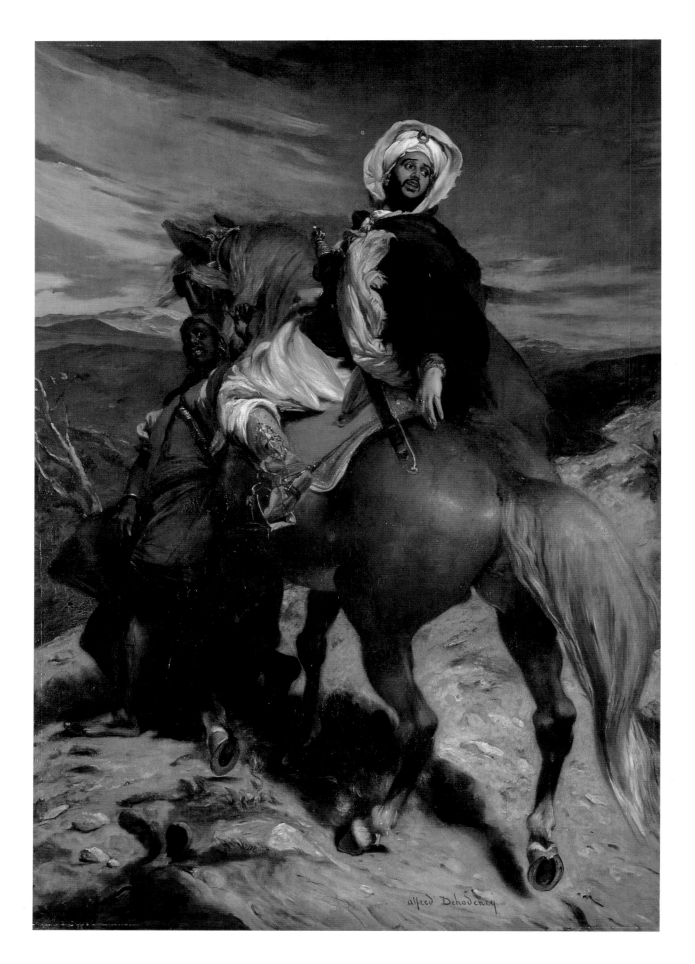

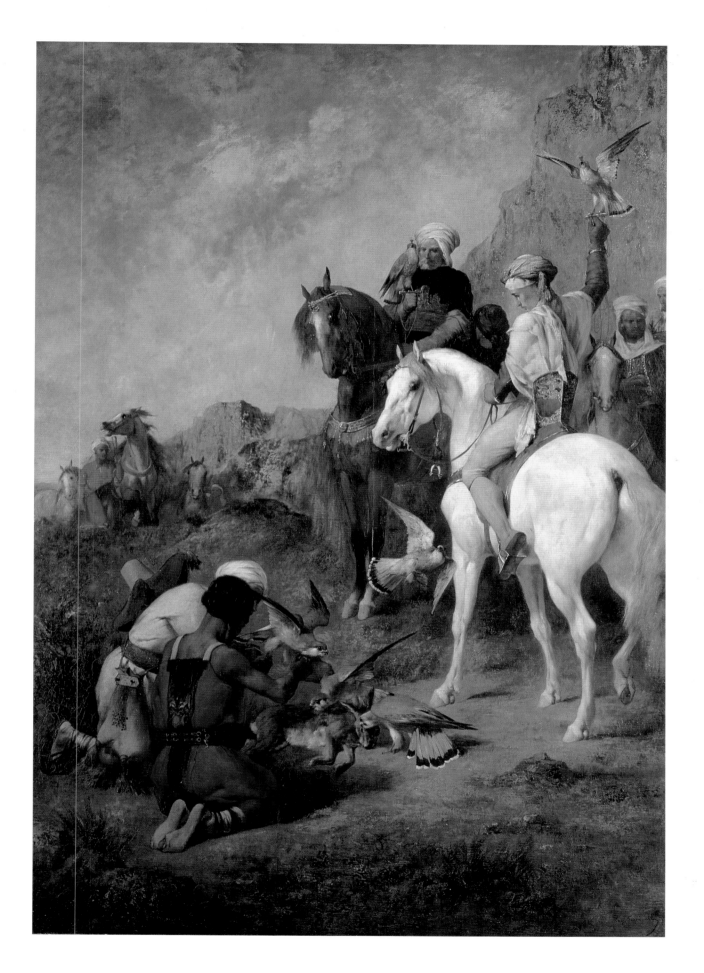

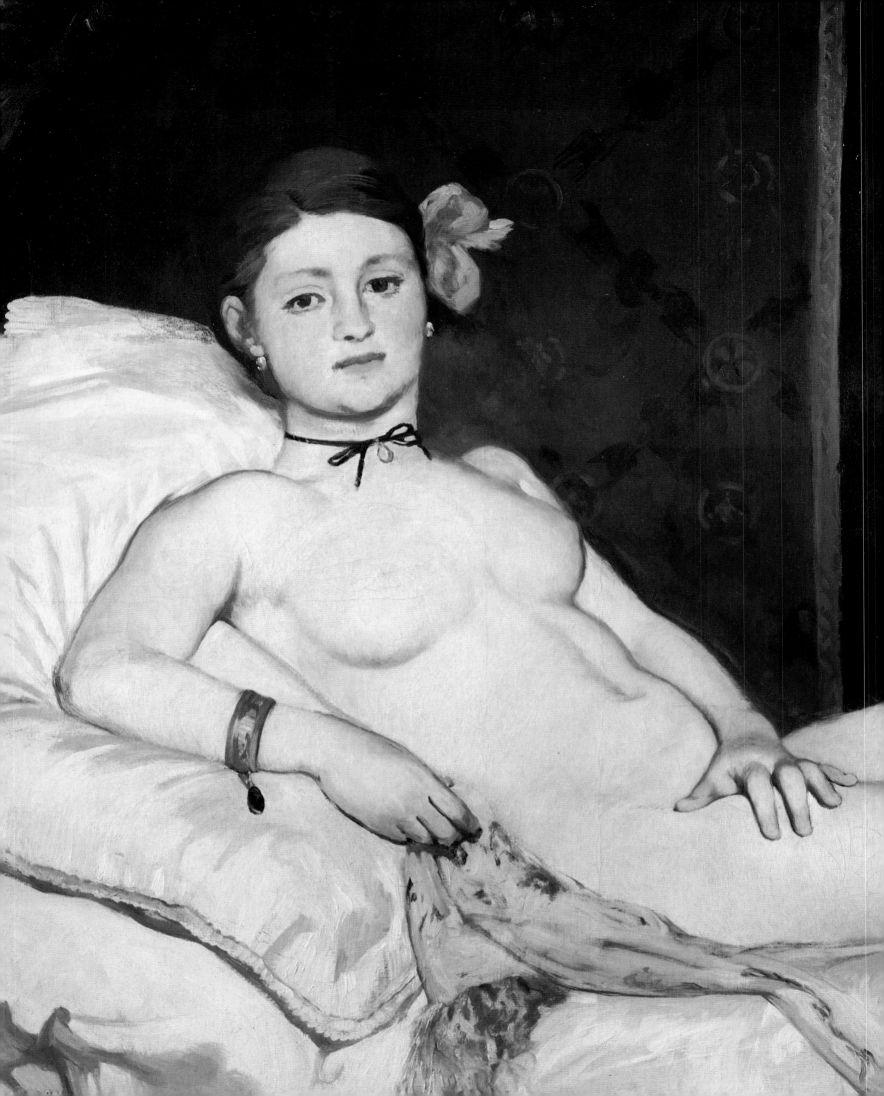

The 1860s

Toward Impressionism

Eugène Boudin
The Beach at Trouville

*O*ne can almost smell and feel the salubrious sea breezes in *The Beach at Trouville*, a small sketchlike painting by an artist whose name always figures in the early history of Impressionism. Boudin, in fact, was Monet's first teacher—a pedigree apparent in this scene of fashionable ladies, gentlemen, and children enjoying the elegant beach resort of Trouville on the Normandy coast. Such watering places had become increasingly popular by the mid-century, when painters on both sides of the English Channel depicted the crowds, more overdressed than undressed, discreetly exposing themselves to sand and sea. Queen Victoria herself, together with her retinue, had visited Trouville in 1863, and Boudin was at hand to jot down the event with his rapid dabs of high-keyed pigment.

Here the vivid sense of casual, on-the-spot immediacy instantly strikes ancestral chords in the dynasty of Impressionism. Within this strangely close and huddled community of wealthy urbanites communing with nature, everything moves and flutters with the changing skies, winds, and waters of the Channel coast. No chairback will stay aligned with its neighbor; every parasol is tilted at its own angle. Our own point of view is no less casual, catching the crowds from behind as they, in turn, look out at the soothing spectacle of picturesque fishermen and the distant horizon. So emphatic is this sense of leisure, of freedom from any imposed order, that even the repeated pairing of two beach houses, two flagpoles, and two spiky towers on the distant hill cannot regiment the freedom of the vacationers. Finally, it is the breadth and openness of the blue sky, gently mottled with clouds, that dominates this elegant vignette.

In tandem with Monet's own depictions of the beach at Trouville, climaxing with the 1870 view of the promenade in front of the Hôtel des Roches Noires (page 275), Boudin offers a tentative liberation of pigment as a speckled camouflage for the things it would describe. It takes a second glance to realize that this dab of yellow or that dab of white may stand for an elaborate shawl or crinoline typical of Second Empire fashions that concealed, with maximum artifice, a woman's body—a charming paradox for a beach resort.

Boudin's painted snapshot of high society at leisure was shown at the Salon of 1864. Its small dimensions—it is less than a foot high—made it acceptable as a diminutive sketch, whereas Monet's experiments in the same domain of plein-air sketches increased in size to a point that suggested ambitious finished canvases rather than unthreatening preparatory studies. Challenging official authority about proper standards of pictorial finish, Monet's larger paintings would often be rejected.

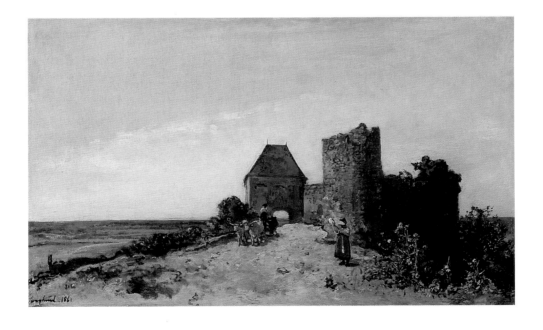

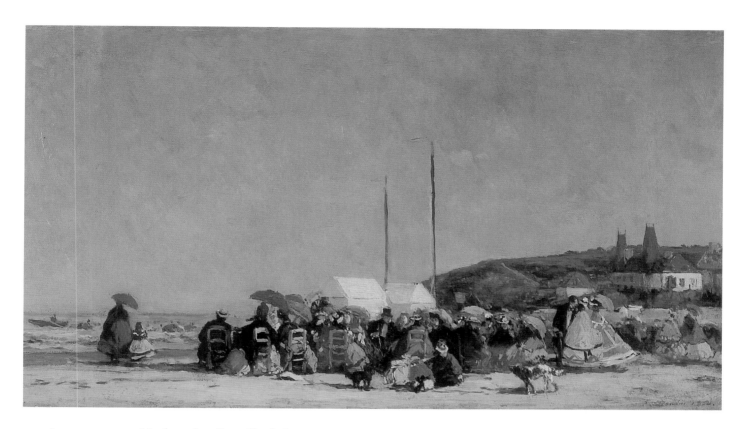

EUGÈNE BOUDIN, Honfleur 1824–Deauville 1898
The Beach at Trouville, 1864
10¼″ x 1′ 7″ (26 x 48 cm) Gift of Eduardo Mollard, 1961.
RF 1961-26

facing page
JOHAN-BARTHOLD JONGKIND
Latrop 1819–Saint-Egrève 1891
Ruins of the Castle at Rosemont, 1861 (Salon des Refusés, 1863)
1′ 1½″ x 1′ 10¼″ (34 x 56.5 cm) Gift of Étienne Moreau-Nélaton,
1906. RF 1703

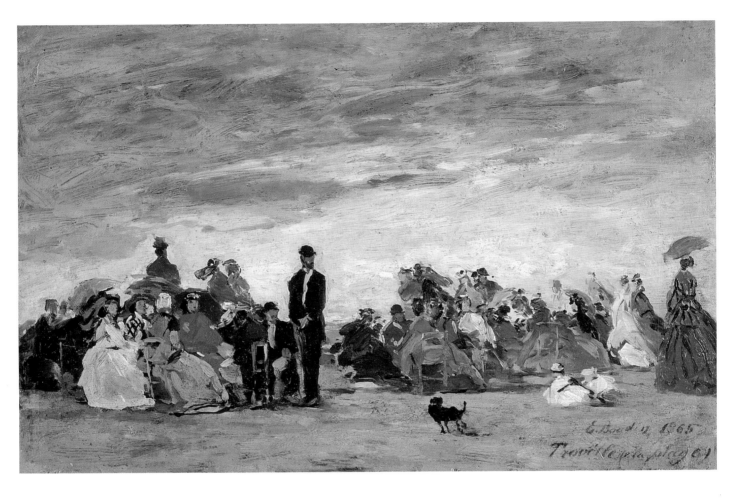

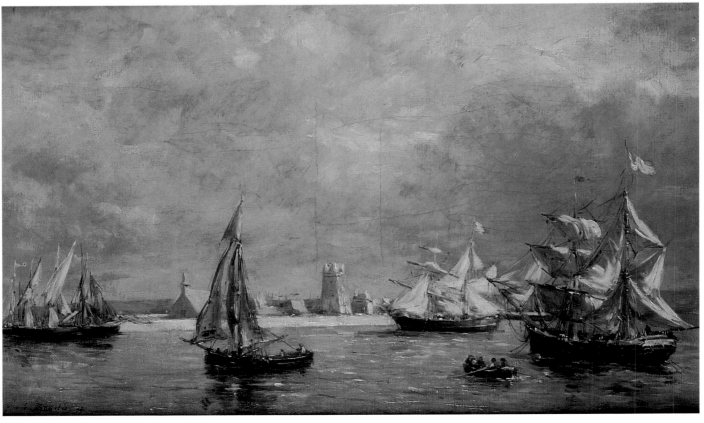

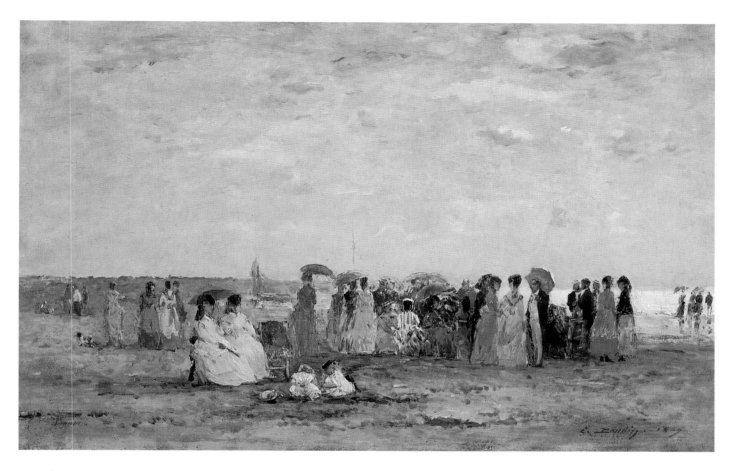

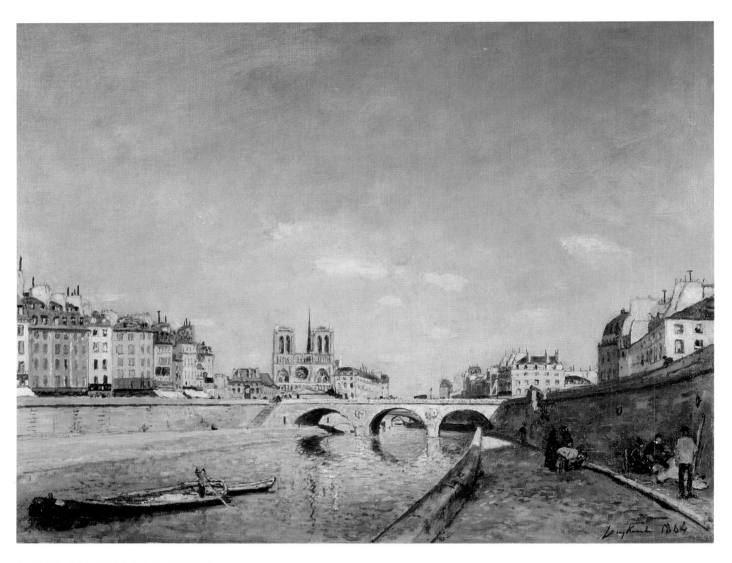

JOHAN-BARTHOLD JONGKIND
The Seine and Notre-Dame de Paris, 1864
1′ 4½″ x 1′ 10″ (42 x 56 cm) Bequest of Enriqueta Alsop in the name of
Eduardo Mollard, 1972.
RF 1972-20

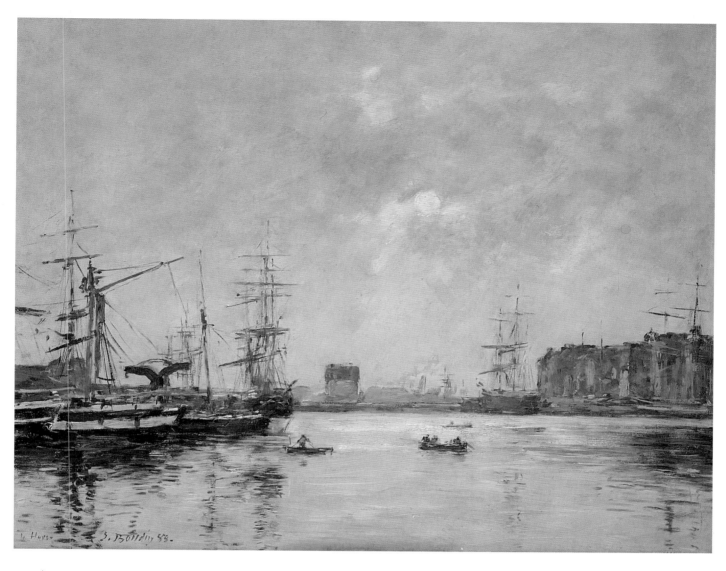

EUGÈNE BOUDIN
The Port of Le Havre (Dock of La Barre), 1888
1′ 1″ x 1′ 4¼″ (32 x 41 cm) Bequest of James N. B. Hill, 1978.
RF 1978-19

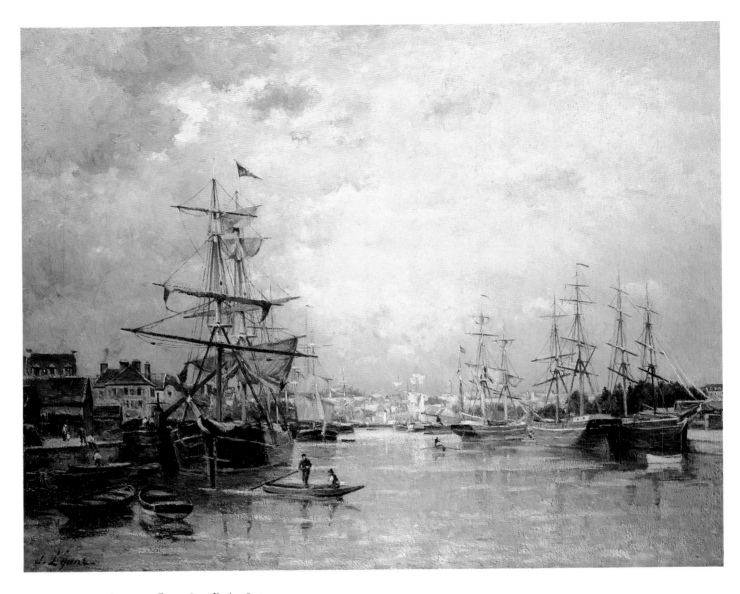

STANISLAS LÉPINE, Caen 1835–Paris 1892
The Port of Caen, ca. 1859
2′ 4½″ x 3′ (72.5 x 91.5 cm) Gift of Paul Jamot, 1938. RF 1938-5

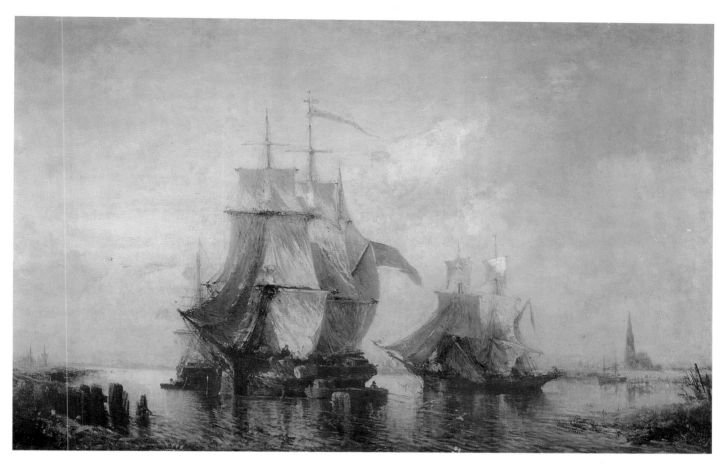

FÉLIX ZIEM, Beaune 1821–Paris 1911
Marine; Antwerp; Gateway to Flanders (1855 Exposition Universelle)
4′ 5″ x 7′ 1¾″ (134.5 x 218 cm) RF 451

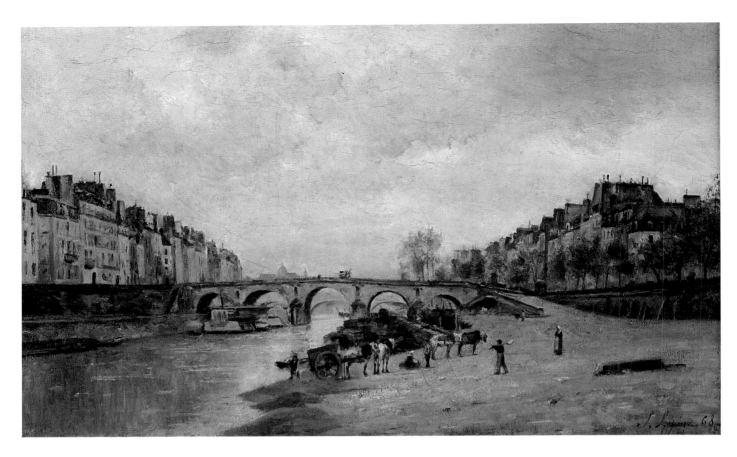

STANISLAS LÉPINE
Quais of the Seine, Pont-Marie, 1868
11¾" x 1' 7¾" (30 x 50 cm) Bequest of Enriqueta Alsop, 1972.
RF 1972-25

facing page, top
JOHAN-BARTHOLD JONGKIND
In Holland; Boats near the Mill, 1868
1' 8¾" x 2' 8" (52.5 x 81.3 cm) Bequest of Count Isaac de Camondo,
1911. RF 1990

facing page, bottom
EUGÈNE BOUDIN
The Port of Bordeaux, 1874
2' 3¾" x 3' 4¼" (70.5 x 102 cm) RF 2716

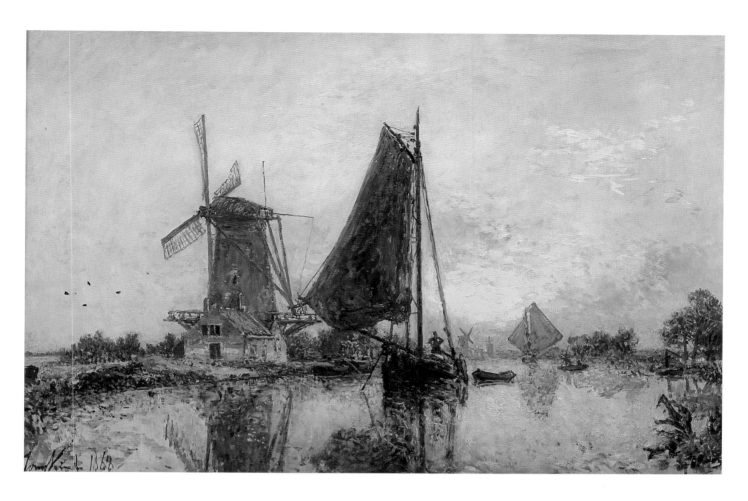

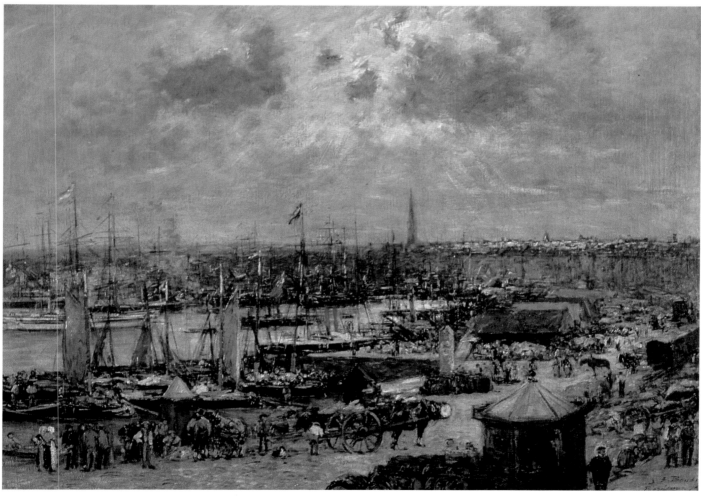

MANET BEFORE 1870

Olympia

*F*or a frontal attack upon the Second Empire's official conventions of female nudity and sexuality, nothing could be shriller or more definitive than *Olympia*. Painted in 1863 but not exhibited until the 1865 Salon, this notorious canvas suddenly brought the brashest of modern truths into the high-art ambience of voluptuous fantasies given propriety by the classical or biblical texts to which they alluded. Next to Cabanel's *Birth of Venus* (page 39), which was considered respectable enough to be purchased by the emperor at the 1863 Salon, or Henner's *The Chaste Susannah* (page 45), which shared the walls with *Olympia* at the 1865 Salon, Manet's new idea of a desirable naked woman is a slap in the viewer's face. No longer is the spectator—surely, by implication, male—a Peeping Tom, casting his gaze upon passive nudes from remote legend who, like Susannah, are unaware of his lustful intentions. Here the roles are reversed. It is Olympia herself who does the looking, staring down, even warding off, the man who would dare approach her. And to underline these scare tactics, she has the assistance of a black cat, also seen head-on, its eyes glowing straight out at the viewer from the foot of the bed, its back arched and tail raised, ready for a fight.

Manet, as usual, knew exactly what he was doing, turning all conventions—of painting, of art history, of erotic decorum—upside down in order to proclaim loudly the fact of being alive in the new Paris of the 1860s. Shocking, of course, was the fact that not only was the model, Victorine Meurent, recognizable to many but, more to the point, that the classical goddess of love had been transformed overnight into a Parisian goddess of sexual commerce. Her very name, Olympia, was often associated with prostitutes of the period; and her tough but intelligent expression made it clear that she was a thinking business woman. No less harsh was the true-to-life casualness of her posture. She has even let drop the slipper on her right foot.

To enforce his points, Manet worked, as Courbet often did before him, in the realm of parody. Here he offers a spoof not only of a long French tradition of representing exotic harem girls with black attendants but, more specifically, of a venerable Titian, the *Venus of Urbino*, which he had copied in Florence in 1853. The effect is that of an outrageous joke at a Beaux-Arts ball, in which a revered old-master image is travestied in a modern language. Even Olympia's left hand participates in this offense, replacing Titian's idea of Venus's modesty in concealing her sex with the suggestion that this new Venus may not yet have decided to be available to the next suitor, whose flowers have just been received.

This close-up confrontation with modern sexual realities is completely matched by the alarming new frontality of Manet's way of painting. Unlike Cabanel's reclining Venus, who exists in a distant spatial fiction clearly separated, as if by a proscenium, from the contemporary world outside, Olympia, together with her servant, her cat, and her linens, imposes herself upon us as if the receding planes behind her gaze were rushing forward to compete for our attention. By official standards of the 1860s, the modeling of Olympia's naked flesh looked flat and shadowless, matching the compressed expanses of dazzling white pillows, sheets, and wrapping paper. This brilliant whiteness was further accented by the abrupt collisions with the polar extreme of darkness, with the cat, the black servant, and much of the background almost camouflaged in inky silhouettes. Even Courbet found the painting stridently flat, comparing it to a playing card, the Queen of Spades.

Today, of course, Manet's abbreviated modeling, his contractions of near and far reveal the skills of an old master more than of a young Turk. Generations have marveled not only at the still disarming insolence of Olympia's steadfast gaze but at the infinite variety of whites and pale flesh tones that she displays on her bed, or at the spatial subtlety with which in layer after layer—curtain, wall, curtain, wall—the darker, secret recesses of her public and private lair are disclosed.

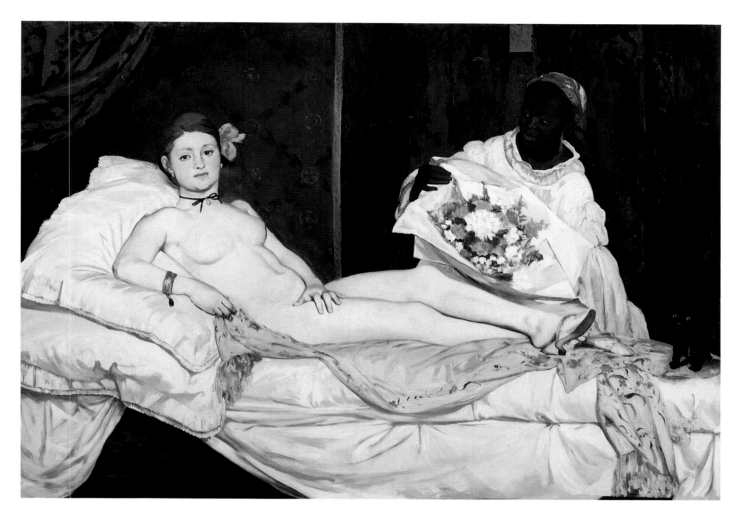

ÉDOUARD MANET, Paris 1832–Paris 1883
Olympia, 1863 (Salon of 1865)
4′ 3½″ x 6′ 2¾″ (130.5 x 190 cm) RF 664

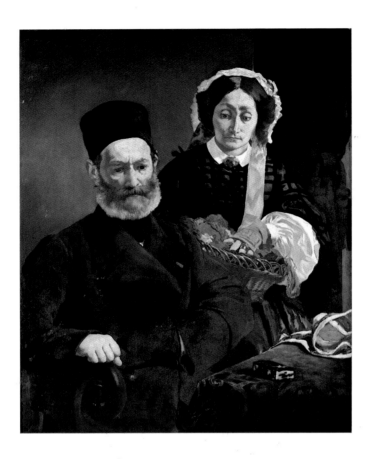

ÉDOUARD MANET
Portrait of M. and Mme. Auguste Manet, 1860 (Salon of 1861)
3' 8" x 2' 11¾" (111.5 x 91 cm) RF 1977-12

ÉDOUARD MANET
Angélina, 1865
3' x 2' 4¾" (92 x 73 cm) Bequest of Gustave Caillebotte, 1894.
RF 3664

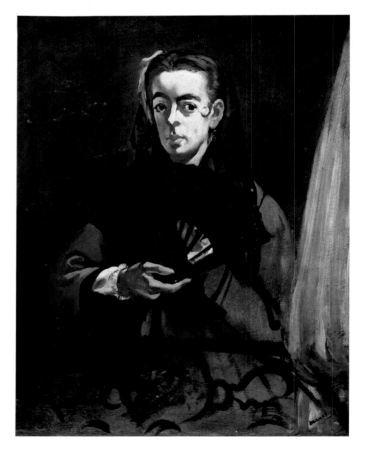

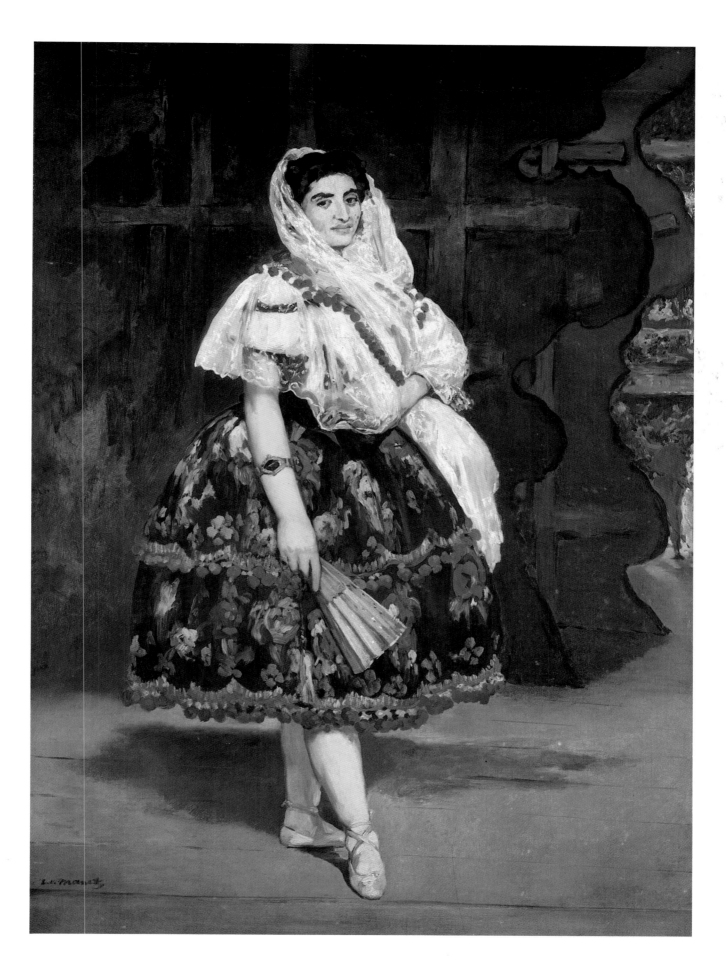

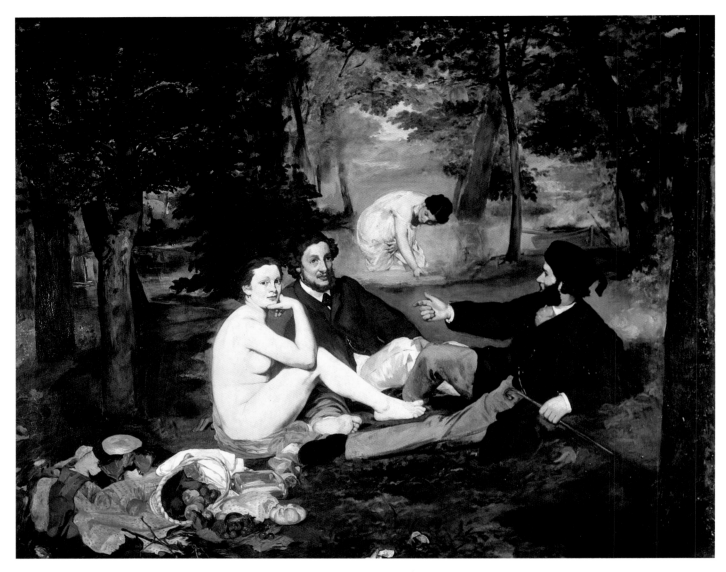

ÉDOUARD MANET
Déjeuner sur l'herbe (The Picnic), 1863 (Salon des Refusés, 1863)
6′ 10″ x 8′ 8″ (208 x 264 cm) RF 1668

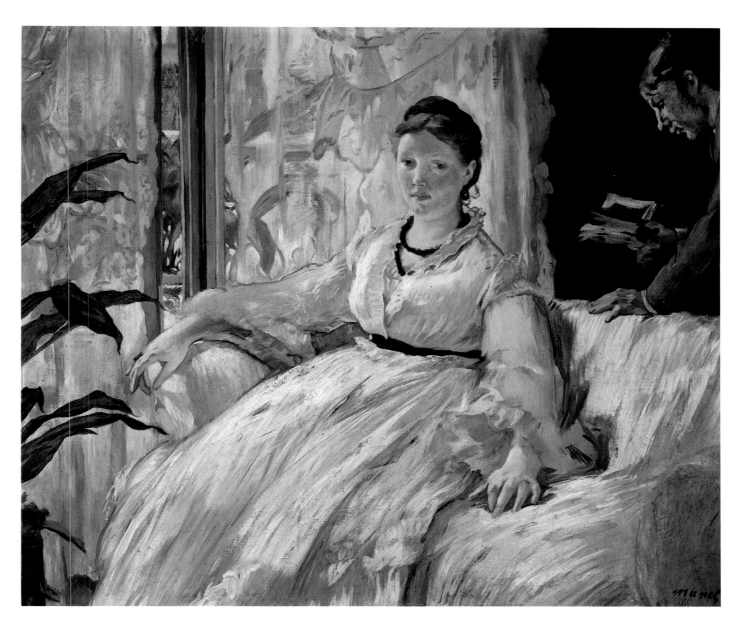

ÉDOUARD MANET
Reading, 1868
1′ 11¾″ x 2′ 5″ (60.5 x 73.5 cm) Bequest of
Princess Edmond de Polignac, 1944. RF 1944-47

ÉDOUARD MANET
Mme. Manet at the Piano, 1868
1′ 3″ x 1′ 6¼″ (38 x 46.5 cm) Bequest of Count Isaac de Camondo,
1911. RF 1994

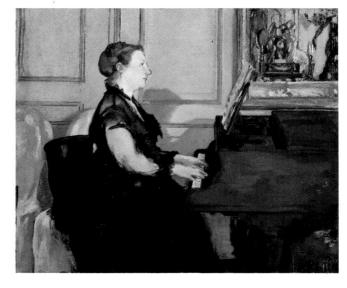

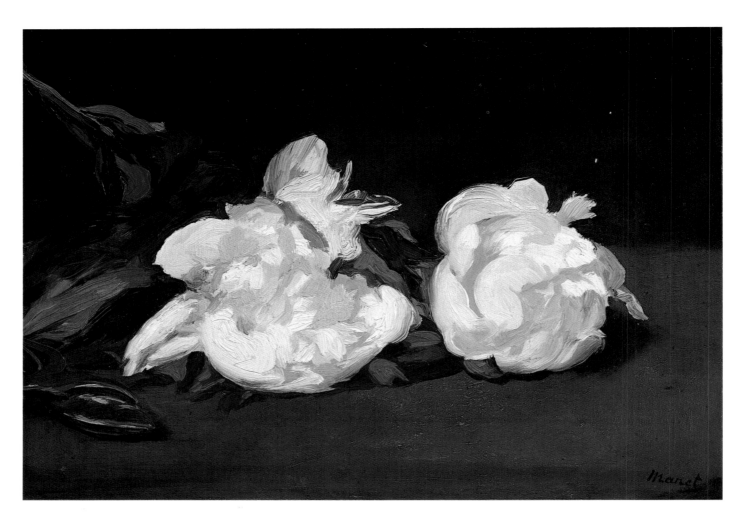

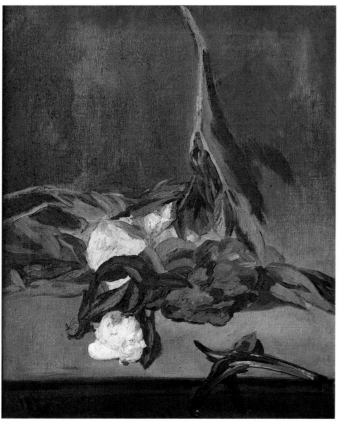

ÉDOUARD MANET
Branch of White Peonies and Shears, 1864
1' x 1' 6¼" (31 x 46.5 cm) Bequest of Count Isaac de Camondo, 1911.
RF 1995

ÉDOUARD MANET
Peony Stem and Shears, 1864
1' 10½" x 1' 6" (57 x 46 cm) Bequest of Count Isaac de Camondo,
1911. RF 1996

facing page
ÉDOUARD MANET
Vase of Peonies on a Pedestal, 1864
3' 1" x 2' 3½" (93.2 x 70 cm) Gift of Étienne Moreau-Nélation, 1906.
RF 1669

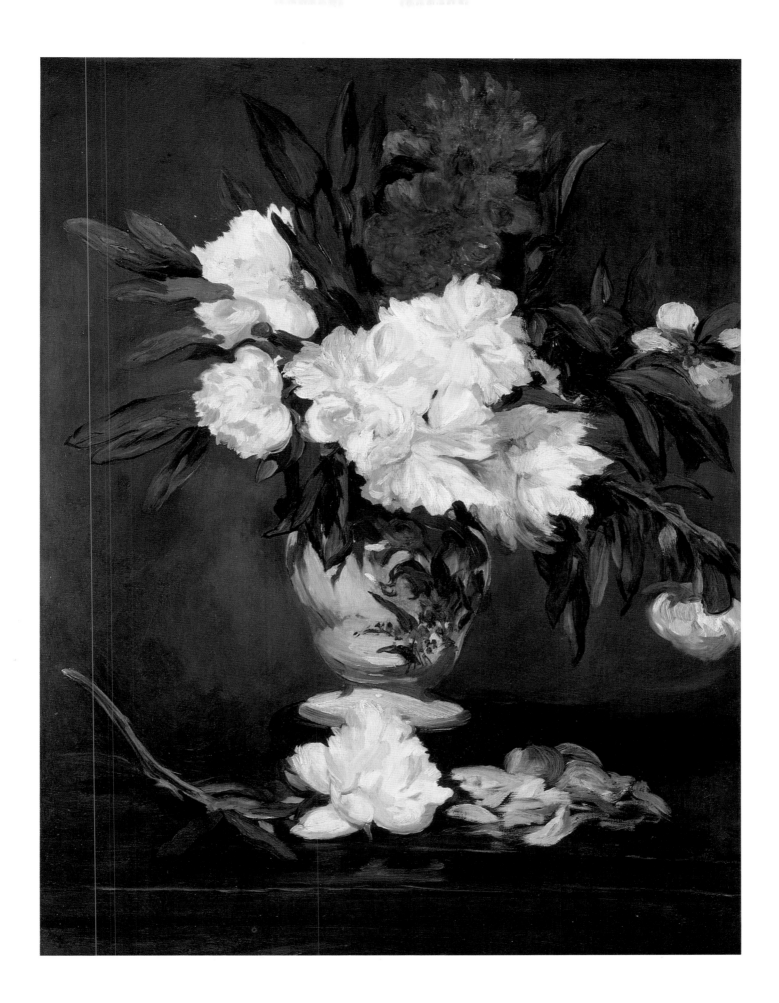

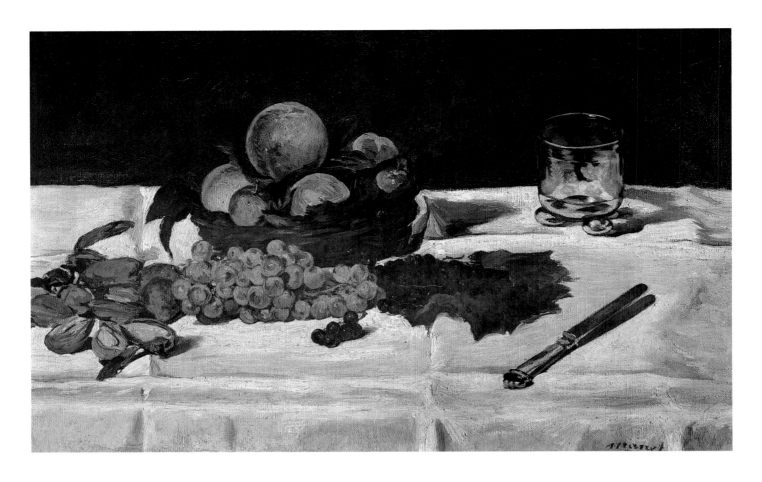

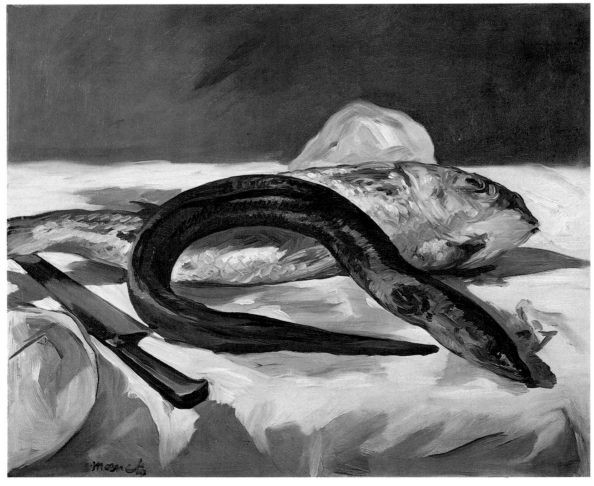

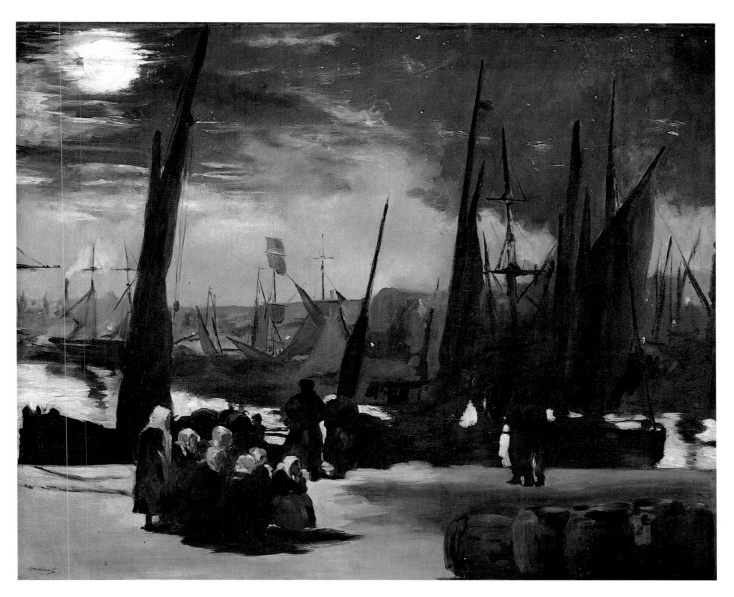

ÉDOUARD MANET
Moonlight over the Port of Boulogne, 1869
2′ 8¼″ x 3′ 3¾″ (82 x 101 cm) Bequest of Count Isaac de Camondo,
1911. RF 1993

facing page, top
ÉDOUARD MANET
Still Life: Fruit on a Table, 1864
1′ 5¾″ x 2′ 5″ (45 x 73.5 cm) Gift of Étienne Moreau-Nélation, 1906.
RF 1670

facing page, bottom
ÉDOUARD MANET
Eel and Red Snapper, 1864
1′ 3″ x 1′ 6¼″ (38 x 46.5 cm) Gift of Dr. and Mrs. Albert Charpentier,
1951. RF 1951-9

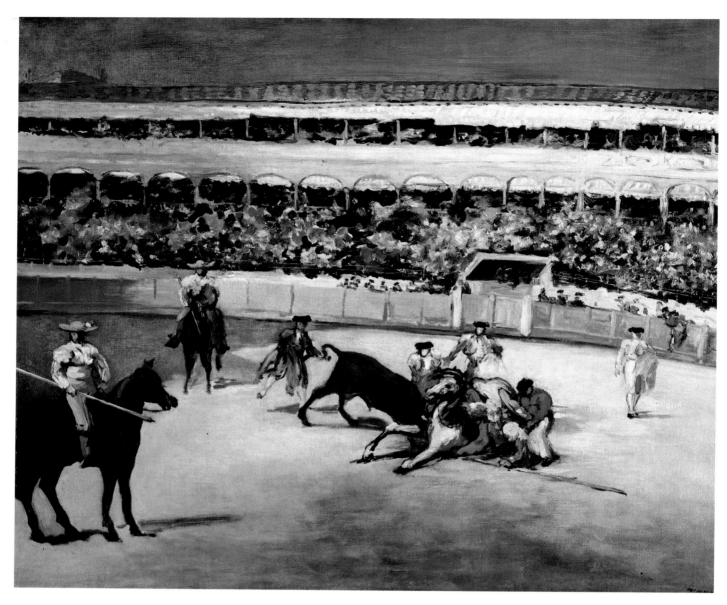

ÉDOUARD MANET
Bullfight, 1865–1866
2′ 11½″ x 3′ 7½″ (90 x 110.5 cm) RF 1976-8

facing page
ÉDOUARD MANET
The Fifer, 1866 (Salon of 1866)
5′ 3½″ x 3′ 2¼″ (161 x 97 cm) Bequest of Count Isaac de Camondo,
1911. RF 1992

page 210
ÉDOUARD MANET
Émile Zola (Salon of 1868)
4′ 9½″ x 3′ 9″ (146 x 114 cm) Gift of Mrs. Émile Zola, 1918.
RF 2205

page 211
ÉDOUARD MANET
The Balcony, 1868–1869 (Salon of 1869)
5′ 7″ x 4′ 1″ (170 x 124.5 cm) Bequest of Gustave Caillebotte, 1894.
RF 2772

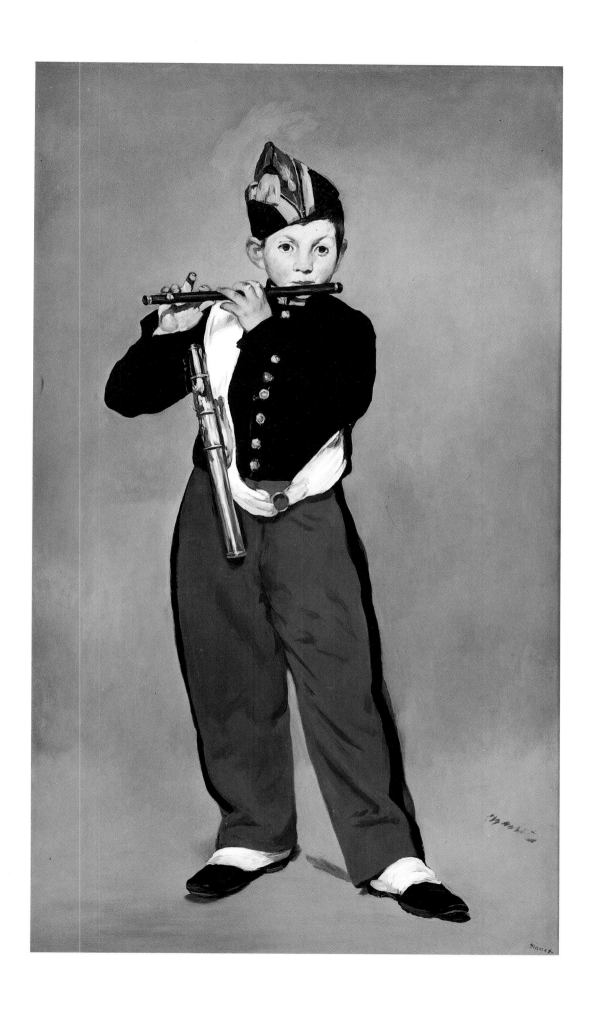

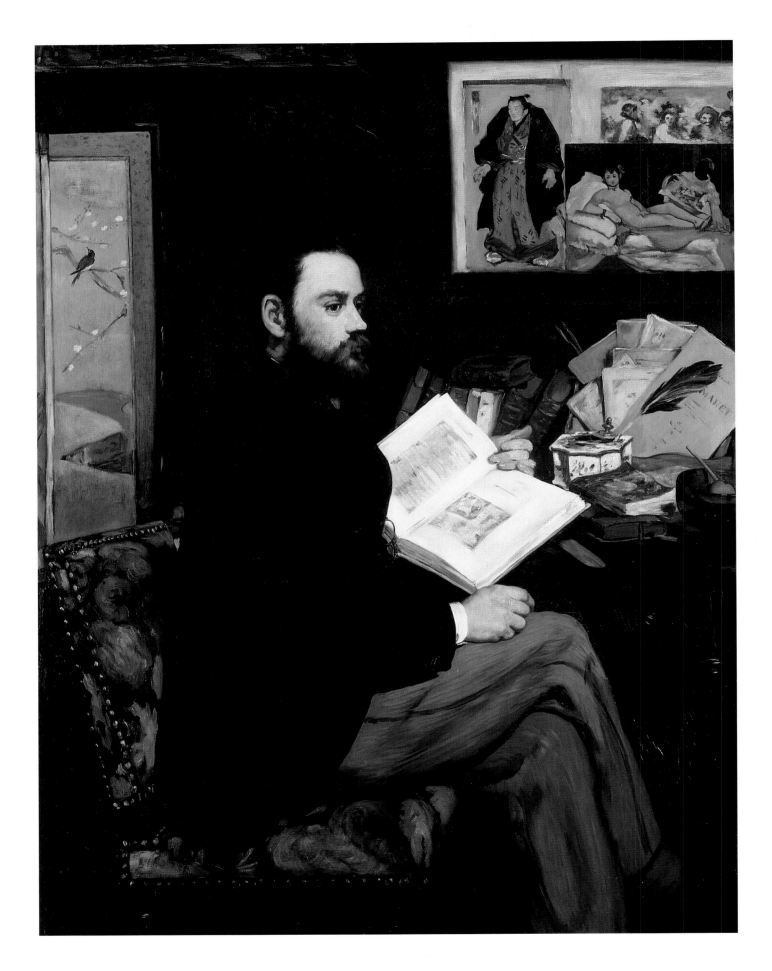

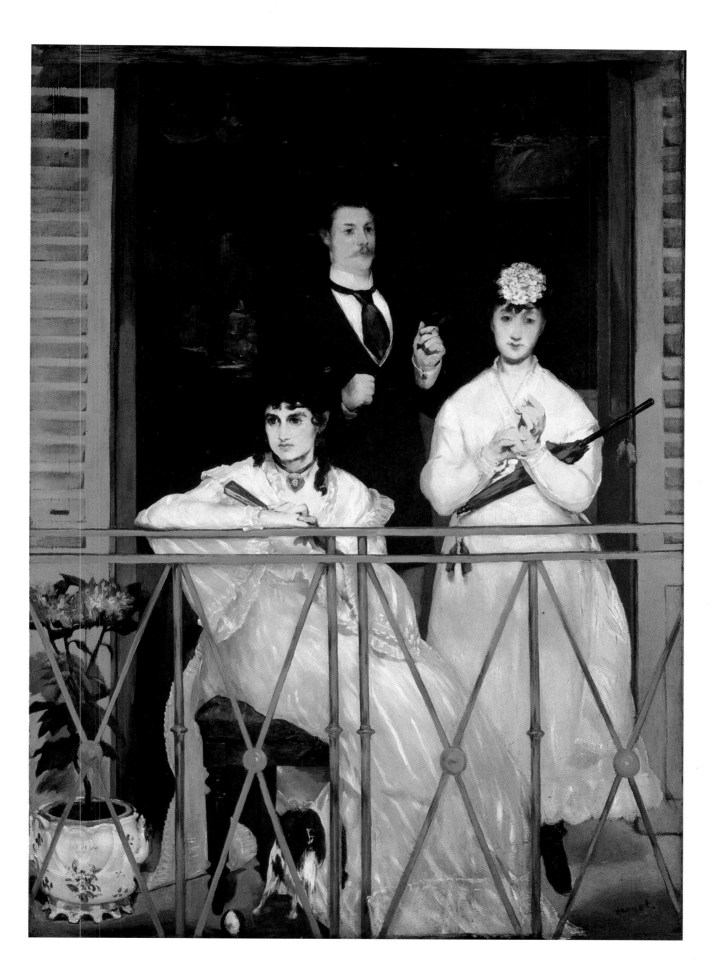

THE EARLY DEGAS

A Degas Family Album

*D*egas's early portraits of himself, his grandfather, his sisters, and his aunt's family in Florence, when seen together, form what looks like an album of Victorian photographs, offering what appear to be objective records of the faces, the psychology, the costumes, and the decorum of well-to-do families, ca. 1860. But for Degas (who, with reverse chic, changed the aristocratic spelling of the family name, de Gas, to the more bourgeois Degas), these readily available sitters could also become a proving ground to define his own sharp personality against the pull of old-master tradition.

In his self-portrait of 1855 (facing page, top left), this twenty-one-year-old looks almost more conservative than his own grandfather, Hilaire, whom he was to draw and paint two years later. Probably alluding to an early self-portrait by Ingres, who was honored by a retrospective in 1855, Degas appoints himself a keeper of this venerable artist's flame. With a charcoal holder in his right hand, Degas emphasizes his own dedication to draftsmanship, as well as his unyouthful willingness to don the severe and unsmiling restraints of authority. Peering through the dark palette, reminiscent of age and dignity, Degas's own expression commands respect. We see a dour observer who, with pouting mouth and sideways gaze, will judge what he sees with detached condescension.

Far more humanly accessible is his grandfather (facing page, top right), who was eighty-seven when Degas painted him twice at his country home near Naples in the summer of 1857. Despite the formality of the more finished portrait, in which the cane and crossed legs keep the spectator at a distance, the sitter reveals a warmth alien to his grandson. Ingres's authority again reverberates here in the incisive contours of the black jacket and the cool, glassy tonalities. But the juggling of the figure against a skeleton of upholstery stripes, picture frame, and the planes of door and wall introduces the kind of abstract armature that Degas would later use to fix all human beings—friends, relatives, or strangers—in the frozen discipline of his art.

As another glimmer of things to come, there is also a more informal portrait of Degas's grandfather from 1857 (page 215). Sketchy and diminutive, it depicts him, cap on head, scrutinizing a print or drawing, perhaps by his grandson. But even this little square of paint precociously reveals the artist's genius. All oblique angles click quietly into place; and a blaze of jewel-like color emerges, a pre-

view of the audacious chromatic adventures found in the master's late work.

Degas's two sisters add to this family ensemble. The younger, Marguerite (facing page, bottom left), is captured in the late 1850s as a teenager trapped in an uncomfortable mix of ramrod stiffness and domestic casualness. The frontal symmetry, rising to the perfect oval of a head crowned by straight hair, parted in the middle, paraphrases Ingres's hierarchic Virgins, but the obvious discomfort of the stance, with one arm bent backward and the other fiddling with the back of an angled chair, instantly brings things down to a world of ordinary truths. Far haughtier is the portrait of his elder sister, Thérèse (facing page, bottom right), probably painted in 1863, the year of her marriage. Resembling her brother in her long, full-lipped face and firmly unapproachable expression, she stands before a door frame that immobilizes her with its unyielding verticality, even though her surprisingly off-center placement suggests that she was seized on the move, leaving or returning home in the full propriety of Second Empire street clothing. Left unfinished, this snapshot-like painting already fulfills the artist's quest for calculated spontaneity.

These individual portraits reach a fully worked-out climax in the large domestic drama known as the *Bellelli Family* but exhibited, more anonymously, at the Salon of 1867 as *Family Portrait*, after Degas had been working on it for almost a decade (page 215). This stiff quartet—composed of Degas's aunt Laura, her Italian husband, Gennaro, and their two daughters, Giovanna and Giulia—is caught together in the formal order of posed domesticity. Within this decorum, however, the family members exist in private, even warring worlds, with the father, his chair turned aside, almost refusing to join his wife and children for posterity. As a witty touch, Degas includes, next to Laura, a framed portrait of his grandfather and her father, Hilaire, who had died in 1858, just before this canvas was begun. It is, in fact, a drawing closely related to the 1857 painting that shows him looking at another work of art. Faint and small though it is, Hilaire's framed image provides the magnetic focus, both of genealogy and abstract pattern, for his progeny, who almost illustrate Leo Tolstoy's famous line "Happy families are all alike; every unhappy family is unhappy in its own way."

Captions are on page 215.

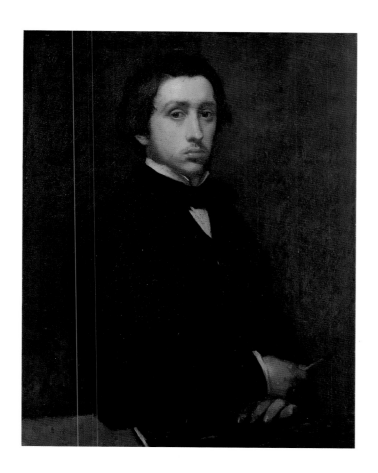

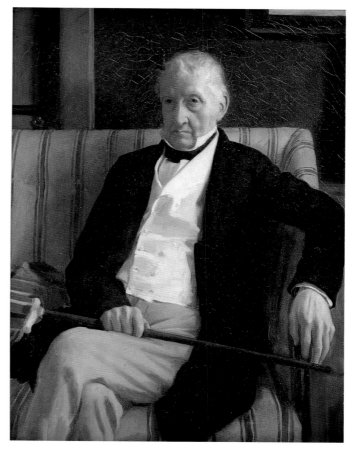

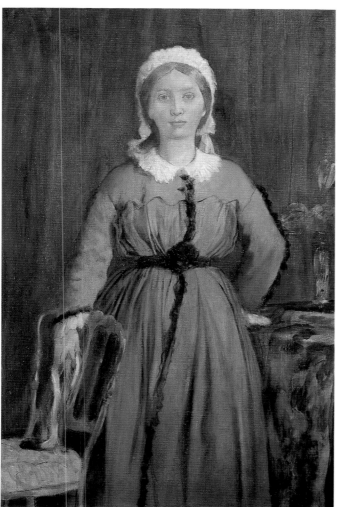

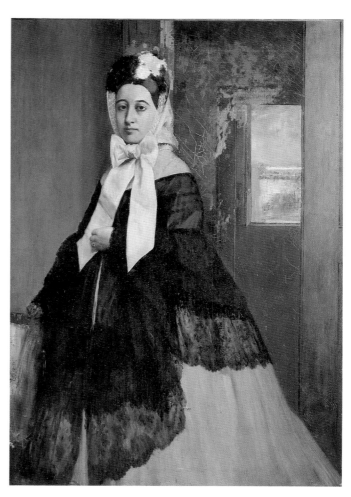

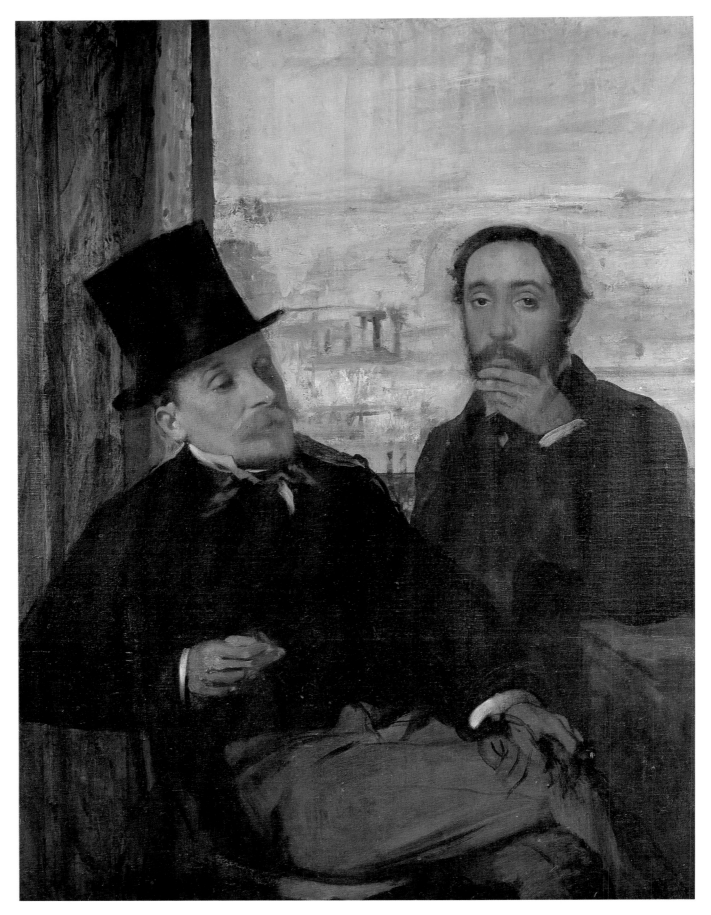

EDGAR DEGAS
*Degas and Evariste de Valernes (1816–1896), Painter and Friend of the
Artist*, ca. 1865
3′ 9¾″ x 2′ 11″ (116 x 89 cm) Gift of Gabriel Fèvre, 1931. RF 3586

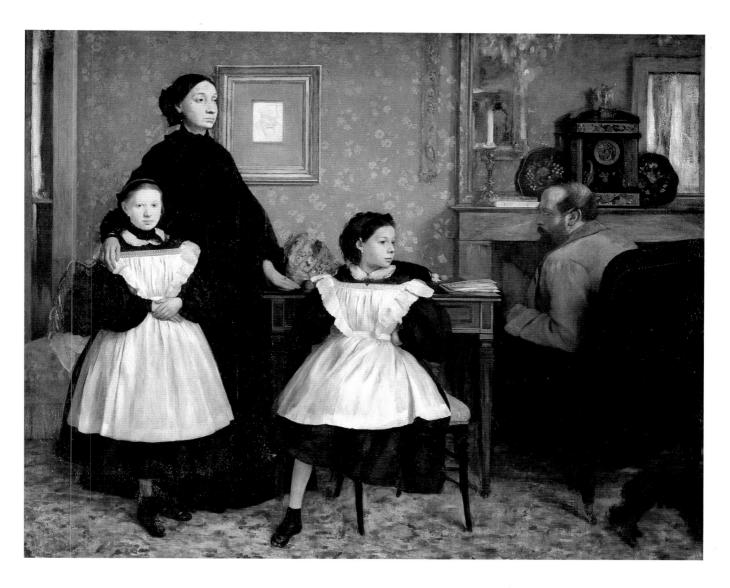

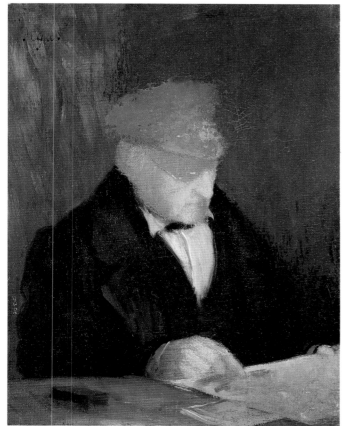

EDGAR DEGAS, Paris 1834–Paris 1917
Family Portrait (or The Bellelli Family), 1858–1860 (Salon of 1867)
6′ 6¾″ x 8′ 2½″ (200 x 250 cm) RF 2210

EDGAR DEGAS
Hilaire de Gas (1770–1858), 1857
10¼″ x 7¾″ (26 x 20 cm) Gift of Mr. and Mrs. Arnold S. Askin,
1981. RF 1981-35

page 213, clockwise from top left
EDGAR DEGAS
Self-Portrait, ca. 1855
2′ 8″ x 2′ 1½″ (81 x 64.5 cm) RF 2649

EDGAR DEGAS
Hilaire de Gas, 1857
1′ 8¾″ x 1′ 4¼″ (53 x 41 cm) Gift of Société des Amis du Louvre,
1932. RF 3661

EDGAR DEGAS
Thérèse de Gas (1840–1912), the Artist's Sister, ca. 1863
2′ 11″ x 2′ 2½″ (89 x 67 cm) RF 2650

EDGAR DEGAS
Marguerite de Gas (1842–1895), the Artist's Sister, 1858–1860
2′ 7½″ x 1′ 9¼″ (80 x 54 cm) RF 3585

Scene of War in the Middle Ages

*A*lmost everything about this painting continues to baffle sensible interpretation. For most spectators, Degas is so firmly rooted in modern life that the very existence of this canvas (with fifteenth-century costumes and a Gothic church on the horizon) is startling. Nevertheless, this unexpected excursion to the Middle Ages is the climax of a long series of early history paintings by Degas that includes not only scenes from Plutarch and the Bible but a huge canvas, also at Orsay, that would evoke Queen Semiramis surveying the construction of the ancient city of Babylon on the banks of the Euphrates. But unlike that misty scene of remote reverie and empire building, this pageant of medieval warfare is a frieze of bizarre violence and sex, which, when exhibited at the Salon of 1865, provoked no criticism, suggesting it was as confusing or embarrassing then as now. A fascinating hypothesis may open one vista onto the painting, namely, that it was originally inspired by accounts of unusual cruelty to women in New Orleans in 1862, after that city was captured during the Civil War by Northern troops. Such reports would surely have concerned the artist, since his mother's family was there. Indeed, the painting was once mistitled *The Miseries of the City of Orleans,* perhaps an accidental conflation of the old French and the new American city.

But as a document of either medieval or modern warfare, Degas's painting is bewildering. There seem to be only two male aggressors: the figure aiming with bow and arrow at the fleeing naked women, and the one cropped at the right who is carrying off another naked victim on horseback; neither of these men seems particularly violent, except in deed. By contrast, the naked women—some apparently dead, others raped, others running—look agonized, like the souls of the damned in a Last Judgment. Moreover, the scale of the figures is disturbing, with the desperately humiliated nudes at the left uncannily small. Considering that the landscape represents a sweeping panorama of scorched earth and leafless trees, the space is oddly contracted, so that we tend to read all the figures as a silhouetted frieze against a high horizon.

What does register unambiguously is Degas's strangely personal exploration of a kind of voluptuous sadism, perhaps as much part of a private psychodrama as Cézanne's own early scenes of temptation (page 241). Inspiration here may have come from such polar opposites as two masterpieces that appeared in 1863: Ingres's *Turkish Bath* and the first publication of Goya's *Disasters of War* in a complete edition. Ingres's proliferation of writhing nudes, with their ambiguous fusion of near and far, in addition to Goya's hideous inventory of physical and sexual violence to women, may well have triggered Degas's own perverse combination of agonized yet fully eroticized female martyrs.

As grist for the many mills of interpretation that would explore Degas's often diagnosed misogyny and warped sexuality, this painting is a key early document. But it is also a painting that in more conventionally dramatic form intersects and prophesies an abundance of motifs and formal devices that the artist would explore. The audacious cropping of the horseman on the right and the general friezelike rhythm of profiled horses transport to the Middle Ages those scenes of modern Parisian racetracks Degas began to paint in the early 1860s (pages 334 and 335); and the centrifugal structure of figures looking off in opposite directions, leaving a tense void between them, is matched even in static portraits of the same decade (page 219). But more remarkable, the anthology here of unexpectedly intimate and oblique views of naked women—prepared in countless pencil drawings of at times almost gynecological candor—announces Degas's full-scale visual assault on the female nude in his brothel scenes and bathers of the 1880s (pages 344 to 347).

facing page, top
EDGAR DEGAS
Scene of War in the Middle Ages, 1865 (Salon of 1865)
2' 8" x 4' 9¾" (81 x 147 cm) RF 2208

facing page, bottom
EDGAR DEGAS
Semiramis Building Babylon, 1861
4' 11½" x 8' 5½" (151 x 258 cm) RF 2207

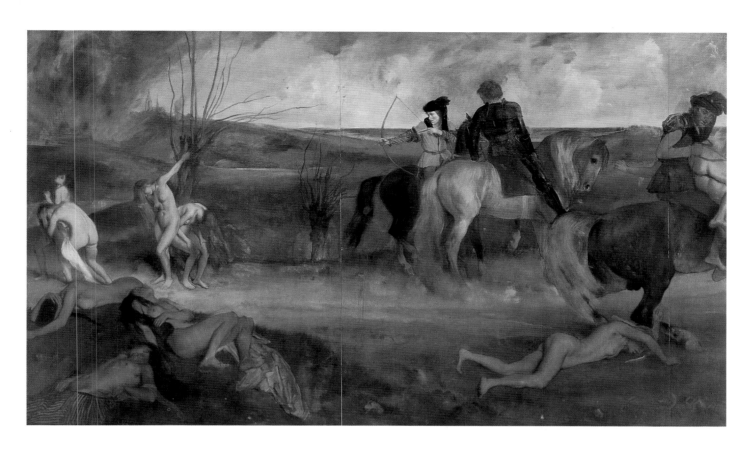

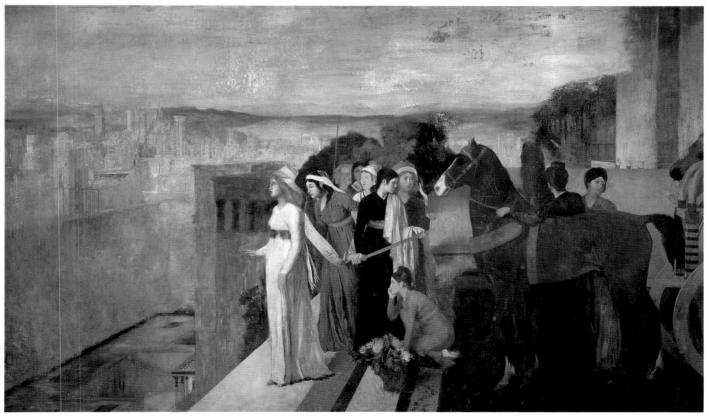

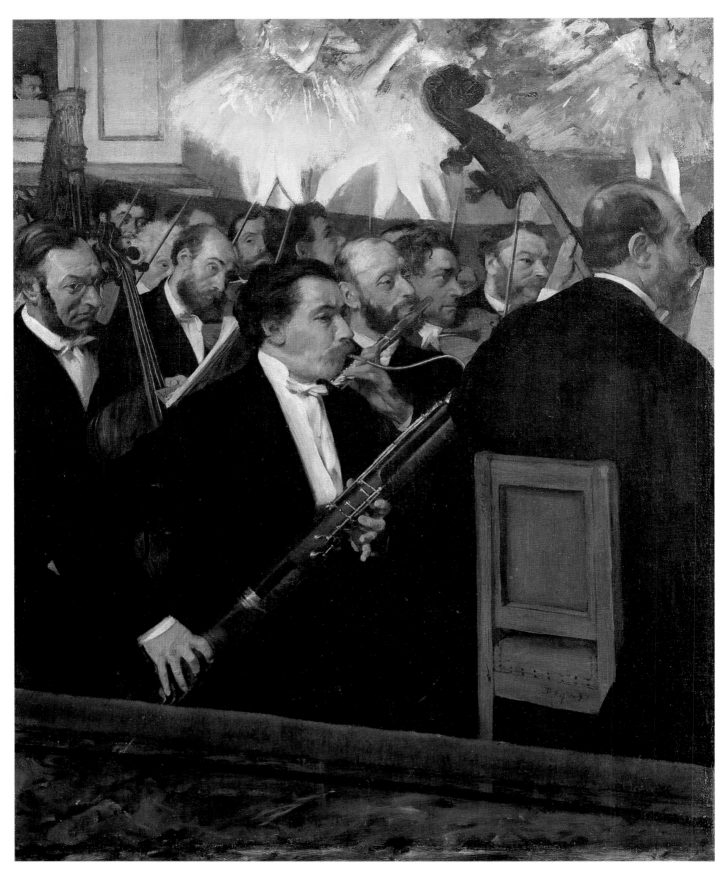

EDGAR DEGAS
The Orchestra of the Opéra, ca. 1868–1869
1′ 10¼″ x 1′ 6″ (56.5 x 46 cm) RF 2417

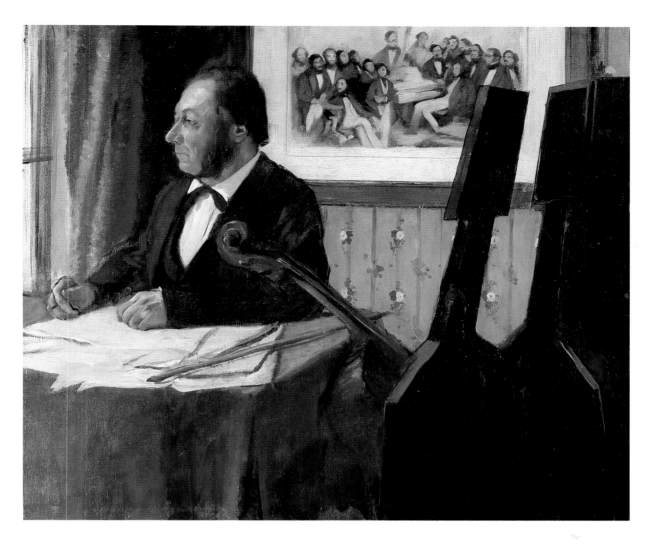

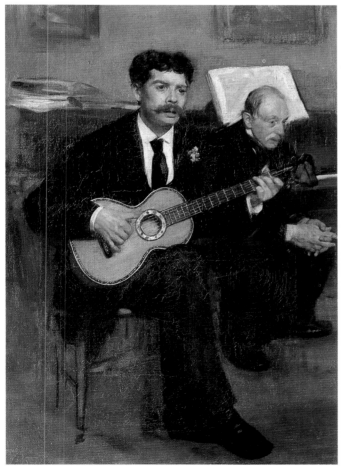

BAZILLE AND THE EARLY RENOIR

Auguste Renoir
Frédéric Bazille

For an on-the-spot glimpse of the camaraderie that grew among a circle of young artists of the 1860s associated with the early years of Impressionism—Sisley, Monet, Renoir, and Bazille—this portrait could not be bettered. It depicts Renoir's twenty-six-year-old friend (and fellow student, with Monet, at Gleyre's academy), Frédéric Bazille, hard at work on a still life in the Flemish tradition of depicting a variety of dead birds: here some jackdaws and a heron with wings spread wide. Countering Courbet's egocentric and grandiose image of the worldly artist in his studio, surrounded by a model and an inventory of his own work and inspiration (page 152), Renoir gives us almost a keyhole view of the tall and lanky Bazille, who seems to be cramped in this restricted space. Relaxed in scruffy slippers and a loose-fitting jacket, he leans over his canvas attentively, brush in hand, offering the illusion of being completely unaware that he is being watched, least of all painted, by his friend and exact contemporary Renoir. To add to this sense of a close and utterly informal fraternity, the snowscape just visible on the wall behind Bazille's head is by Monet; and we know, too, that Sisley painted the same still life of dead birds that Bazille is working on here. We also know that Bazille, in turn, would paint the most casual portrait of Renoir, both feet up on a chair, as well as of Sisley. All of this picture-making took place in 1867, and in this portrait we sense the exploration at this moment of an art that would drop all pretense of the composed and preordained in favor of an intimate, snapshot fidelity to the most commonplace, forgettable facts of daily experience.

To do this, however, involved an equally calculated artifice, that of the willfully casual and accidental. Renoir learned here, for instance, the importance of seemingly random cropping (the painting on the easel, the chairback) and of relaxed, unposed postures (the crossed feet). Such perceptions of uneventful reality would be elevated by the Impressionists into a potent style that could undermine the tyranny of conventional pictorial order. Appropriately, this portrait was included, nine years later, in the second Impressionist exhibition of 1876, where it also must have served as a poignant memorial to the sitter, who had been killed in 1870 in the Franco-Prussian War.

Manet was the first owner of this portrait, which may have attracted him because its grayish-white and black tonalities (accented by the single stripe of red on the slipper) recalled his own work. In its almost Spanish sobriety, this early Renoir seems a far cry from the tropical hothouse of color that would distinguish the artist's palette from the 1870s on.

FRÉDÉRIC BAZILLE, Montpellier 1841–Beaune-la-Rolande 1870
Portrait of Pierre-Auguste Renoir, 1867
3' 1" x 2' 8⅓" (122 x 107 cm) DL 1970-3

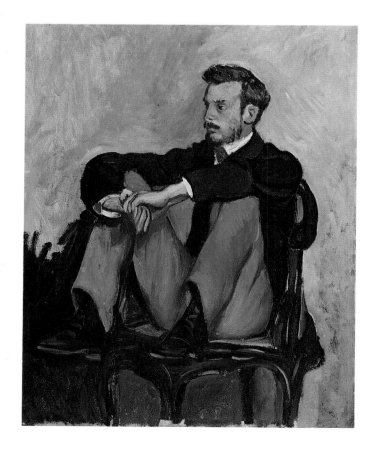

facing page
AUGUSTE RENOIR, Limoges 1841–Cagnes-sur-Mer 1919
Frédéric Bazille, 1867
3' 5¼" x 2' 5¾" (105 x 75.5 cm) Bequest of Marc Bazille, 1924. RF 2448

page 222
AUGUSTE RENOIR
Mme. Théodore Charpentier, ca. 1869
1' 6" x 1' 3¼" (46 x 39 cm) Gift of François Le Coeur, 1924. RF 2741

page 223
AUGUSTE RENOIR
William Sisley, 1864 (Salon of 1865)
2' 8" x 2' 1¾" (81.5 x 65.5 cm) RF 1952-3

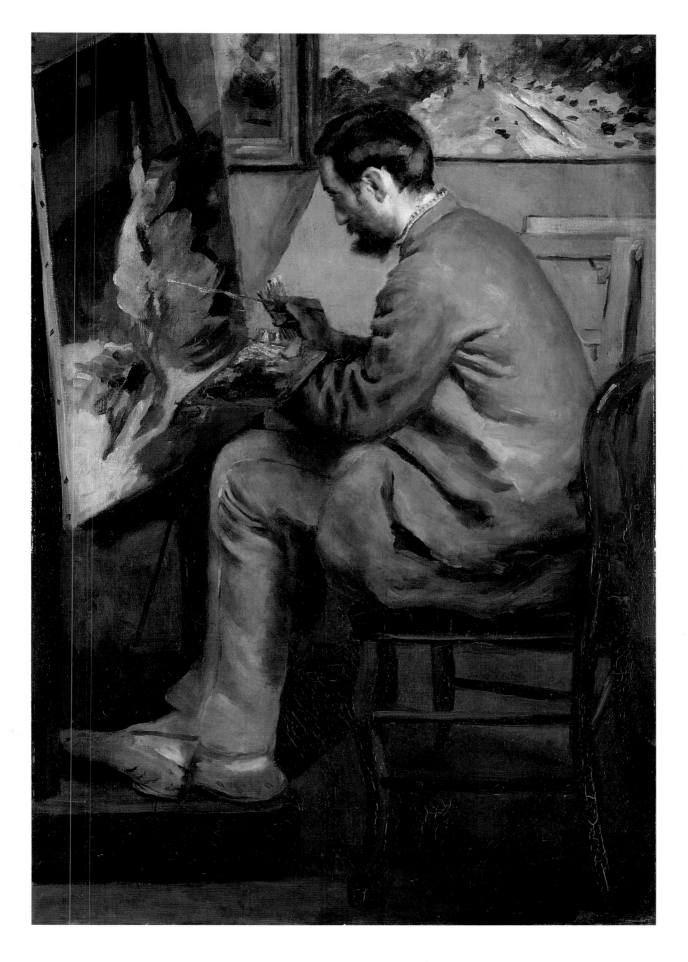

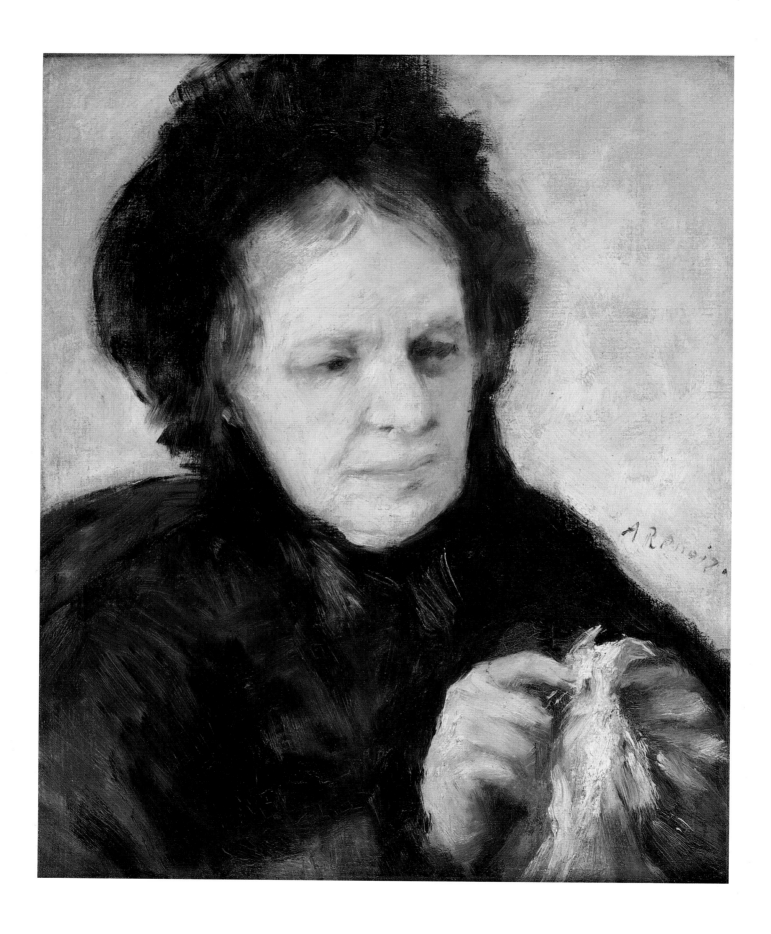

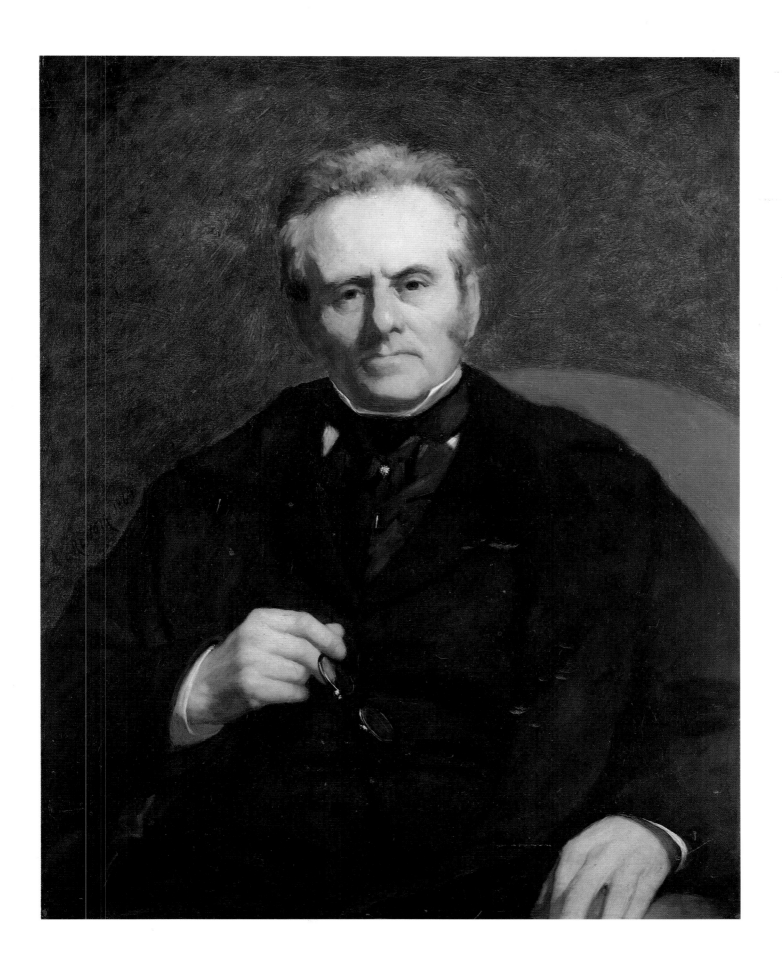

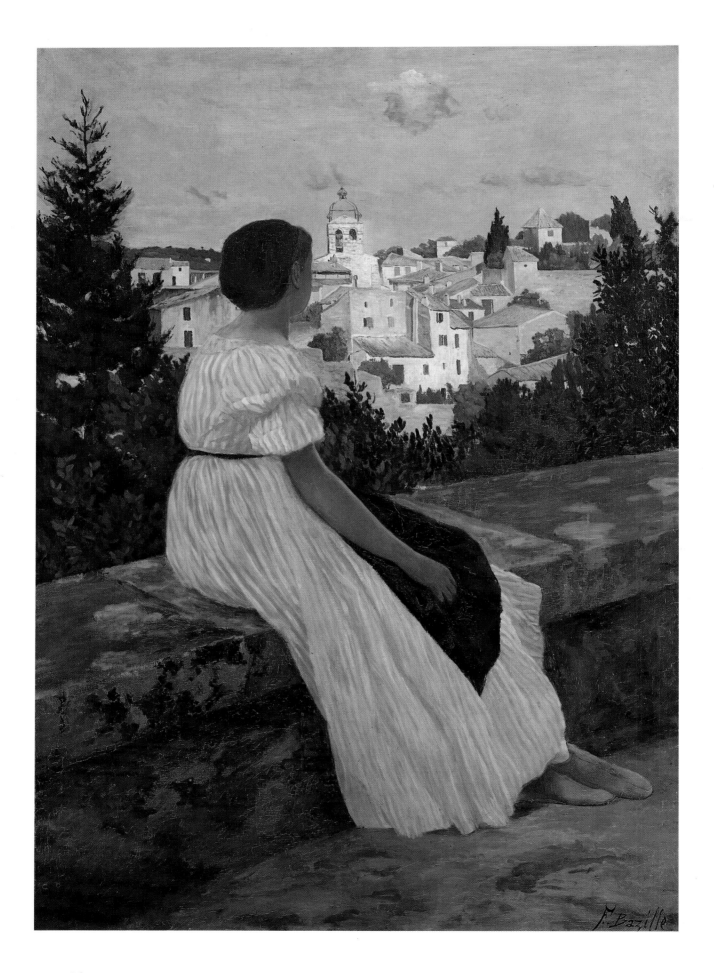

Frédéric Bazille
The Pink Dress

*T*hroughout the 1860s, the once clear dividing lines between traditional categories—still life, portrait, landscape, genre—kept blurring in the hands of younger artists who were fascinated by the accidental juxtapositions we know from the real world rather than from museum conventions. The mixture of figure and landscape, with neither dominating, was a special challenge in these efforts to join two kinds of experience in a single field of vision. It was one brilliantly explored by the precocious Bazille, whose career was cut short on the battlefront of the Franco-Prussian War in 1870, just weeks before his twenty-ninth birthday.

In 1864, when he and Monet often painted together, he could already offer an adventurous hybrid, *The Pink Dress*, in which we shift back and forth between a large figure, who dominates the foreground, and the distant vista. The nominal subject is a woman in a summery pink-striped dress, who happens to be the artist's cousin, Thérèse des Hours, who turns her back toward us, momentarily hiding her face. The view she seems to be enjoying is that of the hill town of Castelnau-le-Lez, near Montpellier, as seen from the terrace of Bazille's family estate. His cousin would later reappear there in a painting of 1867 that assembles the family clan in a relaxed, outdoor group portrait (page 227). The either/or situation is worthy of Degas, obliging us first to consider the full-scale expanse of the pink dress, which offers a luminous, cooling respite in this sunbaked region of Southwest France but then abruptly invites us to redirect our focus to the picturesque pile of clustered buildings whose interlocking beige and gray planes seem to fall

halfway between Corot and Cubism. This jump between near and far, between a large figure who suggests a portrait set-up and a remote view that demands equal pictorial attention, is mediated by an effort to fuse these two visual worlds through color and brushwork. The blue of the southern sky seems to have infused the pink of the dress, just as the dappled light and shadow of the terrace ledge expand into the paint fabric across the valley that weaves the buildings together.

Such a beautiful wedding of figure and landscape might well have prompted Monet himself to attempt his still more ambitious variations on this emergent Impressionist theme—*Déjeuner sur l'Herbe* of 1865–1866 (page 202) and *Women in the Garden* of 1866–1867 (page 235)—paintings whose imposing size can even begin to edge into the conventions of grand-scale, multifigured history painting. It is also worth noting that regional flavors can be discerned within this expanding outdoor territory of sunlit figures. Monet, born in Le Havre and at home in Paris and the Ile-de-France, reflects a more transient, veiled northern light that can readily merge figures and landscape in a dappled whole, whereas Bazille, from the Southwest, near the Mediterranean, mirrors a more enduring, sturdy terrain, where the strong light defines rather than dissolves what we see. Here, as in Bazille's other paintings of his native soil, we feel an affinity with the figures and landscapes of nearby Provence, as recorded not only by such regional painters as Guigou (page 171) but by such universal masters as Cézanne.

facing page
FRÉDÉRIC BAZILLE
The Pink Dress, ca. 1864
4' 9¾" x 3' 7¼" (147 x 110 cm) Bequest of Marc Bazille, 1924.
RF 2722

FRÉDÉRIC BAZILLE
Forest of Fontainebleau, 1865
1' 11½" x 2' 4¾" (60 x 73 cm) Gift of Mrs. Fantin-Latour, 1905.
RF 2721

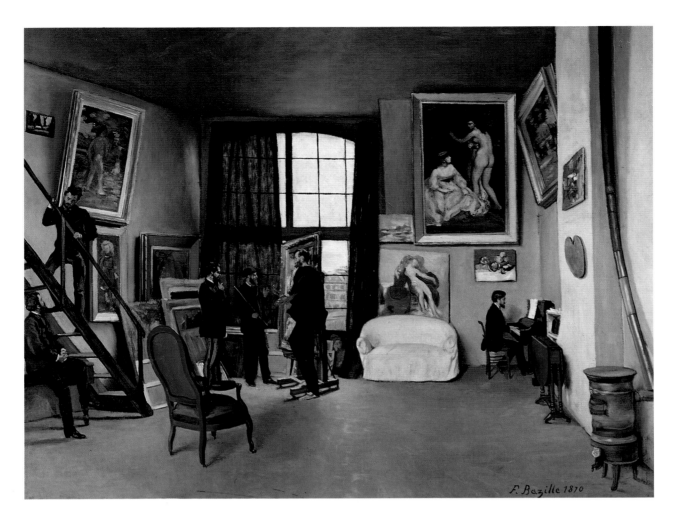

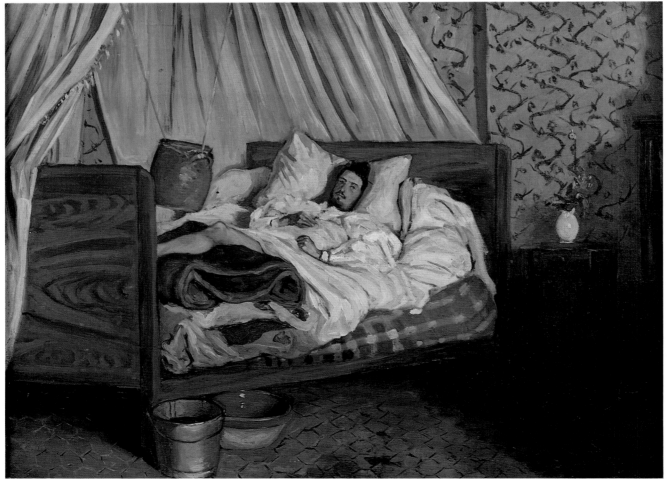

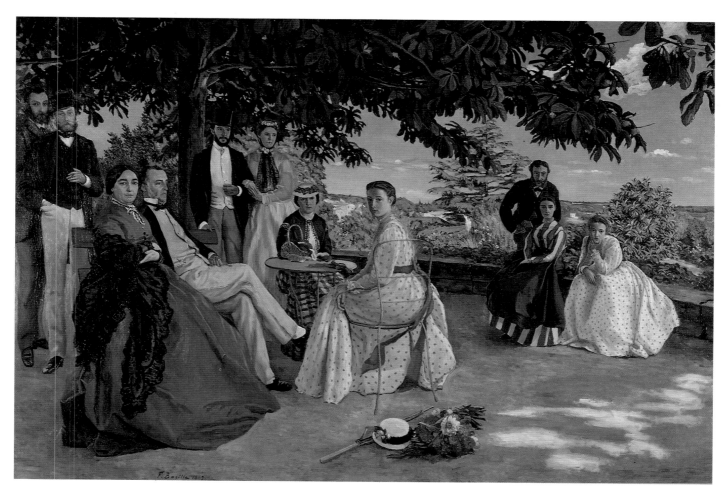

FRÉDÉRIC BAZILLE
Family Reunion, 1867 (Salon of 1868)
4′ 11¾″ x 7′ 6½″ (152 x 230 cm) RF 2749

facing page, top
FRÉDÉRIC BAZILLE
Bazille's Studio; 9 rue de la Condamine, 1870
3′ 2½″ x 4′ 2½″ (98 x 128.5 cm) Bequest of Marc Bazille, 1924.
RF 2449

facing page, bottom
FRÉDÉRIC BAZILLE
The Improvised Field-Hospital (Monet after his accident at the
Inn of Chailly), 1865
1′ 6½″ x 2′ 1½″ (47 x 65 cm) RF 1967-5

THE EARLY MONET

Garden in Bloom at Sainte-Adresse

*F*or most twentieth-century viewers, Monet's vision of nature has come to provide a verdant, dappled balm that can heal all urban wounds. For him and his contemporaries, however, things were more difficult, since he had first to invent a pictorial shorthand that could begin to match his fugitive perceptions of intense color and vibrant light. And for how many viewers of the 1860s could such strange new marks of pigment on canvas be coherent and legible?

A perfect example of Monet's self-education is a view of a flowering garden in Sainte-Adresse, just north of the artist's birthplace, Le Havre, where each year his family spent the more clement months. What is seen could hardly be more modest and casual: a small corner of a large garden, cropped at both sides by trees; a glimpse of the adjacent house concealed in good part by foliage; and, above, a summery fragment of blue sky. The first effect is of an accidental snapshot of a much broader continuum, in which the garden, like the house and sky, might run on in every direction. Our expectation of structural order, where major and minor are distinguished, where edges are carefully framed, is instantly challenged. Still more disconcerting is the application of paint and the brilliance of hue, which, for eyes used to the more modulated tonalities and finished details of, say, landscapes by Corot and the Barbizon school, must have presented a shrill and raw surface. But Monet has set out to explore a language that could seize immediate sensations on the wing, like a rapid sketch. To do this, he follows no formula, only a flexible variety of experimental instincts.

The sky, an uncommonly clear blue, is laid on in broad, horizontal strokes that at first create an almost flat, opaque plane of color. Yet he has also been observant enough to suggest, through the thinnest filter of white brushstrokes, the presence of the clouds so common in the skies over the Channel coast. As for the house, its more foursquare, earthbound character is also matched by the brushstroke, which underscores the rectilinear planes of walls, shutters, and windows, looking almost indistinguishable from a fresh coat of thick paint applied to the house itself.

The garden, however, demands an altogether different touch. For the grass in the foreground, half covered by shadow, the brushwork is broad and ragged, almost the equivalent of something trampled underfoot. The geraniums, on the contrary, are sparkling and buoyant, small flecks of intense white, red, and pink that seem to have been dabbed onto the canvas with such speed that they capture the effervescence of bloom. In fact, their swift cycle of growth is even suggested by the confetti-like sprinkle of petals that have just fallen, it appears, on the earth below. Determined to capture the ephemeral sensations of the sunlit world, Monet has dared to abbreviate and to distill the language of painting, creating a sketchlike immediacy and vitality that, if coarse and illegible to most viewers of the 1860s and 1870s, would eventually become a pictorial lingua franca, communicating its life-enhancing message to vast popular audiences.

Thanks to the often-repeated characterization of Monet as a painter who focused exclusively on recording the constant palpitation of colored light, too little has been made of the new kinds of control and artifice he had to invent in the 1860s in order to give his canvases coherence. Zola put his finger on something when, in an 1868 review, he described Monet as intensely urban and Parisian, attracted to scenes where the civilizing hand of man could be discerned. "As for the countryside," Zola wrote, "he prefers an English garden to a forest retreat"—a contrast that might be borne out by comparing this painting with Rousseau's secluded woods of 1849 (page 111). "He seems to lose interest in nature," the author concluded, "as soon as it no longer bears the stamp of our mores."

Although this generalization was often belied in Monet's later work, it holds true in the 1860s. The garden here could not be more carefully cultivated and pruned, with the geranium plants and trees carefully regimented. Even the staccato brilliance of the floral fireworks is grounded by a quietly sturdy structure that Monet has extracted from the underlying perpendicular order of earth, house, tree, and sky. It was part of his genius that he learned to evoke an unforced clarity without violating the tonic impression of an instant, unedited embrace of the seen world.

facing page
CLAUDE MONET
Garden in Bloom at Sainte-Adresse, ca. 1866
2′ 1½″ x 1′ 9¼″ (65 x 54 cm) MNR 216

pages 230 and 231
CLAUDE MONET
Garden in Bloom at Saint-Adresse, detail

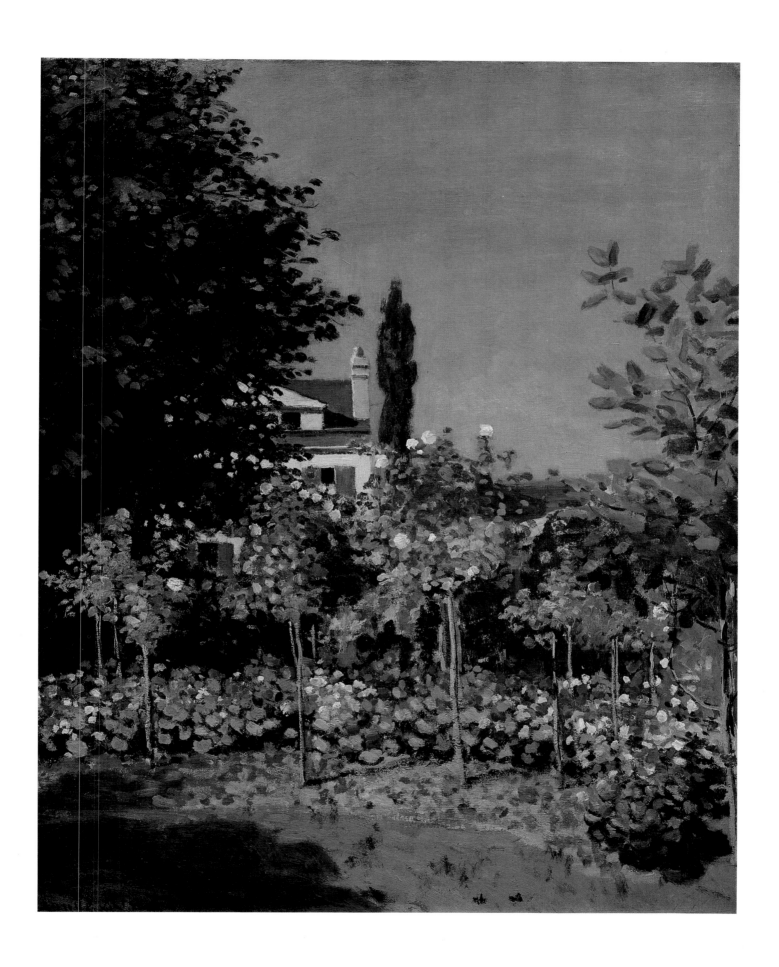

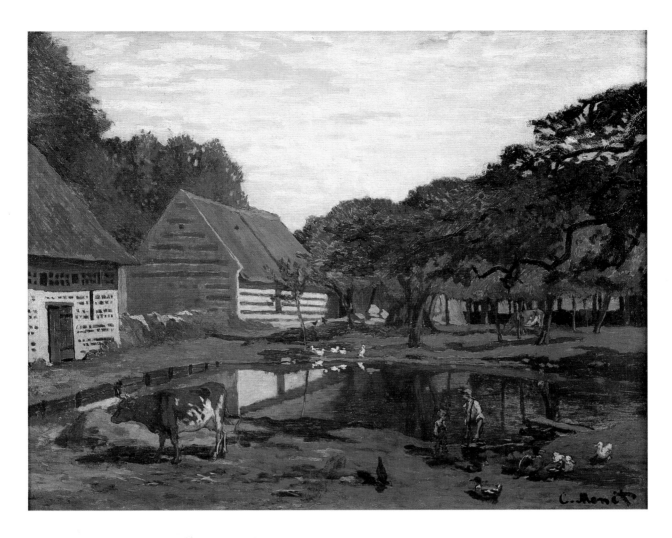

CLAUDE MONET
Farm Courtyard in Normandy, ca. 1863
2′ 1½″ x 2′ 8″ (65 x 81.5 cm) Bequest of Mr. and Mrs.
Raymond Koechlin, 1931. RF 3703

CLAUDE MONET
Studio Corner, 1861
5′ 11¾″ x 4′ 2″ (182 x 127 cm) MNR 136

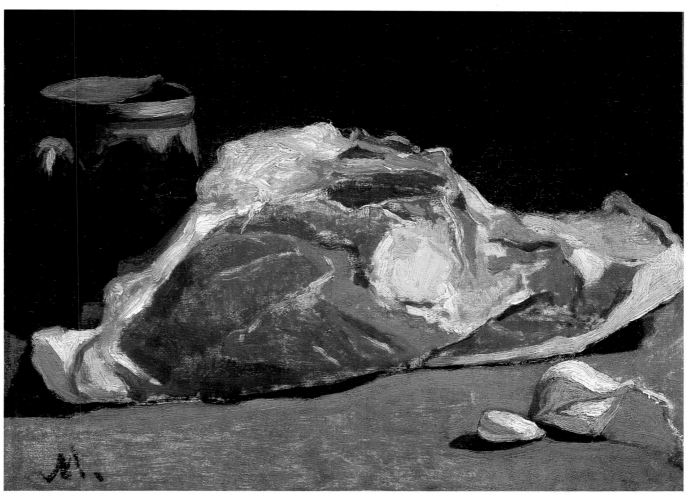

CLAUDE MONET
Hunting Trophy, 1862
3′ 5″ x 2′ 5½″ (104 x 75 cm) MNR 213

CLAUDE MONET
Still Life; Piece of Beef, ca. 1864
9½″ x 1′ 1″ (24 x 33 cm) Gift of Étienne Moreau-Nélation, 1906.
RF 1675

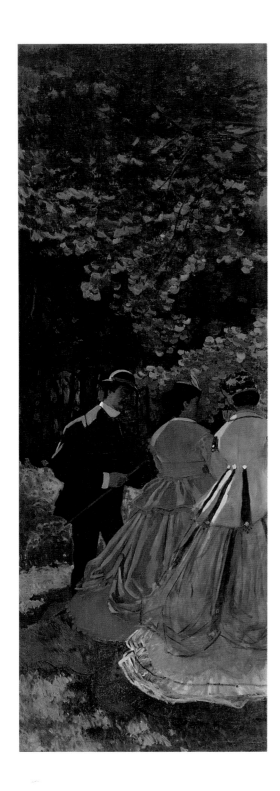

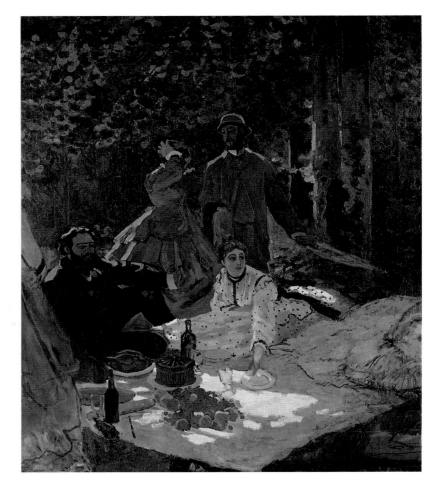

CLAUDE MONET
Déjeuner sur l'herbe (The Picnic), 1865–1866
Left fragment, 13′ 8½″ x 4′ 11″ (418 x 150 cm) Gift of
Georges Wildenstein, 1957. RF 1957-7

CLAUDE MONET
Déjeuner sur l'herbe (The Picnic), 1865–1866
Right fragment, 6′ 3½″ x 5′ 6″ (248 x 217 cm) Gift of
Georges Wildenstein, 1957. RF 1957-7

facing page
CLAUDE MONET, Paris 1840–Giverny 1926
Women in the Garden, 1866–1867
8′ 4½″ x 6′ 8¼″ (255 x 205 cm) RF 2773

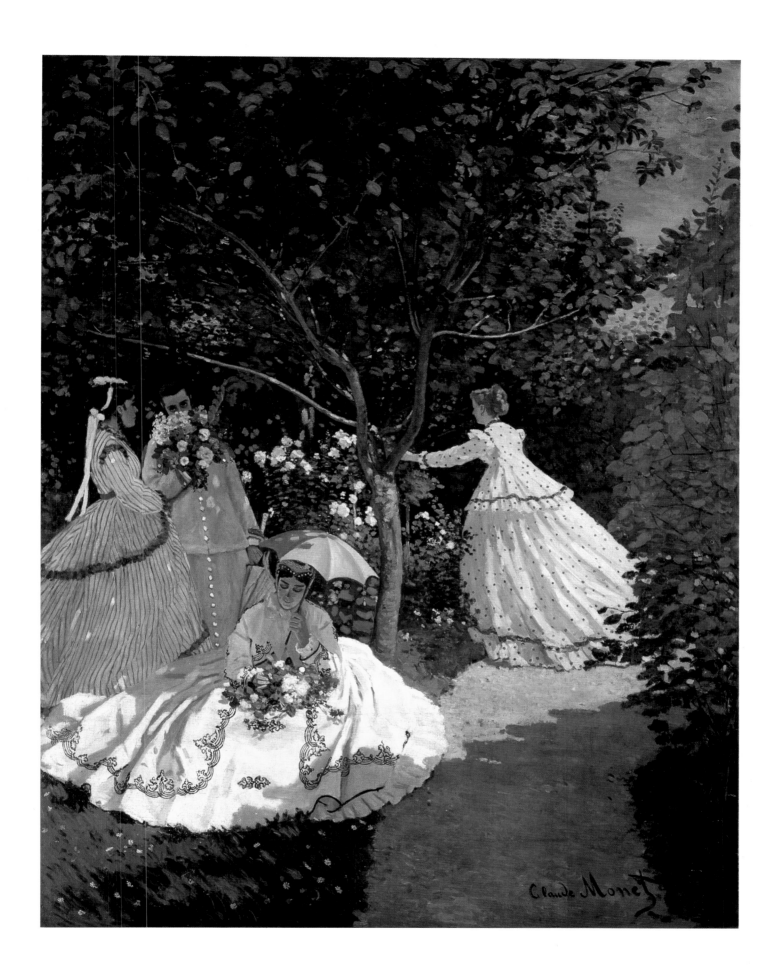

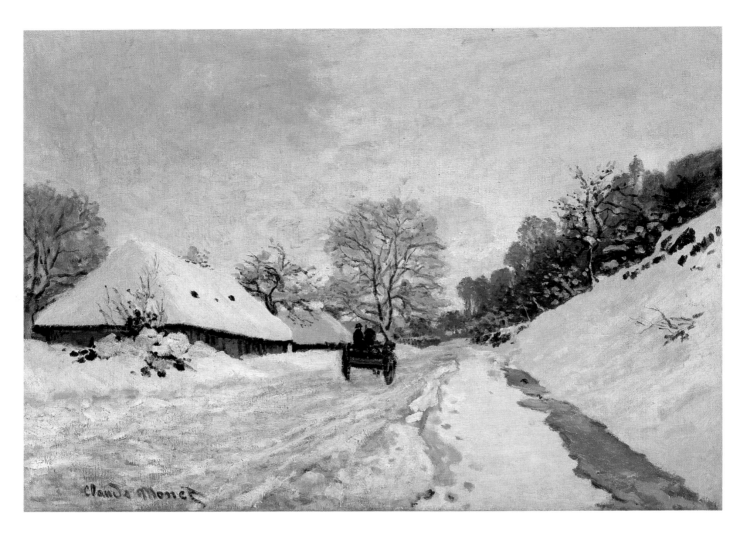

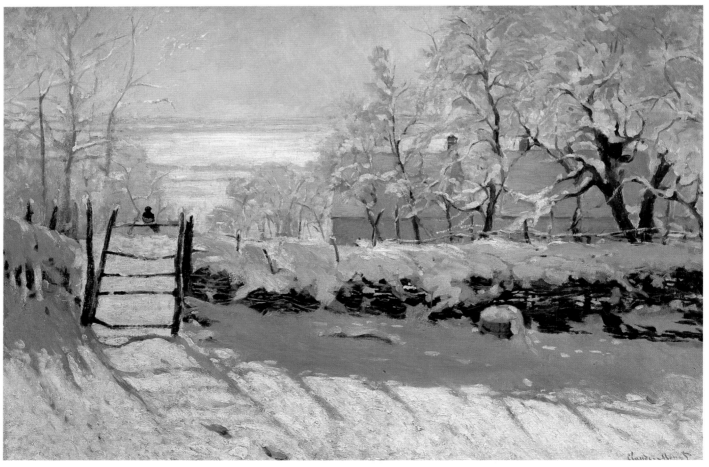

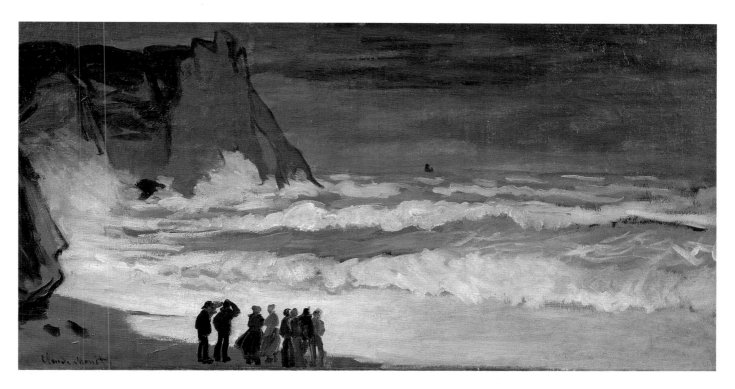

CLAUDE MONET
Rough Sea at Étretat, ca. 1868–1869
2′ 2″ x 4′ 3½″ (66 x 131 cm) Gift of Étienne Moreau-Nélaton, 1906.
RF 1678

facing page, top
CLAUDE MONET
The Cart; Snow-Covered Road at Honfleur, with Saint-Simeon Farm,
ca. 1867
1′ 1½″ x 3′ (65 x 92.5 cm) Bequest of Count Isaac de Camondo, 1911.
RF 2011

facing page, bottom
CLAUDE MONET
The Magpie, ca. 1868–1869
2′ 11″ x 4′ 3¼″ (89 x 130 cm) RF 1984-164

Mme. Louis Joachim Gaudibert

*A*lthough popular myths would cast Monet in the role of an alienated, one-track genius, heroically working against the grain of the establishment (a generalization, like most generalizations, that is in good part true), he was also capable of accommodating his art to the prevailing standards of officialdom. In 1866, at a time when he was exploring dazzling new techniques of painting landscape outdoors (page 229), he had made a successful dent at the Salon with a stylish portrait of his wife-to-be, Camille, in a modish dress and fur-trimmed jacket befitting a chic Parisienne. In 1867 he had fallen on harder times. His startling and ambitious plein-air painting *Women in the Garden* (page 235) had been rejected by the 1867 Salon jury; Camille was pregnant; and he was virtually a pauper, pathetically dependent on his family. By 1868, he could even write to Bazille that he had attempted suicide. It was a wealthy friend and patron, Louis Joachim Gaudibert, a shipowner from Monet's native Le Havre, who came to his rescue with, among other things, commissions for two portraits of himself (both lost) and one of his wife, Marguerite. She was only twenty-four in 1868, but in Monet's portrait has the bearing of a considerably older woman.

We, in fact, see little of her face, which is momentarily turned away from us in what was called a *profil perdu*, a lost profile—a glimpse of a fleeting gesture common in Rococo painting and freshly explored in the world of Impressionism. A sense of the moment, too, is rendered in the way Mme. Gaudibert adjusts her gloved right hand. But these quivers of the ephemeral are balanced by an elegantly studied concession to Second Empire ideals of fashionable portraiture, of which Carolus-Duran's depiction of his wife, shown the following year at the Salon (page 65), provides the clearest statement. In establishing such a dialogue with the most conservative conventions of the Salon, Monet's portrait offers yet another example of the many shades of gray that exist between the black and white polarities traditionally associated with conservatives versus rebels in the battle of modern art.

Nevertheless, Monet's portrait, for all its conformity to official formulas of elegant posture and display, belongs to another pictorial realm. By academic standards, the colors are of a startling flatness and clarity, even if their range is discreetly muted to make a powdery pastel harmony of pale blue curtain, pink roses, and beige dress. The brushwork, though slower and less conspicuous than the speckled dabs of high-keyed pigment that sparkle over the rejected *Women in the Garden*, takes certain risks of swift abbreviation in the description of the complex folds of the copious train. And substantial as Mme. Gaudibert may at first appear in the full volume of her costumed body, the high tilt of the floor—with its discreet floral patterns that offer the flat, artificial equivalent of the real still life on the table at the right—contributes, as does the equally flattened plane of the curtained wall, to that pursuit of buoyant weightlessness familiar in even the most studied outdoor paintings of the 1860s, such as Monet's fragmented *Déjeuner sur l'herbe* (page 234). The more we look, the more the components of period-piece portraiture and fashion recede in favor of what becomes an imposingly beautiful painting by Monet. Here was an artist who could fuse all the disparate luxuries of Second Empire costume and decor into a pictorial harmony that transcends time, place, and person.

facing page
CLAUDE MONET
Mme. Louis Joachim Gaudibert, 1868
7′ 1½″ x 4′ 6½″ (217 x 138.5 cm) RF 1951-20

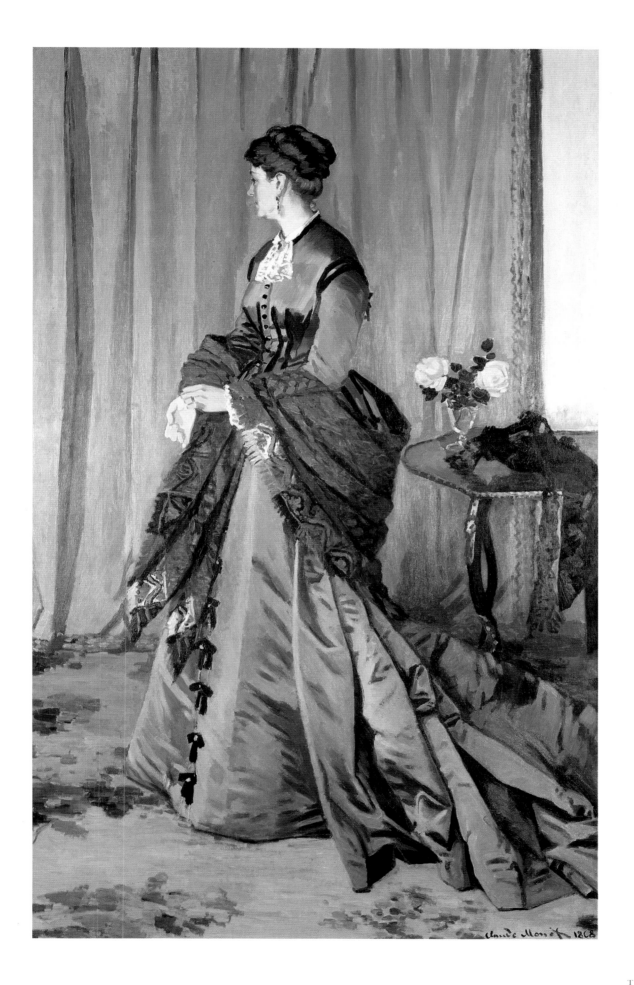

THE EARLY CÉZANNE

Pastoral (Idyll)

Cézanne's *Pastoral* (also titled *Idyll*) is anything but pastoral or idyllic. Although painted in his thirty-first year, it suggests, as do many of his works of the 1860s, the erotic imagination of a turbulent adolescent haunted by guilt-ridden dreams of sexual encounters in remote places. Its charged, autobiographical message is centerstage, a barely disguised self-portrait of the artist looking, as usual, prematurely bald and old. Head on hand, reclining in a languorous posture that recalls Delacroix's *Sardanapalus* directing an operatic spectacle of female carnage, the artist here seems to be inventing his own voluptuous scenario. He is accompanied by two other fully clothed but faceless men—a trio that seems almost a psychoanalytic resurfacing of Cézanne's youth in Aix-en-Provence, where he would bathe in the woods with his two teenage friends, the future writer Emile Zola and Baptistin Baillin, later to be a local scientist. Their pastime probably generated much pubescent talk about sex in the midst of a country idyll that Cézanne had actually illustrated in a drawing of the late 1850s. But here, luridly dramatized, Cézanne and his companions, much like St. Anthony, are tempted by wanton displays of female flesh. The legendary saint was the subject of Flaubert's novel, of such contemporary Salon paintings as that by Isabey of 1869 (page 50), and, even of works by Cézanne (page 355).

The intensely blue night sky, its white clouds reflected in equally blue waters, provides a mysterious nocturnal setting for this struggle. In fact, all three men appear both magnetized and repelled by their female counterparts. Cézanne himself both physically joins and turns his back from the nude who rises behind him; his foreground companion sits next to but faces away from the nude who slithers up to him; and, most conflicted, the frontal nude at the far left who reclines against a tree is polarized with her male counterpart at the far right who, his back to her and to us, seems ready to set sail to a different version of Cythera, the isle of love, on a boat whose hull bears the coarsely inscribed date, 1870. The overwrought sexual tension here is further strained by the tilting thrust of the frugal still life on the dark green shoreline: a glass and wine bottle that join forces with a tall tree and its reflection and seem to penetrate the heights of the dark sky.

That Cézanne's small painting can conjure up in its ancestry not only Manet's *Déjeuner sur l'herbe* (page 202) but also one of Manet's own Renaissance sources, the Louvre's *Concert Champêtre*, then ascribed to Giorgione, may give it the resonance of both a remote Venetian and a contemporary Parisian idyll of pastoral abandon. However, the almost nightmarish tumult of desire and repression here, underlined by the upheaving distortions of figure and landscape, transforms that tradition into a vehicle of wildly agitated personal anxieties, a precursor of Edvard Munch and German Expressionism. At the same time, Cézanne's urgent need for some kind of controlling visual order—the rhyming of the artist's body with the contours of the shore, the upward axial thrust of the wine bottle that fuses foreground and background, shadow and substance—announces what was soon to occur in his work. From the 1870s on, he concentrated more fully on inventing a pulsating but firm structure for figures, landscapes, and still lifes that might conquer, if not wholly submerge, the stormy undertow of private passion so explicitly expressed in his early work.

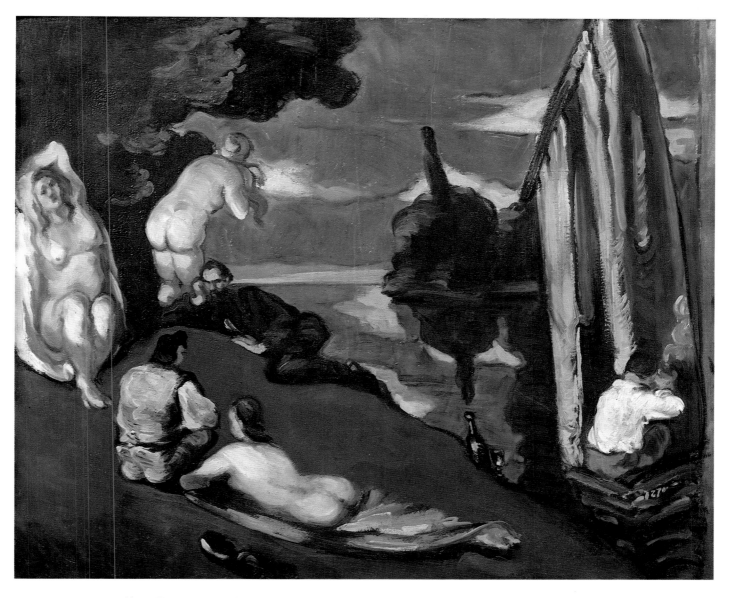

PAUL CÉZANNE, Aix-en-Provence 1839–Aix-en-Provence 1906
Pastoral (Idyll), ca. 1870
2′ 1½″ x 2′ 8″ (65 x 81 cm) RF 1982-48

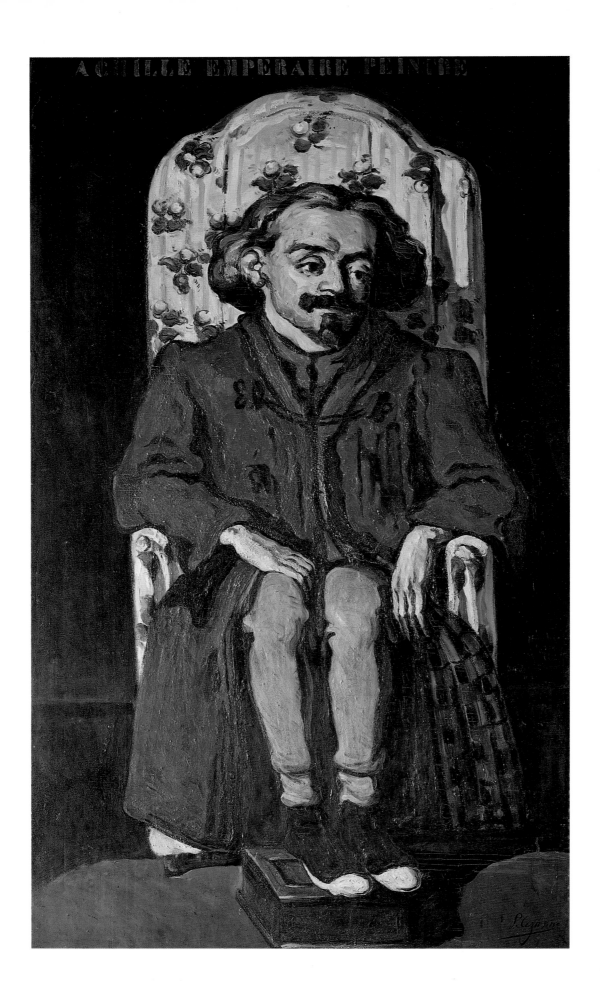

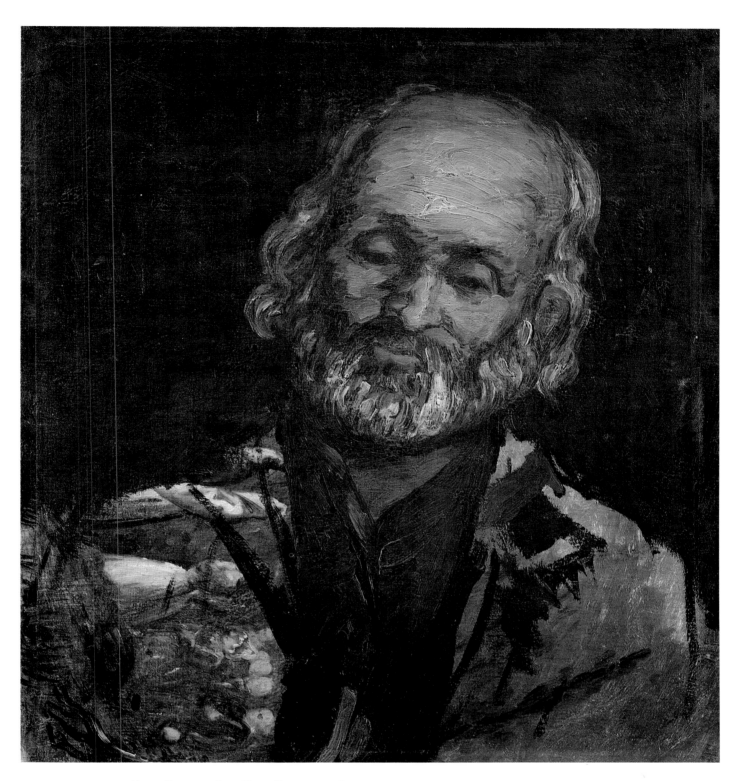

PAUL CÉZANNE, Aix-en-Provence 1839–Aix-en-Provence 1906
Head of an Old Man, ca. 1866
1′ 8″ x 1′ 7″ (51 x 48 cm) MNR 650

page 244
PAUL CÉZANNE
The Magdalen, or *Sorrow*, ca. 1868–1869
5′ 5″ x 4′ 1½″ (165 x 125.5 cm) Gift of an anonymous Canadian, 1952.
RF 1952-10

facing page
PAUL CÉZANNE
Achille Emperaire, ca. 1868
6′ 6¾″ x 4′ (200 x 122 cm) Gift of Mrs. René Lecomte and
Mrs. Louis de Chaisemartin, 1964. RF 1964-38

page 245
PAUL CÉZANNE
The Strangled Woman, 1872
1′ x 9¾″ (31 x 25 cm) Gift of Max and Rosy Kaganovitch, 1973.
RF 1973-11

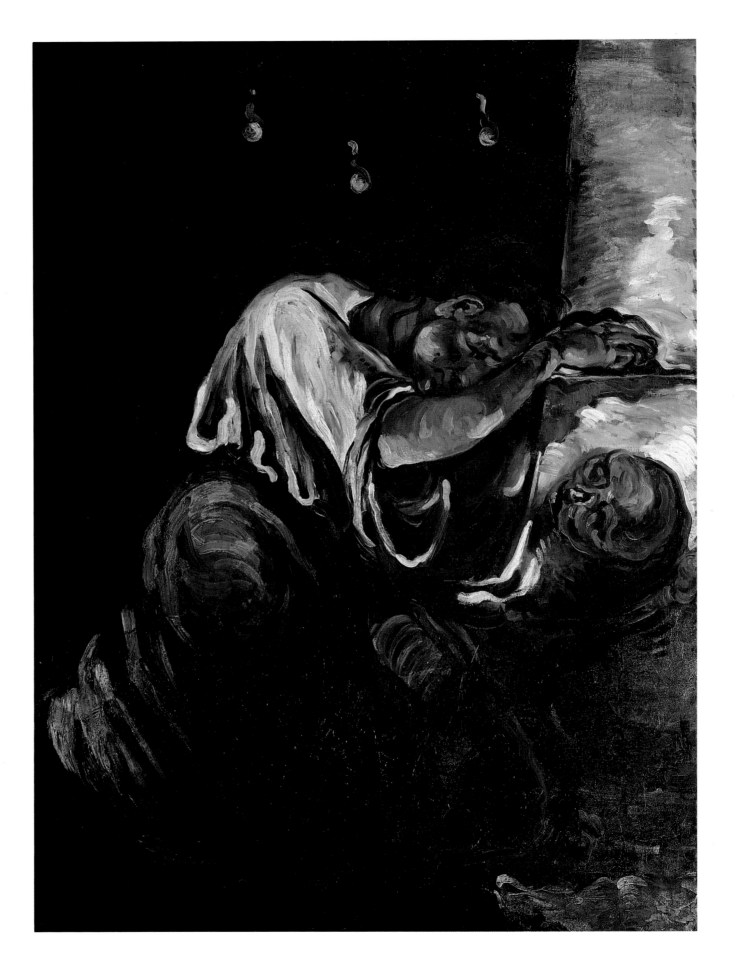

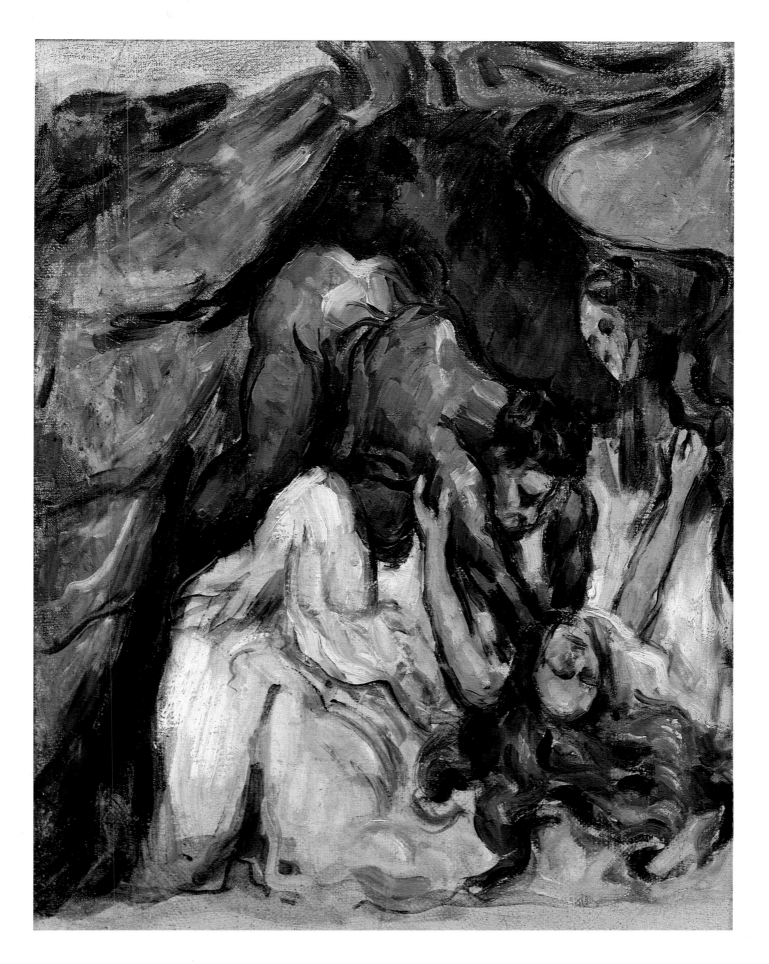

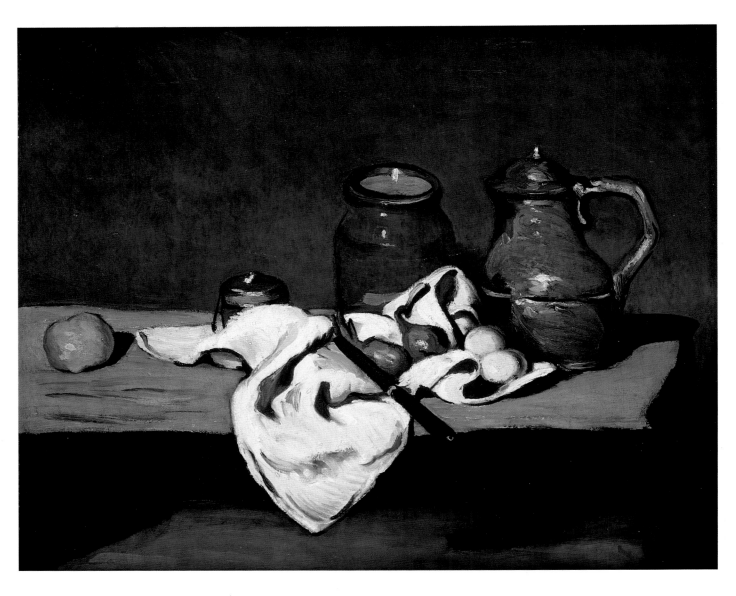

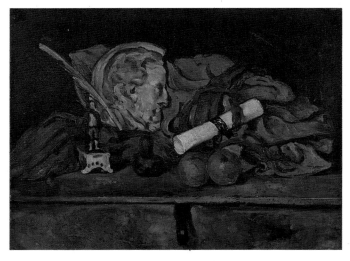

PAUL CÉZANNE
Still Life with Kettle, ca. 1869
2' 1½" x 2' 8" (64.5 x 81 cm) Gift of an anonymous Canadian, 1963.
RF 1964-37

PAUL CÉZANNE
Cézanne's Accessories; Still Life with Philippe Solari's Medallion, ca. 1873
1' 11½" x 2' 8" (60 x 81 cm) Gift of Paul Gachet, 1954. RF 1954-7

facing page
PAUL CÉZANNE
Dahlias, ca. 1875
2' 4¾" x 1' 9¼" (73 x 54 cm) Bequest of Count Isaac de Camondo,
1911. RF 1971

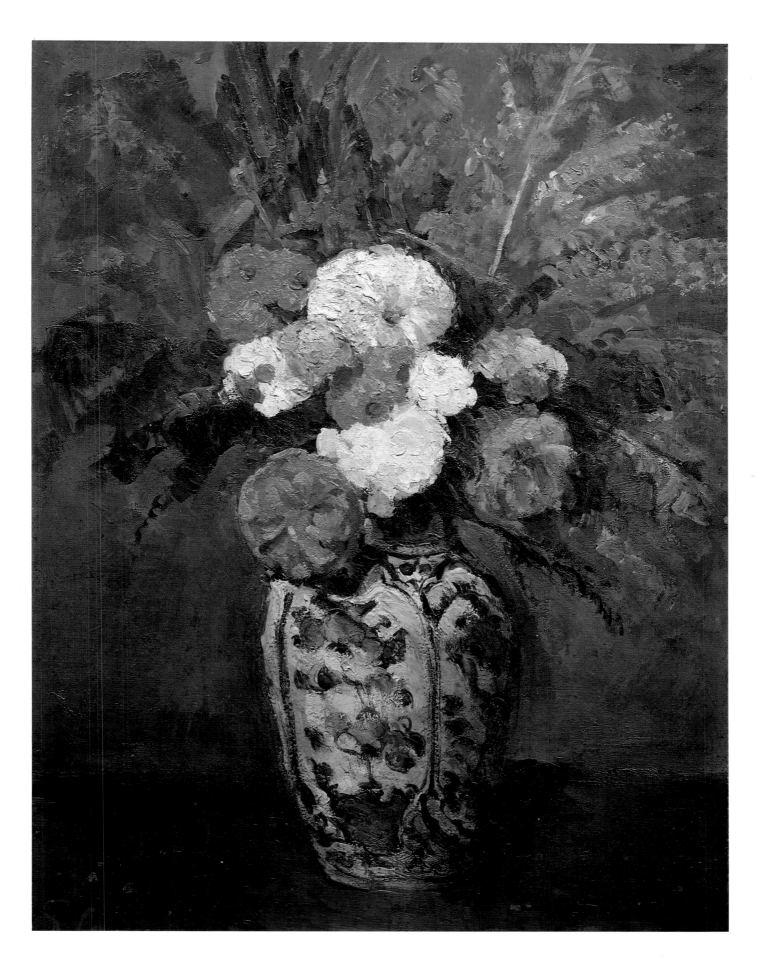

The Impressionist Decade

CLAUDE MONET *Rue Montorgueil, Paris. Festival of June 30, 1878*, detail

THE FRANCO-PRUSSIAN WAR AND THE MILITARY

Paris under Siege

To follow the course of Impressionism across the threshold of 1870-1871, one could scarcely guess that France in general, and Paris in particular, had been traumatized by a period of bloodshed, famine, national humiliation, and civil war. But these were the common denominators of those terrible months, officially beginning in July 1870 with the outbreak of the Franco-Prussian War and concluding, after France's rapid defeat and surrender in January 1871, with the stormy period of the Commune in Paris, an internecine conflict between left-wing forces and the government. By the end of May 1871, when the Commune was finally defeated, corpses had littered the streets; the Vendôme Column had been toppled; and in the heart of Paris the palace of the Tuileries had been burned to the ground, leaving a huge ruin as another wounding memory.

Most artists, whether geniuses or hacks, seemed to wear blinders to these events; several, like Bazille, died in battle; and many, like Monet and Pissarro, left the country. Others tried to respond, both sooner and later, in a remarkable variety of ways. Georges Clairin, a friend of Regnault's (who had been killed at the front in January 1871), made what looks like an on-the-spot documentary sketch of the fire at the Tuileries, an almost Impressionist fusion of smoke, clouds, rubble, and tattered flags (page 253). For others, like Meissonier, who had often painted Napoleonic battles (pages 60–61) and had already recorded the 1848 Revolution as a heap of dead Parisians in the barricades, this terrible year was an occasion to rekindle patriotic fires. In his small painted study, *The Siege of Paris* (page 252), signed and dated 1870 in the midst of the fighting, as it were, Meissonier offers an odd mix of the brutal facts of contemporary battle—an anthology of a fallen horse and of dead and dying officers who had attempted to resist the Prussian onslaught—with the conventional allegories of war. Above, a Prussian eagle and an allegory of famine hover like vultures. Below, the laurel branches of heroes are scattered among the military, while a triumphant symbol of the city of Paris—a courageous woman who wears a lion's-head helmet to convey her bellicose power—stands before a windswept and tattered, but firmly planted, tricolor. The combination of what looks, in its details, like a news photograph (the officers are identifiable portraits and the military costumes accurate to the button) and a resounding, even airborne, hymn to patriotic heavens defines the frequent

clash, in later nineteenth-century art, between the urge to document contemporary history and the need to interpret it with moribund allegories inherited from earlier centuries.

Such warring ambitions found a more original interpretation in an unusual pair of paintings by Puvis de Chavannes, *The Pigeon* and *The Balloon* (page 254). Emerging from his usual milieu of untroubled visions of archaic landscapes and cities (page 74), Puvis responded immediately to the Franco-Prussian War in his art. Here he has represented the city of Paris as a noble, steadfast woman wearing the black of mourning. Isolated and besieged, as was literally the condition of the great city beginning in September 1870, she is seen in one picture from the front and in the other from behind, communicating with the outside world by a balloon, which she sends off, and by a pigeon, which brings her news. In *The Pigeon*, we see Notre Dame and Sainte-Chapelle covered in the snow of the grim winter of 1870-71; in *The Balloon*, we see, on the far side of a remote view protected by cannons, Mont Valérien, the mountain on the outskirts of the city that had been fortified since the July Revolution of 1830. The chilly monochrome palette and stark black silhouettes gloomily underline the historical realities that prompted these melancholy meditations.

No less original, but replacing Puvis's reticent understatement with high melodrama, is an allegory of France's plight invented by Gustave Doré (page 255), whose earlier Dante illustrations (1861) must have served him well for this trip to a contemporary inferno. In his large painting of 1871, titled *The Enigma*, Doré spreads before us an apocalyptic vista of a blazing city and a devastated terrain littered with military and civilian corpses. In its dark and stormy midst, a barely visible winged and weeping woman, evoking the French nation, desperately questions a sphinx, hoping to find some explanation for the universal void and horror left by the war.

These shattering events continued to reverberate in French art. Even a decade later, at the Salon of 1881, a famous military painter, Alphonse de Neuville, would commemorate the courageous defense, but ultimate defeat, of French troops on August 18, 1870, in the cemetery at Saint-Privat in the province of Lorraine, which, together with Alsace, was ceded to the Prussians after the war (page 253). But far more surprisingly, the horror of urban

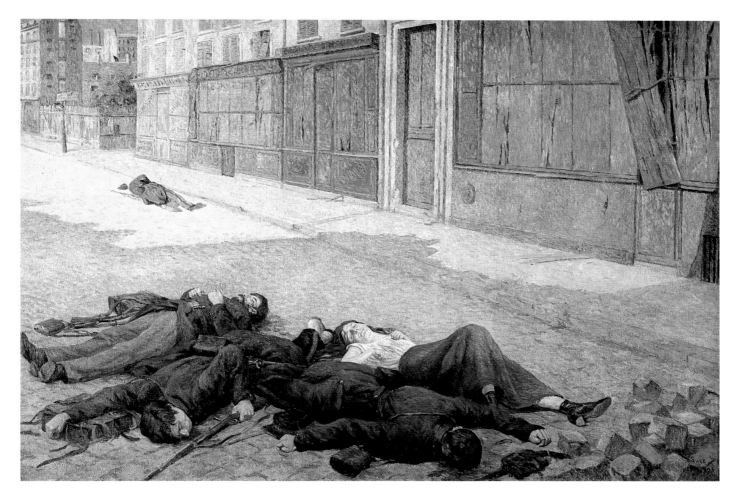

MAXIMILIEN LUCE
A Paris Street in May 1871 (The Commune), 1903–1905
4' 11" x 7' 4½" (151 x 225 cm) Gift of Frédéric Luce, 1948.
RF 1977-235

slaughter of May 1871 would be remembered as late as 1905 when, at the Salon des Indépendants, the Neo-Impressionist Maximilien Luce exhibited *A Paris Street in May 1871 (The Commune)*. Although he would have been only thirteen at the time of the event, the memory was clearly still alive, exorcised in a large painting whose brilliant, sunlit hues, blanching an abandoned Paris street on a spring day, ironically underscore the bloody reality of the corpses of a woman and four members of the National Guard that litter the view, near and far. It has been suggested, too, that Henri Rousseau's seemingly timeless and private allegory titled *War* (page 659), shown at the Salon des Indépendants in 1894, was also a cathartic evocation of the artist's persistent memories of the events of 1870–1871.

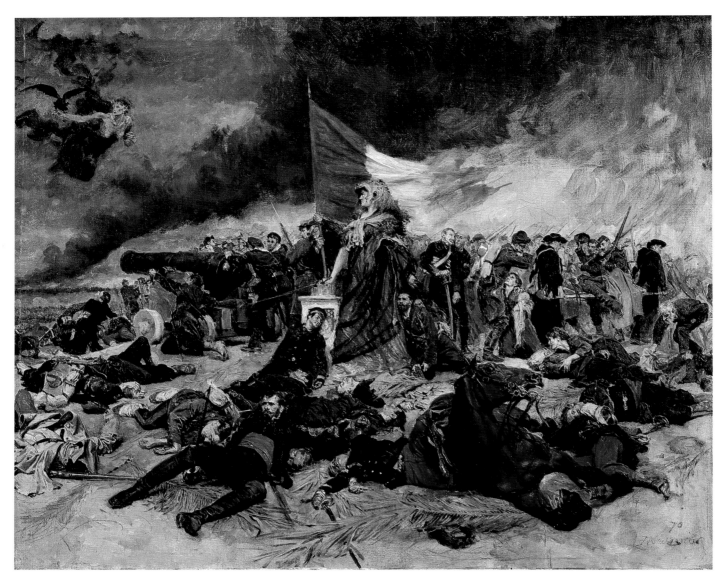

ERNEST MEISSONIER, Lyons 1815–Paris 1891
The Siege of Paris, 1870
1′ 9″ x 2′ 3¾″ (53.5 x 70.5 cm) Bequest of Mrs. Meissonier, 1898.
RF 1249

facing page, top
GEORGES CLAIRIN, Paris 1843–Belle-Ile-en-Mer 1919
The Burning of the Tuileries, 1871
1′ 7″ x 2′ 7″ (48 x 79 cm) RF 1981-31

facing page, bottom
ALPHONSE DE NEUVILLE, Saint-Omer 1835–Paris 1885
The Cemetery at St. Privat, August 18, 1870 (Salon of 1881)
7′ 8¾″ x 11′ 2¼″ (235.5 x 341 cm)

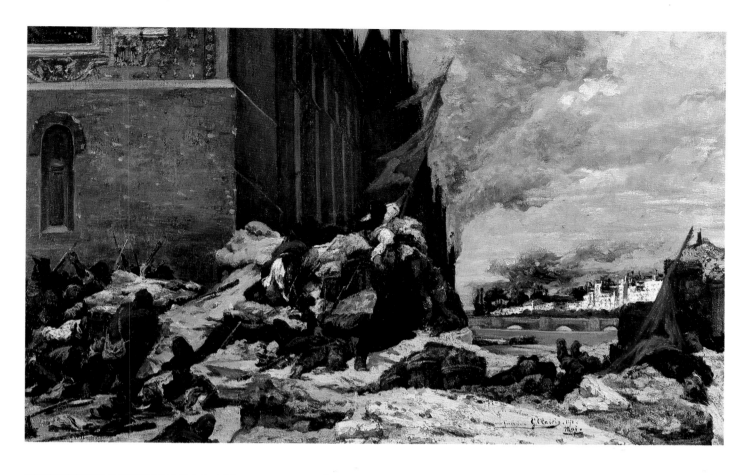

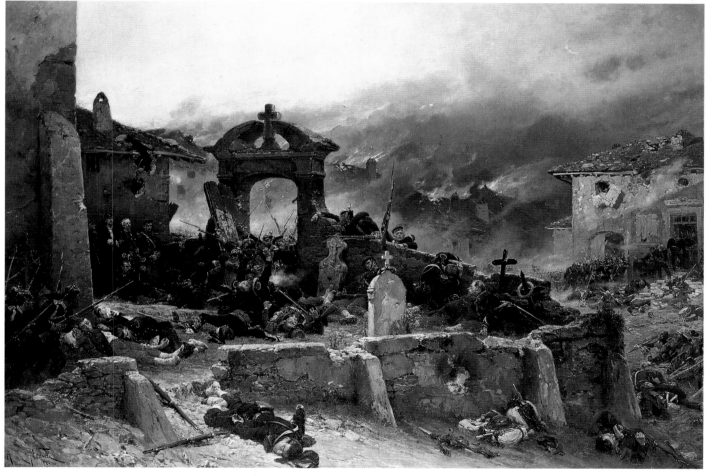

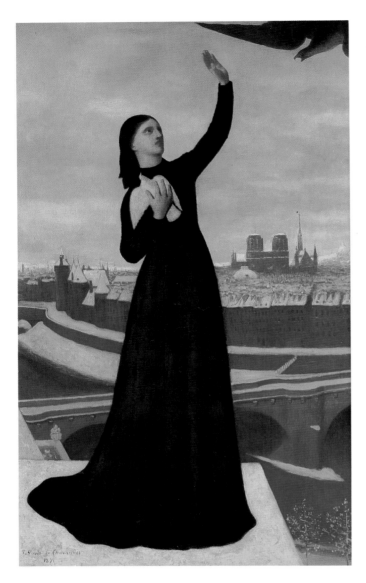 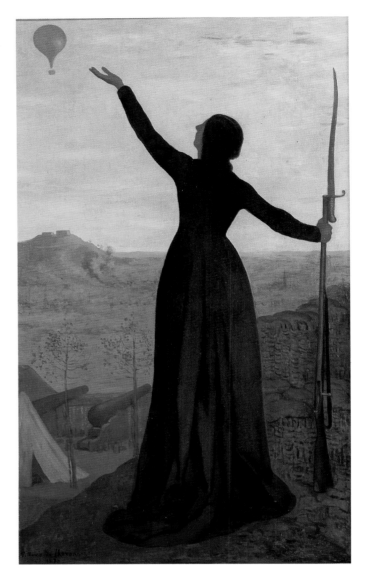

PIERRE PUVIS DE CHAVANNES
The Pigeon, 1871
4′ 6″ x 2′ 9″ (136.5 x 84 cm) Gift of Mr. Acquavella, 1987.
RF 1987-22

PIERRE PUVIS DE CHAVANNES
The Balloon, 1871
4′ 6″ x 2′ 9″ (136.5 x 84 cm) Gift of Mr. Acquavella, 1987.
RF 1987-21

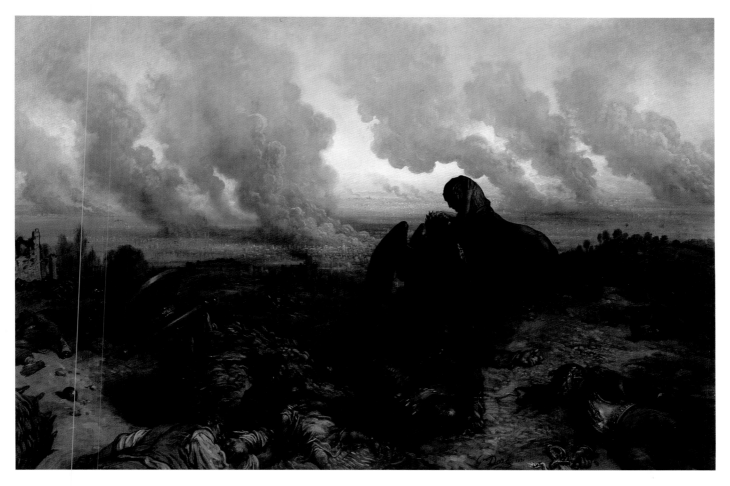

GUSTAVE DORÉ, Strasbourg 1832–Paris 1883
The Enigma, 1871
4' 3¼" x 6' 5" (130 x 195.5 cm) RF 1982-68

Jean-Joseph Weerts
The Death of Barra
Edouard Detaille
The Dream

Although France had a long tradition of painted military propaganda, the fires of patriotism seemed to burn more fiercely after the nation's crushing defeat in the Franco-Prussian War. From the 1880s, the Musée d'Orsay has two major examples of these pictorial hymns to the glory of sacrifice—the kind of paintings that were meant to inspire generations to come, especially those looking eastward to the Rhine. They do so in different but complementary ways. In his reconstruction of the heroism of the thirteen-year-old drummer boy, Joseph Barra (often spelled Bara), during the French Revolution, Weerts, a specialist in the painting of national history, offers what appears to be cinematic truth. Of the legends that clung to the youth, this one depicts the story of his defending with his life two horses that brigands attempted to steal from his cavalry troop. Weerts shows him close up, in full uniform and in a posture almost of crucifixion, as the brutal thieves threaten him while he still tugs possessively at the reins. This uncommon heroism, especially for what is almost a child, is depicted with the documentary realism familiar to the age of photography, offering would-be proof of the veracity of the event. It is no surprise that the government had some five hundred thousand photographs of the painting made for distribution in schools throughout France.

Schoolboys would be equally, if more imaginatively, inspired by a painting that appeared five years later at the Salon of 1888. *The Dream* is the work of an official military artist, Edouard Detaille, who, though his work was often documentary, pulled out all stops for the epic dimensions of this canvas. The split between fact and fantasy could hardly be sharper. The terrestrial zone shows us the level bleakness of a battlefield covered with soldiers who are trying to sleep before duty calls again. Silhouetted against the panoramic vastness of the horizon is a seemingly infinite row of stacked rifles marking the battle lines with regimented precision. The tradition here is of military genre painting, of a sort exemplified in Chenu's bone-chilling image of soldiers straggling along on a wintry road. But above this reportorial truth, Detaille bursts into a celestial pageant where the rewards of armed service are reaped. Infused with patriotic red, white, and blue, a heaven of French military triumphs unfurls, beginning with Saint Denis and Joan of Arc and concluding, in the roseate sky, with the heroes of the Revolutionary and Napoleonic wars. What modern soldier wouldn't give his life to enter this Valhalla?

Lest we feel too smug about the hollowness of Detaille's pompous rhetoric and its collision of truths and fictions about the battlefield, we should remember that this epic dream also pinpoints the popular myths that helped to shape the history—our history—of nationalism and modern warfare, fantasies that are still defying the pull of reality today.

FLEURY CHENU, Briançon 1833–Lyon 1875
The Stragglers; Impression of Snow, 1870 (Salon of 1870)
3' 6¼" x 5' (107 x 152.5 cm) RF 380

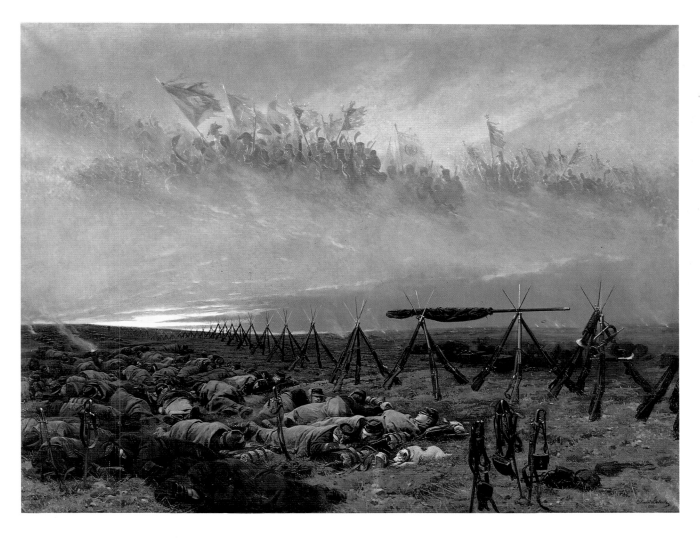

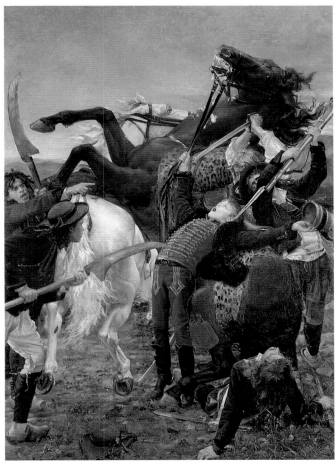

ÉDOUARD DETAILLE, Paris 1848–Paris 1912
The Dream, 1888 (Salon of 1888)
9′ 10″ x 12′ 9½″ (300 x 390 cm) RF 524

JEAN-JOSEPH WEERTS, Roubaix 1847–Paris 1927
The Death of Barra, 1883 (Salon of 1883)
11′ 5¾″ x 8′ 2½″ (350 x 250 cm) RF 570

Manet after 1870

The Beer Waitress

Like many Parisian artists from Daumier to Degas, Manet was eager to depict the burgeoning new confusion of urban life, especially as witnessed in cafés and music halls or, as would often be the case, in a *café-concert*, which combined in one place these two kinds of public leisure—drinking and watching a show. But what sort of picture could seize all this coming and going, in which eyes are directed this way and that, in which some people are rushing and others are at ease, in which everyone is huddled together, but few know their neighbors? One of Manet's solutions can be seen here, a vivid fragment of planned disorder that scatters all conventional expectations about major and minor, parts and whole, center and side.

Every time we decide what to look at, our vote is canceled by another distraction. It would be hard not to start with the harried waitress (for whom Manet chose a real waitress as model). Another working woman like Olympia (page 199), she meets our gaze with commercial eyes; but having just placed one glass of beer on an invisible table at the lower left and rushing off with two more glasses in hand, she is clearly eager to catch our order on the fly and run off to another customer. When we turn instead to the foreground figure, he turns his back to us in order to watch another focus of attention, a stage with a singer who is sliced in two by the frame, leaving her face to our imagination. Or should we then look at what is apparently a couple, the wealthier lady and gentleman whose proper hats separate them socially from the smocked, pipe-smoking neighbor behind them and nearer to us, a man who, in real life, we learn, looked after the waitress.

To capture this new urban world, fully launched in Second Empire Paris and familiar to us today, Manet and his contemporaries had to find new ways of seeing and painting. Here Manet explores what might be called a centrifugal composition, an everyday explosion in which each look and movement directs us from the center outward, beyond the frame. Thrust right into the midst of this raucous, unbounded world of public leisure, we must fumble for our seats or focus. The very application of paint confirms this sense of the rapid and the impermanent, with the light of the stage or the folds of the blue smock suggested only by a swift flurry of brushstrokes that, like the croppings, may echo the economy of commerical artists' sketchy techniques of illustrating vignettes of contemporary life. Recent research has indicated how much Manet and the whole circle of Impressionists may owe to the abbreviated language of popular art found in the newspapers and magazines of the day.

But, as always, Manet transcends the ordinary, creating from this potential turmoil the suavest and wittiest pictorial juggling. Only he could have balanced the inky black cylinder of a stovepipe hat on the white base of an extended pipe held by another spectator, or have enclosed the pipe smoker's head within the moving contours of the waitress's bosom. And who else would have anchored this restless scene by dropping a vertical down the exact center, as in *Olympia*, and then diffusing such obvious geometric clarity by multiplying this rhythm, left and right, with infinite variations of wide and narrow decorative stripes?

It is no surprise that this seemingly effortless image of spontaneity was the distillation of many other drawings and paintings Manet has made of café scenes in the 1870s, demonstrating yet again that only the most experienced master can transform the appearance of chaos into an enduring pictorial order.

facing page
ÉDOUARD MANET
The Beer Waitress, 1878–1879
2' 6½" x 2' 1½" (77.5 x 65 cm) RF 1959-4

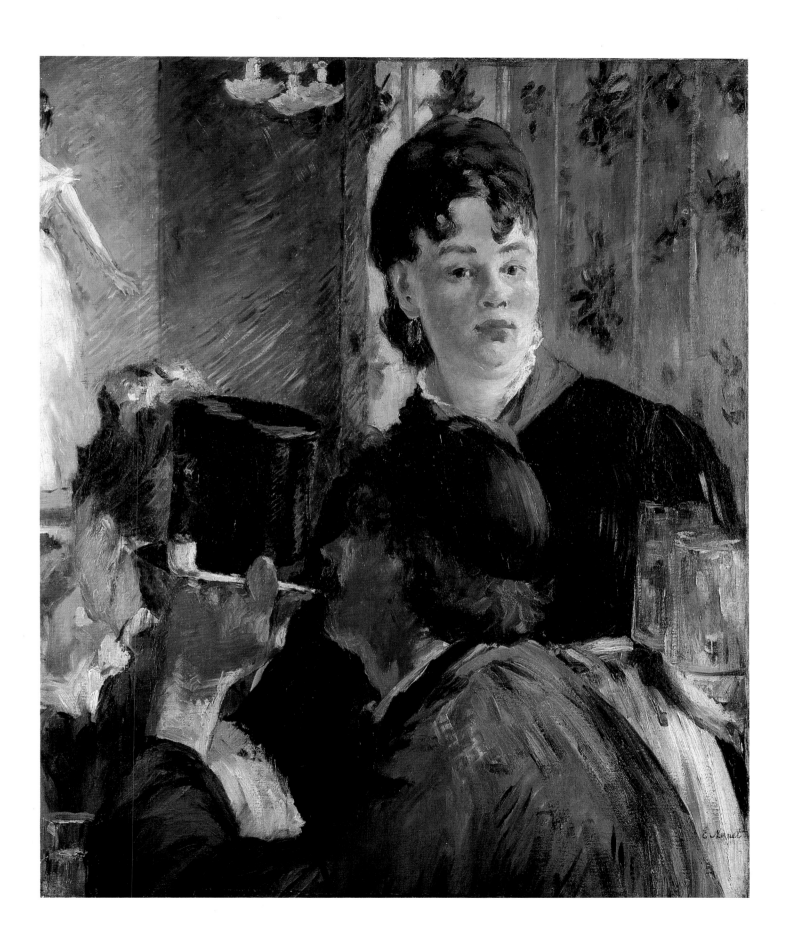

The Asparagus; The Lemon

*I*n what were to be the last years of his short life, Manet drew and painted many still-life vignettes—a lady's hat, a cracked almond, lanterns, a glimpse of stylish shoes and stockings, a peach—elegant fragments of a Parisian world dedicated to the pleasures of food, clothing, and festivities. Within this group of miniature souvenirs of sensuous experience, two little paintings at Orsay are special gems: one a single stalk of white asparagus on a marble table, the other an uncut lemon on a gray faience plate.

The often-told story of the lone asparagus is particularly indicative of Manet's style and wit. He had sold a painting of an entire bunch of asparagus to his friend Charles Ephrussi for eight hundred francs, but received a generous overpayment of one thousand francs. Manet's response was this painted coda to the transaction: an extra stalk, which he sent off to Ephrussi with a note, "There was one missing from your bunch." The tiny canvas—it can be held in one hand—seems to have been dashed off, like a quick riposte, mirroring the elegant brio of this exchange of art, money, and friendship. What we see is the merest fragment of a still life, not even wide enough to encompass the entire length of the single asparagus or to give us a clue as to the actual size of the table upon which the stalk has been strewn so carelessly.

But within what seems the most accidental of snapshots, Manet offers a microcosm of his subtlest pictorial skills, creating delicious visual ironies. The casual diagonal of the stalk overlaps the table edge sufficiently to create an unexpected pocket of darkness and shadow that contradicts the flat expanse of marble above; the swiftly brushed paint strokes of the marble grain run in tracks that parallel the diagonal crossing of asparagus and table edge; the asparagus itself is almost camouflaged against a background we know must be of drastically different texture and shape; and even the rapid scribble of a signature—only an M for Manet, as if written after a postscript on a letter—plays a visual role in this juggling of a decorative surface of paint and a virtuoso illusion of the missing asparagus supplied to his patron.

No less a distillation of the master's pictorial magic is found in the even smaller still life of a lemon on a gray plate. Again, the fragment is so minuscule that even the plate's edges are cropped, obliging us to concentrate fully on the single lemon, whose variations of yellow, tinged with gray reflections and shadows, pinpoint both an object and a color sensibility that ran through Manet's entire work. Lemons—and even an occasional orange—had often been used by him as a chromatic accent against a gray ground, a coolly discreet juxtaposition typical of his preference for colors and tones that pushed as far away as possible from the obvious warmth and sensuality of reds. In this tiny still life the temperature could hardly be lower, the perfect citrine complement in sight and taste to the oysters and salmon that Manet, with a nod to Flemish and Spanish still lifes, has often painted. And speaking of food, Manet's painted edibles conjure up the pleasures of Paris's most luxurious cuisine. It is a cultural and economic jolt to recall that during the same years, the early 1880s, Van Gogh would be painting still lifes of cabbages and potatoes.

facing page, top
ÉDOUARD MANET, Paris 1832–Paris 1883
The Asparagus, 1880
6½" x 8½" (16.5 x 21.5 cm) Gift of Sam Salz, 1959.
RF 1959-18

facing page, bottom
ÉDOUARD MANET
The Lemon, 1880
5½" x 8¾" (14 x 22 cm) Bequest of Count Isaac de Camondo, 1911.
RF 1997

261

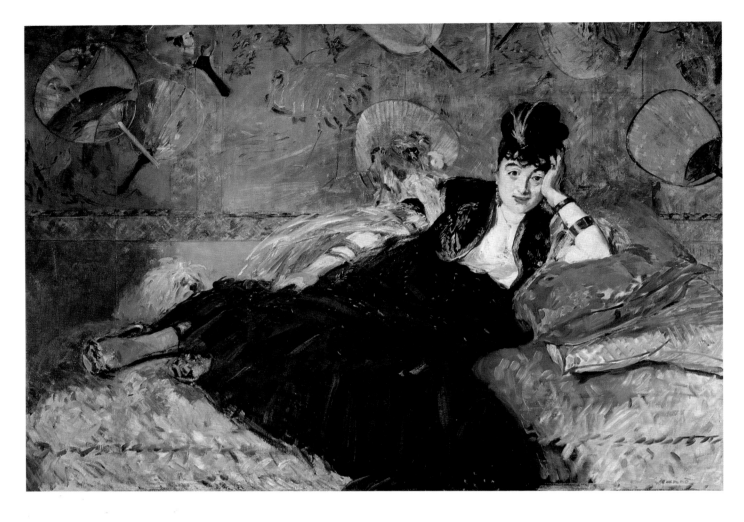

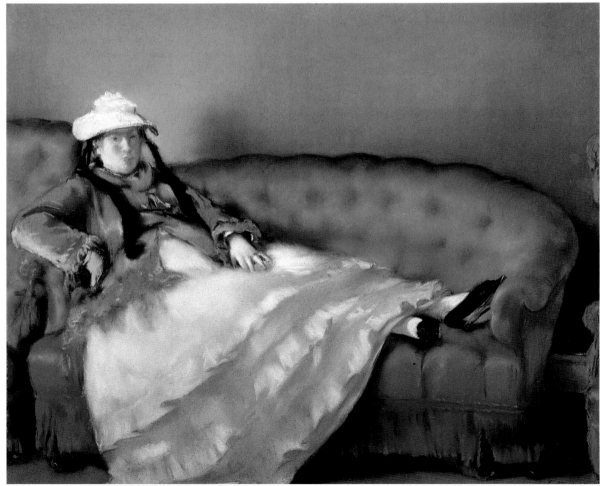

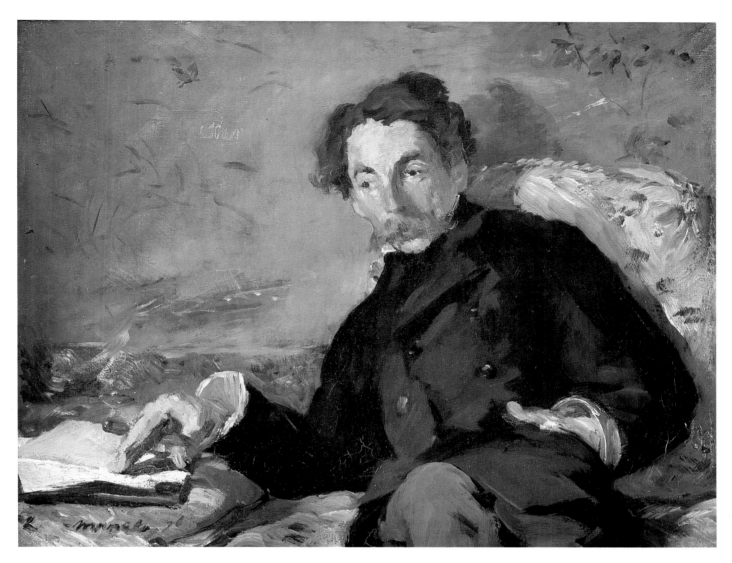

ÉDOUARD MANET
Stéphane Mallarmé, 1876
10¾″ x 1′ 2¼″ (27.5 x 36 cm) RF 2661

facing page, top
ÉDOUARD MANET
Woman with Fans (Nina de Callias), 1873
3′ 8¾″ x 5′ 5½″ (113.5 x 166.5 cm) Gift of Mr. and Mrs.
Ernest Rouart, 1930. RF 2850

facing page, bottom
ÉDOUARD MANET
Portrait of Mme. Manet on a Blue Sofa, ca. 1874
Pastel, 1′ 8″ x 2′ (50.5 x 61 cm) RF 4507

pages 264 and 265
ÉDOUARD MANET
Woman with Fans, detail

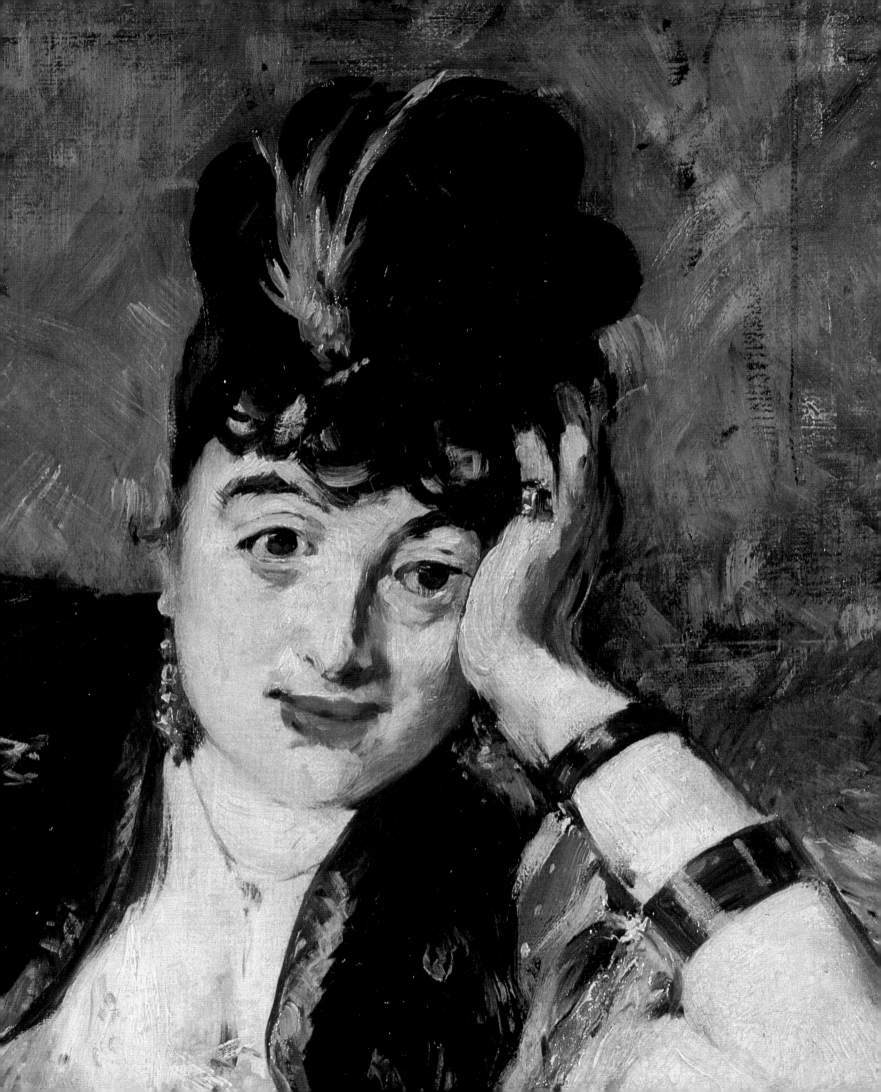

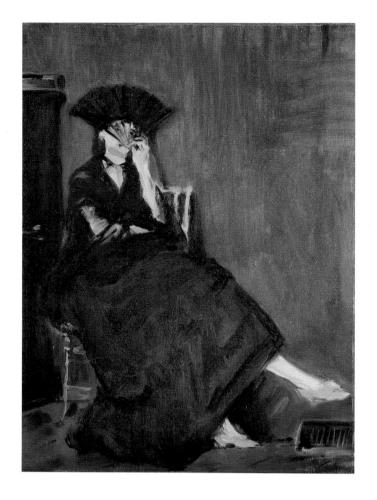

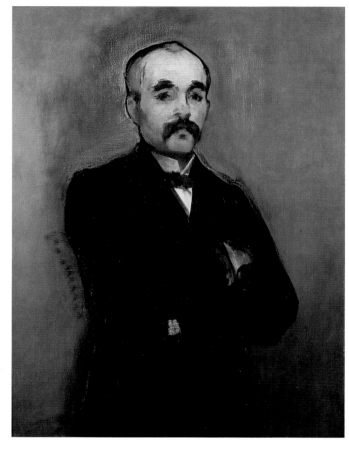

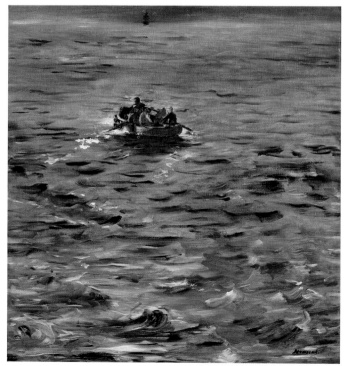

ÉDOUARD MANET
Georges Clemenceau, 1879–1880
3′ 1¼″ x 2′ 5¼″ (94.5 cm x 74 cm) Gift of Mrs. Louisine W.
Havemeyer, 1927. RF 2641

left, top
ÉDOUARD MANET
Berthe Morisot with a Fan, 1872
1′ 11½″ x 1′ 5¾″ (60 x 45 cm) Gift of Étienne Moreau-Nélation,
1906. RF 1671

left, bottom
ÉDOUARD MANET
The Escape of Rochefort, 1880–1881
2′ 7½″ x 2′ 4¾″ (80 x 73 cm) RF 1984-158

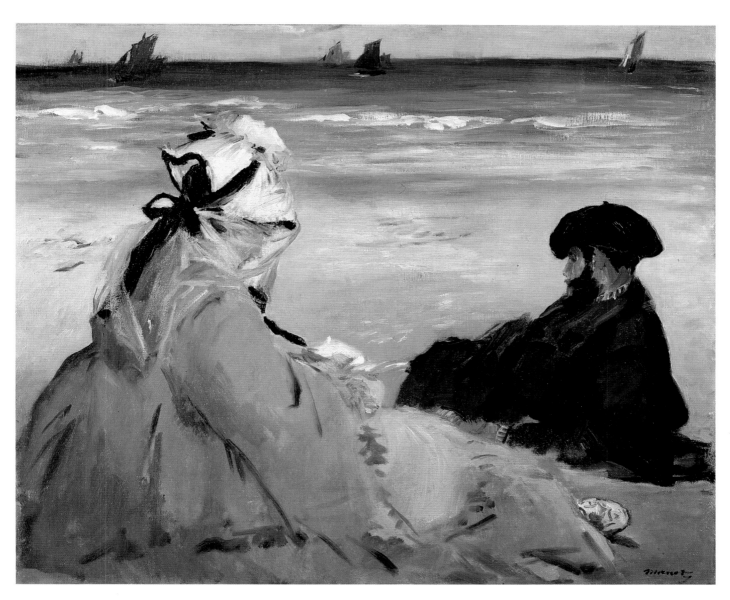

ÉDOUARD MANET
At the Beach, 1873
1′ 11½″ x 2′ 4¾″ (59.5 x 73 cm) Gift of Jean-Édouard Dubrujeaud,
1953. RF 1953-24

page 268
ÉDOUARD MANET
Carnations and Clematis in a Crystal Vase, 1883
1′ 10″ x 1′ 2″ (56 x 35.5 cm) MNR 631

page 269
ÉDOUARD MANET
Blonde Woman with Naked Breasts, ca. 1878
2′ 1″ x 1′ 8½″ (62.5 x 52 cm) Bequest of Étienne Moreau-Nélation,
1927. RF 2637

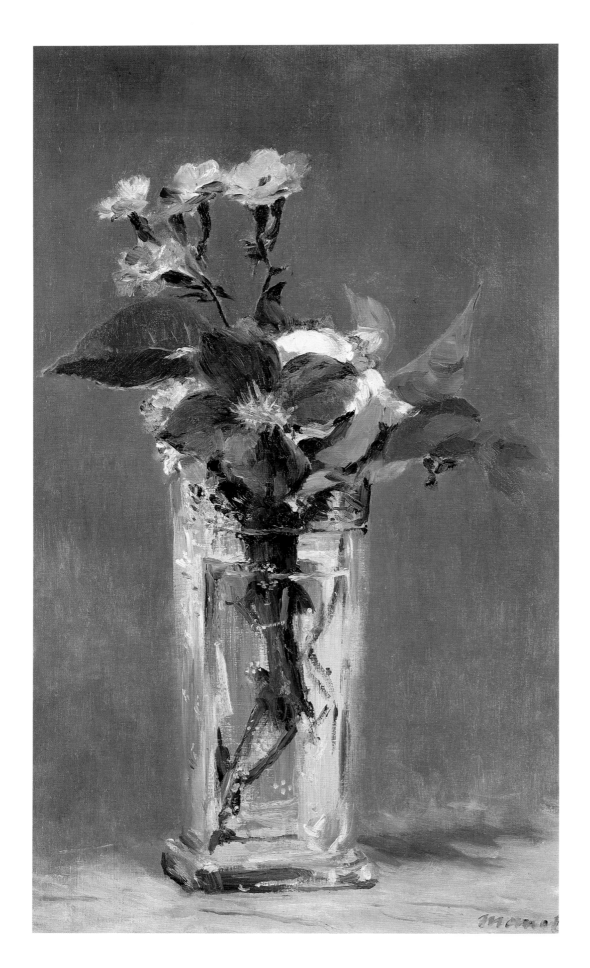

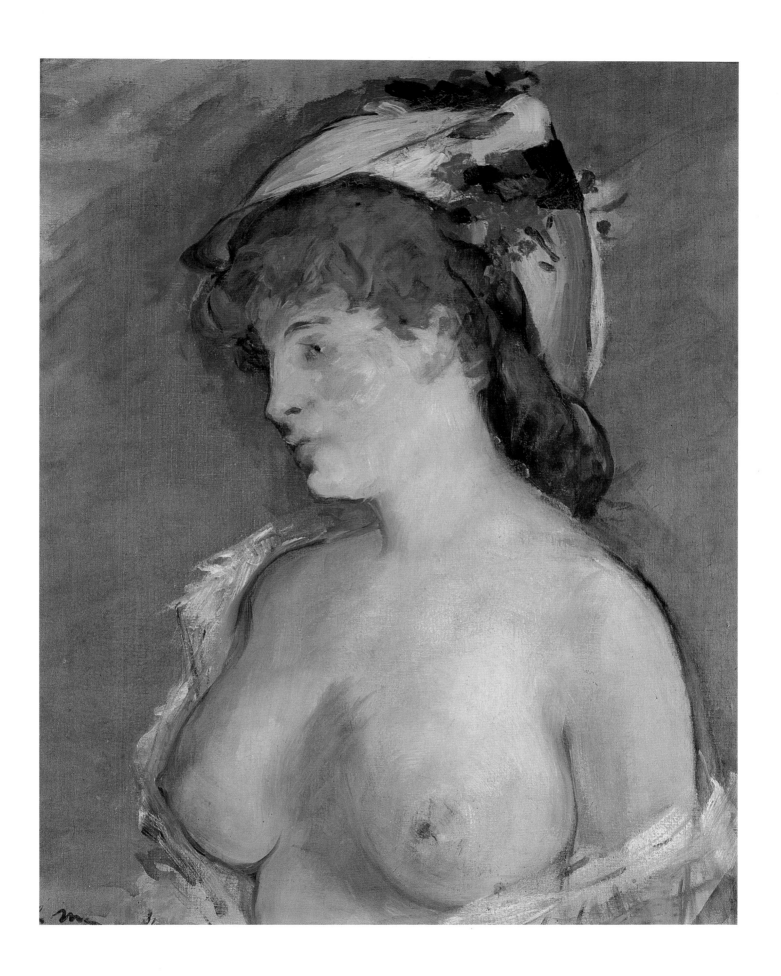

Monet in the 1870s

Gare Saint-Lazare

For some, what the cathedrals were to the Middle Ages, the glass-and-iron marvels of Paris's new train sheds and market halls were to the later nineteenth century, an observation made famous by Henry Adams's theme of the Virgin and the dynamo. Clearly, Monet responded to these triumphs of technology, for in 1876-77 he rented an apartment near the railway terminus, the Gare Saint-Lazare, and got official permission to work inside the station. There he produced a series of ten constantly changing views of this dynamic spectacle, of which eight were shown at the third Impressionist Exhibition of 1877. Although most of these views are oblique and cropped, the painting at Orsay has an unexpected symmetry of structure, with its airy skeleton of glazed metal ribs, that reinforces the effect of an awesome vista down the center of the modern counterpart to a Gothic nave. Indeed, like everything else in the painting, the architecture dissolves before our eyes, the glass roof fusing with the blue-white sky of Paris, the distant clouds blending with the bluish steam that condenses within this lofty space, both open and closed, which frames the seemingly weightless new buildings that cluster around the terminus. Like visitors in a church, railway workers and voyagers are reduced to minuscule proportions, far smaller and more insignificant than they would look in reality; and similarly, the trains themselves, disappearing in the screen of smoke and pulsating activity, are more spectral than real.

As would become more and more often the case, Monet's art here hovers between the documentary and the phantasmagoric. His calculated inventory of multiple views of the railway station conforms to the quasi-scientific spirit of the time, which would record, as in the stop-action photography of Etienne Marey and Eadweard Muybridge, the changing truths of a reality in constant motion. The results, however, are filtered through so nuanced and subjective a response to the noisy, harsh facts of traffic in the heart of Paris on a sunny day that the painting can become almost dreamlike, as impalpable as the vaporous puffs of painted steam that cloud our view of the railway bridge and city beyond. As Emile Zola had noted in his critique of the Impressionist exhibition that showed Monet's Gare Saint-Lazare series, "Our painters today have been forced to discover the poetry of railway stations, much as their predecessors discovered that of forests and rivers."

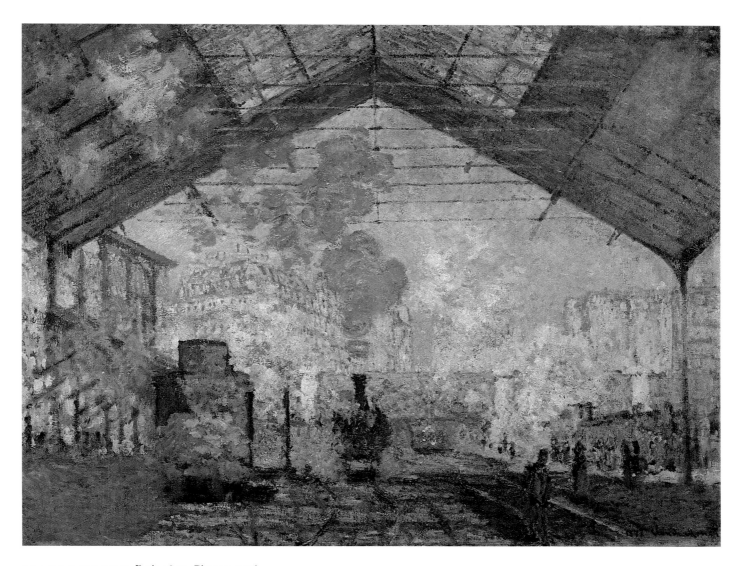

CLAUDE MONET, Paris 1840–Giverny 1926
Gare Saint-Lazare, 1877
2′ 5¾″ x 3′ 5″ (75.5 x 104 cm) Bequest of Gustave Caillebotte, 1894.
RF 2775

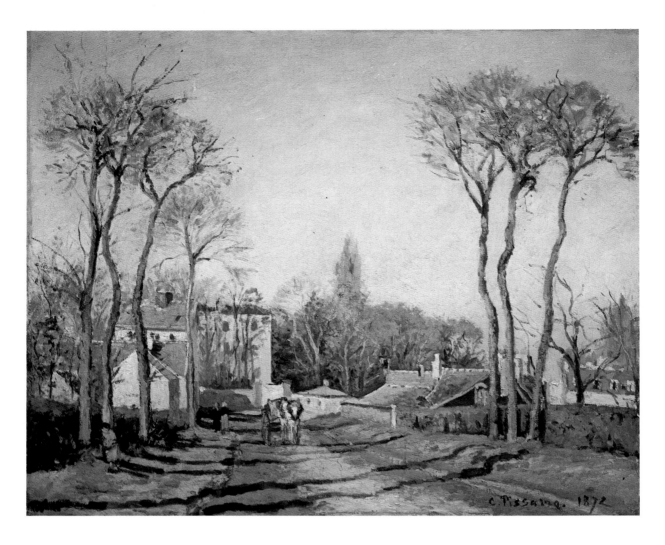

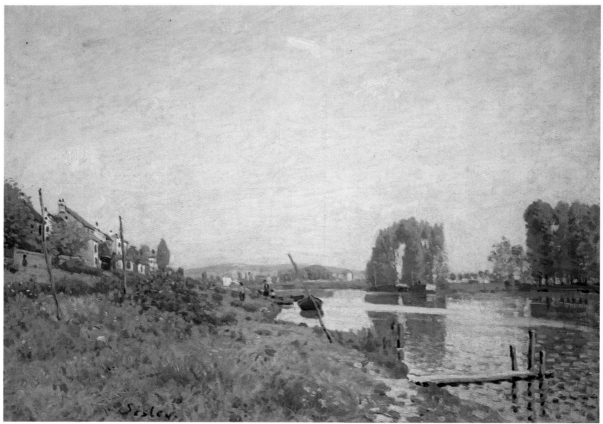

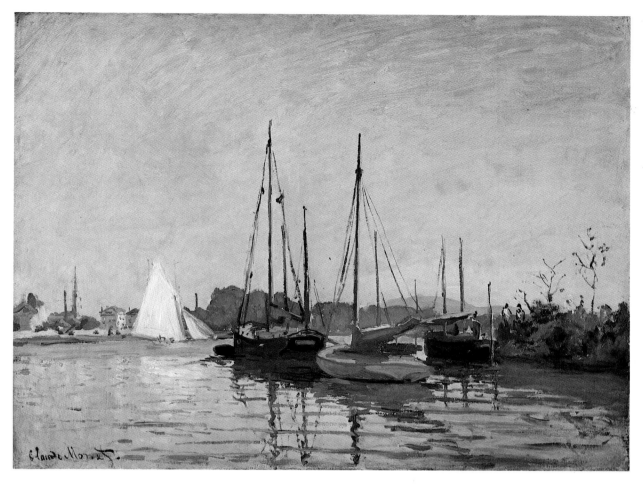

CLAUDE MONET
Pleasure Boat, Argenteuil, ca. 1872
1′ 7¼″ x 2′ 1½″ (49 x 65 cm) Gift of Ernest May, 1923. RF 2437

facing page, top
CAMILLE PISSARRO
Entrance to the Village of Voisins, 1872
1′ 6″ x 1′ 9¾″ (46 x 55.5 cm) Gift of Ernest May, 1923. RF 2436

facing page, bottom
ALFRED SISLEY
The Ile Saint-Denis, ca. 1872
1′ 8″ x 2′ 1½″ (50.5 x 65 cm) Gift of Ernest May, 1923. RF 2435

At Orsay, these three landscapes by three different Impressionists are
framed together as a triptych. They have, in fact, a unity. Not only were
they all collected by the same early patron of the movement, Ernest May,
but they are all about the same size, were all painted at approximately the
same date, 1872, and are all by artists who repeatedly showed together
at the Impressionist exhibitions. Seen as a trinity, they reflect the
remarkable convergence of individual viewpoints into a communal style
just before the first group show in 1874. To be sure, the Impressionists
were very dissimilar as artists. Who would mistake Monet for Degas,
Sisley for Manet, Morisot for Caillebotte, Pissarro for Renoir? Yet there
were points in their separate careers when some of them seemed almost to
be painting with the same goals in mind and the same brush in hand,
momentarily transcending individual temperament.

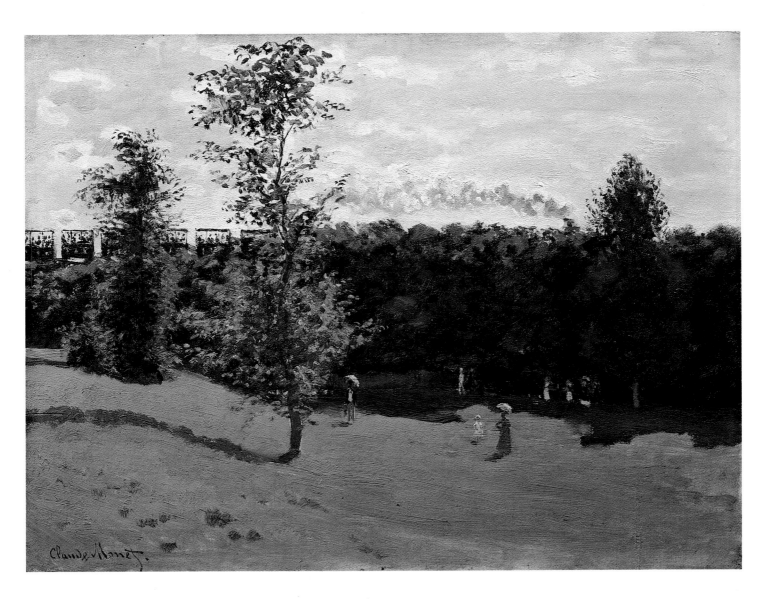

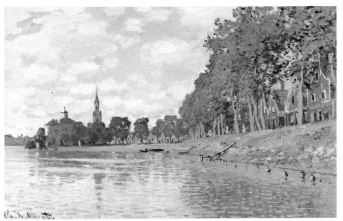

CLAUDE MONET
Train in the Country, ca. 1870
1′ 7¾″ x 2′ 1½″ (50 x 65 cm) MNR 218

CLAUDE MONET
Zaandam (Holland), 1871
1′ 7″ x 2′ 4¾″ (48 x 73 cm) Gift of Étienne Moreau-Nélation, 1906.
RF 1673

facing page
CLAUDE MONET
Hôtel des Roches Noires, Trouville, 1870
2′ 8″ x 1′ 11″ (81 x 58.5 cm) Gift of Jacques Laroche, 1947.
RF 1947-30

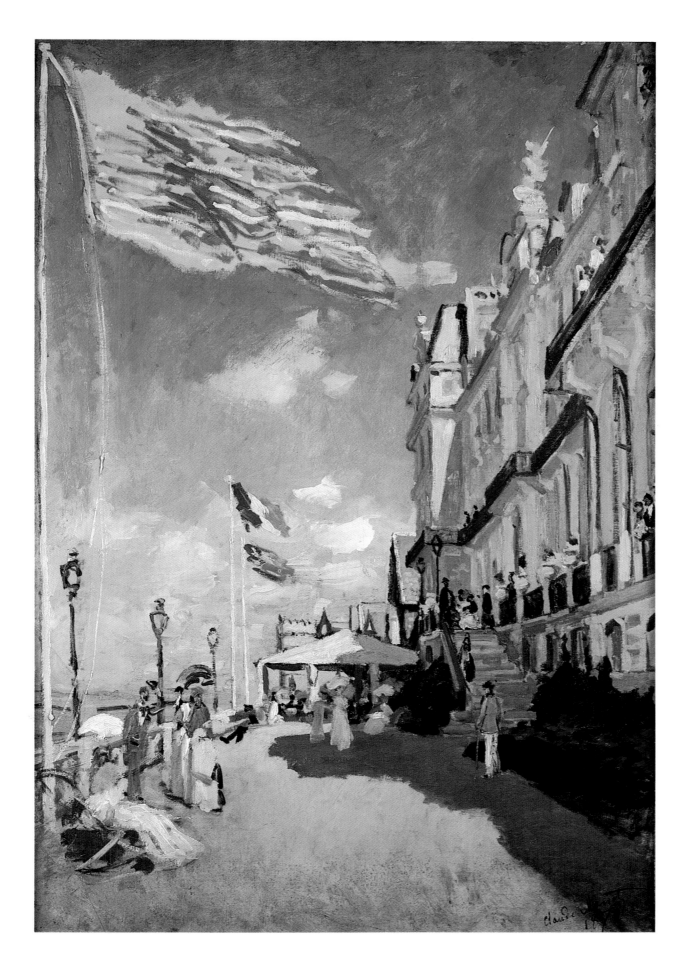

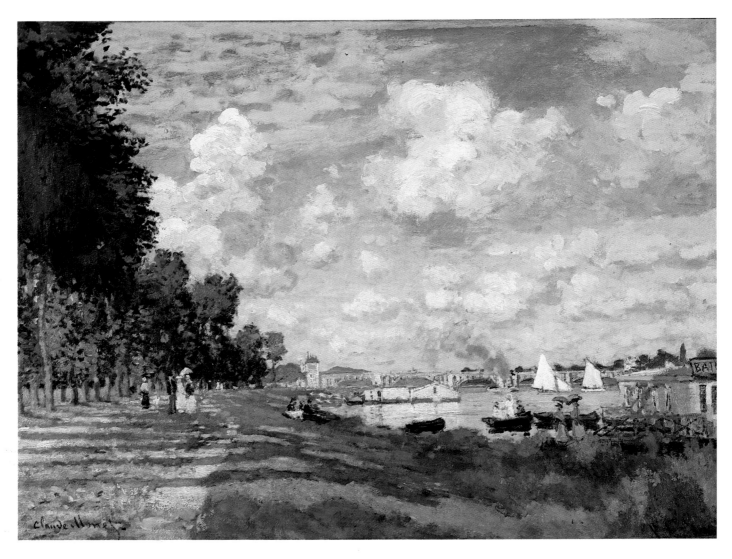

CLAUDE MONET
The Dock at Argenteuil, ca. 1872
1′ 11½″ x 2′ 7¾″ (60 x 80.5 cm) Bequest of Count Isaac de Camondo,
1911. RF 2010

facing page, top
CLAUDE MONET
The Regatta at Argenteuil, ca. 1872
1′ 7″ x 2′ 5½″ (48 x 75 cm) Bequest of Gustave Caillebotte, 1894.
RF 2778

facing page, bottom
CLAUDE MONET
The Robec Stream, at Rouen, 1872
1′ 7¾″ x 2′ 1½″ (50 x 65 cm) Bequest of
Antonin Personnaz, 1937. RF 1937-43

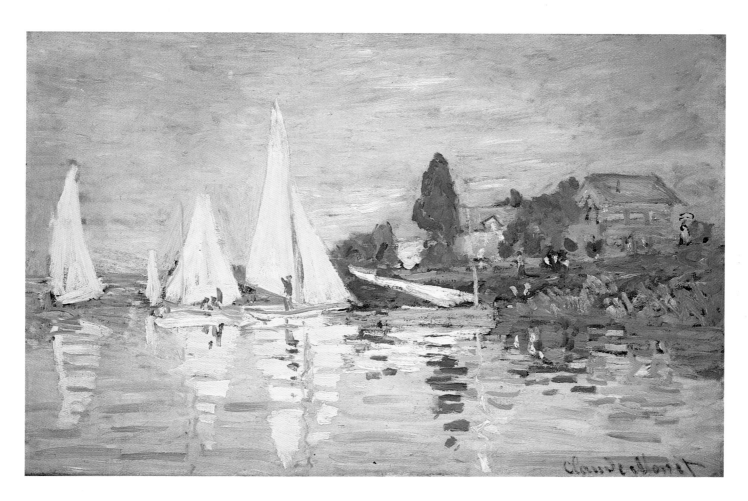

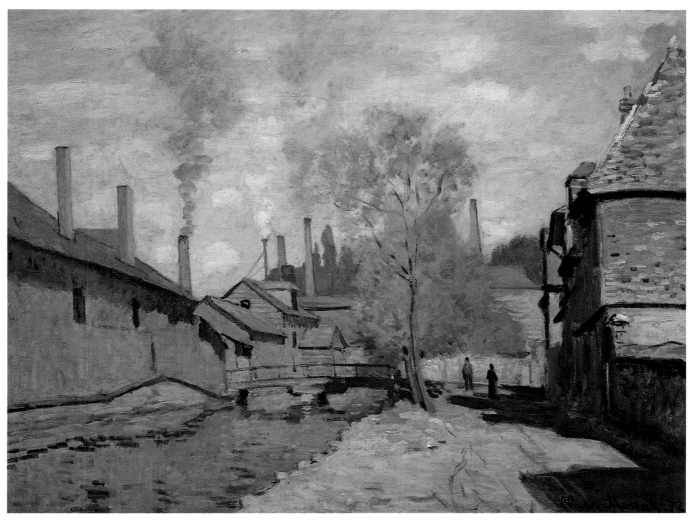

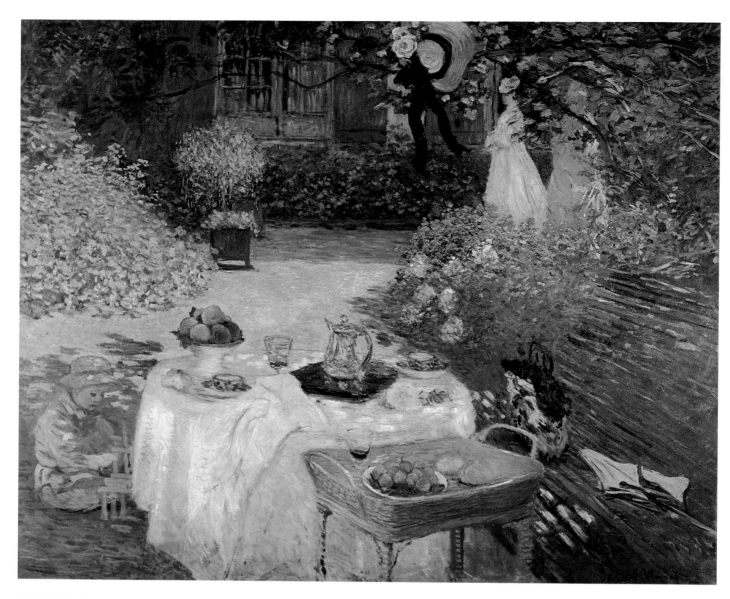

CLAUDE MONET
The Lunch; Decorative Panel (Monet's Garden at Argenteuil), ca. 1873
5' 3" x 6' 7¼" (160 x 201 cm) Bequest of Gustave Caillebotte, 1894.
RF 2774

facing page
CLAUDE MONET
The Corner of an Apartment, 1875
2' 8" x 1' 11¾" (81.5 x 60.5 cm) Bequest of Gustave Caillebotte, 1894.
RF 2776

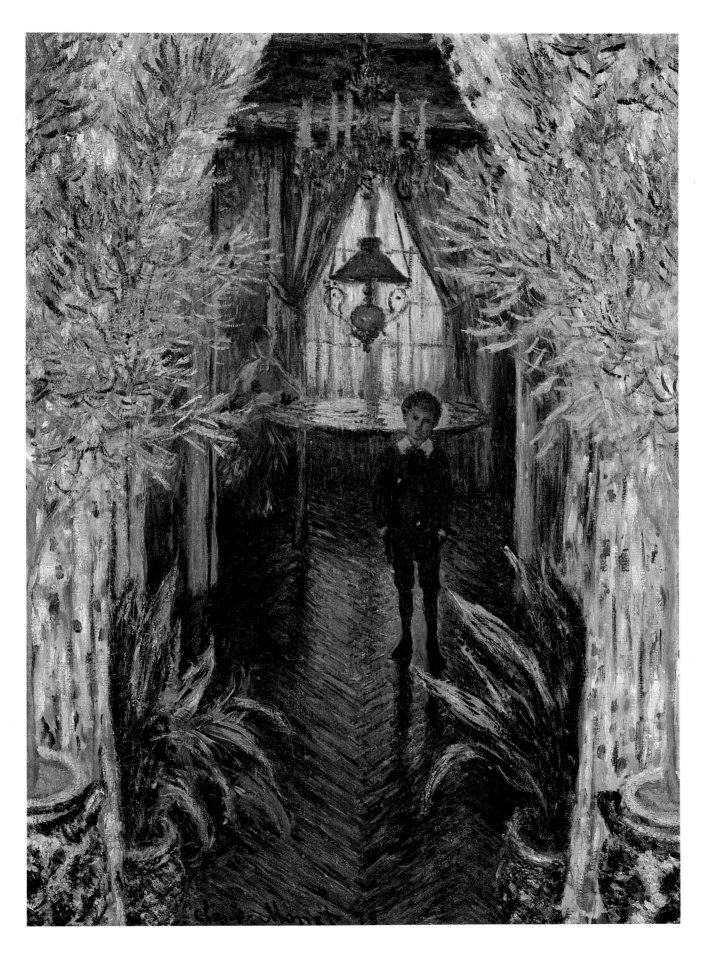

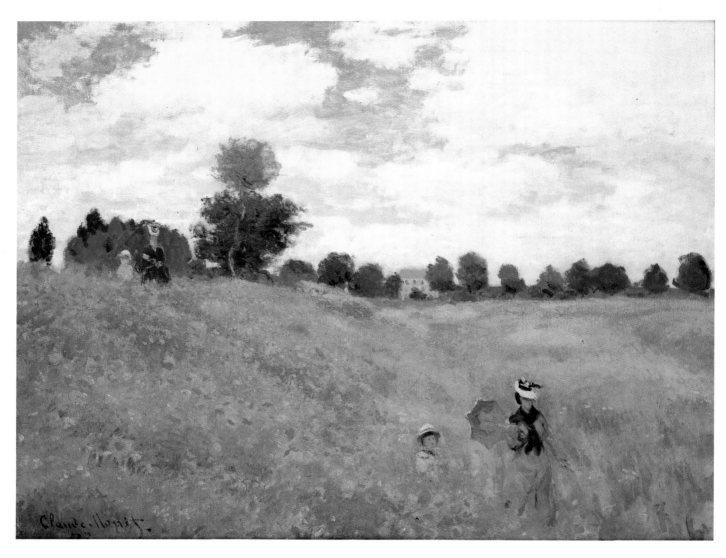

CLAUDE MONET
Poppies; near Argenteuil, 1873
1' 7¾" x 2' 1½" (50 x 65 cm) Gift of Étienne Moreau-Nélation, 1906.
RF 1676

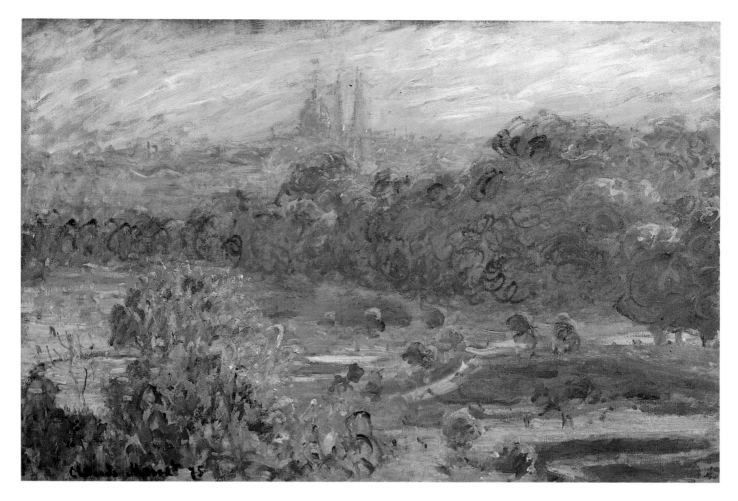

CLAUDE MONET
The Tuileries; Study, 1875
1′ 7¾″ x 2′ 5½″ (50 x 75 cm) Bequest of Gustave Caillebotte, 1894.
RF 2705

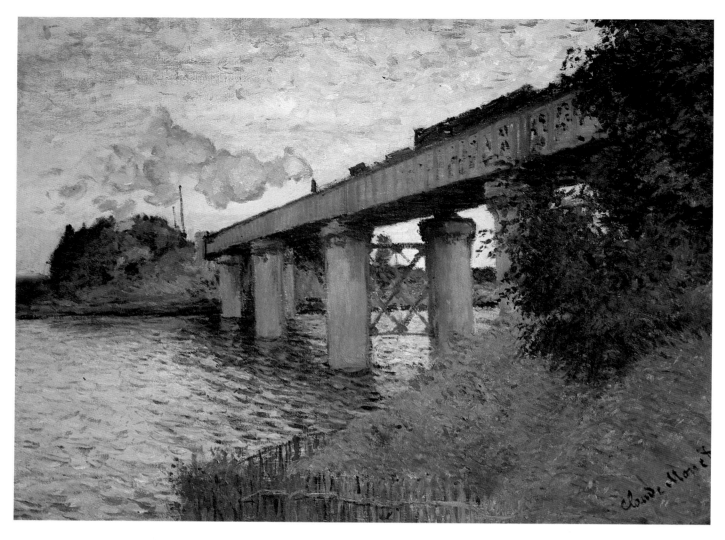

CLAUDE MONET
The Railway Bridge at Argenteuil, ca. 1873–1874
1′ 9¾″ x 2′ 4¼″ (55 x 72 cm) Gift of Étienne Moreau-Nélation, 1906.
RF 1679

facing page, top
CLAUDE MONET
The Bridge at Argenteuil, 1874
1′ 11¾″ x 2′ 7½″ (60.5 x 80 cm) Bequest of Antonin Personnaz, 1937.
RF 1937-41

facing page, bottom
CLAUDE MONET
The Barks; Regatta at Argenteuil, 1874
1′ 11½″ x 3′ 3¼″ (60 x 100 cm) Bequest of Count Isaac de Camondo,
1911. RF 2008

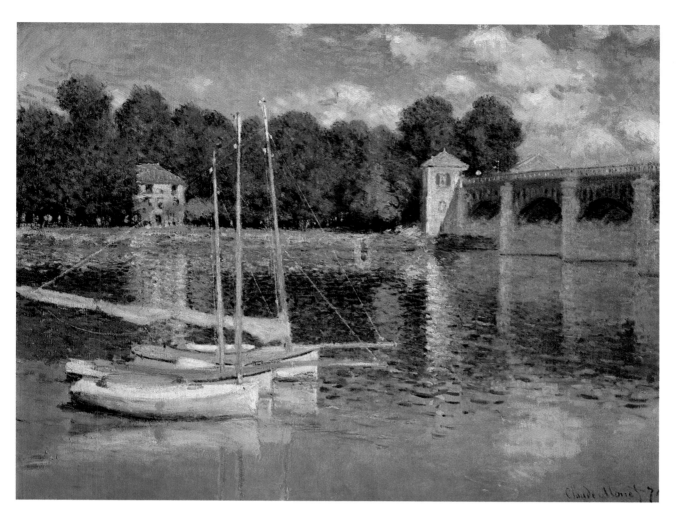

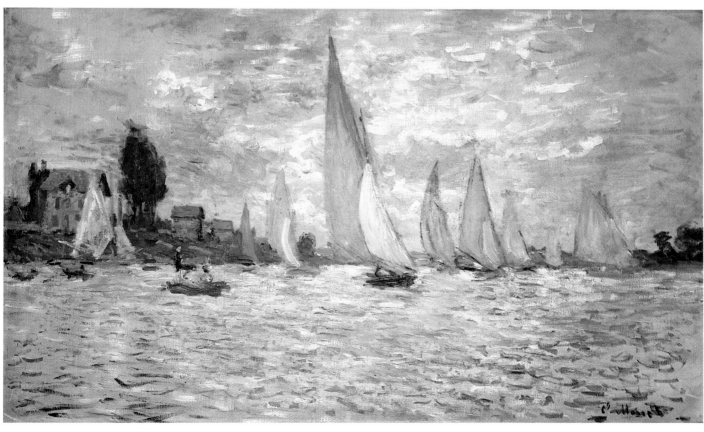

Camille Monet on Her Deathbed

*I*t is startling, even shocking, to find within Monet's ostensibly sunstruck, untroubled world of sensation the image of a dying woman. She is his first wife, Camille Doncieux, who, after years of illness, died on September 5, 1879, at the age of forty-two. Prior to her death, Monet had been having a long-standing affair with Alice Hoschedé, the wife of one of his patrons and the woman he would soon live with and eventually marry. To paint Madame Monet's dying (or already dead?) face and body, withering, like the bouquet she holds, under a shroud of bed linens, must have been an act of exorcism, mixing grief, trauma, and guilt. But ironically it was also a pictorial task that would tax the objectivity of the artist's hyper-refined perception to an acute degree. Decades later, without revealing her identity, Monet confided to his friend Georges Clemenceau that he had once painted a woman on her deathbed and that his vision had become so finely attuned to the most nuanced perceptions of color that, to his distress, he responded first not to the pathetic spectacle of death but to the strange gradations of tone—blue, yellow, gray—that he discerned on her face.

It is true that, compared to such earlier Realist deathbed scenes as Henri Regnault's record of his great aunt expiring in 1866 (page 68), Monet's corpse seems at first lost in a network of dulled light, shimmering with iridescent tones. But this pictorial veil, initially almost mistakable for a Futurist explosion of light-charged energy or an Abstract-Expressionist painting of ca. 1950, registers simultaneously as a spectral image of death and dissolution, a fragile cocoon that surrounds, like a halo, the wizened pink-and-violet face of Madame Monet. Her clothed body seems already to have crumbled into dust, decomposed, as it were, by what look like slapdash streaks of colored light. Monet had often, of course, disintegrated figures into pulsating screens of pigment, but here the effects announce unfamiliar territories. Rather than the exhilaration of sun-filled natural perception, this image approaches an almost supernatural domain of spirit and mystery, closer to the Symbolist mood of the 1890s than to the Impressionist joie de vivre of the 1870s. Indeed, by the end of the century, as in his visions of Rouen Cathedral (page 406), Monet himself would move more fully into this ethereal domain, proclaimed unexpectedly here in this singular and poignant canvas.

CLAUDE MONET
Meditation; Mme. Monet on a Sofa, ca. 1870–1871
1′ 7″ x 2′ 5½″ (48 x 75 cm) Bequest of Mr. and Mrs. Raymond Koechlin, 1931. RF 3665

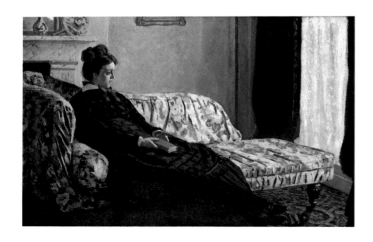

facing page
CLAUDE MONET
Camille on Her Deathbed, 1879
2′ 11½″ x 2′ 2¾″ (90 x 68 cm) Gift of Mrs. Katia Granoff, 1963. RF 1963-3

page 286, top
CLAUDE MONET
Chrysanthemums, 1878
1′ 9½″ x 2′ 1½″ (54.5 x 65 cm) Gift of Paul Gachet, 1951. RF 1951-36

page 286, bottom
CLAUDE MONET
The Turkeys; Château of Rottembourg, at Montgeron, 1877
5′ 8¾″ x 5′ 8″ (174.5 x 172.5 cm) Bequest of Princess Edmond de Polignac, 1944. RF 1944-18

page 287
CLAUDE MONET
Rue Montorgueil, Paris. Festival of June 30, 1878, 1878
2′ 8″ x 1′ 8″ (81 x 50.5 cm) RF 1982-71

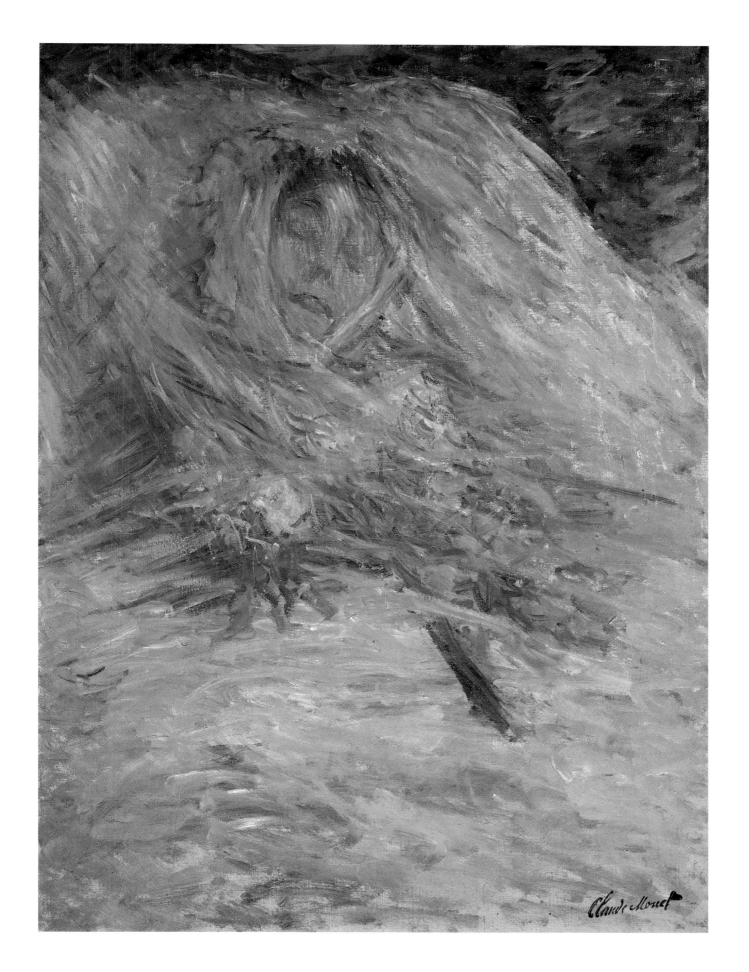

Claude Monet

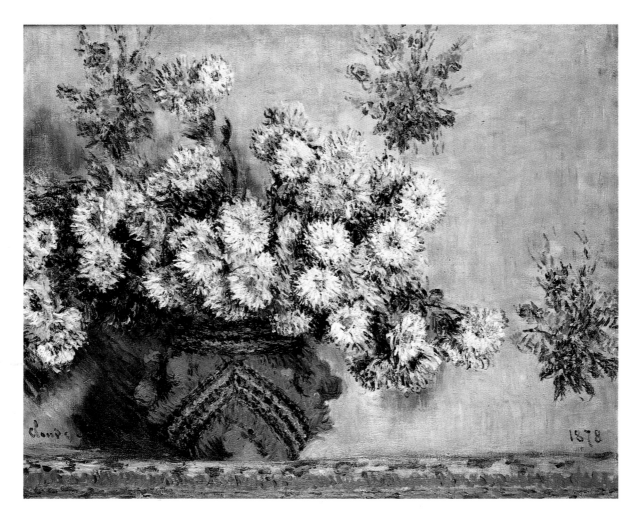

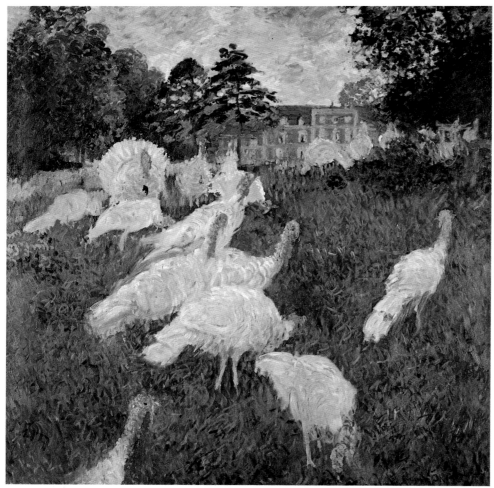

286

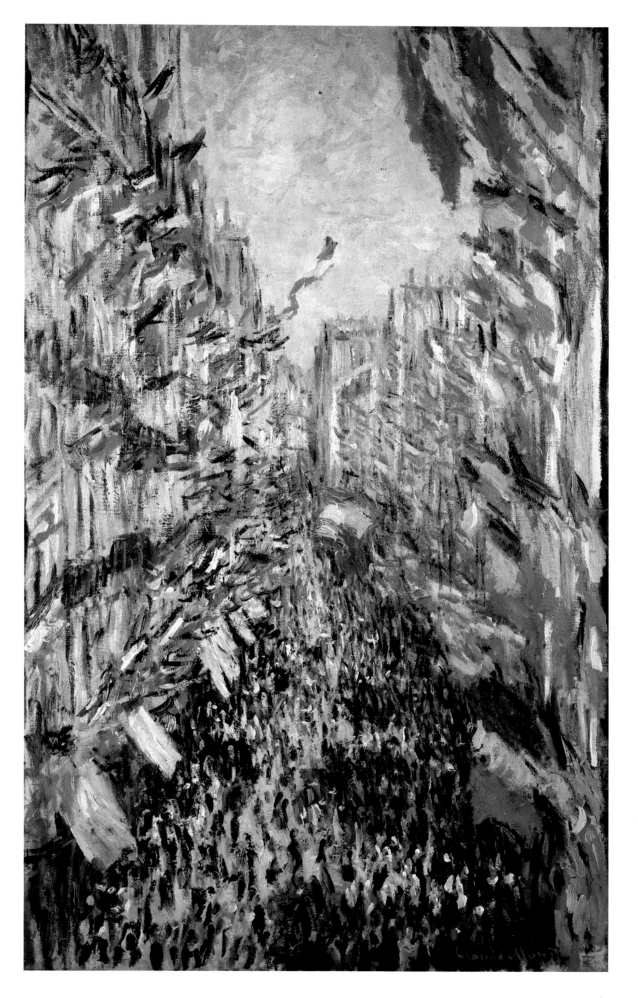

RENOIR IN THE 1870S

The Swing

*E*ven when it was first seen at the third Impressionist group show in 1877, Renoir's *Swing* was recognized as having Rococo ancestry. "To match its charm," a critic found, "one would have to go back to Watteau." In fact, the theme of aristocratic gardens, where attractive young women enjoy the childlike pleasures of swinging while their potential suitors watch, is familiar throughout Rococo painting, from Watteau and Fragonard to early Goya. As was so often the case, Renoir seems to reincarnate, in the context of modern working-class Paris, the pre-Revolutionary dreams of a land where all are young and carefree.

The scene here is set in the garden of a ramshackle house in Montmartre, where Renoir had rented a room; the characters are probably a local woman, Jeanne, the painter Norbert Goeneutte (page 382), and an unidentified man and child. But if they and the site are real, Renoir has dissolved the whole into a balm of softly dappled paint, an almost liquid blur of speckled yellows and blues that, inspired by sunlight seen through leaves, lead a pulsating life of their own. The innovation of these soft but discrete strokes of bright hues offended many conservative eyes of the 1870s, such as those of the critic who noted their resemblance to spots of grease on the models' clothing; but for twentieth-century eyes, especially those of the vast audiences who believe in Renoir's smiling messages, these melting flecks of sunshot color become an elixir of youth and happiness. Under their restorative powers, the sun always shines, cheeks and lips are forever red, and the only form of exertion is swinging in a shady spot. Even though the sense of time, as in most Impressionist painting, is ephemeral (one can almost feel the shifting balance of the swing or the child's restlessness), an eternal Arcadia, untroubled by the mundane problems of earning one's bread, is promised. As in Rococo art, adults are on a perpetual vacation.

By the 1870s, Renoir had temporarily dissolved the strong sense of modeled, bounded forms that characterizes his work of the 1860s, suggesting now a kind of floating intangible world where near and far, substance and shadow, color and light are one. It was a vision he would further amplify the same year in the *Ball at the Moulin de la Galette* (page 298), another variation on the Fountain of Youth inspired by the popular outdoor dance hall near Renoir's quarters in Montmartre. And like *The Swing*, this more ambitious painting is spotted with the organic, sunlit equivalent of the stroboscopic lighting effects that would create eternal cheer and vitality in the discos of our own time.

facing page
AUGUSTE RENOIR, Limoges 1841–Cagnes-sur-Mer 1919
The Swing, 1876
3′ x 2′ 4¾″ (92 x 73 cm) Bequest of Gustave Caillebotte, 1894.
RF 2738

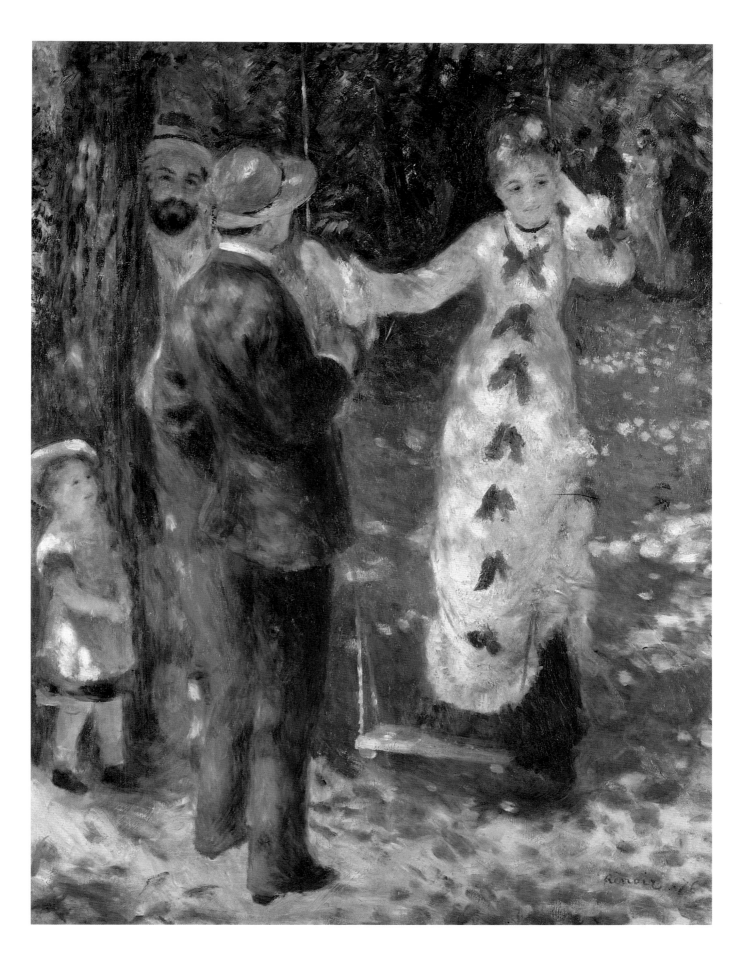

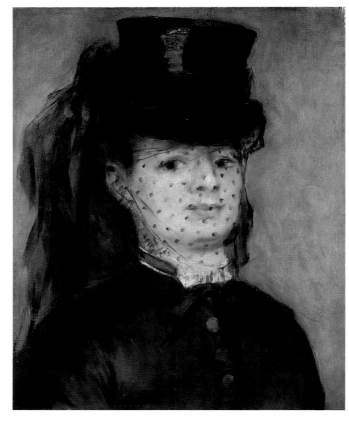

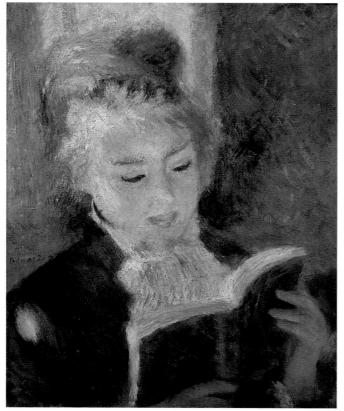

AUGUSTE RENOIR
Mme. Darras, ca. 1873
1′ 6¾″ x 1′ 3¼″ (47.5 x 39 cm) Gift of
Baroness Eva Gebhard-Gourgaud, 1965. RF 1965-11

left, top
AUGUSTE RENOIR
Self-Portrait, 1879
7½″ x 5½″ (19 x 14 cm) Gift of Daniel Guerin, 1952. RF 1952-33

left, bottom
AUGUSTE RENOIR
Woman Reading, 1874
1′ 6¼″ x 1′ 3¼″ (46.5 x 38.5 cm) Bequest of Gustave Caillebotte,
1894. RF 3757

facing page
AUGUSTE RENOIR
Charles Le Cœur, 1874
1′ 4½″ x 11½″ (42 x 29 cm) Gift of Eduardo Mollard, 1961.
RF 1961-22

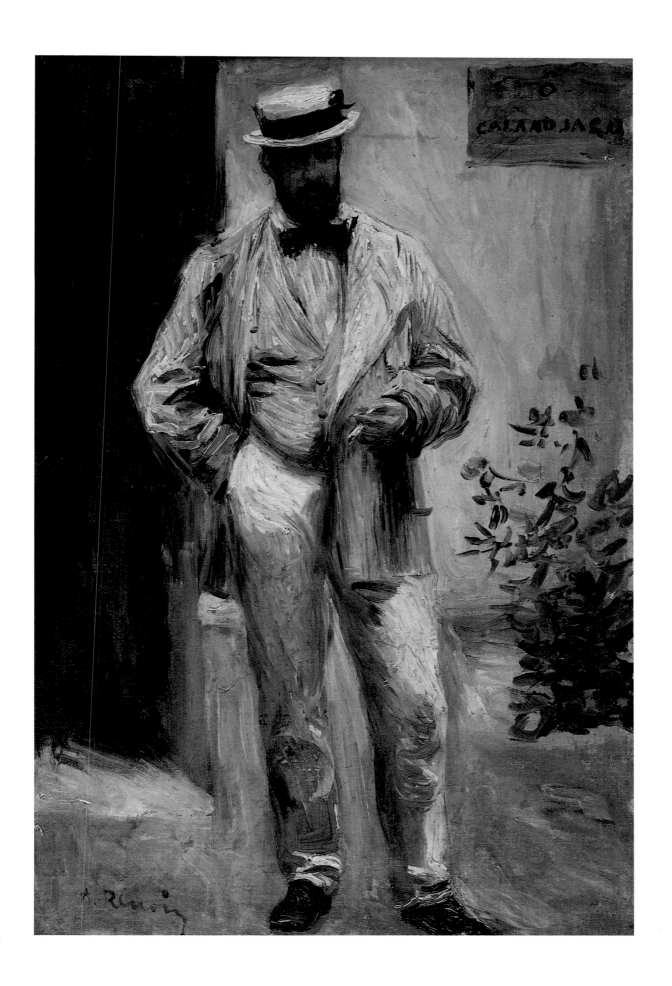

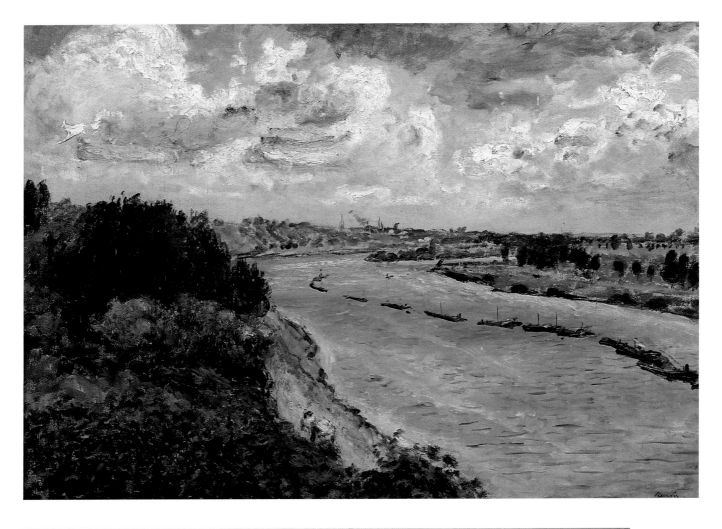

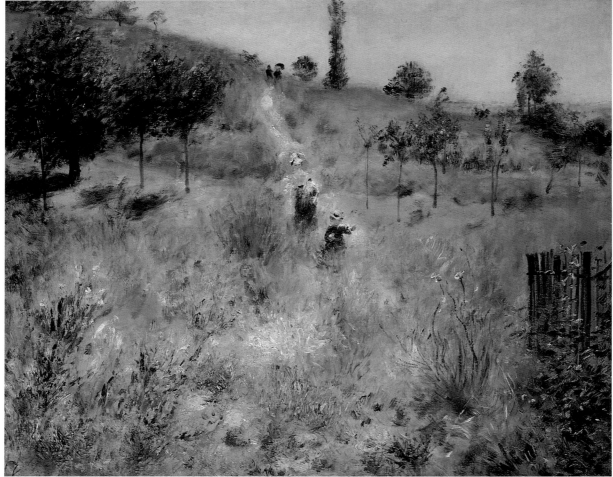

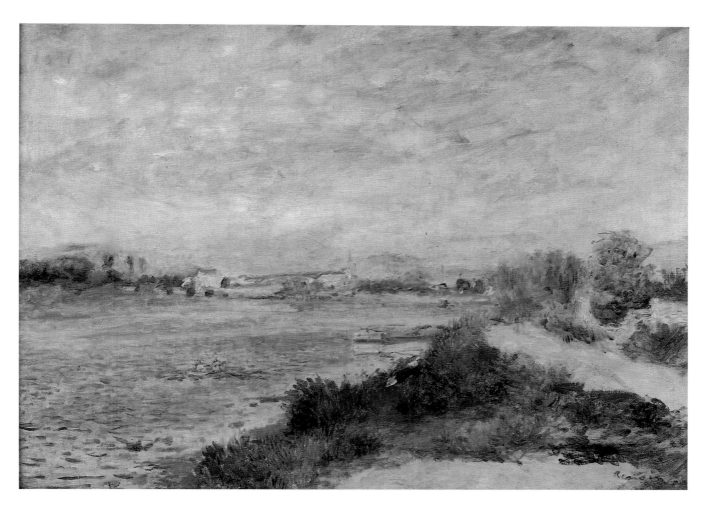

AUGUSTE RENOIR
The Seine at Argenteuil, ca. 1873
1′ 6¼″ x 2′ 1½″ (46.5 x 65 cm) Gift of Dr. and Mrs.
Albert Charpentier, 1951. RF 1951-14

facing page, top
AUGUSTE RENOIR
Barges on the Seine, 1869
1′ 6½″ x 2′ 1¼″ (47 x 64 cm) Bequest of Mr. and Mrs.
Raymond Koechlin, 1931. RF 3667

facing page, bottom
AUGUSTE RENOIR
Road Rising into Deep Grass, ca. 1876–1877
1′ 11½″ x 2′ 5¼″ (60 x 74 cm) Gift of Charles Comiot, 1926. RF 2581

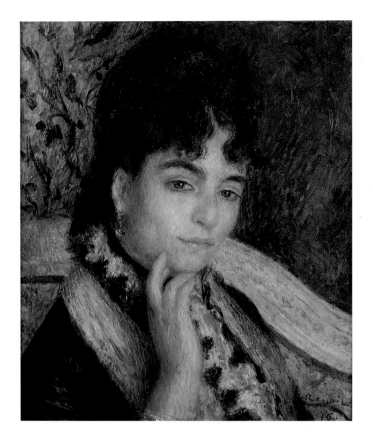

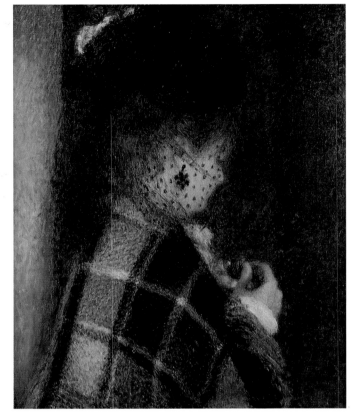

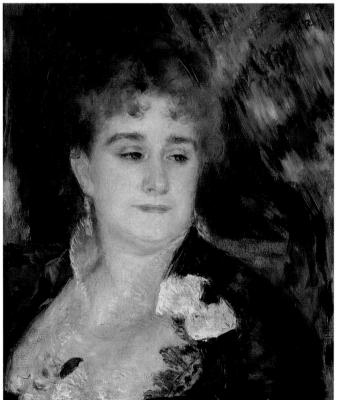

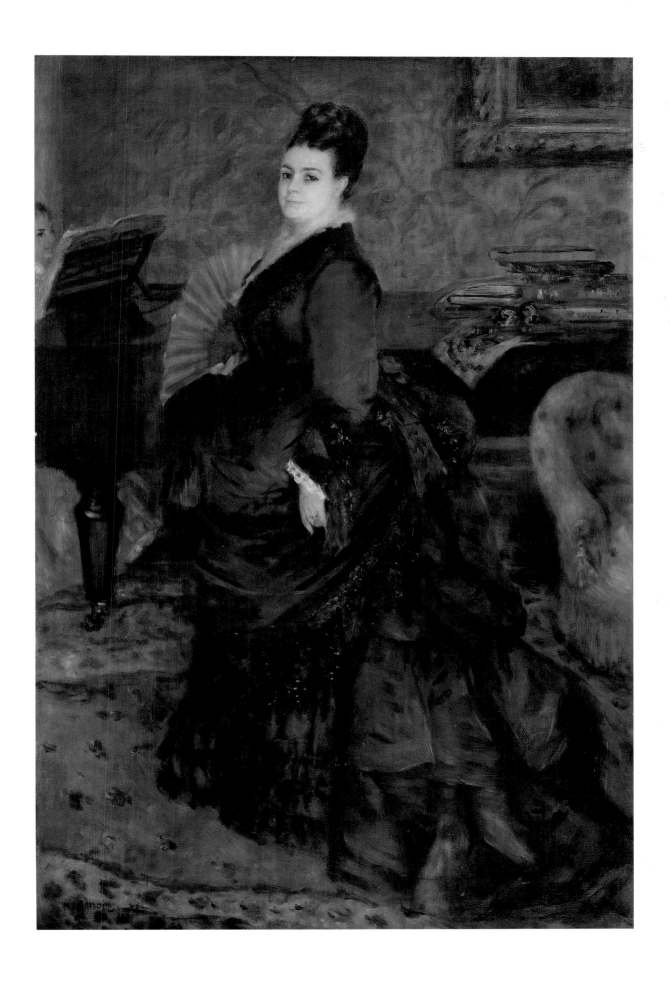

Study; Torso, Sunlight Effect

*W*hen it was first seen in 1876, at the second Impression-
ist group show, Renoir's light-dappled nude divided critical
opinion, as it still may do for us. Some found the flesh color
a triumph of luminous softness, whereas others, venomous-
ly hostile to the Impressionists' new techniques of violating
a local color (here the pink of the body) with a kaleidoscope
of reflected hues (here a melting rainbow of yellows, greens,
blues, and purples), compared the effect to that of a putre-
fying corpse or of game that had been hung far too long.
Today, of course, Renoir's way of painting a naked woman
seems far more natural than the artificial perfection of the
ivory-smooth, often colorless nudes that reigned in the
Salons of the 1870s; and for most international audiences of
the late twentieth century, his depiction of flesh is like an
immersion in the Fountain of Youth.

But for some, the caressing fluidity of Renoir's high-
keyed palette leaves too sweet a taste, especially compared to
the tarter colors of Degas's and Manet's nudes; for others,
such a typical Renoir female also contributes to assumptions
about womankind that we can no longer tolerate. In Renoir's
vision, woman and nature are equated, in this case as a ripe,
young jungle goddess emerging from a sunstruck verdant
landscape. The model, Anna, was only nineteen when
Renoir painted her; and if we are to follow the artist's
intuition, she was born only for love and procreation, her
small head happily incapable of serious thought. Still, we
must also be awed by the power of Renoir's imagination,
which could re-create such deeply rooted prototypes in terms
of the most youthful pictorial innovations. Within a commu-
nal style that proclaimed modernity, he offered his personal
version of a newborn Venus, invigorating the official erotic
mythologies of Cabanel and Bouguereau (pages 39, 43).

facing page
AUGUSTE RENOIR
Study; Torso, Sunlight Effect, ca. 1876
2′ 8″ x 2′ 1½″ (81 x 65 cm) Bequest of Gustave Caillebotte, 1894.
RF 2740

AUGUSTE RENOIR
Alphonsine Fournaise, 1879
2′ 5″ x 3′ 1″ (73.5 x 93 cm) Gift of D. David-Weil, 1937. RF 1937-9

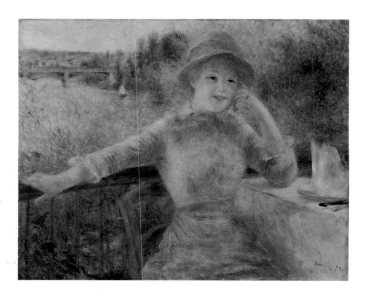

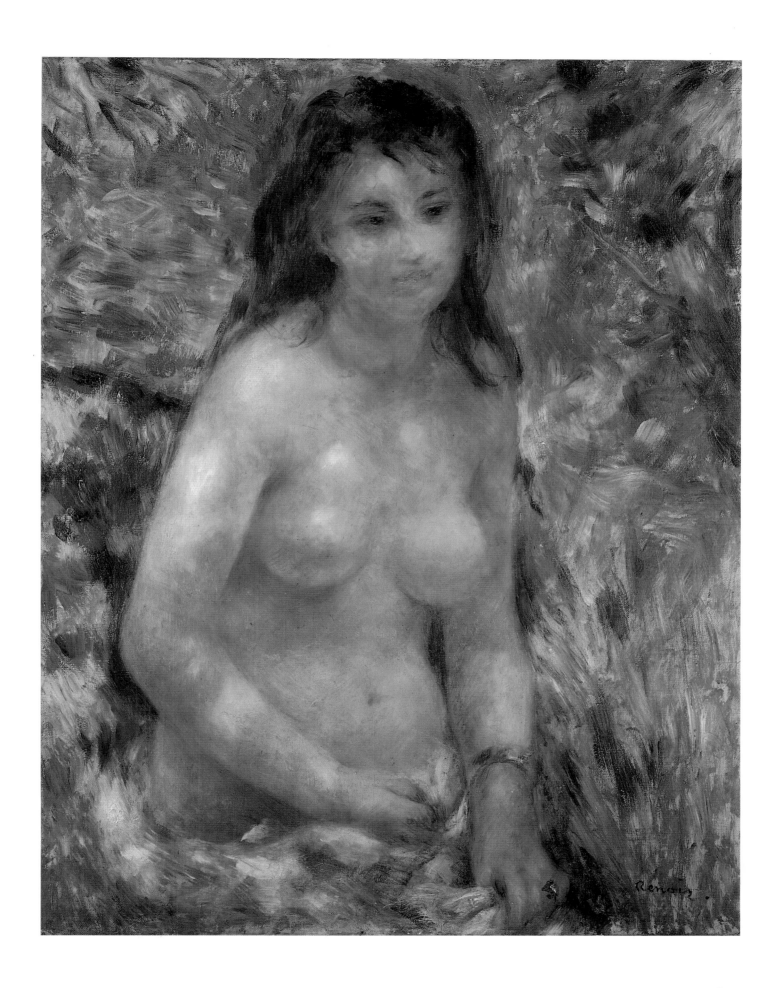

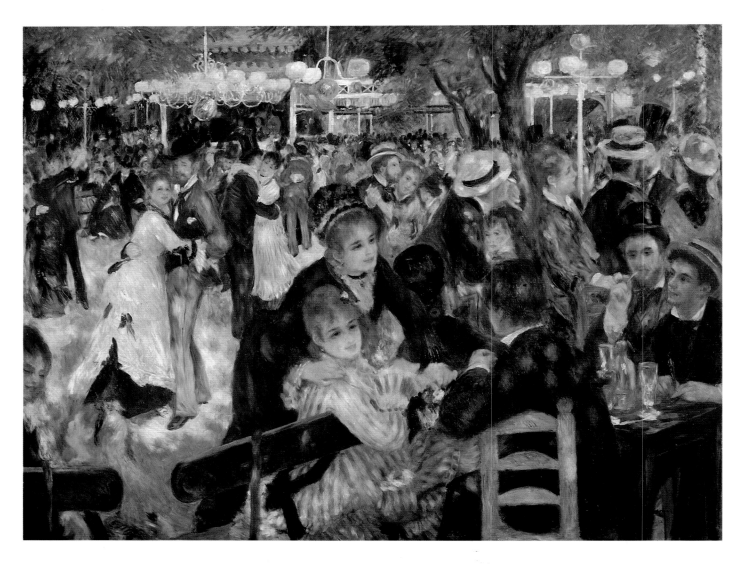

AUGUSTE RENOIR
Ball at the Moulin de la Galette, Montmartre, 1876
4′ 3½″ x 5′ 9″ (131 x 175 cm) Bequest of Gustave Caillebotte, 1894.
RF 2739

facing page
AUGUSTE RENOIR
Claude Monet, 1875
2′ 9½″ x 1′ 11¾″ (85 x 60.5 cm) Bequest of Mr. and Mrs.
Raymond Koechlin, 1931. RF 3666

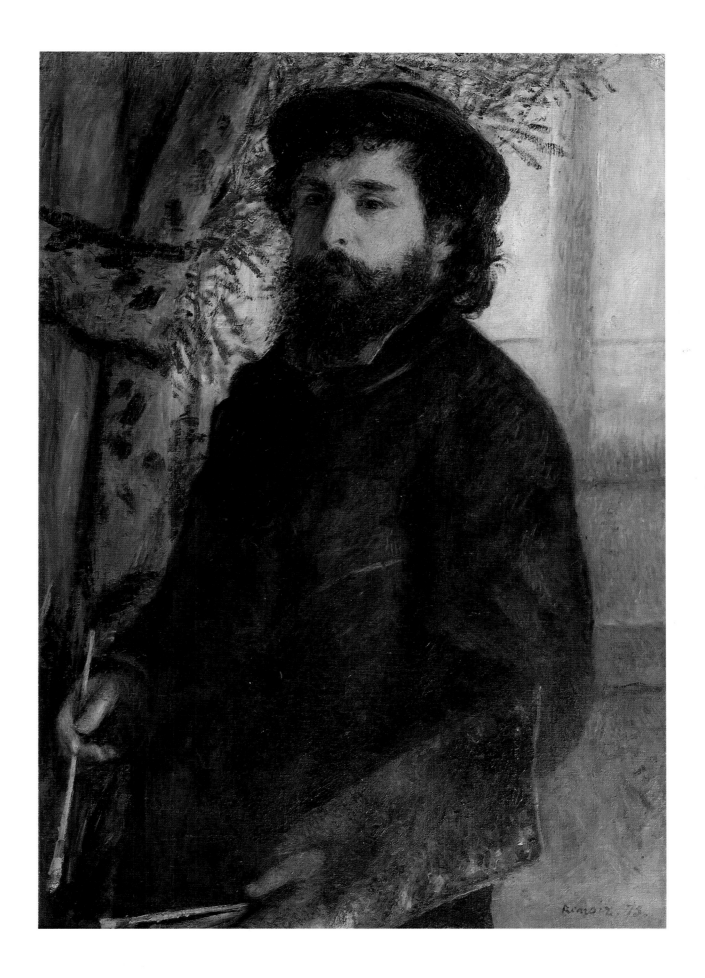

Morisot and Cassatt

Berthe Morisot
The Cradle

*L*ong a popular icon of modern maternity, Morisot's small painting now figures large, too, in feminist reconsiderations of the women painters included in the Impressionist group. Like her unmarried American counterpart Mary Cassatt (page 304), Morisot tended to restrict her themes to a world where men seldom intrude—an elegant, well-heeled society of women and children involved in the finer rituals of indoor and outdoor domesticity: sewing, boating, taking tea, gardening, mothering, and reading. For both artists, the mother-and-child theme was treated with a special freshness of observation. In the case of *The Cradle*, it was a birth in Morisot's own family, that of her sister Edma's baby, Blanche, in 1871.

Although Impressionist painting of the 1870s generally suggests a split-second world of perpetual motion, Morisot's nursery offers a surprising mood of long, stable contemplation, that of a mother, hand on cheek, gazing at her sleeping infant, who assumes almost the same posture. This vision of intimate reverie, of a mother scrutinizing her new baby, is given added intensity by the canopy over the cradle through which we, like the mother, must seek out the infant's features, so blurred and unformed in contrast to the sharply incised rendering of the mother's distinctive profile. (As a morbidly ironic counterpart to this, Monet, seven years later, would scrutinize the face of his wife on her deathbed as seen through another screen of gauzy paint, page 285.)

In a counter-movement to this strong sense of prolonged time, Edma's fingers subtly break the stillness, fidgeting with the fringe of the cover, as if to move it. Moreover, the broadly brushed veils of paint on curtains and canopy, with their abbreviated suggestions of diamond basketry pattern and pink embroidery, seem to rustle gently like a filmy breeze. The pastel delicacy, as well as the pampered, intimate environment, again conjures up, like many Impressionist paintings, a Rococo ancestry. This kinship was often felt by later writers on Morisot, one of whom claimed that "she had ground flower petals into her palette"; others asserted that she was literally a direct descendant of Fragonard, which she may actually have been.

Already exhibited in 1873 at the Durand-Ruel gallery in London, in a group show that included Monet, Sisley, Pissarro, and Degas, *The Cradle* was to make its Paris debut the following year at the first Impressionist exhibition. It must have looked far more conservative than Morisot's *Hide and Seek*, a painting of 1873 that depicts the same mother and child outdoors in what seemed to hostile critics an illegible torrent of camouflaging brushwork. And in 1874, the year of Morisot's marriage to Manet's brother Eugène, she painted the same pair, adding Edma's brand-new baby, Jeanne. In this canvas, *The Butterfly Hunt* (page 303), the stable enclosure of the nursery has been replaced by the openness of the garden, where a butterfly hunt among the dabs of yellow paint (flowers or butterflies?) further contributes to the Impressionist exploration of random motion and composition—a scene where even mother and daughters, if only for a moment, go their separate ways.

facing page
BERTHE MORISOT, Bourges 1841–Paris 1895
The Cradle, 1872
1′ 10″ x 1′ 6″ (56 x 46 cm) RF 2849

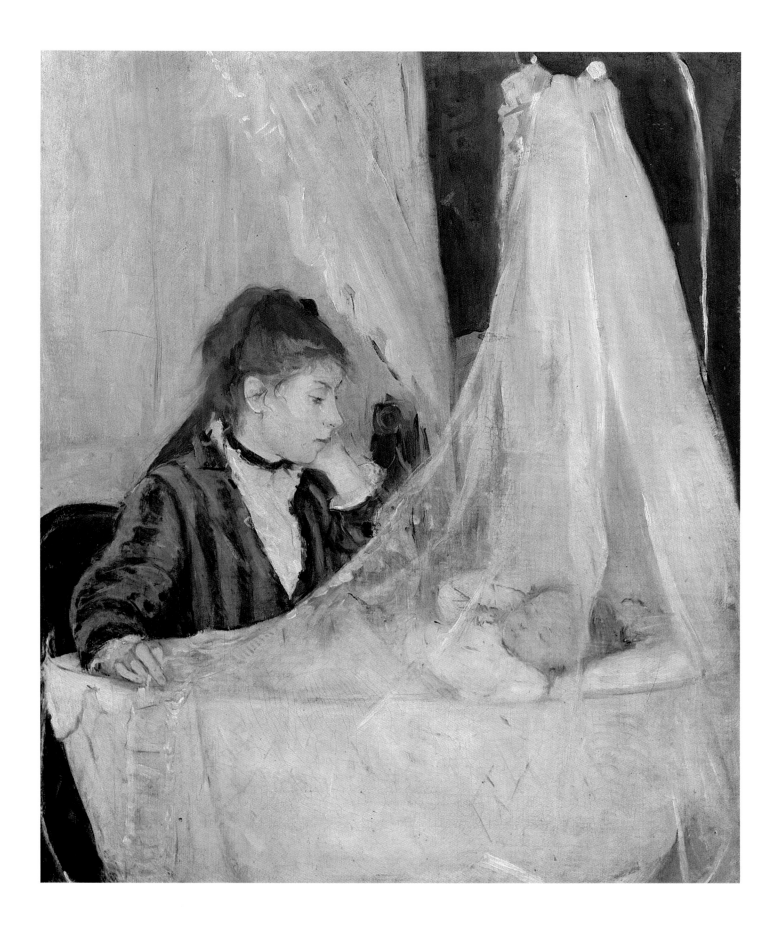

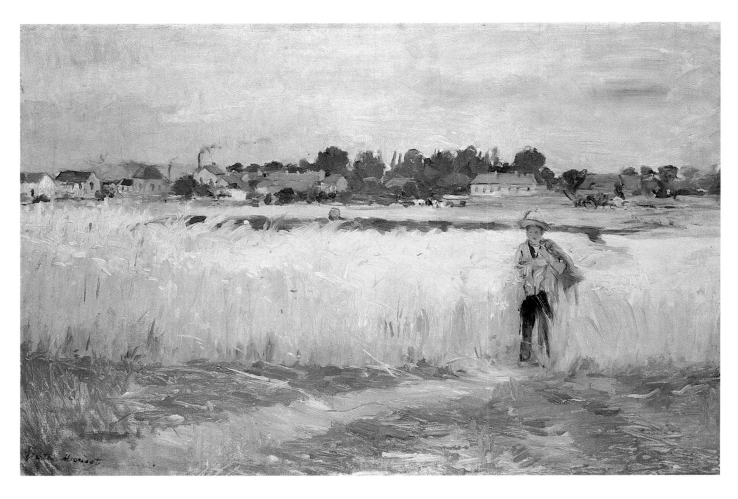

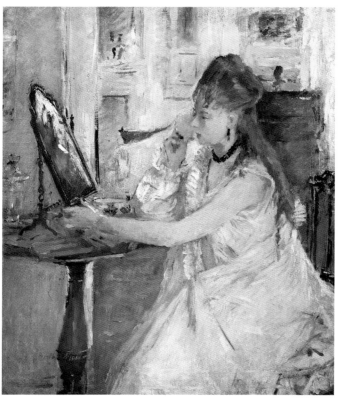

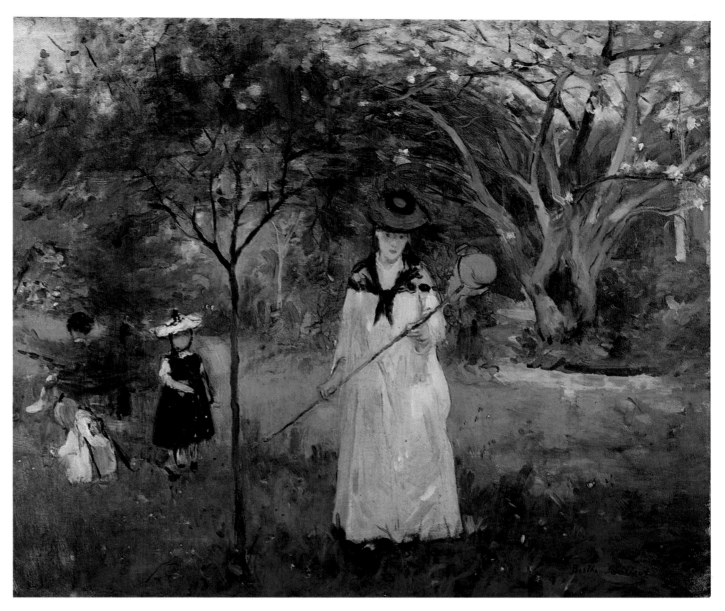

BERTHE MORISOT
The Butterfly Hunt, 1874
1′ 6″ x 1′ 10″ (46 x 56 cm) Gift of Étienne Moreau-Nélaton, 1906.
RF 1681

page 304
MARY CASSATT
Sewing Woman, ca. 1880–1882
3′ x 2′ 1″ (92 x 63 cm) Gift of Antonin Personnaz, 1937. RF 1937-20

page 305
BERTHE MORISOT
Young Woman in Evening Dress, 1879
2′ 4″ x 1′ 9¼″ (71 x 54 cm) RF 843

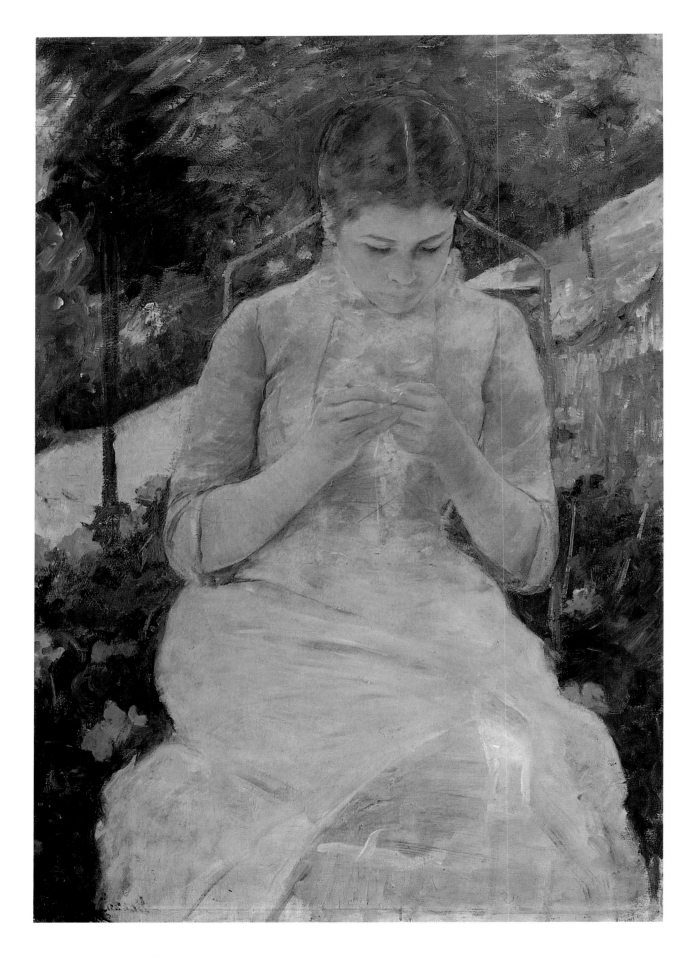

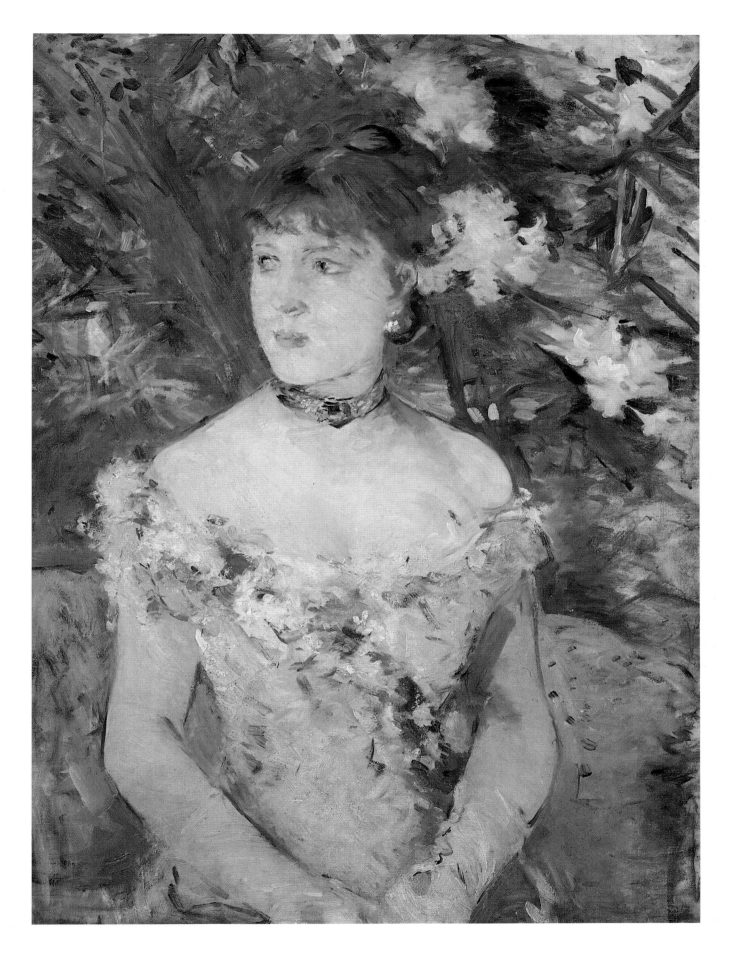

SISLEY AND GUILLAUMIN

Snow at Louveciennes

*W*ithin the Impressionist orbit of the 1870s, Sisley remains a lesser figure, a minor planet to Monet's sun. His canvases have almost a generic character, an impersonal textbook idea of a perfect Impressionist painting. *Snow at Louveciennes* is such a painting. Its title proclaims its theme, that of recording the effects of a snow-covered countryside not far from Paris, a rural landscape of a kind often frequented by the Impressionists when they substituted nature for the city as their pictorial motif. Typically, Sisley's snow is seen as a shimmer of white flakes of pigment, almost the equivalents of the real thing. These broad, animated brushstrokes even leave in doubt whether there is still snow in the air or whether it has all finally settled for the moment on the trees, the fences, the path that confronts us or the distant rooftop. Within this flurry of white paint, we also discern secondary layers of iridescent blues that reflect the overcast sky.

Like the snow itself, this is a world of fragile instability in both substance and tonality, where the blinking of an eye, a patch of sunlight, or a lesser breeze could change everything. Almost ironically, Sisley has composed his cropped, casual vista with a nod in the direction of one-point perspective, producing a head-on view of parallel walls that, like the proverbial railroad tracks, should converge on the horizon. Moreover, he has placed a dark smudge of a figure at the end of this plunging view. But this traditional effect of depth is canceled by the mottled surface, whose pigmented crust denies, as in a tapestry, a convincing illusion. And this old-fashioned sense of narrative focus, here upon a single figure, is also belied by the accidental character of the scene—an ephemeral glimpse of the countryside as we walk down a path to the house beyond. For all its centrality, the figure yields no message. All these assaults on traditions of space, subject, and surface finish typify a major aspect of Impressionist innovation in the 1870s, producing in Sisley's hands modest but authentic poetry of vintage date.

Of English birth and descent, Sisley, like the thoroughly French Monet, also reveals here connections with English painting. Often invoked as prophets of Impressionism, John Constable and J.M.W. Turner, whom Sisley had studied during a London sojourn, must have offered support for these visual adventures. There is not only the flecked vibrancy of brushwork, so apparent in Constable's sketches, but also the fascination with misty, pulverized

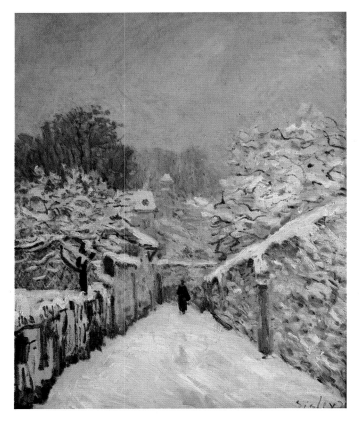

ALFRED SISLEY, Paris 1839–Moret-sur-Loing 1899
Snow at Louveciennes, 1878
2′ x 1′ 8″ (61 x 50.5 cm) Bequest of Count Isaac de Camondo, 1911.
RF 2022

facing page, top
ALFRED SISLEY
The Bark during the Flood, Port Marly, 1876
1′ 8″ x 2′ (50.5 x 61 cm) Bequest of Count Isaac de Camondo, 1911.
RF 2021

facing page, bottom
ALFRED SISLEY
The Flood at Port Marly, 1876
1′ 11½″ x 2′ 8″ (60 x 81 cm) Bequest of Count Isaac de Camondo,
1911. RF 2020

whiteness that Turner had used to suggest the mysterious energies of snow, wind, and steam. Such Romantic ambitions, however, were quickly domesticated by Sisley and Monet. Their visions in the 1870s of impalpable nature were rooted in first-person encounters with a rural, generally benign landscape. Indeed, even when Sisley painted the aftermath of the flood that devastated Port-Marly, the waters of the Seine, which half submerged the village, look almost as inviting as a trip to Venice.

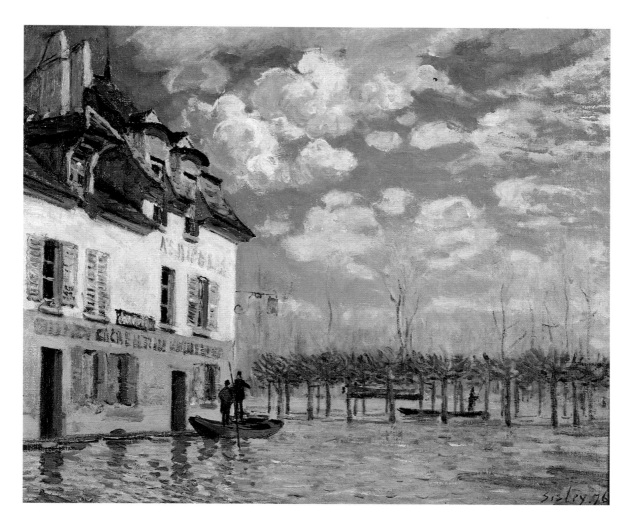

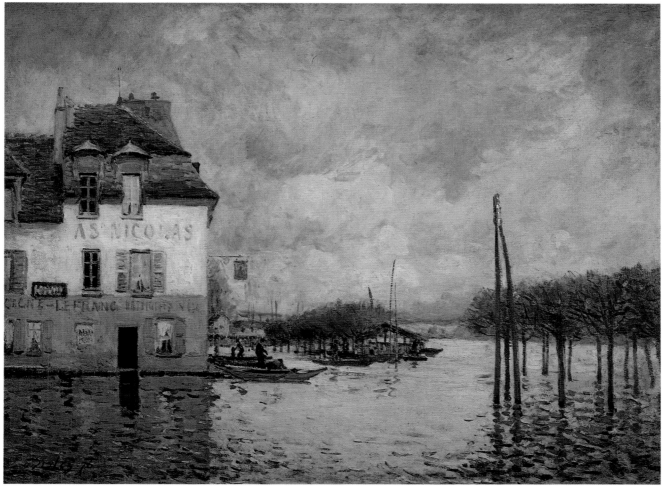

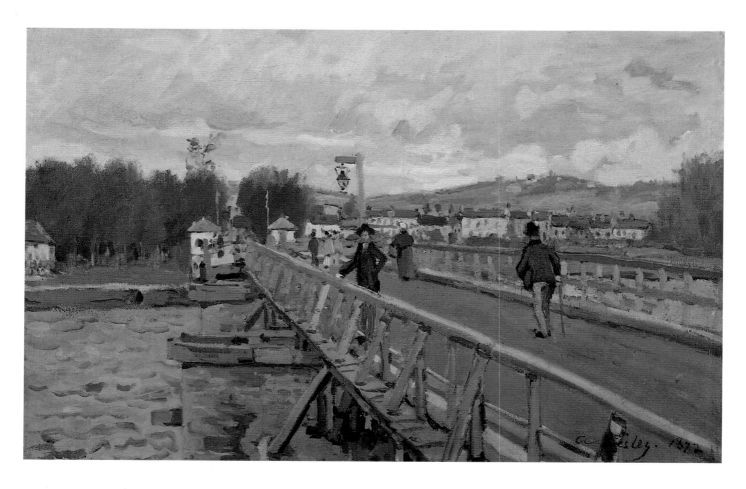

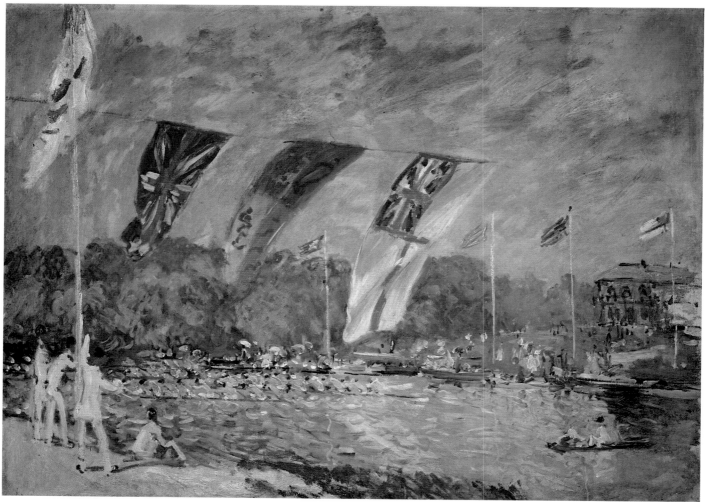

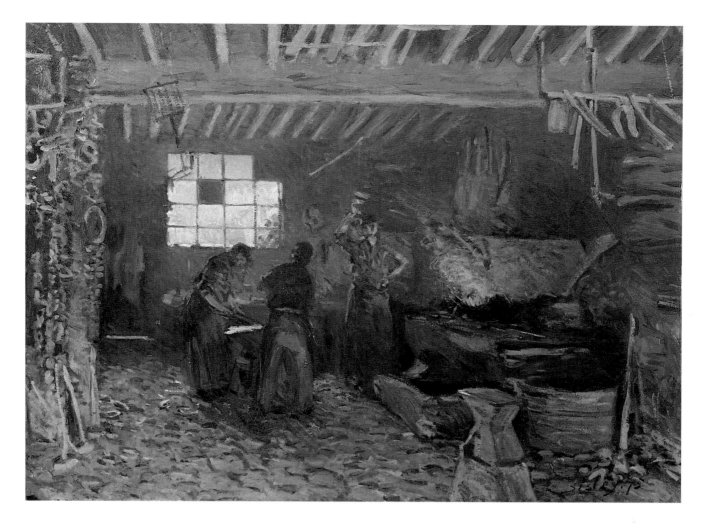

ALFRED SISLEY
The Forge at Marly-le-Roi (Yvelines), 1875
1′ 9¾″ x 2′ 5″ (55 x 73.5 cm) Gift of Étienne Moreau-Nélaton, 1906.
RF 1689

ALFRED SISLEY
Fog, Voisins, 1874
1′ 7¾″ x 2′ 1½″ (50 x 65 cm) Bequest of Antonin Personnaz, 1937.
RF 1937-64

facing page, top
ALFRED SISLEY
Footbridge at Argenteuil, 1872
1′ 3¼″ x 1′ 11½″ (39 x 60 cm) Gift of Étienne Moreau-Nélaton,
1906. RF 1688

facing page, bottom
ALFRED SISLEY
The Regatta at Molesey (near Hampton Court), 1874
2′ 2″ x 3′ (66 x 91.5 cm) Bequest of Gustave Caillebotte, 1894.
RF 2787

Armand Guillaumin
Self-Portrait; Reclining Nude; Setting Sun at Ivry

*A*s with all groups, the artists who showed at the eight Impressionist exhibitions, from 1874 to 1886, shared communal viewpoints but were also individuals; and it is fascinating to seek out, especially among the lesser-known painters represented there, the distinctive flavor that marks a personal signature. In the case of Guillaumin, many canvases of the 1870s reveal a surprising undertow, akin to that of his friend Cézanne, conveying distress signals beneath their would-be objective accounts of things seen. His self-portrait clearly announces the disturbed spirit that also seems to trouble the model in his *Reclining Nude*. Seen at the third Impressionist group show of 1877, this figure belies the rapid decorative flourishes of flowered curtains and fan with an inward, melancholy expression unknown in the emotional repertory of the robust and contented nudes of Renoir, but familiar in the anxieties of Cézanne's earlier erotic fantasies (page 241).

Oddly disconcerting, too, is the view of a spectacular sunset in the Parisian suburb of Ivry (page 313), which figured at the first Impressionist show of 1874. What might have been a canvas of picture-postcard allure turns into a brooding, awkward vista of darkly silhouetted trees against the distorting swell of a distant shore, where an ugly complex of factory buildings belches forth gusts of polluting smoke into the blaze of an overcast sky. Moving from fiery red and orange to, at the top, a daylight blue, this dramatic spectrum is choppily reflected in the waters of the Seine below, transforming Monet's concern with the vibrant continuities of sky and water into something more like an engulfing anxiety. Indeed, such a canvas seems only a few steps away from the overt, near-apocalyptic drama of Van Gogh's and Munch's later landscapes (pages 487 and 569), where earth, tree, and sky heave and pulsate together with the artists' turbulent emotions.

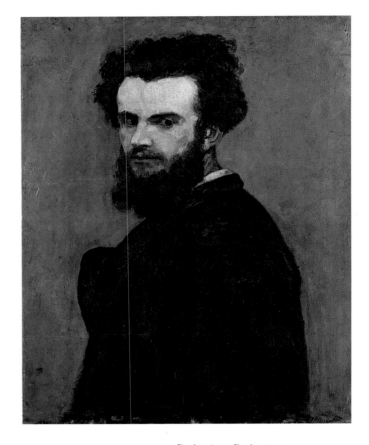

ARMAND GUILLAUMIN, Paris 1841–Paris 1927
Self-Portrait, ca. 1875
2′ 4¾″ x 1′ 11½″ (73 x 60 cm) Gift of Paul and Marguerite Gachet, 1949. RF 1949-18

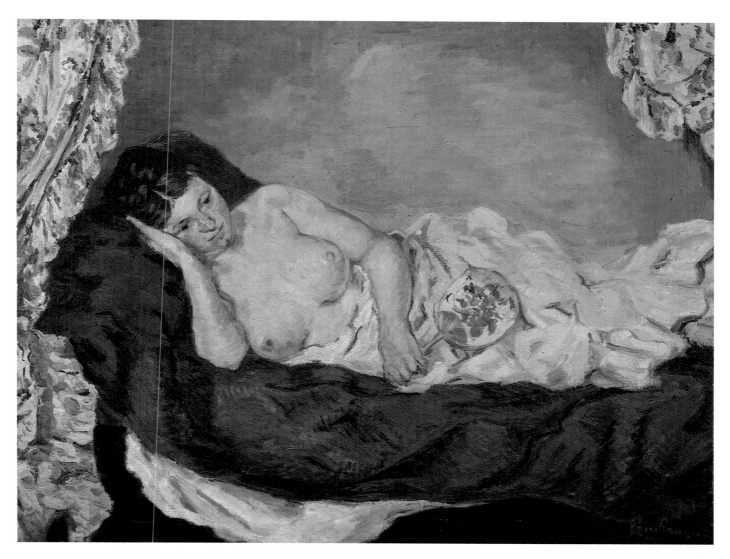

ARMAND GUILLAUMIN
Reclining Nude, ca. 1877
1' 7¼" x 2' 1½" (49 x 65 cm) Gift of Paul Gachet, 1951. RF 1951-35

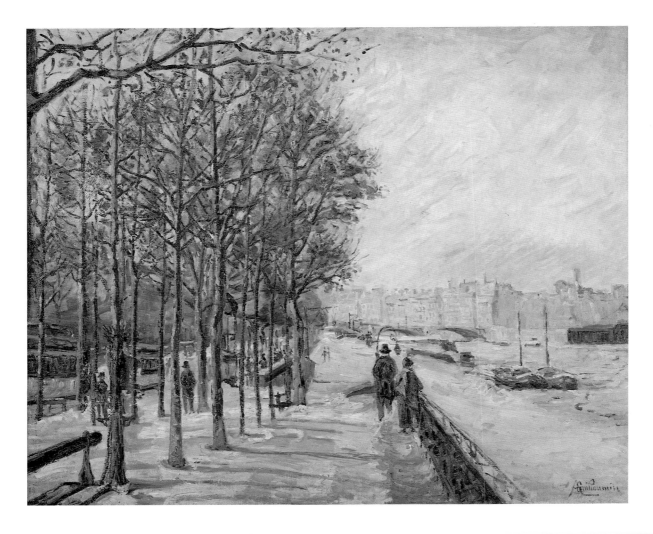

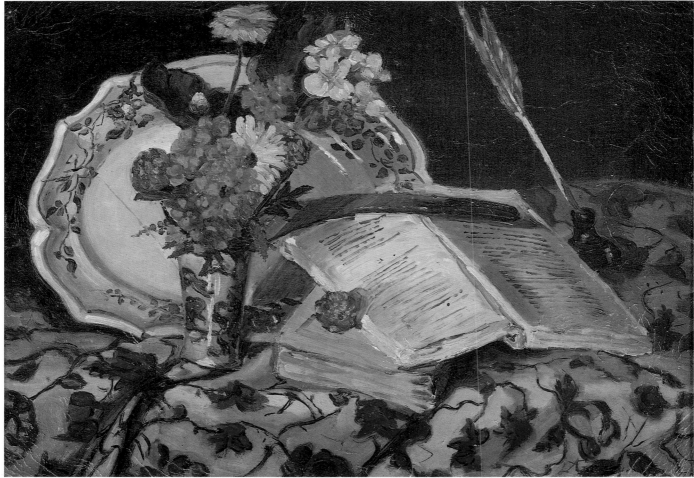

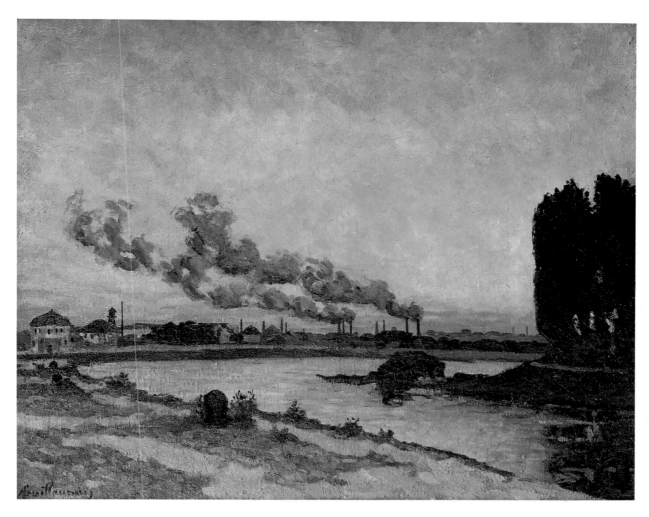

ARMAND GUILLAUMIN
Setting Sun at Ivry, ca. 1869–1871
1′ 1½″ x 2′ 8″ (65 x 81 cm) Gift of Paul Gachet, 1951. RF 1951-34

facing page, top
ARMAND GUILLAUMIN
Quai de la Gare, Impression of Snow; Quai de Bercy, Paris, ca. 1873
1′ 8″ x 2′ (50.5 x 61.2 cm) Bequest of Antonin Personnaz, 1937.
RF 1937-29

facing page, bottom
ARMAND GUILLAUMIN
Still Life; Flowers, Faïence, Books, 1872
1′ 1″ x 1′ 6″ (32.5 x 46 cm) Gift of Paul Gachet, 1954. RF 1954-9

PISSARRO: THE 1870S AND BEYOND

Hoarfrost

*A*lthough the popular image of Impressionism would waft us to a sunny vacation spot in a verdant landscape near Paris, there are also scenes that chill the bone and remind one of the hard life of peasants. Pissarro's painting is one of these. Described only in terms of its nominal subject, a peasant walking with a stick and carrying a bundle of branches along a wide path over a plowed field covered with hoarfrost, it might be from the hand of Millet or of countless other mid-century painters who depicted with respectful sobriety the hard lives of the rural poor. But, in fact, Pissarro's treatment of this theme was audacious enough to be included in the first Impressionist exhibition of 1874, where one of the more hostile critics, Louis Leroy, joked about how the work might make a conventional landscape painter try to clean his glasses; how it seemed to have neither foreground nor background, neither top nor bottom; how the frost looked like dirty palette scrapings.

Negative criticism can at times be even more telling than positive criticism, since it often pinpoints exactly what offends tradition in works of adventurous innovation. Leroy did precisely this by singling out in this painting many general characteristics of not only Pissarro's work but that of Monet, Renoir, and Morisot in the 1870s. These artists did willfully blur their colors and edges, leaving visible brush marks of pigment (the better to intensify their stenographic response to fugitive, pulsating sensation), and they did defy conventional perspective in a way that repeals the laws of gravity and fuses near and far. All of this can be discerned in Pissarro's canvas, in which the most nuanced veils of color evoke the complex layerings of furrows, of frost, of earth reflecting a winter sun, and of shadows (in the right foreground) cast by invisible trees. Moreover, the balance between figure and landscape (which is the dominant theme?) is upset in what becomes a visual continuum that can absorb a nearly sentimental image of the rigors of rural labor into a fabric of flickering pigment. Suddenly the lonely old man dissolves into what becomes almost a mirage of muffled striations and phantom colors.

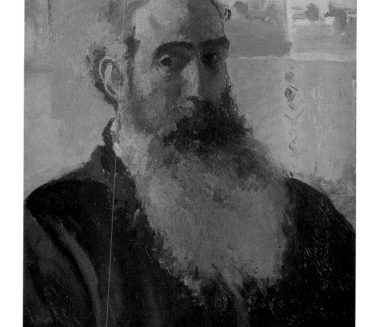

CAMILLE PISSARRO, St. Thomas 1830–Paris 1903
Self-Portrait, 1873
1′ 10″ x 1′ 6¼″ (56 x 46.5 cm) Gift of Paul-Émile Pissarro, 1930.
RF 2837

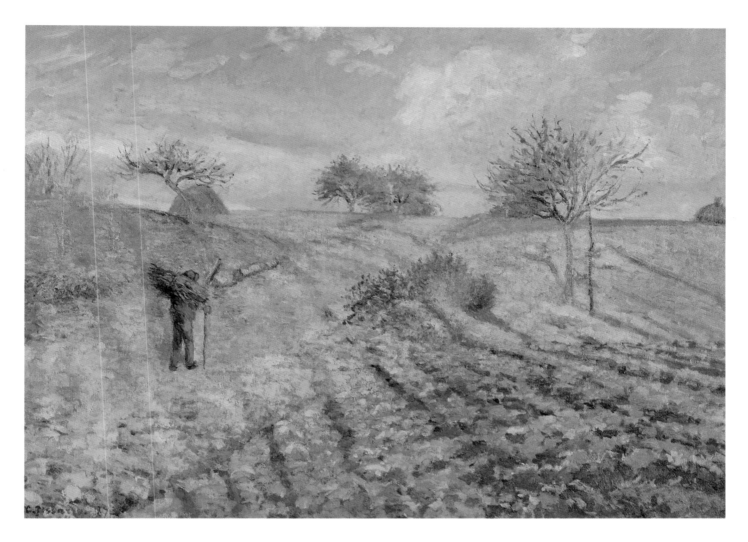

CAMILLE PISSARRO
Hoarfrost, 1873
2' 1½" x 3' 1" (65 x 93 cm) Bequest of Enriqueta Alsop, 1972.
RF 1972-27

CAMILLE PISSARRO
Landscape at Montmorency, ca. 1859
8½" x 10¾" (21.5 x 27.5 cm) Gift of Baron d'Albenas, 1943.
RF 1943-8

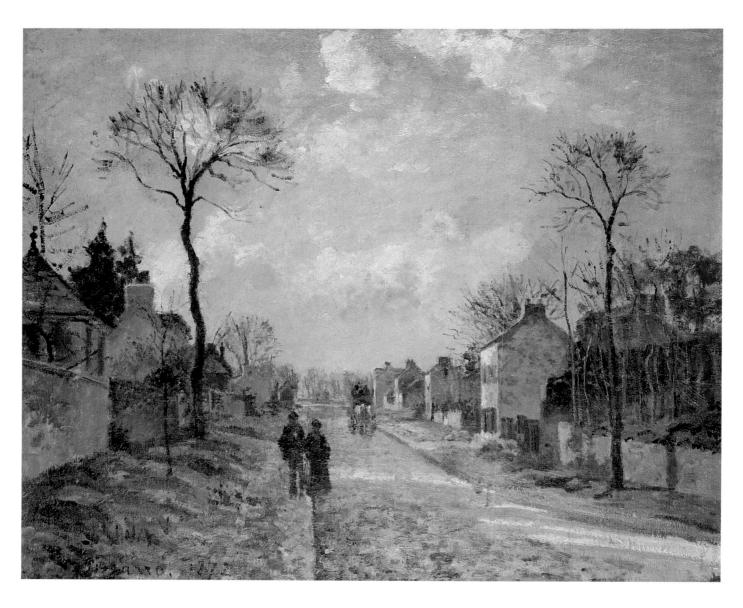

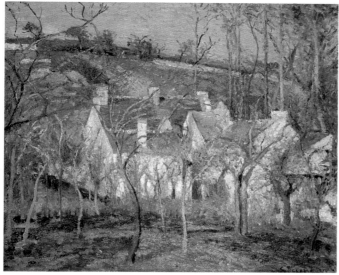

CAMILLE PISSARRO
The Road to Louveciennes, 1872
1′ 11½″ x 2′ 5″ (60 x 73.5 cm) Gift of Paul Gachet, 1951. RF 1951-37

CAMILLE PISSARRO
Red Roofs; Village Corner, Impression of Winter, 1877
1′ 9½″ x 2′ 1¾″ (54.5 x 65.5 cm) Bequest of Gustave Caillebotte,
1894. RF 2735

facing page, top
CAMILLE PISSARRO
The Harvest at Montfoucault, 1876
2′ 1½″ x 3′ (65 x 92.5 cm) Bequest of Gustave Caillebotte, 1894.
RF 3756

facing page, bottom
CAMILLE PISSARRO
Vegetable Garden and Trees in Flower; Spring, Pontoise, 1877
2′ 1¾″ x 2′ 8″ (65.5 x 81 cm) Bequest of Gustave Caillebotte, 1894.
RF 2733

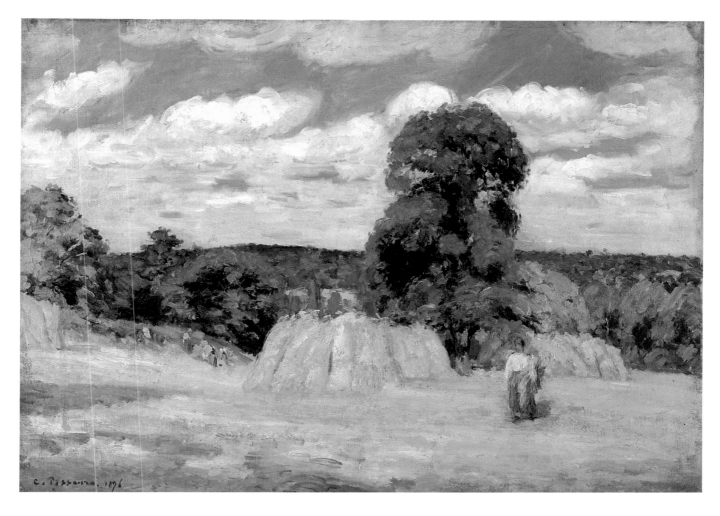

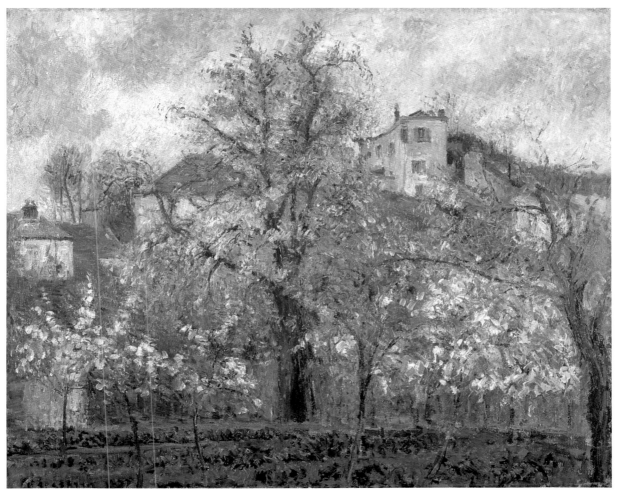

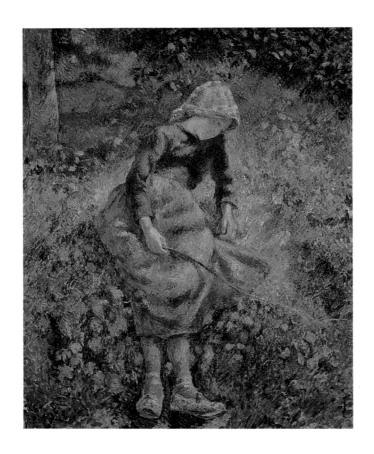

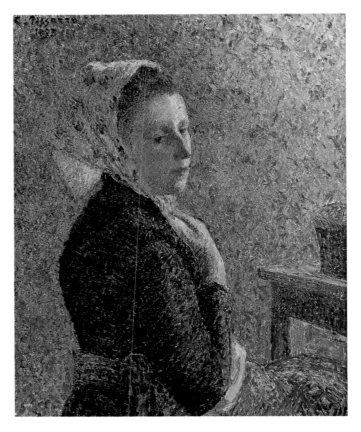

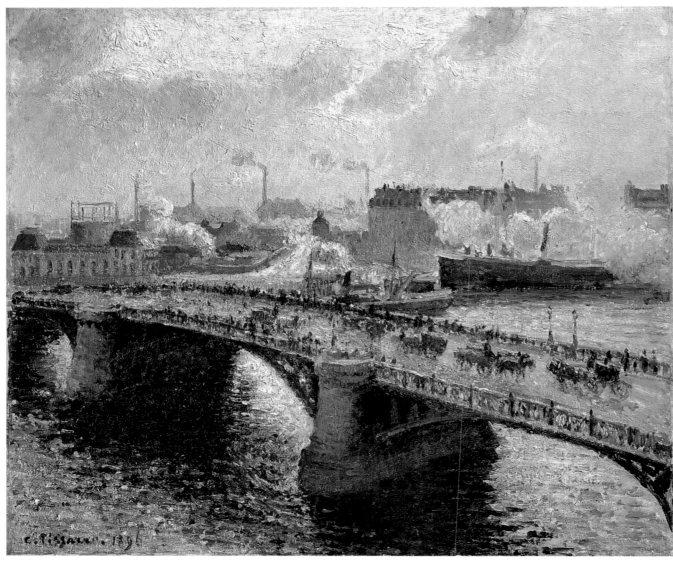

CAMILLE PISSARRO
The Church of St. Jacques at Dieppe, 1901
1′ 9½″ x 2′ 1¾″ (54.5 x 65.5 cm) MNR 22

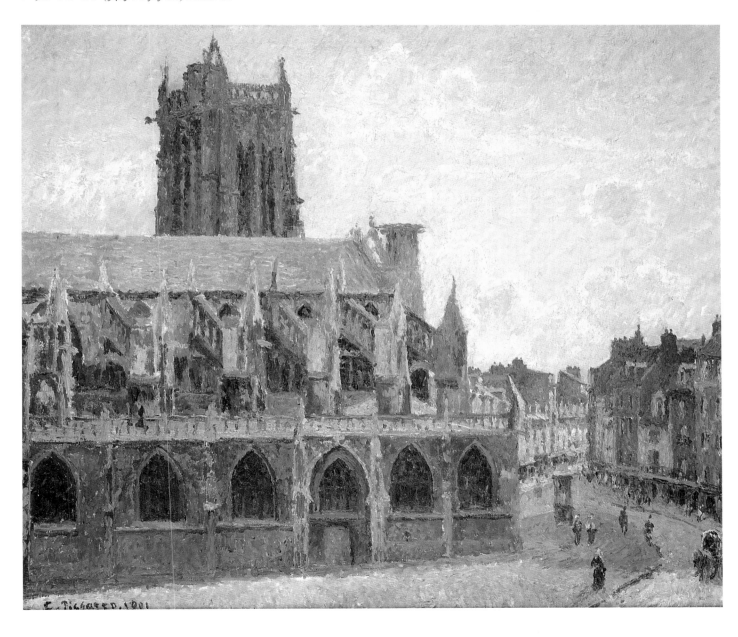

Woman Hanging Laundry

Cheerful, miniature laundresses often populated the fairy-tale countryside of Rococo paintings, but it is more surprising to see them still at work in the Impressionist sunshine of the 1870s and 1880s. In this and in many other ways, Pissarro's little canvas is both old and new. Like his *Hoarfrost* of ca. 1873 (page 315), which took an old-fashioned, melancholy theme of a peasant's endurance and transformed it into a study of iridescent color and atmosphere on a bitter-cold winter day, this, too, takes us far from Paris and the modern social problems that persuaded Pissarro to espouse the cause of anarchism in the 1880s. We are instead in an untroubled rural world, a reflection of life in the village of Eragny-sur-Epte, where the artist lived after 1884 and where, using wheelbarrows instead of machinery, women take their solid place as workers and mothers. Compared to Daumier's Seine-side washerwoman and child (page 85), this mother and daughter offer a perfect vignette of pink-cheeked contentment and sunlit optimism.

For all its archaism and sentimentality of subject, however, the techniques explored here are as radically new as the Paris-Dieppe railway line that Pissarro had painted the year before, adapting the scientific inflections given to Impressionism in the mid-1880s by Seurat and Signac. A man of the modern world as well as a keeper of pre-industrial flames, Pissarro was eager to try this methodical, corrective approach to the intuitive freedom of hue and brushstroke enjoyed by the Impressionists. It is the age of the machine and of scientific faith that is reflected in Pissarro's tidy and predetermined fabric of paint, in which the weave of tiny points of pure hues looks as though it were made in a factory rather than y the peasant woman next door. The dots of yellow pigment that create the blonde hair of mother and daughter have the proper proportion of reflected blues; the points of green that fuse into a patch of grass have their exact complements of red; and even the sparkling whiteness of the laundry is tinted with dots of yellow sun and blue shadow. For a scene that would flee from the ferment of nineteenth-century life, these new methods of painting, in which a study of modern color theory was used to determine every hue and brushstroke, could not be more up-to-date in a century that believed in science and in the building of complex wholes like the Eiffel Tower from modular, mechanical parts.

CAMILLE PISSARRO
Woman in a Field; Spring Sunlight in the Meadow at Eragny, summer 1887
1' 9½" x 2' 1½" (54.5 x 65 cm) Bequest of Antonin Personnaz, 1937.
RF 1937-47

facing page
CAMILLE PISSARRO
Woman Hanging Laundry, 1887
1' 4¼" x 1' 1" (41 x 32.5 cm) Bequest of Enriqueta Alsop, 1972.
RF 1972-29

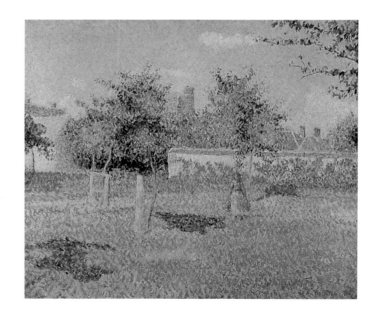

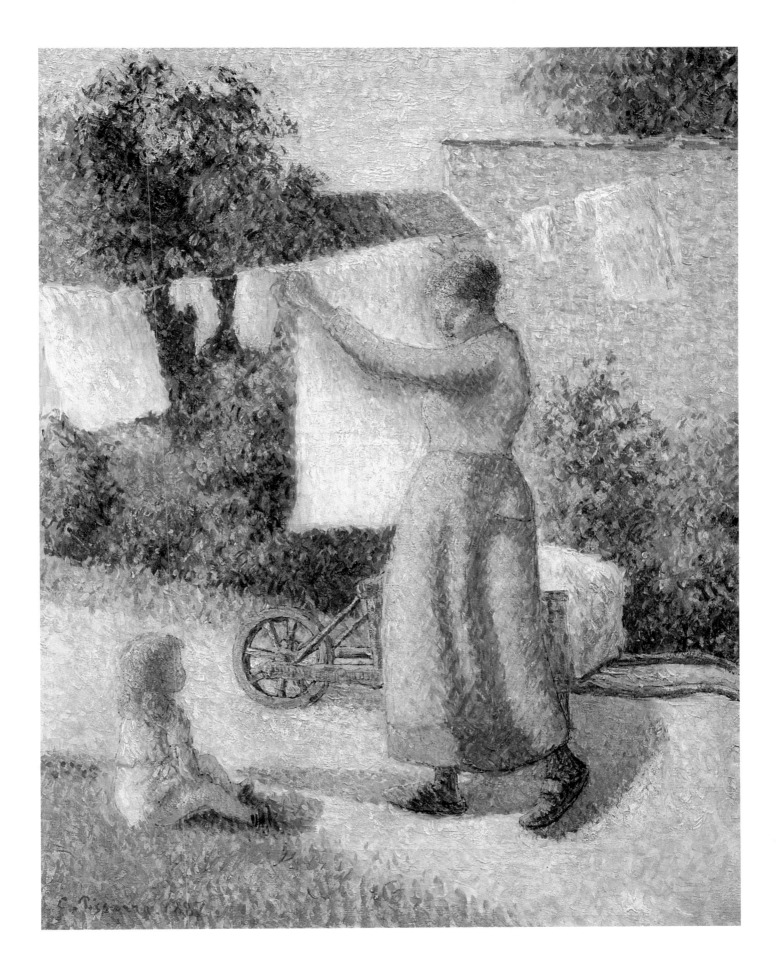

CAILLEBOTTE

The Floor-Scrapers

*A*lthough Courbet and Millet had already disarmed Parisian audiences by thrusting in their faces full-scale, even heroic, images of lower-class workers in city and country, Caillebotte's trio of Parisian laborers scraping the floors of an empty new room down to an even finish was and still is startling, even to the point of eccentricity. For here, as with Degas's laundresses (page 328), the most mundane theme of hard manual labor is filtered through the most refined, almost perverse, sensibilities.

For one thing, the three men oddly echo, in reverse, Millet's famous trio of gleaning women from the 1857 Salon (page 91), translating their agrarian remoteness into the immediacy of urban laborers who are building a new and modern Paris. Located, like Millet's peasant women, below a high horizon line, they look so eternally fixed in their back-breaking, bent postures that we feel they, too, might never be able to rise above the leveling horizon that keeps them in the place of underdogs. And the robotlike nature of their labor is further underlined by the repetitive stripes of the floorboards—an insistent beat that makes them function like machines.

But this mechanized image is ironically dandified, conforming in every way to Caillebotte's intensely personal aesthetic, so that even these anonymous, barebacked workers hold their utensils with aristocratic grace. The kind of labor involved is, in fact, skilled, demanding precision instruments equipped with sharp blades and files and trained workers attuned to such refined adjustments of plane and edge. Caillebotte himself was such a worker, as suggested by the meticulously calculated disposition of every figure and object in the painting. Viewed from an unexpectedly high vantage point, the scene is transformed into a taut network of almost abstract patterns: the linear curves of the balcony grille versus the belt-line decoration of rectangular moldings; the parallel floor stripes versus the perfectly placed tools and wood shavings that interrupt the vertiginous rush of a converging perspective diagram.

Instantly conspicuous in size, style, and subject when it was shown in 1876 at the second Impressionist exhibition, *The Floor-Scrapers* is still an unforgettably anomalous painting. Although it clearly bears the marks of Caillebotte's academic training with Léon Bonnat (page 399) in its full and detailed modeling and its dark-brown, old-master tonality, its audacious modernity is no less apparent in the insistent geometries and the oddly cropped and steeply tilted ground plane. At the right, the wine bottle and glass, as in later works by Degas and Cézanne, seem to defy gravity, hovering against a floor that refuses to support them; and for late twentieth-century eyes, the relentless pattern of dark, vibrantly edged stripes, measuring out the entirety of a flat plane, can even evoke Frank Stella's black paintings of 1959.

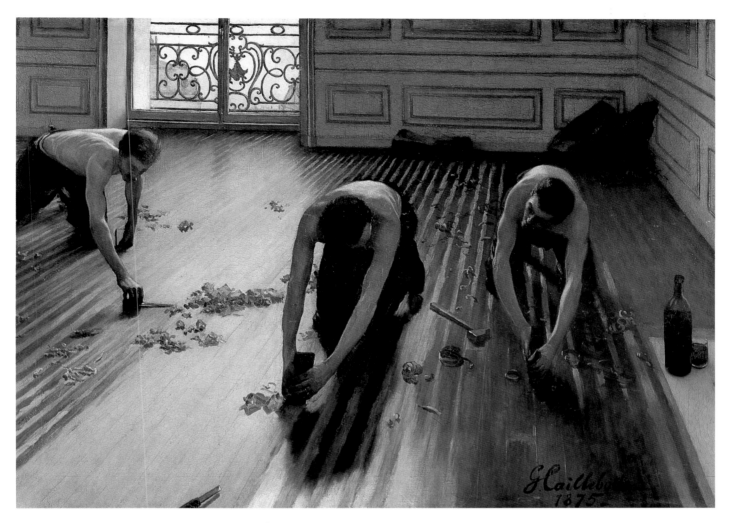

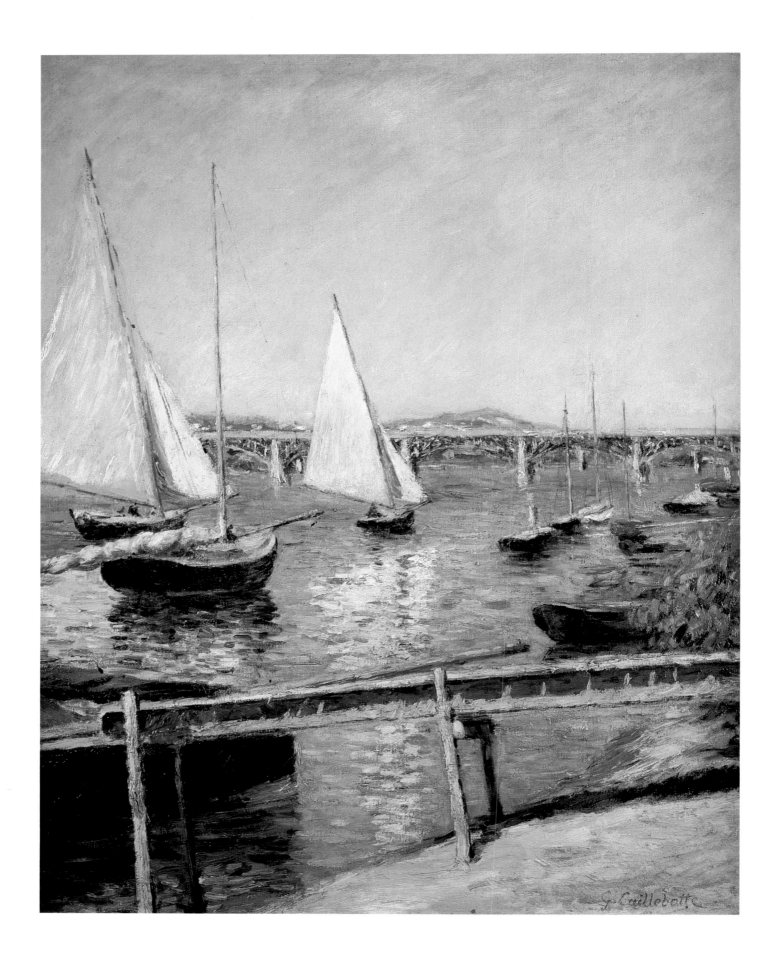

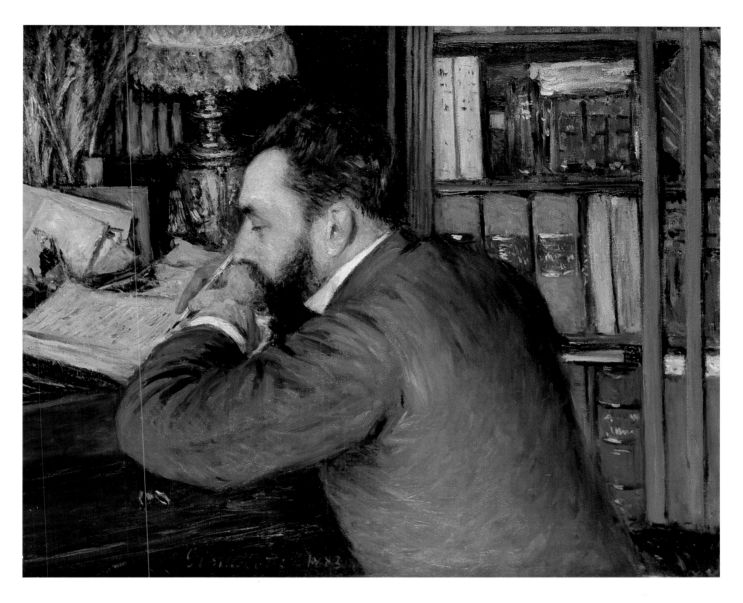

GUSTAVE CAILLEBOTTE
Henri Cordier, 1883
2' 1½" x 2' 7½" (65 x 80 cm) Gift of Mrs. Henri Cordier, 1926.
RF 2729

GUSTAVE CAILLEBOTTE
Rooftops in the Snow, 1878
2' 1" x 2' 8" (64 x 82 cm) RF 876

facing page
GUSTAVE CAILLEBOTTE
Sail Boats at Argenteuil, ca. 1888
2' 1½" x 1' 9¾" (65 x 55.5 cm) RF 1954-31

Gustave Caillebotte
Self-Portrait

Within the context of Caillebotte's art, this small but intense self-portrait is surprisingly personal—a piercing revelation from an artist whose aesthetic stance, like that of Manet and Degas, usually resembled that of a detached observer. Although Caillebotte could hardly have guessed that he would die only two years later, before his forty-sixth birthday, this self-portrait, given that biographical hindsight, suddenly carries a tragic, introspective charge, unexpectedly akin to what were also to be the prematurely late self-portraits of Van Gogh (page 476).

The Impressionist use of bluish tones for shadows had become a common formula by the 1890s. Here they create, as in Van Gogh's blue grounds, an almost otherworldly aura around the tight but nervous contours of the figure, singling it out from the neutral white ground which, lacking suggestions of any particular environment, cannot deflect our attention from the dark, penetrating stare. Nor is there any detail of clothing to distract us, for the deep blue jacket is so generalized that it becomes a vague enclosure from which the intense facts of physiognomy and psychology emerge with all the more arresting immediacy. Like his mouth and posture, Caillebotte's gaze is fixed, even strained; but this taut discipline, so familiar to his sense of aesthetic order, is countered by the darkly shadowed eyes and far cheek, which plumb strange territories of private unrest like an entry in a diary.

As a final irony, this late self-portrait bears an uncanny resemblance in expression and bearing to a youthful self-portrait by Caillebotte's own master, Bonnat, painted in 1855, when he was only twenty-two (page 67).

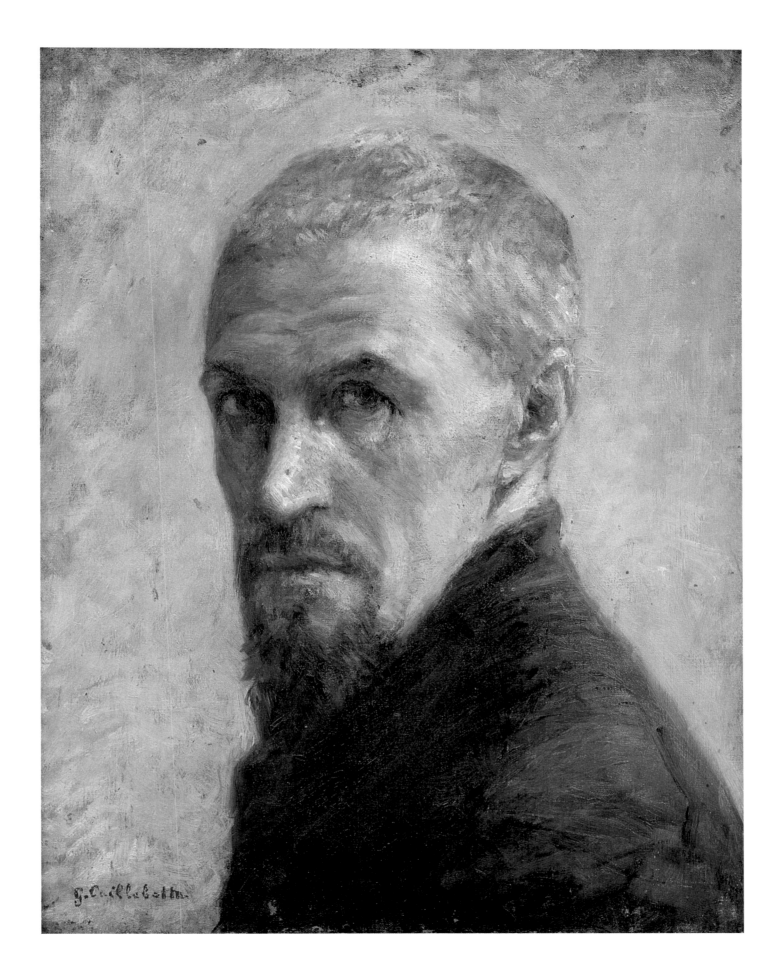

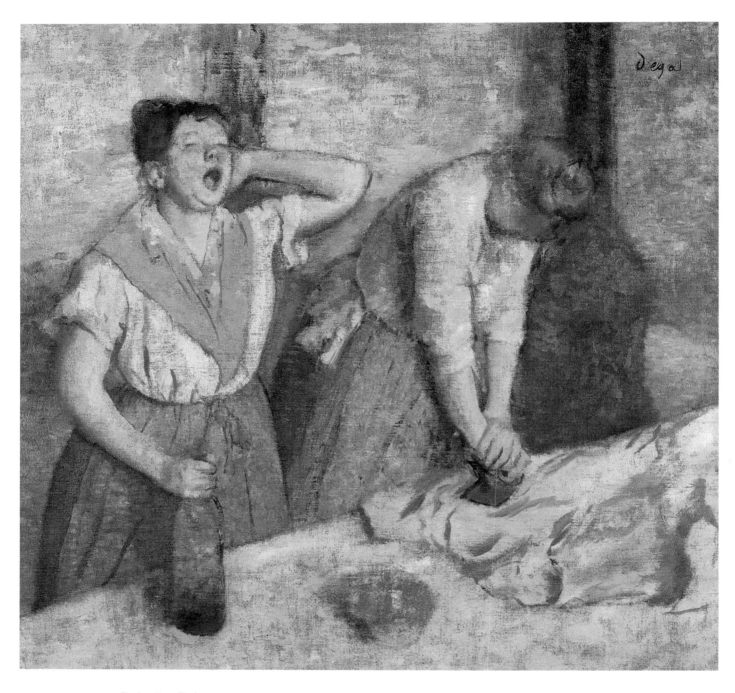

EDGAR DEGAS, Paris 1834–Paris 1917
The Laundresses, 1884–1886
2′ 6″ x 2′ 8″ (76 x 81 cm) Bequest of Count Isaac de Camondo, 1911.
RF 1985

Degas: The 1870s and Beyond

Women Ironing

Like many of Degas's best works, this one offers a series of delicious ironies that juggle every possible contradiction. For one, there is its casual, snapshot immediacy. How else is one to interpret the goal of a painting that records the instant in which an anonymous laundress stops to yawn? But as Degas would have been the first to insist, such seeming spontaneity is totally calculated; and it is perhaps no surprise to find that this is the third of four versions, painted and drawn over a period of some fifteen years, of the same two women who here, as in the other variations, seem to exist in only a split second of time. As for the seemingly accidental view, framed as if we had just glimpsed the two women from a passing angle, this, too, is rigidly determined. The figures seem controlled by a taut skeleton of perpendicular and diagonal axes that, blurred as they are by the increasingly mottled, pastel-like surfaces of Degas's oils in the 1880s, nevertheless lock them in place. Even their seemingly uncoordinated movements, each laundress doing something quite different, end up with the anatomical rhyming that so fascinated Degas in his scenes of dancers who moved like robots, or like the figures photographed in stop-action by Eadweard Muybridge, whose work Degas was to study and copy. Here the postures are those of extreme but complementary contrast, almost a clockwork beat of downward strain versus upward relaxation, stretched versus contracted muscles.

And then there is the subject. Unlike Daumier, who painted his washerwomen with heroic, old-master generalization (page 85), Degas recorded these sweatshop workers with both the documentary eye of novelists like Zola and Edmond de Goncourt and the effete detachment of the aesthete he was. Working conditions for laundresses, as recent studies have confirmed, mixed every kind of misery, from the lowest wages and the longest hours in cold, dank basements to the need for alcohol (the yawner clutches a nearly empty wine bottle) and occasional prostitution to sustain life during and after work. Degas's image, however, is not that of a muckraker but of an elegant voyeur who seems to enjoy the scrunched-up features of the redhead's coarse but pert face and who can transform this scene of backbreaking labor into a pretext for the most nuanced arrangement of vibrant, muted colors, from the warm yellow of the shawl to the smudged coral of the almost vanishing bowl of water in the foreground. Moreover, inspired by the cropped, tilted asymmetries of the Japanese prints he so admired, Degas turns these working-class victims into decorative props that support an aesthetic armature of abstract pattern.

As a final stroke of ironic insolence, could it be that the laundress who stretches in drowsy fatigue parodies the noble physical and spiritual torment of Michelangelo's *Dying Slave* in the Louvre?

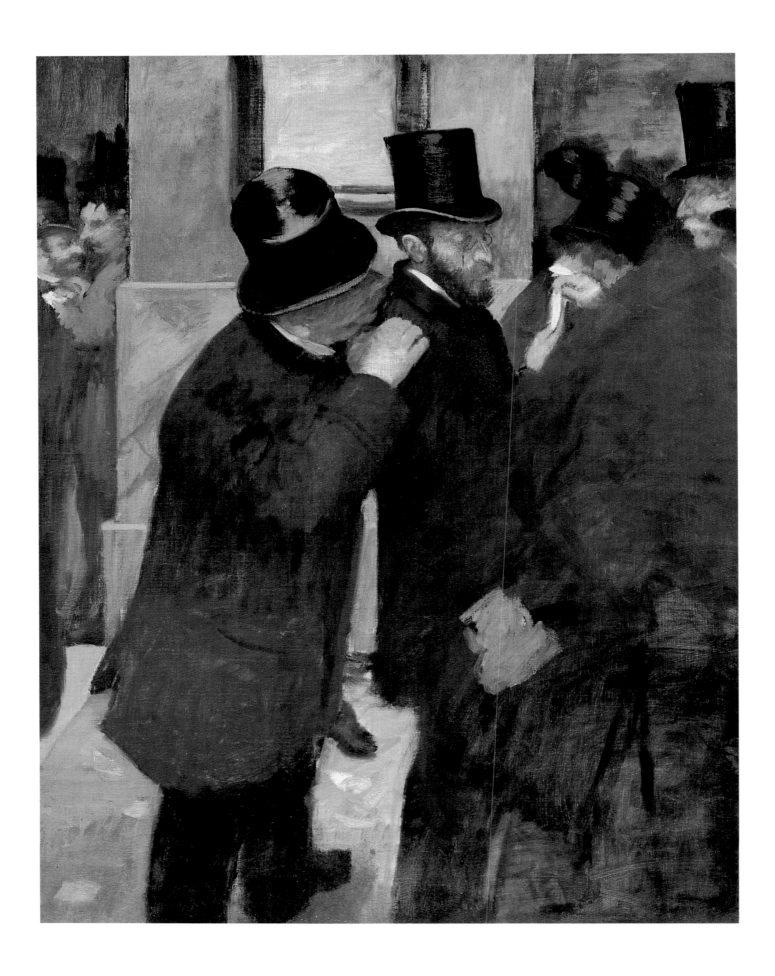

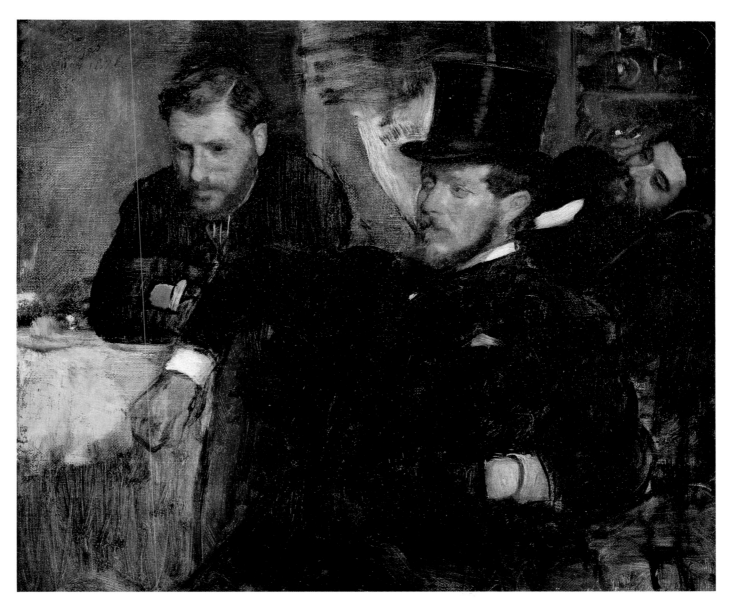

EDGAR DEGAS
Jeantaud, Linet and Lainé, March 1871
1′ 3″ x 1′ 6″ (38 x 46 cm) Bequest of Mrs. Jeantaud, 1929. RF 2825

facing page
EDGAR DEGAS
At the Stock Exchange, ca. 1878–1879
3′ 3¼″ x 2′ 8¼″ (100 x 82 cm) Gift of Ernest May, 1923. RF 2444

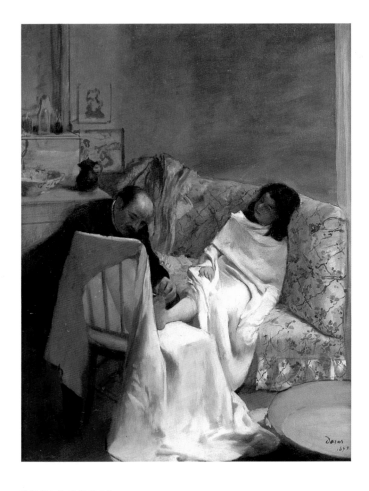

EDGAR DEGAS
The Pedicure, 1873
Paper on canvas, 2′ x 1′ 6″ (61 x 46 cm) Bequest of
Count Isaac de Camondo, 1911. RF 1986

EDGAR DEGAS
Woman with Porcelain Vase, 1872
2′ 1½″ x 1′ 9¼″ (65 x 54 cm) Bequest of Count Isaac de Camondo,
1911. RF 1983

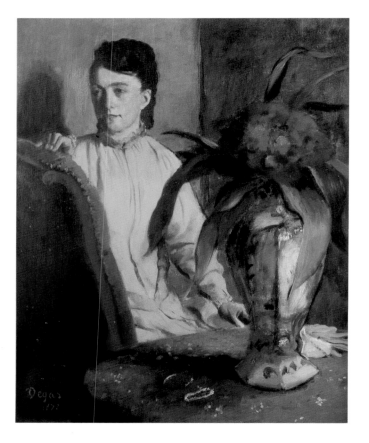

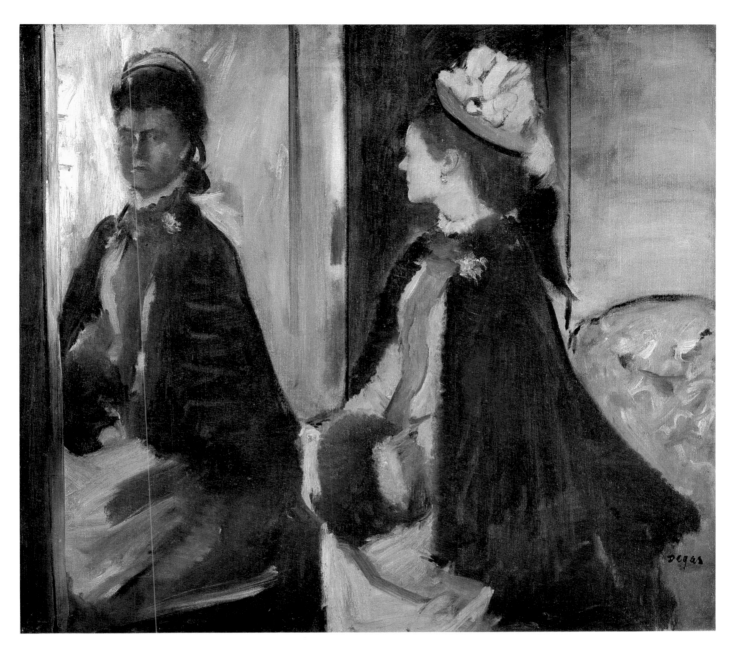

EDGAR DEGAS
Mme. Jeantaud at the Mirror, ca. 1875
2′ 3½″ x 2′ 9″ (70 x 84 cm) Bequest of Jean-Édouard Dubrujeaud,
1970. RF 1970-38

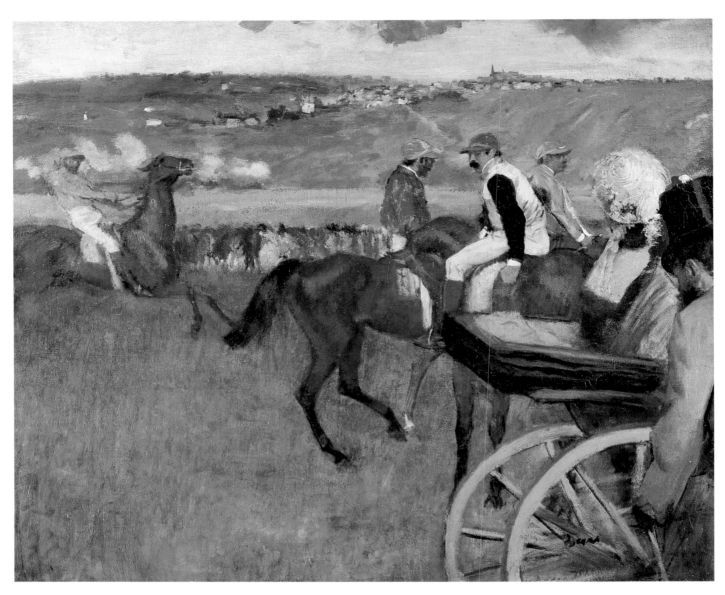

EDGAR DEGAS
The Race Track; Amateur Jockeys near a Carriage, ca. 1877–1880
2′ 2″ x 2′ 8″ (66 x 81 cm) Bequest of Count Isaac de Camondo, 1911.
RF 1980

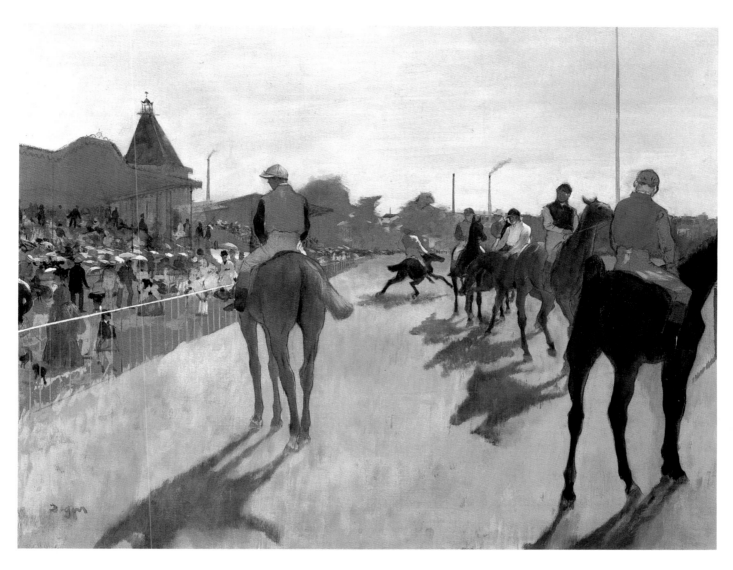

EDGAR DEGAS
Race Horses before the Stands, ca. 1879 (also dated 1866–1868)
1′ 6″ x 2′ (46 x 61 cm) Bequest of Count Isaac de Camondo, 1911.
RF 1981

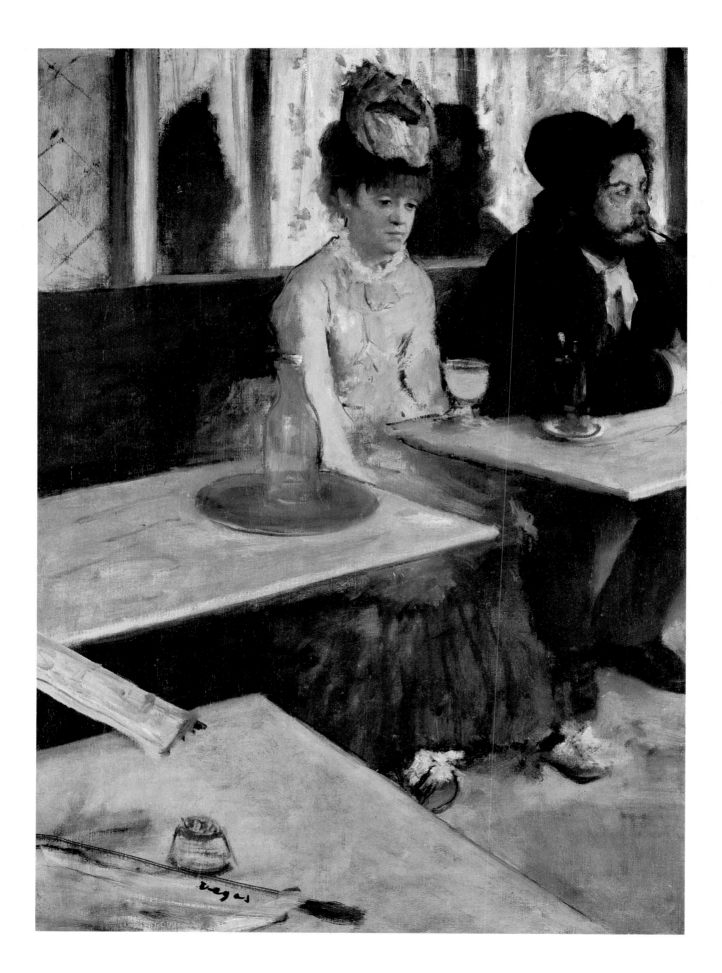

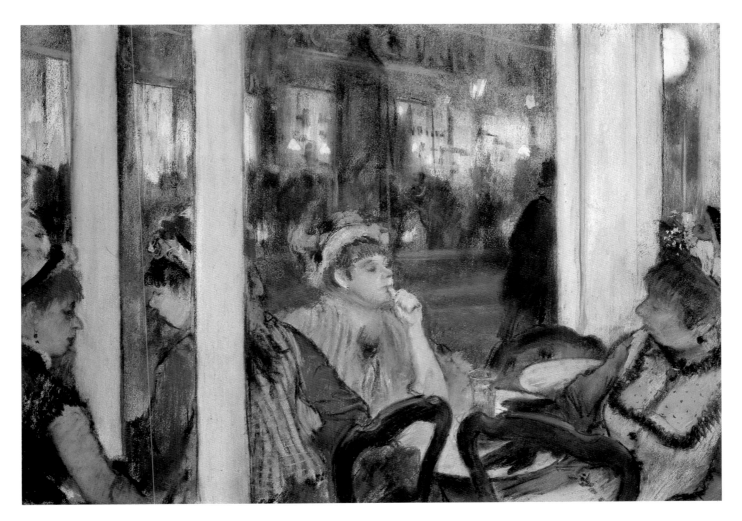

EDGAR DEGAS
Women, on a Café Terrace, 1877
Pastel, 1′ 4½″ x 1′ 9¾″ (54.5 x 71.5 cm) Bequest of Gustave
Caillebotte, 1896. RF 12257

facing page
EDGAR DEGAS
Absinthe, ca. 1876
3′ x 2′ 2¾″ (92 x 68 cm) Bequest of Count Isaac de Camondo, 1911.
RF 1984

page 338
EDGAR DEGAS
The Dancing Lesson, 1871–1874
2′ 9½″ x 2′ 5½″ (85 x 75 cm) Bequest of Count Isaac de Camondo,
1911. RF 1976

page 339, top
EDGAR DEGAS
The Dance Foyer at the Opéra on the rue Le Peletier, 1872
1′ 1″ x 1′ 6″ (32 x 46 cm) Bequest of Count Isaac de Camondo, 1911.
RF 1977

page 339, bottom
EDGAR DEGAS
Ballet Rehearsal on the Set, 1874
2′ 1½″ x 2′ 8″ (65 x 81 cm) Bequest of Count Isaac de Camondo, 1911.
RF 1978

pages 340 and 341
EDGAR DEGAS
The Dancing Lesson, detail

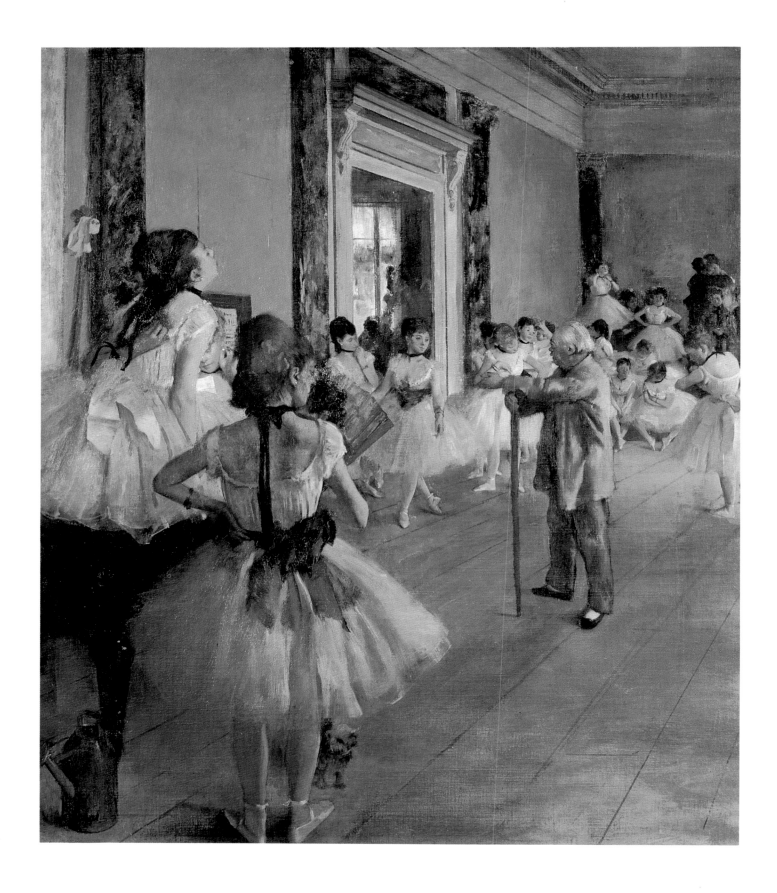

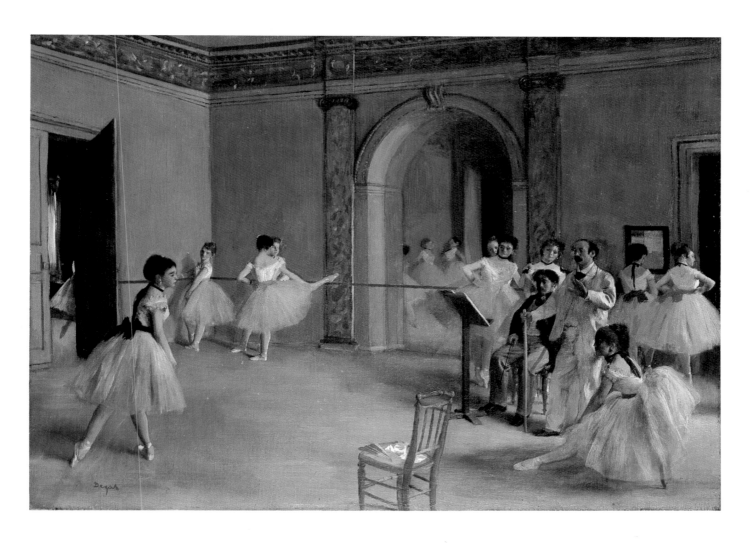

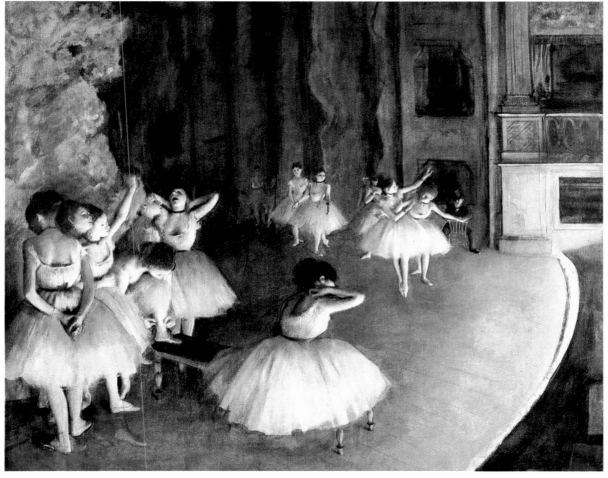

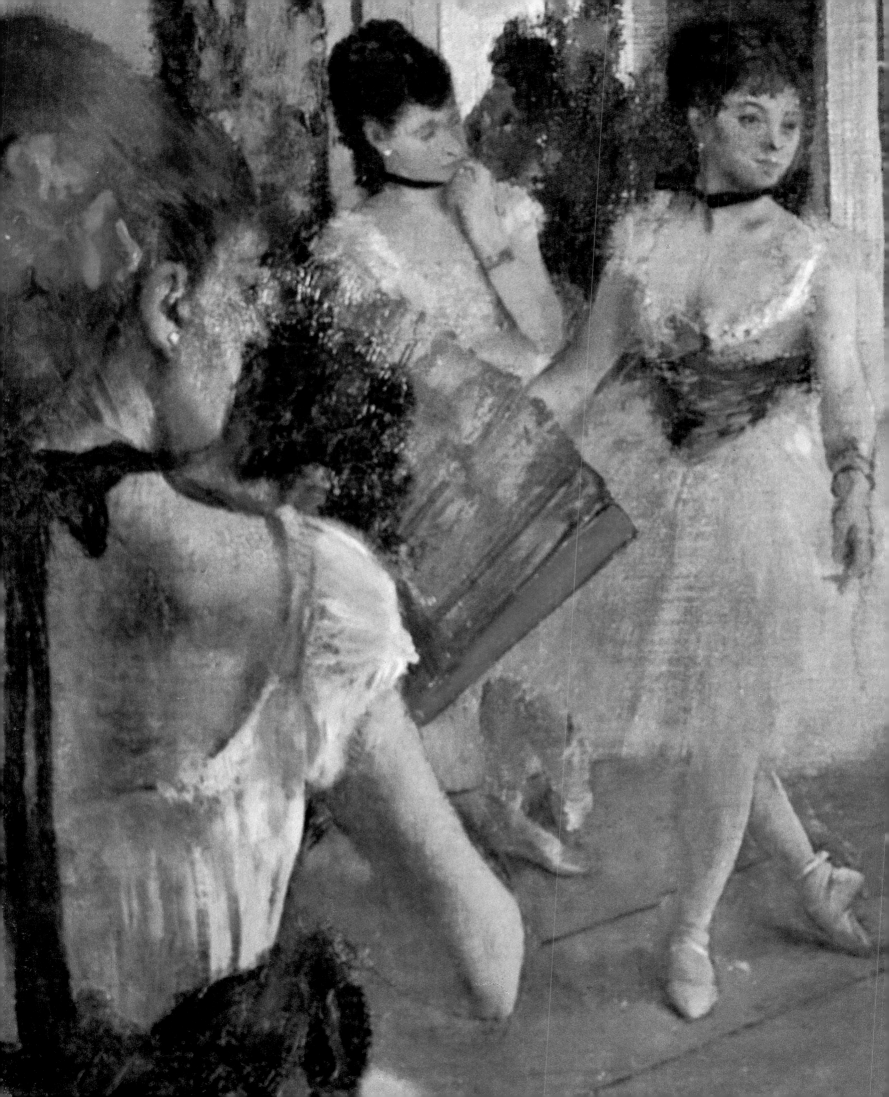

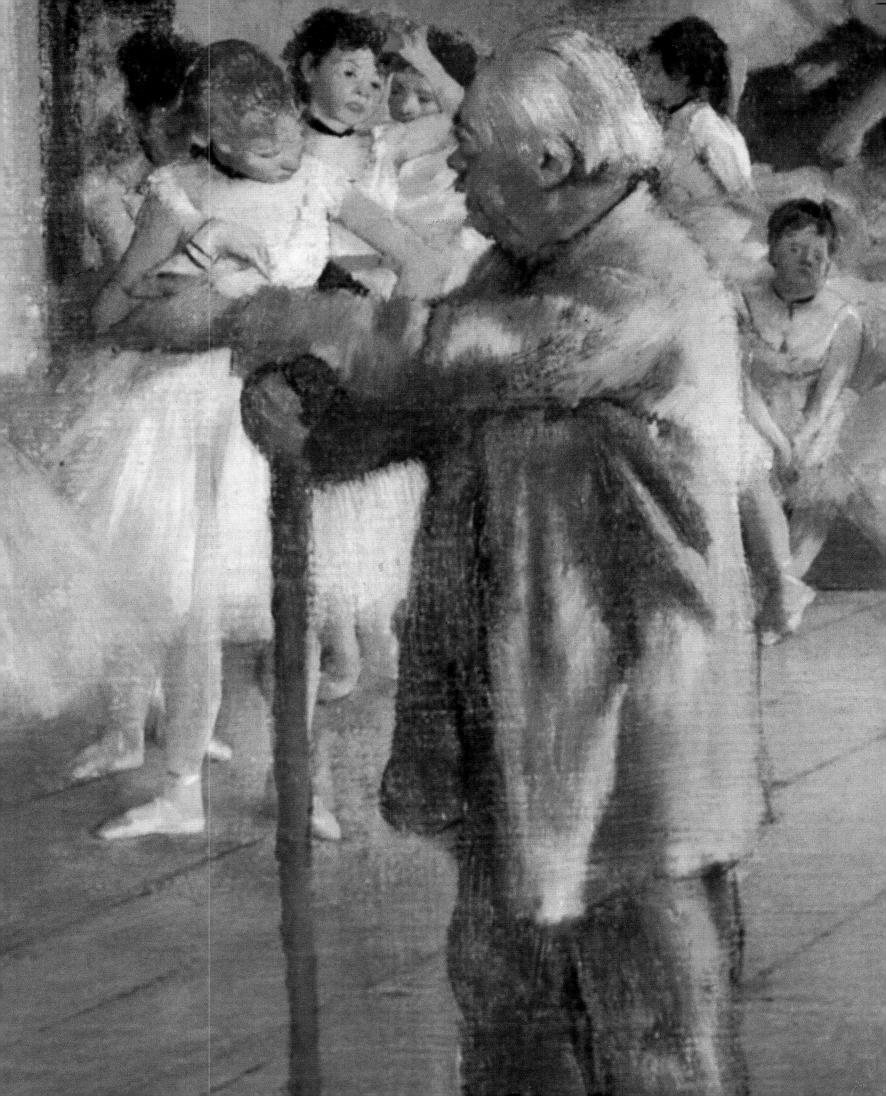

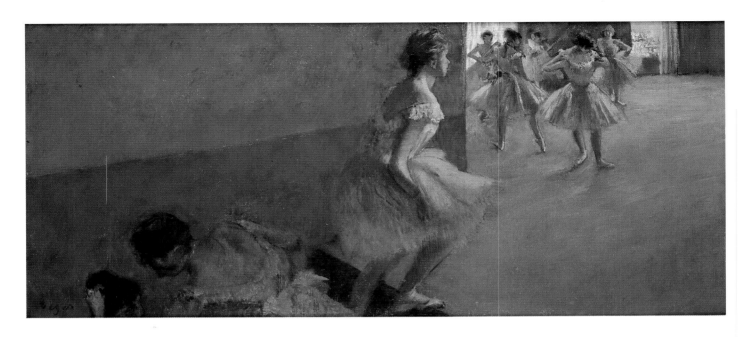

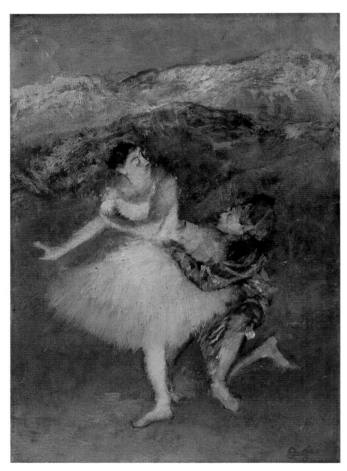

EDGAR DEGAS
Dancers Climbing a Stair, ca. 1886–1890
1′ 3¼″ x 2′ 11¼″ (39 x 89.5 cm) Bequest of Count Isaac de Camondo, 1911. RF 1979

EDGAR DEGAS
Harlequin and Colombine, ca. 1886–1890
1′ 1″ x 9¼″ (33 x 23.5 cm) Gift of Eduardo Mollard, 1961.
RF 1961-28

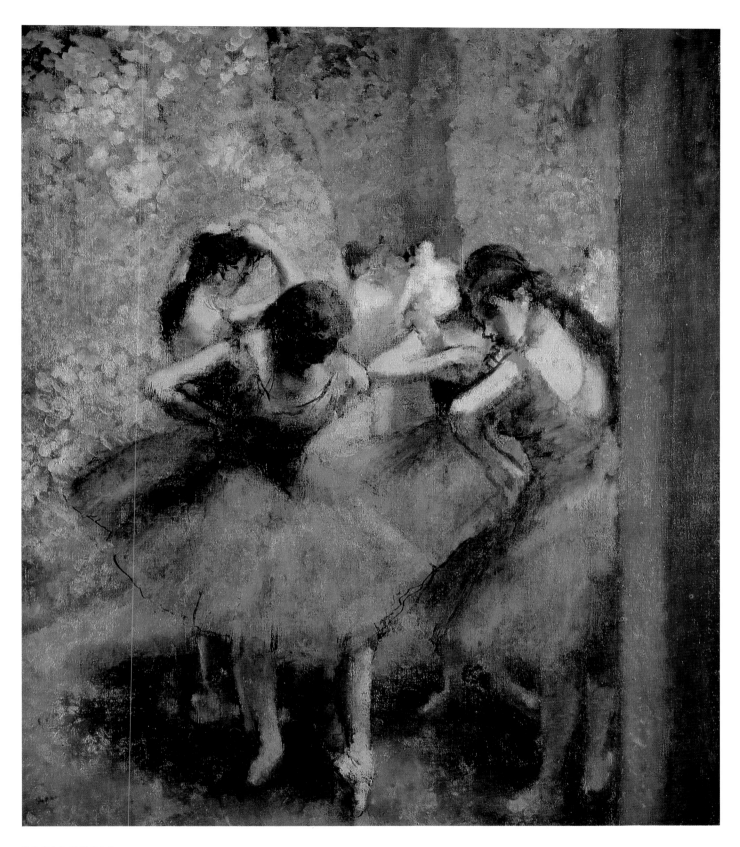

The Tub

*A*lthough Bouguereau's newborn Venus would resurrect the timeless perfection of a classical marble (page 43), Degas's modern Venuses were constantly involved in the more mundane chores of keeping their bodies clean and in shape. At the eighth and last Impressionist show of 1886, Degas exhibited a group of ten pastels that depicted, as his title explained, a series of naked women bathing, washing, and drying themselves, combing their hair or having it combed. The results provided, among other things, almost an impersonal documentation of the mechanics of the human body similar in snapshot precision and split-second timing to photographic inquiry into human and animal locomotion. However, the quasi-scientific objectivity of Degas's naked women going about their mundane ablutions was hardly impersonal, and these pastels are charged with layers of visual and psychological complexity that still provoke as many different responses as they did when first seen in Paris.

In his ambitious 1865 Salon painting of medieval warriors assailing and humiliating their desperate nude female victims (page 217), Degas had already conveyed oddly mixed sexual messages. These pastels are equally fraught. For one thing, the choice of such intimate activities—sponging, wiping, crouching—violates any sense of the nude's personal privacy, turning the artist into a kind of Peeping Tom who observes his models in postures of awkward intimacy they would never want recorded, and certainly not publicly exhibited. Such postures transform the models into mindless, feral creatures who take care of their bodies the way felines do, mixing the graceful and the uncensored. In fact, the carnal, uninhibited behavior of these bathers gives strong plausibility to the suggestion that the women depicted were actually prostitutes whose profession demanded constant bathing and grooming. In a series of monotypes of the late 1870s, Degas had documented the women in a Parisian brothel, seen in postures of animal abandon. As representations of humanity, they are clearly relegated to the lowest rung on Degas's ladder, creatures who exist at a remote polarity from the artist's own keen intelligence and elegant decorum. He seems to have enjoyed, as a condescending observer, these glimpses of sheerly physical concern for the body.

At the same time, Degas miraculously transforms this flesh into a language of ennobling abstract order, a domain of rigorous structure and witty ironies. In *The Tub*, for example, the posture of the bather who has to work like a contortionist to squat and sponge simultaneously recalls, as was already noted by Degas's contemporaries, a famous antique marble of a crouching Venus, thereby demoting antiquity as well as elevating the contemporary. And as usual in Degas, the transitory pose becomes eternal and inevitable, skewered by insistent patterns. The startlingly high overhead view, which in itself suggests the domination of a surveying overlord, divides the scene into two unequal, trapezoidal parts. In the larger enclosure, the nude and her tub are tightly constrained, imprisoned by this odd geometry. In the smaller plane at our right, Degas places the edge of a tabletop that parallels and regiments the axis of her left arm. Shooting upward at an impossible tilt, this precarious surface nevertheless juggles a still life so gravity-defiant that we gasp in amazement. But Degas's virtuosity keeps even these hovering forms forever in place. From the rhyming pot and pitcher above to the curling irons and hairpiece below, each object of the bather's toilette is as carefully positioned as the bather herself. The result is like a tennis match, in which we must not only switch abruptly from one side to the other but feel the shock of discovering that, in Degas's inverted hierarchy, the human and the inanimate are of equal interest, both obedient to the laws of his art.

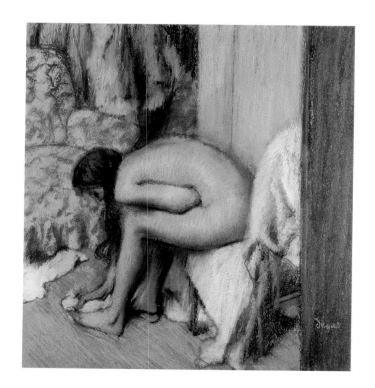

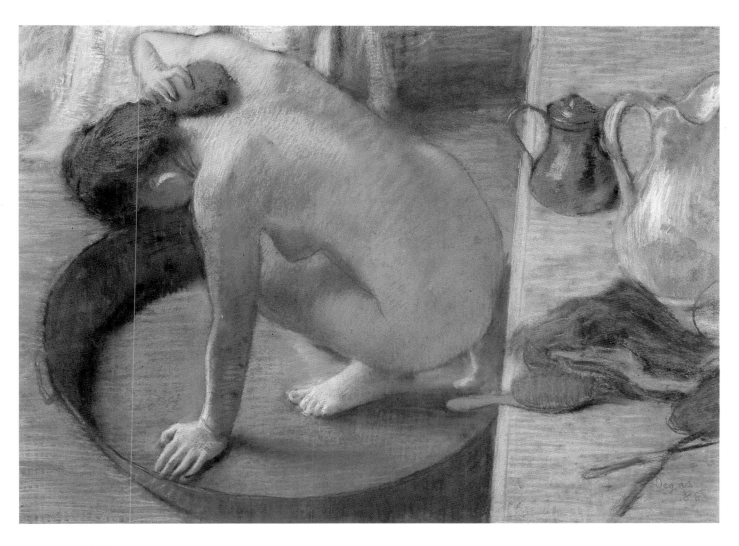

EDGAR DEGAS
The Tub, 1886
Pastel, 1′ 11½″ x 2′ 8¾″ (60 x 83 cm) RF 4046

facing page
EDGAR DEGAS
Nude Wiping Her Foot, ca. 1885–1886
Pastel, 1′ 9½″ x 1′ 8¾″ (54.3 x 52.4 cm) RF 4045

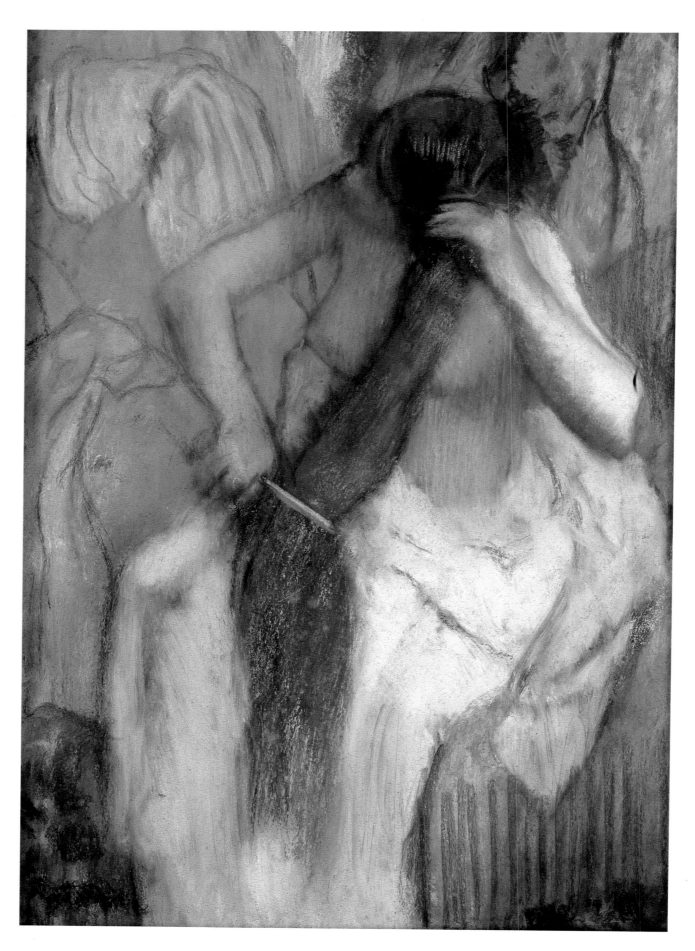

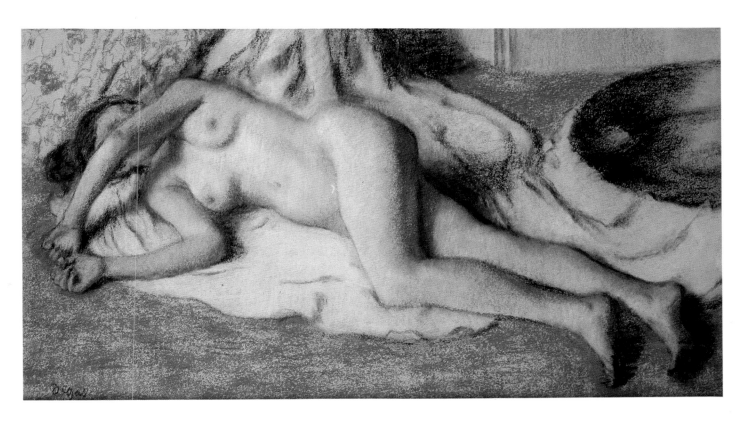

EDGAR DEGAS
Bather Stretched out on Floor, 1886–1888
Pastel, 1′ 7″ x 2′ 10¼″ (48 x 87 cm) Récupération no. 50

EDGAR DEGAS
At the Milliner's, ca. 1898
Pastel, 2′ 3¾″ x 1′ 9″ (91 x 75 cm) RF 37073

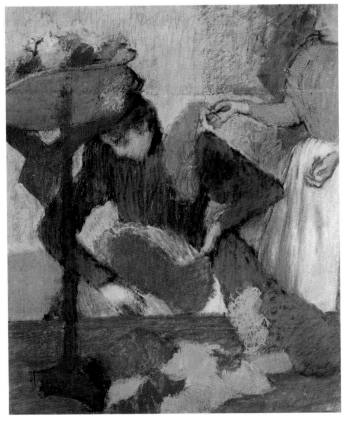

facing page
EDGAR DEGAS
Woman Combing Her Hair, ca. 1897
Pastel, 2′ 1″ x 1′ 5″ (82 x 57 cm) RF 1942-13

Cézanne: The 1870s and Beyond

Green Apples; Still Life with Soup Tureen

Even a pair of still lifes can speak volumes about Cézanne as man and as artist. One such story can be told in these two canvases of the 1870s. Despite the difference of only some four years in date—from about 1873 to about 1877—they almost look like the work of two different painters and the mirror of two different temperaments. In the earlier still life, inconsequential as it is in size (only about one foot wide) and in subject (merely two large and two small green apples plus some leaves), we can still feel the tempestuous emotions agitating the figural fantasies of erotic yearning and violence that the artist had conjured up in the 1860s. Here, what must have started as the simplest of still lifes arranged on a table ends up looking like the windswept debris of a storm, with leaves rustling and apples tumbling. Where are the Olympian harmonies of spheres and planes Cézanne's commentators have so often admired? The ambient brushwork is choppy and impulsive, moving from murky blacks to flashing white highlights—a tonal range that casts ominous shadows, like those in a darkening sky. And the apples themselves look wildly precarious, upsetting our sense of gravity. The two smaller apples become unruly moons to even more unruly planets.

That Cézanne could convey such potently warring forces through so modest a still life is an indication not only of the raging conflicts within him but of an emerging pictorial genius that would learn to harness these titanic energies of magnetic attraction and repulsion. Already we can see a strong flicker of his clumsy but passionate struggle to master the more refined discipline of Impressionist color and brushwork that had been achieved by his almost paternal mentor of the early 1870s, Camille Pissarro. So it is that the flashes of light on the apples can also look like bursts of sunshine piercing a cloudy sky. Their volumes are kneaded through strong contrasts of intense hues, a broadly brushed variety of greens and yellows given luminous accents with dabs of white or, in the large apple at the upper left, a few blushes of red. It is as if the artist were trying to grasp these rebellious forms with a newly discovered palette that belonged to a visible, sunlit world rather than to a private domain of gloomy darkness and desire.

In the later still life, this inner turmoil appears to have been dispelled, replaced by a quite different personality. Probably painted in 1877, the same year in which Cézanne exhibited five other still-life and flower paintings at the third Impressionist group show, this complex arrangement of a basket of apples, a soup tureen, and a wine bottle on a brilliantly patterned red tablecloth embraces a new world of sensuous color and rigorous discipline. It was apparently painted in Pissarro's home in Pontoise and may be read as a tribute to the older master who had so encouraged him and had urged Cézanne's inclusion in the first Impressionist group show of 1874, where he must have appeared coarse and awkward in the company of artists like Monet, Degas, and Renoir. The background, in fact, displays a trio of paintings by Pissarro, of which two—a country road and a barnyard scene—are decipherable, though all are cropped by the frame. They provide a setting of pictorial wit and complexity—pictures within pictures—that Pissarro himself, not to mention Degas, Manet, Renoir, and Bazille, had often used in a subtle visual dialogue.

The rectilinear patterns of these framed paintings—in marked contrast to the oceanic upheavals of the background in the earlier still life—establish a firm rhythm of perpendiculars that also disciplines the tabletop, the bottle, and the tureen. As for the colors, they display an unfamiliar rainbow richness, exploring the entire spectrum from yellow to purple with the almost childlike zeal of a convert to the chromatic dazzle of the Impressionist palette. The green apples of the earlier painting now ripen in sun-drenched hues that give them an almost tangible presence.

Yet within this liberated world in which the controlling reason of rectangles, cylinders, and spheres is balanced against an intensity of color that heralds Matisse, we still sense the undercurrents of Cézanne's suppressed turbulence. Against the straitjacket patterns of geometry, the shapes seem subtly to rebel, expanding and contracting in response to one another. The apples nearly burst through the enclosing confines of the basket; the wine bottle swells outward to embrace the soup tureen; and the tureen, in turn, appears uncomfortably compressed by the pressures of these planar restrictions. Both serene and restless, sensuous and regimented, such a still life announces the far more heroic resolutions of the paintings to come.

facing page, top; and detail, pages 350 and 351
PAUL CÉZANNE
Green Apples, ca. 1873
10¼″ x 1′ 1″ (26 x 32 cm) Gift of Paul Gachet, 1954. RF 1954-6

facing page, bottom
Still Life with Soup Tureen, ca. 1877
2′ 1½″ x 2′ 8″ (65 x 81.5 cm) Bequest of Auguste Pellerin, 1929.
RF 2818

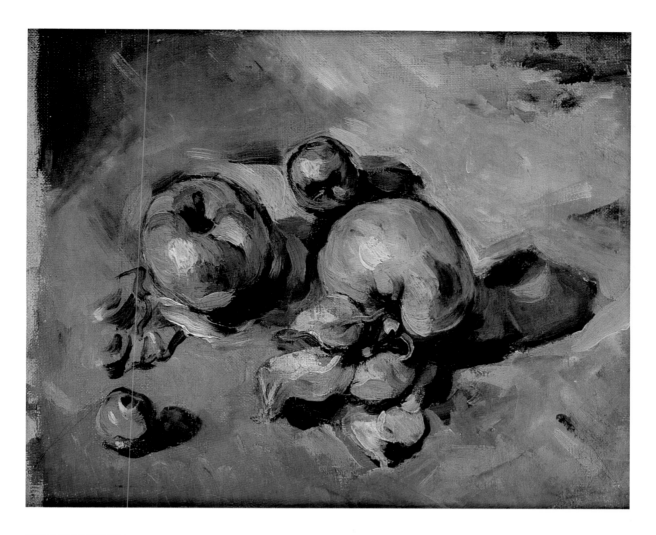

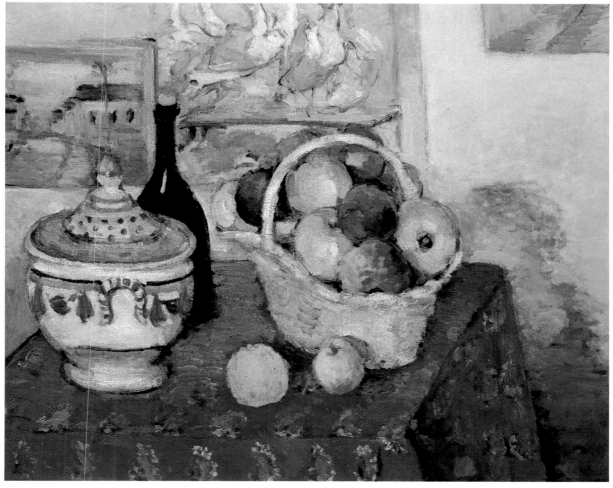

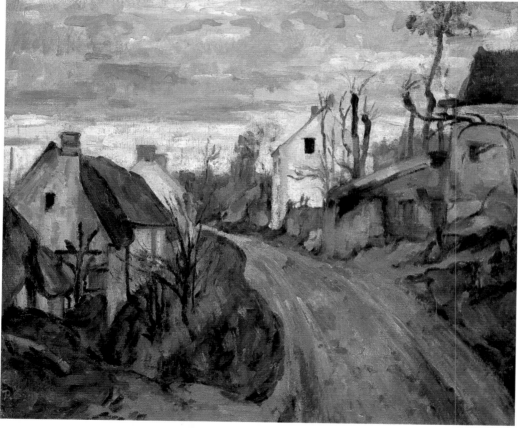

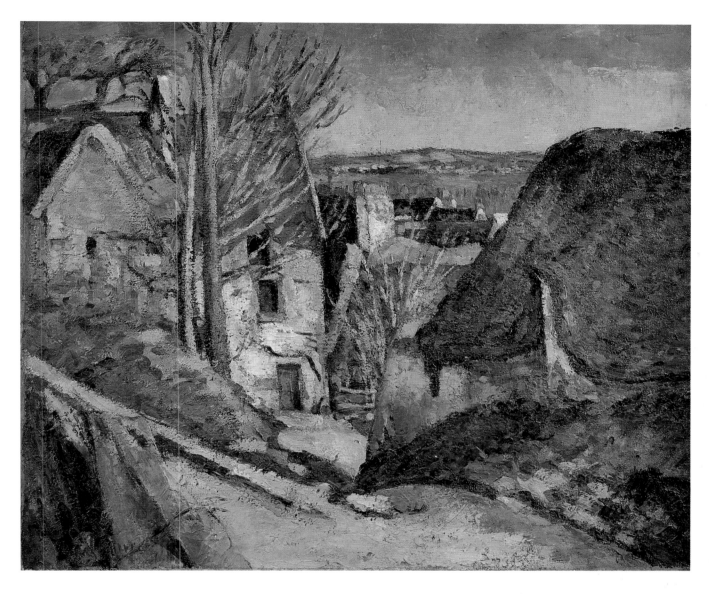

PAUL CÉZANNE
The Hanged Man's House, 1873
1' 9¾" x 2' 2" (55 x 66 cm) Bequest of Count Isaac de Camondo, 1911.
RF 1970

PAUL CÉZANNE
Dr. Gachet's House at Auvers, ca. 1873
1' 6" x 1' 3" (46 x 38 cm) Gift of Paul Gachet, 1951. RF 1951-32

facing page, top
PAUL CÉZANNE
Crossroad of the rue Rémy, Auvers, ca. 1873
1' 3" x 1' 6" (38 x 45.5 cm) Gift of Paul Gachet, 1954. RF 1954-8

facing page, bottom
PAUL CÉZANNE
Village Road, Auvers, ca. 1872–1873
1' 6" x 1' 9¾" (46 x 55.5 cm) Gift of Max and Rosy Kaganovitch,
1973. RF 1973-12

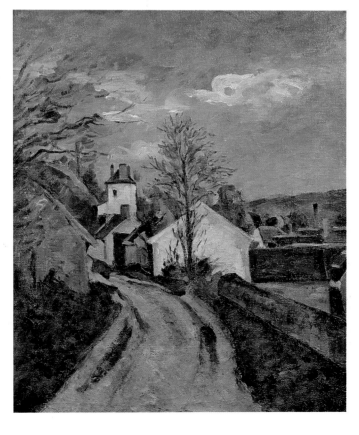

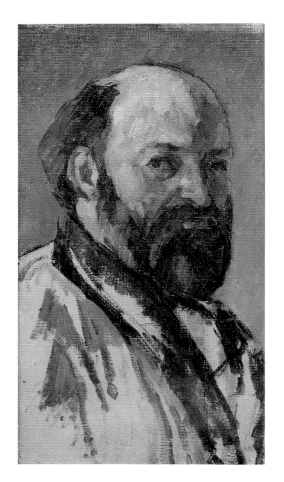
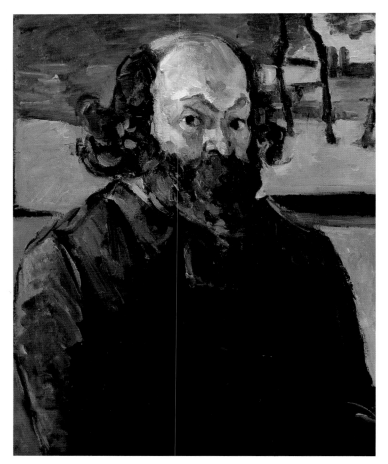

PAUL CÉZANNE
Self-Portrait, ca. 1877–1880
10″ x 5¾″ (25.5 x 14.5 cm) MNR 228

top right
PAUL CÉZANNE
Self-Portrait, ca. 1873–1876
2′ 1¼″ x 1′ 8¾″ (64 x 53 cm) Gift of Jacques Laroche, 1947.
RF 1947-29

facing page, top
PAUL CÉZANNE
A Modern Olympia, ca. 1873–1874
1′ 6″ x 1′ 9¾″ (46 x 55.5 cm) Gift of Paul Gachet, 1951. RF 1951-31

facing page, bottom
PAUL CÉZANNE
Temptation of St. Anthony, ca. 1875
1′ 6½″ x 1′ 10″ (47 x 56 cm) RF 1982-46

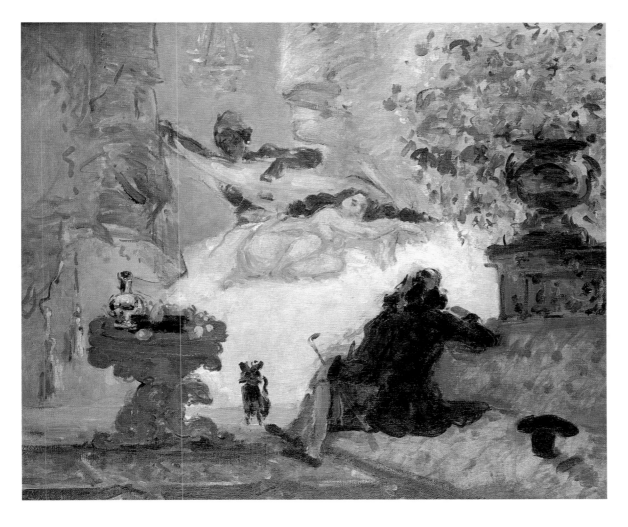

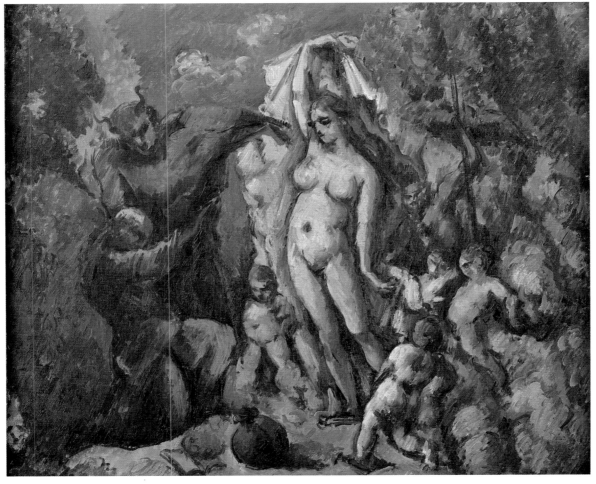

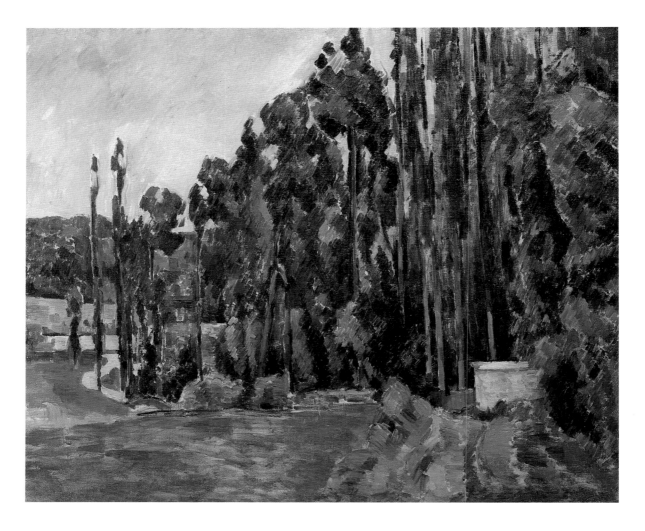

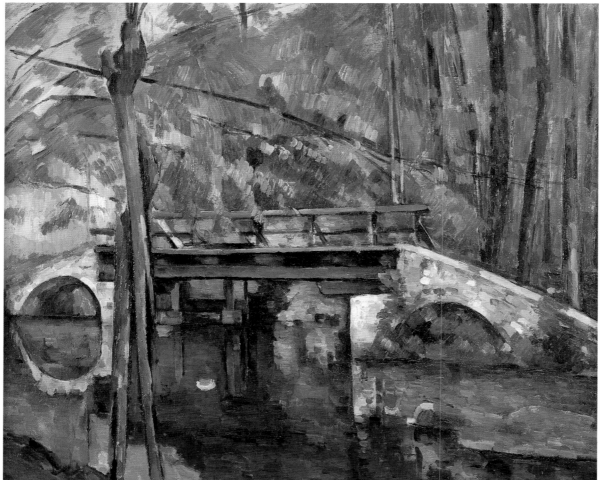

356

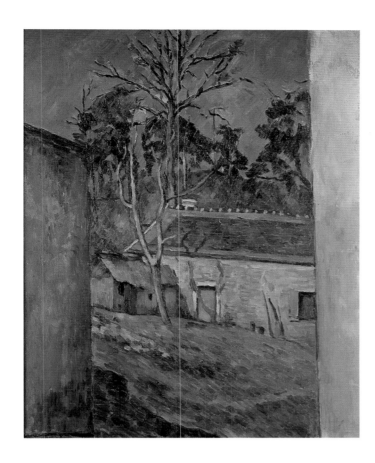

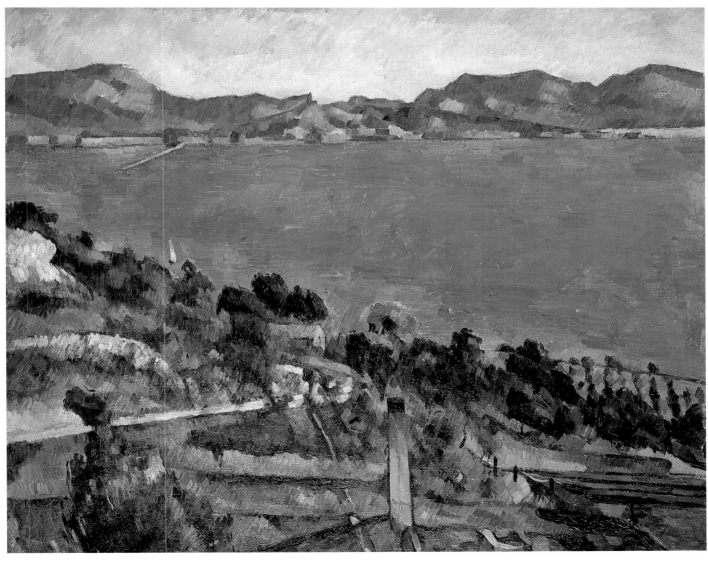

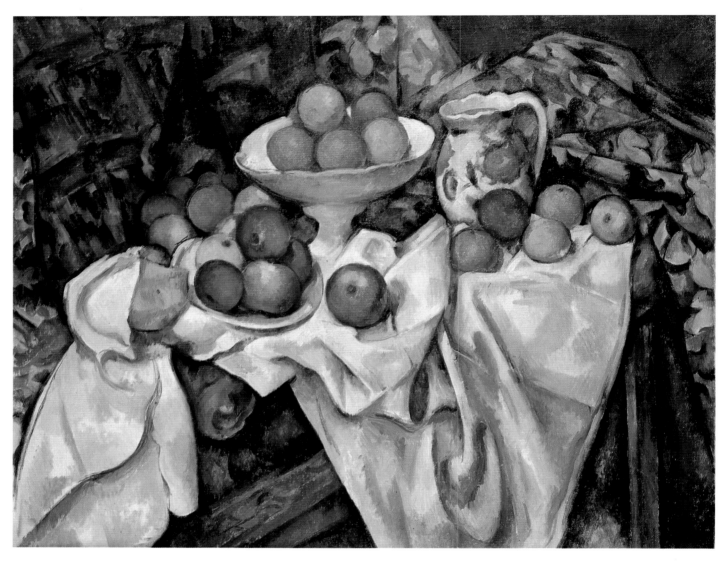

PAUL CÉZANNE
Apples and Oranges, ca. 1895–1900
2′ 5¼″ x 3′ 1″ (74 x 93 cm) Bequest of Count Isaac de Camondo, 1911.
RF 1972

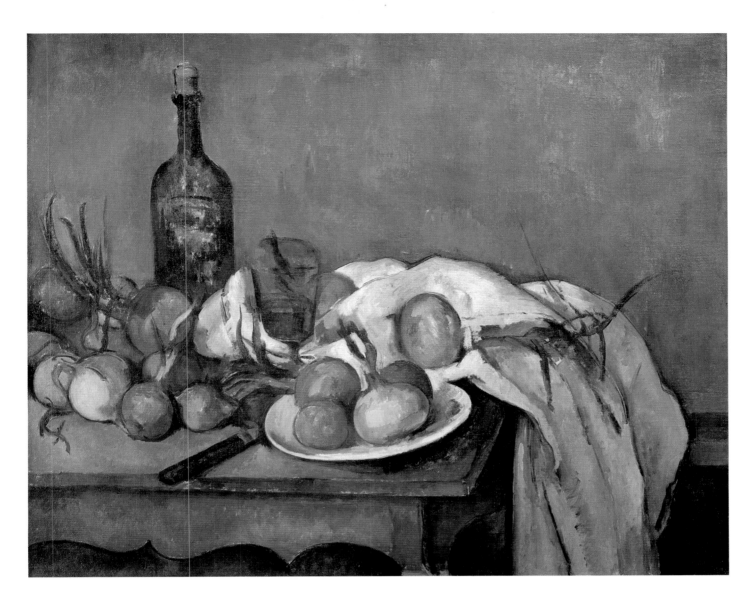

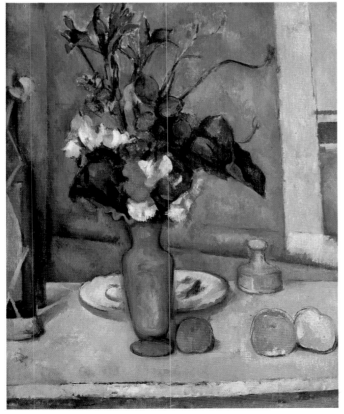

PAUL CÉZANNE
Still Life with Onions, ca. 1895–1900
2′ 2″ x 2′ 8¼″ (66 x 82 cm) Bequest of Auguste Pellerin, 1929.
RF 2817

PAUL CÉZANNE
The Blue Vase, ca. 1885–1887
2′ x 1′ 7¾″ (61 x 50 cm) Bequest of Count Isaac de Camondo, 1911.
RF 1973

pages 360 and 361
PAUL CÉZANNE
Apples and Oranges, detail

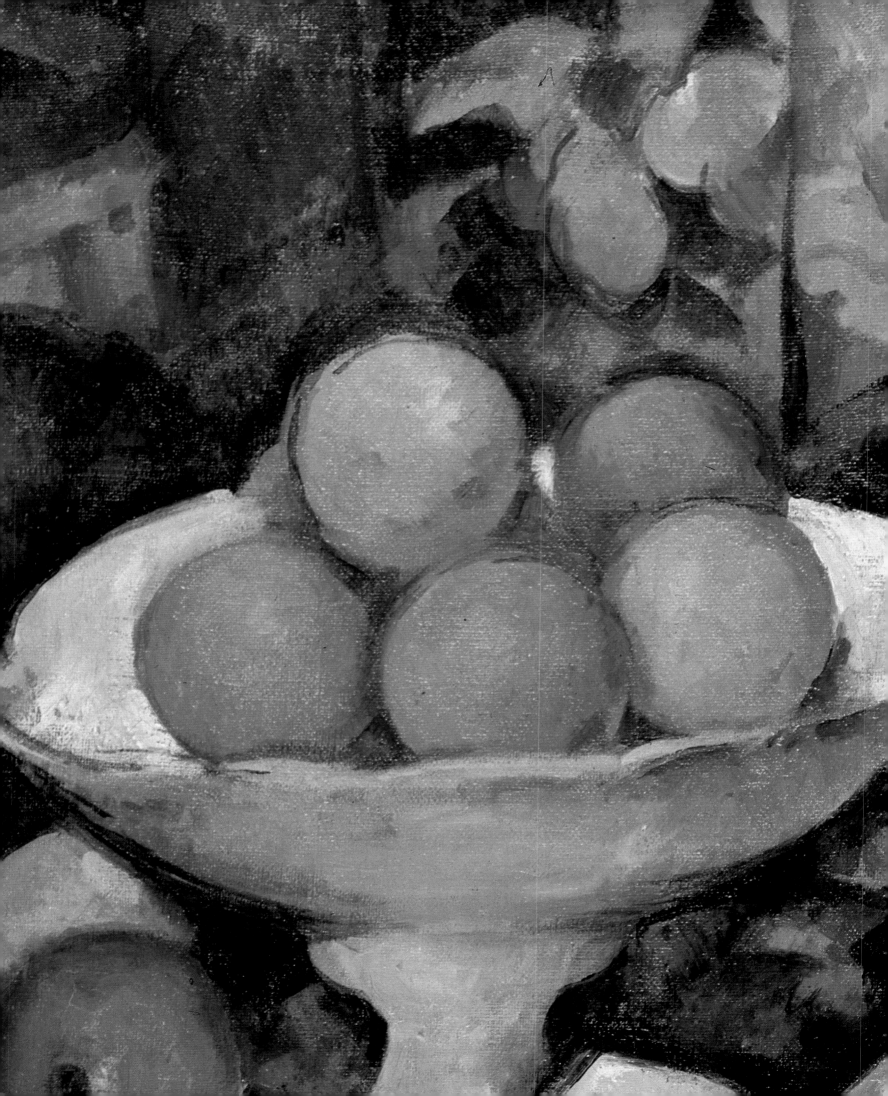

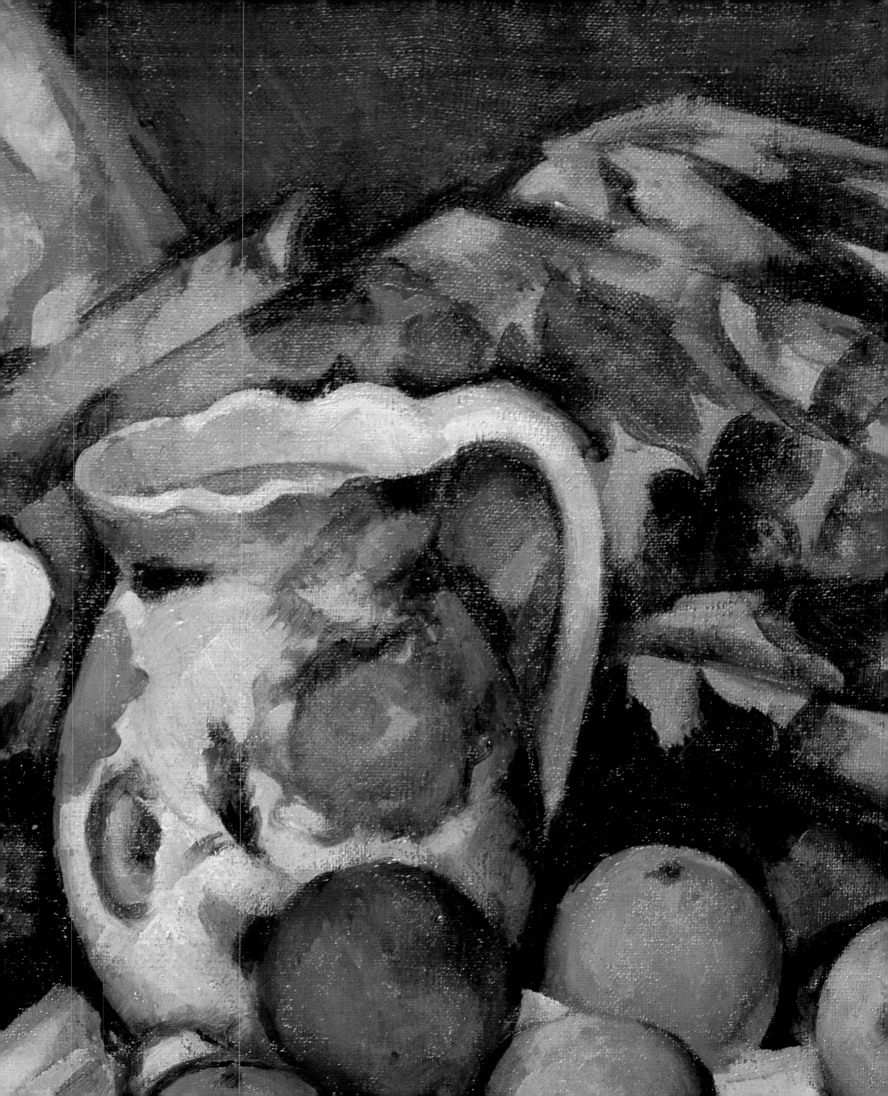

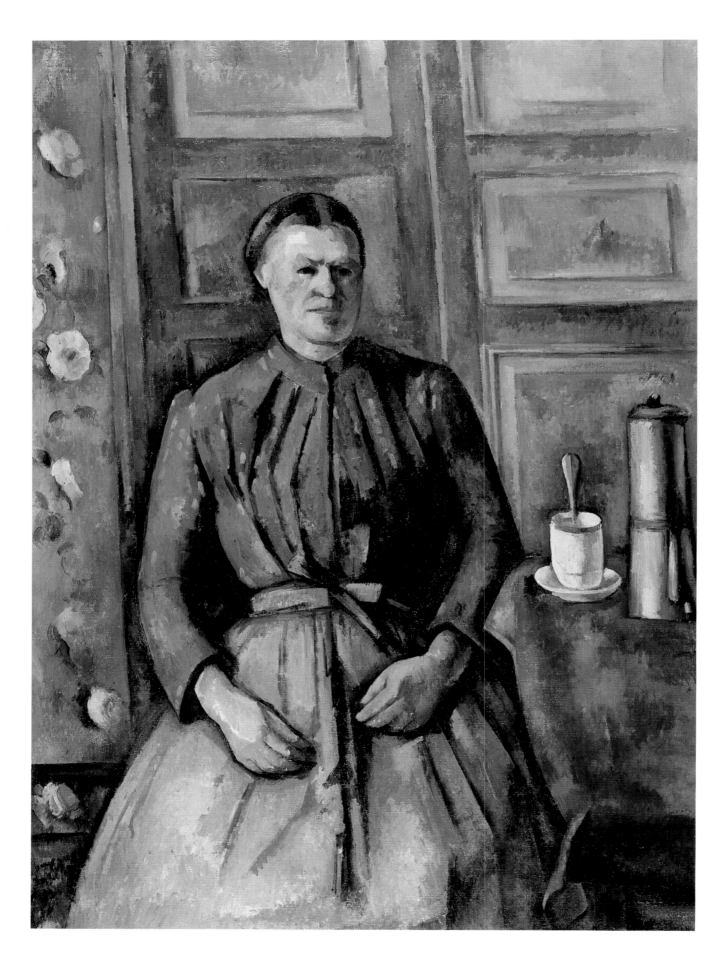

Woman with Coffee Pot

*I*n Cézanne's mature paintings, the mixture of stubborn endurance and constant change becomes a complete microcosm, eternally magnetized like our solar system. Initially the center of attention must be the plain-faced, simply dressed woman—probably a servant in the Cézanne household—who seems to have sat on her invisible chair for all time. The strong vertical axis that runs down from her collar to a more widely opened pleat in her skirt would hold her in place, as would the restricting vertical axes of the rectangular paneling behind her. Yet she quietly lives and breathes, her tensely angled elbows expanding and contracting, her coarse hands bearing, beneath their would-be stability, the marks of restlessness. And her ruddy face, fixed in tandem with this vertical scaffolding, begins, as we study it, to shift forward and backward, the shadowed plane at the right unexpectedly vying for foreground attention.

Commanding as her frontal presence is, almost the secular equivalent of a blue-robed Madonna, she must compete with one of Cézanne's simplest yet most incredible still lifes: a coffee pot and a saucer, cup, and spoon. Offering at first glance an illustration of the old bromide about Cézanne's seeking the underlying geometries of nature, these would-be cylinders then completely deny rational structure. For one thing, they are uncannily animate, so that the metal handle of the spoon exerts an erect upward thrust that belongs to the human will of Cézanne and of his model to remain rigidly upright in a world where all forms are tyrannized by the powerful pull of an imposed vertical order. The coffee pot violates its cylindrical clarity by subtle shifts of axis, contour, and reflective surface that seem to respond not only to the no less subtle movements of the cup and saucer but to the grander sense of underlying unease we intuit in the human figure. Like moons to a planet, these humble objects must forever remain obedient to the larger force.

It is a world in which every brushstroke, every object and shape are vibrantly and inevitably connected. The diagonal of warm red cloth on the tabletop will always

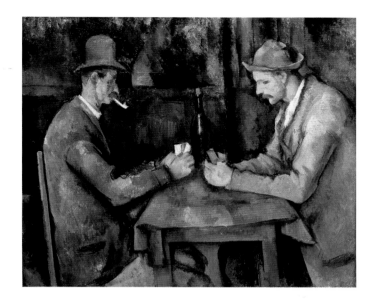

PAUL CÉZANNE
The Card Players, ca. 1890–1895
1′ 6¾″ x 1′ 10½″ (47.5 x 57 cm) Bequest of Count Isaac de Camondo, 1911. RF 1969

belong to the volume of the sitter's sleeved forearm; the relieving pink bloom of the vertical strip of floral wallpaper at the left will always be reflected in the pink and white tones that shimmer under the blue of the sitter's skirt; the part in her hair will always crown the invisible spine of the painting, just as the brushstrokes above the part will forever fuse her head with the rectangular plane that frames it. But unlike other artists, even such great ones as Seurat and Degas, who make us feel that their order is calculated in systems of rhymes and repeats, Cézanne never seems to depend upon predictable formulas. Each canvas would begin from scratch, a colossal struggle to impose upon the fluid, shifting perception of things seen and felt a majestically controlling order. So intense is the battle that from the smallest brushstroke to the broadest network of restricting discipline, we sense, as in the sculptures of Michelangelo that Cézanne had often copied, an eternal dialogue between passionate turbulence and noble restraint.

facing page
PAUL CÉZANNE
Woman with Coffee Pot, ca. 1890–1895
4′ 3½″ x 3′ 2″ (130.5 x 96.5 cm) Gift of Mr. and Mrs. Jean-Victor Pellerin, 1956. RF 1956-13

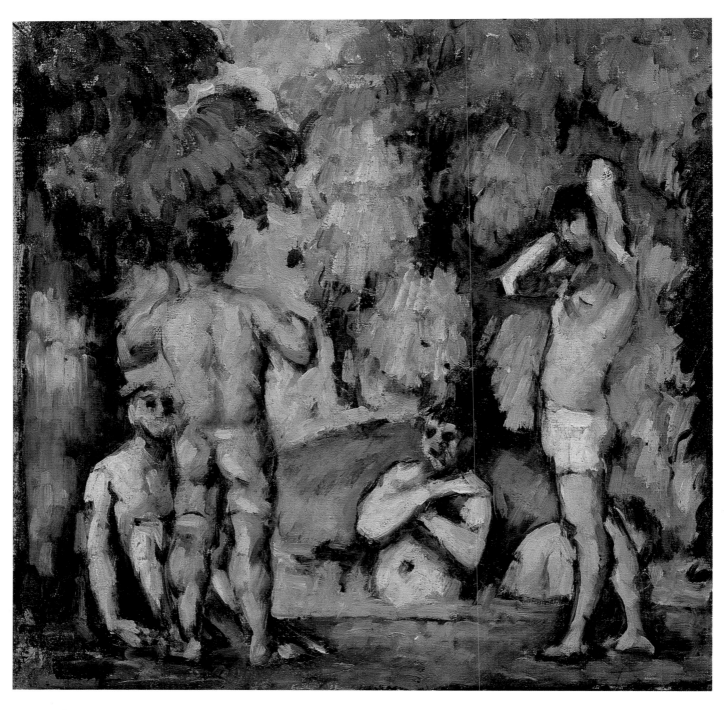

PAUL CÉZANNE
Five Bathers, ca. 1875–1877
9½″ x 9¾″ (24 x 25 cm) RF 1982-42

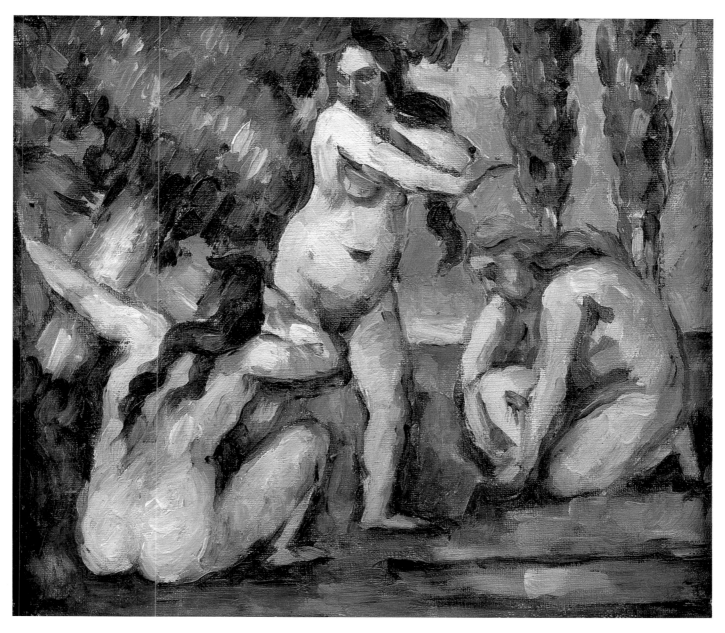

PAUL CÉZANNE
Three Bathers, ca. 1875–1877
8¾″ x 7½″ (22 x 19 cm) RF 1982-40

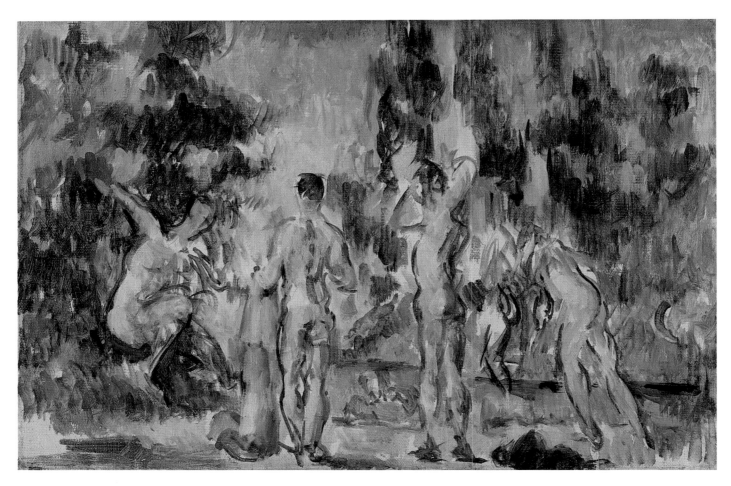

PAUL CÉZANNE
Bathers, ca. 1890–1900
8¾" x 1' 2" (22 x 35.5 cm) RF 1949-30

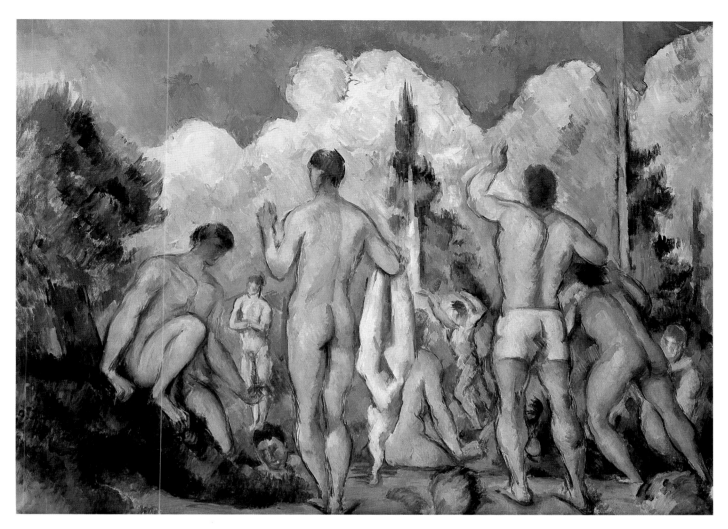

PAUL CÉZANNE
Bathers, ca. 1890–1892
1′ 11½″ x 2′ 8¼″ (60 x 82 cm) Gift of
Baroness Eva Gebhard-Gourgaud, 1965. RF 1965-3

AROUND IMPRESSIONISM

Disciples and Minor Masters

*I*mpressionism was not about one artist, but many; not about one style, but many different, even contradictory ones, ranging from Monet's palpitating colored light that could register every nuance of weather and atmosphere to Degas's crisply calculated snapshots of the lives of rich and poor in Paris. Such new ways of depicting things experienced in city and country were created by younger painters of the 1860s and 1870s, some of whom were later elevated to the pantheon of old masters linking Delacroix and Matisse. But their fresh and varied visions also radiated throughout the world of countless secondary artists who reward our attention even if their names are not included in the roster of Impressionist divinities.

At Orsay, they may be discovered in all their diversity, sometimes as worshipful clones of a genius like Monet, sometimes as only partial disciples whose individual contours are clearly marked. There are even foreigners from the New World who add their voices to the history of Impressionism. Among these is the Puerto Rican Francisco Oller, who left his native San Juan in 1858 to study painting, first with Couture and then with Gleyre. In the 1860s he not only exhibited at the Salon but also became part of a circle of young artists that included Cézanne and Pissarro. So rooted was he to Paris that after a sojourn in Puerto Rico (1865–1873), where he established a public academy of drawing and painting, he returned there for another decade.

The paintings that Oller made would look completely at home in an Impressionist group show. His *Banks of the Seine* of 1875 is a generic Impressionist landscape. The quiet but constant fluctuations of the barges moving on the river, of light filtering through the low clouds and smoke, are seized here in a technique that suggests, too, the swift but intense perception of a minor experience. His indoor scene, *The Student* (page 371), is more problematic in every way, including the date; some scholars place it in the 1860s, during Oller's first Parisian sojourn, and others in the 1870s, during his second. Its rich and legible domestic details, however, resemble many interiors of the 1860s, such as Bazille's record of Monet in bed, convalescing after a leg injury in 1865 (page 226). In any case, this scene of work and concentration—the woman sewing; the man, hand on skull, studying—is flooded with a subtly filtered light that transforms the scene into a luminous whole that may even make us forget the identity of the figures. It has

been suggested that the man is a Cuban medical student and painter, Aguiar, who also figures in the Impressionist orbit. Aguiar's *Houses at Auvers* (page 370), dated 1875, is a branch off Cézanne's and Pissarro's tree, a modest reflection of the local village north of Paris where these two painters also worked in the early 1870s. Dr. Paul Gachet, one of the great patrons of Impressionism (and later of Van Gogh), lived in Auvers; he bought, among other works, Oller's *The Student*.

Other foreigners were no less integrated with the Impressionist milieu. The Italian de Nittis, who came to Paris in 1868 and exhibited at both the Salon and the first Impressionist show of 1874, can offer, at Orsay, a remarkable document of Paris after the destruction of the Tuileries under the Commune in 1871, a view of the Place des Pyramides shown at the 1876 Salon (page 372). Here, we catch the typical Impressionist view of a *flâneur*, a stroller who happens to catch a topographical slice that includes not only pedestrians and street vendors moving every which way under a threatening sky, but also an unexpected contrast: a fragment of the ruined Tuileries being rebuilt under scaffolding that looms over an equally casual rear view of the statue of Joan of Arc, her silhouetted flag held high. So surprising is the juxtaposition that we almost feel its subliminal patriotic message was achieved, following the shadow of Degas, by accident rather than intention.

Degas's shadow is cast, too, over the work of Béraud, whose glimpse of a Paris street sets up a high-wire spatial and psychological tension between the elegant, unaccompanied lady who waits at the edge of the curb at the left and the distant figure of a gentleman just coming into view at the right around the corner curve (page 373). But Degas, of course, would never have troubled to fill in so many details or to present so obvious a narrative to magnetize near and far.

This formula for catching offbeat and off-center slices of urban life, both rich and poor, was often repeated, as in the work of Raffaëlli, who exhibited with the Impressionists. In his vignette of wedding guests outside a shabby, probably suburban city hall (page 374), he almost caricatures the facts of lower-class life on a fancy occasion, complete with a tattered bulletin board almost worthy of a Cubist collage.

In surveying this selection, we usually feel the influence of one particular master on a disciple. It was as a pupil of

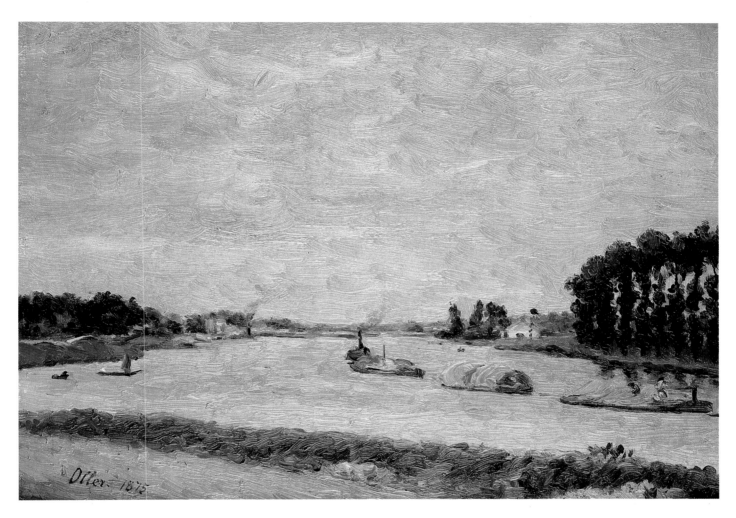

FRANCISCO OLLER Y CESTERO
Banks of the Seine, 1875
9¾" x 1' 1½" (25 x 34 cm) Gift of Dr. Martinez, 1953. RF 1953-19

Manet, for example, that Gonzalès identified herself when she exhibited *A Loge at the Théâtre des Italiens* at the 1879 Salon (page 378). The pedigree is obvious in the subtle psychological balance between the couple, the cool colors set afloat in a sea of velvety blacks and starchy whites, and the dazzling bouquet of flowers thrown in for good measure. And it is at the shrine of Monet that both Lebourg and Loiseau worship in their soft-focus accounts of changes in weather and atmosphere in places as near to Paris as Rouen and as far away as Algiers (pages 380 and 381).

There are many surprises and lessons, too, in considering this translation of Impressionism into a lingua franca. By the 1880s, even a conservative academic like Gervex could adapt the flecked, sunlit hues of Monet to the conventions of high-style society portraiture (page 384), whereas other minor masters could give the innovations of Impressionism a more personal inflection. There is, for example, the remarkably intimate record by Goeneutte of Dr. Gachet

(page 382). Painted in 1891, it begs and withstands comparison with Van Gogh's portrait of the same man painted the year before (page 490), providing, as it were, a second intensely private view of this kind, red-haired doctor who had always supported the Impressionists and who would offer Van Gogh succor in the last year of his life.

There are other discoveries as well in the ongoing afterlife of Impressionism, such as Helleu's oblique glimpse of a marble statue at Versailles during an autumn walk through the gardens (page 384). Using the Impressionists' dappled brushwork and narrow range of vision to transform the axial rigidity of this awesomely expansive formal park into an intimate experience, Helleu, in this painting of the 1890s, conjures up an unexpected melancholy, a private memory of something once seen and felt, like Atget's nostalgic photographs of historic French gardens. It is fitting that Helleu gave this canvas to his friend Marcel Proust.

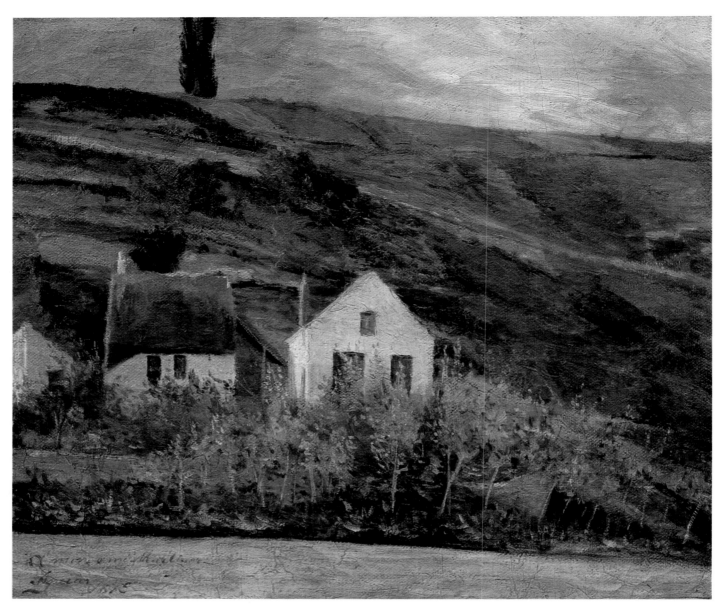

AGUIAR
Houses at Auvers, 1875
1′ 1″ x 1′ 3¾″ (33 x 40 cm) Gift of Dr. Martinez, 1953. RF 1953-20

facing page
FRANCISCO OLLER Y CESTERO
San Juan, Puerto Rico 1833–Santurce 1917
The Student
2′ 1¾″ x 1′ 9¼″ (65.2 x 54.2 cm) Gift of Paul Gachet, 1951.
RF 1951-41

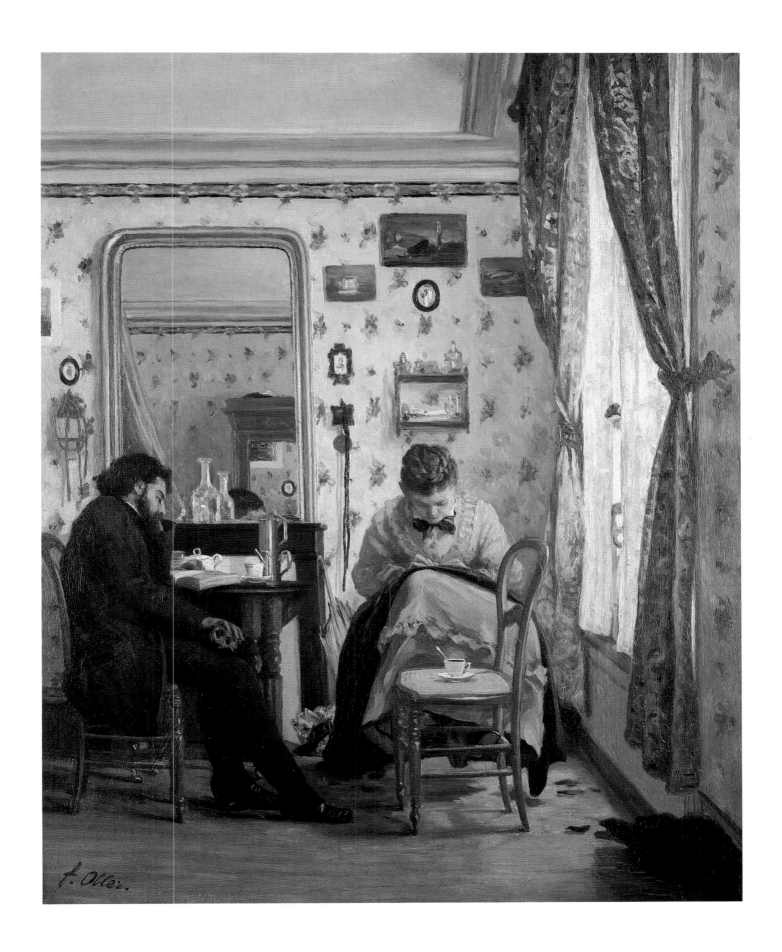

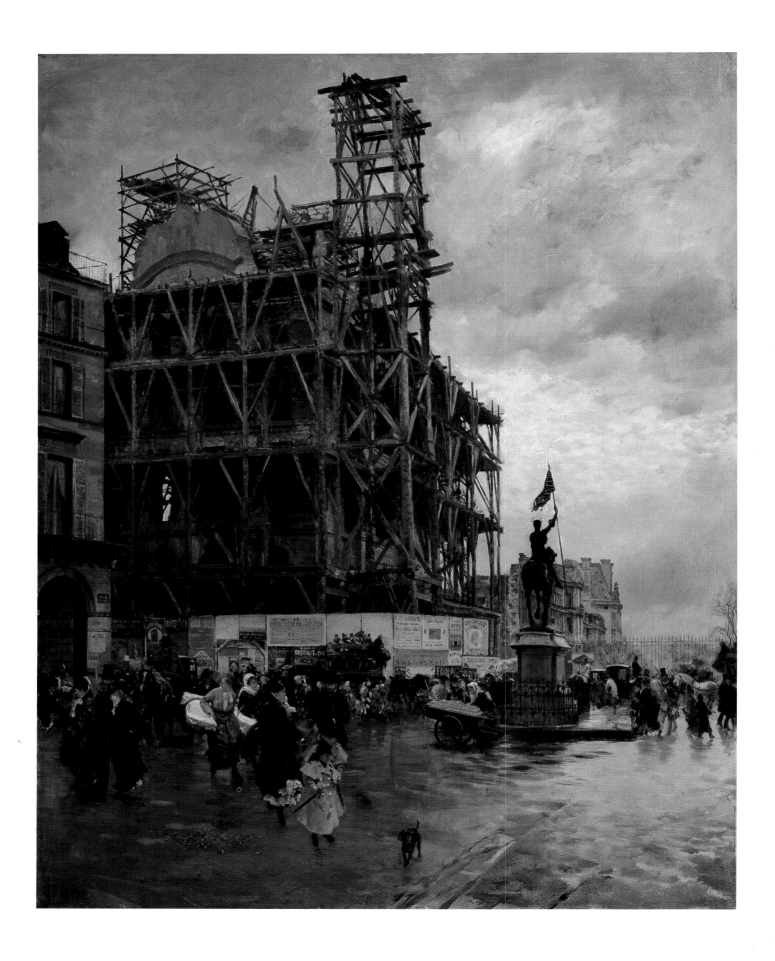

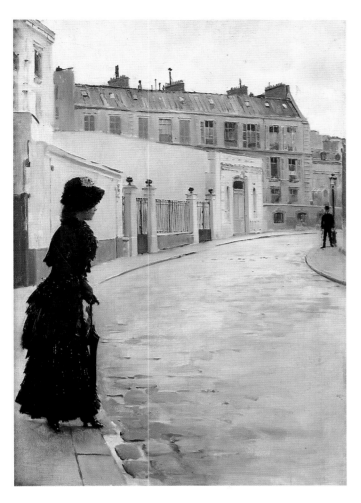

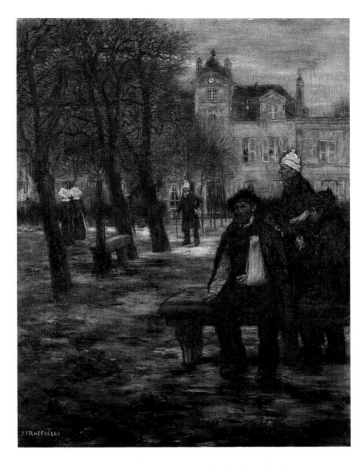

JEAN BÉRAUD
Waiting, rue de Chateaubriand, Paris
1' 10" x 1' 3½" (56 x 39.5 cm) Anonymous gift, 1935. RF 1977-36

JEAN-FRANÇOIS RAFFAËLLI, Paris 1850–Paris 1924
The Old Convalescents (Salon of 1892)
4' 8" x 3' 7¾" (142 x 111 cm) RF 745

facing page
GIUSEPPE DE NITTIS, Barletta 1846–St-Germain-en-Laye 1884
The Place des Pyramides, 1875 (Salon of 1876)
3' x 2' 5¼" (92 x 74 cm) Gift of the artist, 1883. RF 371

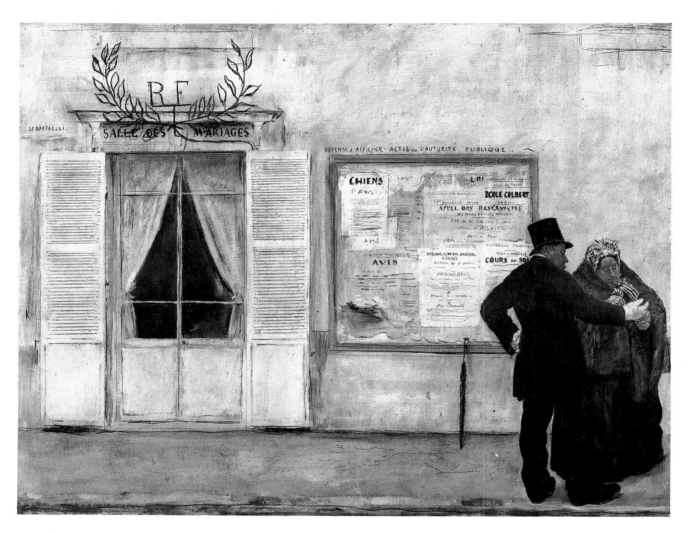

JEAN-FRANÇOIS RAFFAËLLI
Guests Attending the Wedding (before 1898)
1′ 8¼″ x 2′ 3″ (52.5 x 68.5 cm) Gift of Charles Hayem, 1898.
RF 1140

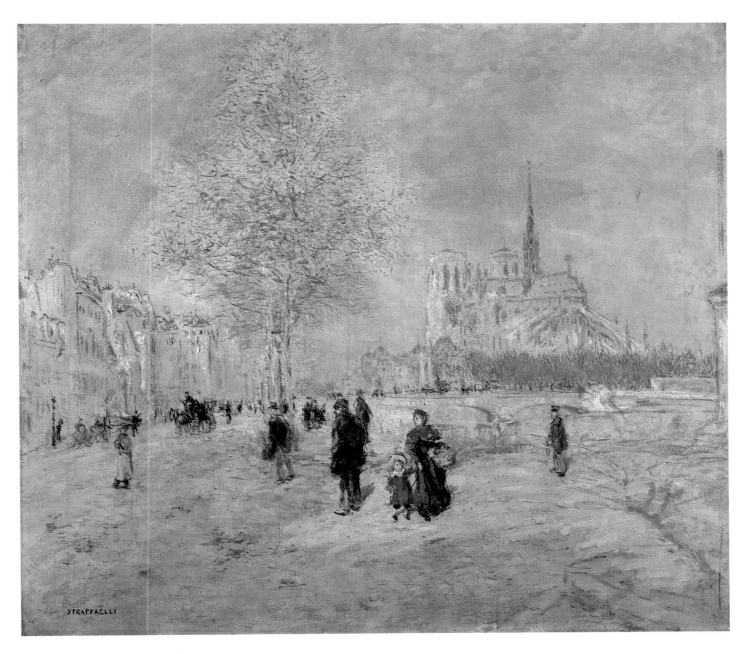

JEAN-FRANÇOIS RAFFAËLLI
Notre-Dame de Paris (Salon of 1896)
2′ 3¾″ x 2′ 7¾″ (70.5 x 80.5 cm) RF 1050

page 376
ERNEST QUOST, Avallon 1842–? 1931
Roses, Decorative Panel, ca. 1909–1916
8′ 1″ x 4′ 7″ (246 x 139.5 cm) RF 1980-34

page 377
ERNEST QUOST
Roses, Decorative Panel, ca. 1909–1916
7′ 9″ x 3′ 10″ (236 x 117 cm) RF 1980-35

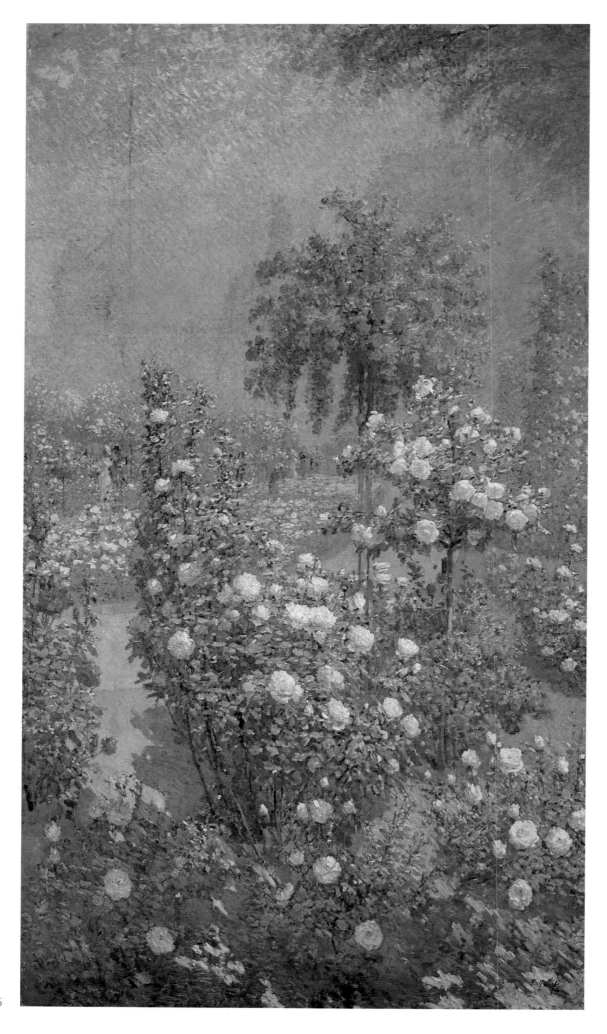

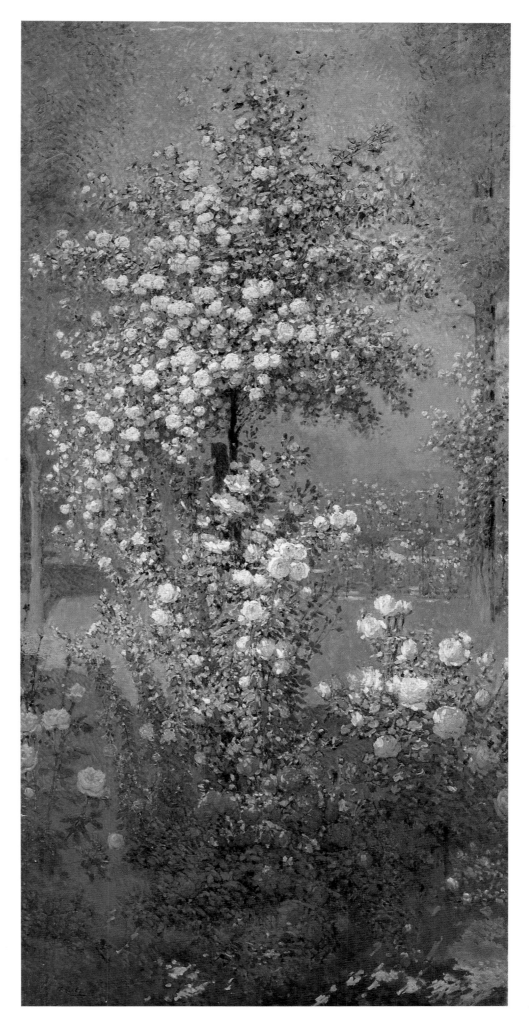

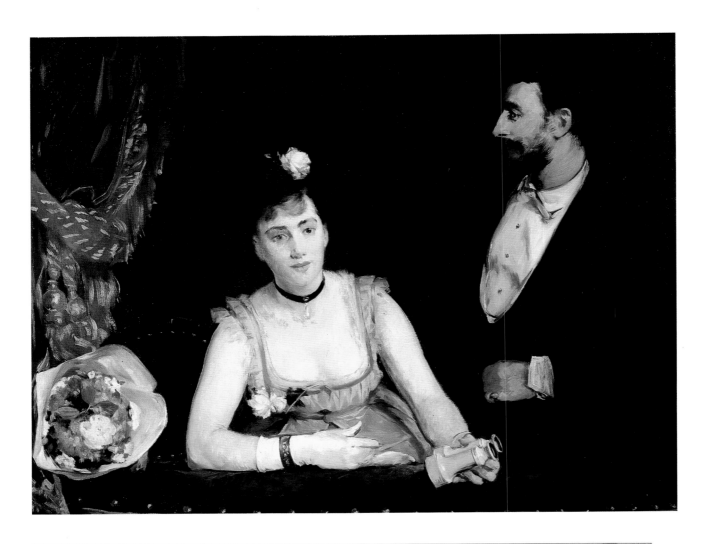

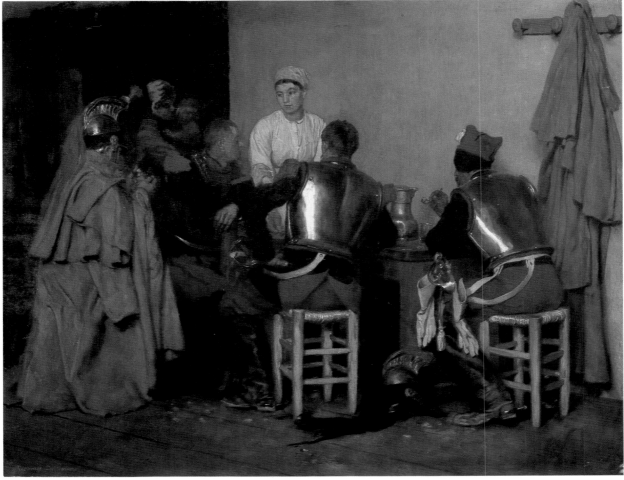

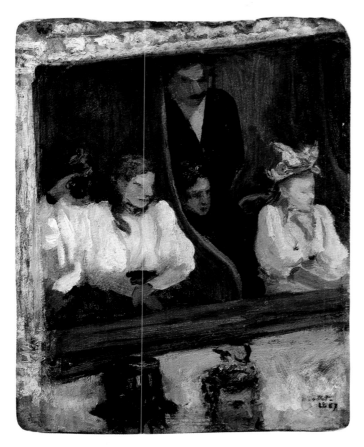

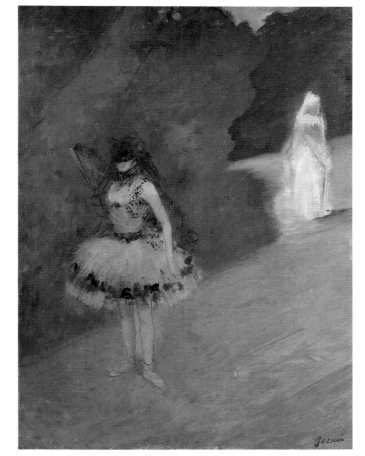

CHARLES COTTET
Loge at the Opéra-Comique, 1887
1' 1½" x 10¾" (34 x 27.5 cm) Bequest of the artist, 1925. RF 1977-119

JEAN-LOUIS FORAIN
Dancer Standing behind a Stage Prop
1' 6" x 2' (46 x 61 cm) Bequest of Étienne Moreau-Nélaton, 1927.
RF 3796

page 380, top left
STANISLAS LÉPINE, Caen 1835–Paris 1892
The Apple Market at Paris, Quai de l'Hôtel-de-Ville
(Salon of 1889)
1' 1¾" x 10¾" (35 x 27 cm) RF 968

page 380, top right
GUSTAVE LOISEAU, Paris 1865–Paris 1935
The Eure River in Winter, ca. 1903
2' 1¾" x 2' 8" (65.5 x 81 cm) Gift of Durand-Ruel, 1933.
RF 1977-228

page 380, bottom
ALBERT LEBOURG
The Port of Algiers, 1876
1' x 1' 6½" (31 x 47 cm) Bequest of Antonin Personnaz, 1937.
RF 1937-40

facing page, top
EVA GONZALÈS, Paris 1849–Paris 1883
A Loge at the Théâtre des Italiens, ca. 1874 (Salon of 1879)
3' 2½" x 4' 3¼" (98 x 130 cm) Gift of Jean Guérard, 1927. RF 2643

facing page, bottom
GUILLAUME RÉGAMEY, Paris 1837–Paris 1875
Cuirassiers at the Tavern, 1874 (Salon of 1875)
2' 4¾" x 3' (73 x 92.5 cm) Gift of Félix Régamey, 1901. RF 2702

page 381, top
ALBERT LEBOURG
Tug Boats at Rouen, 1903
1' 7¾" x 2' 5" (50 x 73.5 cm) RF 1973-4

page 381, bottom
ALBERT LEBOURG
Edge of the Ain River, 1897
1' 7¾" x 2' 1¾" (50 x 65.5 cm) Bequest of Étienne Moreau-Nélaton,
1927. RF 3793

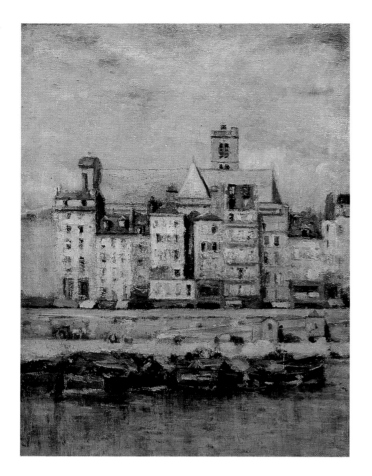

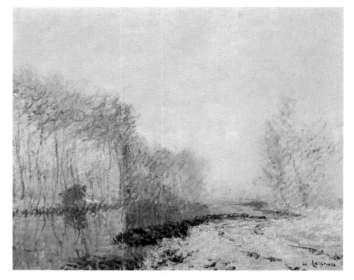

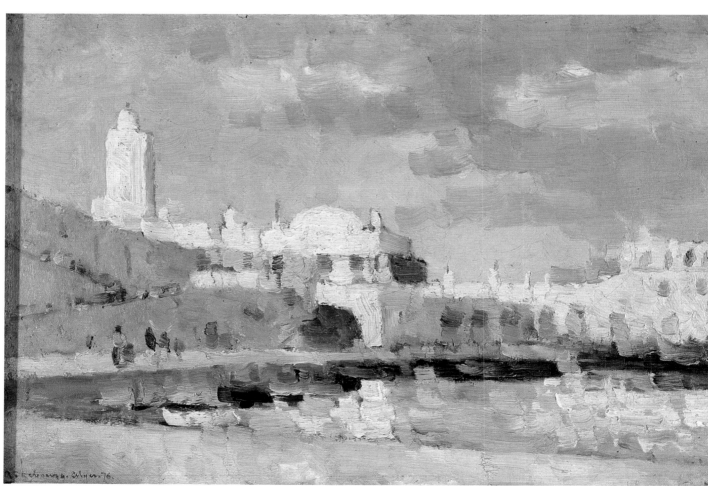

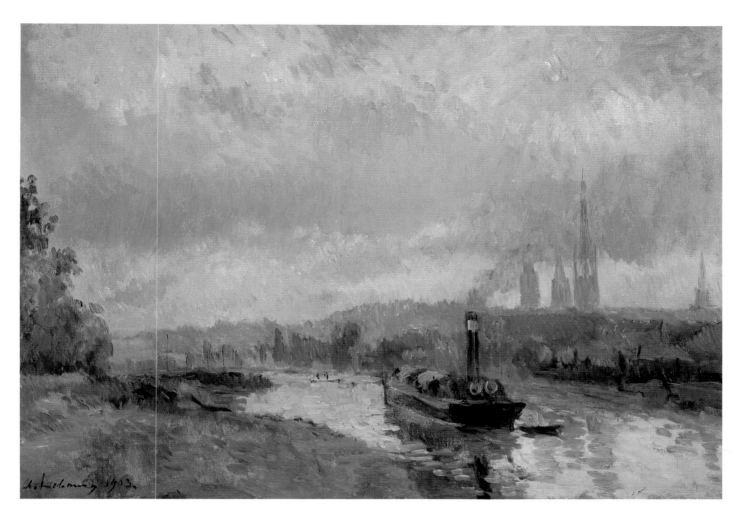

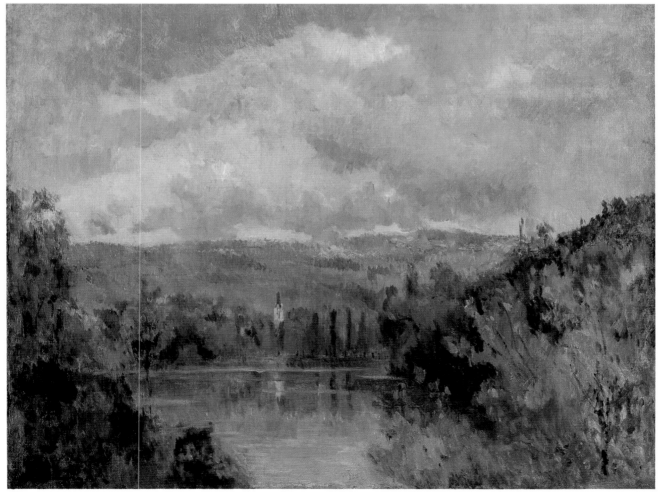

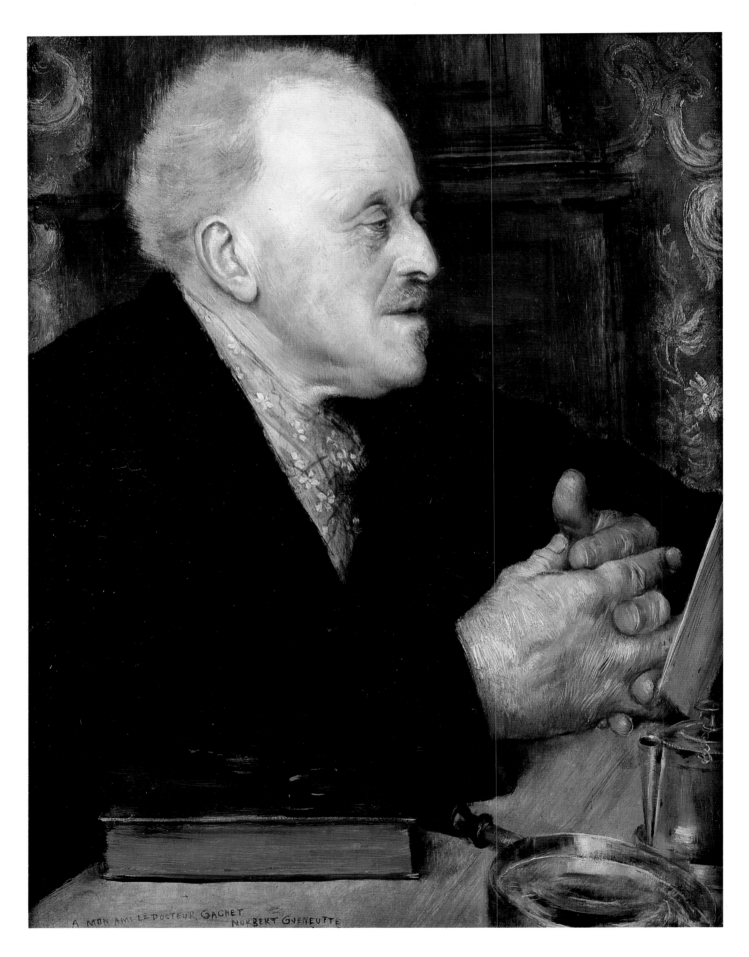

A MON AMI LE DOCTEUR GACHET
NORBERT GOENEUTTE

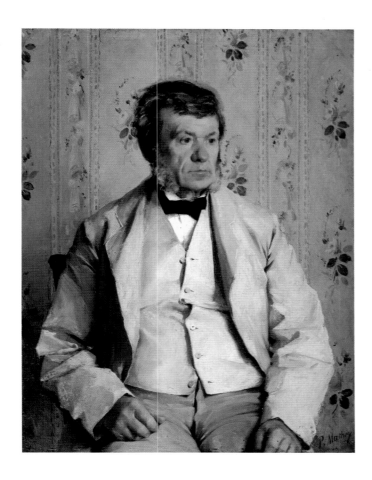

PAUL MATHEY, Paris 1844–Paris 1929
Pierre Mathey (the Artist's Father), before 1887
3′ x 2′ 4¾″ (92 x 73 cm) Gift of Jacques Mathey, 1969. RF 1969-19

JEAN-LOUIS FORAIN, Reims 1852–Paris 1931
The Widower (Salon of 1885)
4′ 7½″ x 3′ 3¼″ (141 x 100 cm) Bequest of Étienne Moreau-Nélaton, 1927. INV 20053

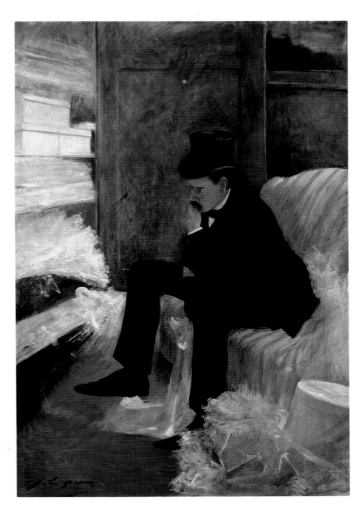

facing page
NORBERT GOENEUTTE, Paris 1854–Auvers-sur-Oise 1894
Dr. Paul Gachet, 1891 (Salon of 1892)
1′ 1¾″ x 10¾″ (35 x 27 cm) Gift of Dr. Paul Gachet, 1892. RF 757

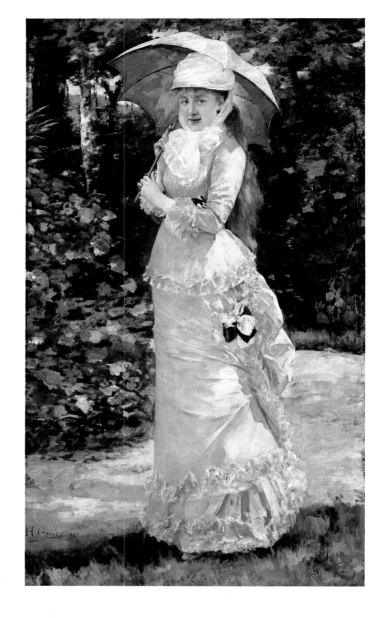

HENRI GERVEX
Mme. Valtesse de la Bigne, 1889
6′ 6¾″ x 4′ (200 x 122 cm) Gift of Mrs. Valtesse de la Bigne, 1906.
INV 20059

PAUL HELLEU, Vannes 1859–Paris 1927
Autumn at Versailles, ca. 1897
4′ 1½″ x 4′ 1½″ (126 x 126 cm) Bequest of Étienne Moreau-Nélaton,
1927. RF 1982-62

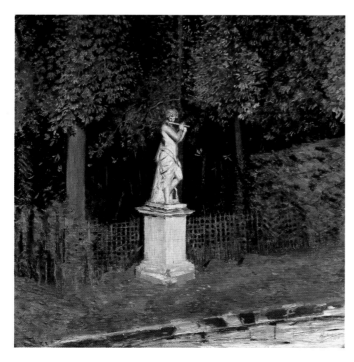

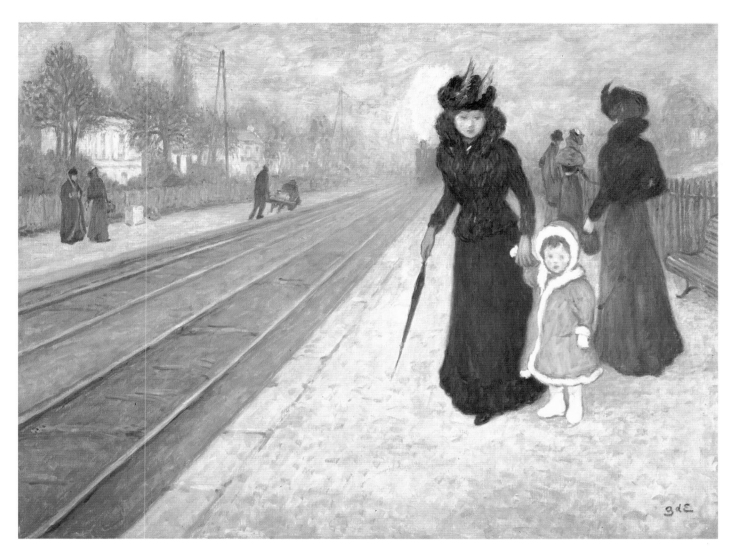

GEORGES D'ESPAGNAT, Melun 1870–Paris 1950
The Suburban Railroad Station
3′ 2¼″ x 4′ 3¼″ (97 x 130 cm) Gift of Bernard d'Espagnat, 1979.
RF 1979-21

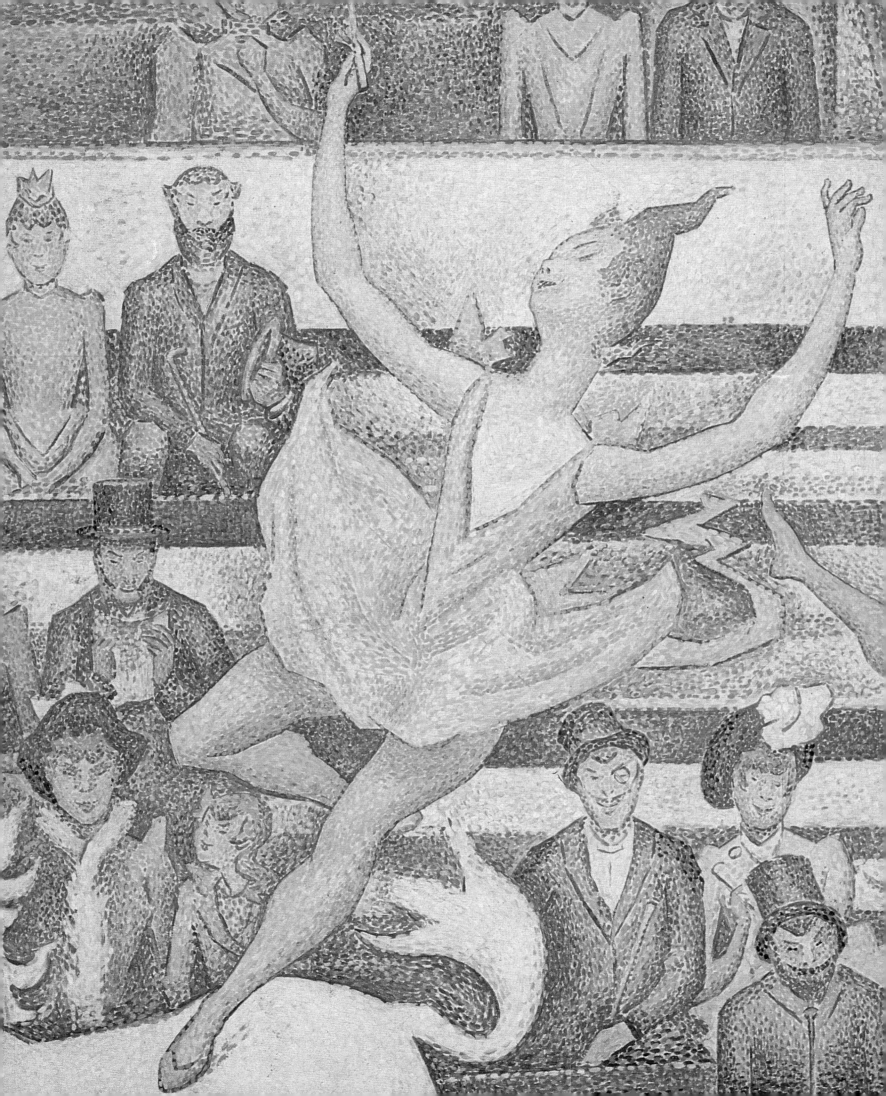

After Impressionism

THE ESTABLISHMENT IN FRANCE, 1880–1914: HISTORY PAINTING

Fernand Cormon
Cain

*A*lmost twenty-five feet wide, Cormon's epic biblical fantasy dominated, in both size and willful crudeness, the Salon of 1880, where it got the lion's share of attention from spectators and critics. Even within the encyclopedically expanding range of nineteenth-century history painting, which could reconstruct life in Egypt, Greece, Moorish Spain, Renaissance France, or the Napoleonic battlefield, *Cain* must have opened a thrilling new vista, that of prehistoric mankind. The subject is nominally from the Book of Genesis and represents the first murderer followed by his brutal clan; but the milieu evoked belongs with speculations from the age of Darwin that were particularly newsworthy in 1879 when the Paleolithic cave paintings of Altamira, Spain, were discovered. Here Cormon attempted to imagine and to document the look of our boorish ancestors who could slay one of their own kin with a jawbone much as they would slay wild animals in order to provide the bloody chunks of raw meat and the pelts of ragged clothing so prominent in the painting. To give high moral support for this excursion to the origin of our own species, Cormon quoted in the Salon brochure three lines from Victor Hugo's *La Légende des siècles* (1859), which also deals with the story of Cain's murder of Abel and the first awakening of human conscience. And to convey this sense of dread before the weight of Jehovah's moral law, Cormon has exaggerated the length of the shadows cast before the fleeing procession of man, woman, and child, as if the oppressive light of truth were pursuing this guilty tribe across the barren plain.

The style was appropriately rugged and was criticized for being so coarse that it looked as though it reflected the ideas of Darwin's disciples. By comparison with the slick, glossy surfaces and the artificial colors of such official Salon paintings of the 1870s as Regnault's *Execution without Trial* (page 181) or Bouguereau's *Birth of Venus* (page 43), Cormon proposes a rawness consonant with the theme. The colors are earthy, fusing the toughened, swarthy skins of the primitive family with the wild hunting dogs that follow them through the desert. The brushwork, too, has a rough, grainy quality that would accommodate some of the physical coarseness of Courbet's application of paint to the more refined standards of official painting. Indeed, by 1880, the painting of the establishment in Paris would absorb with growing speed the innovations of the rebellious youth of the mid-century, and even the dappled, brightly hued surfaces of Impressionism would become, in somewhat diluted form, a commonplace at the Salon.

As for Cormon's own efforts to create painted scenes of prehistoric life, they would later find their most suitable setting in Paris's Museum of Natural History, where he executed wall and ceiling decorations depicting the evolution of mankind (1898). He would find academic imitators, too, in other painters represented at Orsay such as Léon-Maxime Faivre, who at the 1888 Salon showed a picture of a cave woman defending her child against an oncoming bear who clutches her own cub. More surprising is that Cormon's best-known student was an artist who lived completely in the contemporary world, Toulouse-Lautrec.

Pompous and melodramatic, Cormon's vast canvas looks, to twentieth-century eyes, as if it might have been directed by Cecil B. deMille; and indeed its theme of an excursion to a land before time heralds, too, another popular aspect of movie entertainment. And it also parallels, within the academic establishment, the efforts of rebels like Cormon's contemporary, Gauguin, to capture the primal passions and primitive styles of the most distant civilizations.

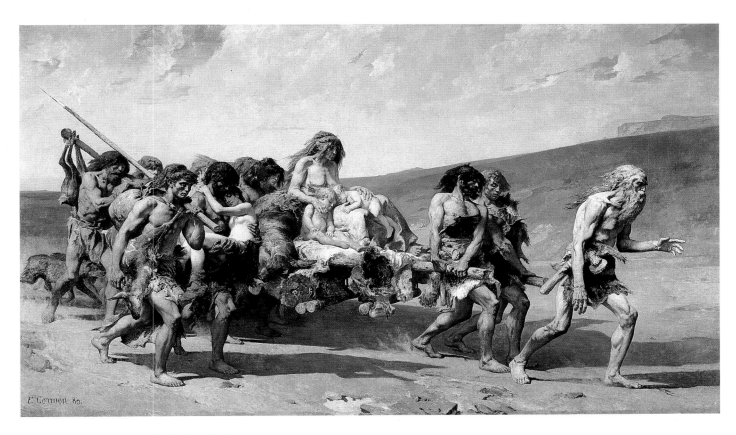

FERNAND CORMON, Paris 1845–Paris 1924
Cain (Salon of 1880)
12′ 5½″ x 22′ 11½″ (380 x 700 cm) RF 280

page 390
ANDRÉ DEVAMBEZ, Paris 1867–Paris 1944
The Police Charge, 1902 (Salon of 1902)
4′ 2″ x 5′ 3¾″ (127 x 162 cm) RF 1979-61

page 391, top
JEAN BÉRAUD, St. Petersburg (Russia) 1848–Paris 1935
The Magdalen at the House of the Pharisees, 1891 (Salon of 1891)
3′ 5″ x 4′ 3½″ (104 x 131 cm) Gift of Mr. and Mrs. Robert Walker,
1982. RF 1982-55

page 391, bottom
HENRI GERVEX, Paris 1852–Paris 1929
The Coronation of Nicholas II, 1896
3′ 9¾″ x 4′ 11¾″ (116 x 151.5 cm) RF 1977-184

pages 392 and 393
ANDRÉ DEVAMBEZ
The Police Charge, detail

André Devambez
The Police Charge

Still startling today, this dizzying upper-story view of a police brigade quelling a riot in the Boulevard Montmartre must have been even shriller when it made its debut in conservative company at the 1902 Salon. As a student of Benjamin-Constant (page 398) and Lefebvre (page 44) compliant enough to win the 1890 Prix de Rome, Devambez knew how to accommodate officialdom and even received a commission for painted decorations at the Sorbonne. At other times, as in this imposingly large canvas, he could embrace the new century with jolting originality. To be sure, Monet, Pissarro, and Caillebotte had often looked down on pedestrians milling about Paris's traffic arteries. Devambez, however, turns such cheerful Impressionist bustle into an urban nightmare, like a siren piercing the city's electric night. Probably prompted by the anarchist uprisings familiar at the turn of the century, he transformed a thoroughfare of kiosks, terraced cafés, and street lamps into a precariously tilted arena of social battle. Like Gulliver, he looks down from a remote height at a Lilliputian world of urban violence in which the robotlike police line is pitted against the chaos of fleeing rioters. Such collision courses, erupting within the regimented framework of a street's plunging axis, prophesy and may even have influenced the explosions of human and mechanical forces that the Italian Futurists would celebrate with youthful militancy from 1909 to the outbreak of the First World War. Devambez, however, was born a whole generation before them, yet another tribute to his singular imagination, which stretches the limits of nineteenth-century Realism to a near-hysterical breaking point.

Captions are on page 389.

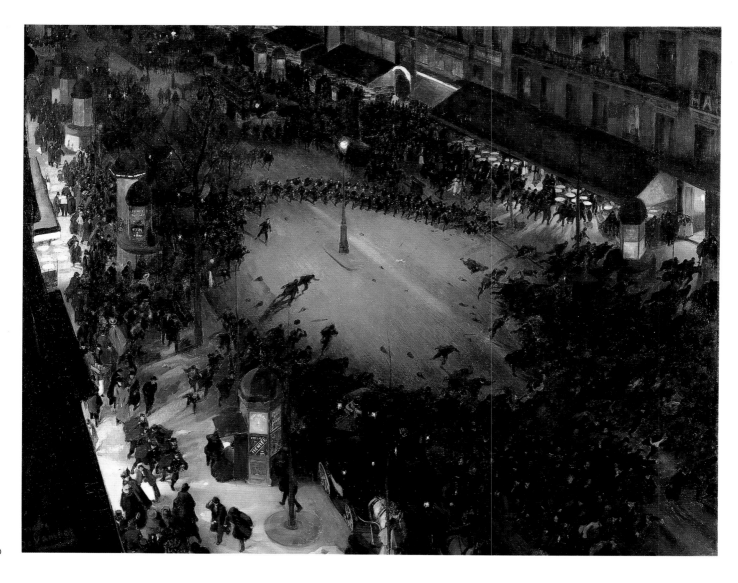

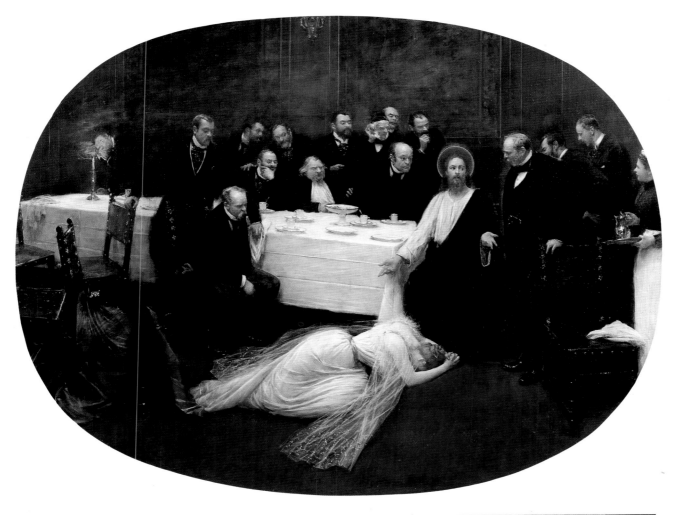

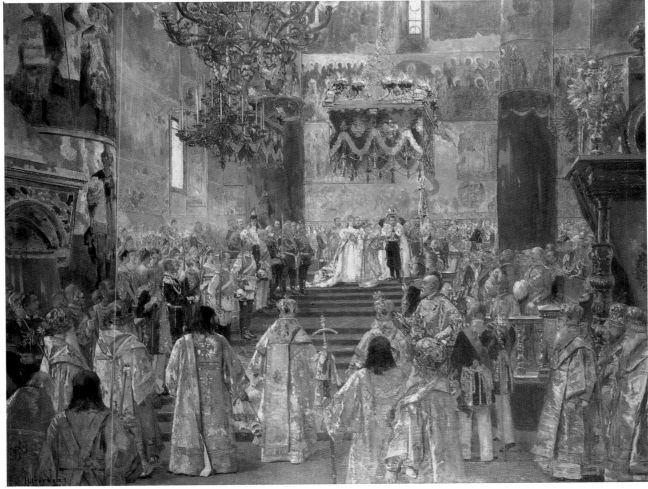

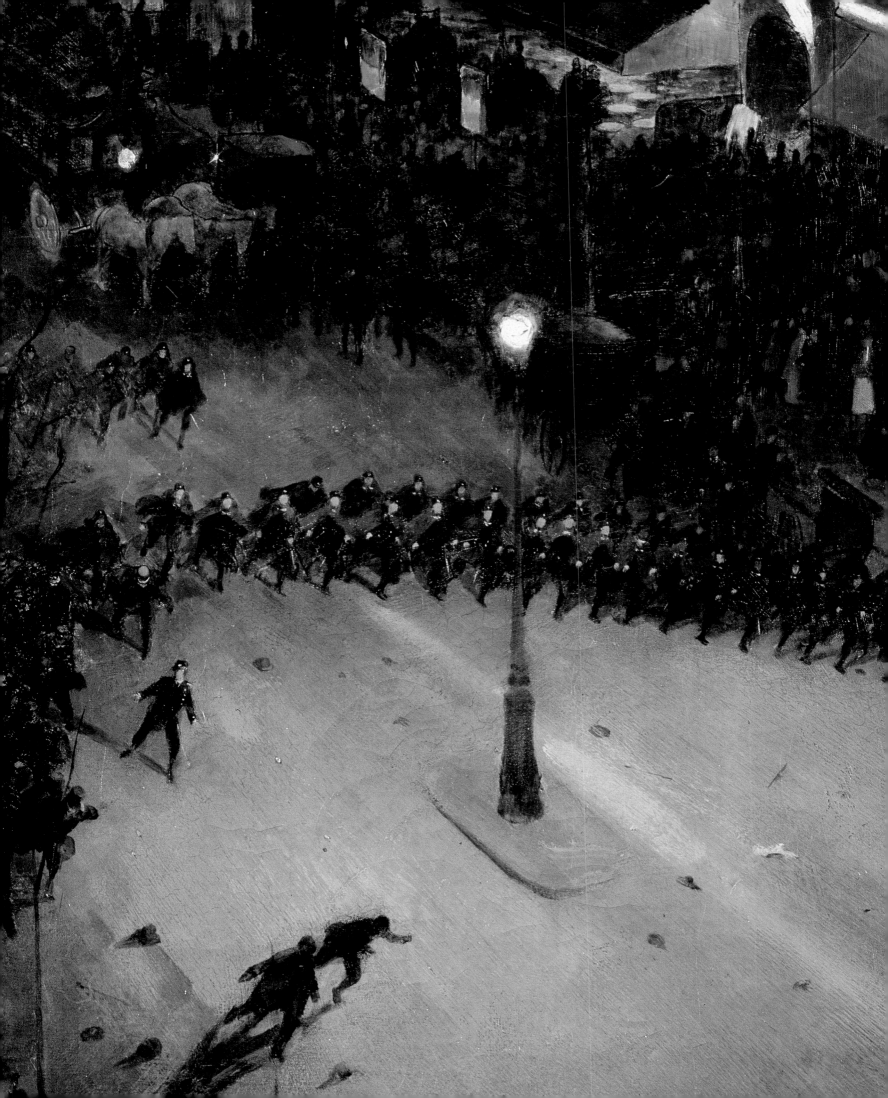

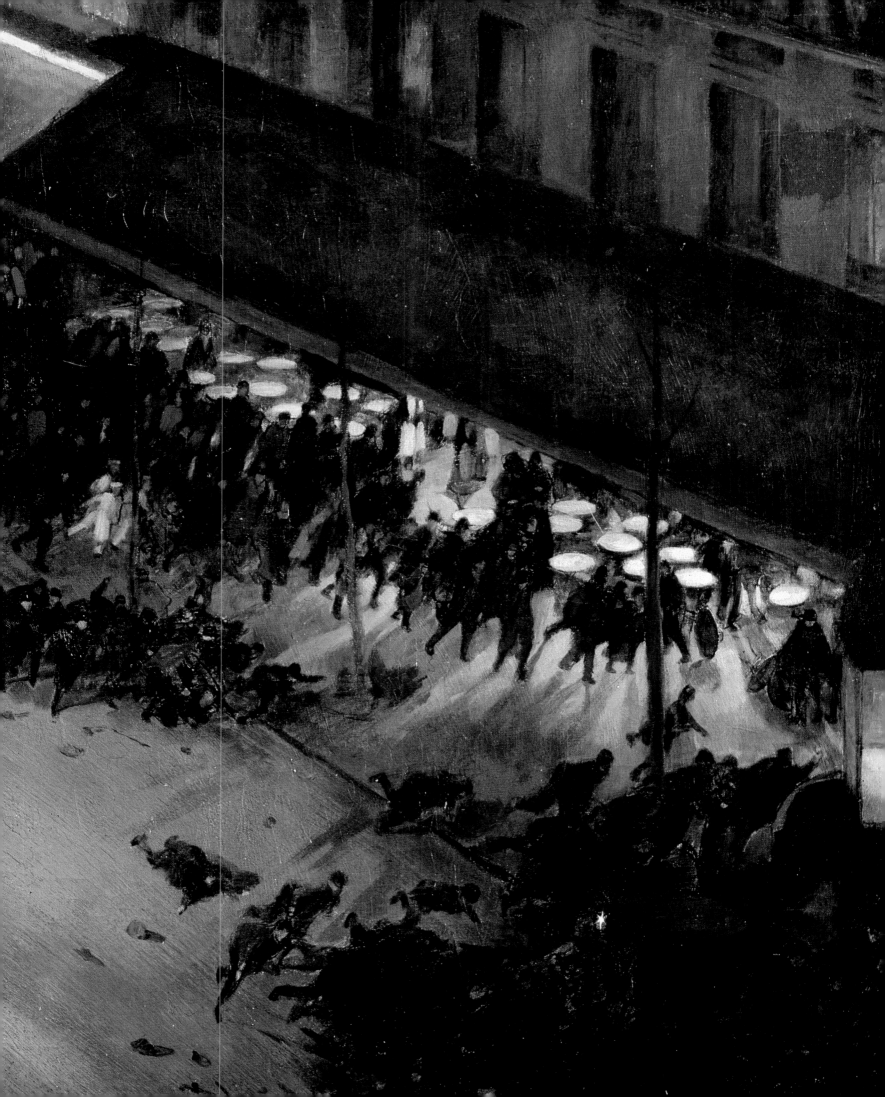

Decorations for Three Paris Theaters

With three models for the painted domes that crown the auditoriums of three of Paris's most famous theaters—the Opéra, the Opéra-Comique, and the Théâtre des Champs-Elysées—the Musée d'Orsay offers a thumbnail sketch of the history of official decoration under the Third Republic, from the 1870s to the eve of World War I. The sequence begins with Lenepveu's project for the cupola of Charles Garnier's Opéra, the resplendent Neo-Baroque palace of culture and entertainment that, begun under the Second Empire, finally opened in January 1875. Its ceiling was a characteristically Neo-Baroque aerial fantasy, conjuring up an allegory of the hours of the day and night, and wafting upward-gazing spectators into an ethereal sky-blue cloud-land that, in the more religious seventeenth century, would have been inhabited by saints and angels ascending to heaven. It was a perfect resurrection of Baroque virtuosity, a tour de force of gravity-defying illusionism, which, almost a century later, had become so unfashionably retarda-taire (despite its congruence with the Opéra's period style) that it was covered over with a new kind of airborne allegory by Marc Chagall in 1963–1964. (Now that Post-modernism has given nineteenth-century Historicism a new lease on life, Lenepveu's original frescoes may well be unveiled by a future generation!)

By the 1890s, reflecting the Symbolist decade, even the mood of public art had changed, and Benjamin-Constant's study of 1898 for the dome of the brand-new Opéra-Comique reflects these welling mysteries. A conventional allegory representing Fame, Symphony, Song, and Poetry is nevertheless given a ghostly, imaginative aura by the nocturnal monochrome, which turns shopworn symbols into a phantom dream of a sort inspired by the musical performances within these halls. It is a vision reminiscent of such earlier pictorial responses to opera as Fantin-Latour's *Three Rhine Maidens* (page 168).

This sequence reaches a very different conclusion in Denis's project of 1911 for the cupola of the emphatically modern Théâtre des Champs-Elysées, which opened in 1913 on the eve of war (page 396). Like Auguste Perret, the theater's famous architect, Denis offers a typically French compromise between the respectable pull of classical traditions and the obligatory nod toward modernity. The quartet of allegories (Dance, Opera, Symphony, and Lyric Drama) is presented in grandly symmetrical schemes whose pedigree goes back to such huge official canvases as Cou-ture's *Romans of the Decadence* (page 23); yet these myths of artistic creation, inhabited by the likes of Apollo, the Three Graces, and an assortment of airborne spirits, are depicted in a consciously archaizing style, indebted to Puvis de Chavannes but brought up to date by the even more severe stylization of lucid geometries, where cylinders of columns and tree trunks are almost interchangeable, and by an abstract iridescence of color that seems to glow with the yellow and lavender light of ancient Mediterranean inspi-ration. However, such shockingly modern innovations, which offended many, were hardly a match for Igor Stra-vinsky's *Rite of Spring*, which might have blown Denis's roof off when the work had its world premiere in 1913 at the Théâtre des Champs-Elysées, within months of its opening.

395

MAURICE DENIS
Scale Model for the Cupola of the Théâtre des Champs-Elysées, 1911–1912
Tempera on plaster and glass, 7′ 10½″ (240 cm) diameter RF 1983-27

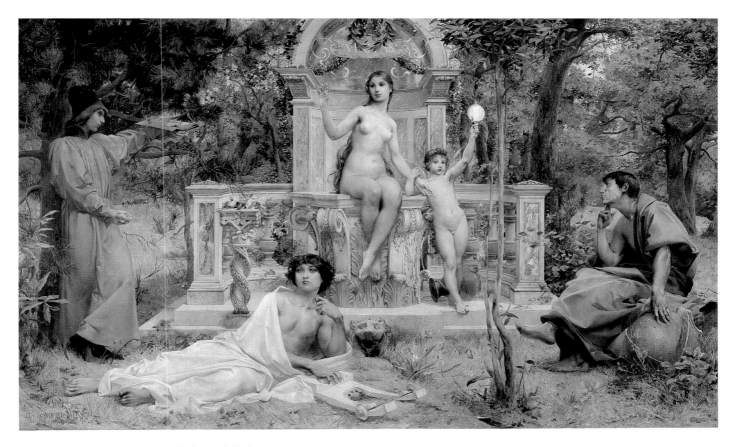

LUC-OLIVIER MERSON, Paris 1846–Paris 1920
Truth (from Hôtel Watel-Dehaynin), 1901
7′ 3″ x 12′ 2½″ (221 x 372 cm) RF 1974-27

THE ESTABLISHMENT IN FRANCE, 1880–1914: PORTRAITS

Bonnat and Benjamin-Constant

For images of establishment power under the Third Republic, these two portraits could hardly be bettered, combining would-be photographic truth to their venerable sitters' here-and-now reality of age, face, and clothing with an awesome, almost godlike authority. Bonnat's pillar of society is the brand-new president of France, Jules Grévy, elected in 1879 at the age of seventy-two and presented to his fellow citizens in the form of this solemn icon only months later, at the Salon of 1880, in such diverse company as Cormon's *Cain* (page 389) and a dapper portrait by Manet of another politician, Antonin Proust. Manet, in fact, had also painted in the same year a portrait of the statesman and journalist Georges Clemenceau (page 266), who published many radical opinions during Grévy's eight-year presidency. In a way, his Clemenceau is a perfect complement to Bonnat's Grévy, sharing the no-nonsense palette of official black. But Manet's preference for casual

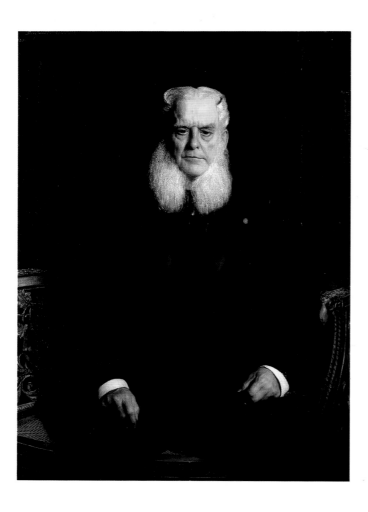

posture and swift brushwork is severely corrected by Bonnat, who prefers for his sitter the lofty, immutable symmetry of a Last Judgment and, rushing back to earth, a surface that, as in a sharp-focus photograph, would replicate every seen fact, from white whiskers and blue veins just visible through aging flesh to the gilding of the Empire table. Such mirrorlike truth to appearances, familiar in many painted portraits of the period, has often been rejected out of hand as belying the selectivity that good painting is supposed to require. However, our growing ability to distinguish enthusiastically between genius and hack in the work of nineteenth-century photographers (or, for that matter, Photo-Realist painters of the 1970s) has overcome the earlier prejudices of modernist generations. It would be hard not to be impressed by Bonnat's unsmiling ideal of solemn, presidential authority. Grévy not only commands the republic, he can make us bow before him.

Such an official image that was both true to literal fact and ideal as political rhetoric created a mold often filled by other fixtures of the French establishment. Benjamin-Constant's 1896 portrait of Alfred Chauchard is one of these. Chauchard, who was seventy-four when he sat for this portrait, was a major force at the Louvre, a generous donor and organizer of its storerooms. Like Grévy, he seems, in this portrait, to have reigned forever, dominating a lesser world beneath him; his confrontational symmetry, which extends right through the part in his thinning hair, calls us to attention. With only the red of his Legion of Honor decoration to distract us, his image, too, is created from the most intense of blacks, echoing the familiar tonalities of contemporary photographs. Even today, a century later, these official portrait paintings may make us quiver a bit before the power of establishment law and order, both in the seat of French government and in the home of its official repository of art treasures, the Louvre.

BENJAMIN-CONSTANT, Paris 1845–Paris 1902
Alfred Chauchard, 1896 (Salon of 1897)
4' 3½" x 3' 2¼" (130.5 x 97 cm) Bequest of Alfred Chauchard, 1909.
RF 1776

facing page
LÉON BONNAT, Bayonne 1833–Monchy-Saint-Eloi 1922
Portrait of Jules Grévy, 1880 (Salon of 1880)
4' 11¾" x 3' 9¾" (152 x 116 cm) Gift of Mr. Grévy, 1939.
DO 1986-15

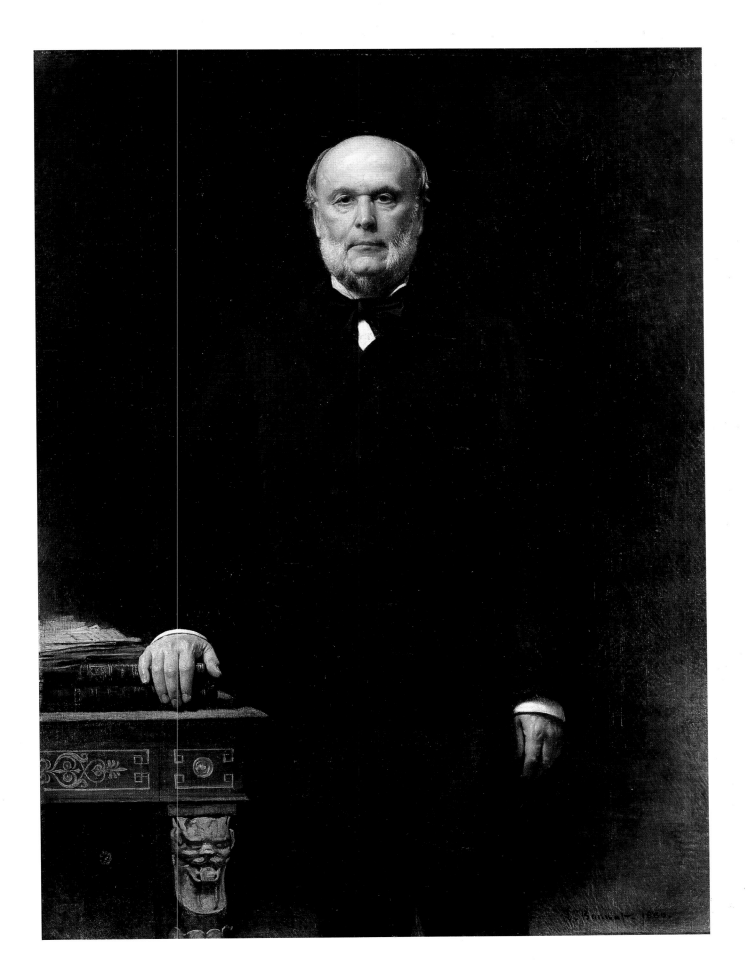

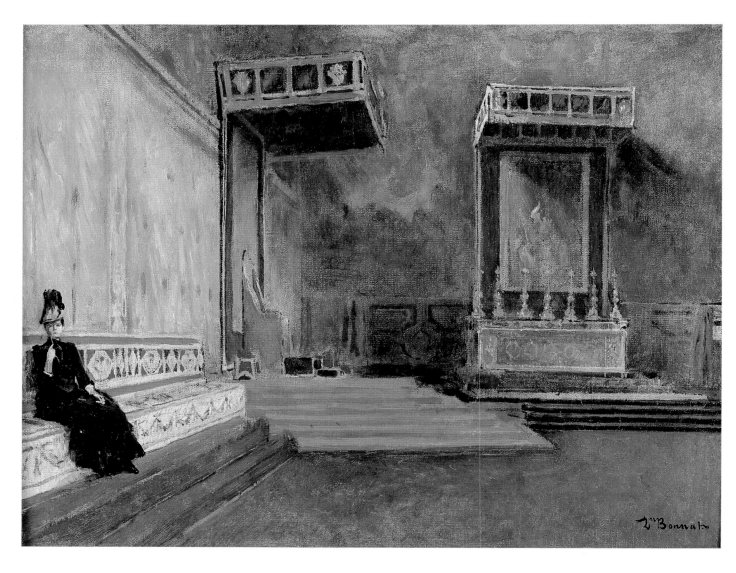

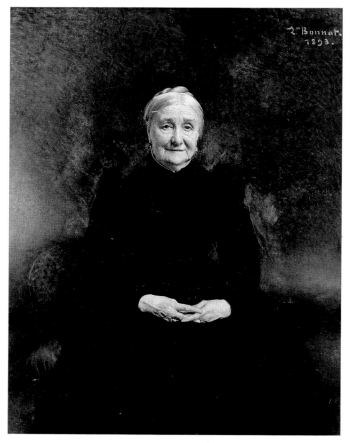

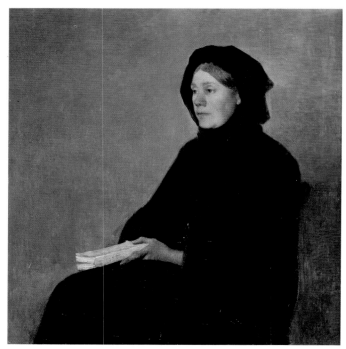

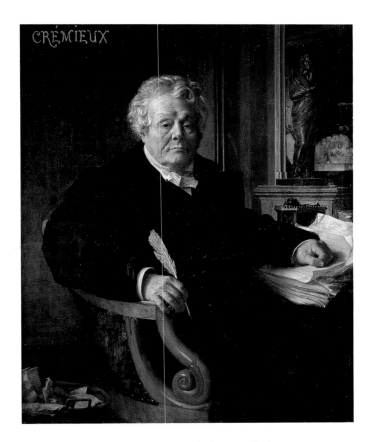

JEAN LECOMTE DU NOUY, Paris 1842–Paris 1923
Adolphe Crémieux, 1878 (Salon of 1878)
3′ 11¾″ x 3′ 3¾″ (121 x 101 cm) Gift of Mrs. Paul Landowski, 1968.
RF 1968-11

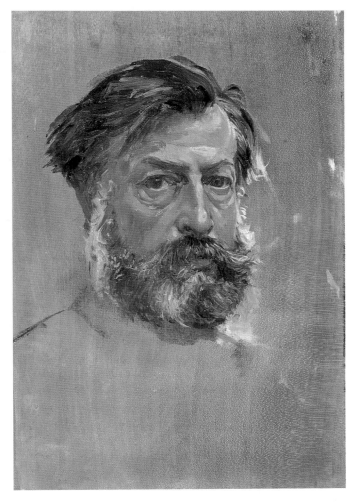

ERNEST MEISSONIER, Lyons 1815–Paris 1891
Self-Portrait, 1889
7½″ x 5¼″ (19 x 13.5 cm) RF 1251

facing page, top
LÉON BONNAT
Interior of the Sistine Chapel (Portrait of Mme. Edouard Kann?),
ca. 1877
1′ 6″ x 1′ 7¾″ (45.5 x 50 cm) Bequest of Mrs. Edouard Kann, 1929.
RF 2685

facing page, bottom left
LÉON BONNAT, Bayonne 1833–Monchy-Saint-Eloi 1922
Madame Bonnat, the Artist's Mother, 1893
4′ 3½″ x 3′ 4½″ (131 x 103 cm) Bequest of the artist, 1922. RF 2667

facing page, bottom right
HENRY LEROLLE, Paris 1848–Paris 1929
Portrait of the Artist's Mother (Salon de la Société Nationale
des Beaux-Arts, 1895)
3′ 3¼″ x 3′ 3¼″ (100 x 100 cm) RF 941

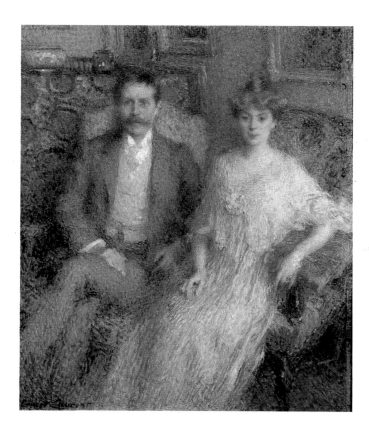

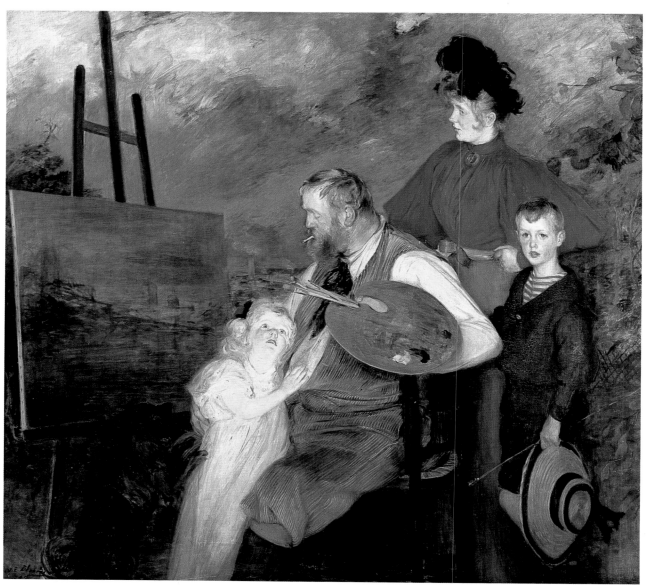

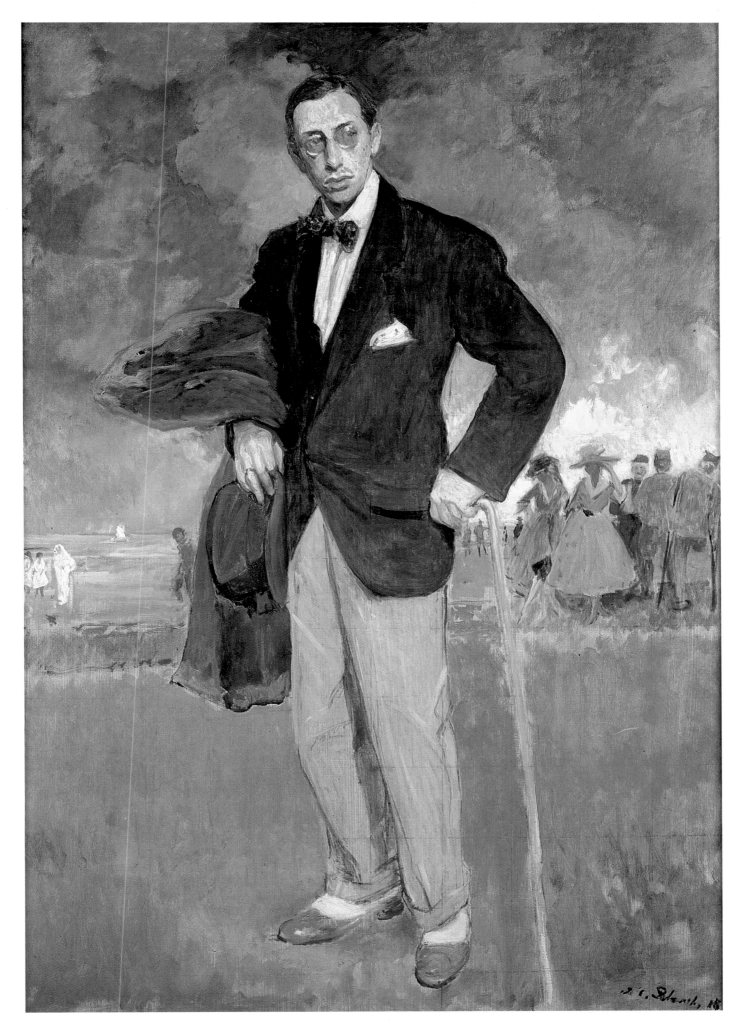

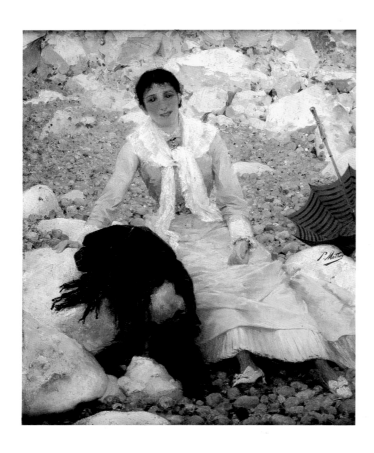

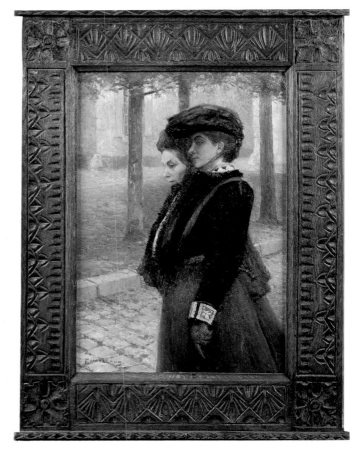

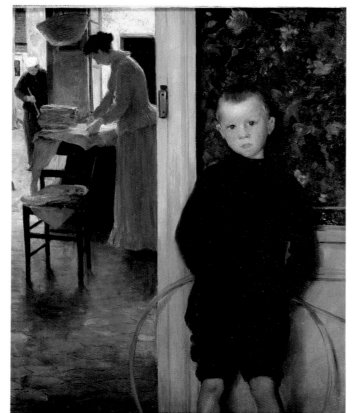

GUILLAUME MAILLAUD, Mouhet 1862–Paris 1948
The Maillaud Ladies, ca. 1900 (artist's wife and mother)
1′ 10″ x 1′ 3¼″ (56 x 38.5 cm) Gift of André Boule, 1981.
RF 1981-49

left, top
PAUL MATHEY, Paris 1844–Paris 1929
Mme. Fernande Mathey (1857–1941), The Artist's Wife
1′ 9¾″ x 1′ 6″ (55 x 46 cm) RF 1982-8

left, bottom
PAUL MATHEY
Woman and Child in an Interior (son Jacques, born 1883, at right)
1′ 7″ x 1′ 3″ (48.5 x 38 cm) Gift of Miss Dubreil, 1981. RF 1982-9

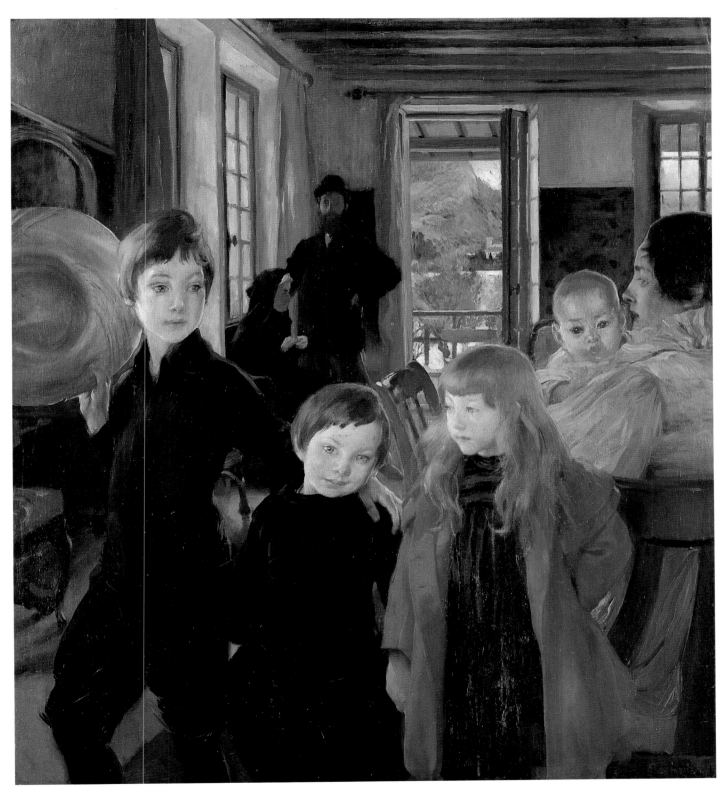

ALBERT BESNARD, Paris 1849–Paris 1934
A Family (The Artist's Family), 1890 (Salon of 1890)
4′ 4″ x 3′ 11½″ (132 x 120.5 cm) RF 1977-40

THE LATER MONET

The Rouen Cathedral Series

*B*y the 1890s, Monet had gone through the looking glass of his ever more refined perception, emerging in a phantom realm, more shadow than substance. He had left far behind his bustling scenes of the 1870s—the excitement of a railway station or of a crowded working-class street (page 287)—in favor of motifs remote from the facts of nineteenth-century life, whether found in an untouched landscape or in a survivor of the Middle Ages, Rouen Cathedral. In 1877 he painted a quasi-documentary series of canvases recording, from different angles, the Gare Saint-Lazare (page 271); but between 1892 and 1894, he replaced this symbol of modern technology with a symbol of Catholic faith. In order to paint what turned out to be more than thirty views of the late Gothic cathedral facade, Monet rented a room on the square facing it, above a shop, Au Caprice. From this vantage point he could scrutinize the infinite changes of light that transformed ancient stone into a gravity-defiant specter behind a vibrant scrim.

The cathedral had often been painted before, not only by Monet but by Pissarro and lesser artists, but these records tend to be picturesque and literal, rendering its craggy silhouette within the core of a sprawling modern townscape. For this new series, Monet vastly amplified the scale by implying the spectator's immersion in a close-up view, as if through a window—a fragment that suggests Gothic immensities expanding far beyond the edges of the frame. In 1895 twenty of these canvases were exhibited at a large Monet show in Paris. Seen in such quantity, the series must have achieved the seemingly impossible goal of documenting through changing moments of time the most gossamer perceptions of both outer eye and inner consciousness. There had been a long tradition of painting the times of day and the seasons of the year, but Monet's ambitions were virtually to trace the seamless flow of subjective experience. It was a task worthy of the writer Marcel Proust.

Five of these views are at Orsay, telling at least a partial story. In one, a morning scene subtitled, in a Whistlerian vein, *Harmony in White*, the low secular building on the left of the square is included, an intrusion that gives the painting a more topographical character. In the other four paintings, however, such earthbound reality vanishes, and we become absorbed in what looks more like the ghost of an ancient monument of faith than an actual building in the heart of a thriving modern city. To be sure, the crust of his layered pigments somehow conveys the weathered complexity of the Gothic stone. This appeal to the tactile sense is undone, however, by the camouflage effect of overcast sunlight that can vary from a heavenly, golden-blue shimmer to the melancholic gray of a winter sky. To achieve such modulations, Monet did more than scrutinize each transition of colored light on the spot. He reworked the canvases later in his country house at Giverny, continuing the metamorphosis of what had begun as objective perception in the documentary spirit of serial photography and ended as an exploration of nuance so attenuated as to verge on the mystical. Indeed, these Gothic mirages would not be out of place in the Symbolist ambience of the 1890s and might make a more persuasive case for a new religious art than the more literally spiritual paintings of the decade, such as Osbert's ectoplasmic vision of St. Genevieve (page 550).

Even more than its predecessors—the many views of haystacks and poplars—the Rouen Cathedral series has become a watershed in modern painting, paralleling Cézanne's own continued reexamination of a single motif. And its progeny seems infinitely expandable, heralding a long tradition that would include not only Mark Rothko's own chromatic and atmospheric variations on the same repeated format but also less expected territories in Pop art. Roy Lichtenstein re-created Monet's Rouen Cathedral series in his own language of Benday dots (which ironically turns inside out Monet's intensely personal facture); and even Andy Warhol, when he ran off a belt-line series of Marilyn Monroes or Campbell soup cans, was still working under the long, fertile shadow cast by Monet's innovative achievement.

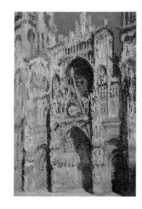
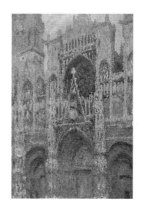
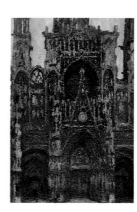

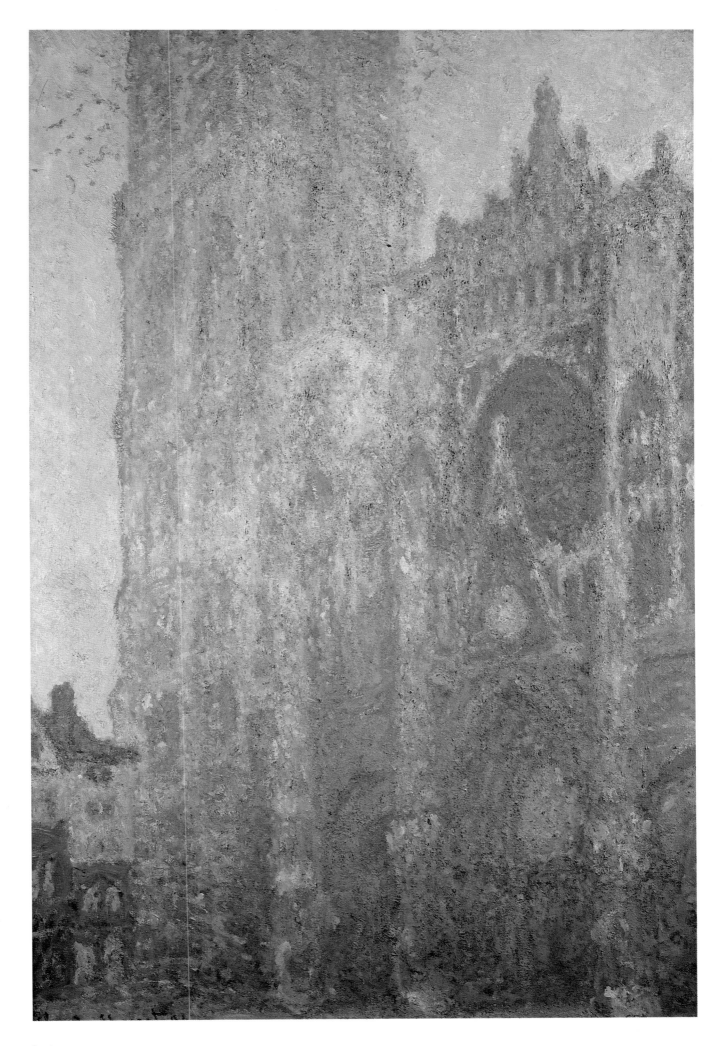

407

Captions are on page 413.

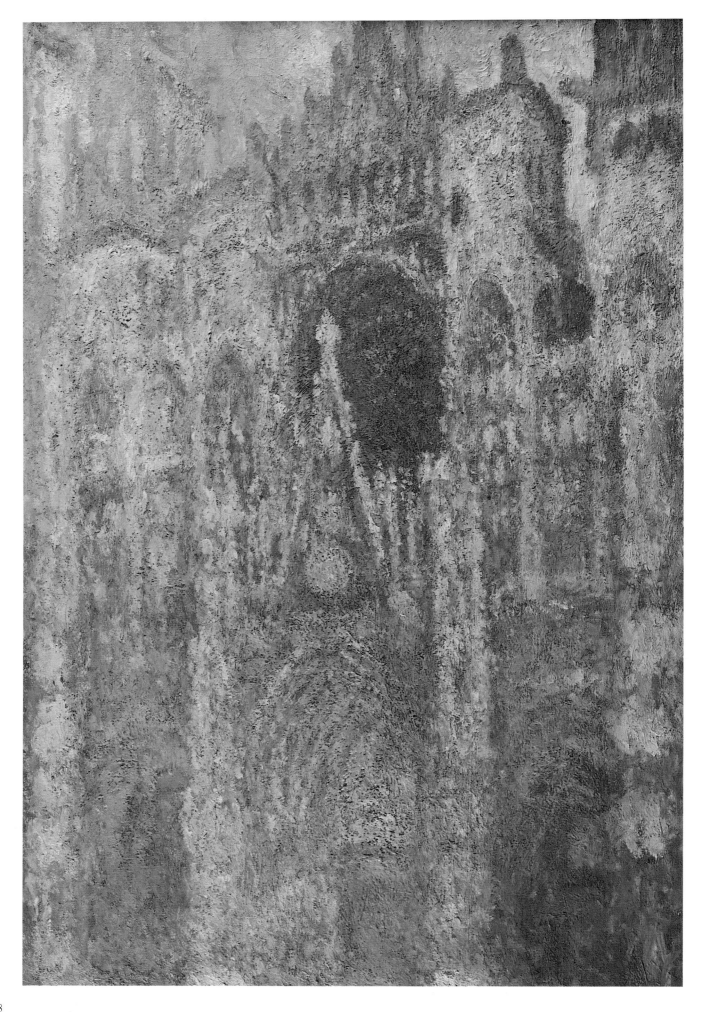

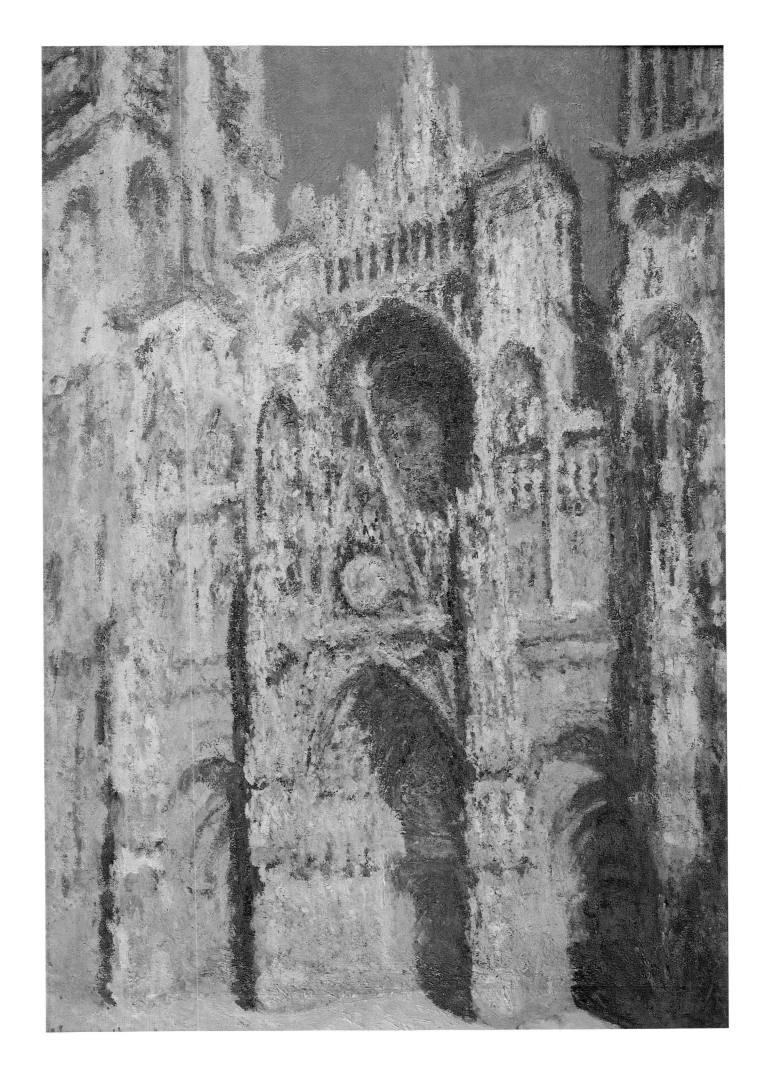

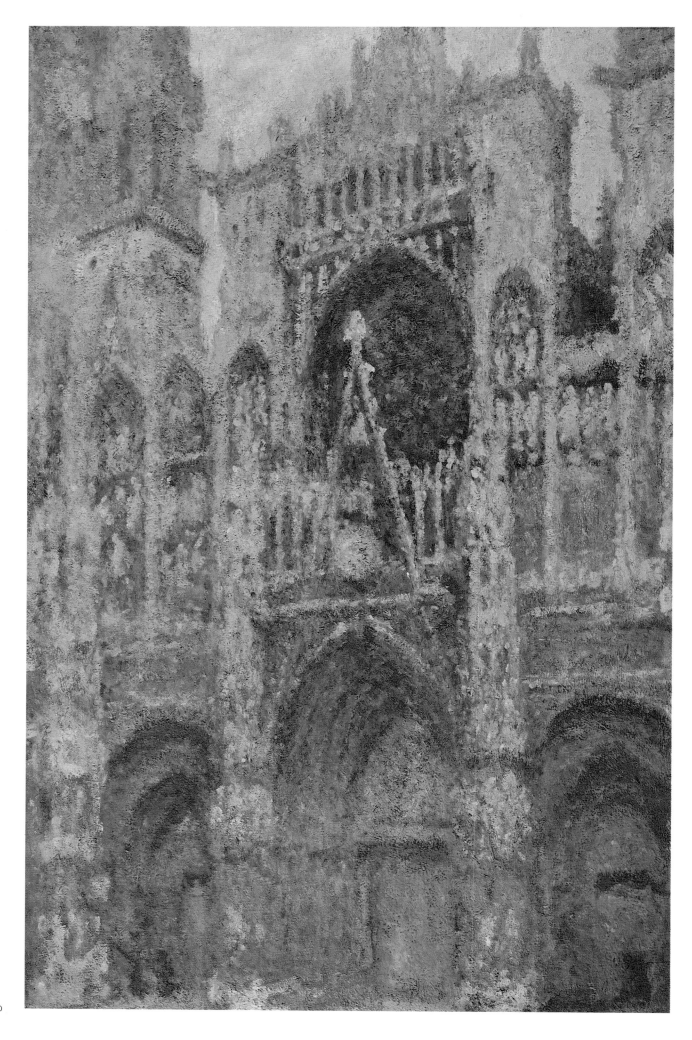

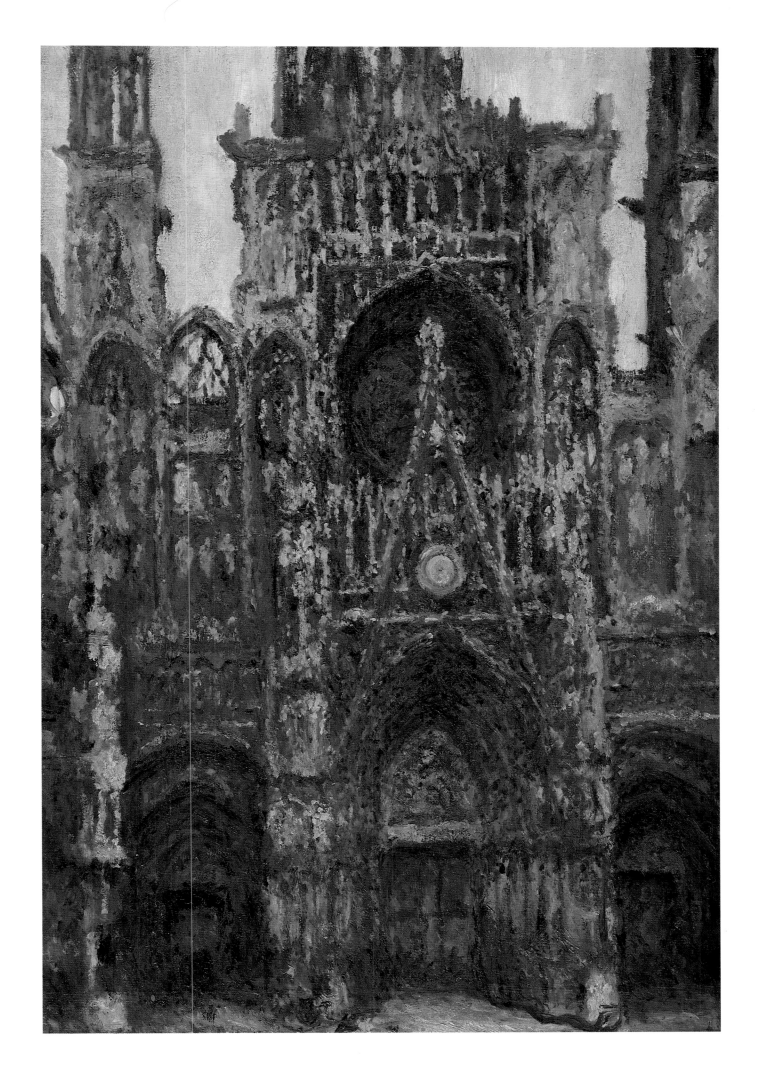

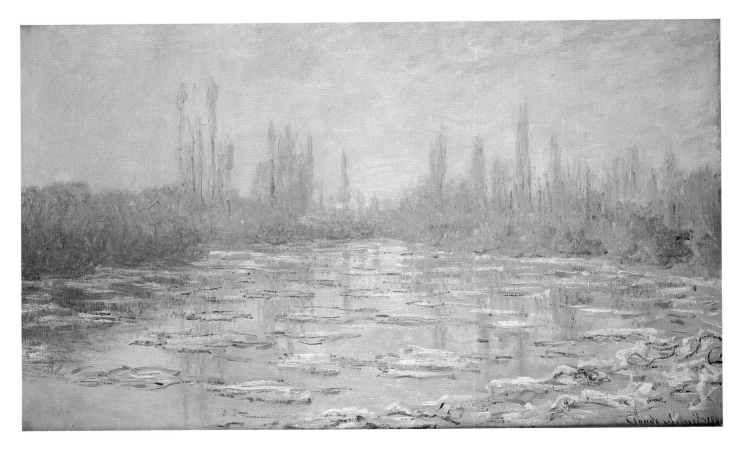

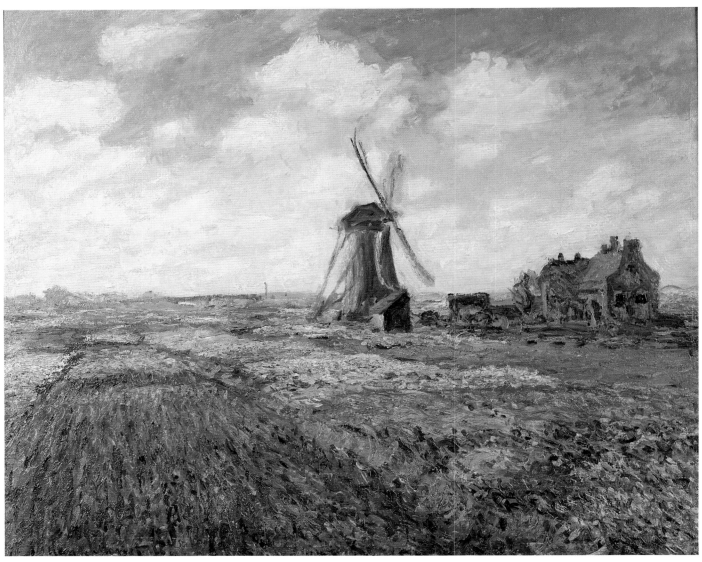

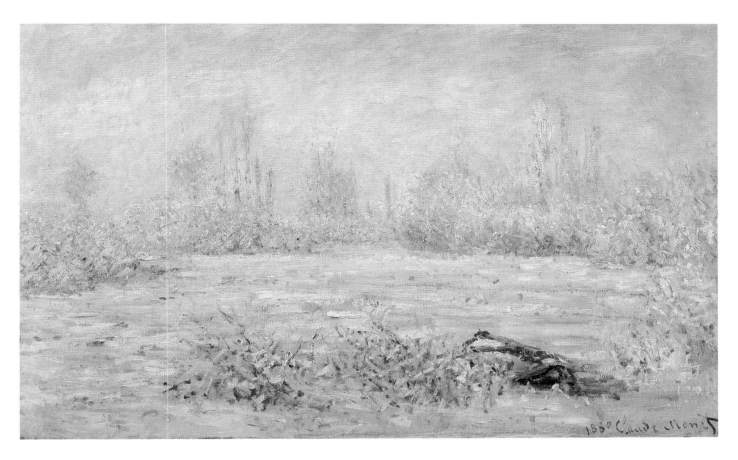

CLAUDE MONET
Hoarfrost, near Vétheuil, 1880
2′ x 3′ 3¼″ (61 x 100 cm) Bequest of Gustave Caillebotte, 1894.
RF 2706

facing page, top
CLAUDE MONET
Ice Thawing on the Seine (The Ice Blocks near Vétheuil), 1880
1′ 11½″ x 3′ 3¼″ (60 x 100 cm) Bequest of
Baroness Eva Gebhard-Gourgaud, 1965. RF 1965-10

facing page, bottom
CLAUDE MONET
Tulip Fields in Holland, 1886
2′ 1¾″ x 2′ 8″ (65.5 x 81.5 cm) Bequest of
Princess Edmond de Polignac, 1944. RF 1944-19

page 407
CLAUDE MONET
*Rouen Cathedral (The Portal and Tour Saint-Romain, Impression of
Morning; Harmony in White)*, 1894
3′ 5¾″ x 2′ 4¾″ (106 x 73 cm) Bequest of Count Isaac de Camondo,
1911. RF 2001

page 408
CLAUDE MONET
Rouen Cathedral (The Portal, Morning Sun; Harmony in Blue), 1894
2′ 11¾″ x 2′ 1″ (91 x 63 cm) Bequest of Count Isaac de Camondo,
1911. RF 2000

page 409
CLAUDE MONET
*Rouen Cathedral (The Portal and the Tour Saint-Romain, Bright Sun;
Harmony in Blue and Gold)*, 1894
3′ 6¼″ x 2′ 4¾″ (107 x 73 cm) Bequest of Count Isaac de Camondo,
1911. RF 2002

page 410
CLAUDE MONET
Rouen Cathedral (The Portal, Gray Weather; Harmony in Gray), 1894
3′ 3¼″ x 2′ 1½″ (100 x 65 cm) Bequest of Count Isaac de Camondo,
1911. RF 1999

page 411
CLAUDE MONET
Rouen Cathedral (The Portal Seen Head On; Harmony in Brown), 1894
3′ 6¼″ x 2′ 4¾″ (107 x 73 cm) RF 2779

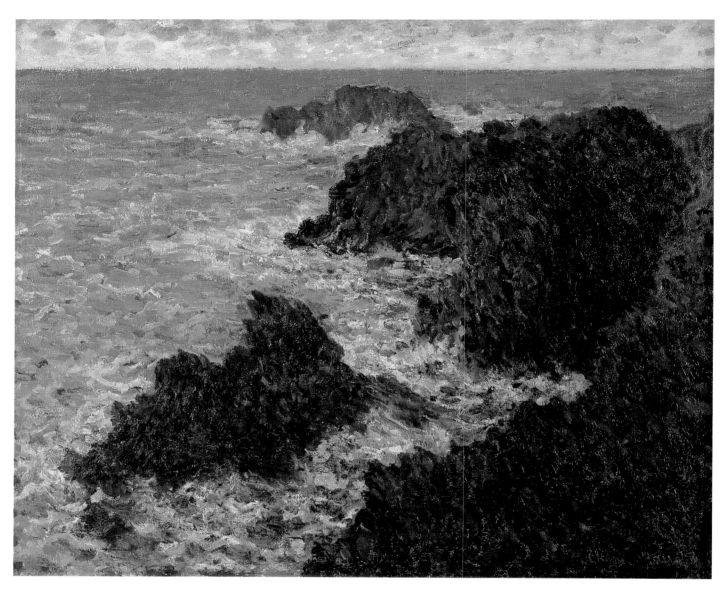

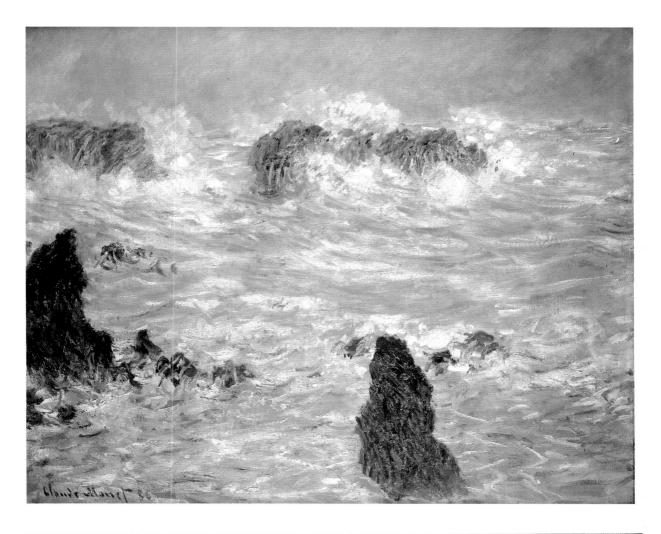

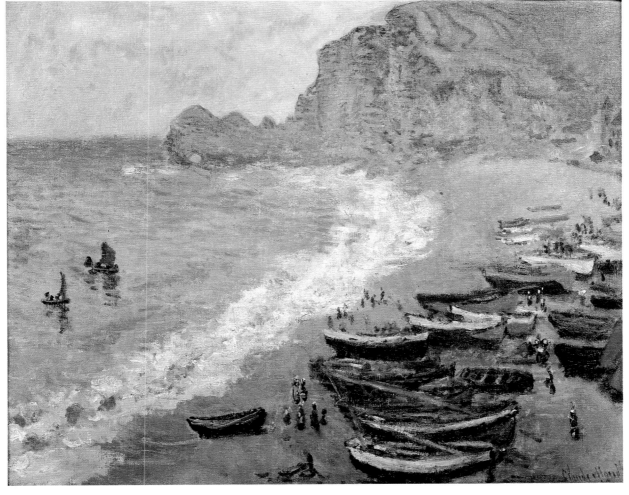

415

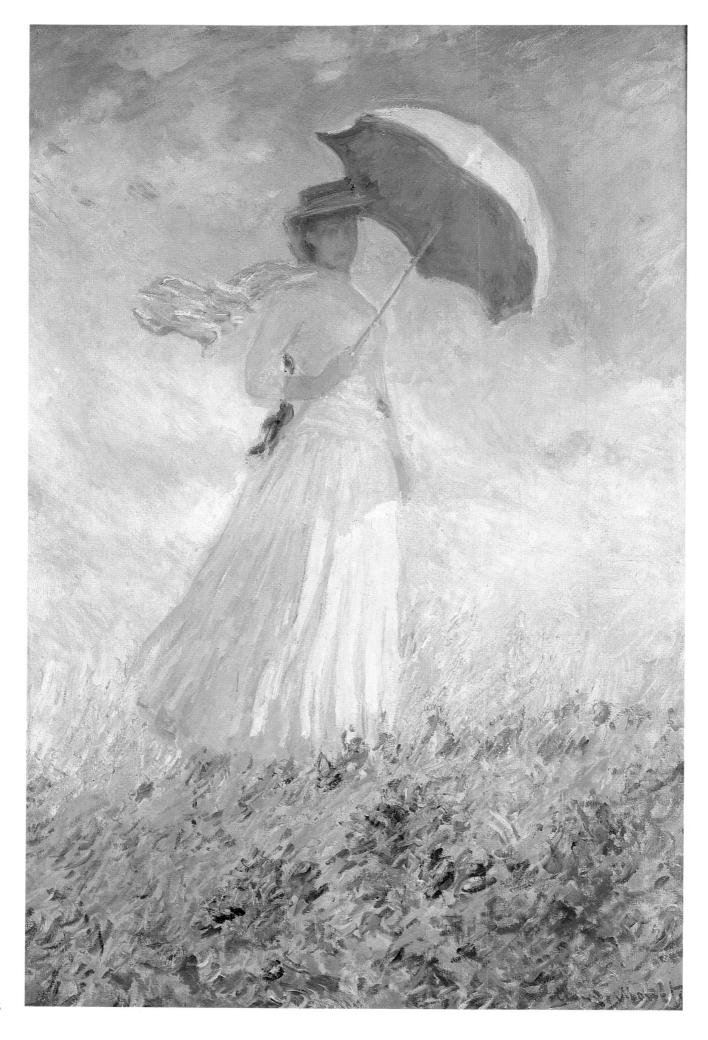

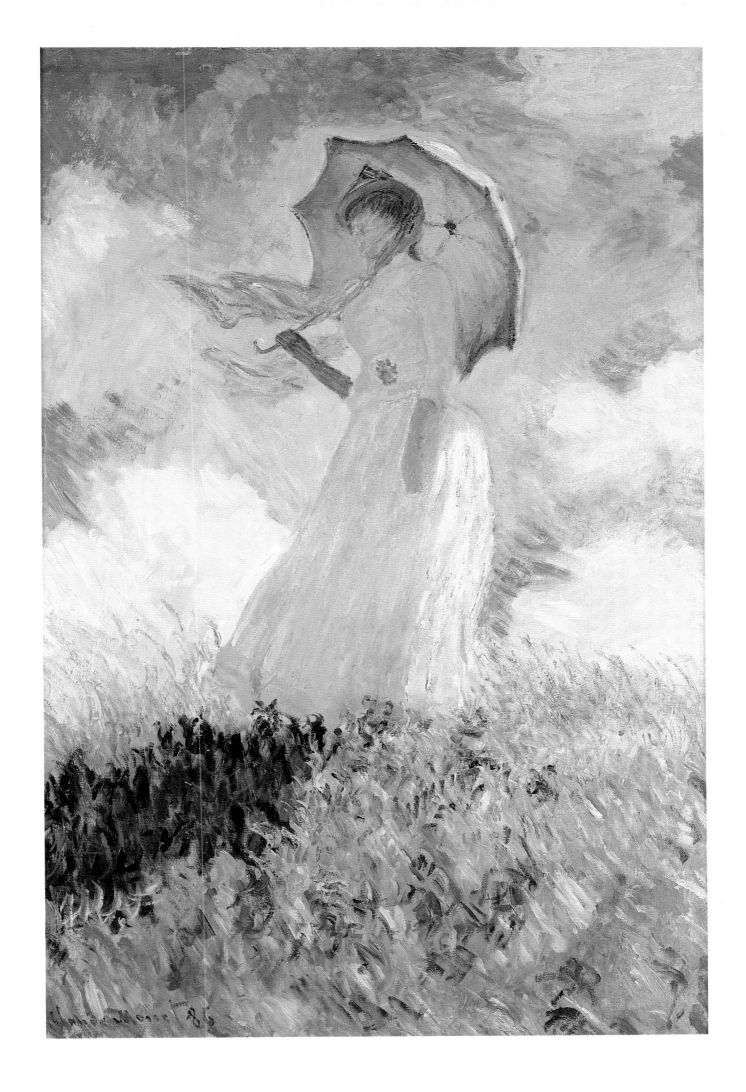

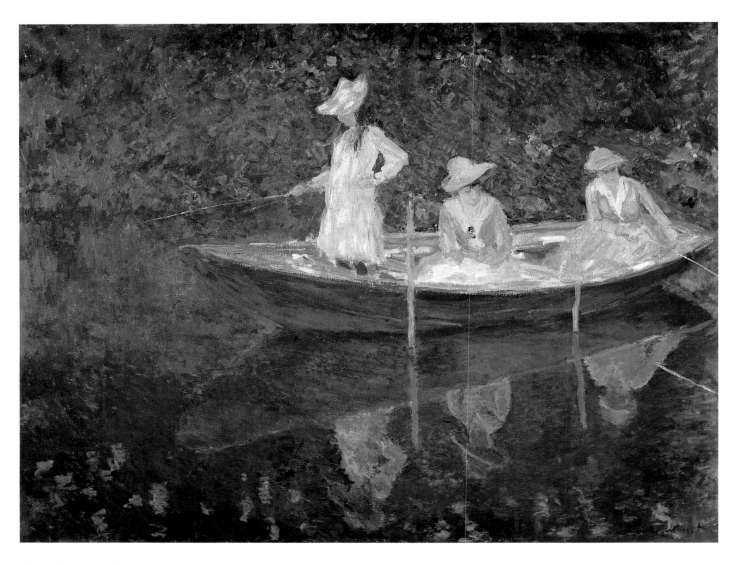

CLAUDE MONET
The Bark at Giverny, ca. 1887
3′ 2½″ x 4′ 3½″ (98 x 131 cm) Bequest of
Princess Edmond de Polignac, 1944. RF 1944-20

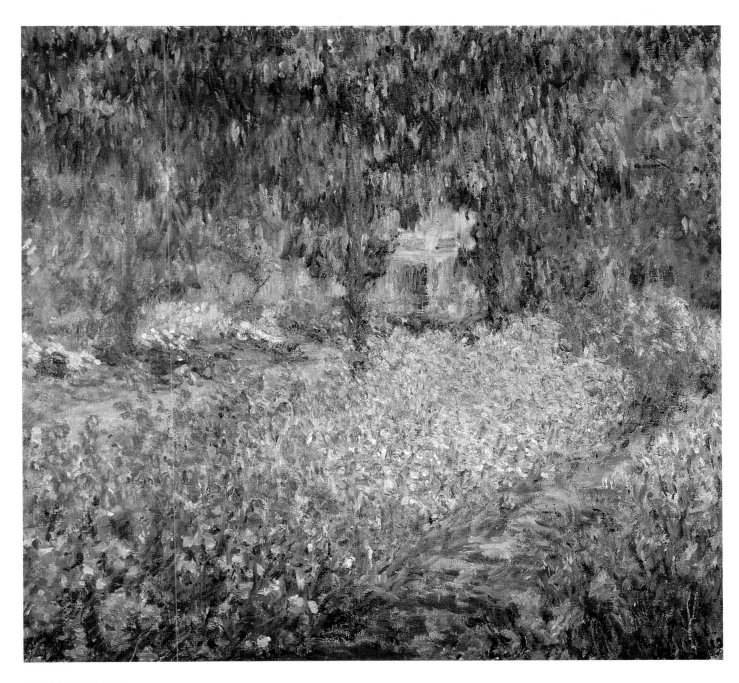

CLAUDE MONET
The Artist's Garden at Giverny, 1900
2′ 8″ x 3′ (81 x 92 cm) RF 1983-6

Mount Kolsaas in Norway

*I*n his later decades, Monet gradually turned away from a man-made world, seeking an ever more remote and immaterial nature, which he found in the strange effects of fog and dawn on the Seine or created artificially in his own private water gardens at Giverny. In geographic terms, his most distant excursion to the extremities of landscape experience was a trip in 1895 to Norway, where he visited his stepson, who was married to a Norwegian. There, in a series of paintings, he attempted to record Mount Kolsaas, which loomed above the little village of Sandikan near the capital, Kristiania (now Oslo). The going was rough, and Monet wrote how he had once spent a good part of the day painting in the snow, which fell continually and left him entirely white, his beard covered with icicles like stalactites.

This total immersion in a pure and magical whiteness is conveyed in a view of the mountain that offers the visual and climatic polarity to Cézanne's beloved Mont Sainte-Victoire. Almost impalpable, as if pulverized by the snow, it becomes a mirage, its white-on-whiteness part of a camouflage of snowy paint that, like so many of Monet's works of the 1890s, would annihilate substance and gravity. This veiled world of tonal nuance is based, as we know, on close, on-the-spot observation, but the effect, as in the earlier Rouen Cathedral series (page 406), takes us to the brink of the invisible, entering from an unexpected angle the terri-

tory of Symbolist fantasy that dominated so much painting of the *fin de siècle*. Even the ethereal whites and lavenders contribute to this otherworldly mood.

In Norway the renowned Monet was awaited with excited anticipation by Scandinavian painters and writers. One of them, the Danish journalist Hermann Bang, claimed that the French master saw the mountain as if it were a mythical human being clothed in snow—at times an old woman, at other times a bride—making quite clear the potential of Symbolist dreaming inherent in Monet's veiled image. He was met on more equal terms by the Norwegian painter Frits Thaulow, who had spent much time in Paris in the 1890s and who had helped to persuade Monet to make the trip to his homeland, promising a spectacle of winter wonder perfect for a nature painter. In fact, the Orsay collection offers many snow-covered comparisons with Monet's mountain view, including one of Thaulow's own Norwegian landscapes (page 616). But next to the documentary character of such picturesque souvenirs, Monet's painting looms large as a more serious, even spiritual, meditation upon a sublime landscape, where mountains and snow bridge the gap between earth and the most unpolluted skies. To rival it, one would have to turn to the Alpine view of the Swiss Symbolist Ferdinand Hodler (page 572).

facing page, top
CLAUDE MONET
Mount Kolsaas in Norway, 1895
2' 1¾" x 3' 3¼" (65.5 x 100 cm) RF 1967-7

facing page, bottom
CLAUDE MONET
The Hay Ricks; Late Summer, Giverny, 1891
1' 11¾" x 3' 3½" (60.5 x 100.5 cm) RF 1975-3

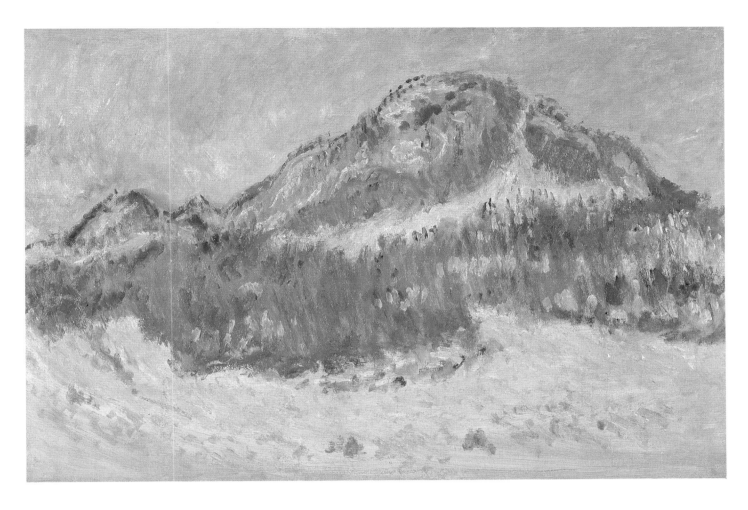

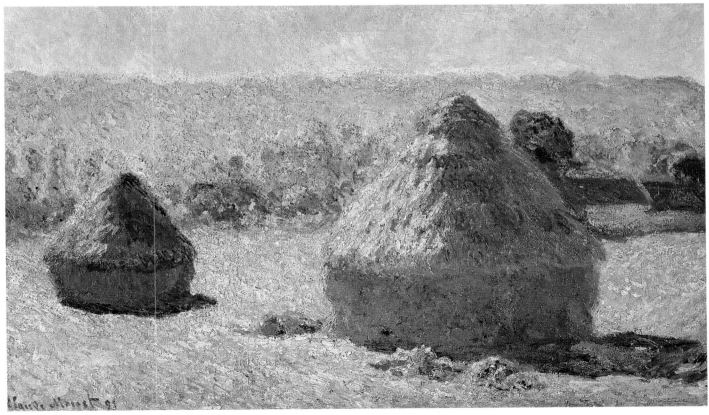

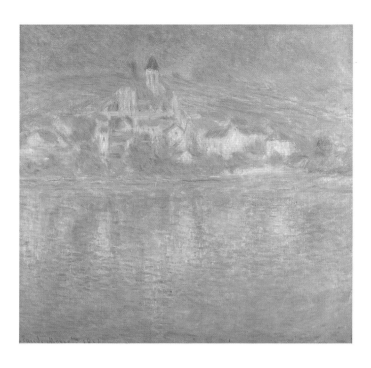

CLAUDE MONET
Vétheuil; Setting Sun, 1901
2′ 11″ x 3′ (89 x 92 cm) Bequest of Count Isaac de Camondo, 1911.
RF 2006

CLAUDE MONET
London, Parliament (Patch of Sun in the Fog), 1904
2′ 8″ x 3′ (81 x 92 cm) Bequest of Count Isaac de Camondo, 1911.
RF 2007

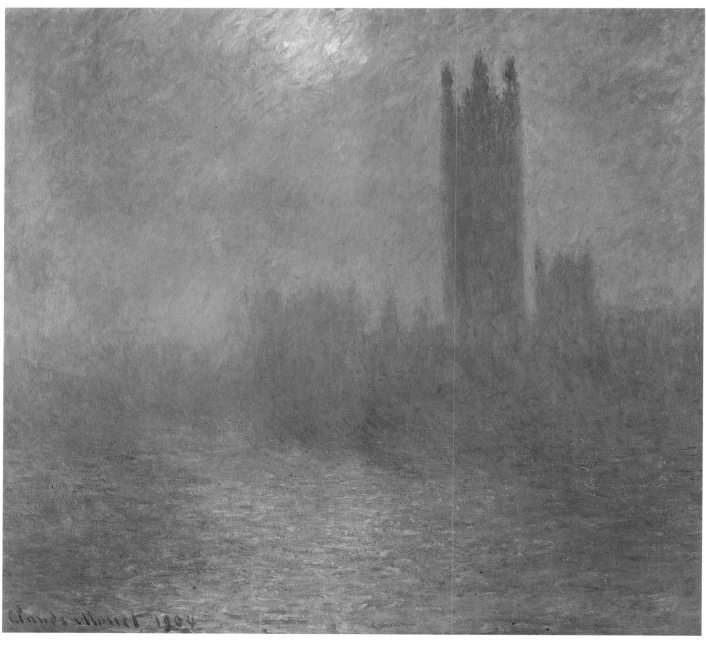

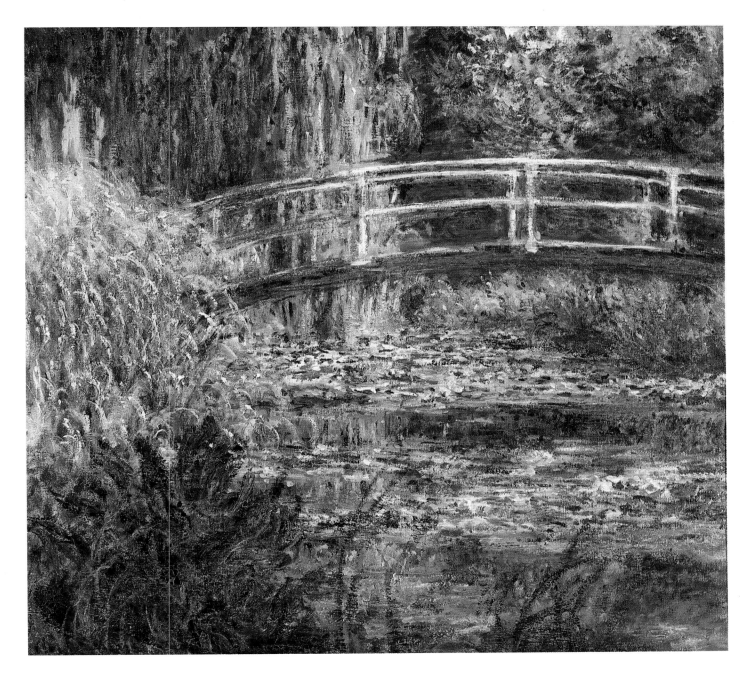

CLAUDE MONET
The Water Lily Pond; Pink Harmony, 1900
2′ 11¼″ x 3′ 3¼″ (89.5 x 100 cm) Bequest of Count Isaac de Camondo,
1911. RF 2005

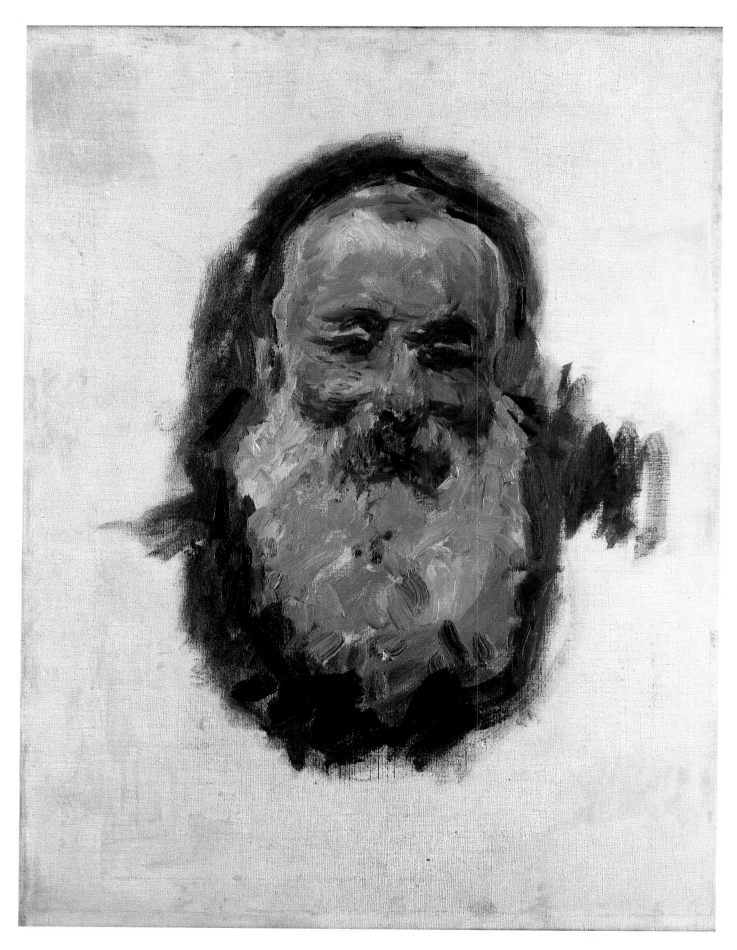

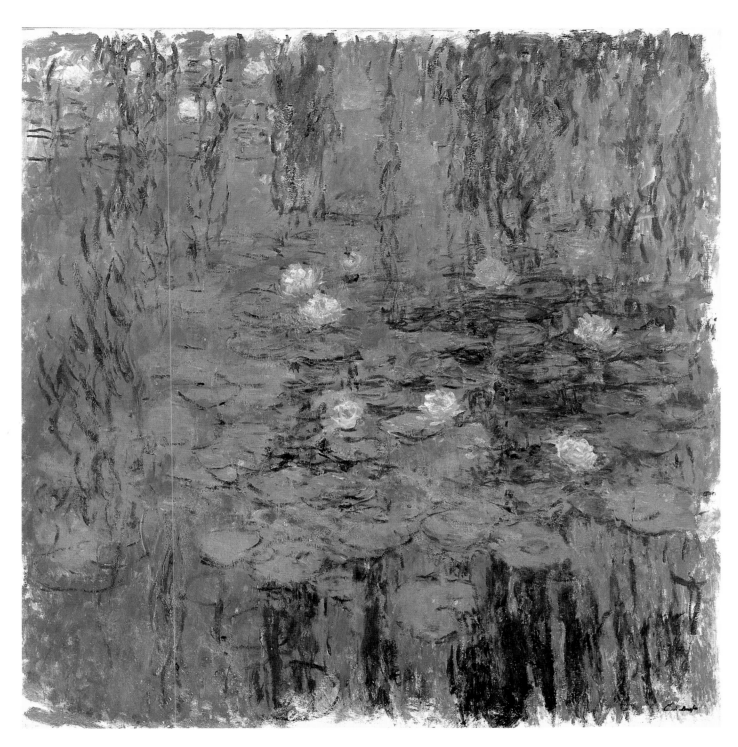

CLAUDE MONET
Blue Water Lilies, ca. 1916–1919
6′ 6¾″ x 6′ 6¾″ (200 x 200 cm) RF 1981-40

facing page
CLAUDE MONET
Self-Portrait, 1917
2′ 3½″ x 1′ 9¾″ (70 x 55 cm) Gift of Georges Clemenceau, 1927.
RF 2623

THE LATER RENOIR

The Bathers

*P*ainted as he approached the 78th and last year of his life, 1919, Renoir's pair of giantesses summarize one of the grand, if now bitterly anachronistic, themes of his art: the equation of women with earth goddesses, fecund but mindless beings at one with nature. In this large canvas, contemporary facts—the discarded flowered hat at the left—evaporate into a mythical realm where blue skies, a distant watering spot, and a burgeoning tapestry of flowers and trees provide an organic ocean of landscape motifs as a background to what become mythical nudes, the anonymous descendants of Diana and her nymphs. Such a grandly orchestrated hymn to womankind, in which the female of the species represents passive carnality and procreative power rather than aggressive masculine intelligence, was common coin among such academic contemporaries of Renoir as Bouguereau and Cabanel. It was equally challenged, however, by such Impressionist colleagues as Manet, Degas, and Cassatt, who could depict women as thinking, reading members of modern society—a concept totally alien to these virtually timeless, prehistoric women.

But apart from its weight of cultural prejudice so apparent to late twentieth-century eyes more widely opened to the subliminal messages delivered by works of art, Renoir's painting is immersed in the marvelously fluid, gravityless visual environment achieved as well in Monet's late landscapes and water gardens (pages 423 and 425), also executed in the early decades of the twentieth century as a kind of old-master counterpoint to the more youthful spatial innovations of Matisse and Picasso. Despite the almost palpable cornucopia of ripe, sun-drenched flesh displayed by these tiny-headed nudes (whose three background companions bathe in what one feels is a magic pond of fertility), they almost dissolve in waves of heated, florid color, creating a floating world unanchored by traditional perspective. As is often the case, Renoir here evokes old-master memories, with a lineage that runs from Rubens and the Rococo bathers of Boucher to Courbet's coarser veneration of female flesh. And the painting also looks forward, for surely the fantastically ample and monumental anatomies of Renoir's late nudes inspired Picasso to paint his own mythical race of classical giantesses just after this master's death in 1919.

AUGUSTE RENOIR, Limoges 1841–Cagnes-sur-Mer 1919
Sleeping Odalisque (Odalisque with Babouches), ca. 1915–1917
1′ 7¾″ x 1′ 8¾″ (50 x 53 cm) Gift of Dr. and Mrs. Albert Charpentier, 1951. RF 1951-15

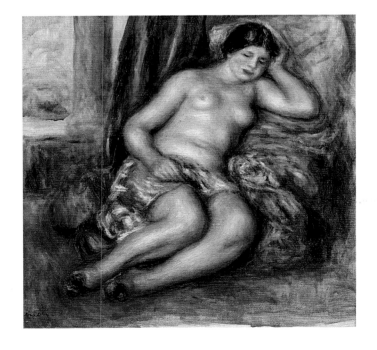

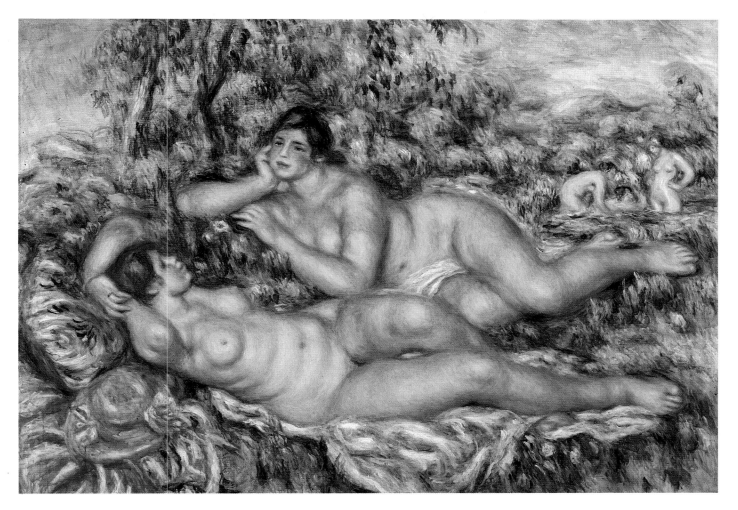

The Bathers, 1918–1919
3′ 7¼″ x 5′ 3″ (110 x 160 cm) RF 2795

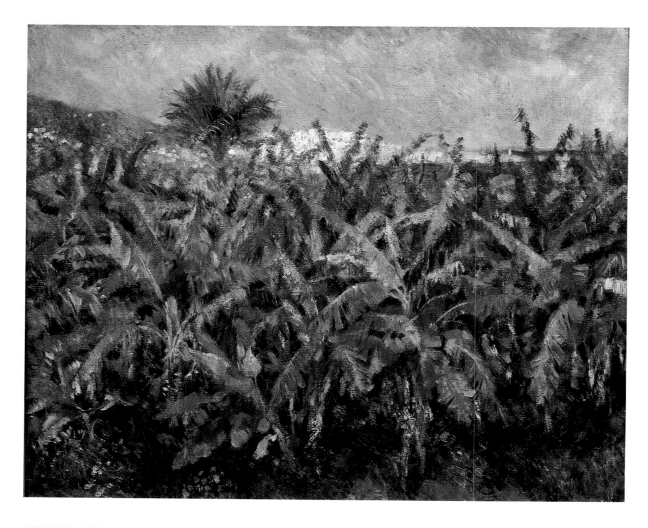

428

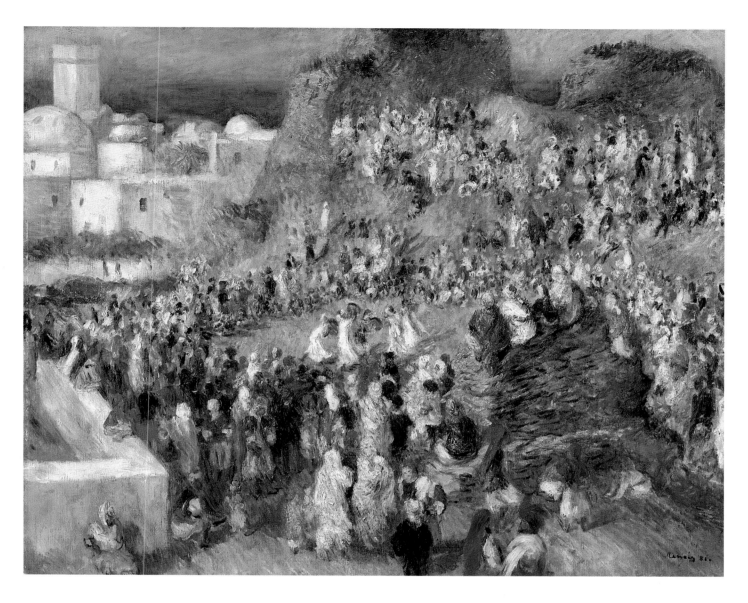

AUGUSTE RENOIR
The Mosque (Arab Holiday), 1881
2′ 5″ x 3′ (73.5 x 92 cm) Gift of the Biddle Foundation, 1957.
RF 1957-8

AUGUSTE RENOIR
Railway Bridge at Chatou, 1881
1′ 9¼″ x 2′ 1¾″ (54 x 65.5 cm) Bequest of Gustave Caillebotte, 1894.
RF 3758

facing page, top
AUGUSTE RENOIR
Field of Banana Trees, 1881
1′ 8¼″ x 2′ 1″ (51.5 x 63.5 cm) RF 1959-1

facing page, bottom
AUGUSTE RENOIR
Algerian Landscape. The Ravine of the "Femme Sauvage," 1881
2′ 1¾″ x 2′ 8″ (65.5 x 81 cm) RF 1943-62

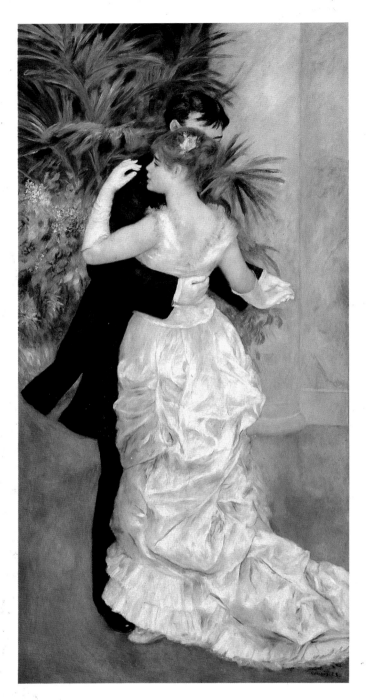

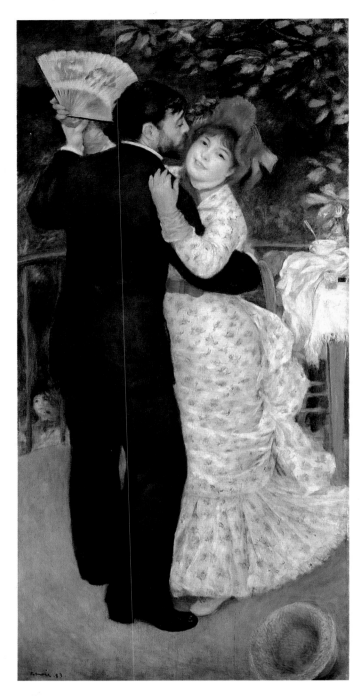

AUGUSTE RENOIR
A Dance in the City, 1883
5′ 10¾″ x 2′ 11½″ (180 x 90 cm) RF 1978-13

AUGUSTE RENOIR
A Dance in the Country, 1883
5′ 10¾″ x 2′ 11½″ (180 x 90 cm) RF 1979-64

facing page
AUGUSTE RENOIR
A Dance in the Country, detail

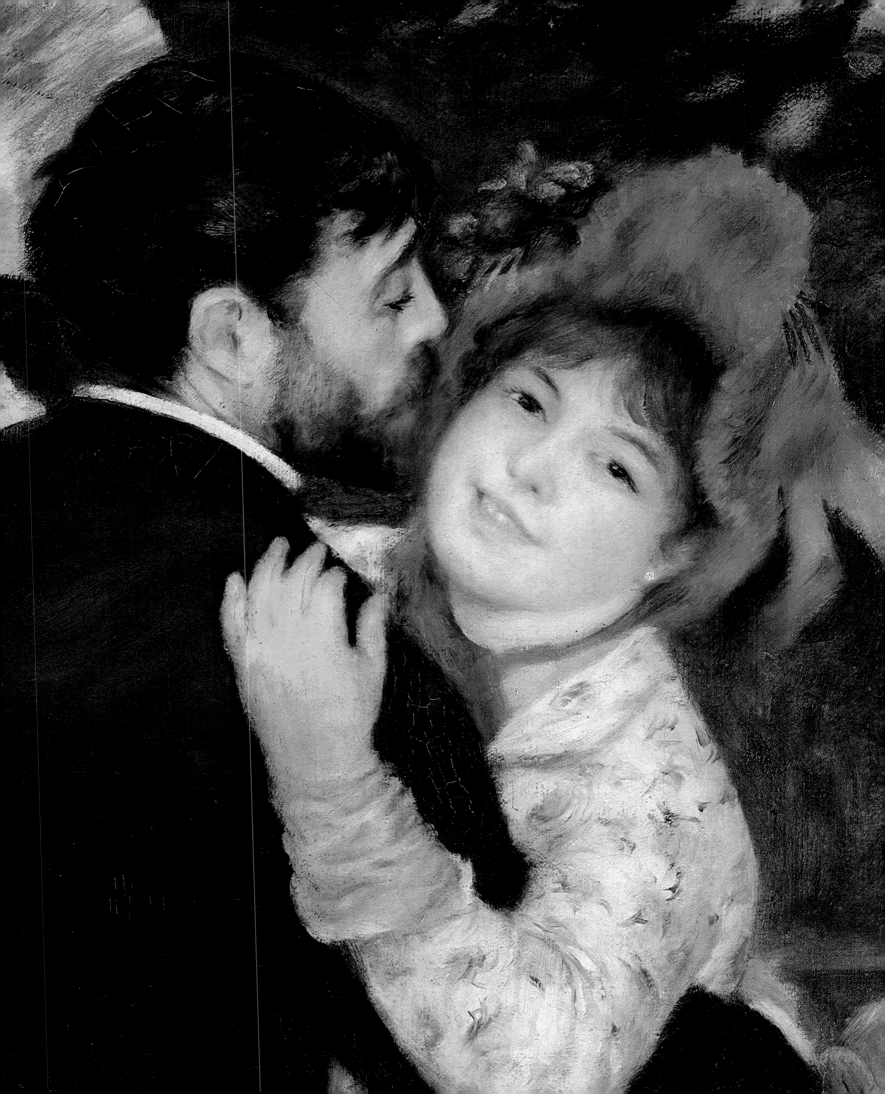

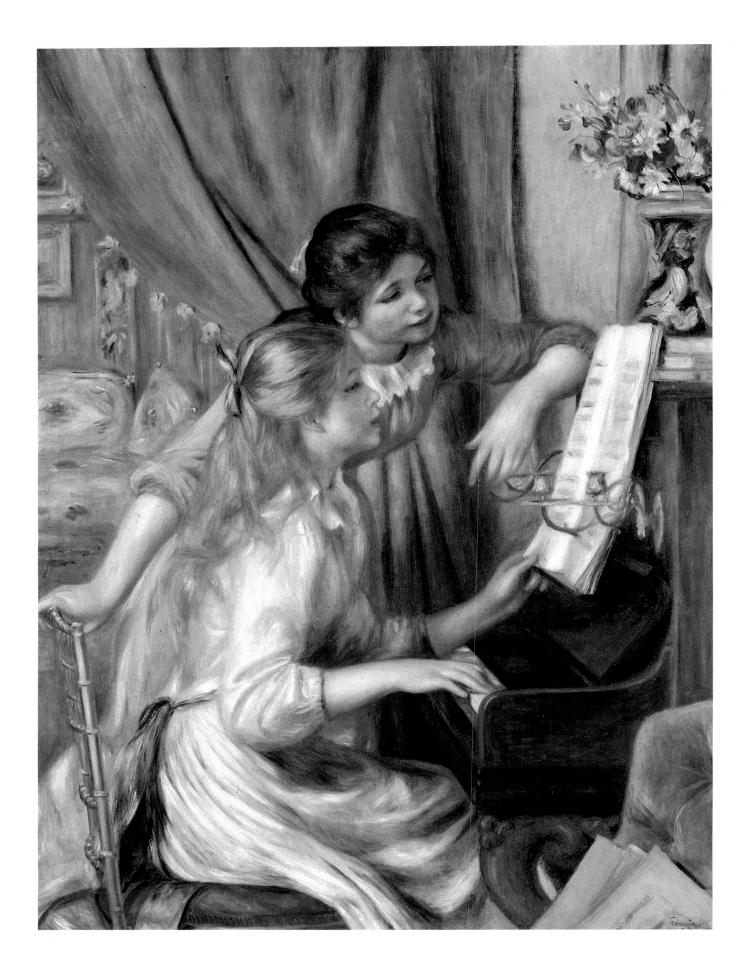

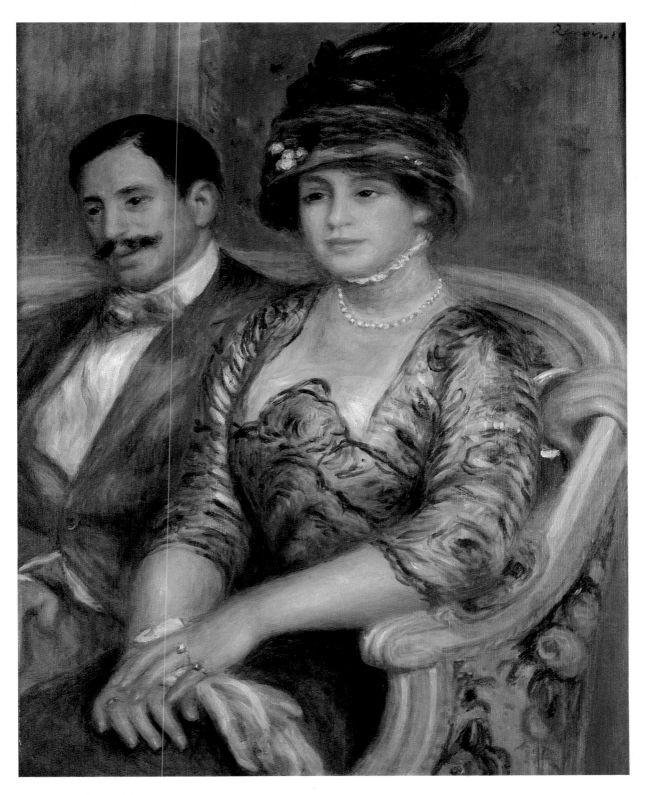

AUGUSTE RENOIR
M. and Mme. Bernheim de Villers, 1910
2′ 8″ x 2′ 1¾″ (81 x 65.5 cm) Gift of Mr. and Mrs.
Gaston Bernheim de Villers, 1951. RF 1951-28

facing page
AUGUSTE RENOIR
Young Girls at the Piano, 1892
3′ 9¾″ x 2′ 11½″ (116 x 90 cm) RF 755

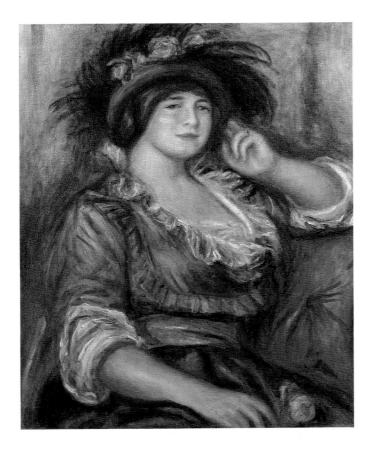

AUGUSTE RENOIR
Young Girl with a Rose (Mme. Colonna Romano), 1913
2' 1¾" x 1' 9½" (65.5 x 54.5 cm) RF 2796

AUGUSTE RENOIR
Richard Wagner, January 15, 1882
1' 8¾" x 1' 6" (53 x 46 cm) Gift of Alfred Cortot, 1947. RF 1947-11

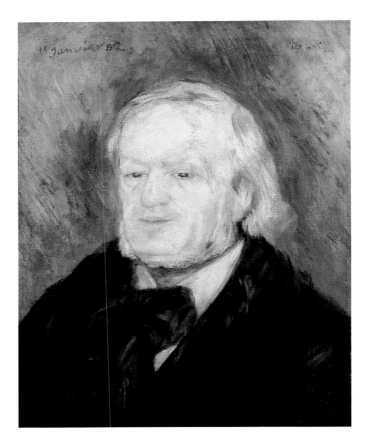

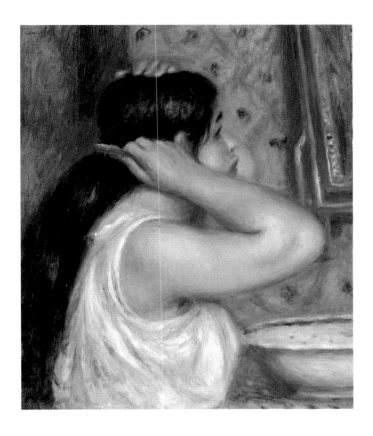

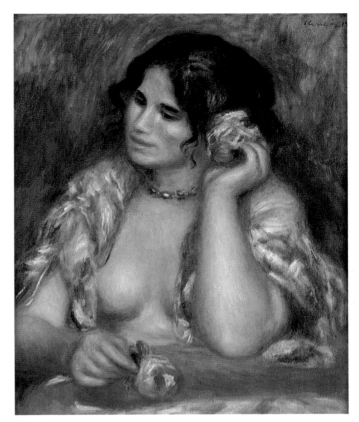

AUGUSTE RENOIR
The Toilette; Woman Combing Her Hair, ca. 1907–1908
1′ 9¾″ x 1′ 6¼″ (55 x 46.5 cm) Bequest of Count Isaac de Camondo,
1911. RF 2016

right, top
AUGUSTE RENOIR
Gabrielle with a Rose, 1911
1′ 9¾″ x 1′ 6½″ (55.5 x 47 cm) Gift of Philippe Gangnat, 1925.
RF 2491

right, bottom
AUGUSTE RENOIR
Seated Young Girl (Hélène Bellon), 1909
2′ 1¾″ x 1′ 9½″ (65.5 x 54.5 cm) Bequest of Count Isaac de Camondo,
1911. RF 2018

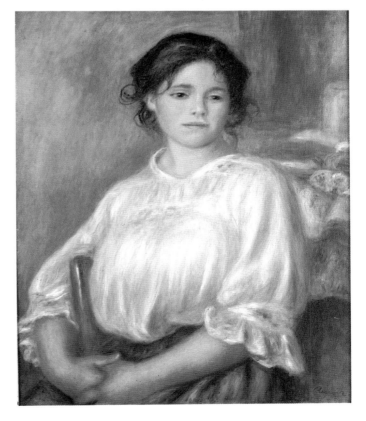

Seurat

Two Studies

Despite his unreasonably brief life span—he was to die before his thirty-second birthday—Seurat managed to change the history of painting within a period of only eight years, from 1883 to 1891. With the major exception of his last unfinished canvas of 1891, *The Circus* (page 441), his masterpieces have all been dispersed outside France—to London, Otterlo, New York, Chicago, and Merion, Pennsylvania. But even without these paintings, Orsay permits us to glimpse some of the foothills that would ascend to the heights of his monumental achievements.

It was characteristic of Seurat's nascent genius that he would make rapid, on-the-spot sketches related to Monet's work of the 1870s and 1880s, but conceive them not as ends in themselves but as means to large, ambitious canvases that might wed the most contradictory of partners. On the one hand, there was the freshness of rapid-fire, modern experience, so often seized by the Impressionists in their scenes of Parisian life; on the other, there was the enormous weight of academic tradition, an image of immutable, timeless order that would make Seurat want to say, with Poussin, "I have neglected nothing."

In an early painted sketch on panel, we can see Seurat at work on the Impressionist raw material that would go into his first masterpiece, *A Bathing Place at Asnières* (1883–1884). At first glance, it looks like a typical Seine-side scene of the 1870s, with its mood of outdoor leisure, casual disposition of figures on land and water, and rapidly brushed, sun-drenched pigment that would capture the pulsating fusion of air, water, and earth. But with our knowledge of the sturdy oak tree that was to grow from such an acorn, we immediately adjust our vision of this tiny study to an opposite angle. From this contrary vantage point, we may notice how the ragged brushstrokes of sky and river establish a sustained, regular beat that affirms the broad dividing line of the horizon and measures distance from near to far in repeated strips. Moreover, the figures begin to look other than casual, their profiles anchoring them in the landscape with an archaic clarity that echoes the pagan idylls of Puvis de Chavannes, to whom Seurat had rendered homage in an early copy of his *Poor Fisherman* (page 77) seen in an Impressionist landscape. But this Utopian simplicity is rendered contemporary, too, by the intrusion of the utilitarian geometries of a factory complex seen on the far shore from this working-class suburb of Paris.

The emergence of such controlling, elemental order from an Impressionist observation of a transitory scene is even more willful in one of the two equally tiny studies for *Sunday on the Grande Jatte*. Here the sawdust-like dabs of pigment, akin to the vibrant, sunlit greenery of a Monet, miraculously line up in a grid of perpendiculars severe enough to provide a backdrop for an ancient Egyptian pageant. The Parisians who have come to enjoy their Sunday on the sliver of an island in the Seine, opposite Asnières, have no choice but to relax on perfect axis with the regimented rhythms of trees and grass. In this microcosm of Seurat's huge masterpiece, we see distilled his miraculous transformation of Impressionism into its opposite: from the ephemeral and contemporary to the timeless and ancient. The centuries-old skeleton of the French classical tradition is suddenly brought back to life with youthful flesh.

Such a marvel may also be seen in the trio of nude figure studies for *The Models* of 1888—Seurat's modern studio translation of the theme of the Three Graces or of Puvis's three ideal nudes by the sea (page 75). Each study scrutinizes the nude from a different angle of permanence—back, front, and side—re-creating academic postures with modern Parisiennes (one of whom is seated amid her discarded clothing). All of them come to life through Seurat's new, quasi-scientific technique of atomic, modular dots of pure pigment that mirror the mechanical methods of color printing evolving in the 1880s. Underneath this granular scrim that can both dissolve and congeal these figures in a new version of chiaroscuro, we nevertheless recognize the pedigree of the academy in the purified contours and surfaces. The tradition of Ingres's nudes is unexpectedly revitalized here, a reminder that Seurat had not only copied a nude (*Angelica*) by the master but had studied under Henri Lehmann, an Ingres pupil.

facing page, top
GEORGES SEURAT, Paris 1859–Paris 1891
Study for "A Bathing Place at Asnières," 1883
6" x 9¾" (15.5 x 25 cm) Gift of Baroness Eva Gebhard-Gourgaud, 1965. RF 1965-13

facing page, bottom
GEORGES SEURAT
Study for "A Sunday on the Grande Jatte," 1884–1885
6" x 9¾" (15.5 x 25 cm) Gift of Thérèse and Georges-Henri Rivière, 1948. RF 1948-1

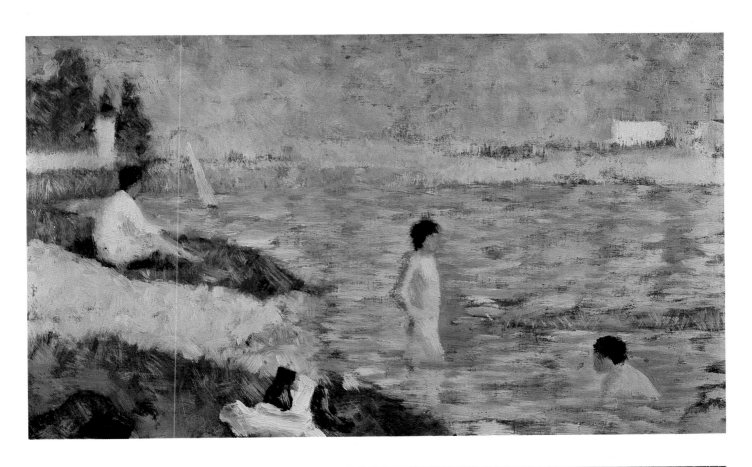

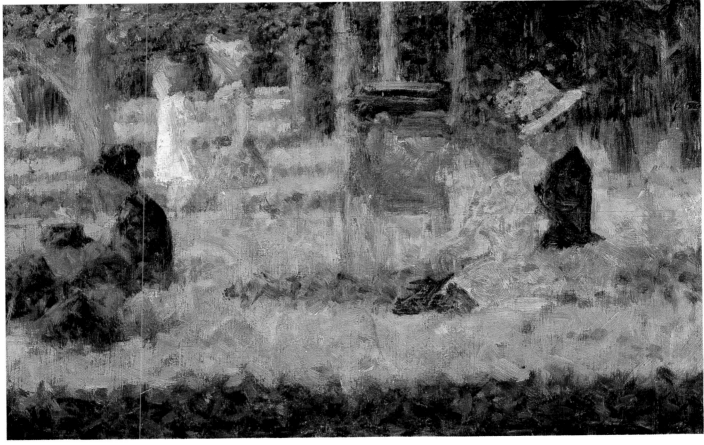

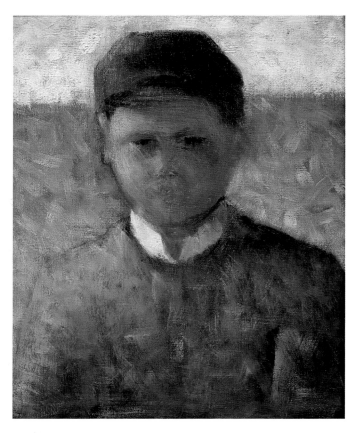

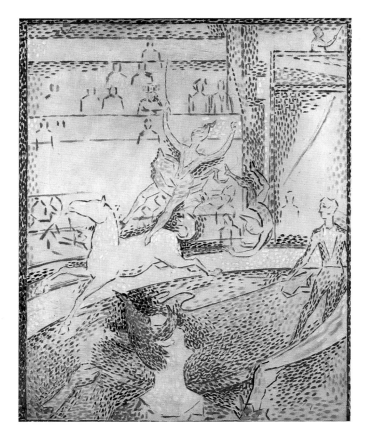

GEORGES SEURAT
The Little Peasant in Blue (The Jockey), ca. 1882
1′ 6″ x 1′ 3″ (46 x 38 cm) Gift of Robert Schmit, 1982. RF 1982-54

GEORGES SEURAT
Study for "The Circus," 1891
1′ 9¾″ x 1′ 6″ (55 x 46 cm) RF 1937-123

facing page, top
GEORGES SEURAT
Port-en-Bessin, Outer Harbor, High Tide, 1888
2′ x 2′ 8¼″ (61 x 82 cm) RF 1952-1

facing page, bottom left
GEORGES SEURAT
Model, Back View, 1887
9¾″ x 6″ (24.5 x 15 cm) RF 1947-15

facing page, bottom center
GEORGES SEURAT
Model, Front View, 1887 (Salon des Indépendants, 1887)
9¾″ x 6¼″ (25 x 16 cm) RF 1947-13

facing page, bottom right
GEORGES SEURAT
Model, Profile View, 1887 (Salon des Indépendants, 1890)
9¾″ x 6¼″ (25 x 16 cm) RF 1947-14

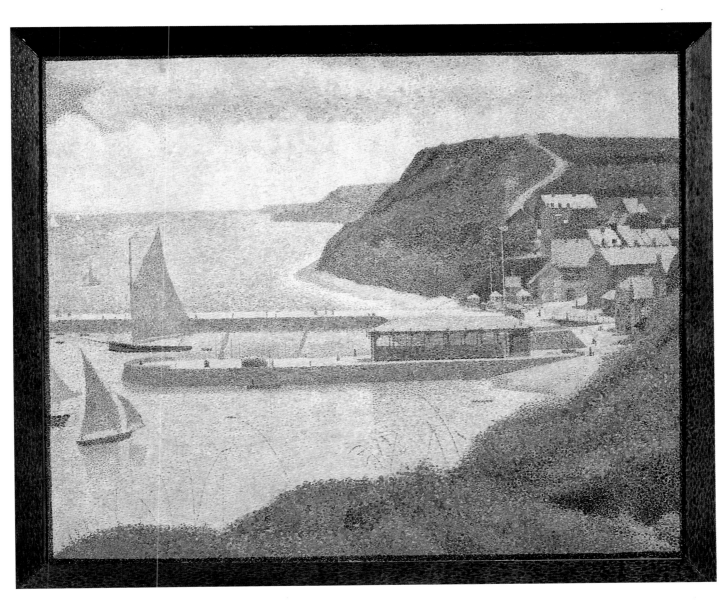

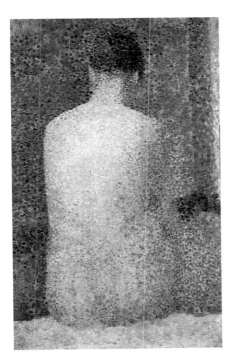
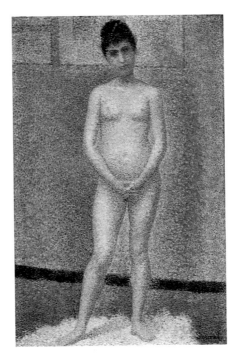
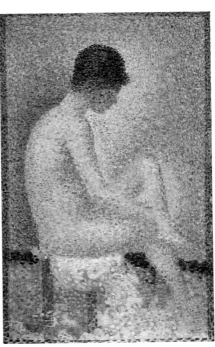

The Circus

*L*eft unfinished at the time of his premature death in 1891, Seurat's *Circus* nevertheless brings to a full, but contradictory, conclusion the decade-long evolution of his art, which began in the early 1880s in the sunstruck outdoor light of Impressionism (page 437). *The Circus* is, in fact, the exact opposite of anything natural, whether in subject, shape, or color; its very frame, enclosing the posterlike image with a precise infinity of tiny, luminous blue dots, proclaims the painting's total artifice.

Inspired by the reality of the Cirque Fernando in Paris, Seurat nevertheless creates an almost utopian fantasy appropriate to the new technological world heralded at the Paris World's Fair of 1889 and symbolized by Eiffel's soaring tower. The blueprint category here might be "Urban Entertainment," with Seurat providing the most robotic conception of both performers and spectators. Responding to the serpentine lash of the ringmaster's whip and the directorial hands of the clown in the foreground, who almost usurps the role of the band conductor at the upper right, everything suddenly clicks into both motion and emotion, like a new race of automatons: the redheaded clown in the background, his white-gloved hands prefiguring Mickey Mouse's; the somersaulting acrobat (from the same mechanical breed of creatures with a flame of hair and splayed hands); the bareback rider, poised with wind-up-doll perfection on a white-and-blue horse that would be at home on a carousel. As for the members of the audience, they, too, take their assigned places (alternately rigid and relaxed, in singles, couples, and trios), corresponding in clothing and demeanor to the price of tickets, from the costliest ringside seats below to the bleachers in which the roughest crowd, elbows on the railing, seems compressed by the frame. Most of them, whether rich or poor in this precise system of economic strata, register their pleasure with a diabolically mechanical smile. This is underscored by the repetitive abstract rhythms of collars, mustaches, bow ties, skirts, and shoulder silhouettes that ascend with would-be cheerfulness from the insistent horizontals imposed on what is nevertheless a curving gallery that arcs around the ring of the arena (and is reflected, upper right, in the rectangular mirror). This rigorous system-making extends to the choice of colors, artificially restricted to the primary hues of yellow, red, and blue. It also includes, via the theoretical writings of Charles Henry, quasi-scientific theories about how to attain moods of gaiety, melancholy, or serenity by selecting the appropriate relation of abstract rhythms to the horizon line (the simplified image equivalent of a frown being a smile upside-down).

In this, as in other aspects, *The Circus* reveals close connections with a rapidly growing world of popular imagery, of so-called "low art," whose dialogue with the grand traditions of "high art" constantly rejuvenated the story of modern art, from Courbet and Manet through Pop art and beyond. The circus imagery here may, in fact, reflect popular do-it-yourself circus toys of the 1880s, with their simplified faces and stage-flat constructions. It has long been known, too, that the painting's flat, cartoonlike figural style is related to contemporary posters, especially those by Jules Chéret, that shouted the wares of Parisian entertainment centers. Moreover, it has been suggested that Seurat's fascination with painted dots as the atomic unit of image reproduction, as well as his growing restriction to the primary colors (most emphatic in this, the last painting), represents, among other things, his response to the new techniques of chromolithography, launched in the 1880s as a kind of populist means of reproducing works of art in color. In this, as in countless other ways, Seurat, viewed from the late twentieth century, is an unexpected prophet of the printer's-ink colors and benday-dot techniques transformed from low art to high art by Roy Lichtenstein. And speaking of prophecy, the whiplash motif, so pervasive in the decorative vocabulary of the Art Nouveau that would burgeon throughout France just after Seurat's death, is here to be seen both literally and figuratively, reduced, in fact, to an even more abstract arabesque in Seurat's preparatory study for *The Circus*, also housed in Orsay (page 438).

facing page
GEORGES SEURAT
The Circus, 1891 (Salon des Indépendants, 1891)
6' 1" x 5' (185.5 x 152.5 cm) Bequest of John Quinn, 1924. RF 2511

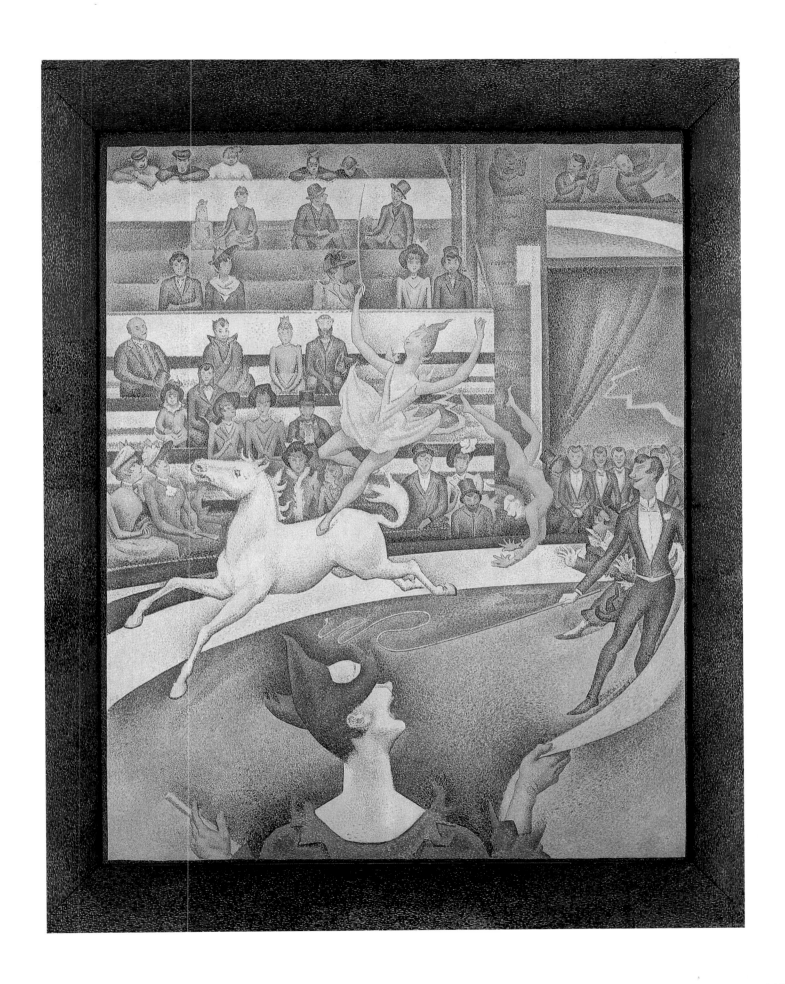

NEO-IMPRESSIONISM

Henri Edmond Cross

*T*his quartet of paintings by Cross testifies to the way in which one artist adapted old and new kinds of subjects to the quasi-scientific methods codified in Seurat's Neo-Impressionism, regimenting discrete dabs of color in tidy rows that would fuse, like the tesserae in a mosaic, into a total image meant to vibrate with light. In the earliest, the 1891 portrait of the woman whom Cross was to marry four years later, the tradition of elegant society portraiture—practiced alike by artists as divergent as Monet and Carolus-Duran, Renoir and Bonnat—is revitalized with a fashionable Japanese inflection under the most refined screen of tiny dots. Madame Cross's profiled silhouette, with its long train, seems to float chicly off-center in an immaterial world approached from below through a decorative border of rhododendrons cropped, Japanese-syle, by the lower frame. This exotic motif is made more literal by the frieze of Japanese fans behind, disposed in a repeated modular rhythm that amplifies the basic unit of belt-line points of paint. But for all the patterned flatness of these jigsaw-puzzle geometries against the steeply tilted floor, the picture is softly charged with a granular, atmospheric glow in which the diffused light and shadow of this glittering soiree are reflected.

Such nuanced luxury is pruned to almost abstract starkness in the paradisiac vista of a Mediterranean island resort, the Iles d'Or. From the pebbled foreground, rising upward through the welling intensity of the blue of the sea, to the pinkish silhouettes of the low-lying hills beyond, we are confronted with a perfect fusion of earth, water, and sky that seems at once to expand to infinite horizons and to contract to the almost palpable pigment pattern on the surface. It is a vision of dense colored light that, for us, prefigures the canvases of Mark Rothko.

More time-bound in character is the slightly later painting of a woman combing her hair. This venerable theme, echoing back to paintings of the newborn Venus (page 43), appearing in Japanese prints, and modernized often by Degas and Toulouse-Lautrec (page 467), is strange to see when translated into Cross's almost mechanical facture—the handmade counterpart to the printed color particles in chromolithography. And with comparably mechanical exactness, the angle of the comb is repeated in a modular rhythm that rules this faceless woman's hair. This rhythm is immediately countered, however, by the more wayward, fluent shapes of the decorative vocabulary that, under the name of Art Nouveau, would become in the same decade a signature of youthful innovation. More unexpectedly, Cross's glimpse of feminine coiffure released in a serpentine flow intersects the more sinister theme of entrapping, tentacular locks that, from Baudelaire's poetry to the femmes fatales of the 1890s, weaves through nineteenth-century sexual fantasies. Next to them, however, this neat coiffure could hardly be less menacing.

The motif was soon to be the centerpiece of a more overtly sensual, and far more ambitious, canvas that Cross exhibited at the Salon des Indépendants in 1894, *Evening Breeze*. Here the artist's exposure to real-life Arcadias on the Côte d'Azur is transported to a dreamlike realm. In the middle, a robed woman unwinds her unusually long hair, which undulates gently in the evening breeze, in rhythm with the pliant silhouettes of trees, meadows, and sails. If this vision of remote Mediterranean serenity and order conjures up Puvis de Chavannes's public murals (page 74), the colors now speak another language, vibrating with the stippled yellows, oranges, and reds that mirror the warmth of sunset. Pushed only a few steps further in terms of subject and rainbow palette, Cross's painting might become Matisse's only canvas in the Orsay collection, his *Luxe, calme et volupté* of 1904 (page 665), another coastal idyll of pagan freedom and harmony with a title borrowed from Baudelaire. Not surprisingly it was painted in another Garden of Eden, Saint Tropez, while Matisse was staying with an older Neo-Impressionist master, Paul Signac.

facing page

HENRI EDMOND CROSS
Mme. Hector France, née Irma Clare and later, in 1893, Mme. Henri Edmond Cross, 1891 (Salon des Indépendants, 1891)
6′ 10″ x 4′ 10¾″ (208 x 149 cm) RF 1977-127

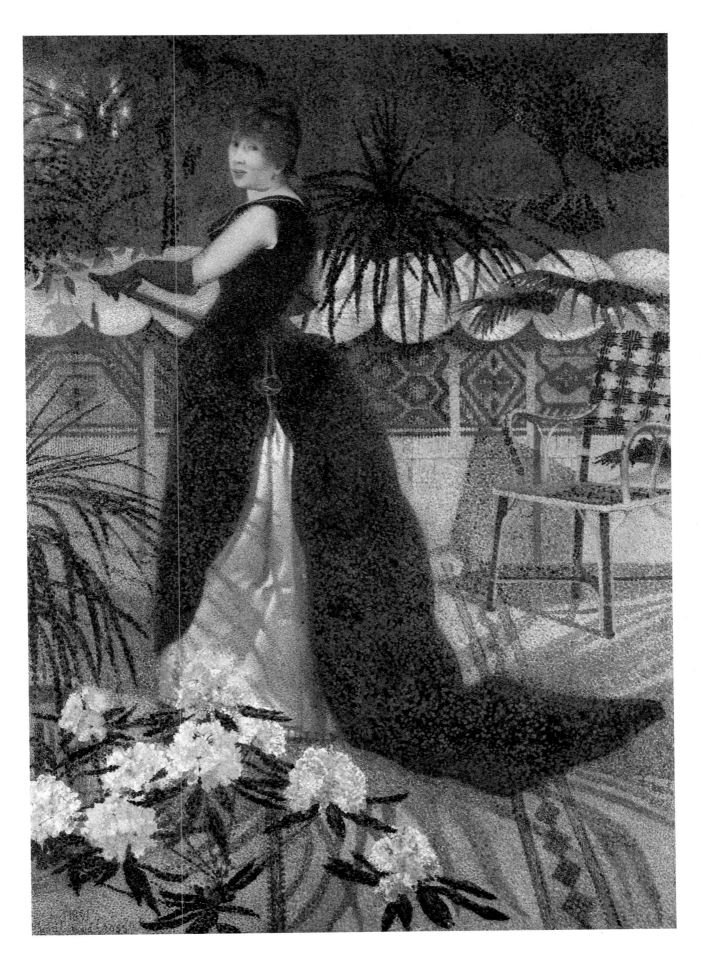

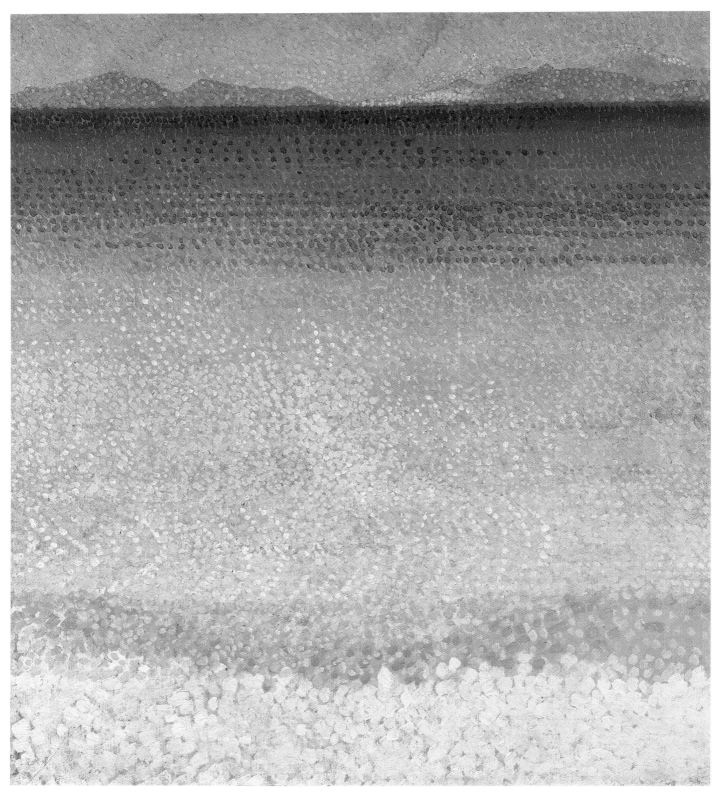

HENRI EDMOND CROSS, Douai 1856–Saint-Clair 1910
The Iles d'Or (Iles d'Hyères), 1892
1′ 11¼″ x 1′ 9¼″ (59 x 54 cm) RF 1977-126

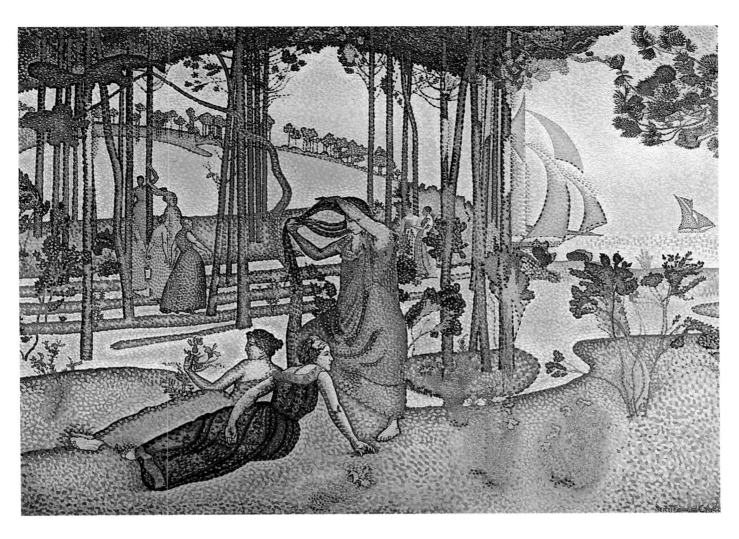

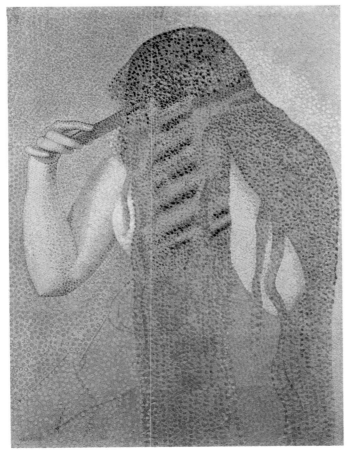

HENRI EDMOND CROSS
Evening Breeze, 1893–1894 (Salon des Indépendants, 1894)
3' 9¾" x 5' 5" (116 x 165 cm) Gift of Miss Ginette Signac. RF 1976-81

HENRI EDMOND CROSS
The Head of Hair, ca. 1892
2' x 1' 6" (61 x 46 cm) RF 1977-128

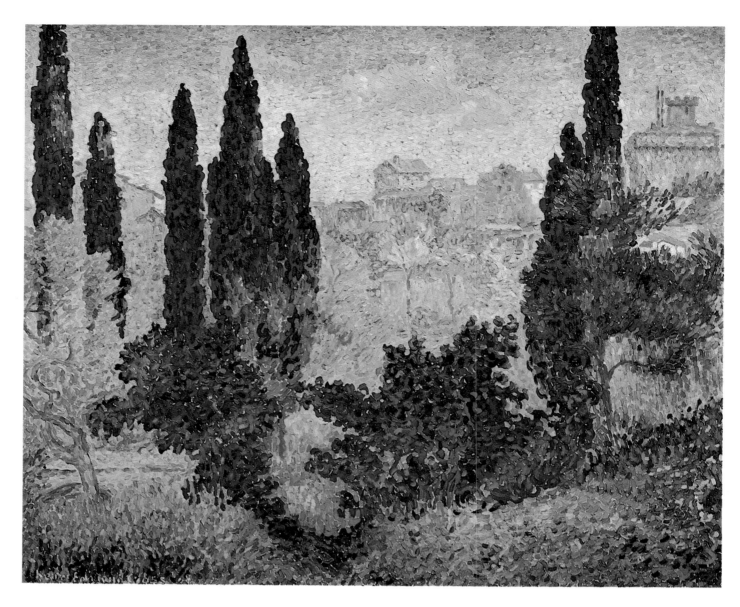

HENRI EDMOND CROSS
Cypress Trees at Cagnes, 1908
2′ 8″ x 3′ 3¼″ (81 x 100 cm) Bequest of Viscount Guy de Cholet, 1923.
RF 1977-124

HENRI EDMOND CROSS
The Shipwreck, 1906–1907 (Salon des Indépendants, 1911)
1′ 6″ x 1′ 9¾″ (46 x 55 cm) Gift of Mrs. Ginette Signac, 1976.
RF 1976-80

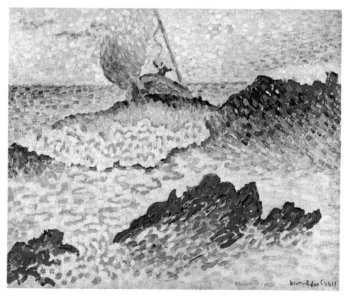

facing page
HENRI EDMOND CROSS
Afternoon at Pardigon, 1907
2′ 8″ x 2′ 1½″ (81 x 65 cm) Bequest of Viscount Guy de Cholet, 1923.
RF 1977-125

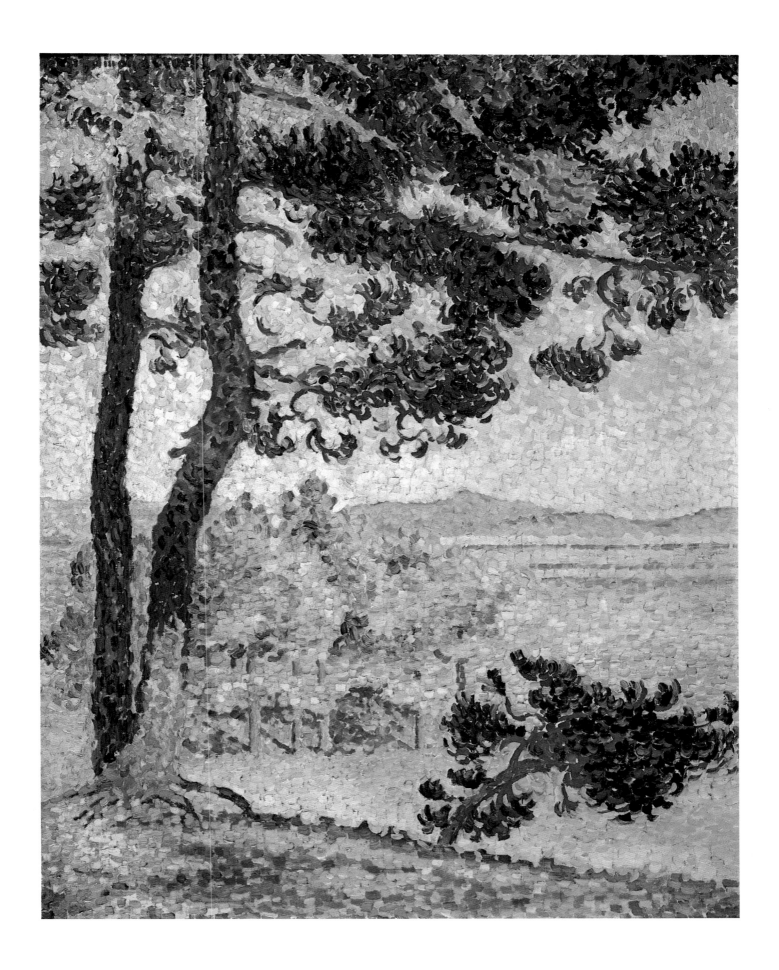

Paul Signac

*T*he seesawing balance between the excitement of modernity and the heavy weight of tradition was in constant motion by the 1890s, and the results were often oddly precarious. Such is the case in *Women at the Well,* a large decorative panel of Provençal women fetching water in front of the bluest of Mediterranean seas. In the early 1880s in Paris, Signac had begun to record the dreary realities of the welling industrial suburbs (page 450), and by 1886, he was converted to Seurat's quasi-scientific technique of applying paint in tiny colored dots. He would later justify this technique in theoretical terms as a logical, modern conclusion to Delacroix's innovative liberation of color. Moreover, his espousal of the modern world was reflected in his strong involvement with the radical doctrines of anarchism. Nevertheless, by 1892, when he began to establish residence in the not yet fashionable Saint-Tropez, he often turned his back on the world of the Eiffel Tower in favor of scenes of remote harmony that recall, like Cross's *Evening Breeze* (page 445), the idylls of Puvis de Chavannes (page 74). We are placed here in a distant world of classical, even biblical, memory, where the local women carry water in simple earthenware jugs, where postures in profile give the impression of archaic clarity and permanence, where the sun blesses earth and sea.

But the modern world of the 1890s also permeates this timeless vision. The continuing use of the technique invented by Seurat, who had died just the year before this work was painted, conveys in itself an image of technological precision more suitable, one feels, to the age of the sewing machine than to the age of ancient handicraft; and the clean geometries of the lighthouse, the sailboats, and the pure cylinder of the well reflect Signac's earlier fascination with the utilitarian, preeminently modern shapes of industrial architecture.

No less up to date is the insistence on turning a traditional illusion of depth into a tapestry-like decorative pattern in which, for instance, the irregular curve of the coastline, if followed from foreground to distant horizon, lands us in exactly the same place where we began: the flat surface. The restless sinuosity of these abstractly contoured shapes, from the stylized shadows cast in the foreground by the invisible tree to the winding road that looks ribbon-flat, are in synchrony, too, with the dates of the painting's completion (1892) and exhibition in Paris (1893). Those exact years marked the rapid burgeoning of the tentacular, whiplash motifs that, under the name of Art Nouveau, would announce modernity throughout architecture and decoration in Paris and Brussels. It was fitting that just four years later, in 1897, Signac would choose as his winter residence an apartment in the brand-new Castel Béranger, designed by his friend Hector Guimard, who in 1900 would go on to apply his Art Nouveau fantasies to the very symbol of Parisian modernity, the Métro.

No less astute an observer than Gauguin apparently recognized and disliked in this painting the collision of the modern with the archaic, complaining that the peasant women looked like chicly dressed Parisians (so unlike his own Breton field workers) and that, despite their search for water, the well looked dry, for the whole picture was made of confetti!

facing page
PAUL SIGNAC, Paris 1863–Paris 1935
Women at the Well (Young Provençal Women at the Well), 1892
(Salon des Indépendants, 1893)
6' 4¾" x 4' 3½" (195 x 131 cm) RF 1979-5

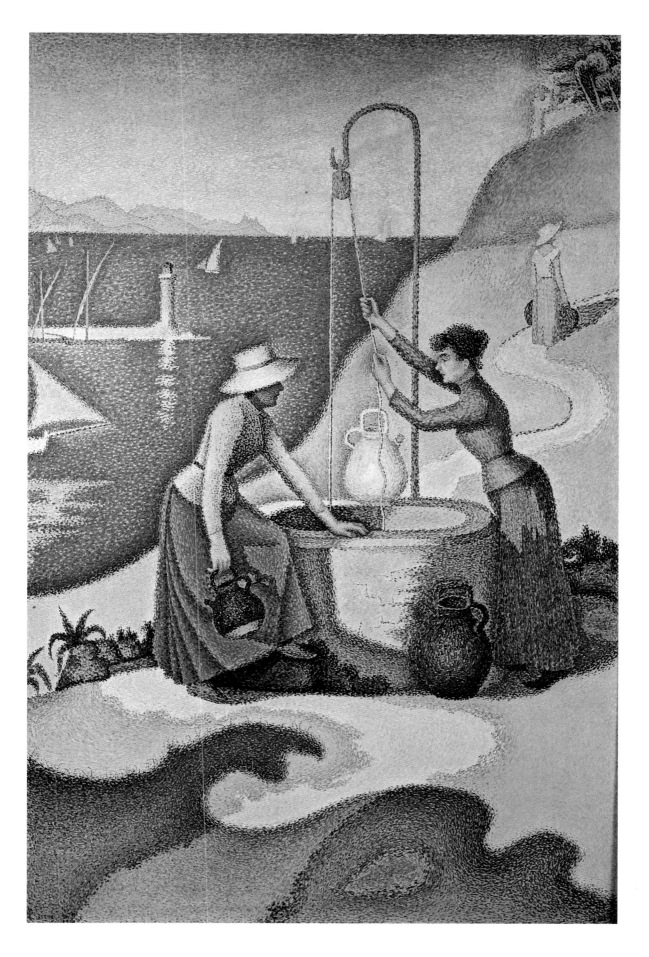

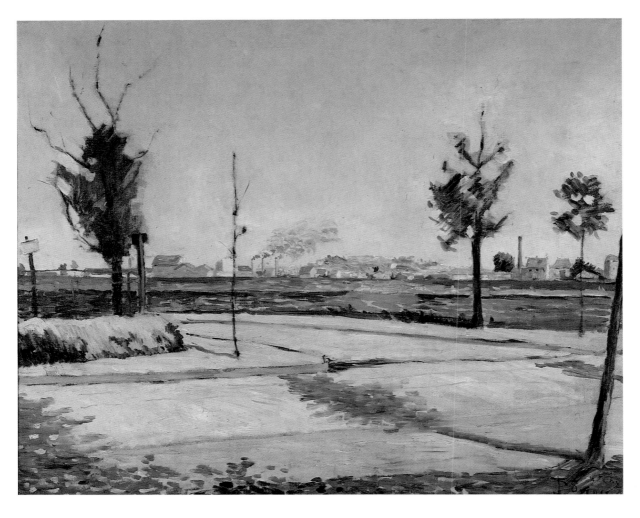

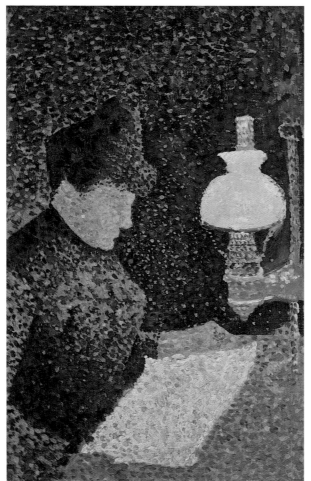

PAUL SIGNAC
The Road to Gennevilliers, 1883
2′ 4¾″ x 3′ (73 x 91.5 cm) RF 1968-3

PAUL SIGNAC
Woman by Lamplight, 1890
9¾″ x 6″ (24.5 x 15 cm) Gift of Mrs. Ginette Signac, 1976.
RF 1976-78

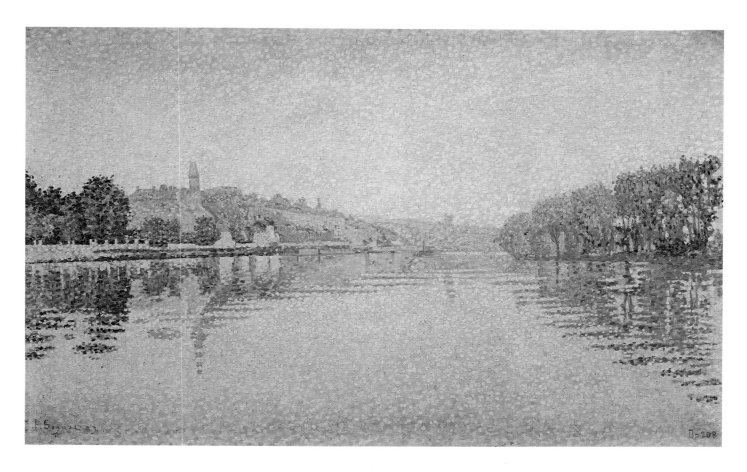

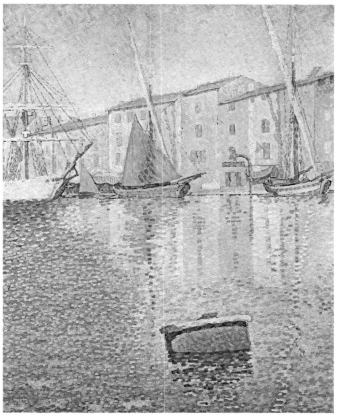

PAUL SIGNAC
River's Edge; The Seine at Herblay, 1889 (Salon des Indépendants, 1891)
1′ 1″ x 1′ 9¾″ (33 x 55 cm) RF 1958-1

PAUL SIGNAC
The Red Buoy, 1895
2′ 8″ x 2′ 1½″ (81 x 65 cm) RF 1957-12

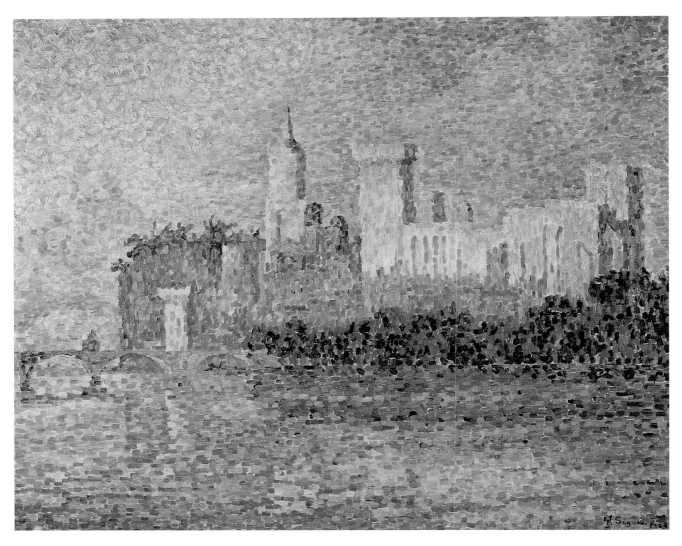

PAUL SIGNAC
The Papal Palace, Avignon, 1900 (Salon des Indépendants, 1912)
2′ 5″ x 3′ (73.5 x 92.5 cm) RF 1977-323

facing page, top
PAUL SIGNAC
Port of La Rochelle, 1921 (Salon des Indépendants, 1922)
4′ 3¼″ x 5′ 3¾″ (130 x 162 cm) Bequest of Mrs. Ginette Signac, 1980.
RF 1982-59

facing page, bottom
PAUL SIGNAC
The Green Sail, Venice, 1904
1′ 1½″ x 2′ 8″ (65 x 81 cm) Gift of Mrs. Ginette Signac, 1976.
RF 1976-77

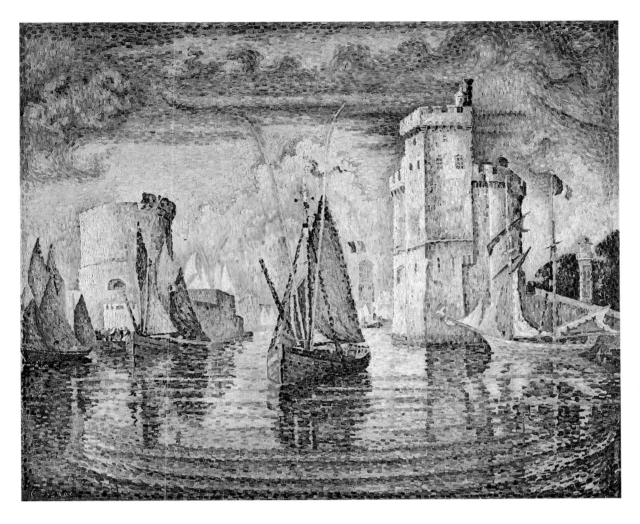

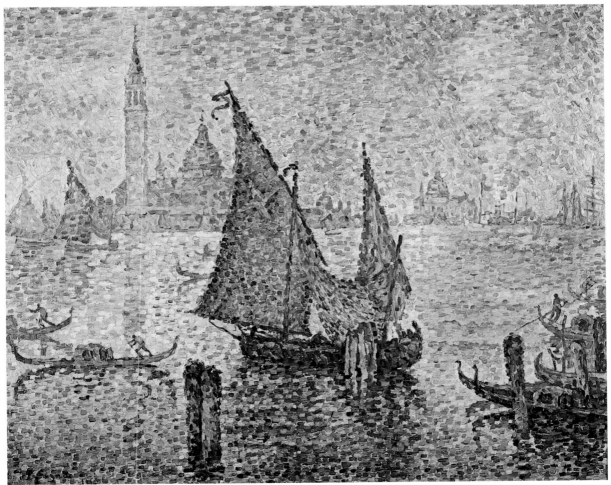

453

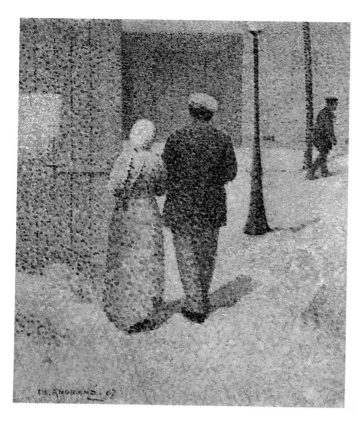

facing page, top
ALBERT DUBOIS-PILLET, Paris 1846–Le Puy 1890
The Marne River at Dawn, ca. 1888
1′ 1″ x 1′ 6″ (32 x 46 cm) RF 1977-155

facing page, bottom
LUCIEN PISSARRO, Paris 1863–Hewood (Somerset) 1944
The Church at Gisors, 1888
1′ 11½″ x 2′ 4¾″ (60 x 73 cm) Gift of Mrs. Esther Pissarro, 1948.
RF 1977-290

CHARLES ANGRAND, Criquetot-sur-Ouville 1854–Rouen 1926
Couple in the Street, 1887
1′ 3¼″ x 1′ 1″ (38.5 x 33 cm) RF 1977-27

CHARLES ANGRAND
Hay Ricks in Normandy, undated
6¼″ x 9¼″ (16 x 23.5 cm) RF 1985-83

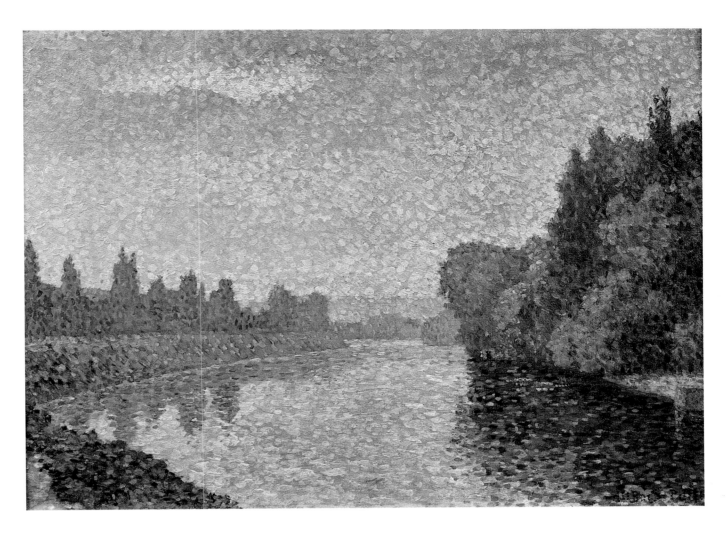

455

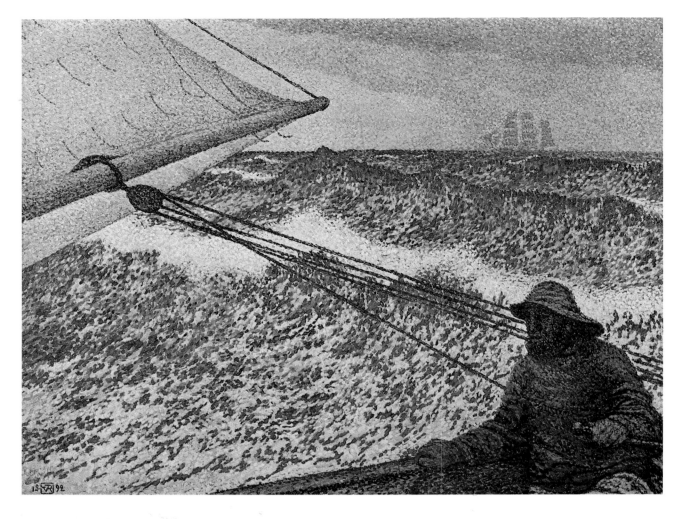

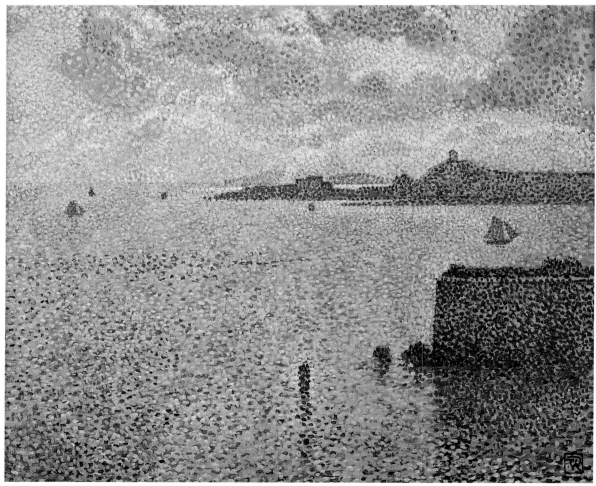

facing page, top
THÉO VAN RYSSELBERGHE, Ghent 1862–Saint-Clair 1926
Man at the Helm, 1892
1' 11¾" x 2' 7½" (60.2 x 80.3 cm) Gift of Mrs. Ginette Signac, 1976.
RF 1976-79

facing page, bottom
THÉO VAN RYSSELBERGHE
Sailboats and Estuary, ca. 1892–1893
1' 7¾" x 2' (50 x 61 cm) RF 1982-16

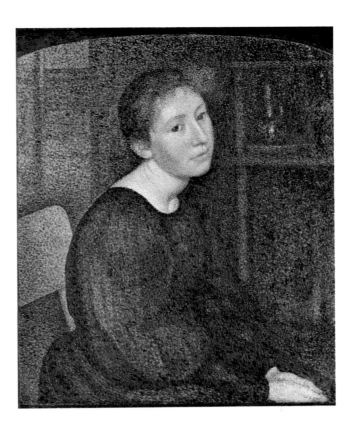

GEORGES LEMMEN, Shaerbeek (Brussels) 1865–Brussels 1916
Portrait of Mme. Lemmen, 1893
1' 6¼" x 1' 3½" (60 x 51 cm) RF 1984-149

GEORGES LEMMEN
Beach at Heist, ca. 1891–1892
Oil on panel, 1' 2¾" x 1' 6" (37.5 x 45.7 cm) RF 1987-35

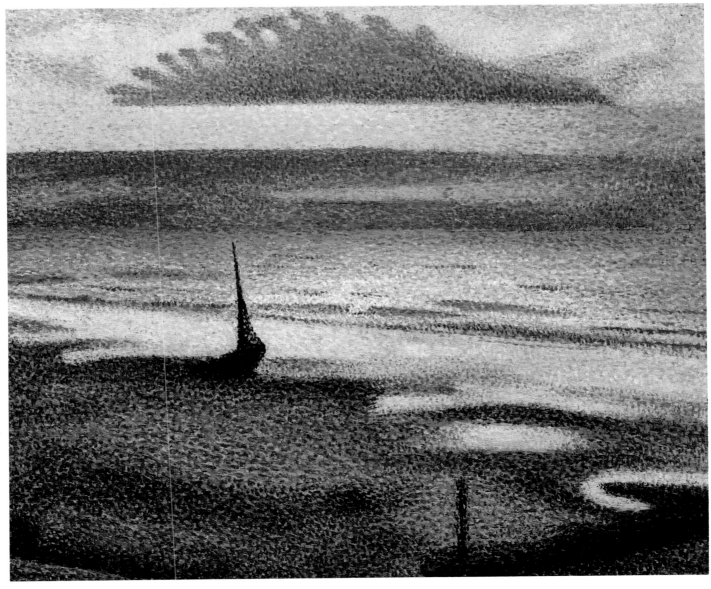

457

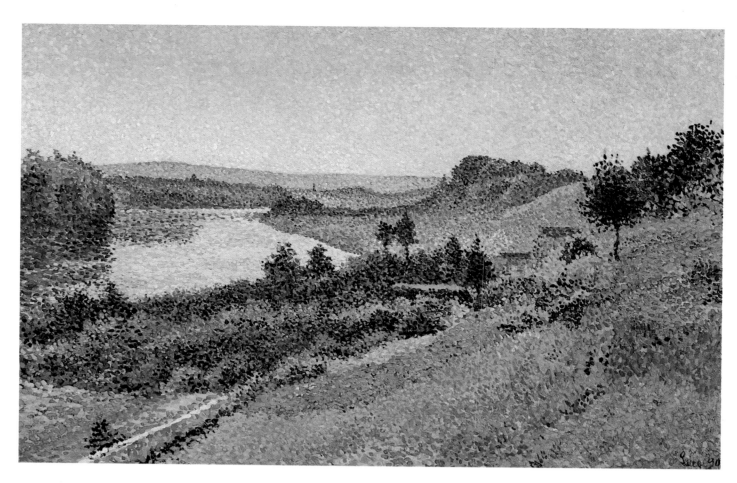

MAXIMILIEN LUCE
The Seine at Herblay, 1890
1′ 8″ x 2′ 7¼″ (50.5 x 79.5 cm) RF 1977-232

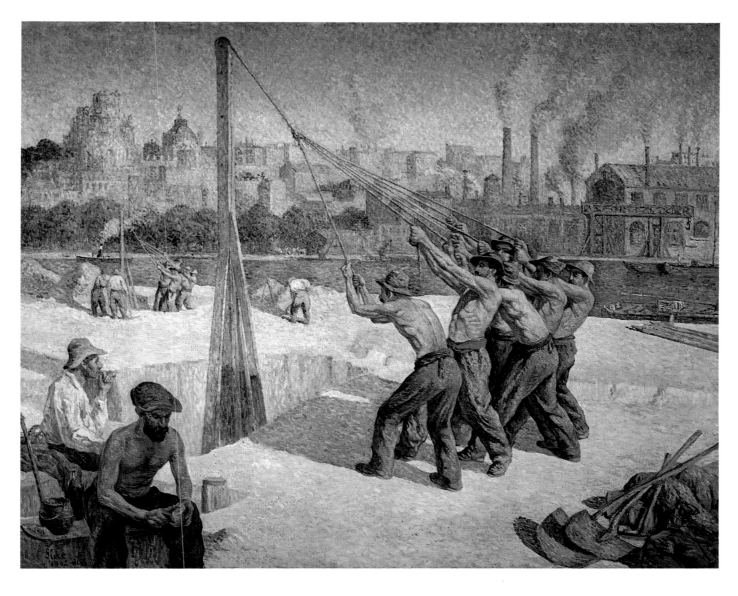

MAXIMILIEN LUCE
The Pile Drivers, Quai de la Seine at Billancourt, 1902–1903
(Salon des Indépendants, 1903)
5′ x 6′ 4¾″ (153 x 195 cm) Gift of Frédéric Luce, 1948. RF 1977-234

MAXIMILIEN LUCE
The Quai Saint-Michel and Notre-Dame, 1901
2′ 4¾″ x 1′ 11½″ (73 x 60 cm) Gift of Christian Humann, 1981.
RF 1981-14

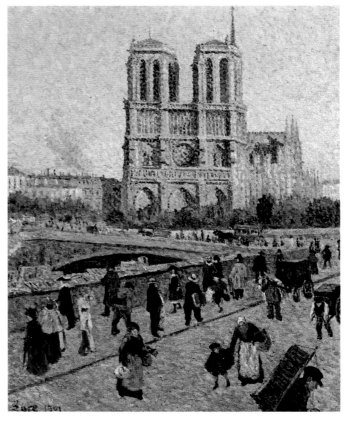

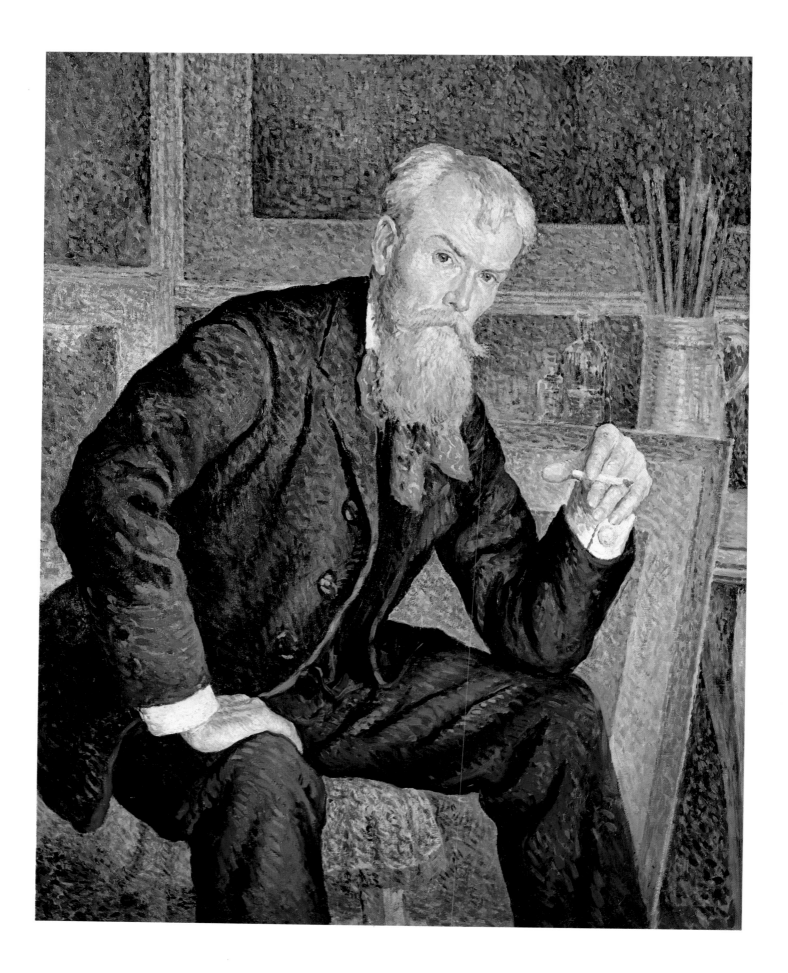

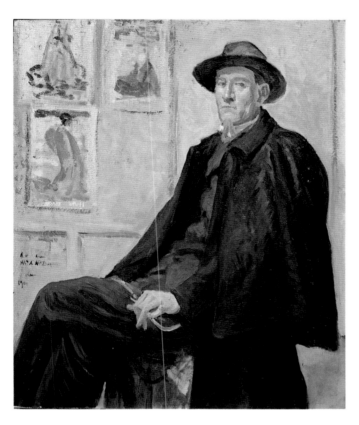

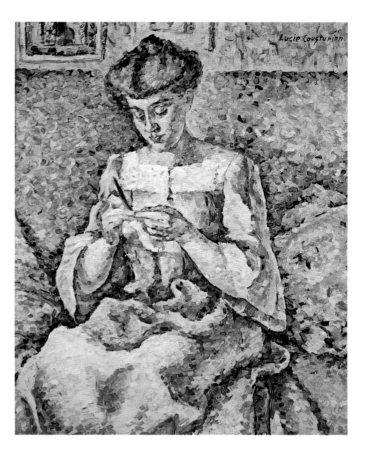

MAXIMILIEN LUCE
Félix Fénéon, 1901
1′ 6″ x 1′ 3¼″ (46 x 39 cm) RF 1980-189

LUCIE COUSTURIER, Paris 1870–Paris 1925
Woman Crocheting, ca. 1908 (Salon des Indépendants, 1909?)
3′ x 2′ 5″ (92 x 73.5 cm) RF 1977-121

facing page
MAXIMILIEN LUCE
Henri Edmond Cross, 1898
3′ 3¼″ x 2′ 8″ (100 x 81 cm) RF 1977-233

TOULOUSE-LAUTREC

Henri de Toulouse-Lautrec
Alone

*T*his vignette speaks volumes. Like Degas, whose footsteps he so often followed in theme and style, Toulouse-Lautrec liked to report on the facts of life as it was lived in the brothels of Paris. But unlike Degas, who approached these *maisons closes* as an elegant voyeur, Toulouse-Lautrec, perhaps because of his physical deformity, seems to have been accepted, like an eccentric pet or mascot, into this society of outcasts. Indeed, his many views of prostitutes of the 1890s register how totally at home he was in this clandestine sorority, recording their off-duty hours when they relaxed—sleeping, chatting, sitting—from their carnal chores. In this utter abbreviation of an oil sketch, Toulouse-Lautrec seizes a swift, oblique glimpse of a prostitute who, exhausted, has collapsed in sleep across the bed. Every detail counts. The smudge of orange hair tells all about the cosmetic brashness of her profession; the thinly

clothed and overused body seems to sink and vanish on the yielding mattress in instant relief from its customary exertions. But even in the ephemeral privacy of a bed, her sexual profession is evoked. Her right hand is clasped near her groin, and the startling pair of black silhouettes, rendered with such rapid economy, describe the unshod but stockinged legs that are still separated, as if by occupational reflex.

What might, however, be a sordid snapshot of the coarse fatigue of an anonymous prostitute turns out, in Toulouse-Lautrec's hands, to have a sense of compassion, the record of a particular woman who was probably a friend he knew well. And as a poignant trace of his on-the-spot intimacy with this illicit scene, the unexpectedly high position of the figure should be noted, in all likelihood a reflection of the artist's own dwarfed height as he looked up at his model from the foot of her bed.

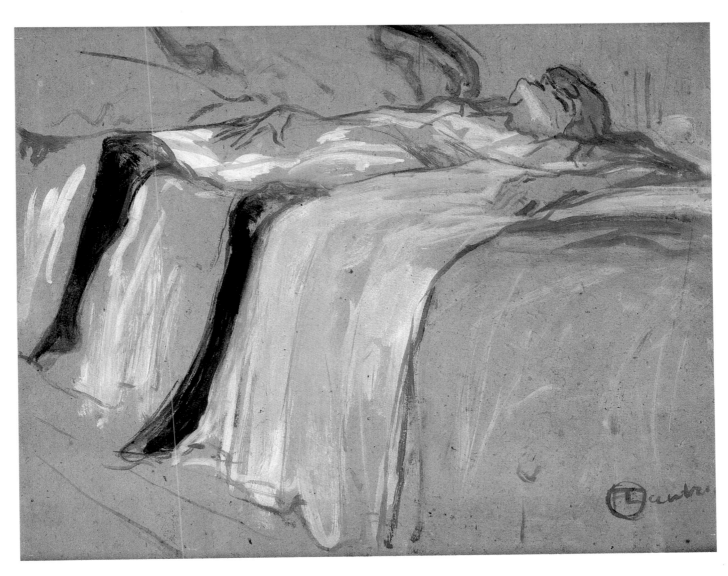

HENRI DE TOULOUSE-LAUTREC

Albi 1864–Château de Malromé 1901

Alone, 1896

Oil on board, 1′ x 1′ 3¾″ (31 x 40 cm) Gift of Florence J. Gould

Foundation, 1984. RF 1984-30

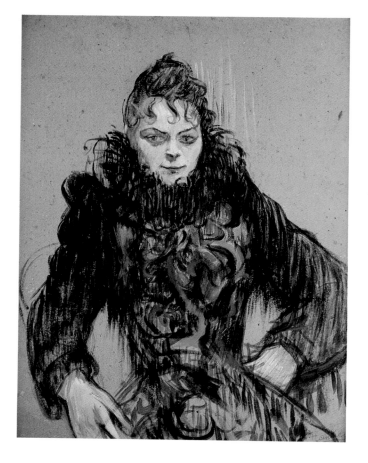

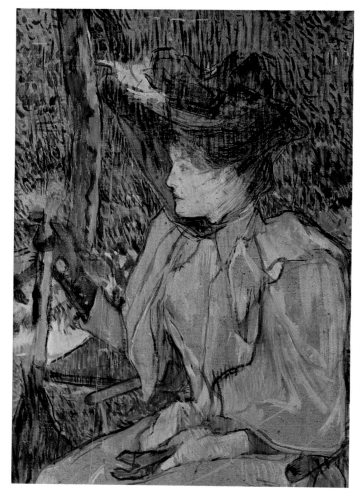

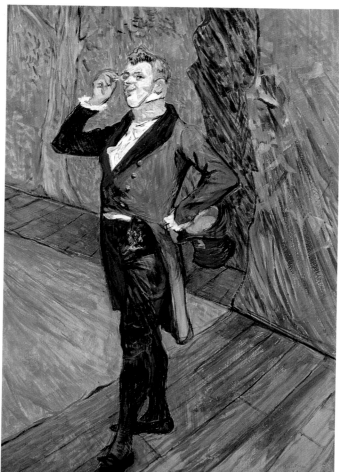

HENRI DE TOULOUSE-LAUTREC
Woman with Gloves (Honorine Platzer), 1891
1′ 9¼″ x 1′ 3¾″ (54 x 40 cm) Gift of Société des Amis du Louvre,
1953. RF 1953-29

left, top
HENRI DE TOULOUSE-LAUTREC
Woman with a Black Boa, 1892
1′ 8¾″ x 1′ 4¼″ (53 x 41 cm) Gift of Countess
Alphonse de Toulouse-Lautrec, 1902. INV 20140

left, bottom
HENRI DE TOULOUSE-LAUTREC
Henry Samary, 1889
2′ 5½″ x 1′ 8½″ (75 x 52 cm) Gift of Jacques Laroche, 1947.
RF 1947-32

facing page
HENRI DE TOULOUSE-LAUTREC
Justine Dieuhl, ca. 1891
2′ 5¼″ x 1′ 10¾″ (74 x 58 cm) RF 1959-3

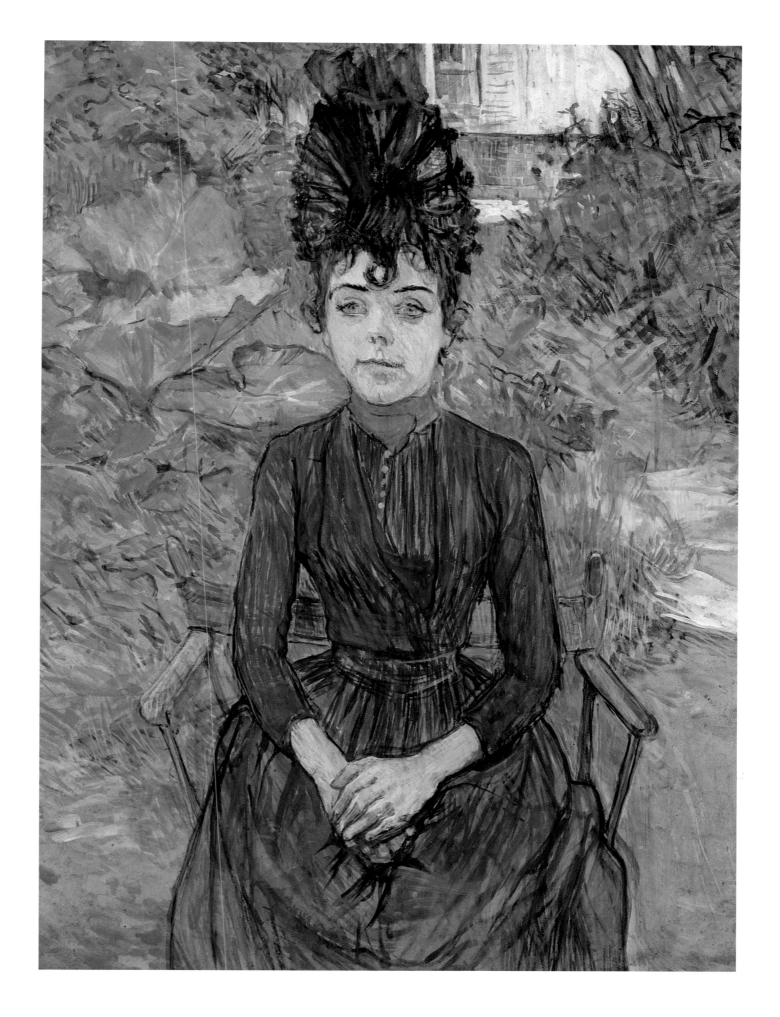

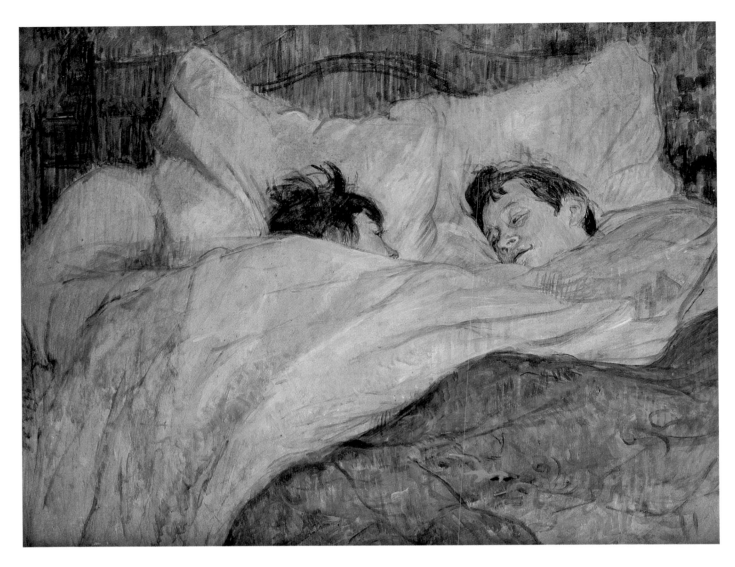

HENRI DE TOULOUSE-LAUTREC
The Bed, ca. 1892
1′ 9¼″ x 2′ 3¾″ (54 x 70.5 cm) Bequest of Antonin Personnaz, 1937.
RF 1937-38

facing page, top left
HENRI DE TOULOUSE-LAUTREC
Woman Pulling Up Her Stocking, ca. 1894
1′ 10¾″ x 1′ 6″ (58 x 46 cm) Gift of André Berthelemy, 1930.
RF 1943-66

facing page, top right
HENRI DE TOULOUSE-LAUTREC
Woman Combing Her Hair, 1891
Oil on board, 1′ 5¼″ x 11¾″ (44 x 30 cm) Bequest of
Antonin Personnaz, 1937. RF 1937-36

facing page, bottom
HENRI DE TOULOUSE-LAUTREC
Paul Leclercq, 1897
1′ 9¼″ x 2′ 2½″ (54 x 67 cm) Gift of Paul Leclercq, 1920. RF 2281

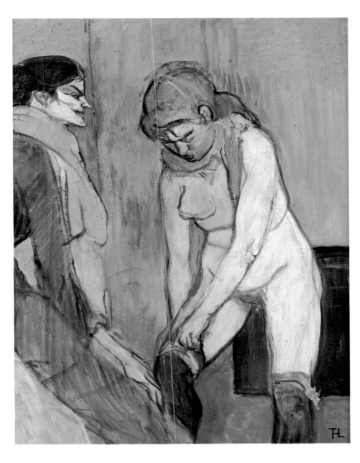

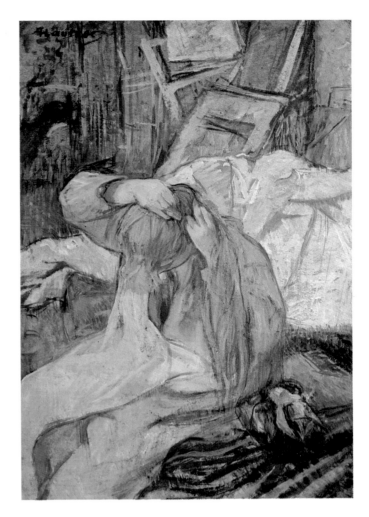

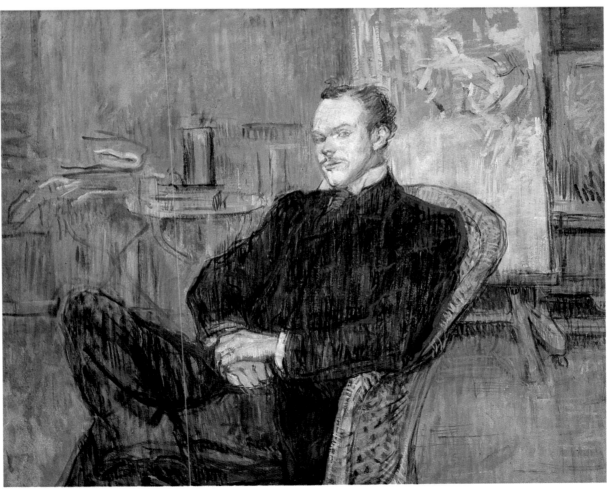

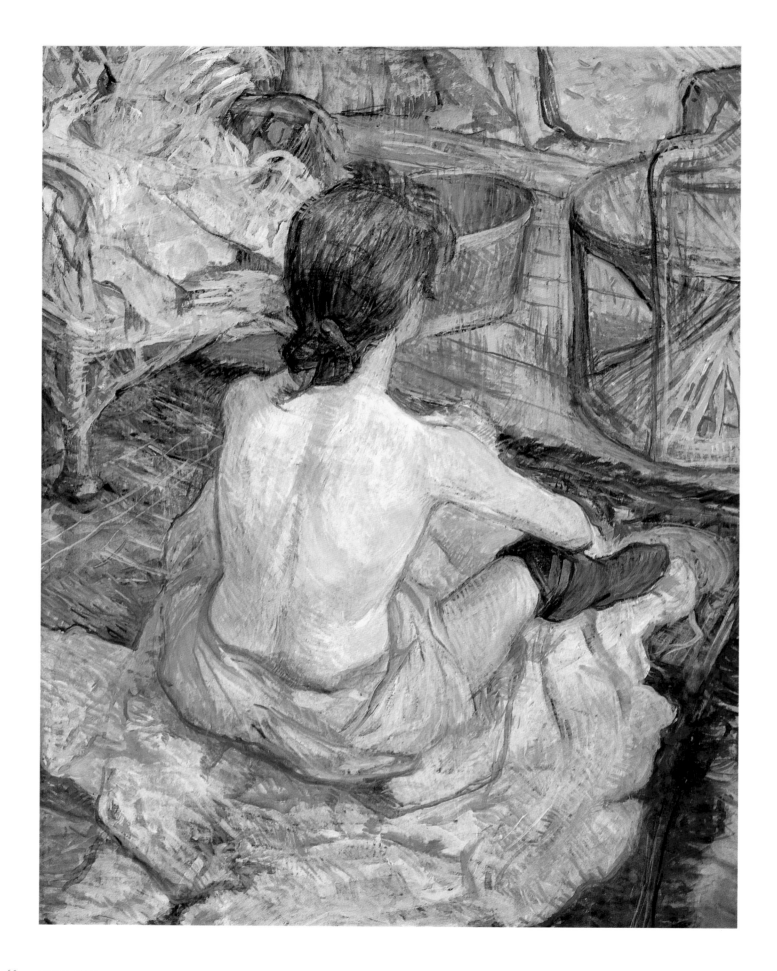

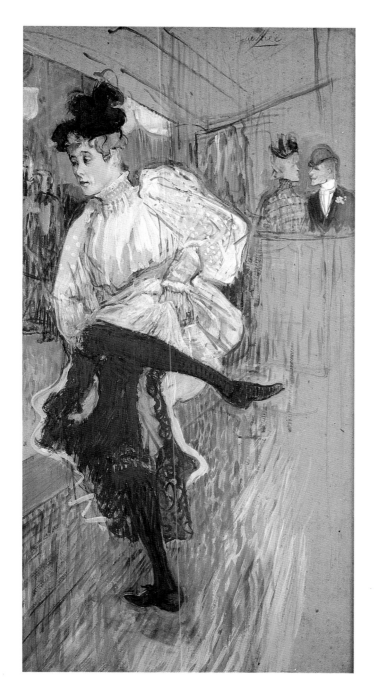

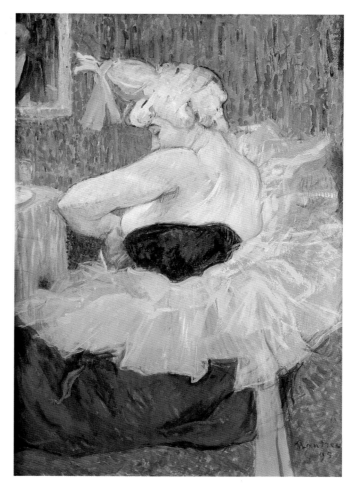

HENRI DE TOULOUSE-LAUTREC
The Lady Clown Chau-U-Kao, 1895
2′ 1¼″ x 1′ 7¼″ (64 x 49 cm) Bequest of Count Isaac de Camondo,
1911. RF 2027

HENRI DE TOULOUSE-LAUTREC
Jane Avril Dancing, ca. 1892
2′ 11¾″ x 1′ 5¾″ (85.5 x 45 cm) Bequest of Antonin Personnaz, 1937.
RF 1937-37

facing page
HENRI DE TOULOUSE-LAUTREC
The Toilette, 1896
2′ 2½″ x 1′ 9¼″ (67 x 54 cm) Bequest of Pierre Goujon, 1914.
RF 2242

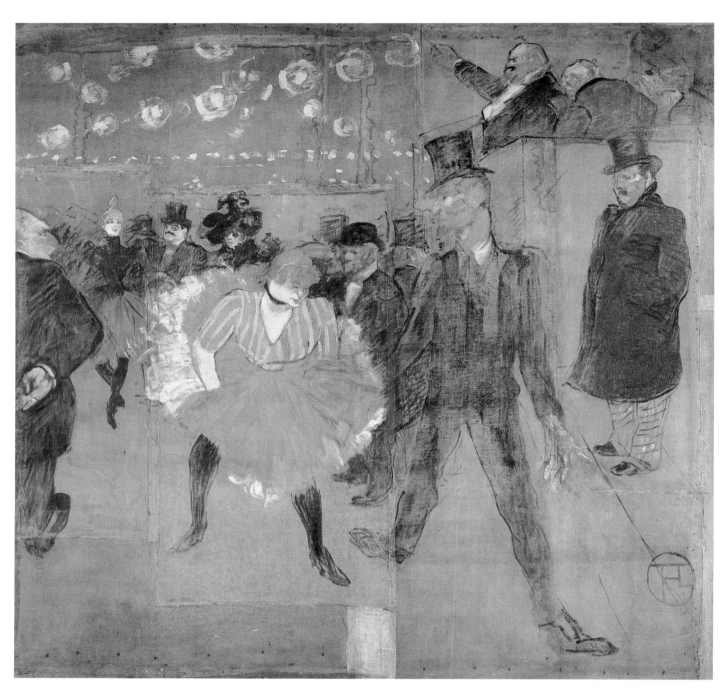

HENRI DE TOULOUSE-LAUTREC
Dancing at the Moulin Rouge, 1895
9′ 9¼″ x 10′ 4½″ (298 x 316 cm) RF 2826

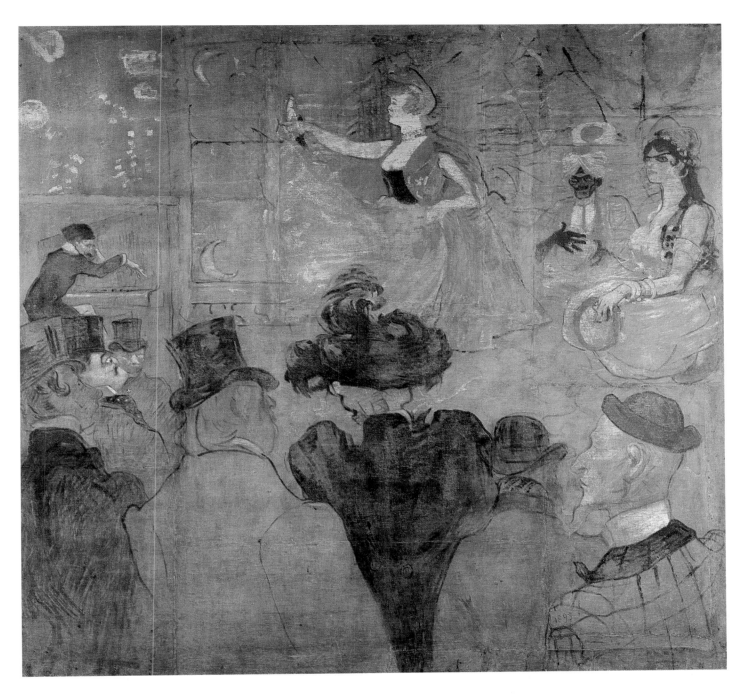

The Moorish Dance, 1895
9′ 4¼″ x 10′ 1″ (285 x 307.5 cm) RF 2826

VAN GOGH

The Italian Woman

During his two-year sojourn in Paris (March 1886 to February 1888), Van Gogh was intoxicated by the new kinds of aesthetic order revealed in the freshest young French painting, as well as by the exotic flatness of color and shape in the Japanese prints that he and his artist friends excitedly circulated, copied, and exhibited. But, as usual, his own empathy with particular people and with the inanimate objects that reflected their presence led to a passionate collision course between his efforts to achieve the balanced perfection of art and what were, in fact, outpourings of his own turbulent emotions.

The Italian model here is Agostina Segatori, who had earlier posed for Corot and Manet. She was forty-six when Van Gogh met her in Paris, had a brief affair with her, and arranged a show of Japanese prints at the little café *Le Tambourin*, which she then ran. Confronted by Agostina, Van Gogh may have wanted to transfix her in an ambience of decorative harmony that fused the lessons he was learning from both French and Japanese art, but the results seethe with a ragged, restless spirit. For miraculously, Van Gogh as always translates these foreign vocabularies into the language of his own private universe.

The golden yellow background probably reflects the spell of those opaque fields of pure color that, in Japanese prints, provided a tonic shock for Western painters from Manet to Matisse. But Van Gogh's interpretation is unexpectedly forceful, also offering a vibrant, coarsely woven response to the thickly flecked, luminous brushwork of Impressionists like Monet. The painting also heralds the almost pagan worship of the sun and its symbolic hues that would soon flood the artist's canvases in the light of Pro-

vence. As for the would-be elegant asymmetry of the perpendicular slats of the chairback vis-à-vis the adaptation, at the top and right-hand side, of the striped margins often found around Japanese images, this turns into a tense, almost straitjacketing brace that locks Agostina in. For she is, indeed, a special model, her black hair, almond eyes, and full broad mouth conveying a warm, breathing presence in what might have become, for another artist, a masklike stylized face.

Most remarkably, the opposing hues of red and green—derived from Impressionist practice and Neo-Impressionist theory about achieving with complementary pigments more truthful facsimiles of color perception—lead an unexpectedly agitated life of their own. Beginning with the marginal stripes, still relatively orderly, they then pulsate with flowing energy around the volumes of the exposed head and hands, ending with almost reckless slashes in the rendering of the blouse, skirt, and what seems to be the patterned cloth on a tabletop. As in the flattened spaces of Japanese prints, the horizontal plane is tilted up at so steep an angle that Western perspective is obliterated, leaving two folded hands and a pair of daisies (the attribute, it has been suggested, of a fortune-teller) to hover in midair. The explosive conflict between these juxtaposed as well as separated reds and greens transforms what might be a static decorative icon into a human presence of magnetic vitality. This work virtually illustrates the statement Van Gogh would make the following year, 1888, when, in attempting to put the night café at Arles on canvas, he hoped to be able "to express the terrible passions of humanity by means of red and green."

facing page
VINCENT VAN GOGH, Groot-Zudert 1853–Auvers-sur-Oise 1890
The Italian Woman, 1887
2′ 8″ x 1′ 11½″ (81 x 60 cm) Gift of Baroness Eva Gebhardt-Gourgaud, 1965. RF 1965-14

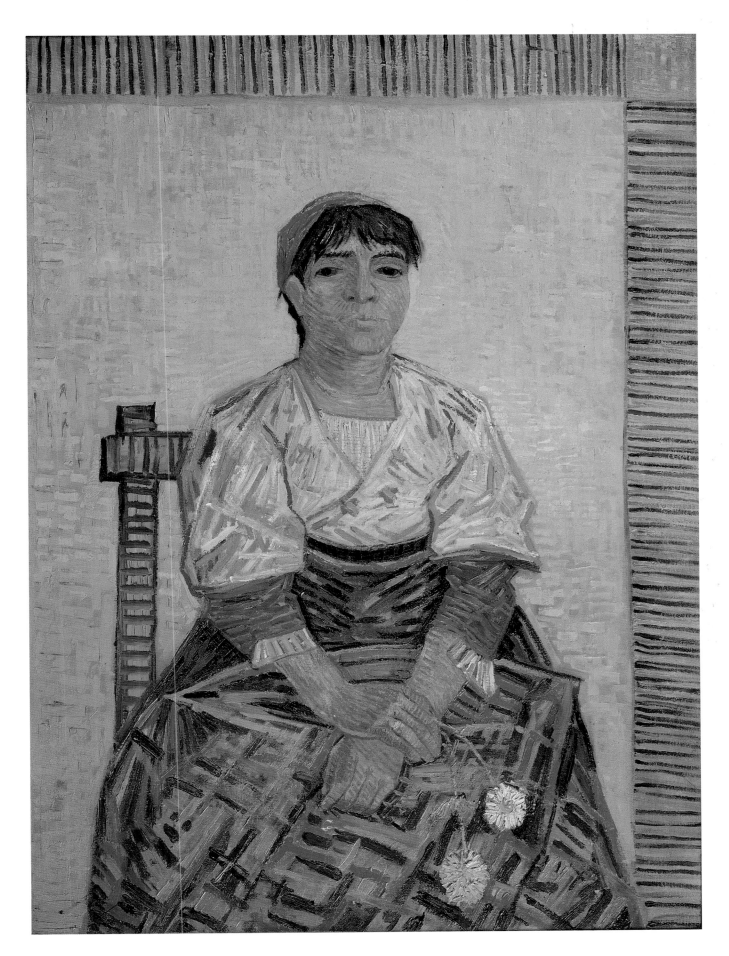

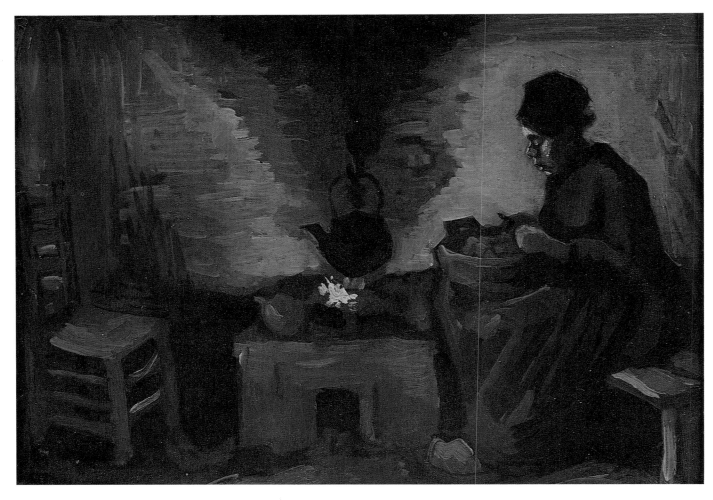

VINCENT VAN GOGH
Peasant Woman near the Hearth, 1885
6⅔″ x 1′ (22 x 40 cm) Gift of the heirs of Georges Renand. RF 1988-10

VINCENT VAN GOGH
Head of a Dutch Peasant, 1885
1′ 3¼″ x 10½″ (38.5 x 26.5 cm) RF 1954-20

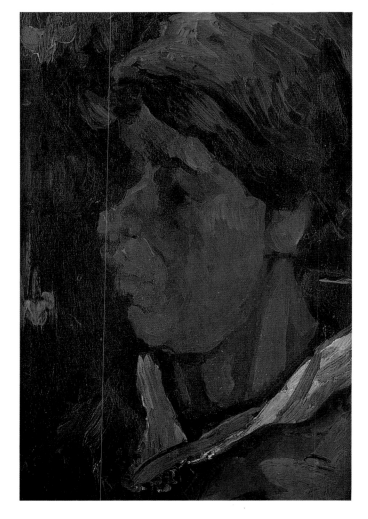

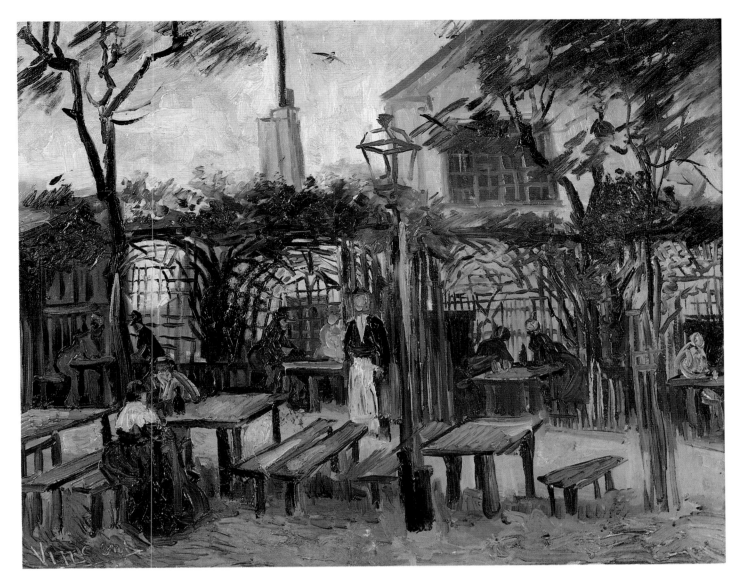

VINCENT VAN GOGH
The Guingette at Montmartre, October 1886
1′ 7½″ x 2′ 1⅓″ (49.5 x 64.5 cm) Bequest of Pierre Goujon, 1914.
RF 2243

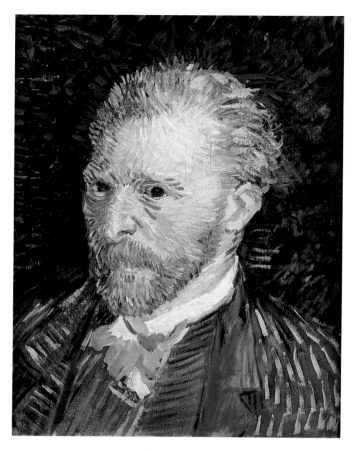

VINCENT VAN GOGH
Self-Portrait, 1887
1′ 5¼″ x 1′ 1¾″ (44 x 35 cm) Gift of Mr. Jacques Laroche, 1947.
RF 1947-28

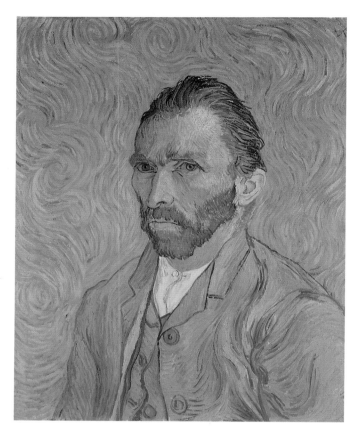

VINCENT VAN GOGH
Self-Portrait, 1889
2′ 1½″ x 1′ 5¾″ (65 x 45 cm) Gift of Paul and Marguerite Gachet,
1949. RF 1949-17

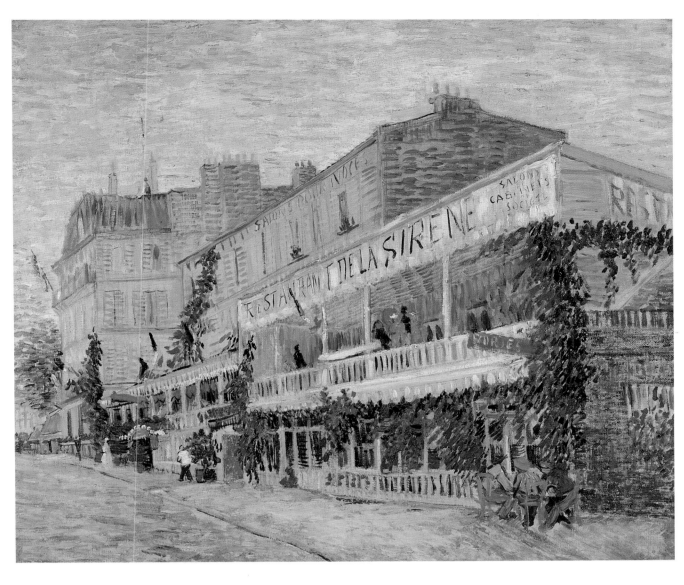

VINCENT VAN GOGH
The Restaurant de la Sirène, summer 1887
1′ 9½″ x 2′ 1¾″ (54.5 x 65.5 cm) Bequest of Joseph Reinach, 1921.
RF 2325

VINCENT VAN GOGH
Imperial Crown Fritillaria in a Copper Vase, 1887
2′ 4¾″ x 1′ 11¾″ (73 x 60.5 cm) Bequest of Count Isaac de Camondo,
1911. RF 1989

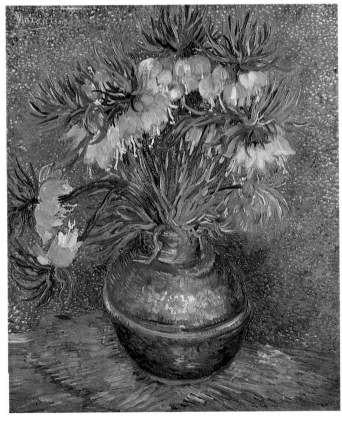

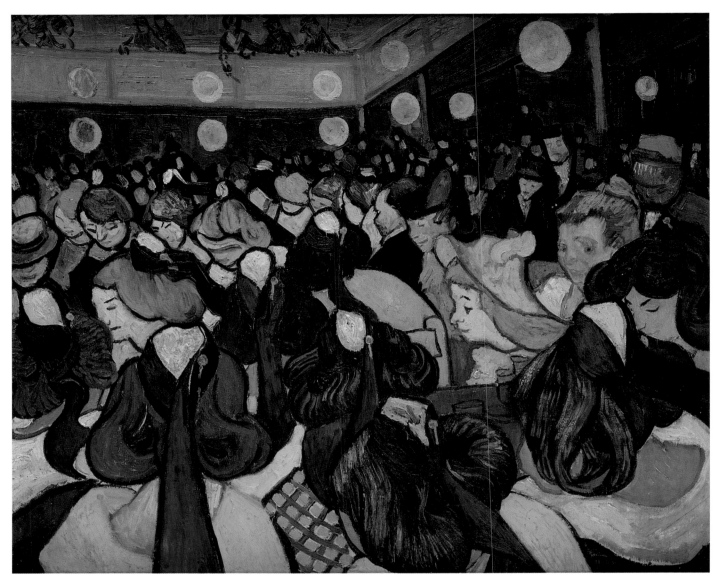

VINCENT VAN GOGH
The Dance Hall at Arles, 1888
2′ 1½″ x 2′ 8″ (65 x 81 cm) Gift of Mr. and Mrs. André Meyer, 1950.
RF 1950-9

facing page
VINCENT VAN GOGH
Eugène Boch, 1888
1′ 11⅔″ x 1′ 5¾″ (60 x 45 cm) Bequest of Eugène Boch, 1941.
RF 1944-9

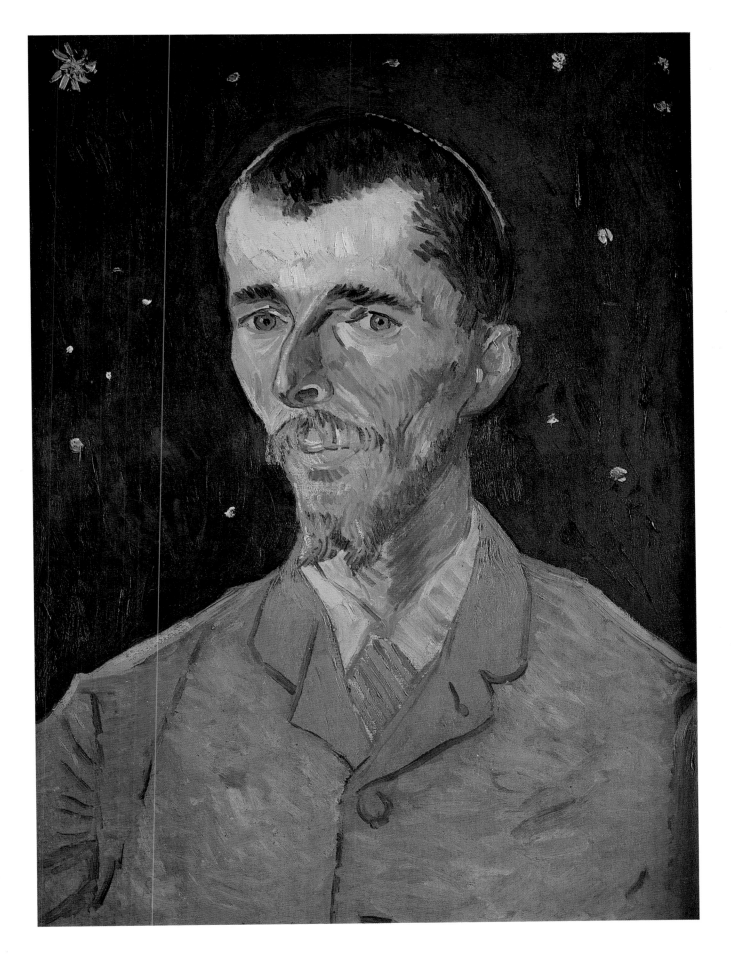

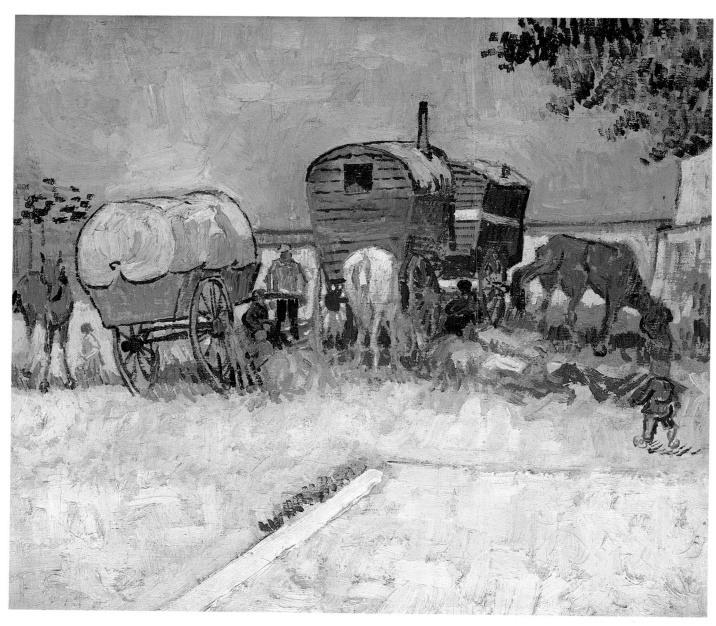

VINCENT VAN GOGH
The Caravans, Gypsy Camp near Arles, August 1888
1′ 5¾″ x 1′ 8″ (45 x 51 cm) Bequest of Mr. and Mrs. Raymond
Koechlin, 1931. RF 3670

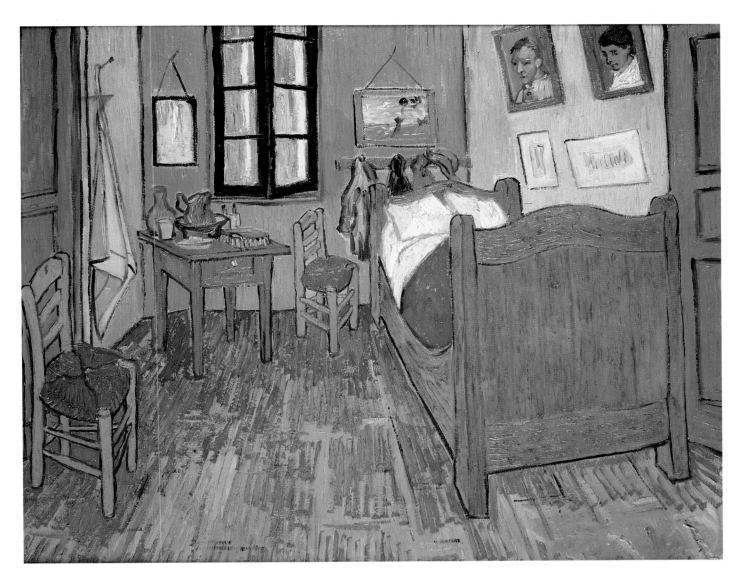

VINCENT VAN GOGH
Van Gogh's Bedroom at Arles, 1889
1′ 10½″ x 2′ 5¼″ (57 x 74 cm) RF 1959-2

The Noonday Nap (The Siesta)

*V*an Gogh venerated Millet, as he did many lesser artists, both French and British, who depicted the lives of the poor in city and countryside. In the case of Millet, as in that of Gustave Doré, his homage took the form of translating their black-and-white prints into his own language of palpable, viscous oil pigment and a wild intensity of color that would have shocked the older nineteenth-century masters at whose shrines he worshiped. The present example, a young peasant couple taking a nap in the noonday sun, is closely based on an engraving made after one of a series of drawings in which Millet described the routine work cycle of the fields—an engraving whose black-and-white evocations of light and shadow Van Gogh hoped to re-create in color and paint.

He seems to have set the engraving on fire. The muted sky of Millet's northern French countryside here turns into a sea of saturated blue; the earth and the two stacks of grain that provide a pair of anchors in space, both near and far, are almost crackling with the heat of the blue's complementary colors, the yellow-orange flames that convey the overwhelming midday sunlight of Provence. Indeed, Van Gogh repays his debt to Millet so fully that the older master is virtually immolated in the exchange. Nominally a scene of exhausted abandon after the morning toil, every square inch of the canvas heaves with the motor energy typical of Van Gogh's brushwork and emotion in his last two years. Asleep in partial shade, the figures ripple in oceanic waves that finally flood the entire canvas.

As usual, every detail in Van Gogh's painting is drenched in a combination of close observation and strong psychic charge. The distant vignette of the cattle and wagon in the fields sets the grand theme of agricultural labor from which, for the moment, the two peasants have been reprieved, nestled against a stack of grain that repeats the format of the one seen on the horizon. But the man and the woman—primordial Adam-and-Eve symbols of rural life so common in Millet's art—remain wedded to the soil, as

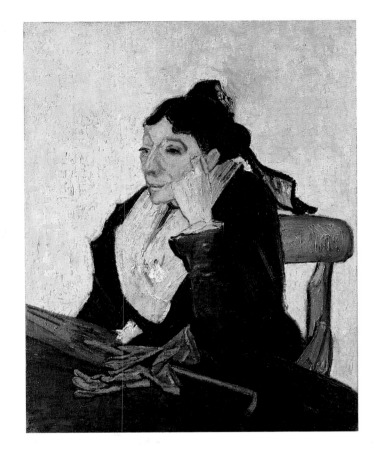

VINCENT VAN GOGH
The Woman of Arles (Madame Ginoux), November 1888
3′ x 2′ 5″ (92.3 x 73.5 cm) Gift of Mrs. R. de Goldschmidt-Rothschild, 1952. RF 1952-6

they are to each other. His unshod feet touch both the earth and her own wooden shoes, which she still wears. Most poignantly, the foreground still life presents a double rhyme, invented by Millet but potently reexperienced by Van Gogh: a pair of sickles locked into place with his discarded but neatly paired wooden shoes. Hugging the earth against the fiery lava flow of Van Gogh's paint, this humble still life distills the message of the entire painting, a passionate emblem of work and rest and of a human pairing that must have been balm to Van Gogh's lonely and troubled spirit in the months before he took his own life.

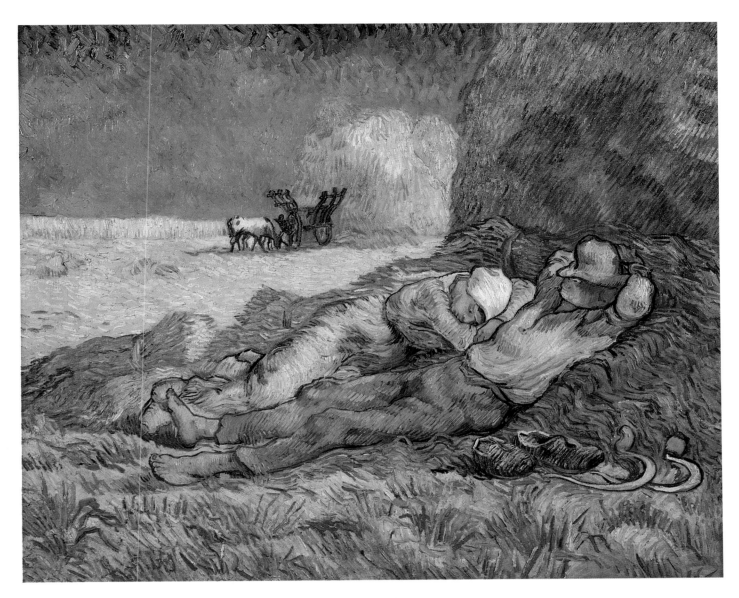

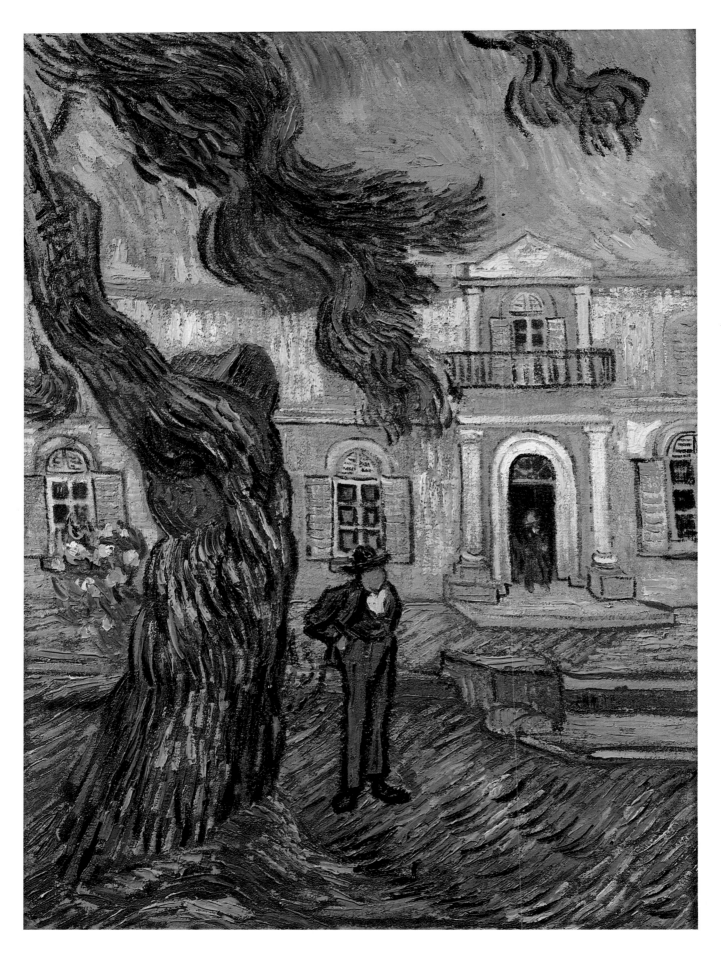

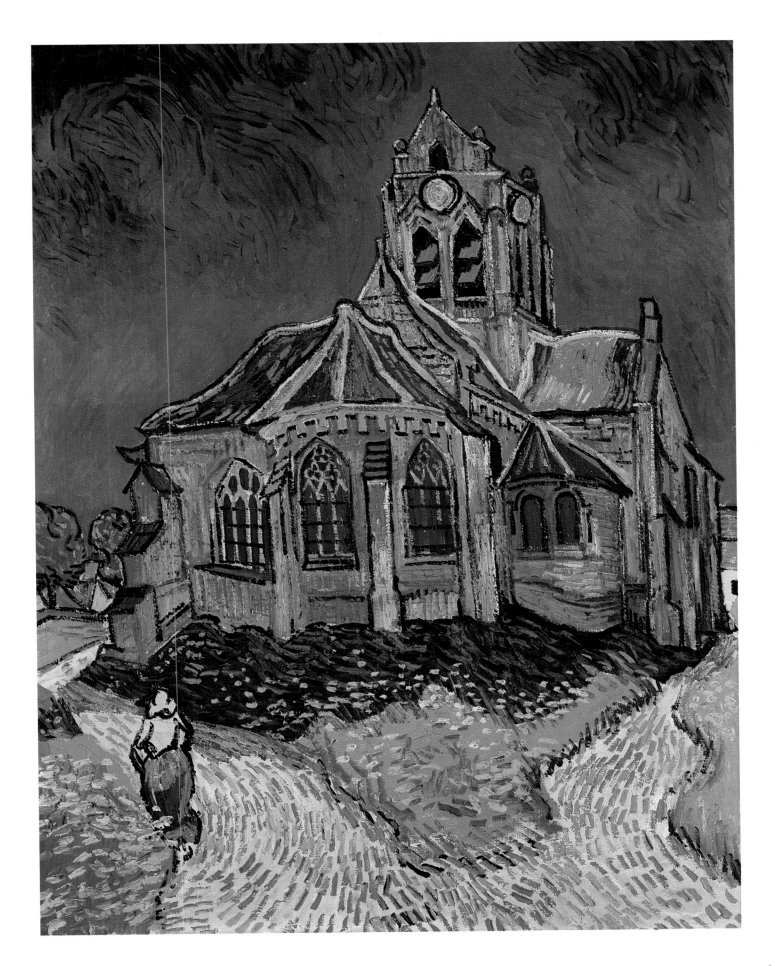

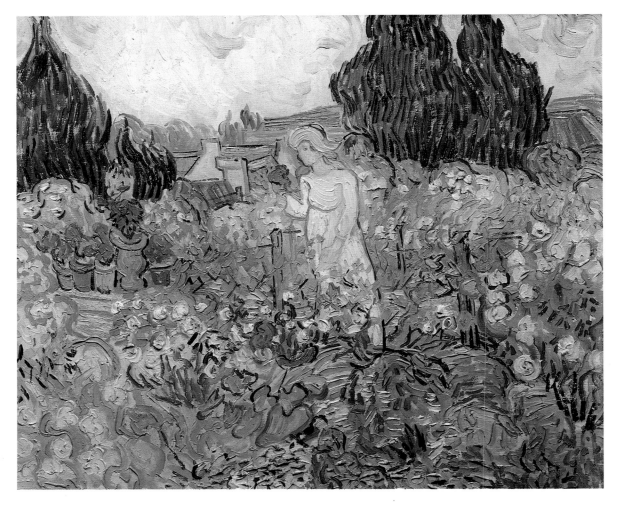

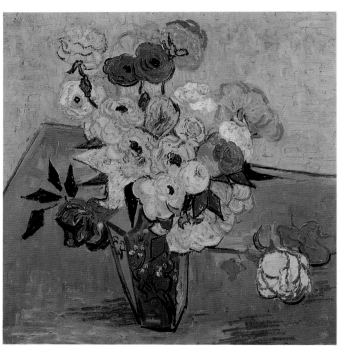

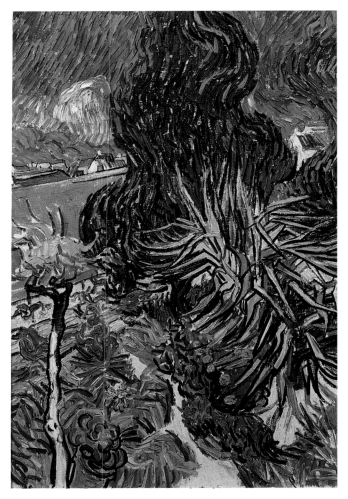

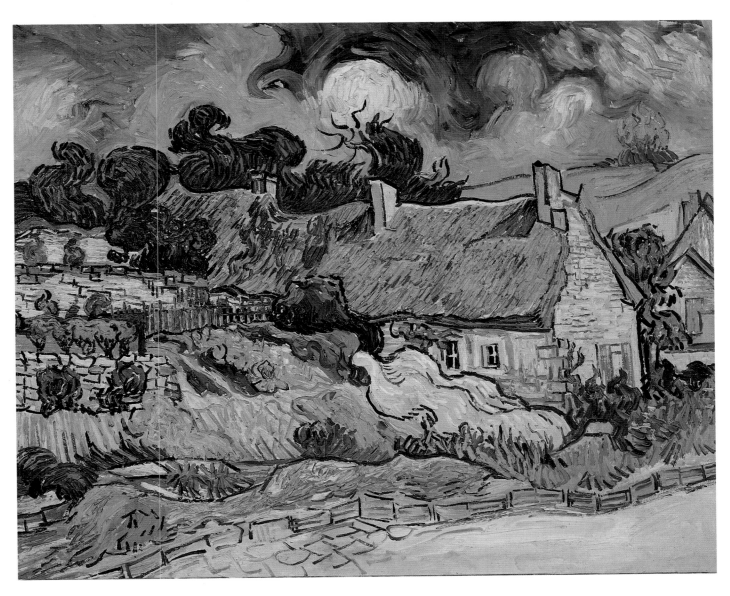

VINCENT VAN GOGH
Thatched Cottages at Cordeville, at Auvers-sur-Oise, June 1890
2′ 4¾″ x 3′ (73 x 92 cm) Gift of Paul Gachet, 1954. RF 1954-14

facing page, top

VINCENT VAN GOGH
Mlle. Gachet in Her Garden at Auvers-sur-Oise, June 1, 1890
1′ 6″ x 1′ 9¾″ (46 x 55.5 cm) Gift of Paul Gachet, 1954. RF 1954-13

facing page, bottom left

VINCENT VAN GOGH
Roses and Anemones, June 1890
1′ 8¼″ x 1′ 8½″ (51.7 x 52 cm) Gift of Paul Gachet, 1954.
RF 1954-12

facing page, bottom right

VINCENT VAN GOGH
Dr. Gachet's Garden at Auvers-sur-Oise, May 27, 1890
2′ 4¾″ x 1′ 8½″ (73 x 52 cm) Gift of Paul Gachet, 1954. RF 1954-15

pages 488 and 489

VINCENT VAN GOGH
Thatched Cottages at Cordeville, detail

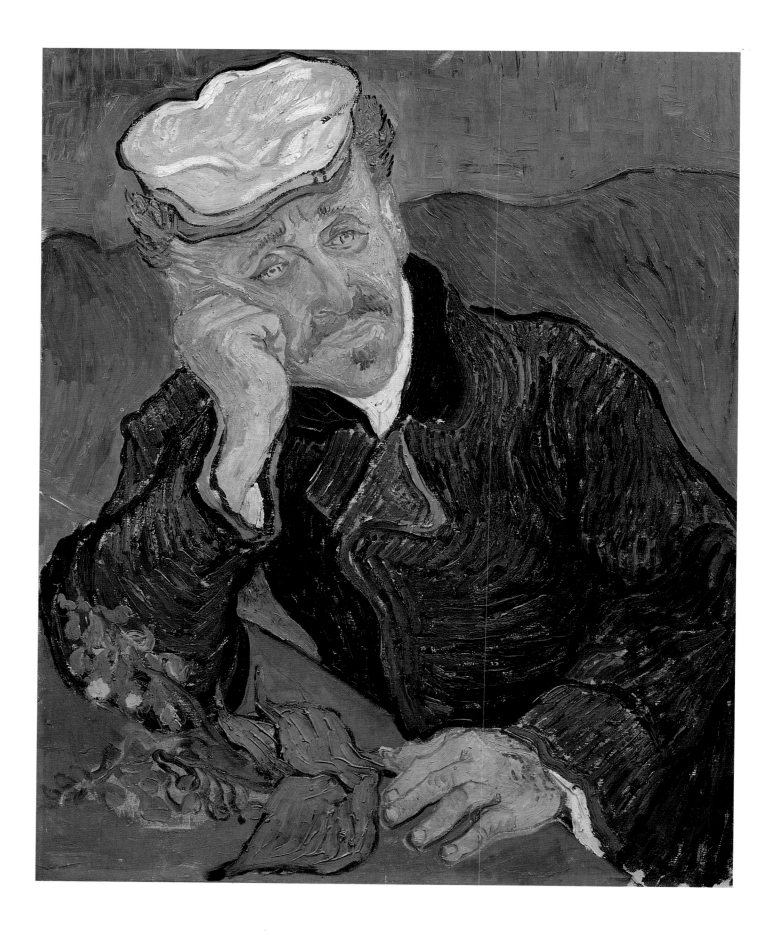

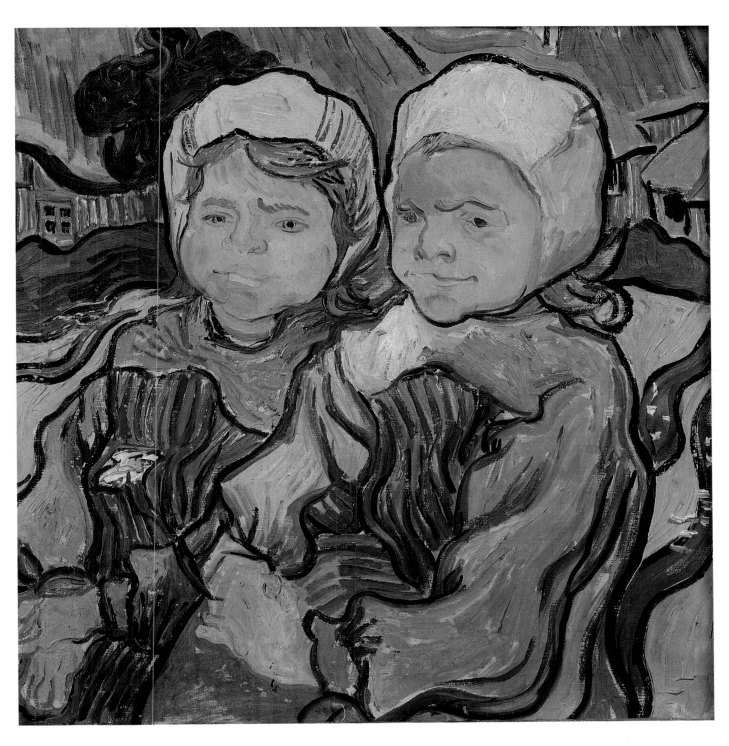

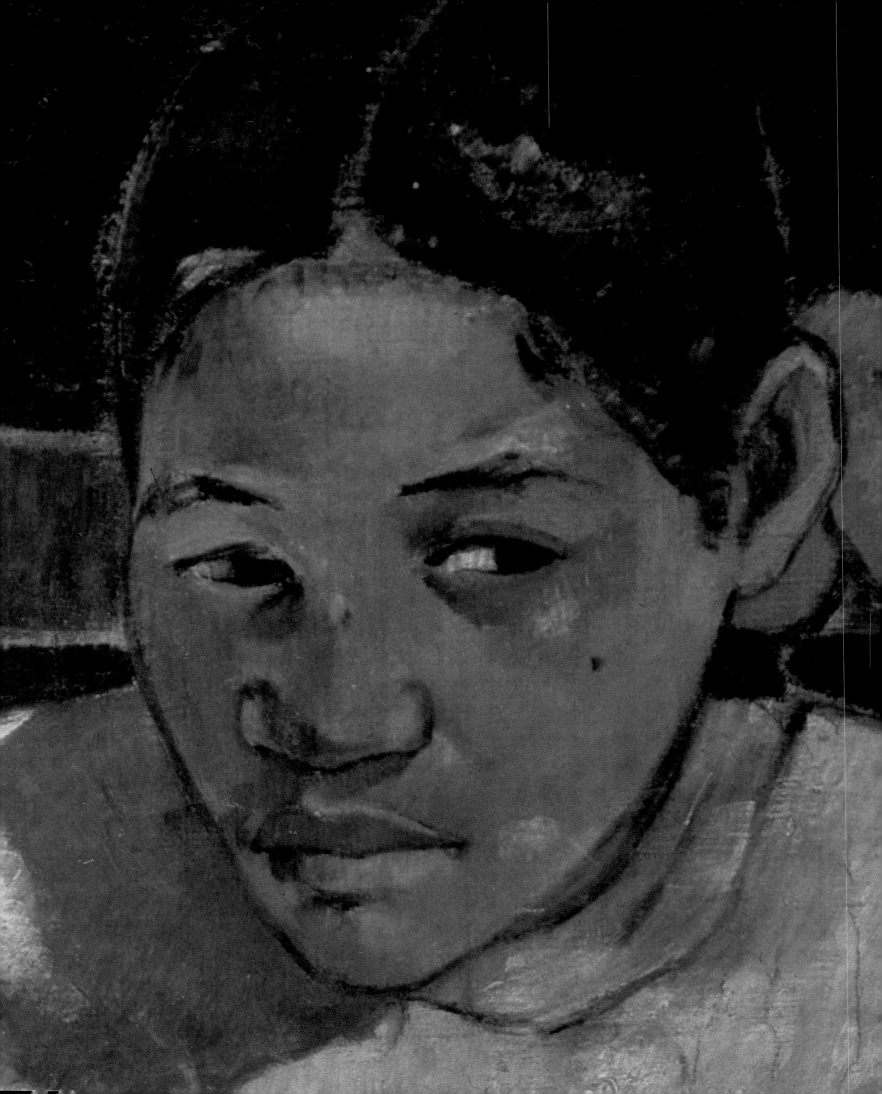

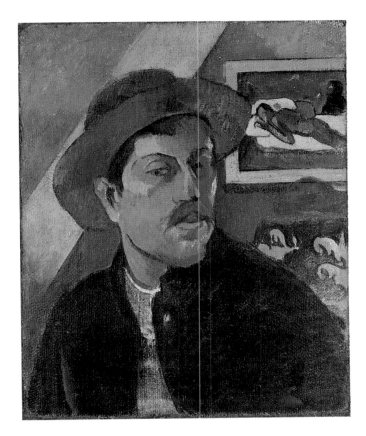

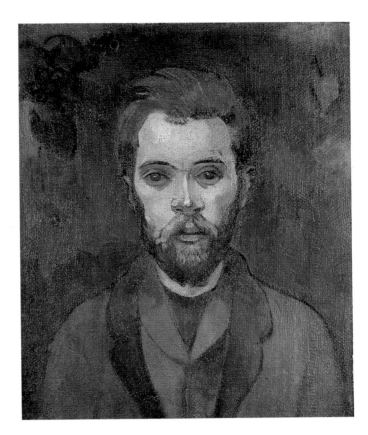

PAUL GAUGUIN, Paris 1848–Atuana 1903
Self-Portrait, ca. 1893–1894
1′ 6″ x 1′ 3″ (46 x 38 cm) RF 1966-7

PAUL GAUGUIN
Portrait of William Molard, 1893–1894
(Reverse of *Self-Portrait*)
1′ 6″ x 1′ 3″ (46 x 38 cm) RF 1966-7

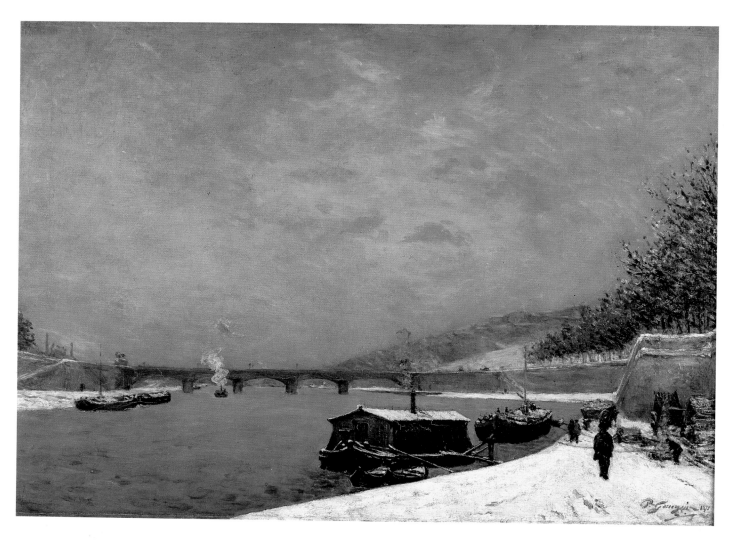

PAUL GAUGUIN
The Seine at the Pont d'Iéna, Snowy Weather, 1875
2′ 1½″ x 3′ (65 x 92.5 cm) Bequest of Paul Jamot, 1941. RF 1941-27

PAUL GAUGUIN
Still Life with Mandolin, 1885
2′ x 1′ 8″ (61 x 51 cm) MNR 219

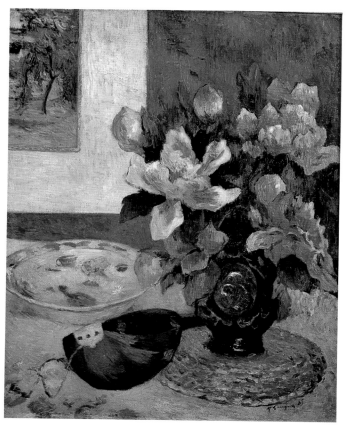

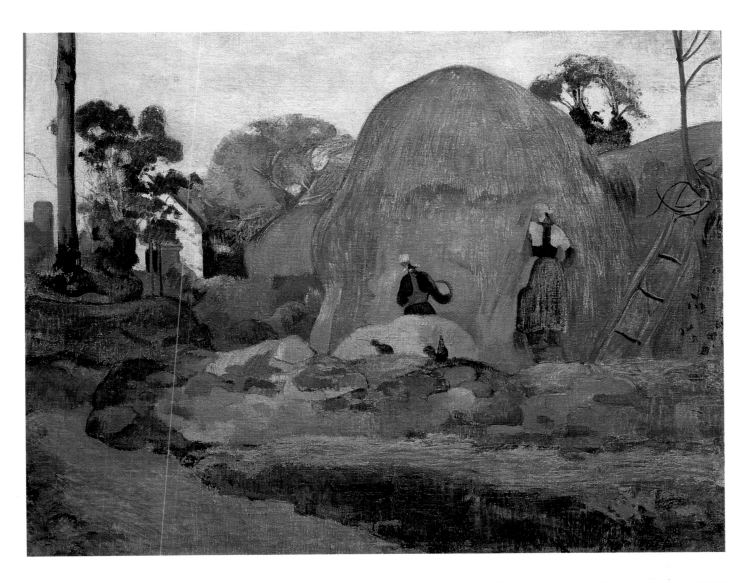

PAUL GAUGUIN
Yellow Hay Ricks (Blond Harvest), 1889
2′ 5″ x 3′ (73.5 x 92.5 cm) Gift of Mrs. Huc de Monfreid, 1951.
RF 1951-6

PAUL GAUGUIN
Washerwomen at Pont-Aven, 1886
2′ 4″ x 2′ 11½″ (71 x 90 cm) RF 1965-17

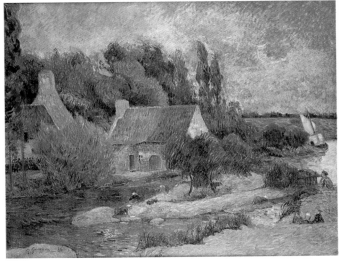

Hay-Making in Brittany; Bouquet of Flowers with a Window Open to the Sea

*I*t is always fascinating to watch artists become themselves. In Gauguin's case, the year in which everything converged was 1888, when, at the end of January, he left Paris again for a remote village in Brittany, Pont-Aven, where a small group of like-thinking painters hoped to escape the urban and artistic pollution of Paris. In their sophisticated eyes, Pont-Aven might have been located on another planet or in another epoch, so far did it seem from contemporary life. With them, Gauguin selected themes of archaic character—fervent religious worship, folkloric art and costume, the primitive labors of agriculture untouched by the industrial era.

It is this latter motif that Gauguin explores in *Hay-Making in Brittany*, a canvas that hovers in both style and meaning somewhere between touristic documentation and mythical fantasy. His early efforts in an Impressionist mode, such as the chilly view of the Seine of 1875 (page 496), still leave their mark here. The site, we know, is a specific one in Pont-Aven, the Derout-Lollichon field; and as in an Impressionist painting, we sense a world of instability. The sky is overcast and uncertain, leaving the distant

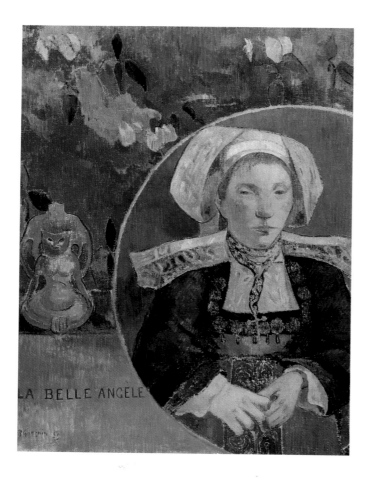

church steeple in a blur of atmosphere; the three field workers, like the scampering dog in the foreground, may change their positions at any moment. But within this Impressionist awareness of the particular and the ephemeral, Gauguin also begins to extract a more enduring order of symbolic resonance. The colors of the field, with their growing intensities of yellow and green (contagious even in the signature and date), almost solidify into a flat band of a kind that, in other paintings, would define a leap into an unseen world of feeling and imagination. And the lucid trinity of the working peasants, the sheltering farmhouse, and the Gothic tower also move in a direction that would encompass, as in an ancient legend, the entirety of this simple world. Earlier painters of rural life, like Millet and Breton, had already underlined the coherence of a pre-industrial society dominated by the distant silhouette of a church on the horizon. Gauguin pushes this one step further in the direction of a fairy-tale world that is more symbol than fact, a complete reversal of the premises of Impressionism that dominated his early view. In terms of Gauguin's life and art, this was, of course, only the beginning. Three years later he would sail to Tahiti, where he hoped to discover an even more elementary and harmonious fantasy, a primitive paradise untroubled by the modern world.

As an unexpected bonus to this canvas, the reverse side reveals another painting, partly obscured by the stretcher bar. It, too, hovers between the perceived and the imagined, an oblique window view of the sea in which near and far—the startlingly large vase of wild flowers and the tiny boats—are abruptly juxtaposed as in a child's drawing. The horizon is so high and the sheet of pale green water so opaque that the casual window view of an Impressionist painting almost becomes a flattened stage set, a perfect backdrop for a folkloric legend about Breton fishermen.

PAUL GAUGUIN
"La Belle Angèle," 1889
3' x 2' 4¾" (92 x 73 cm) Gift of Ambroise Vollard, 1927. RF 2617

facing page, top
PAUL GAUGUIN
Hay-Making in Brittany, 1888
2' 4¾" x 3' (73 x 92 cm) Bequest of Paul Jamot, 1941. RF 1941-28

facing page, bottom
PAUL GAUGUIN
Bouquet of Flowers with a Window Open to the Sea
(Reverse of *Hay-Making in Brittany.*)
2' 4¾" x 3' (73 x 92 cm) Bequest of Paul Jamot, 1941. RF 1941-28

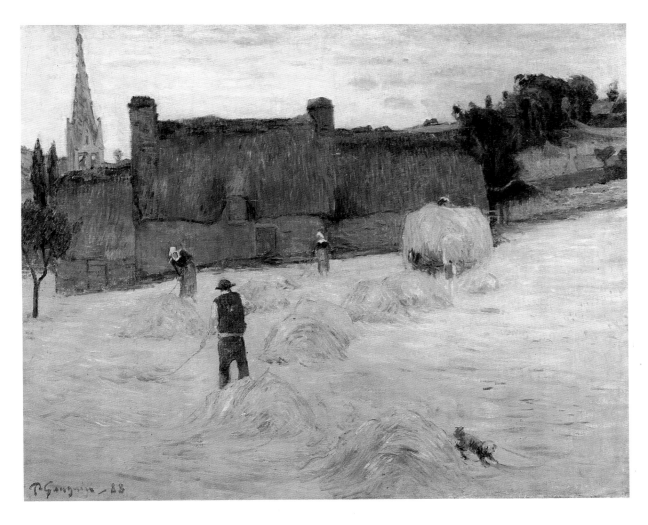

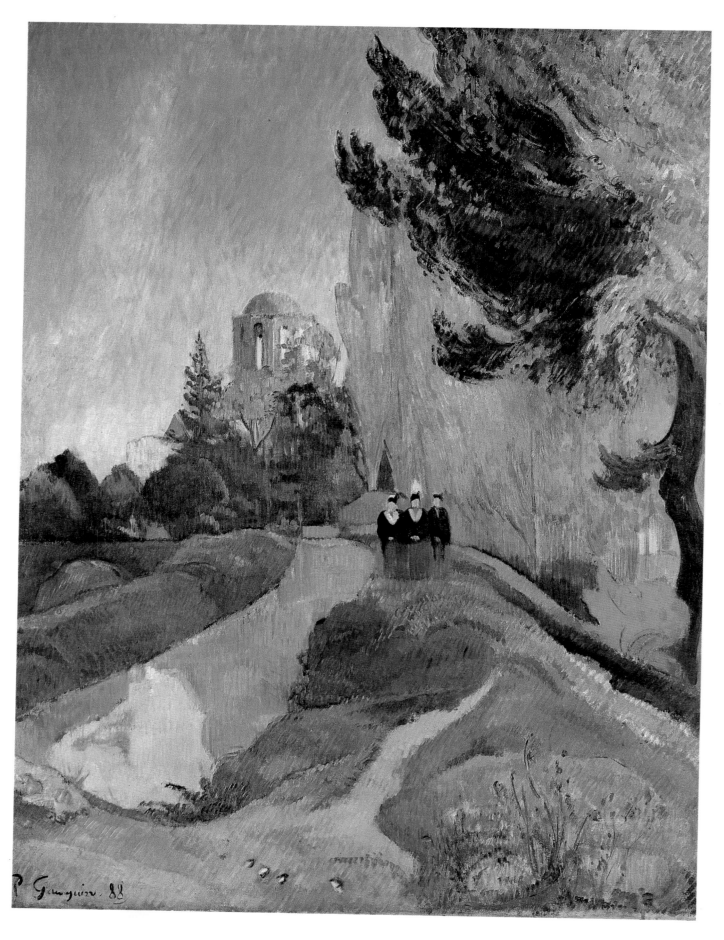

P Gauguin 88

PAUL GAUGUIN
The Alyscamps, 1888
3' x 2' 4½" (91.5 x 72.5 cm) Gift of Countess Vitali, 1923.
RF 1938-47

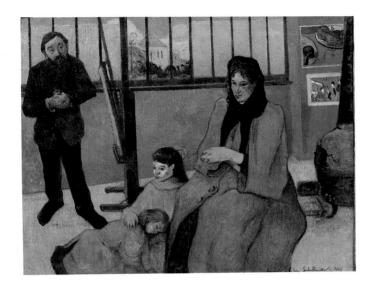

PAUL GAUGUIN
The Studio of Schuffenecker (The Schuffenecker Family), 1889
2' 4¾" x 3' (73 x 92 cm) RF 1959-8

PAUL GAUGUIN
Still Life with Fan, 1889
1' 7¾" x 2' (50 x 61 cm) RF 1959-7

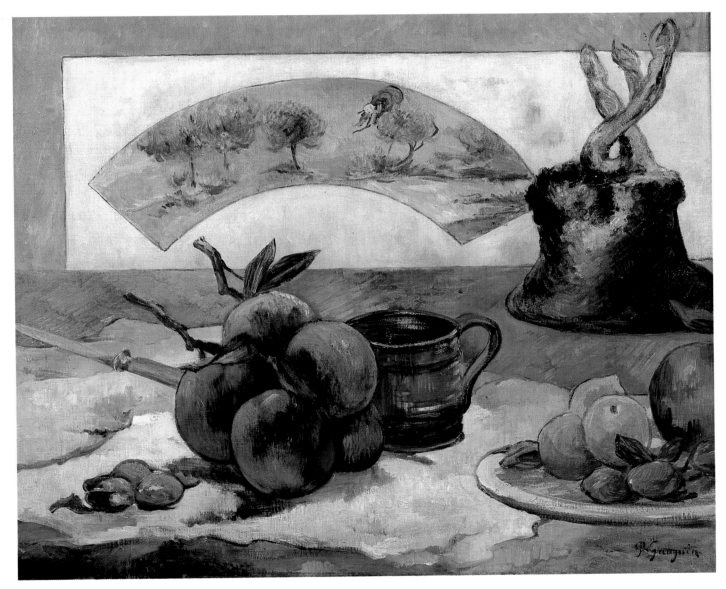

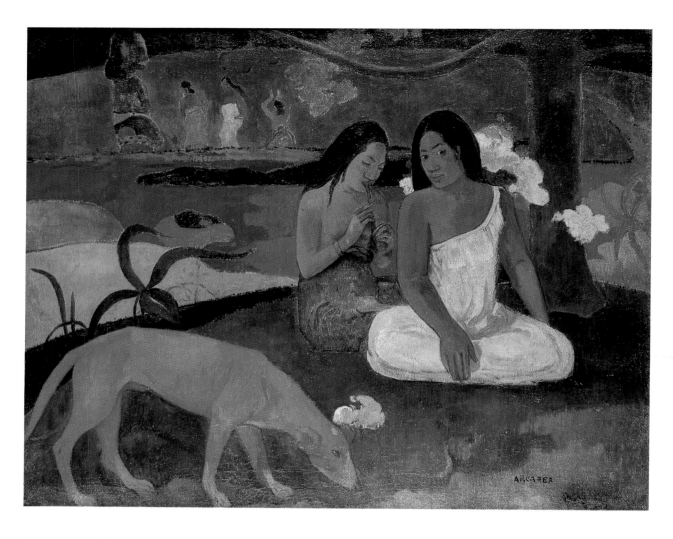

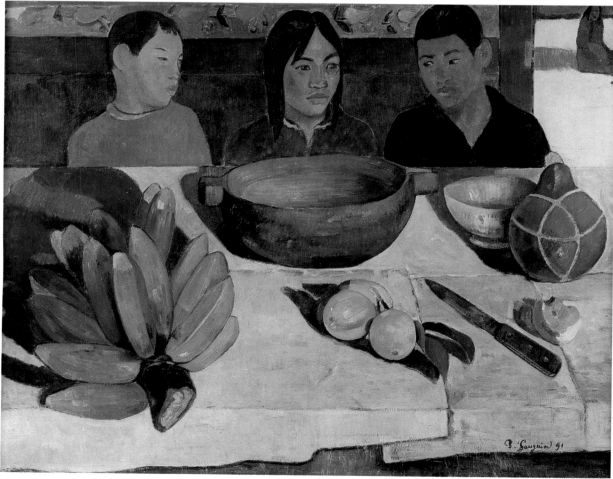

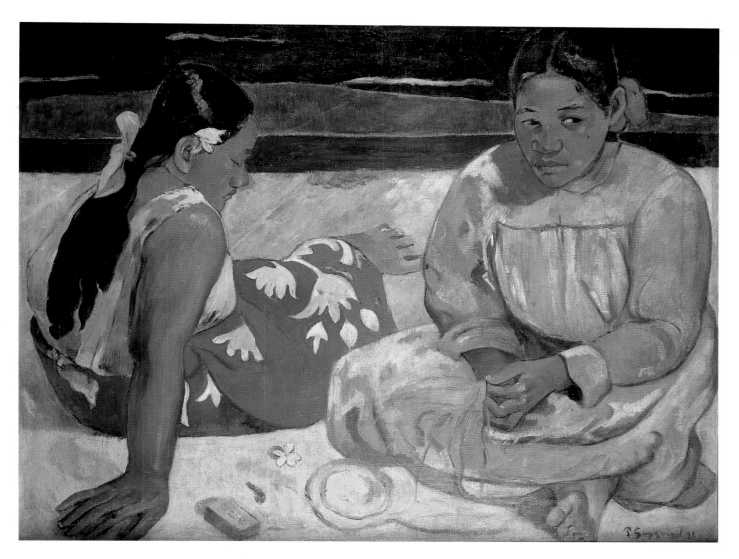

PAUL GAUGUIN
Tahitian Women (On the Beach), 1891
2′ 3¼″ x 3′ (69 x 91.5 cm) Bequest of Viscount Guy de Cholet, 1923.
RF 2765

facing page, top
PAUL GAUGUIN
Arearea (Joyousness), 1892
2′ 5½″ x 3′ 1″ (75 x 94 cm) Bequest of Mr. and Mrs. Frédéric Lung,
1961. RF 1961-6

facing page, bottom
PAUL GAUGUIN
The Meal (The Bananas), 1891
2′ 4¾″ x 3′ (73 x 92 cm) Gift of Mr. and Mrs. André Meyer, 1975.
RF 1954-27

page 504
PAUL GAUGUIN
Floral and Vegetal Motifs, 1893
Painting on glass, 3′ 5¼″ x 2′ 5½″ (105 x 75 cm) Gift of
Mrs. Harold English, 1958. RF 1958-11

page 505
PAUL GAUGUIN
Tahitian Woman in a Landscape, 1893
Painting on glass, 3′ 9¾″ x 2′ 5½″ (116 x 75 cm) Gift of
Mrs. Harold English, 1958. RF 1958-12

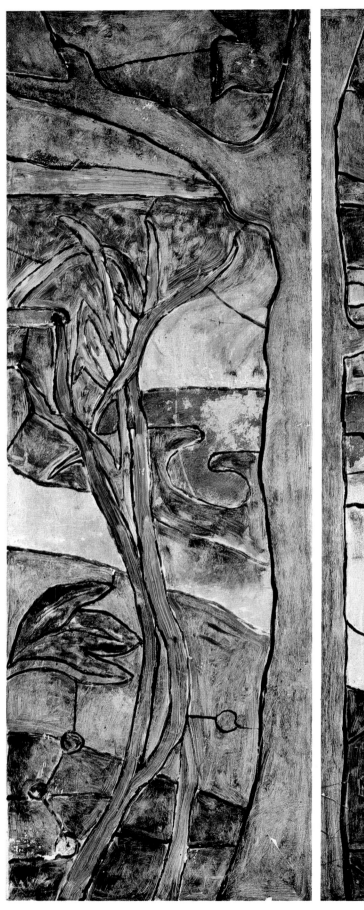
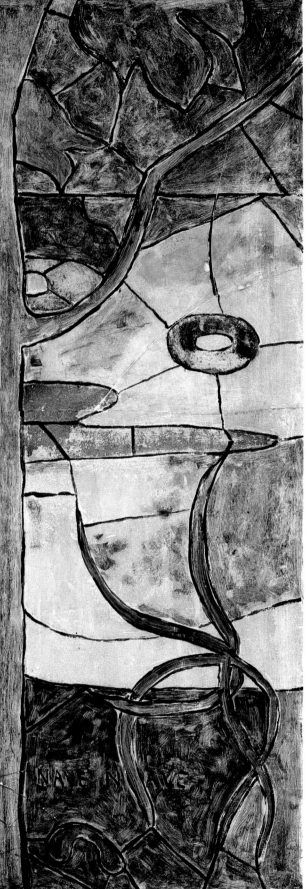

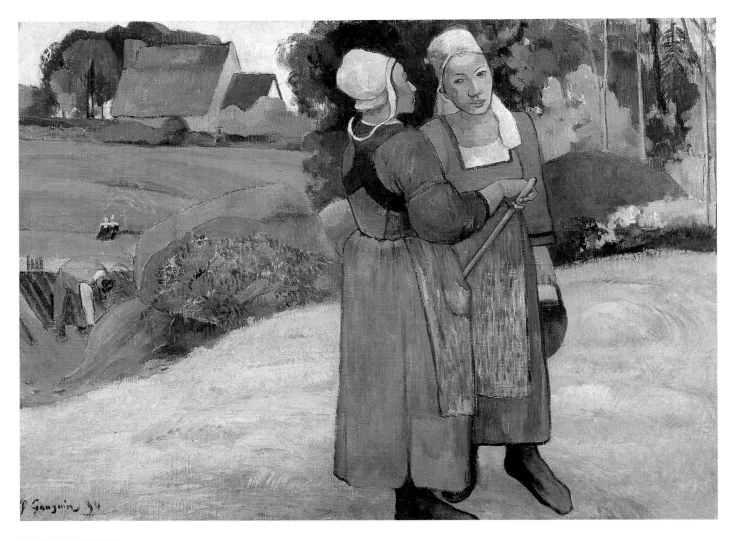

PAUL GAUGUIN
Breton Peasants, 1894
2′ 2″ x 3′ (66 x 92 cm) Gift of Max and Rosy Kaganovitch. RF 1973-17

facing page, top
PAUL GAUGUIN
Breton Landscape (The "Moulin David"), 1894
2′ 4¾″ x 3′ (73 x 92 cm) RF 1959-6

facing page, bottom
PAUL GAUGUIN
Breton Village in the Snow, 1894
2′ x 2′ 10¼″ (62 x 87 cm) RF 1952-29

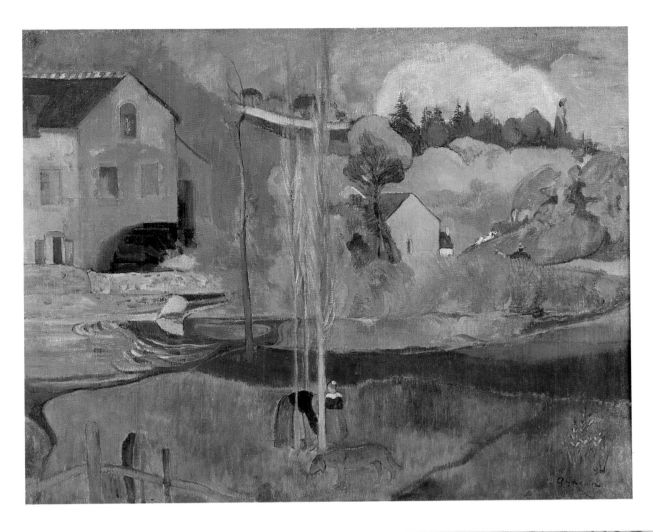

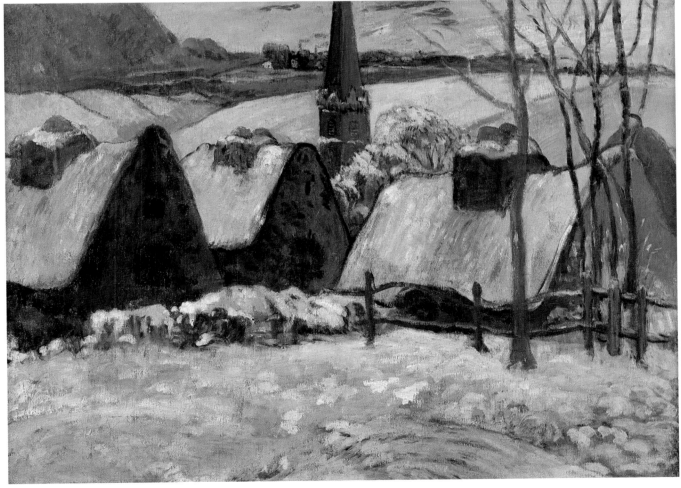

Vairumati

Although Gauguin's final years in Tahiti, from 1895 to his death in 1903, told a story of Paradise Lost, his avowed disillusionment with the Garden of Eden of his fantasies and his private miseries of failing health and poverty barely seem reflected in the still exotic splendor and vitality of his art. In this canvas, the facts and fictions of his dreams remain fused, resurrecting through a living Polynesian girl a mythic earth mother of Tahitian legend, whose name, Vairaumati, Gauguin had misspelled in his inscribed title. With the god Oro as father, she was the Tahitian Eve, from whose loins the entire island race was born.

Gauguin's painted vision closely matched his poetic description of this deity in *Noa Noa*, the illustrated book he prepared for a French audience as a help in understanding the strange subjects of his art. As he put it, Vairumati "was tall, and in the gold of her flesh, the fires of the sun were shining, while all of love's mysteries slept in her hair." Against the blaze of a golden throne-like bed and an earthy red ground, she seems at once a seductive adolescent and a remote icon. Her right arm, as stiff and unarticulated as the most un-Western tribal totem, evokes a primitive image of worship, but the rest of her posture conveys a more Western tradition of sensuous warmth—a new anthropological variant of the harem girls of Delacroix and Ingres. Further magic is added by the symbolic white bird, lizard in claws, who seems to conclude a cycle of desire and pursuit with the finality of death. It was a motif Gauguin was to repeat that year in the huge painting he planned as his last will and testament, *Where Do We Come From? What Are We? Where Are We Going?*, though, in fact, he was to survive his suicide attempt.

Here, as elsewhere, Gauguin was inspired by art that seemed to move as far as possible from the canons of academic beauty that covered the walls of the Salons back in Paris. The luxuriantly decorated bedstead and the two squatting women in the background who raise their hands in rhyming ritual gestures are probably quotations from the reliefs of the Javanese temple at Borobudur, photographs of which Gauguin had bought in Paris at the 1889 World's Fair. The lure of climes even more distant and alien than North Africa or Japan had begun to penetrate music as well. Debussy had been inspired by the Javanese pavilion at the same World's Fair, listening with excitement to the native gamelan players who performed there and weaving these strange and gorgeous sounds into his own Western music, much as Gauguin would revitalize Western painting by his full-blooded espousal of the art and myth of civilizations magically remote from the modern industrial world.

PAUL GAUGUIN
Self-Portrait, 1896
1′ 4″ x 1′ 1″ (40.5 x 32 cm) Gift of Mrs. Huc de Monfreid, 1951.
RF 1951-7

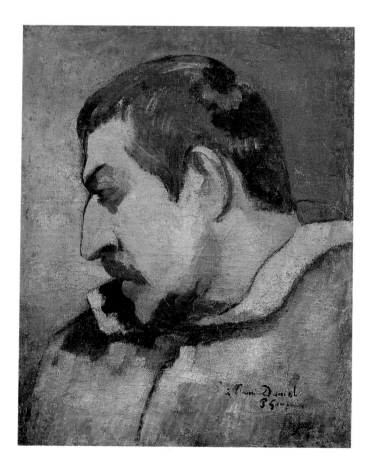

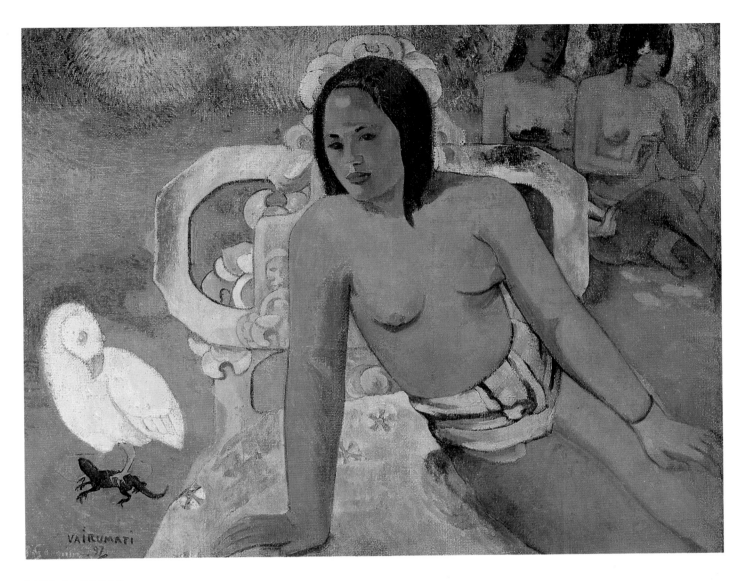

PAUL GAUGUIN
Vairumati, 1897
2′ 4¾″ x 3′ 1″ (73 x 94 cm) RF 1959-5

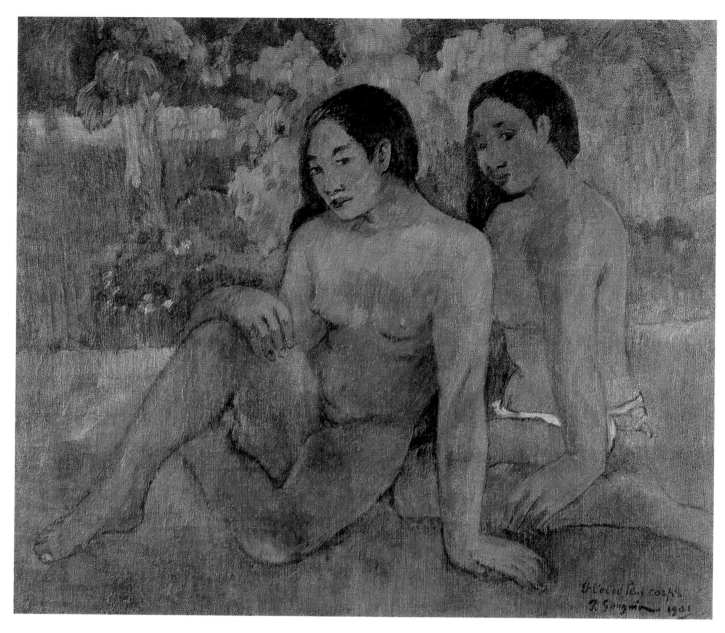

PAUL GAUGUIN
"And the Gold of Their Bodies," 1901
2′ 2½″ x 2′ 6″ (67 x 76 cm) RF 1944-2

facing page
PAUL GAUGUIN
The White Horse, 1898
4′ 7″ x 3′ (140 x 91.5 cm) RF 2616

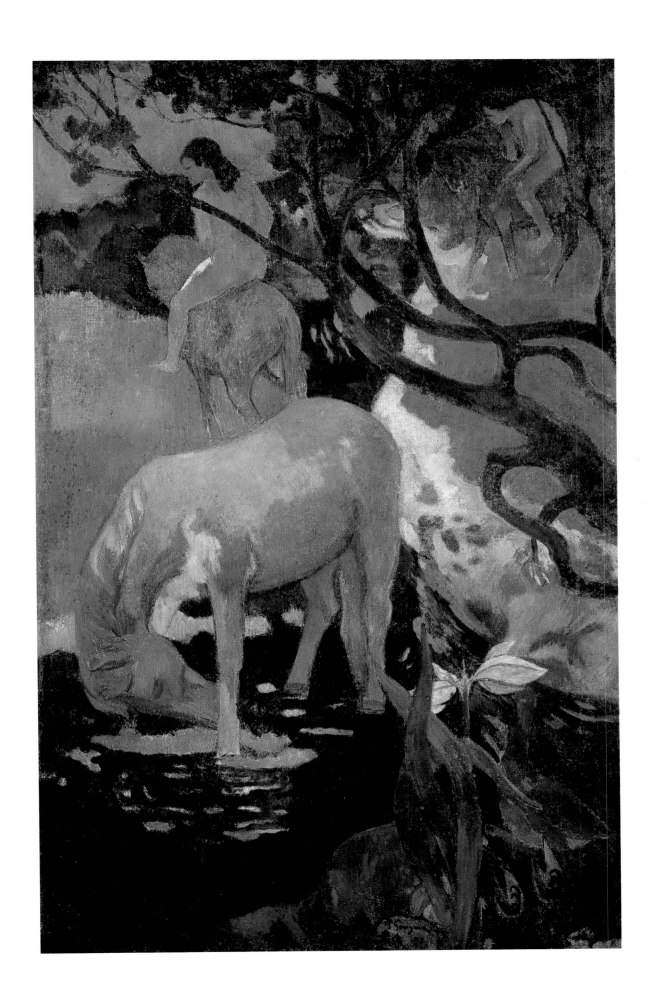

Pont-Aven School and Cloisonism

Emile Bernard

*C*ompared to the casual luxury of Manet's Parisian still lifes, Bernard's stiff and crude arrangement of earthenware pottery and apples rushes us to an archaic, perhaps folkloric world—a perfect setting for a meal in a fairy tale or a remote legend. Painted in 1887, when Bernard had already experienced the art of Cézanne, Van Gogh, and Gauguin, it seems a firm and personal amalgam of startling new ideas from all of these more famous masters. The background could hardly be more willfully flat, a trinity of opaque bands of color that have the rude strength and clarity of freshly painted plaster walls. It is the kind of surface that Van Gogh used, the same year, as background for *The Italian Woman* (page 473), and that we imagine he would have chosen for the walls of his humble bedroom at Arles.

More theoretically, Bernard's assertion of an unyielding two-dimensionality would finally wipe out the conventions of perspectival illusion practiced and preached at the academies. Nevertheless, against this aggressively spaceless ground plane, Bernard has projected his own illusions of volume and shadow, producing a strange juggling act in which objects are at once floating and weight-bound. From Cézanne, Bernard learned how to model an apple, not through graying shadows but through close juxtapositions of intensely varied hues, with green, yellow, and red brushstrokes evoking here a tactile roundness. At the same time, an insistently continuous black contour isolates each of these still-life objects, recalling the simple linear definition of an image that marks the work of a child or a folk artist. It is a technique that recalls, too, the clear metal outlines in the enamels and the stained glass of the Middle Ages, a similarity that prompted the term "Cloisonism" (referring to cloisonné enamels) as a description of the style that emerged in the work of Bernard, Van Gogh, and Gauguin in 1887–1888.

An environment in which such a still life could be at home would have to be light-years from Paris, only accessible, if at all, in the most remote province or village. For Bernard, as for Gauguin, Sérusier, Denis, and other Parisians in the late 1880s and early 1890s, this distant place turned out to be Pont-Aven in Brittany, a rapidly growing artists' colony. There sophisticated young painters could imagine themselves immersed in what they hoped was a primitive, time-capsule society where piety, art, and work were of a raw and enduring kind, strong enough to provide foundations for a new type of painting of simple but magical potency. Rejuvenating the mid-century traditions of painting rural idylls, where, as in canvases by Breton (page 125), men and women worked happily in the fields of France, as they had been doing for centuries, Bernard often painted harvest scenes, such as *Breton Landscape*, that looked as though they came from a world as remote as Japan, the Middle Ages, or Celtic legend. Nor was it any problem to populate this unreal world with archetypal beings. In a paraphrase of the posture often seen in medieval representations of the dormition of the Virgin, as at Chartres Cathedral, Bernard posed his sister Madeleine lying among the trees in the Bois d'Amour, a picturesque wood outside Pont-Aven (page 514). Such a ritualistic image conjures up a strange fusion of expectation, sex, and death, penetrating what Gauguin, who worked closely with Bernard in 1888, would call "the mysterious centers of thought." Within this realm of mythic archetypes, it is not surprising to find even Adam and Eve (page 514) depicted in a small painted sketch that oddly mixes Cézanne's brushwork and the stylized attenuations of the human body found in French Romanesque art. Those forceful medieval images of abstract spirituality would have been totally irrelevant to the Impressionist generation but would find a responsive chord in the circle of Bernard, Gauguin, and other young Parisians looking for myth and primitive beauty.

What the actual hardships of Breton peasant life were like—hardships depicted by such artists as Simon and Cottet (pages 136, 137)—scarcely mattered to these painters. Through their rose-colored glasses, Pont-Aven could look like the Garden of Eden.

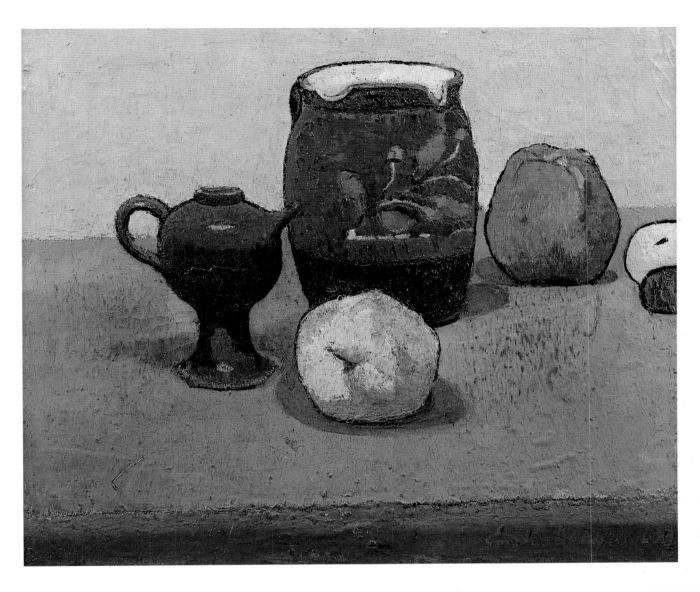

ÉMILE BERNARD, Lille 1868–Paris 1941
Earthenware Pot and Apples, late 1887
1′ 6″ x 1′ 9½″ (46 x 54.5 cm) RF 1977-40

ÉMILE BERNARD
The Harvest (Breton Landscape), 1888
1′ 10¼″ x 1′ 5¾″ (56.5 x 45 cm) RF 1977-42

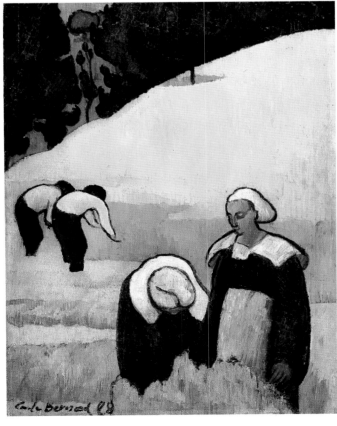

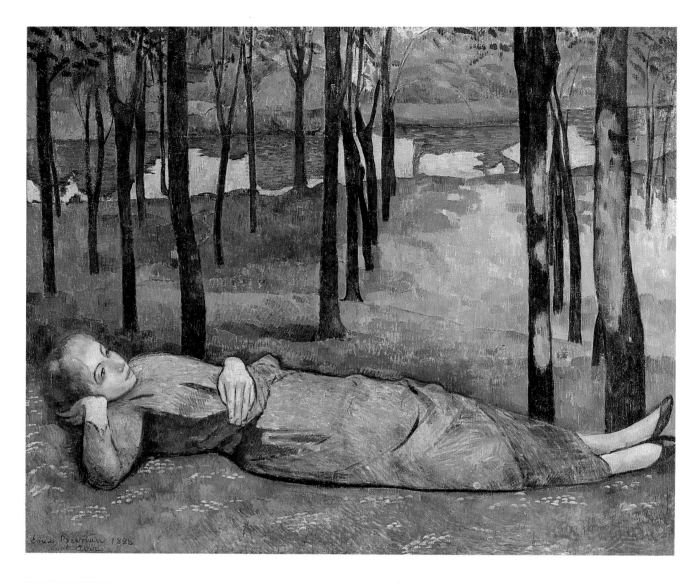

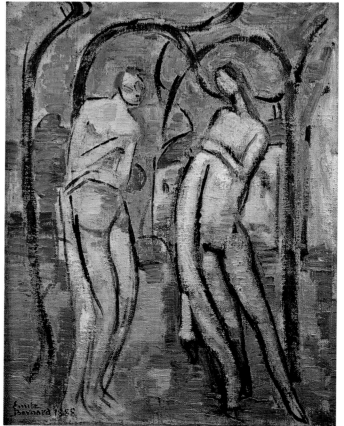

ÉMILE BERNARD
Madeleine in the Bois d'Amour, 1888
4′ 6″ x 5′ 4½″ (137 x 164 cm) RF 1977-8

ÉMILE BERNARD
Adam and Eve, 1888
1′ 4½″ x 1′ 1½″ (42 x 34 cm) Bequest of Dr. Robert Le Masle, 1972.
RF 1977-43

facing page
ÉMILE BERNARD
Bathers with Red Cow, 1887
3′ x 2′ 4½″ (92.5 x 72.5 cm) Gift of Christian de Galéa, 1984.
RF 1984-21

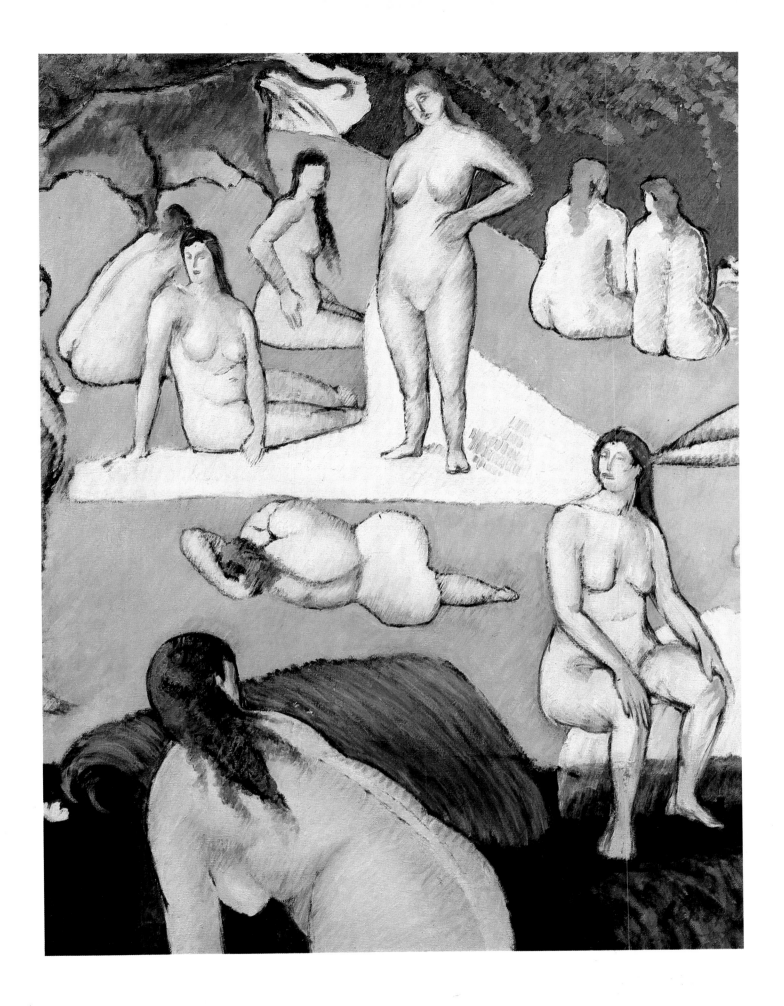

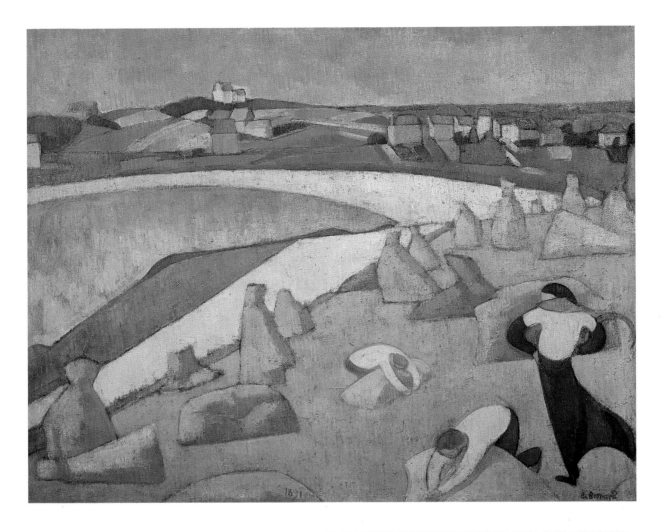

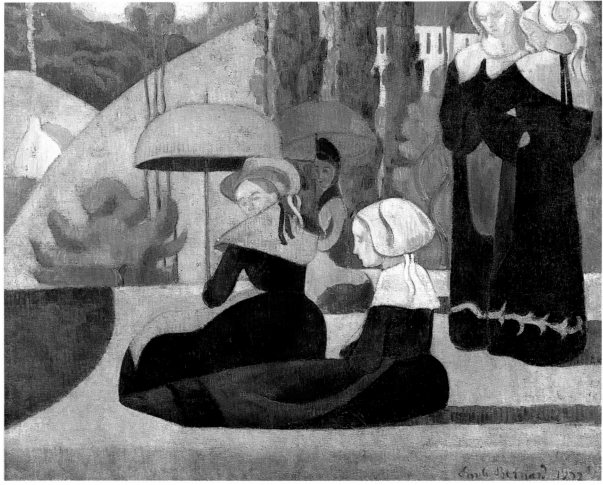

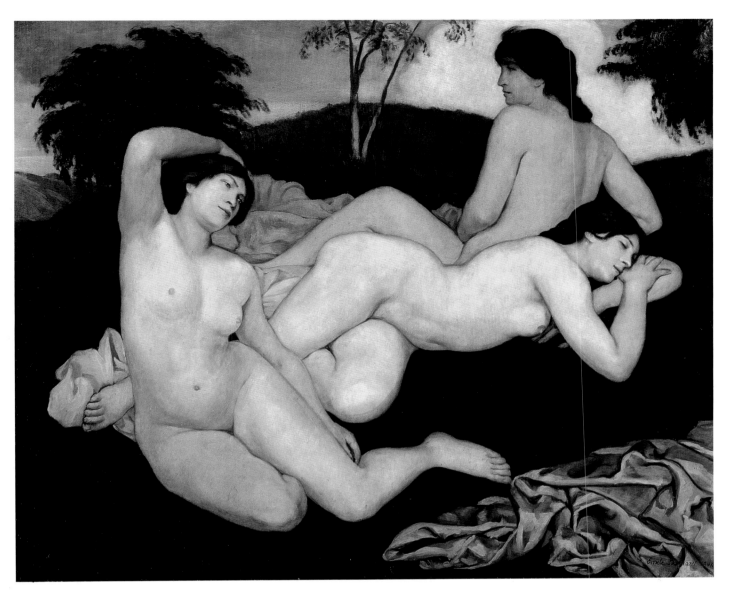

ÉMILE BERNARD
After the Bath, the Nymphs, 1908
3′ 11¾″ x 4′ 11½″ (121 x 151 cm) Gift of Paul Jamot, 1931.
RF 1977-38

facing page, top
ÉMILE BERNARD
Harvest on the Edge of the Sea, 1892 (Salon des Indépendants, 1892)
2′ 3½″ x 3′ (70 x 92 cm) RF 1982-52

facing page, bottom
ÉMILE BERNARD
Breton Women with Parasols, 1892
2′ 8″ x 3′ 5¼″ (81 x 105 cm) RF 1977-41

Paul Sérusier
Breton Eve (Melancholy); The Talisman; The Breton Combat

*L*ike Bernard and Gauguin, Sérusier, working in Brittany, used this remote folkloric region as a stimulus for imaginative subjects of primitive strength and simplicity that could go as far back as the Book of Genesis. In his *Breton Eve*, probably of 1890, he resurrects the primal scene of sin and remorse, which Gauguin himself had depicted in 1889. Expelled from paradise and alone in her shameful nakedness, Eve sits in a posture of painful self-absorption, a perfect symptom of that trend toward inward meditation and melancholy that welled as the century drew to an end. Redon's *With Closed Eyes*, also of 1890 (page 527), offers another variation on this introspective journey.

Despite her relatively small size, Eve completely dominates the painting, her primordial guilt radiating throughout a steeply rising landscape whose rainbow hues almost melt in an orchestration of abstract color. This landscape, in fact, is an extension of Sérusier's famous *Talisman* of 1888, a tiny panel painting of what almost became an illegible landscape under Gauguin's urging that the younger artist intensify his colors to maximum purity.

Other Breton paintings by Sérusier that explore myth and legend are often more legible in their clearly incised patterns. His depiction of a wrestling match between two barefoot boys—a theme already treated by Gauguin—wafts us to an archaic world of clear and potent images, mixing memories of Japanese prints, an athletic combat on a Greek vase, and a medieval illustration of the biblical story of Jacob wrestling with the angel. It is hard to remember that at the time this was being painted, 1890, the Eiffel Tower, back in Sérusier's native Paris, was just one year old and Seurat's idea of public entertainment was not a centuries-old ritual of adolescent virility but a crowded circus on the boulevards, lit by gaslight.

PAUL SÉRUSIER, Paris 1864–Morlaix 1927
The Talisman, 1888
10¾" x 8½" (27 x 21.5 cm) RF 1985-13

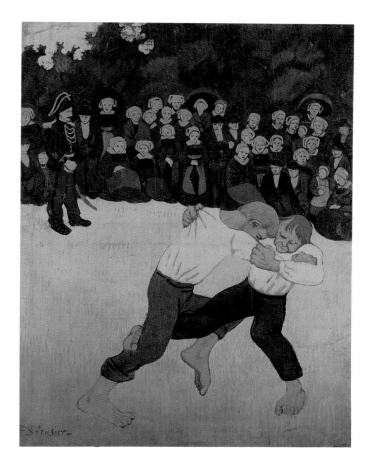

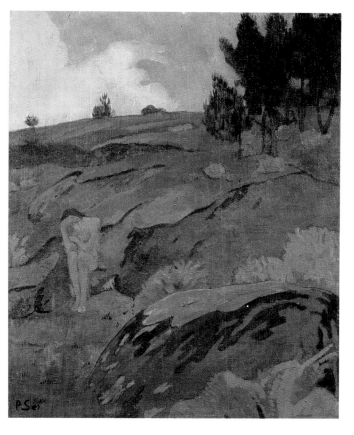

PAUL SÉRUSIER
Breton Wrestling, 1890
3′ x 2′ 4¾″ (92 x 73 cm) Bequest of Miss Henriette Boutaric, 1984.
RF 1984-10

PAUL SÉRUSIER
Breton Eve (Melancholy), ca. 1890
2′ 4½″ x 1′ 11″ (72.5 x 58.5 cm) Gift of Miss Henriette Boutaric,
1980. RF 1981-5

page 520, top
PAUL SÉRUSIER
Grammar (Study), 1892
2′ 4¼″ x 3′ (71.5 x 92 cm) Gift of Miss Henriette Boutaric, 1980.
RF 1981-5

page 520, bottom left
PAUL SÉRUSIER
The Downpour, 1893
2′ 5″ x 1′ 11½″ (73.5 x 60 cm) Gift of Miss Henriette Boutaric, 1980.
RF 1981-7

page 520, bottom right
PAUL SÉRUSIER
Little Breton Girl Seated (Portrait of Marie Francisaille)
(Salon des Indépendants, 1895)
3′ x 1′ 9″ (91.5 x 53.5 cm) Bequest of Mrs. Thadée Natanson, 1953.
RF 1977-320

page 521, top
PAUL SÉRUSIER
The Daughters of Pelichtim, 1908
(Salon des Indépendants, 1908)
3′ 3¼″ x 5′ 3¾″ (100 x 162 cm) "Pelichtim" is Hebrew for
"Philistines." Gift of Conseil des Musées Nationaux, 1935.
RF 1977-317

page 521, bottom
PAUL SÉRUSIER
Bathers with White Veils, 1908 (Salon des Indépendants, 1908)
3′ 3½″ x 4′ 7″ (100.5 x 139.5 cm) Gift of Conseil des
Musées Nationaux, 1935. RF 1977-316

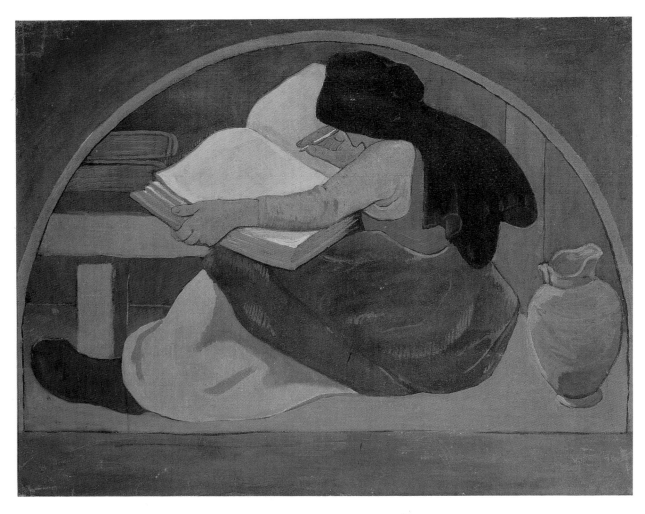

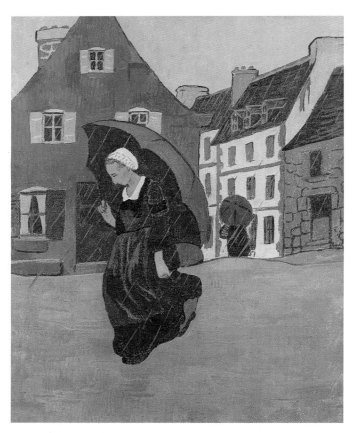

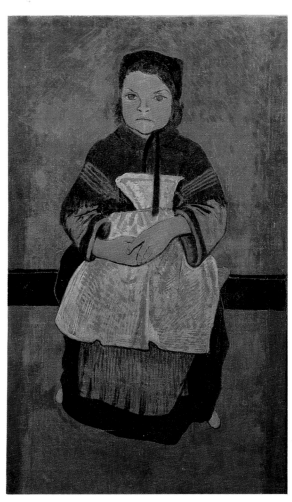

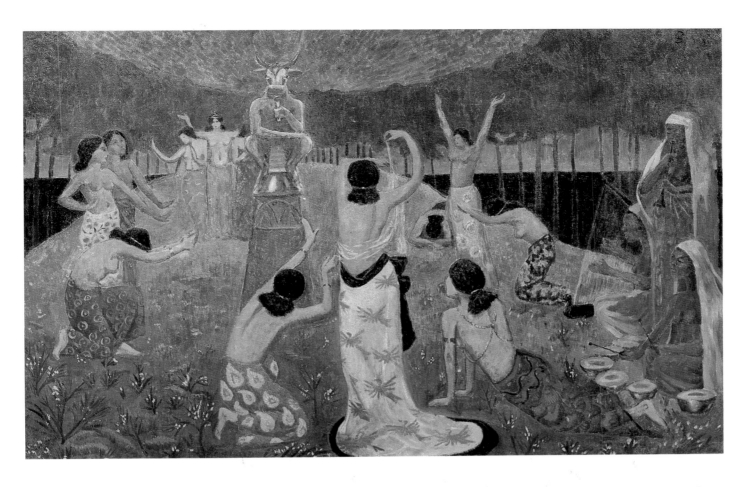

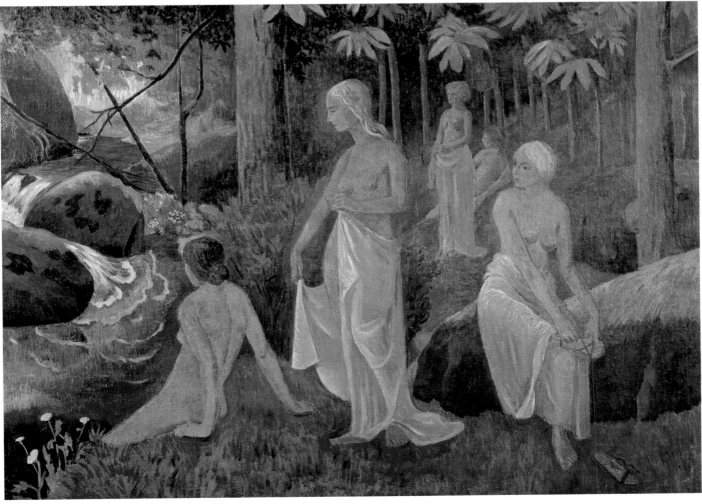

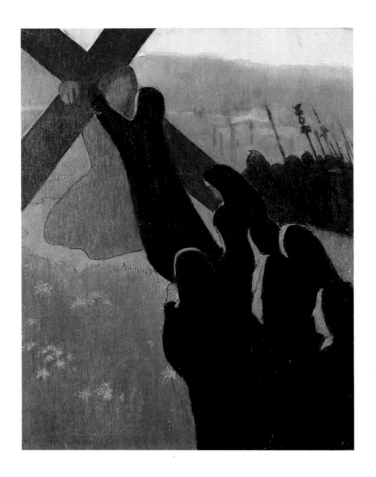

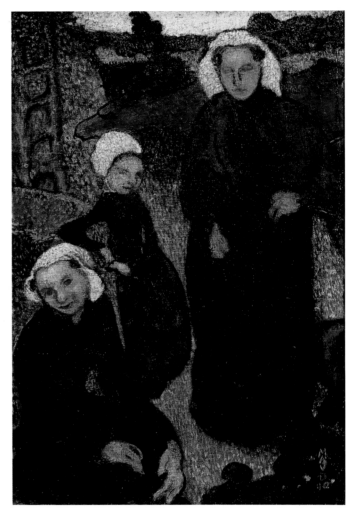

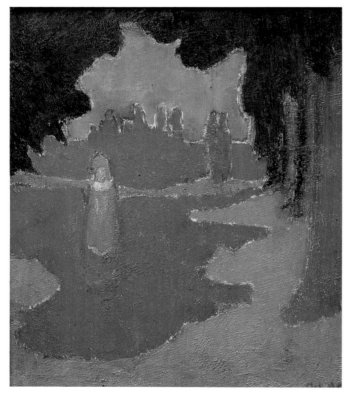

MAURICE DENIS, Granville 1870–Paris 1943
Breton Women, 1890
1′ 4½″ x 11½″ (42 x 29 cm) Gift of Jean Neger, 1953. RF 1977-144

left, top
MAURICE DENIS
The Road to Calvary, November 1889
1′ ½″ x 10″ (41 x 32.5 cm) RF 1986-68

left, bottom
MAURICE DENIS
Spots of Sunlight on the Terrace, October 1890
7⅓″ x 6¼″ (24 x 20.5 cm) RF 1986-70

facing page, top
LOUIS ROY, Poligny 1862–Paris 1907
Large Cutting, Landscape at Poligny, 1895
1′ 6¼″ x 1′ 10″ (46.5 x 56 cm) RF 1977-306

facing page, bottom
ARMAND SEGUIN
Gabrielle Vien, 1893 (according to sitter, window and landscape were painted by Gauguin)
2′ 10¾″ x 4′ 11″ (88 x 150 cm) RF 1977-313

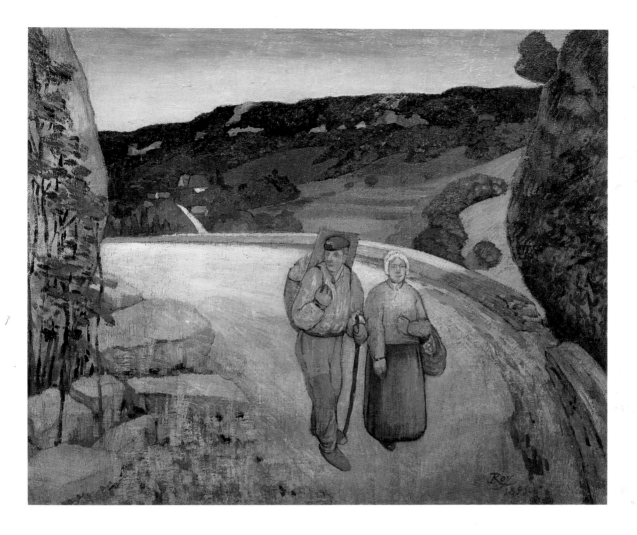

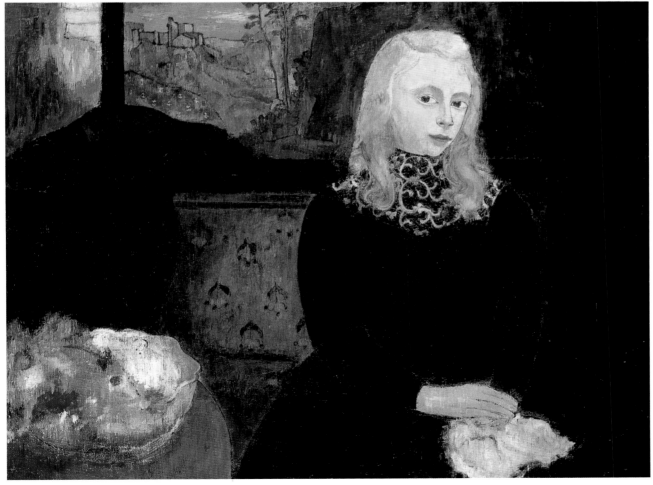

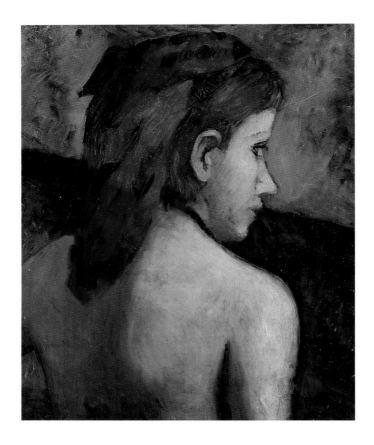

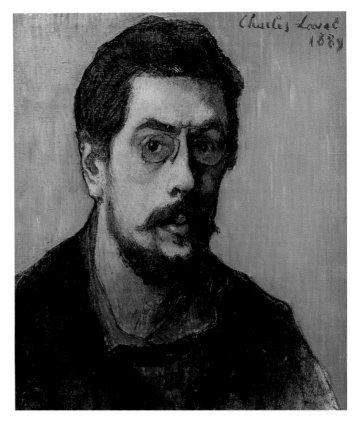

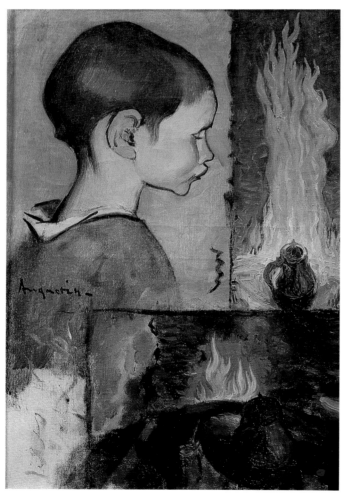

CHARLES LAVAL, Paris 1862–Paris 1894
Self-Portrait, 1889
1′ 6¼″ x 1′ 3″ (46.5 x 38 cm) Gift of Émile Bernard, 1932.
RF 1977-220

left, top
ÉMILE SCHUFFENECKER
Fresne-Saint-Mammès 1851–Paris 1934
Head of a Young Girl
1′ 5¾″ x 1′ 2¾″ (45 x 37.5 cm) RF 1977-312

left, bottom
LOUIS ANQUETIN, Etrépagny 1861–Paris 1932
Child's Profile and Study for a Still Life
1′ 11¼″ x 1′ 4¼″ (59 x 41 cm) Gift of Paul Adry, 1936. RF 1977-25

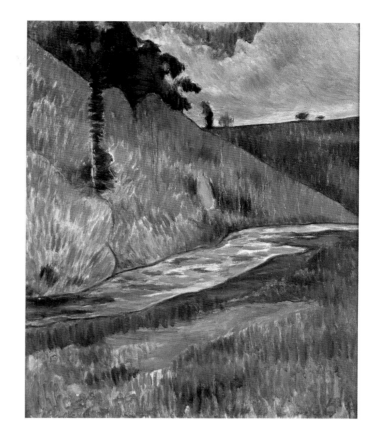

Landscape, 189(?)
Oil on paper on canvas, 1′ 9¾″ x 1′ 8″ (55 x 46 cm) RF 1977-219

ÉMILE JOURDAN, Vannes 1860–Quimperlé 1931
Rain at Pont-Aven, 1900
1′ 11½″ x 2′ 4¾″ (59.5 x 73 cm) RF 1977-201

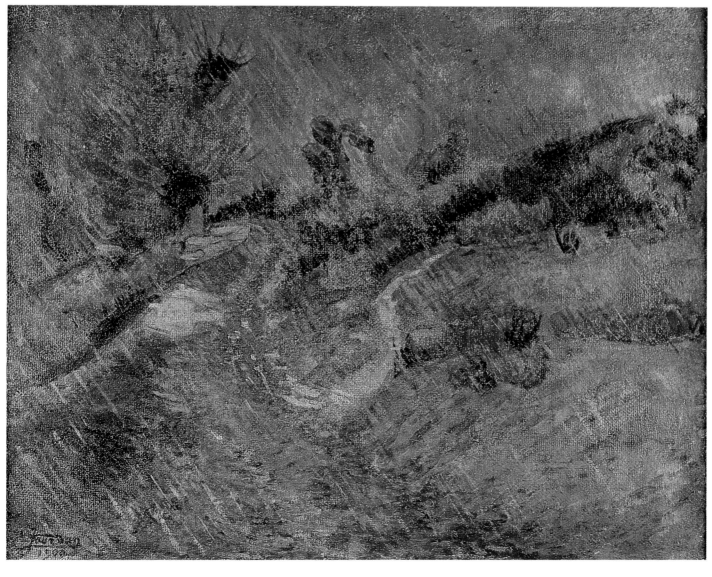

REDON

With Closed Eyes

*I*naugurating the decade when Symbolism reigned, Redon's *With Closed Eyes* lies just on the fragile edge between the territory of things seen and things felt or imagined. We sense that this tilted head, so actively withdrawing from the outside world with its closed eyes and intensely inward expression, must have been inspired by a real person. Perhaps it was Madame Redon herself (née Camille Falte), whom her husband had painted some eight years earlier with her eyes open and her clothing rooting her to a particular time and place. Yet in *With Closed Eyes*, the barrier of individual portraiture is quickly crossed: the figure appears to be submerged in an ambience of hazy, spiritual ether that permits Redon to locate his subjects in an extraterrestrial world where rational scale and the laws of gravity have been thrown back to a planet that worships the gods of reason and matter. Here the haunting face, which has no need of a body to sustain it, rises from a cloudy sea of paint so filmy that the weave of the canvas can easily be seen below it. The bone structure of this at once real and hallucinatory head similarly evaporates at crucial points, such as at the shoulder, where we would expect the strongest physical support. The granular, rubbed surfaces of pastel, one of Redon's favorite media, here serve him well in his metamorphosis of oil pigment into a floating, powdery stuff from which spirits may be conjured up, as in a séance. Could the spirit, in this case, emanate from the head of Michelangelo's *Dying Slave* in the Louvre, who also closes his eyes in order to confront an interior life?

In every way, Redon's painting helps to define the Symbolist milieu that dominated international painting of the 1890s. The closed eyes, for one, force our attention to invisible worlds that Redon would soon populate with his personal reincarnations of Christian, classical, and even Buddhist mythologies; the aura of a fantastic vision, for another, wafts us far from the scientific truths and technological conquests venerated by more earthbound sectors of the late nineteenth century; and the motif of an ectoplasmic, disembodied head, so ubiquitous in the art of Redon in particular and Symbolist art in general, proclaims the triumph of spirit and dream over flesh and reason.

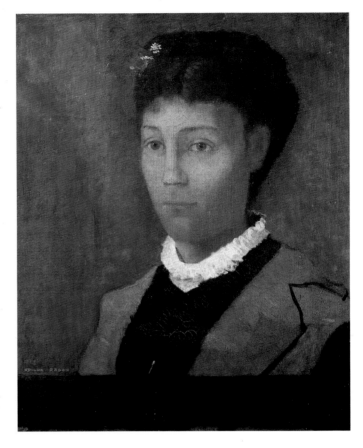

ODILON REDON, Bordeaux 1840–Paris 1916
Madame Redon, 1882
1′ 5¾″ x 1′ 2½″ (45 x 37 cm) Gift of Mrs. J. Goekoop de Jong, 1926.
RF 2703

facing page
ODILON REDON
With Closed Eyes, 1890
1′ 5¼″ x 1′ 2¼″ (44 x 36 cm) RF 2791

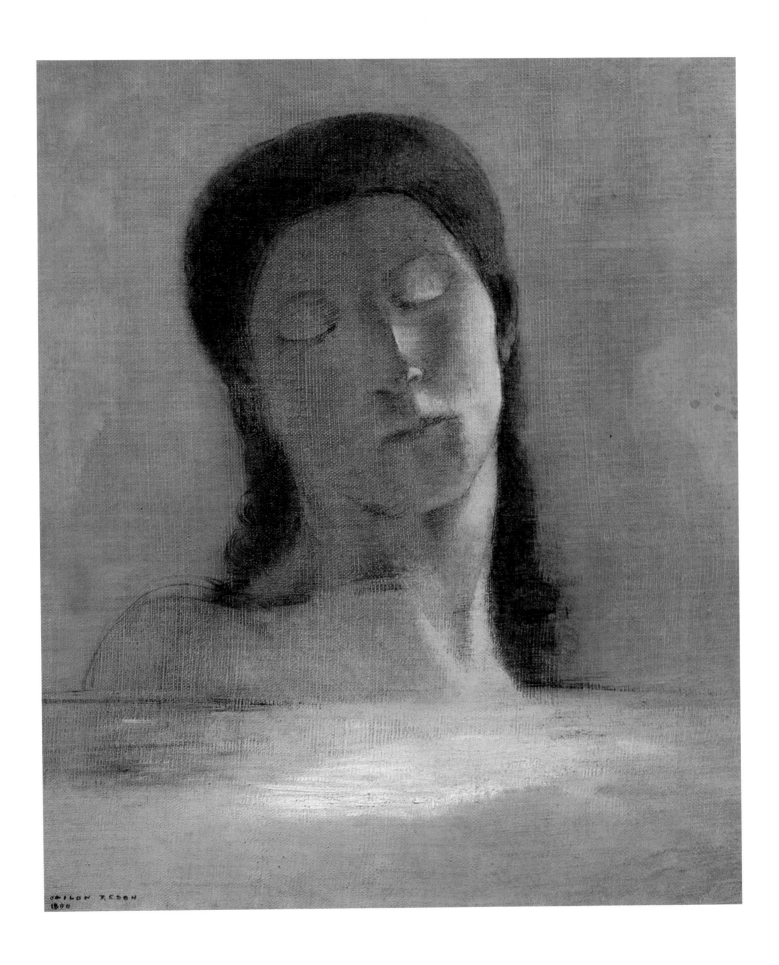

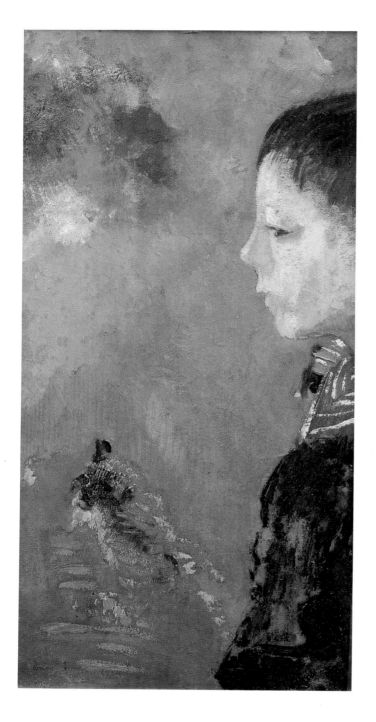

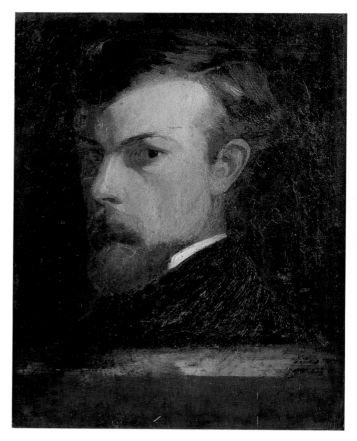

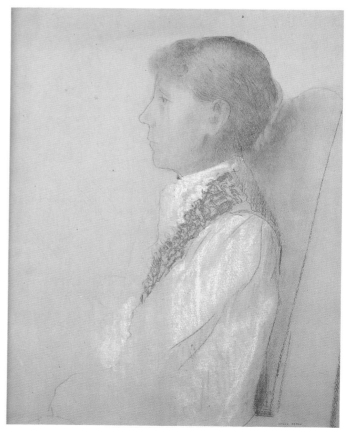

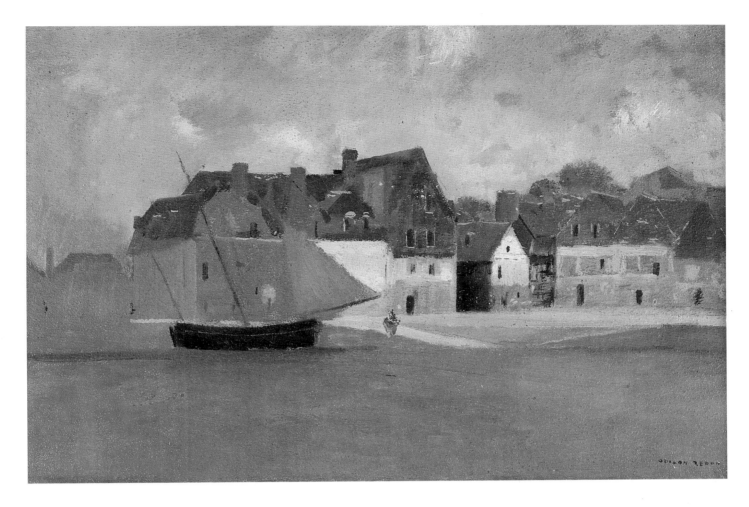

ODILON REDON
Breton Port
10½″ x 1′ 2¾″ (26.5 x 37.5 cm) Bequest of Mrs. Arï Redon, 1982.
RF 1984-82

ODILON REDON
The Road to Peyrelebade
Paper on board, 1′ 6½″ x 1′ 5¾″ (46.8 x 45.4 cm) Bequest of
Mrs. Arï Redon, 1982. RF 1984-92

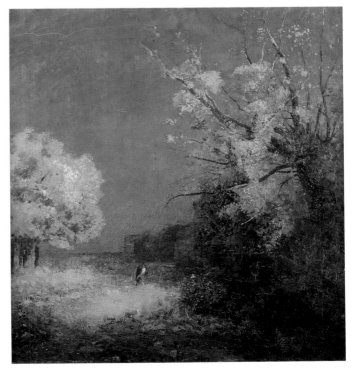

facing page, left
ODILON REDON
Portrait of Arï Redon with Sailor Collar, ca. 1897
1′ 4½″ x 8¾″ (41.8 x 22.2 cm) Bequest of Mrs. Arï Redon, 1982.
RF 1984-42

facing page, top right
ODILON REDON
Self-Portrait, 1867
1′ 4½″ x 1′ 1″ (41.7 x 32 cm) Bequest of Mrs. Arï Redon, 1982.
RF 1984-39

facing page, bottom right
ODILON REDON
Madame Odilon Redon in Left Profile, ca. 1905
Pastel and red chalk, 1′ 4¾″ x 1′ 1½″ (55 x 44.5 cm) RF 29913

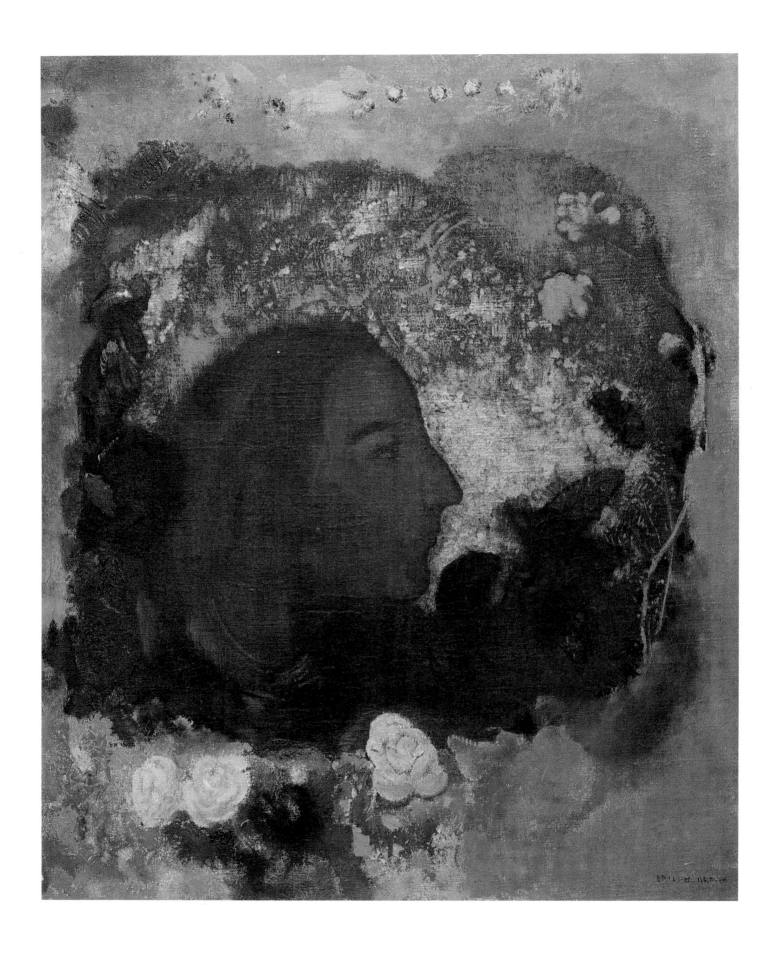

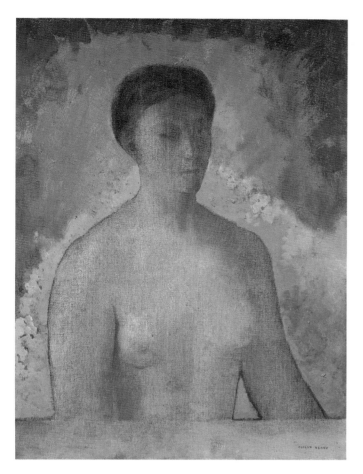

ODILON REDON
Eve, 1904
2′ x 1′ 6″ (61 x 46 cm) RF 1982-72

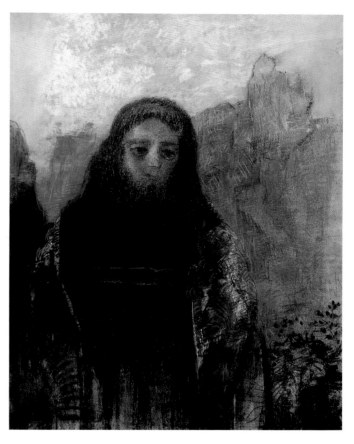

ODILON REDON
Parsifal, ca. 1912
Pastel, 2′ 2″ x 1′ 8½″ (66 x 52 cm) RF 36521

facing page
ODILON REDON
Paul Gauguin, ca. 1903–1905
2′ 2″ x 1′ 9½″ (66 x 54.5 cm) RF 1950-31

page 532
ODILON REDON
Flight into Egypt
1′ 5¾″ x 1′ 3″ (45 x 38 cm) Bequest of Mrs. Arï Redon, 1982.
RF 1984-50

page 533
ODILON REDON
The Buddha, ca. 1906–1907
Pastel, 2′ 11½″ x 2′ 4¾″ (90 x 73 cm) RF 34555

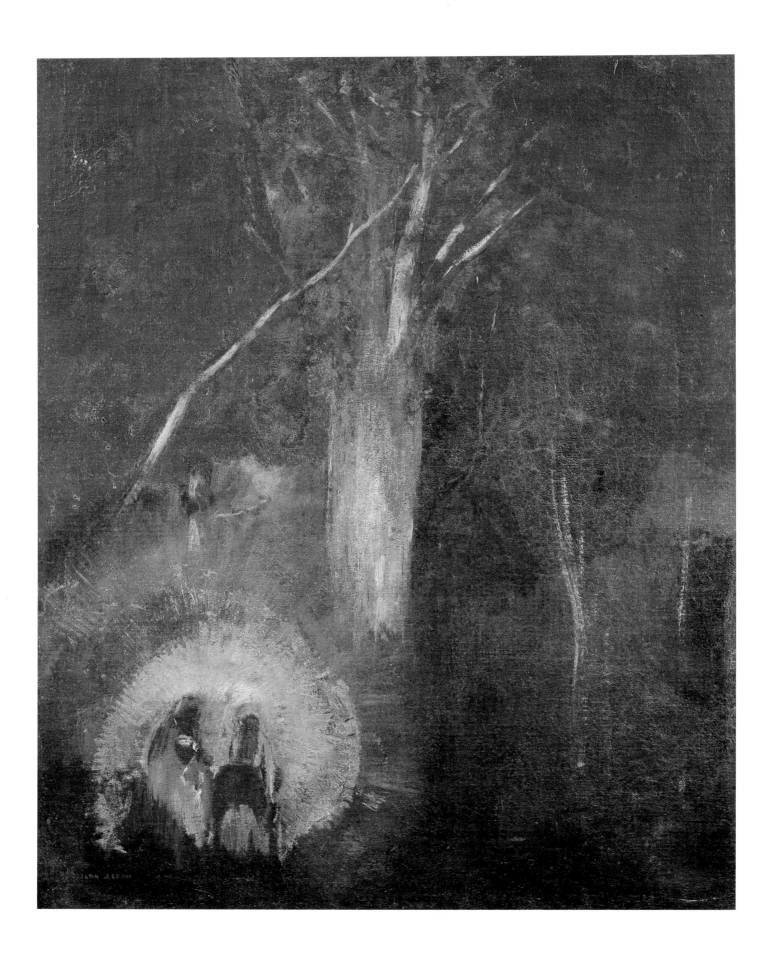

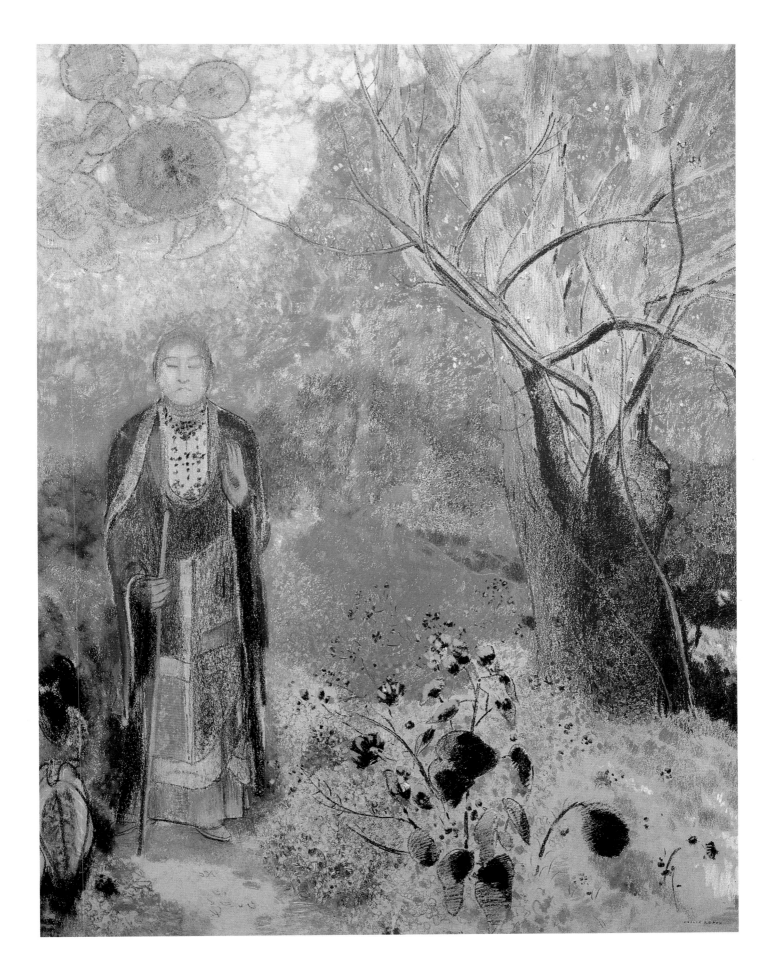

ODILON REDON
Celery Root
9¾" x 1′ 1″ (24.5 x 33.2 cm) Bequest of Mrs. Arï Redon, 1982.
RF 1984-46

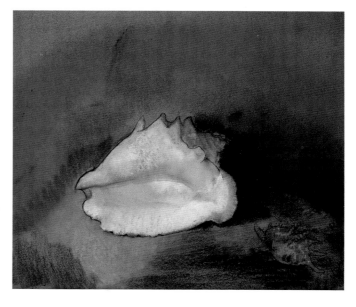

ODILON REDON
The Shell, 1912
Pastel, 1′ 8″ x 1′ 10¾″ (51 x 57.8 cm) RF 40494

facing page
ODILON REDON
Apollo's Chariot, 1905–1914
Pastel, 2′ 11¾″ x 2′ 6¼″ (91 x 77 cm) RF 36724

page 536
ODILON REDON
Crucifixion, ca. 1910
10″ x 1′ 6½″ (25.7 x 47.1 cm) Bequest of Mrs. Arï Redon, 1982.
RF 1984-53

page 537
ODILON REDON
Stained-Glass Window, 1905 (Salon d'Automne, 1905)
Pastel, 4′ 8½″ x 2′ (143.5 x 61.5 cm) Bequest of Mrs. Arï Redon,
1982. RF 36725

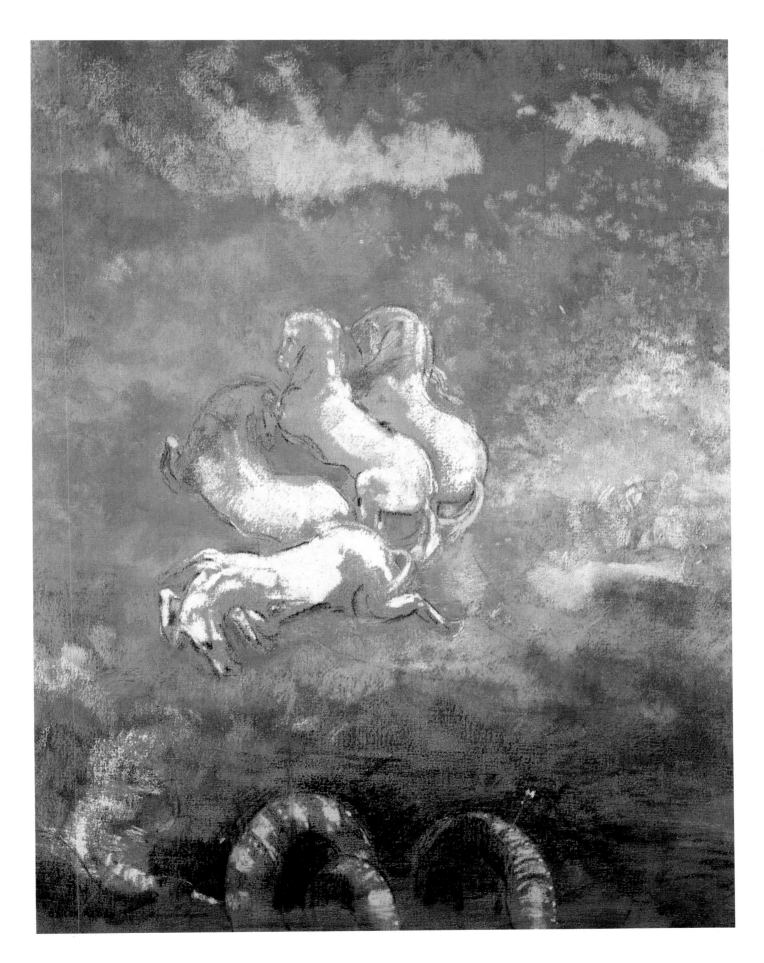

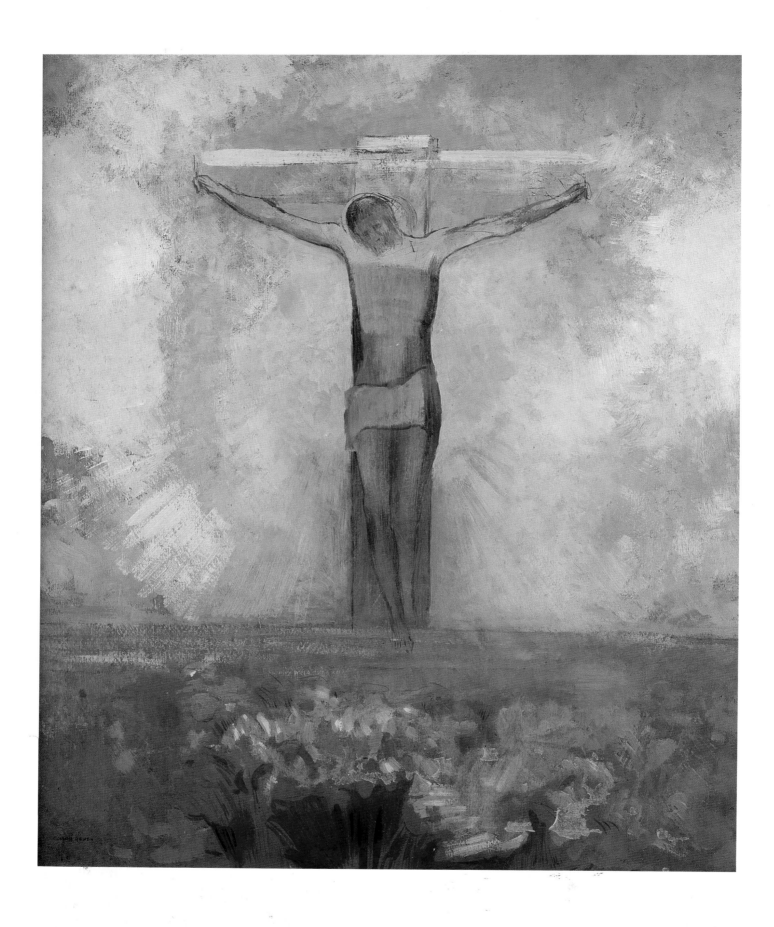

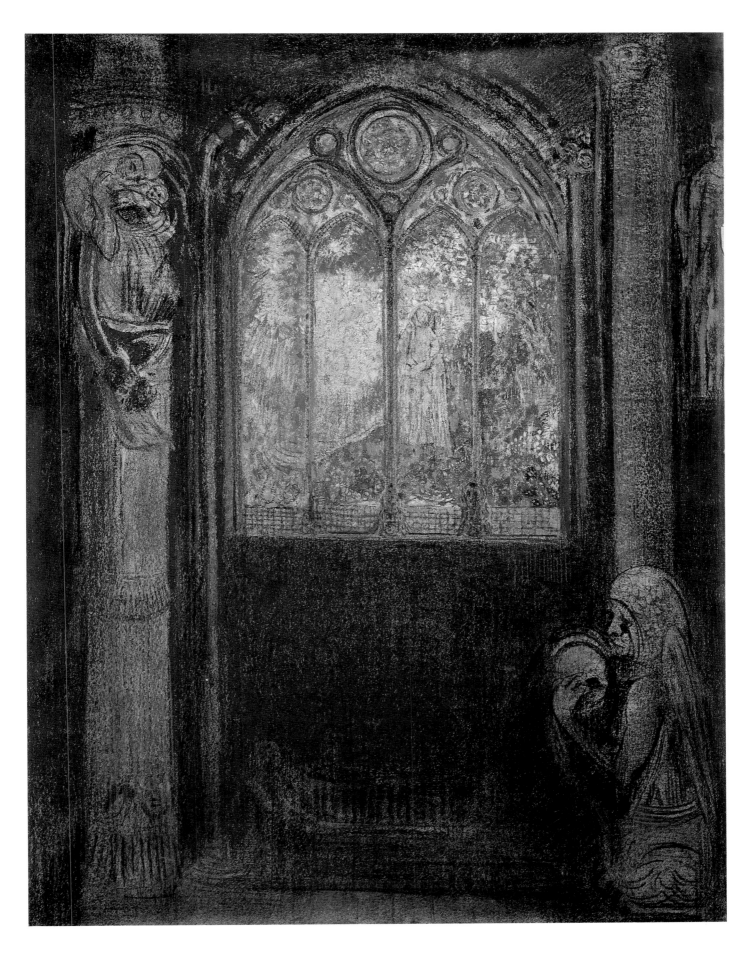

SYMBOLISM IN FRANCE

Eugène Carrière

*B*y the 1880s, the assumptions of Realism and its visual refinements in Impressionism had become passé for many artists, who found that painting need not be restricted to things that could be touched, seen, and viewed on the move. For them, almost everything that mattered was excluded from this empirical domain. Painting, after all, could be a language to explore what can be seen behind closed as well as open eyes, just as it could penetrate emotions lying beneath the flesh.

These imaginative quests were pursued through the widest range of newly invented vocabularies. For Gauguin and his disciples, it was the emblematic magic of clear contours and flat color that might provide the key to unlocking what he called "mysterious centers of thought." But for many other French painters another kind of mystery could be conjured up by an ambience of haze and darkness, a milieu closer to reverie and sleep, where smoky phantoms appear and vanish. So it was with the paintings of Carrière, whose art offers an odd complement to that of Gauguin, whom he knew and admired and with whom he exchanged self-portraits. With other artists grouped under the umbrella term Symbolism, they both shared the goal of evoking nuanced, nameless emotions, but their means of producing such introspection could hardly have differed more.

Carrière's *Sick Child*, a large canvas shown at the 1885 Salon, is a perfect point of departure for this inward journey. In many ways, it is a stock-in-trade sentimental genre scene in which not only the sick child's mother and siblings but even the family pet express a hushed concern about the ominous shadow of illness that casts a pall on the home. But it is exactly this shadow that begins to give Carrière's painting its personal flavor, for here already a darkening tone begins to cloud and soften the ordinary facts of this saddened room, rendering even the simple still life of bowl, glass, and dish as something that almost hovers over rather than rests on a murky brown table. And by the time of *Intimacy*, shown four years later at the 1889 Salon (page 541), this enveloping shadow, which bleeds out all vestiges of sensuous color, has become so pervasive that a trio of a mother and two daughters has become an emotional melting pot. Here family feelings dissolve the obstacles of flesh and matter, much as the passions in the sculpture of Carrière's friend, Auguste Rodin, seem to flow directly from one body to another, transforming marble and bronze into an almost molten medium.

Such depths of ineffably tender interchanges were most often plumbed in Carrière's depictions of women and children, and rarely with such abundance as in his 1893 group portrait of his five daughters, all born within eight years of one another, and his wife (page 541). In front of these dimming spaces, where women and little girls evaporate in a melancholy ambience, one finds it hard not to think of Degas's famous put-down of Carrière: "Someone has been smoking in the nursery."

But if Degas, who always cast a cold eye, was left unpersuaded by these overt displays of feeling, Carrière, in his turn, may have learned something from Degas. Carrière's portrait of the writer Alphonse Daudet with his daughter Edmée (page 540) may recall, in its odd combination of physical proximity and emotional separateness, the family portraits of Degas. But the older master's chill is absent here, replaced by a murky warmth that merges in feeling even figures who look in different directions. It was fitting that, together with the Daudet portrait, Carrière exhibited in 1891 the portrait of another writer, the Symbolist poet Paul Verlaine, whose search for fragile nuances of feeling and sensation paralleled his own goals (page 540). And Verlaine's mood of sad isolation—intensified by his ill health and trips to Paris's lower depths—was consonant with the gathering clouds that shadowed Carrière's own health and work. He had, in fact, immersed himself in Verlaine's poetry in order to comprehend what he called "the tragic sacrifice, even crucifixion, made by this man."

Given such a metaphor, it is no surprise that Carrière attempted Christian subjects, including the Crucifixion itself (page 543). Predictably, Christ, like the cross on which he is suspended, seems more hallucination than reality, a spiritual X ray instead of a flesh-and-blood martyr. This search for evocative mystery could even move from Christ's martyrdom to a Parisian intersection, the Place Clichy, where the artist lived at the turn of the century (page 543). His view of this busy thoroughfare turns the Impressionists inside out, observing their sunlit urban scenes through an almost illegible darkness, creating a dreamlike nocturne where even the eerie glow of streetlights seems more tangible than the pedestrian ghosts who have left an ectoplasmic blur on the city. In Carrière's imagination, the City of Light has become a city of such mystery that Edgar Allan Poe—a writer revived by the Symbolist generation—might well have felt at home in its shadowy mist.

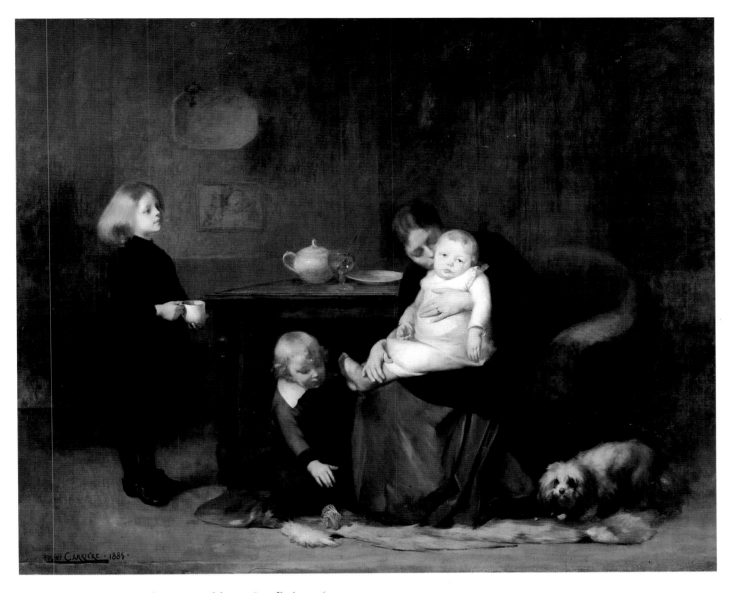

EUGÈNE CARRIÈRE, Gournay-sur-Marne 1849–Paris 1906
The Sick Child, 1885 (Salon of 1885)
6′ 6¾″ x 8′ 1″ (200 x 246 cm) INV 20344

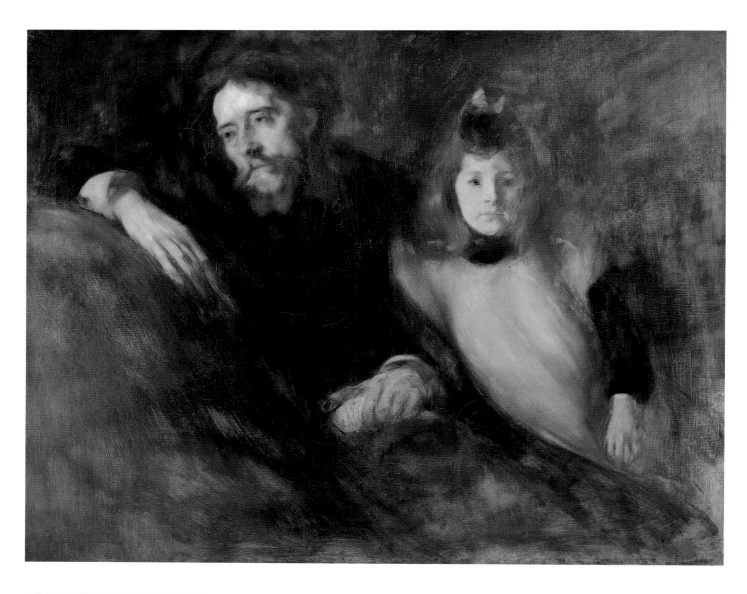

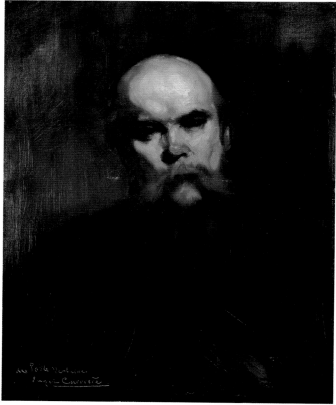

EUGÈNE CARRIÈRE
Alphonse Daudet and His Daughter
2′ 11½″ x 3′ 9¾″ (90 x 116.5 cm) Gift of Joanny Peytel, 1914.
RF 2077

EUGÈNE CARRIÈRE
Paul Verlaine, 1890 (Salon of 1891)
2′ x 1′ 8″ (61 x 51 cm) RF 3750

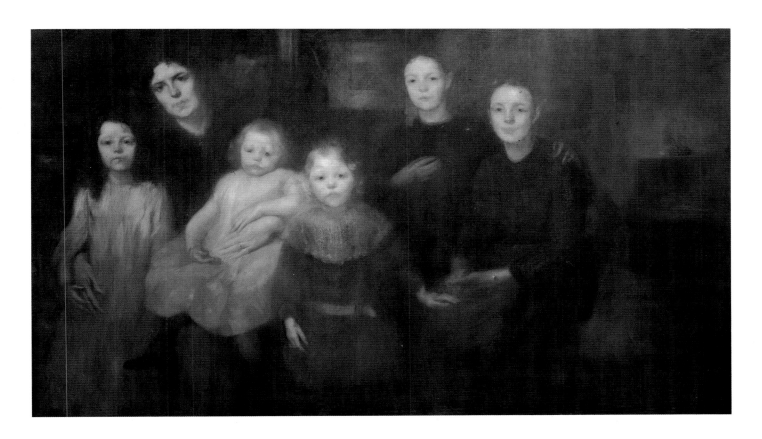

EUGÈNE CARRIÈRE
The Painter's Family, 1893 (Salon de la Société Nationale
des Beaux-Arts, 1893)
4′ 11½″ x 7 3¼″ (125.5 x 221.5 cm) RF 1069

EUGÈNE CARRIÈRE
Intimacy (The Big Sister) (Salon of 1889)
4′ 3¼″ x 3′ 3″ (130 x 99 cm) Gift of Étienne Moreau-Nélaton, 1906.
RF 1604

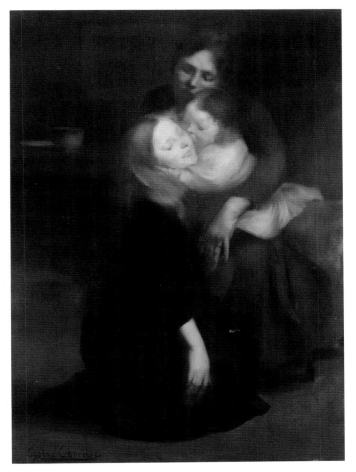

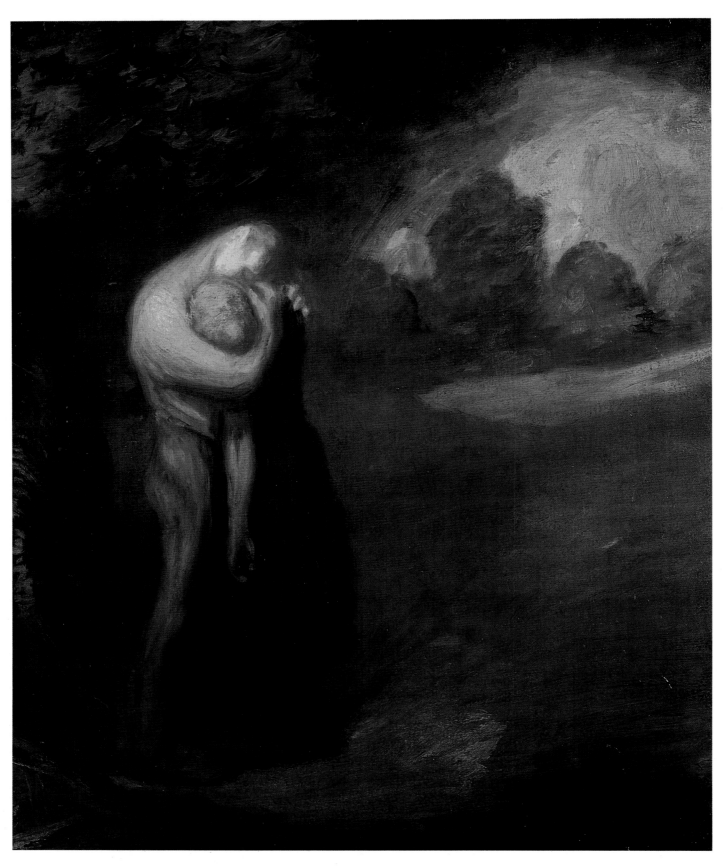

THÉOPHILE-ALEXANDRE STEINLEN
The Kiss
2′ 3¾″ x 1′ 11¾″ (70.5 x 60.5 cm) Bequest of
Mrs. Roger Desormière, 1970. RF 1970-3

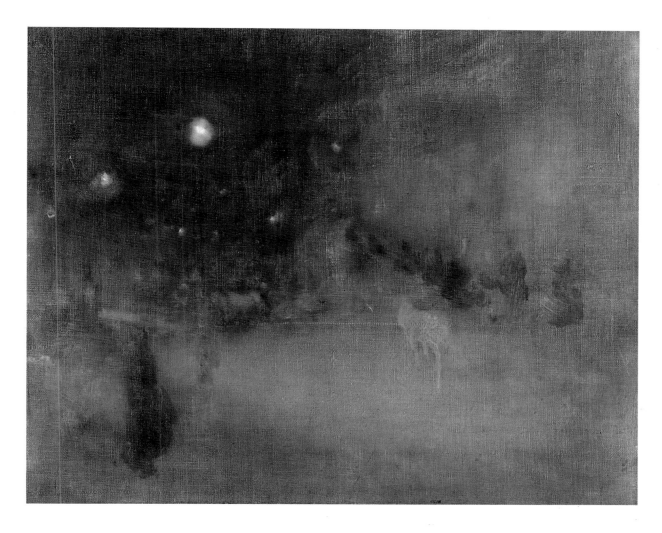

EUGÈNE CARRIÈRE
Place Clichy, Night, ca. 1899–1900
1′ 1″ x 1′ 4¼″ (33 x 41 cm) Gift of Louis-Henri Devillez, 1930.
RF 3121

EUGÈNE CARRIÈRE
Crucifixion (Salon of 1897)
7′ 5¼″ x 4′ 3¼″ (227 x 130 cm) RF 2426

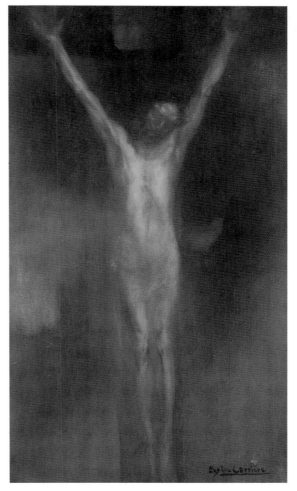

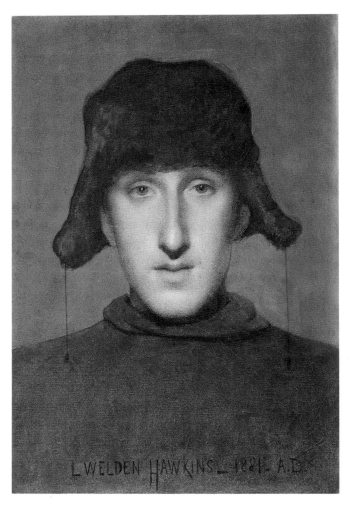

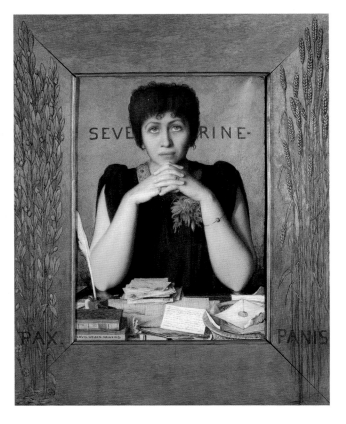

LOUIS-WELDEN HAWKINS
Esslingen 1849–Paris 1910
Portrait of a Young Man, 1881
1′ 10½″ x 1′ 5½″ (57 x 44.5 cm) RF 1983-98

LOUIS-WELDEN HAWKINS
Mme. Séverine, ca. 1895 (Salon of 1895)
2′ 6¼″ x 1′ 9¾″ (77 x 55 cm) Gift of Mrs. Séverine, 1926. RF 2607

facing page
JOSEPH GRANIÉ, Toulouse 1861–Paris 1915
Marguerite Moreno
1′ 5⅔″ x 1′ 2″ (56 x 46 cm) RF 1977-186

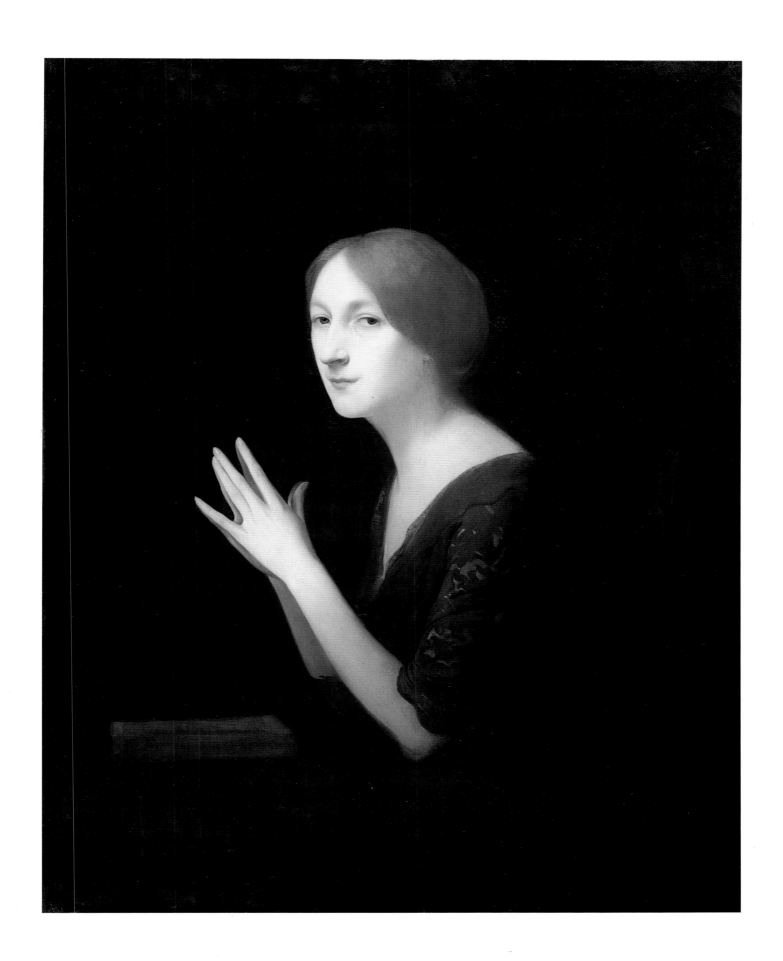

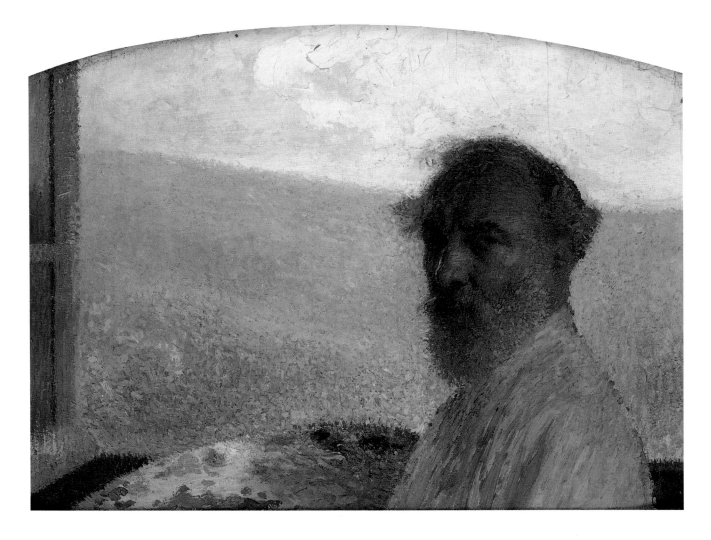

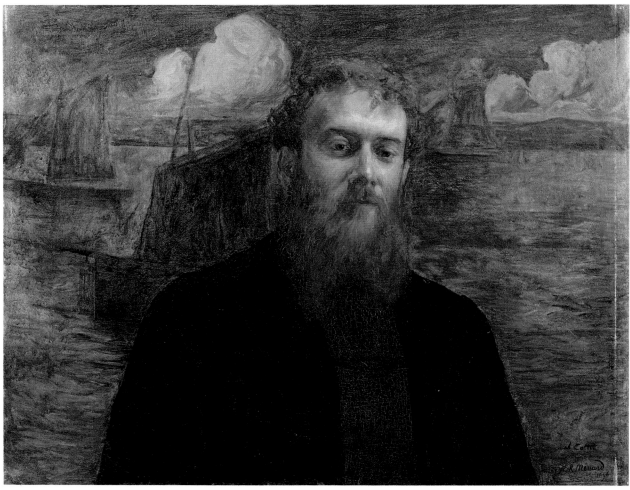

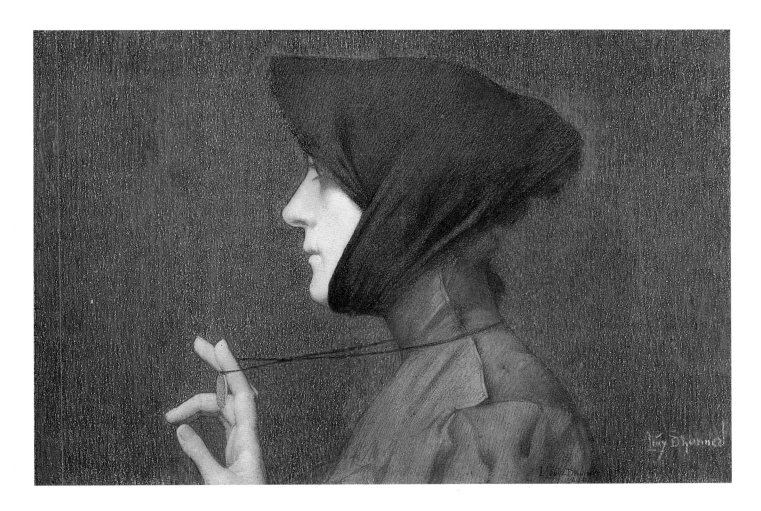

LUCIEN LÉVY-DHURMER
Woman with a Medallion (Mystery), 1896
Pastel, 1′ 1¾″ x 1′ 9¼″ (35 x 54 cm) RF 35501

EDMOND AMAN-JEAN, Chevry-Cossigny 1858–Paris 1936
Thadée Caroline Jacquet, 1892 (Salon of 1892)
3′ 8″ x 2′ 11½″ (112 x 90 cm) RF 733

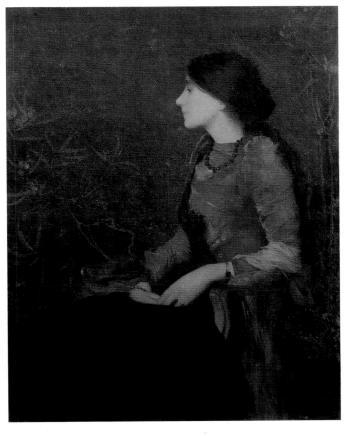

facing page, top
HENRI MARTIN
Self-Portrait, ca. 1912
1′ 10¾″ x 2′ 6″ (57.5 x 76 cm) INV 20050

facing page, bottom
ÉMILE-RENÉ MÉNARD
Charles Cottet, 1896
2′ 1½″ x 2′ 8¾″ (65 x 83.5 cm) Bequest of Charles Cottet, 1925.
RF 1977-255

Henri Martin
Serenity

*E*ven today, as in 1899, when *Serenity* was first seen at the Salon des Artistes Français, spectators may rub their eyes in confusion before this monumental painting. It seems to belong simultaneously to the observed world of Impressionist landscape and to some spirit-tapping realm where ectoplasmic souls, clad in translucent white, can levitate toward heaven with the greatest of ease. But like many artists at the turn of the century, Martin attempted to merge what others saw as antagonistic traditions, often creating strange oil-and-water hybrids.

The ingredients of Martin's complex recipe are many, of which the mystical Symbolist element is most conspicuous. The theme would waft us, via Book IV of Vergil's *Aeneid*, to the ethereal domain of the Elysian Fields, where happy souls dwell in a dreamlike Arcadia, as they are meant to do in Paris's own "Champs-Elysées." That they are free from all cares, including the pull of gravity, is made clear by the ascent of lyre-bearing classical angels at the right, inspired by similar levitations in such works by Puvis de Chavannes as *The Dream* (page 76). From Puvis, too, come not only the vast dimensions—some eighteen feet wide—of Martin's painting, which turn a private fantasy into a public mural, but also the landscape of archaic harmony, in which the lucid rhythms of vertical tree trunks create, as in Puvis's

Summer (page 74), a pure and primitive architecture for a mythic people who know only milk and honey. But being of a younger generation—that of Seurat, who also owed a debt to Puvis—Martin wanted to modernize this vision. Smitten by the luminous, high-keyed palette and vibrant, dotted brushstrokes that Seurat and others had adapted from the Impressionists in order to tell their own truths about the facts of seeing landscape, Martin applied such techniques to the kind of eyes-closed fantasy explored by his Symbolist contemporaries. The result has an odd but distinctive flavor. A filmy tapestry of a sun-drenched countryside that might provide a perfect picnic spot for Parisians is instead invaded by classical ghosts. And the colors, which at first seem to record objectively the scintillating greens, yellows, and blues of a verdant landscape under a summer sky, take on an eerie iridescence that lets us slip from the natural into the supernatural, as in many Symbolist paintings and even in the late work of Monet. Eccentric as these combinations of modern perception and classical fantasy may seem in Martin's painting, they are only a few years and a few steps away from what Matisse himself would be merging in one of his early works at Orsay: his rejuvenating vision of a Mediterranean Arcadia, *Luxe, calme et volupté* of 1904 (page 665).

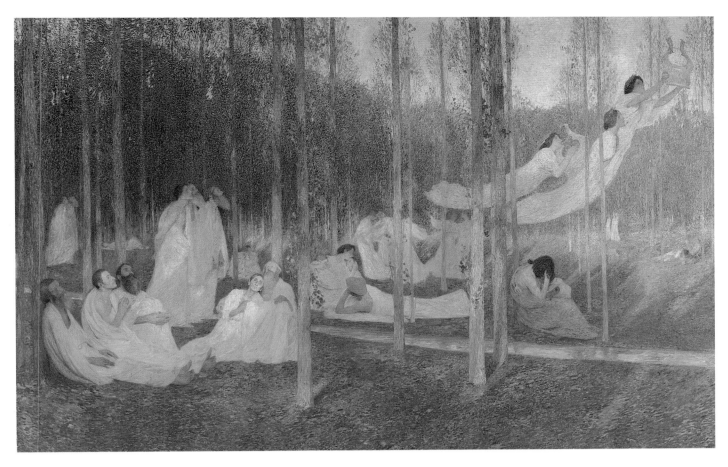

HENRI MARTIN, Toulouse 1860–Labistide-du-Vert 1943
Serenity (Vergil, The Aeneid, Book IV), 1899 (Salon of 1899)
11′ 3¾″ x 18′ 1″ (347 x 544 cm) RF 1177

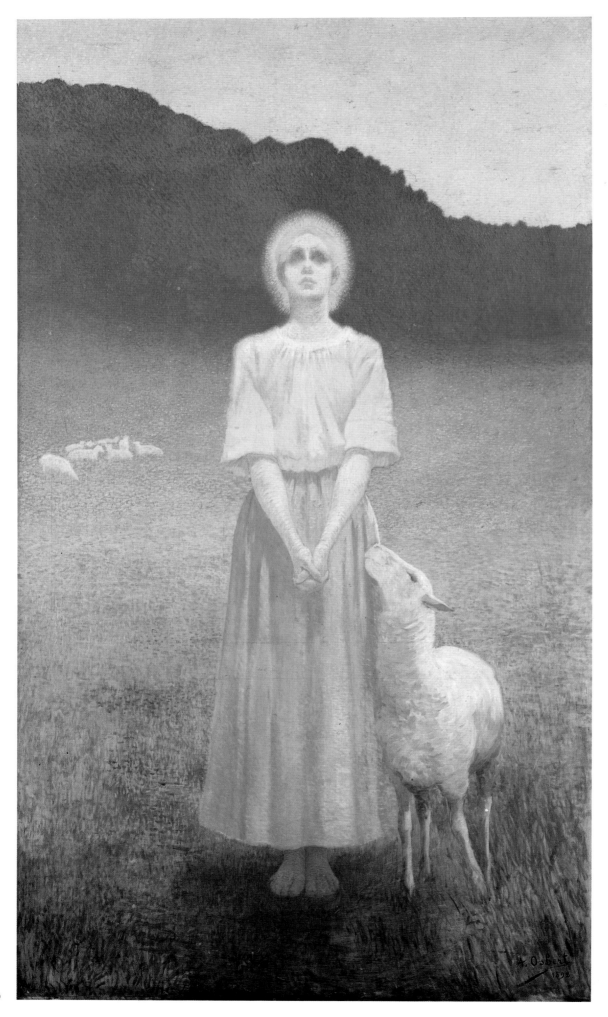

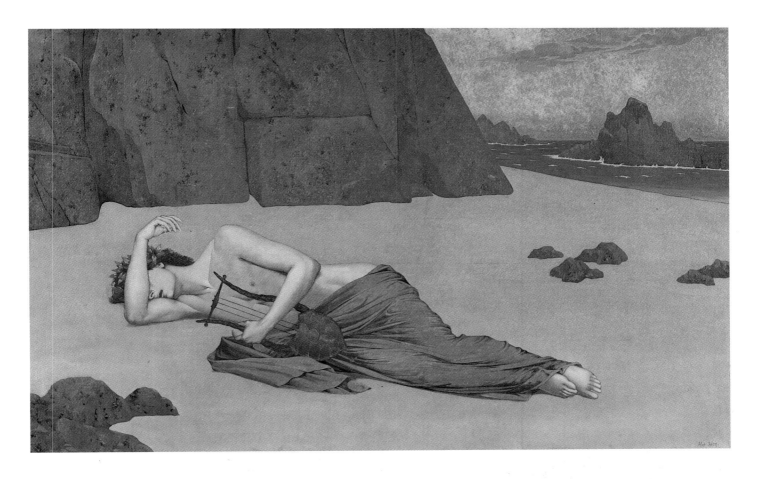

ALEXANDRE SÉON, Chazelles-sur-Lyon 1855–Paris 1917
Orpheus' Lamentation (Salon of 1896)
2′ 4¾″ x 3′ 9¾″ (73 x 116 cm) Gift of Fleury Grosmollard, 1919.
INV 20637

LUCIEN LÉVY-DHURMER
Medusa (Furious Wave), 1897
Pastel, 1′ 11¼″ x 1′ 3¾″ (59 x 40 cm)

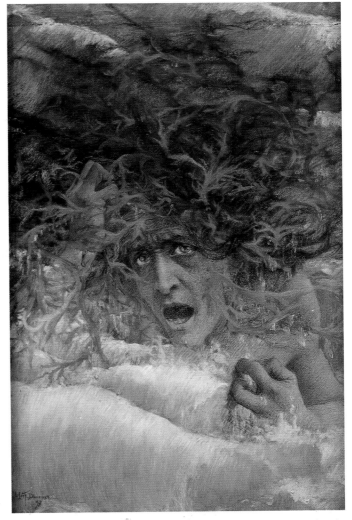

facing page
ALPHONSE OSBERT, Paris 1857–Paris 1939
Vision, 1892
7′ 8½″ x 4′ 6¼″ (235 x 138 cm) RF 1977-451

Georges Rochegrosse
The Knight of the Flowers (Parsifal)

*F*rom *Tannhäuser* (1843–1845) to *Parsifal* (1877–1882), the operas of Richard Wagner sent soaring countless French imaginations, both great and petty. The honor roll includes not only painters like Fantin-Latour (page 168) and Redon (page 531) but also Symbolist poets like Paul Verlaine, who could make the angelic choirs of *Parsifal* reverberate through his own airborne verse. It was to the music of *Parsifal*, in fact, that the most bizarrely visionary group manifestation of Symbolist art, the Rosicrucian Salon, opened its first exhibition in Paris in 1892, a musical prelude to paintings that would waft the spectators off to a never-never land immune to matter and to gravity.

Such lofty dreams, however, could also crash to earth, and nowhere with a more spectacularly vulgar thud than in the works of Georges Rochegrosse. He was often attracted to operatic themes, designing posters for *Louise* and *Pelléas et Mélisande* as well as painting a strange Tannhäuser, seen as a crucified Christ in the clutches of Venus. But his *Knight of the Flowers*, an immense canvas (some twelve feet wide) first shown at the Salon in 1894, would certainly win first prize for the most campily pretentious and deliriously silly illustration to Wagner or any other composer. Here the watery dreamlike haze of Fantin-Latour's *Three Rhine Maidens* of 1876 is fleshed out so palpably that thoughts of spirit instantly evaporate in the crystal-clear air. Explaining his interpretation of Wagner's scenario, Rochegrosse claimed that he wished to drop such literal props as Klingsor's magic castle in favor of what he hoped would be a more general idea of purity versus temptation. In his view of the legend, the flowers, which ordinarily would mind their own business, turned into voluptuous maidens on sensing the approach of this guileless knight, transforming innocent nature into a chorus of 1890s femmes fatales. They are naked, except for the appropriate millinery that includes peony, rose, iris, tulip, violet, daffodil, and hydrangea. Amidst this botanical sea of sexual entrapment, in the most fertile of spring meadows, Parsifal stands transfixed, his eyes toward heaven, his arms warding off evil, and his armor, with its brilliant sheen, literally reflecting the demons of desire that assail his mind, soul, and body on his spiritual quest.

For his contemporaries, Rochegrosse's painting boggled the eye. One critic called its hothouse luxuriance and variety of florid color "a bouquet of fireworks," and compared it to the iridescent butterfly robes worn in Paris by the American dancer, Loie Fuller. For us, the painting not only boggles the eye in its obsessively detailed description of flesh and flower in every color of the rainbow but also the mind, making us both gasp and smile at the way Rochegrosse translated Wagner's venerable Christian theme of sin and salvation into a preview of what might be the envy of any production spectacular at the Folies-Bergère or a Las Vegas casino.

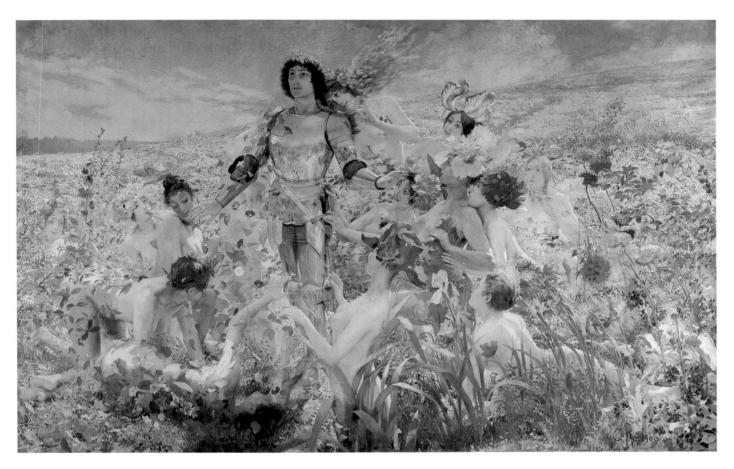

GEORGES ROCHEGROSSE, Versailles 1859–El Biar 1938
The Knight of the Flowers (Parsifal) (Salon of 1894)
7′ 7¼″ x 12′ 2½″ (232 x 372 cm) RF 898

pages 554 and 555
GEORGES ROCHEGROSSE
The Knight of the Flowers (Parsifal), detail

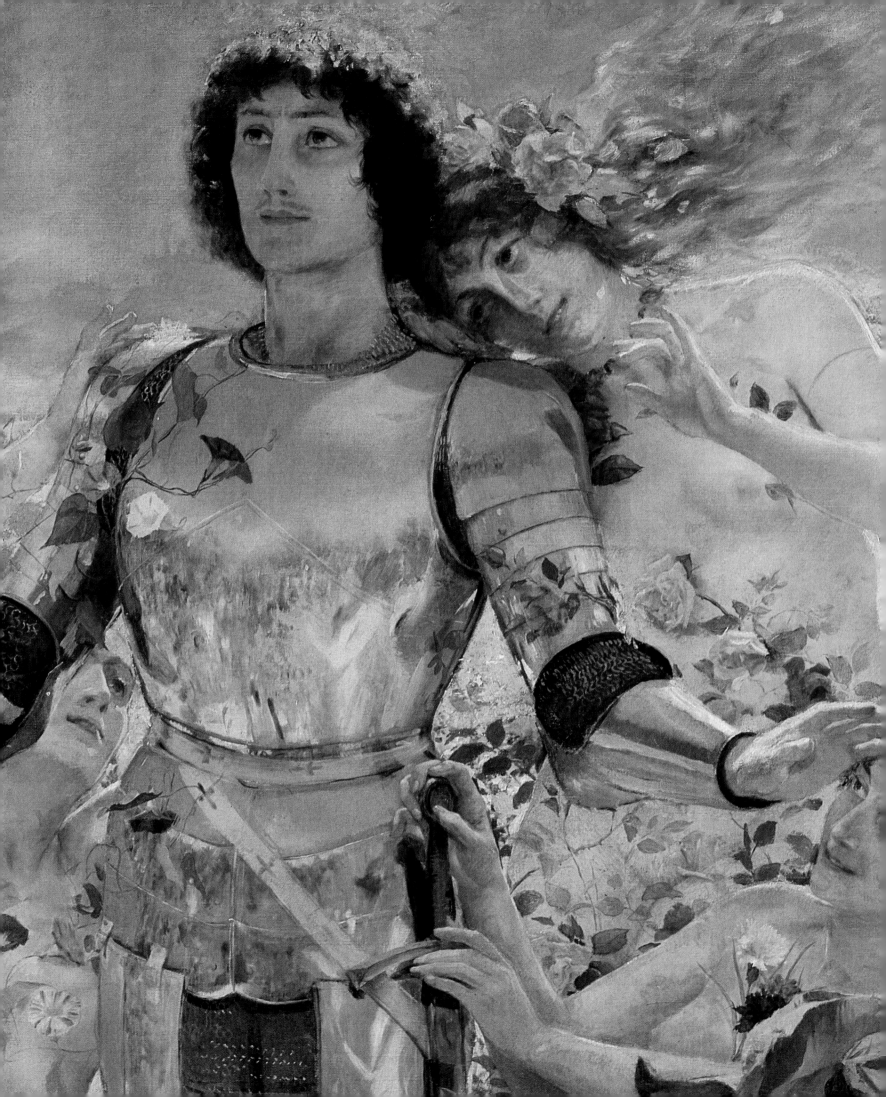

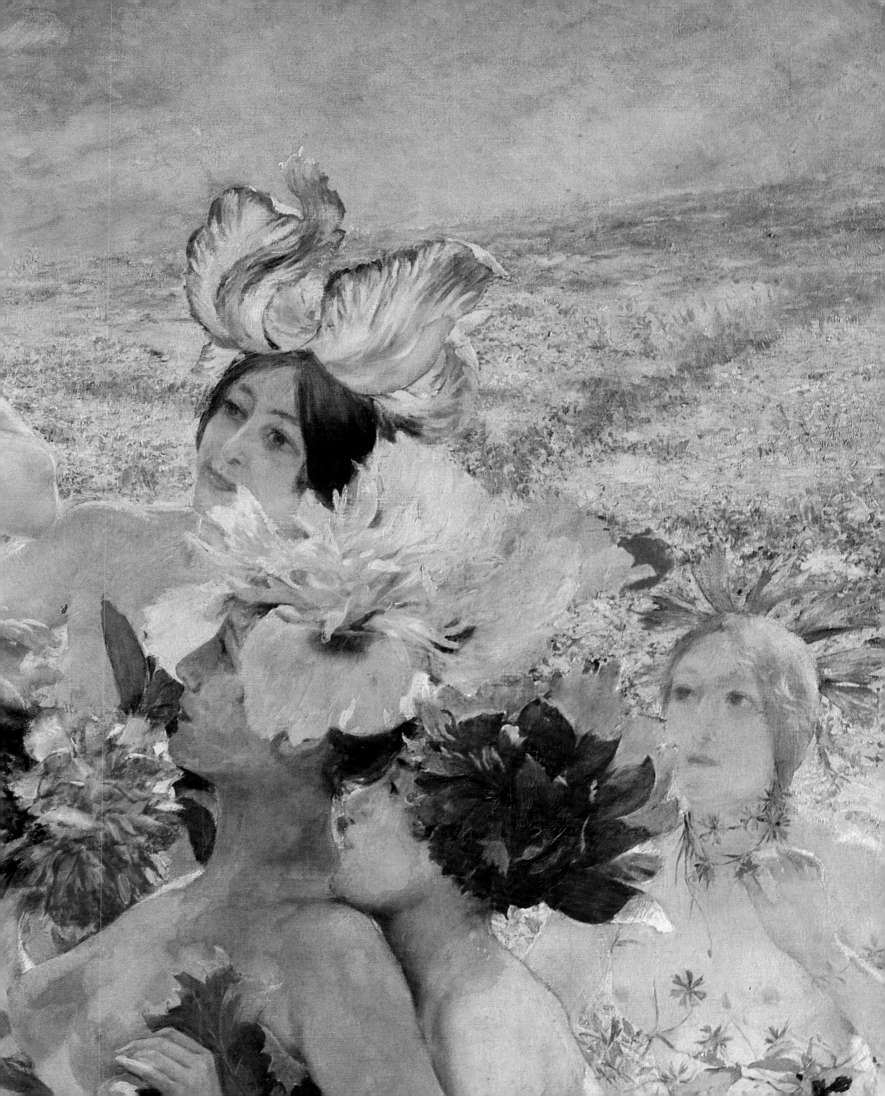

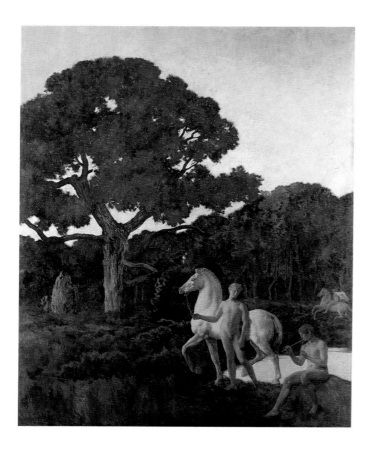

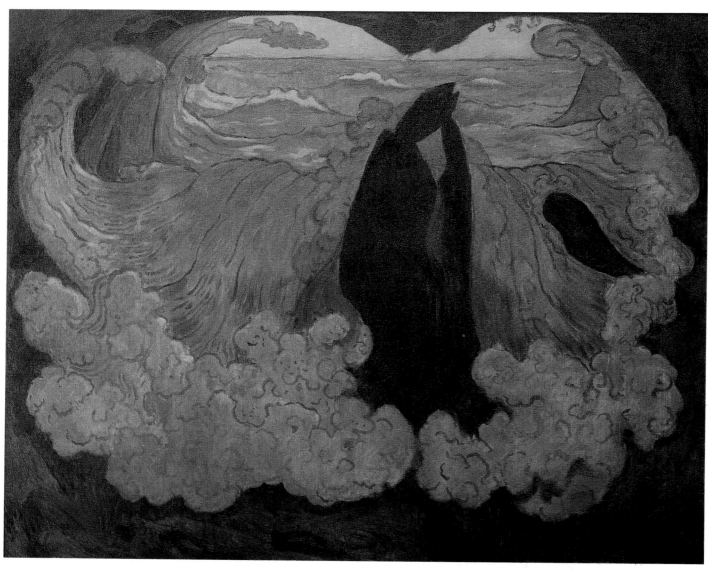

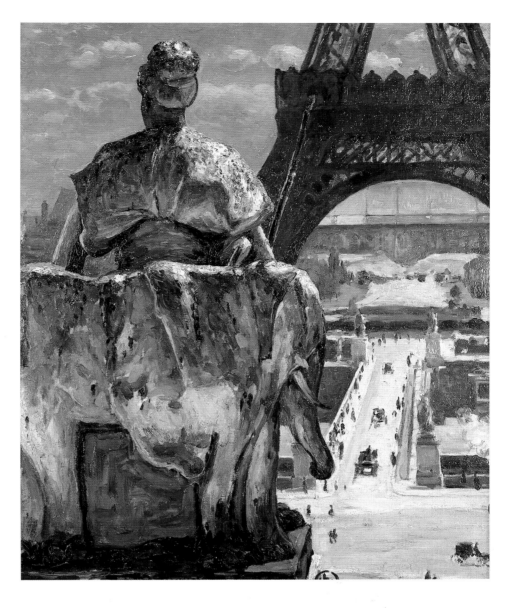

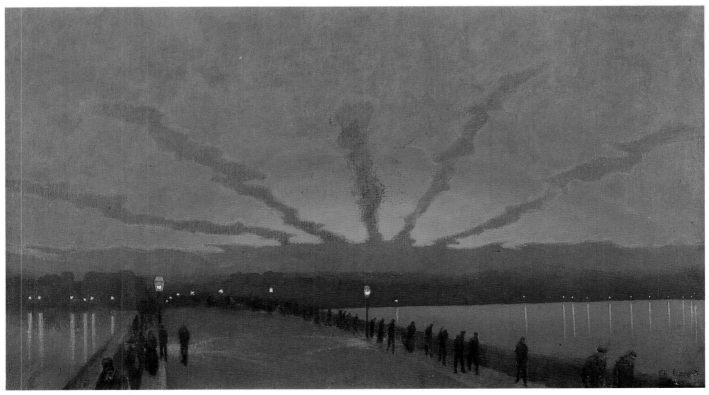

SYMBOLISM OUTSIDE FRANCE

Jean Delville
The School of Plato

*I*n Belgium in the 1890s, some artists, such as Léon Frédéric and Constantin Meunier (pages 562–563 and 628), insisted on mirroring the harsher social realities of their time, from the gloomy Piranesian prisons of the coal mines to the cyclical lives of workers who had become cogs in these industrial wheels. But another breed of artists turned their backs entirely on these modern actualities, locking their doors behind them, closing their eyes, and conjuring up opiate fantasies. Of these Belgian Symbolists, few can rival Jean Delville in his ability to breathe into life a dream world of such rarefied voluptuousness that we feel it might evaporate into the twilight zone.

Despite its imposing public dimensions (some twenty feet wide) and its surprisingly respectable pedigree leading back to Raphael's *School of Athens*, Delville's *School of Plato*, begun in Rome but completed in Brussels in 1898, is the most unexpectedly personal variation on the classical grove of academe where the venerable philosopher held forth to his young disciples. With the permanence of truth, the lucid central axis proclaims Plato's deification on a marble bench aligned with a wisteria tree, while the twelve almost totally nude students of all complexions, from fair to dark, dispose themselves around this fount of wisdom with rhyming and coupling symmetries. But this academic compositional formula is betrayed by Delville's hothouse atmosphere of fragile, exquisite longing. When the work made its debut in 1898 in both Brussels and Paris, one critical response claimed quite rightly that the painting recalled Puvis de Chavannes (page 74) except for the fact that it was so precious.

So precious, in fact, is this vision of classical philosophy that one wonders what kind of lessons in truth and beauty are being taught. This sacred grove, the fulfillment of a kind of *Death in Venice* dream that only a Northerner could sustain about the ancient Mediterranean world, burgeons with a whispered sensuality. Olive, cypress, and laurel trees; a carpet of quivering white and blue spring flowers; three white peacocks, near and far; an expansive vista of calm blue sea and blissful clouds—all create a balmy landscape of the imagination where lithe young male bodies can be guiltlessly displayed and entwined as in a classical gymnasium. These youths' odd combination of harem-girl languor and Michelangelesque muscularity suggests an ideal of androgyny, the perfect mixture of male and female attributes that Delville and so many other Symbolist artists and writers aspired to in the 1890s for reasons both mystical and sexual. Indeed, an early description of Delville's painting refers to the disciples, with mistaken naiveté, as a group of young men and women.

Familiar as well to the Symbolist ambience is the pervasive twilight blue, reflecting that magical moment of the day between reality and dream often referred to, at the turn of the century, as "l'heure bleue." Delville's variations on such ethereal blue tonalities merge with the irradiation of pink flesh and fading sunlight, again creating an environment of muted desire. And in common, too, with much Symbolist thought is the strange fusion of different myths, religions, and cultures: clearly, this vision of Plato and his twelve disciples registers subliminally, and perhaps even heretically, as a classical prototype for Christ and his own apostles. Delville's Plato, in fact, recalls, in his pastel tonalities and archaic gesture and drapery, not so much a marble Greek philosopher as the Christ of a Last Judgment by Fra Angelico.

For all his indebtedness to earlier authority in both subject and structure, Delville's personal flavor of hyperrefined sensibility and sexuality emerges indelibly, one of the most eccentric fruits of the Symbolist movement. And it may even be likely that the wan blue tonality favored by Delville and his international contemporaries, from Osbert (page 550) to Mašek (page 567), helped to cast the better-known pall of blue over the work of a young Spaniard named Picasso.

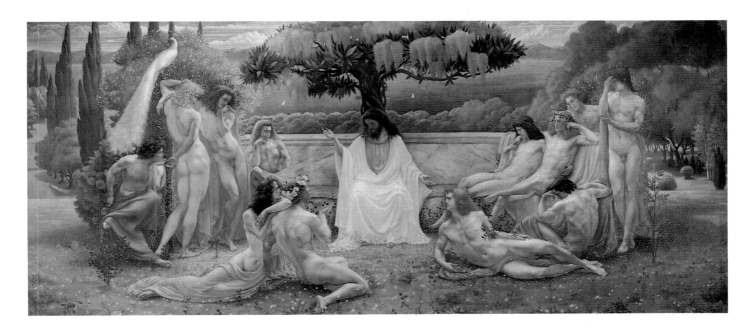

JEAN DELVILLE, Louvain 1867–Brussels 1953
The School of Plato, 1898
6′ 9″ x 19′ 10¼″ (206 x 605 cm) RF 1979-34

WILLIAM DEGOUVE DE NUNCQUES
Nocturne in the Parc Royal, Brussels
Pastel, 1′ 5⅔″ x 1′ 1½″ (58 x 44.5 cm) RF 38999

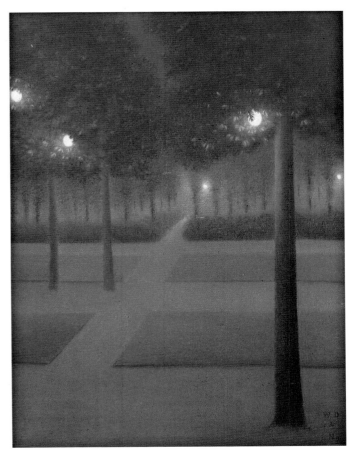

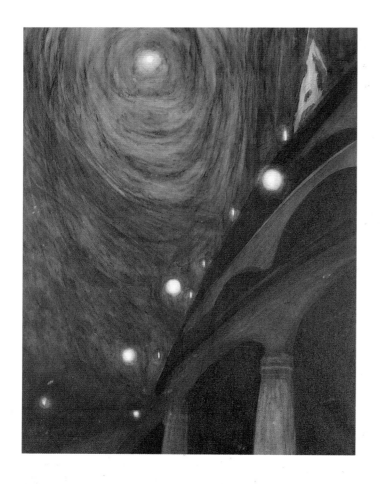

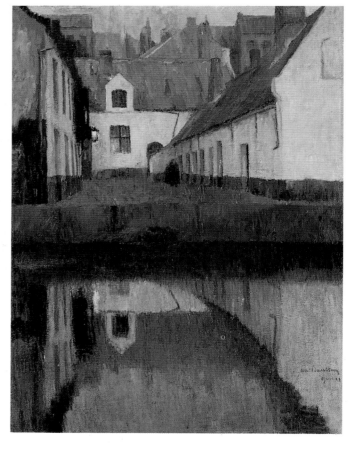

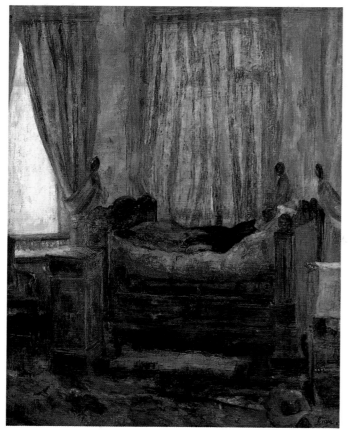

ALBERT BAERTSOEN, Ghent 1866–Ghent 1922
Little Town on the Edge of Water (Flanders), 1899
4′ 7½″ x 3′ 6¾″ (141 x 108.5 cm) RF 1977-29

top left
LEON SPILLIAERT, Ostende 1881–Brussels 1946
Moonlight and Light, ca. 1909
Pastel, 2′ 1½″ x 1′ 7¾″ (65 x 50 cm) Gift of Mrs. Leon Spillaert,
1981. RF 38835

bottom left
JAMES ENSOR, Ostende 1860–Ostende 1949
"The Lady in Distress," 1882
3′ 3¼″ x 2′ 7½″ (100 x 79.7 cm) Gift of Armilde Lheureux, 1932.
RF 1977-165

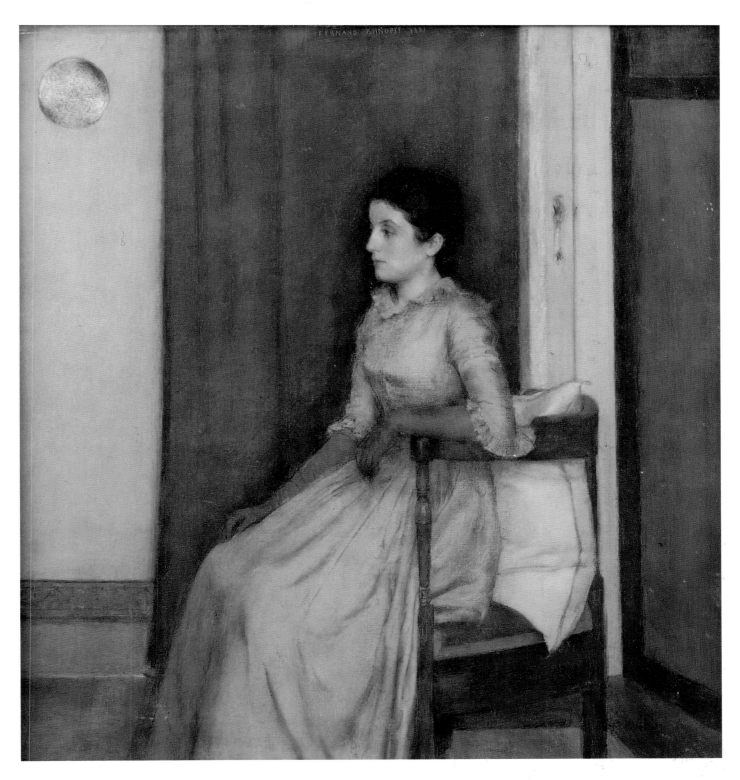

FERNAND KHNOPFF
Grembergen-lez-Termonde 1858–Brussels 1921
Marie Monnom, 1887
1′ 7½″ x 1′ 7¾″ (49.5 x 50 cm) RF 1982-10

LÉON FRÉDÉRIC, Brussels 1856–Brussels 1940
The Age of the Worker, 1895–1897
Triptych: center, 5′ 4¼″ x 6′ 1½″ (163 x 187 cm); sides,
each 5′ 4¼″ x 2′ 4⅔″ (163 x 94 cm) RF 1152

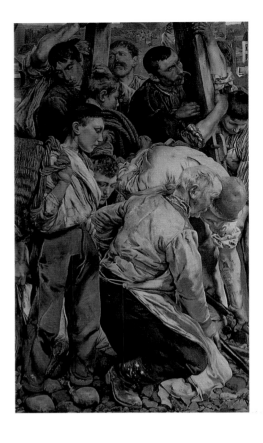

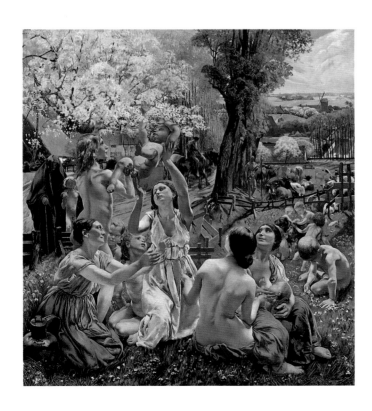

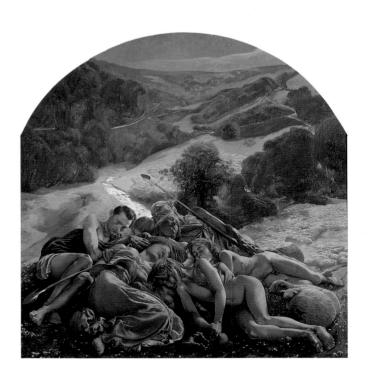

562 SYMBOLISM

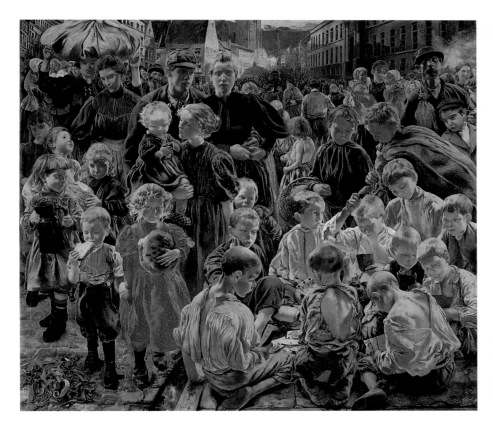

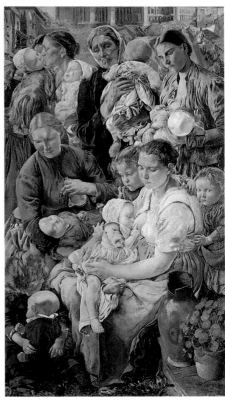

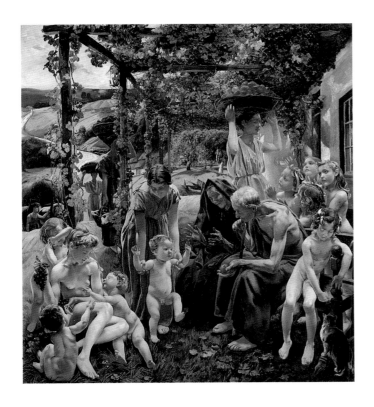

LÉON FRÉDÉRIC
The Golden Age (Morning; Night; Evening), 1900–1901
Triptych: center, 3′ 10¼″ x 3′ 10¼″ (117.5 x 117.5 cm); sides, each:
4′ 2″ x 3′ 10″ (126.5 x 117 cm) Gift of Georges Michonis, 1903.
RF 1492, 1483, 1494

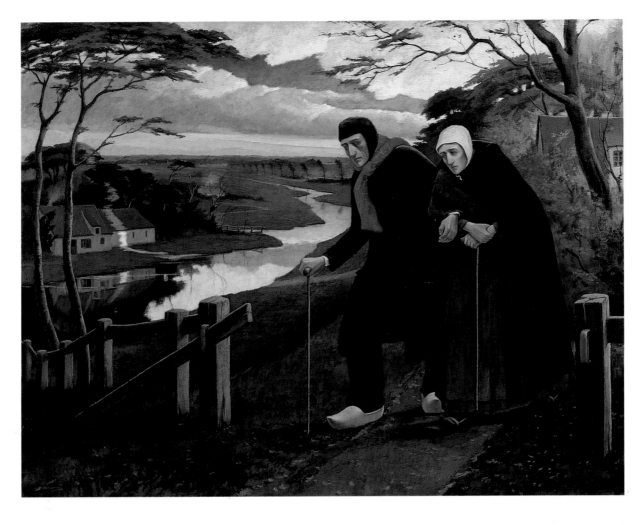

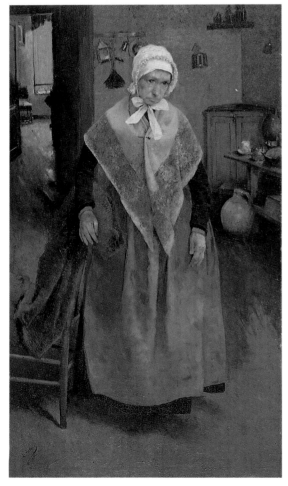

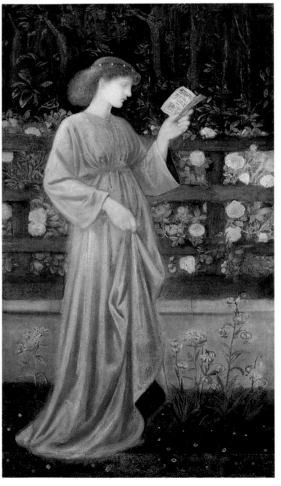

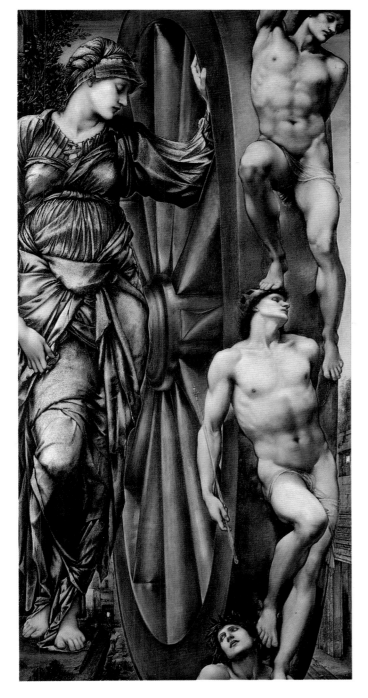

SIR EDWARD BURNE-JONES
Birmingham 1833–London 1898
The Wheel of Fortune, 1883
6′ 6¾″ x 3′ 3¼″ (200 x 100 cm) RF 1980-3

facing page, top
EUGÈNE LAERMANS
Molenbeek-Saint-Jean 1864–Brussels 1940
The Blind One, 1899
3′ 11¼″ x 4′ 11″ (120 x 150 cm) RF 1324

facing page, bottom left
LÉON FRÉDÉRIC
Old Servant Woman, 1884
3′ 6½″ x 3′ 3¾″ (107.7 x 101 cm) RF 1330

facing page, bottom right
SIR EDWARD BURNE-JONES
Princess Sabra (The King's Daughter), 1865–1866
3′ 5¼″ x 2′ (105 x 61 cm) Gift of Edmund Davis, 1915. RF 1977-442

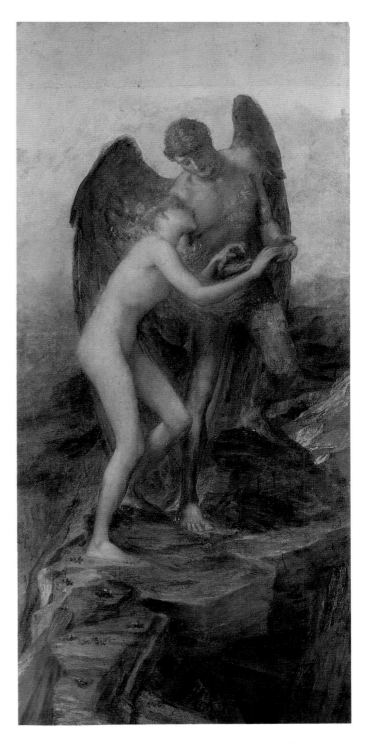

GEORGE FREDERIC WATTS, London 1817–London 1904
Love and Life, 1893
8′ 3½″ x 4′ (253 x 122 cm) Gift of the artist, 1894. RF 866

Vitežlav Karel Mašek
The Prophetess Libusa

*O*f the mysterious, extraterrestrial deities who congeal before our astonished eyes in the international repertory of Symbolist painting, few are as strange or exotic as this lofty giantess. Rising to cosmic heights above a starlit night sky, she stands over a schematic map that would conjure up her geographical roots and those of the artist himself: the mountains and rivers of Prague. For this is a depiction of the half-mythical prophetess Libusa, who, according to legend, reigned over Bohemia in the early eighth century and was responsible for the founding of the city of Prague. She was also said to have ushered in a new era of peace and prosperity after a period of barbarian turmoil. Here she seems magically to bring her new nation into being with her wand, a linden-tree branch. Blessed with mystical powers of divination, she could even locate rich mines on the Bohemian earth below, though she apparently belongs more fully to the heavens, as suggested by the mystical sequence of the phases of the moon on her robe. As remote as the reincarnation of an Egyptian goddess or a Byzantine empress, whose fearful symmetry her rigid posture invokes, she may nevertheless bear contemporary messages relevant to the welling nationalism of Czechoslovakia, Poland, and Hungary, as they tried to free themselves from the rule of the Austro-Hungarian Empire. In fact, the legend of Libusa, as well as the special beauty of the Moldau River, often inspired Czech literature and music of the period, including an opera and a famous tone poem by the internationally renowned Czech composer Smetana.

Although he had begun his studies in Prague, Mašek's artistic education was as international as his Symbolist style. It included sojourns in Munich and Paris, where he began to explore the Neo-Impressionist technique of painting with tiny vibrant points of color that French artists applied to both earthly and visionary themes. Mašek adapted here, too, the pervasive blue tonality that engulfed so many paintings of the 1890s, creating a twilight mood appropriate to a spirit-rapping session. Libusa's closest French counterpart at Orsay is probably Osbert's no less mystifying *Vision* (page 550), in which St. Genevieve hears the Word of God while cloaked in ethereal blue and staring upward in a trancelike state. Like Mašek's prophetess, Osbert's eerie vision must also have registered a patriotic message, since she was the patron saint of Paris and, especially after the Franco-Prussian War, a growing symbol of civic pride. Puvis de Chavannes himself would honor her in a mural cycle at the Pantheon completed in the 1890s. Oddly, both these paintings, as weirdly remote as an occult séance, are rooted in the chauvinist realities of modern European history on the eve of the First World War.

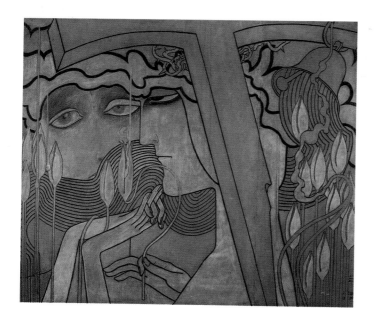

JAN TOOROP, Poerworedjo (Java) 1858–The Hague 1928
Desire and Gratification (The Appeasing), 1893
2' 6" x 2' 11½" (76 x 90 cm) RF 36166

facing page
VITEŽLAV KAREL MAŠEK, Komorany 1865–Prague 1927
The Prophetess Libusa
6' 4" x 6' 4" (193 x 193 cm) Gift of the Jean-Claude Gaubert Gallery, 1974. RF 1974-9

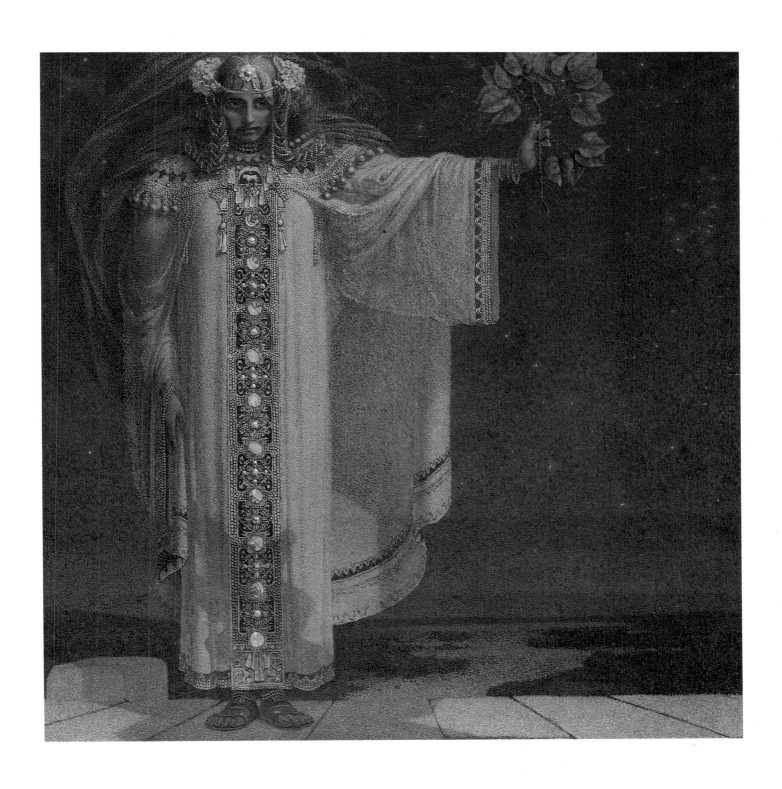

PRINCE EUGÈNE DE SUÈDE
Stockholm 1865–Stockholm 1947
The Old Château, 1912 (replica of 1893 painting shown at 1900
Exposition Universelle)
3′ 4¼″ x 3′ 2¾″ (102 x 98.5 cm) Gift of the artist, 1929. RF 1980-99

AUGUST STRINDBERG , Stockholm 1849–Stockholm 1912
Wave VII, ca. 1900–1901
1′ 10½″ x 1′ 2¼″ (57 x 36 cm) RF 1981-32

EDVARD MUNCH, Løten (Norway) 1863–Ekely (Norway) 1944
Summer Night at Aasgaardstrand, 1904
3′ 3″ x 3′ 4¾″ (99 x 103.5 cm)

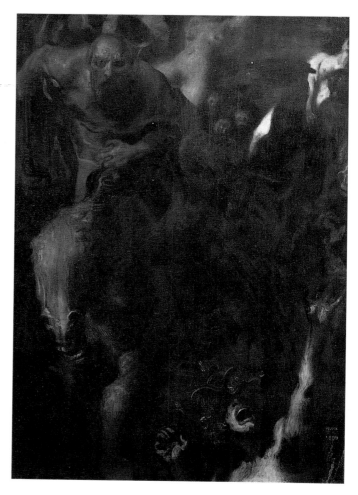

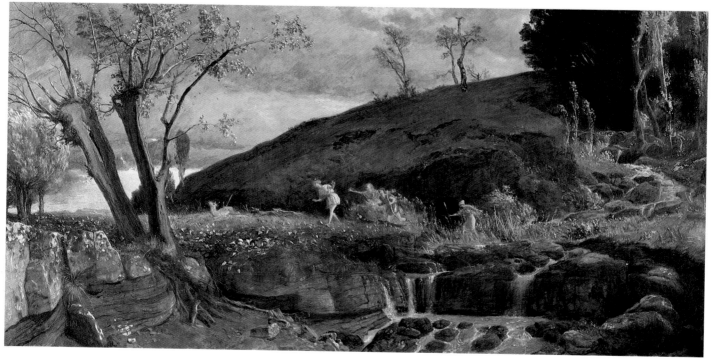

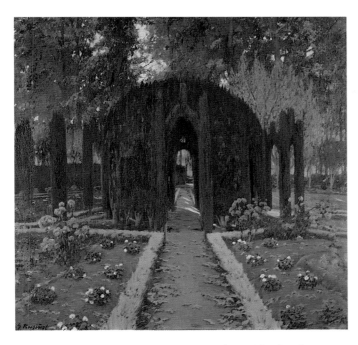

SANTIAGO RUSIÑOL PRATS, Barcelona 1861–Aranjuez 1931
La Glorieta (Aranjuez) (Salon de la Société Nationale des Beaux-Arts, 1909)
2′ 7⅓″ x 3′ 7¼″ (102.8 x 110 cm) RF 1980-22

GUSTAV KLIMT, Vienna 1862–Vienna 1918
Rose Bushes Under the Trees, 1905
3′ 7¼″ x 3′ 7¼″ (110 x 110 cm) RF 1980-195

facing page, top left
ALPHONSE MUCHA, Ivancice (Moravia) 1860–Prague 1939
The Gulf, ca. 1897–1899
Pastel, 4′ 2¾″ x 3′ 3¼″ (129 x 100 cm) Gift of Jiri Mucha, 1979.
RF 37333

facing page, top right
FRANZ VON STUCK, Tettenweis 1863–Munich 1928
The Wild Hunt, 1899
3′ 2¼″ x 2′ 2½″ (97 x 67 cm) RF 1980-7

facing page, bottom
ARNOLD BÖCKLIN, Basel 1827–San Domenico 1901
Diana's Hunt, 1896
3′ 3¼″ x 2′ 7½″ (100 x 80 cm) RF 1977-1

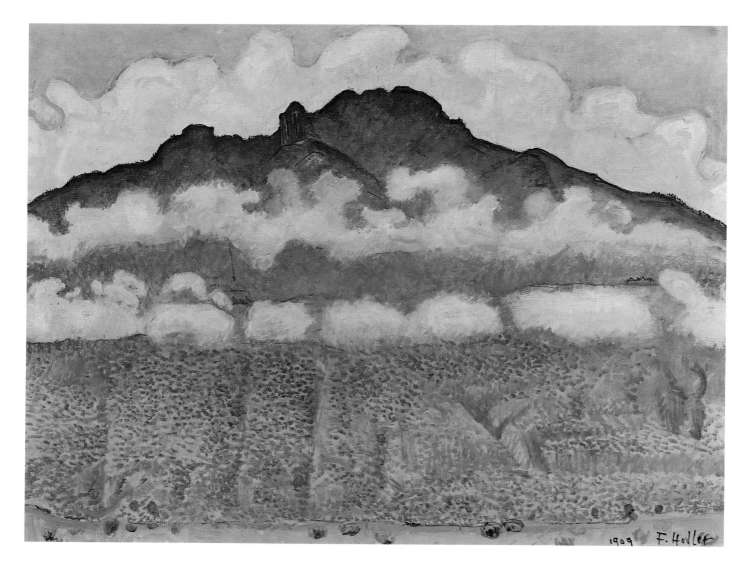

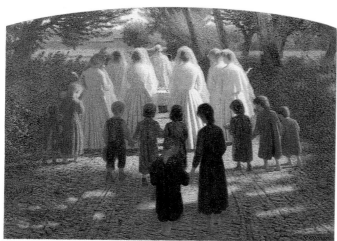

GIUSEPPE PELIZZA DA VOLPEDO, 1868–1907
Broken Flower, 1896–1902
2′ 7¼″ x 3′ 6¼″ (79.5 x 107 cm) RF 1977-281

VITTORE GRUBICY DI DRAGON, Milan 1851–Milan 1920
Morning
1′ 6¾″ x 1′ 4¼″ (47.4 x 41.1 cm) RF 1977-426

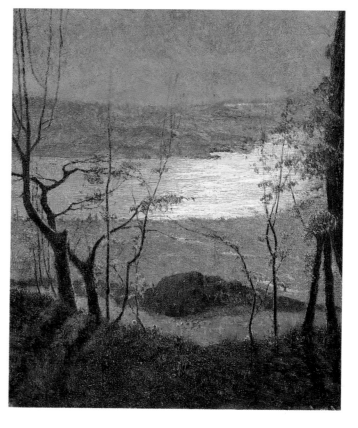

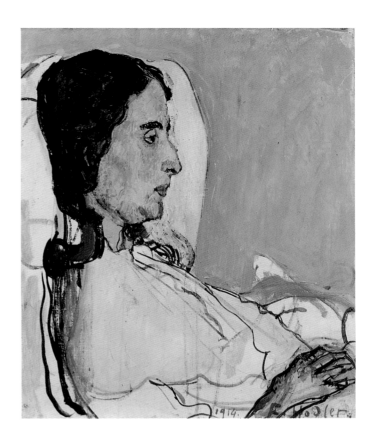

facing page, top

FERDINAND HODLER, Berne 1853–Geneva 1918
Schynige Platte, 1909
2′ 2½″ x 2′ 11¾″ (67 x 90.5 cm) RF 1987-3

FERDINAND HODLER
Mme. Godé-Darel, Ill, 1914
1′ 6½″ x 1′ 3¾″ (47 x 40 cm) RF 1977-195

AUGUSTE BAUD-BOVY, Geneva 1848–Davos 1899
Serenity (before 1898)
2′ 11¼″ x 3′ 9¾″ (89.8 x 116.5 cm) Gift of the artist, 1898.
RF 1980-59

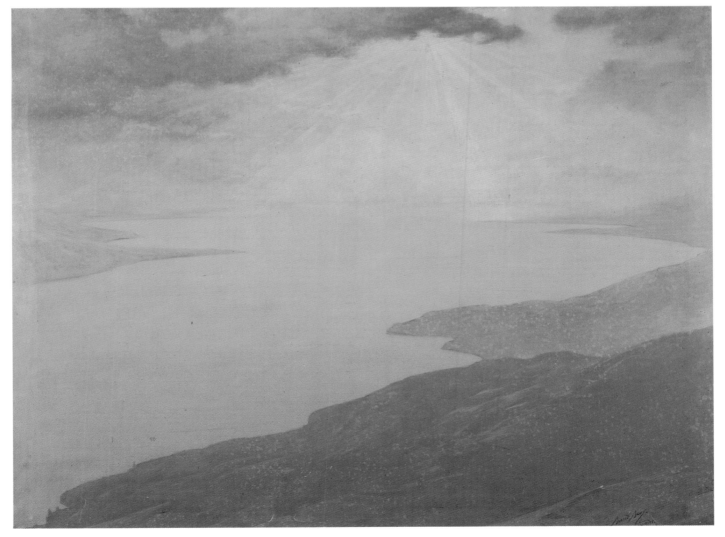

Henry Ossawa Tanner

*F*or reasons of both art and society, Tanner is memorable. A black American whose father was a minister and then a bishop in the African Methodist Episcopal Church, Tanner first studied with Eakins in Philadelphia at the Pennsylvania Academy of the Fine Arts and painted scenes of life in the black ghetto that he knew firsthand. The racial and aesthetic restrictions in the United States in the 1880s prompted him to seek a freer environment, and he settled in Paris in 1891, where he studied with two members of the establishment—Benjamin-Constant and Laurens—both of whom are represented at Orsay.

Attracted to the Symbolist mode that pervaded the 1890s, Tanner soon aspired to mystical religious painting that must have fulfilled some of the dreams instilled in him as the child of a clergyman; from 1895 on, he exhibited with growing success at the Paris Salons. His *Raising of Lazarus* painted in 1896 and shown the following year at the Salon, was not only awarded a medal but then promptly purchased by the state for the international collection of modern art at the Musée du Luxembourg. Although the painting may begin on the path of Realist observation as practiced by Eakins, it soon crosses over the brink of the seen world into a more shadowy domain where we can believe that these real-life figures in biblical costume are awed spectators watching a barely earthbound Christ raising from the dead a more corporeal man covered with a white shroud. The somber brown palette absorbing the crowd into an engulfing darkness is the vehicle, as in the work of Carrière, to lead us from the visible to the invisible, creating a mysteriously theatrical tableau whose ambience of rapt wonder and quietly glowing light transforms the natural into the supernatural.

After the success of *The Raising of Lazarus*, Tanner, under the sponsorship of an American patron, made several trips to the Holy Land. Like many earlier nineteenth-century painters, including Tissot, he felt he could there immerse himself more fully in the spiritual as well as the documentary truths of the biblical tales he wanted to re-create with the conviction of a believer. His canvases, however, became more visionary, their narrative dissolving illegibly in the murk of a Rembrandtesque chiaroscuro or a twilight haze. In his *Christ and His Disciples on the Bethany Road* (page 576), we cling to the title for help in reading a picture that seems more hallucination than illustration. The tiny figures of the resurrected Christ and his two companions, who have yet to recognize him, are almost vaporized beneath the foggy sky dimly lit by a full moon. For Tanner, as for many other Symbolists, the imagination could travel farther when the light on the road was blurred.

As an American expatriate who was assimilated into the French painting establishment, Tanner was often honored by France and even became a member of the Legion of Honor in 1923. (His native country, in turn, belatedly put his head on an eight-cent stamp.) Tanner's two-part career, which saw him begin as a parochial American painter of black poverty and piety and then emerge as a Symbolist who would transcend race and nationality in his other-worldly depiction of biblical themes, dramatically encapsulates the story and the ambitions of countless foreign artists at the turn of the century. Abandoning their provincial and limiting backgrounds for Paris, they could at last flourish in an international community of artists who painted for the entire world. It was a pattern Picasso himself would follow.

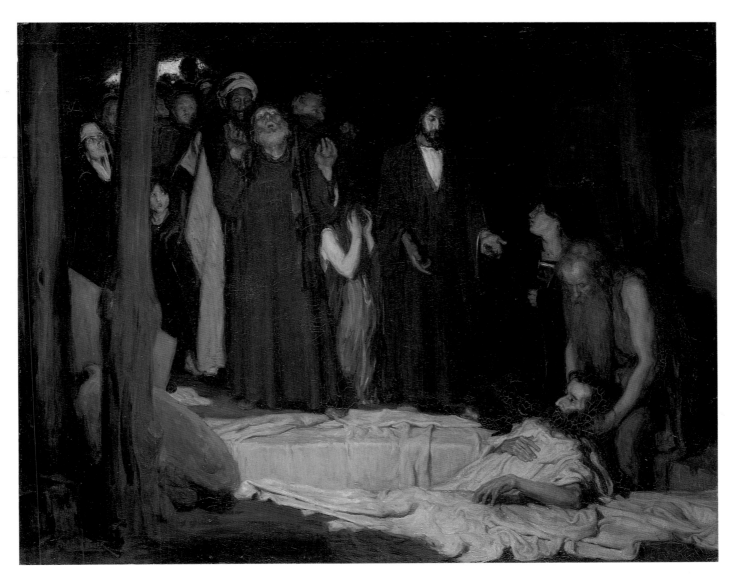

HENRY OSSAWA TANNER
The Raising of Lazarus, 1896 (Salon of 1897)
3′ 1½″ x 3′ 11¾″ (95 x 121.5 cm) RF 1980-173

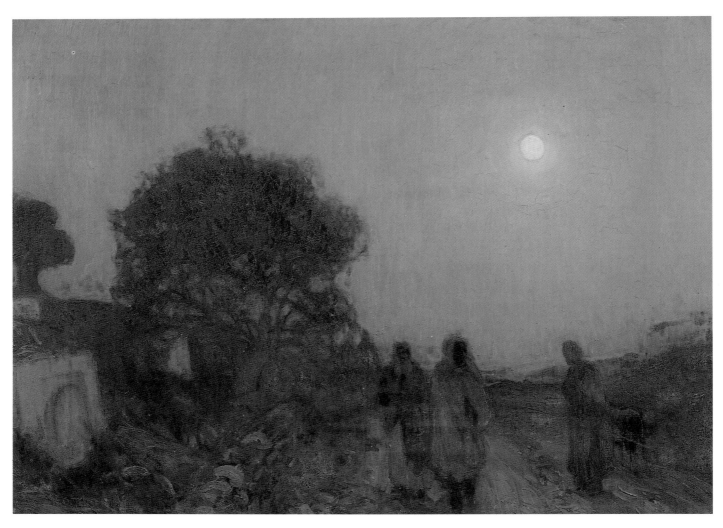

Christ and His Disciples on the Bethany Road, ca. 1905
2′ 2″ x 3′ 1″ (66 x 93 cm) RF 1980-74

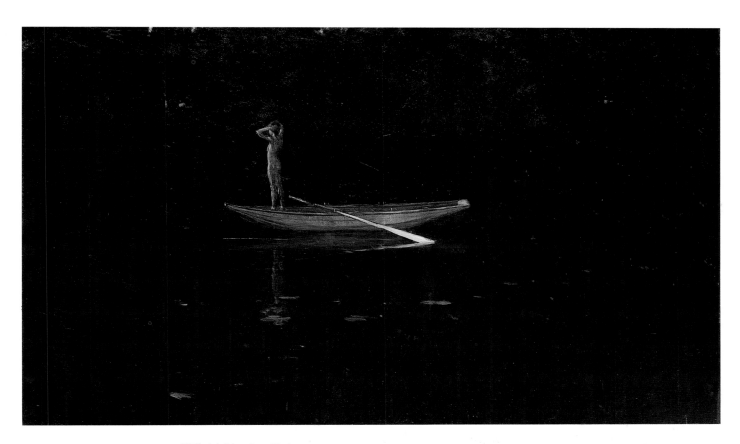

ALEXANDER HARRISON, Philadelphia 1853–Paris 1930
Solitude (Salon de la Société Nationale des Beaux-Arts, 1893)
3′ 3¼″ x 5′ 7″ (100 x 170 cm) RF 870

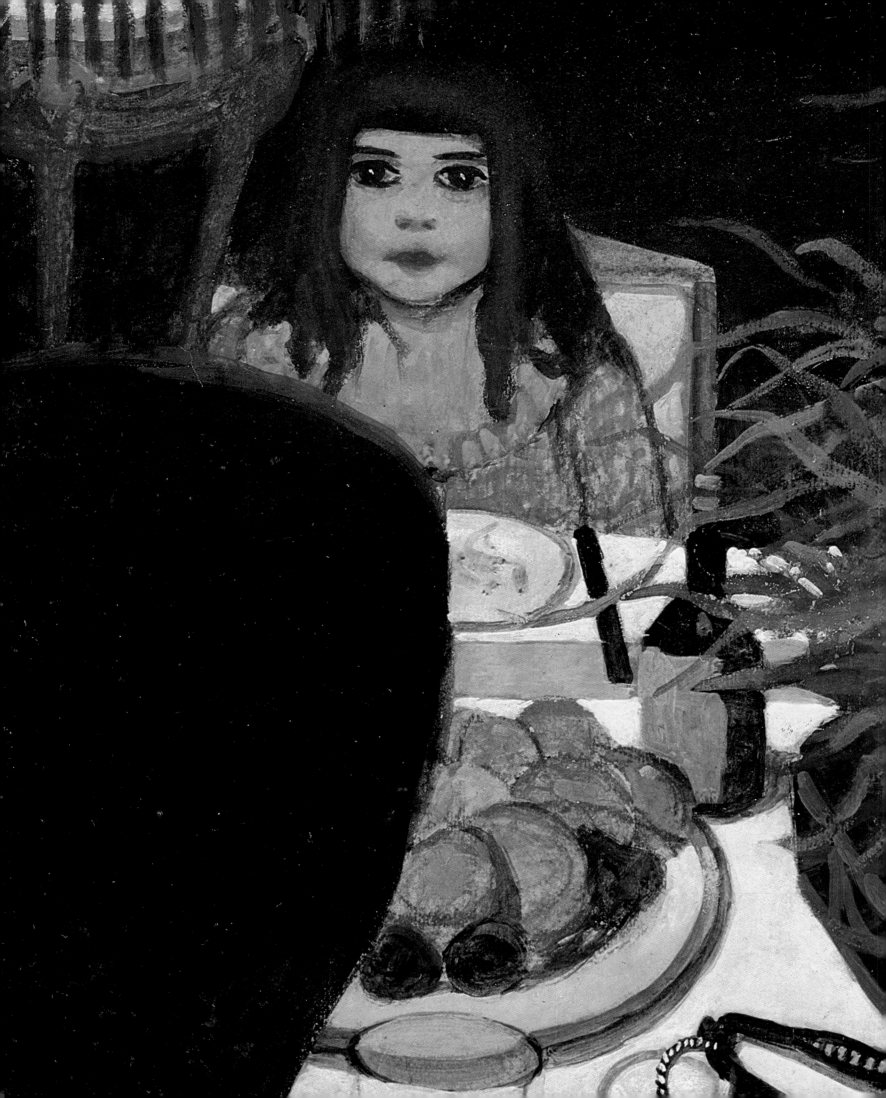

The Turn of the Century

Nabis and Intimistes

Félix Vallotton
Dinner, by Lamplight

*T*he boundaries around the artistic progeny that Gauguin spawned in Pont-Aven in the late 1880s are blurry. With the master, some artists, like Sérusier, Denis, and Ranson, tended to pursue themes as exotic and mystical as the name, *Les Nabis* (the Hebrew word for "prophets"), which they gave themselves in Paris in 1888 when their secret-society meetings were first held. But other members, like Bonnard and Vuillard, kept their eyes fixed on the facts of contemporary French life, whether in city or country, though they viewed it through private lenses that could transform the mundane into a language of mysterious, elusive sensibility. Their particular cultivation of domestic scenes where quiet and intimacy reigned led to their being dubbed, in turn, Intimistes.

Such a rubric is particularly suitable for another member of this circle, the Swiss-born but Paris-based Vallotton, who, in fact, was to become a French citizen in 1900. In the 1890s his art grew close to that of Bonnard and Vuillard, focusing on the comforting rituals of Parisian domesticity, but camouflaging these everyday scenes with offbeat decorative patterns and abrupt fusions of near and far. His strong personal inflection is always clear as in his intimate view of a lamplit dinner table. A master of wood engraving, he carried his abbreviated contrasts of black and white into the silhouetted style of his paintings. Here, what might have been the casual unwinding of a French family dinner, when bread, nuts, wine, and fruit are left on the table, takes on a Halloween-like spookiness. We discover, one by one, the almost concealed black presence of a large paper-flat foreground figure—the artist himself—who partly blocks our view; the uncanny radiance of the tilted tabletop, floating as if at a séance; the unblinking head-on stare of the little girl—his stepdaughter—who confronts us with unexpected urgency; and, above, the witty silhouettes of black cats on the lampshade that shields the source of this eerie light.

In *Poker* (page 583), Vallotton moves on to the aftermath of such a dinner, when ladies and gentlemen assemble around a card table with a similar lamplit intensity. Once again, such a commonplace is transformed into a diminutive stage set where we anticipate the intrusion of a dramatic event. There are close reflections here of the Nabis' involvement with contemporary theater, both as stage designers and spectators. A play by Henrik Ibsen might well be imagined in one of these Vallotton interiors.

Out-of-doors, too, he could cast a spell. A small child in a yellow straw hat chasing a red ball in a park is observed from a startling overhead view that turns the everyday into a smaller-than-life fairy-tale world of unexpected color accents. These even include, in the distance, a pair of tiny blue and white figures oddly detached from the little girl, who may be in their care (page 582). And in a surprising excursion from the city to remote, unpopulated nature, this otherworldly mood is expanded to an almost Japanese recreation of a moonlit night (page 582). Here the flattened, weightless patterns of the meandering cloud shapes and winding river are illuminated by a mesmerizing full moon as lucid in the night sky as in its watery reflection below. It is a perfect visual pendant to Debussy's *Clair de Lune*, composed a few years later.

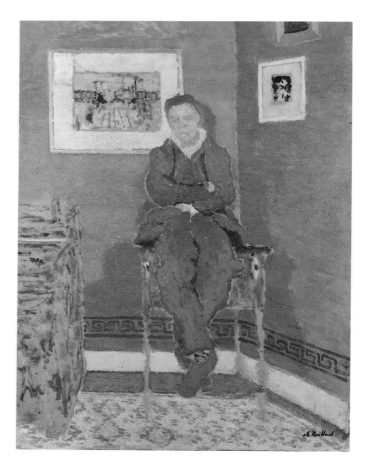

ÉDOUARD VUILLARD
Félix Vallotton, 1900
2′ 1″ x 1′ 7½″ (63 x 49.5 cm) Bequest of Carle Dreyfus, 1977.
RF 1977-390

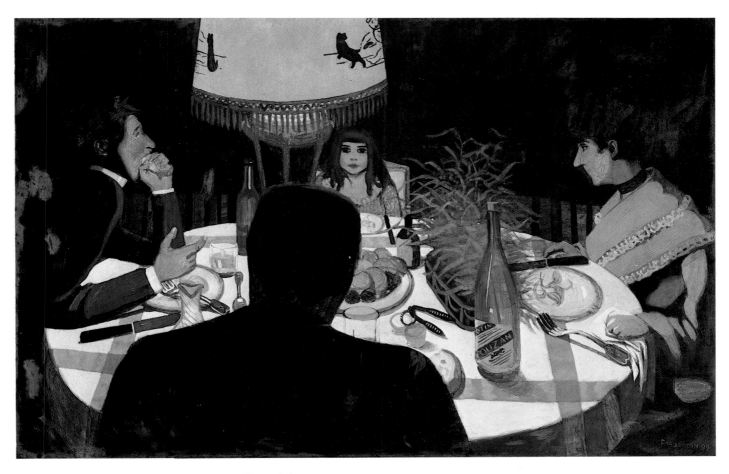

FÉLIX VALLOTTON, Lausanne 1865–Neuilly-sur-Seine 1925
Dinner, by Lamplight, 1899
1′ 10½″ x 2′ 11¼″ (57 x 89.5 cm) RF 1977-349

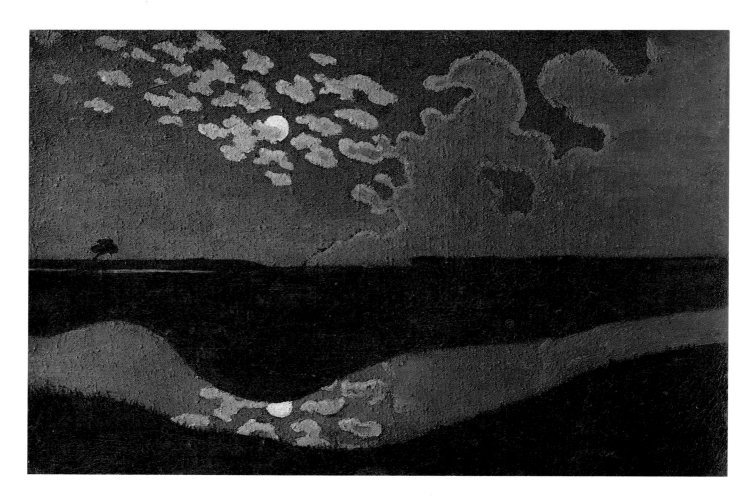

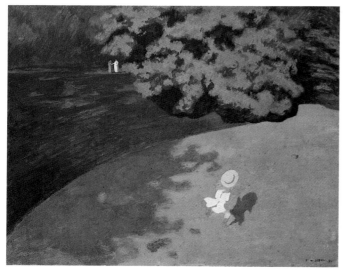

FÉLIX VALLOTTON
Moonlight, ca. 1895
10¾" x 1′ 4¼" (27 x 41 cm) RF 1979-60

FÉLIX VALLOTTON
The Ball (Corner of the Park, Child Playing with Ball), 1899
1′ 7" x 2′ (48 x 61 cm) Bequest of Carle Dreyfus, 1953. RF 1977-353

facing page, top
FÉLIX VALLOTTON
Poker, 1902
1′ 8¾" x 2′ 2½" (52.5 x 67.5 cm) RF 1977-347

facing page, bottom
FÉLIX VALLOTTON
The Third Gallery at the Théâtre du Chatelet, 1895
1′ 7½" x 2′ (49.5 x 61.5 cm) Bequest of Carle Dreyfus, 1953.
RF 1977-352

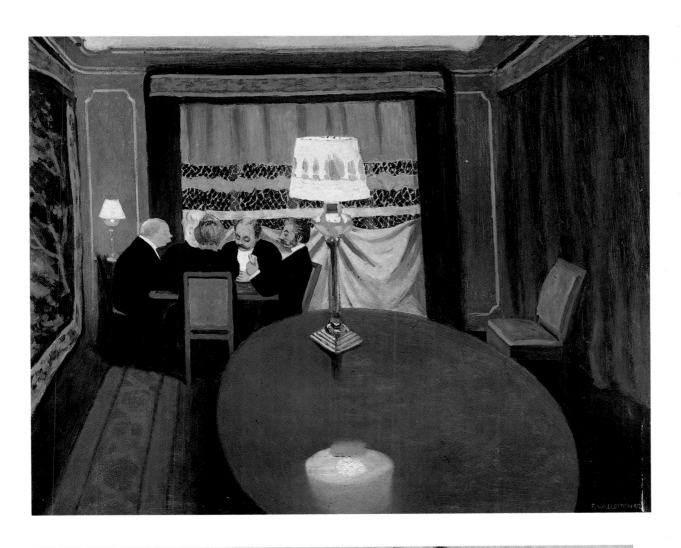

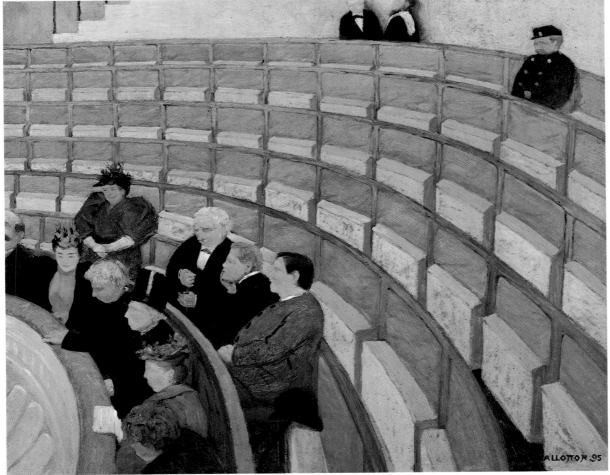

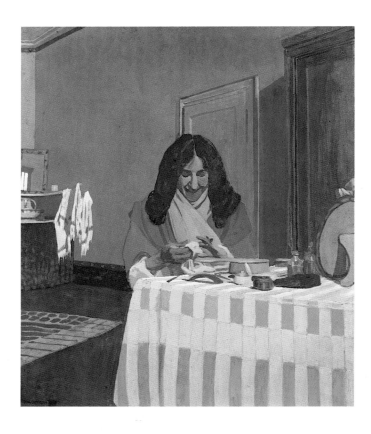

FÉLIX VALLOTTON
Mme. Félix Vallotton, 1899
1′ 11″ x 1′ 7¾″ (58.5 x 50 cm) Gift of Mr. and Mrs.
Gaston Bernheim de Villers, 1953. RF 1977-354

left, bottom
FÉLIX VALLOTTON
Marthe Mellot, 1906
(wife of Alfred Natanson)
2′ 7¾″ x 2′ 1½″ (80.5 x 65 cm) Gift of George Moos, 1951.
RF 1977-350

FÉLIX VALLOTTON
Alfred Athis, 1906
(pseudonym of Alfred Natanson)
2′ 8″ x 2′ 1½″ (81.5 x 65 cm) Gift of George Moos, 1951.
RF 1977-351

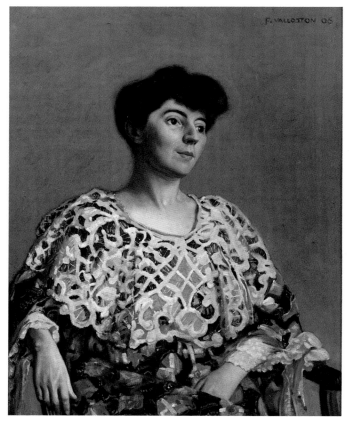

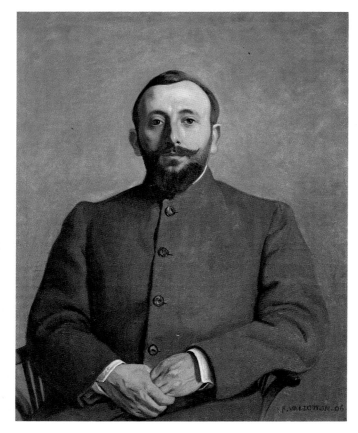

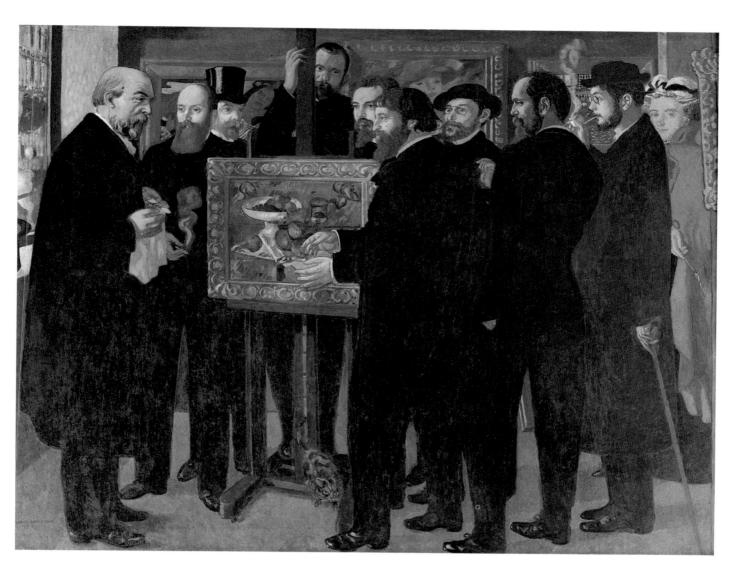

MAURICE DENIS, Granville 1870–Paris 1943
Homage to Cézanne, 1900
5′ 10¾″ x 7′ 10½″ (180 x 240 cm) Gift of André Gide, 1928.
RF 1977-137

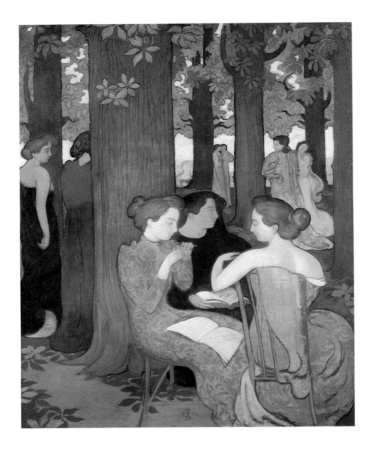

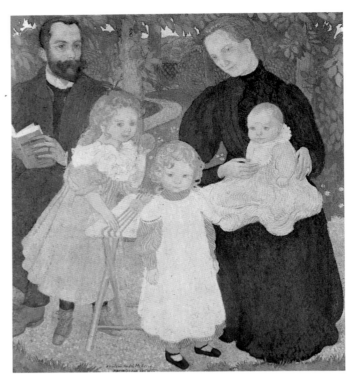

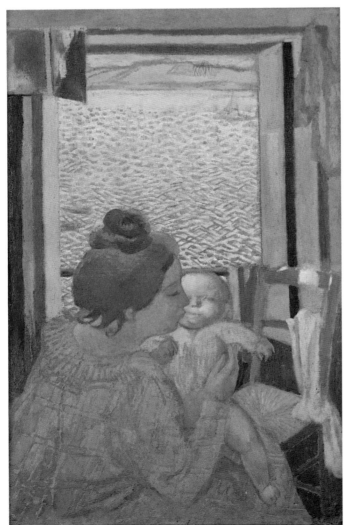

MAURICE DENIS
The Mellerio Family, 1897
3′ 10¾″ x 3′ 7½″ (118.5 x 110.5 cm) RF 1977-142

top left
MAURICE DENIS
The Muses, 1893 (Salon des Indépendants, 1893)
5′ 7½″ x 4′ 6¼″ (171.5 x 137.5 cm) RF 1977-139

bottom left
MAURICE DENIS
Motherhood, at the Window, ca. 1899
(with second daughter, Bernadette)
2′ 3½″ x 1′ 6″ (70 x 46 cm) Bequest of Paul Jamot, 1941. RF 1941-42

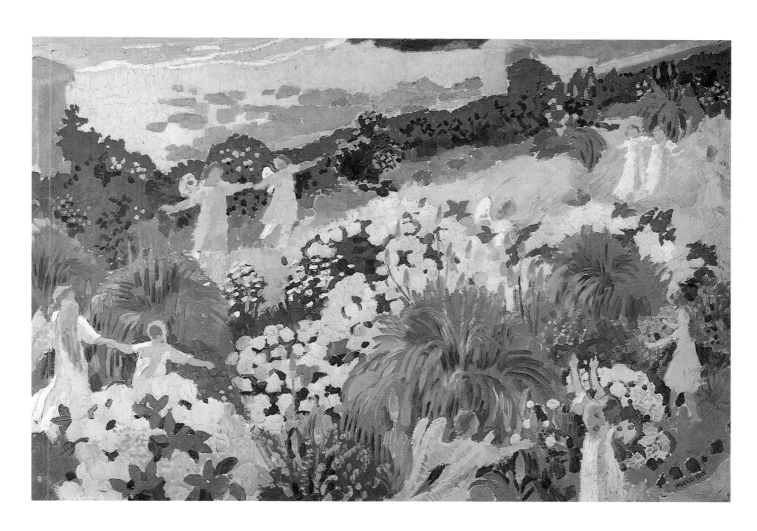

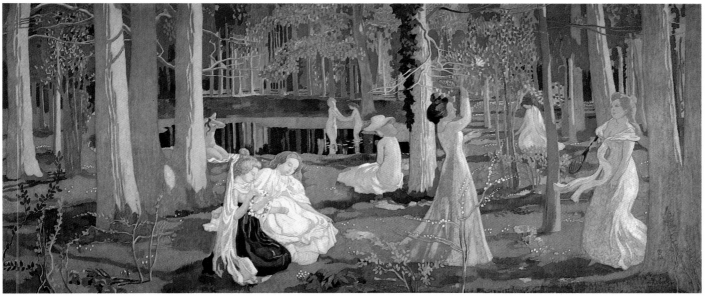

MAURICE DENIS
Paradise, 1912
1' 7¾" x 2' 5½" (50 x 75 cm) Bequest of Paul Jamot, 1941.
RF 1941-35

MAURICE DENIS
A Game of Badminton, 1900
4' 2" x 9' 10½" (127 x 301 cm) Bequest of Étienne Moreau-Nélation,
1927. RF 1982-61

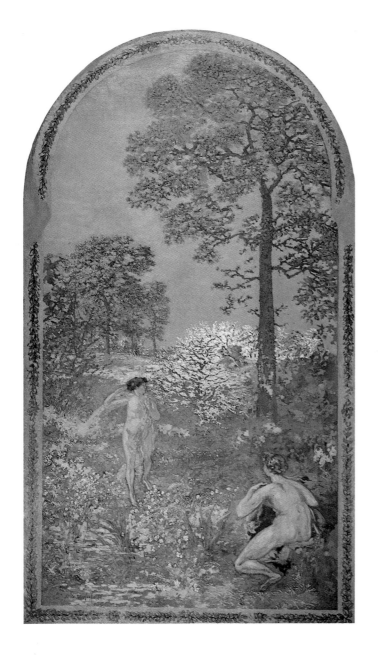

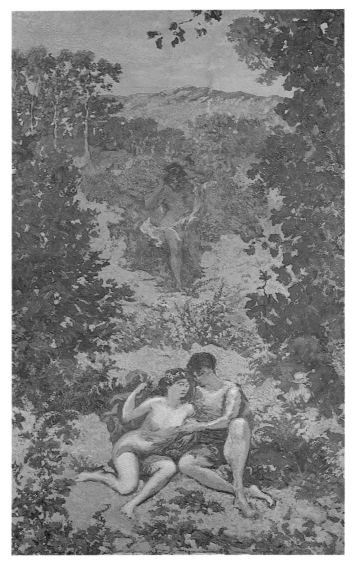

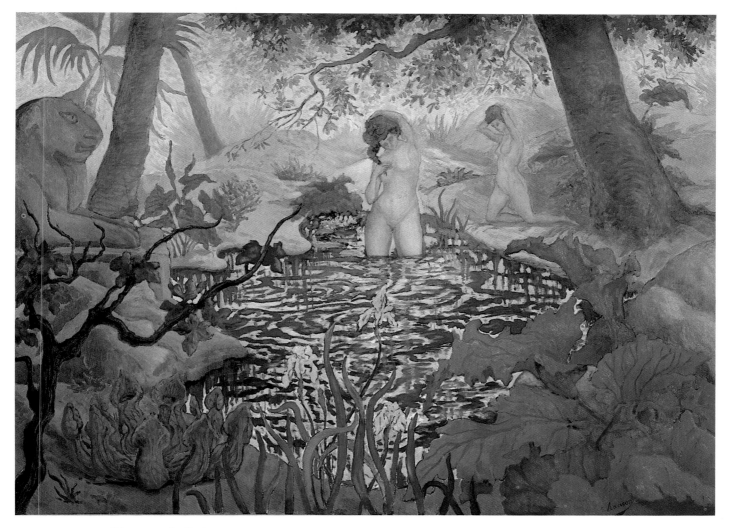

PAUL RANSON, Limoges 1861–Paris 1909
The Bathing Place (Lotus), ca. 1906
3′ 1½″ x 3′ 11¼″ (95 x 120 cm) RF 1977-297

facing page, top left
KER-XAVIER ROUSSEL
Lorry-lès-Metz 1867–L'Étang-la-Ville 1944
The Rape of the Daughters of Leucippus, 1911
14′ 1¼″ x 7′ 10½″ (430 x 240 cm) RF 1977-303

facing page, top right
KER-XAVIER ROUSSEL
Polyphemus, Acis and Galatea
Oil on paper on canvas, 8′ 11½″ x 5′ 5¼″ (273 x 165.5 cm)
RF 1977-304

facing page, bottom
KER-XAVIER ROUSSEL
The Procession of Bacchus
2′ 10¼″ x 6′ 10¾″ (87 x 210.5 cm) Gift of the artist, 1944.
RF 1977-305

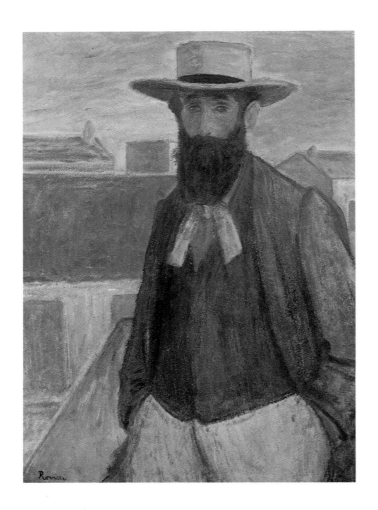

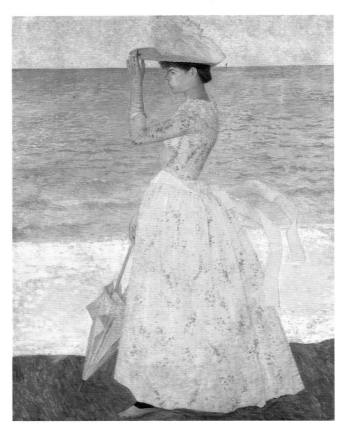

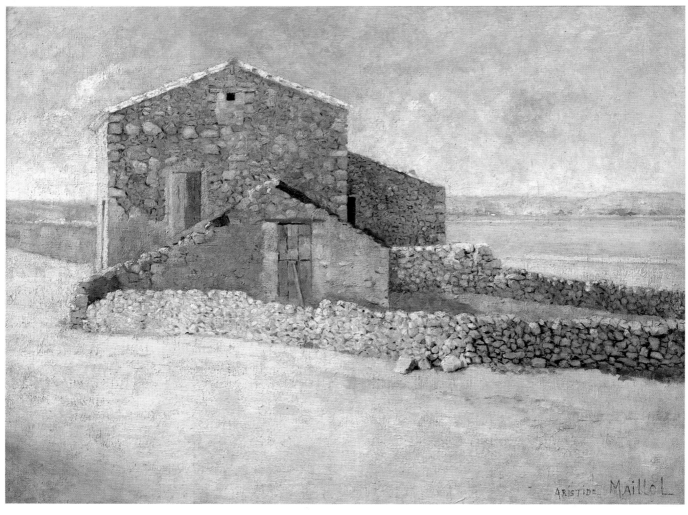

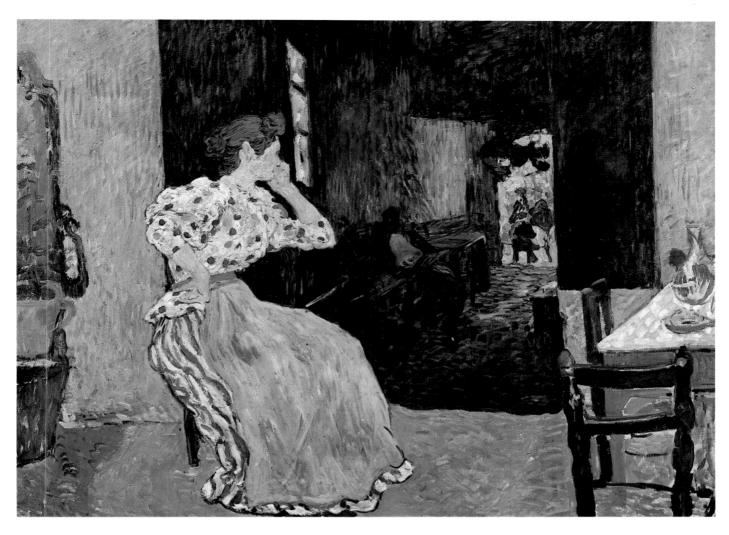

LOUIS VALTAT, Dieppe 1869–Paris 1952
Woman in a Tavern (The Café), ca. 1896
4′ 6″ x 6′ 2¾″ (137 x 190 cm) RF 1977-16

facing page, top left
JOZSEF RIPPL-RONAI, Kaposvar 1861–Kaposvar 1927
Aristide Maillol, 1899
3′ 3¼″ x 5′ 9″ (100 x 175 cm) Gift of Mr. Petrovics, 1936.
RF 1977-299

facing page, top right
ARISTIDE MAILLOL
Banyuls-sur-Mer 1861–Banyuls-sur-Mer 1944
Woman with Parasol
6′ 2¾″ x 4′ 10¾″ (190 x 149 cm) RF 1977-241

facing page, bottom
ARISTIDE MAILLOL
House in Roussillon
1′ 9¼″ x 2′ 4¾″ (54 x 73 cm) RF 1977-240

BONNARD

Twilight (The Croquet Party)

*I*s this a croquet party or a camouflage screen? The answer, of course, is both, since in the 1890s, Bonnard, like Vuillard, became a master at juggling the sweet facts of French middle-class domesticity, both indoors and out, with a prodigious virtuosity in concealing these scenes under what looks like an abstract tapestry of paint, an intricate weave of elegantly muffled textures and patterns.

Exhibited at the Salon des Indépendants in 1892, when it was titled *Twilight*, Bonnard's painting is a hymn to what, for many, were the quiet joys of life at the end of the century: an enclosed world of refined sensation where men, women, children, dogs, and cats inhabit a contemporary Garden of Eden. In this hide-and-seek surface, we seem to peer through a confusing flutter of leaves into a private garden, suddenly discerning one detail after another that gives the scene a charming, earthbound truth. The scene represents members of Bonnard's own family—father, sister, and brother-in-law—enjoying their country home in the Isère. And the croquet game, too, can come into surprisingly literal focus, as the quartet of players and the mallets, balls, and wickets emerge from a forest of dappled greens, browns, and beiges in which a playful dog almost disappears. In the background, on the greenest of lawns, a quintet of young girls in long white gowns are dancing in a round that recalls, in more mythical guise, a modern tradition of Golden Age fantasies, from Ingres to Matisse.

Croquet, first fashionable in England in the late 1850s and soon turning up in countless cultivated gardens on both sides of the Channel and the Atlantic, was a popular subject for plein-air painters of the 1860s and 1870s (both Homer and Manet tried their hand at it). In this, as in many other things, Bonnard reveals his allegiance to the outdoor world of Impressionism, in which figures, moving freely in a landscape, would have their most accidental movements captured, as in a snapshot, within a richly decorative web of paint. Unlike the Impressionists, however, Bonnard dissolves his scenes in patterns of quietly insistent geometry, the equivalent of the textile designs, from plaids to floral motifs, worn by his elegantly dressed cast of characters. Indeed, the surfaces of his paintings, like those of Vuillard, often resemble the artisanship of the finest fabric-makers, to be savored as one would a Harris Tweed or a Japanese kimono. Refinement, in fact, is pushed to uncommon extremes, with the twilit autumnal colors matching, in muffled sensibility, the no less muted inventory of repeated patterns in both clothing and foliage.

Looking backward to Impressionist roots, Bonnard's painting also prophesies a world of twentieth-century innovation, from the mysterious, camouflaging surfaces of Analytic Cubism, in which reality keeps vanishing and reappearing, to purer modes of abstraction that could veer, in flattened silhouettes, between the rectilinear shapes of manmade geometry and the quivering contours of a living landscape.

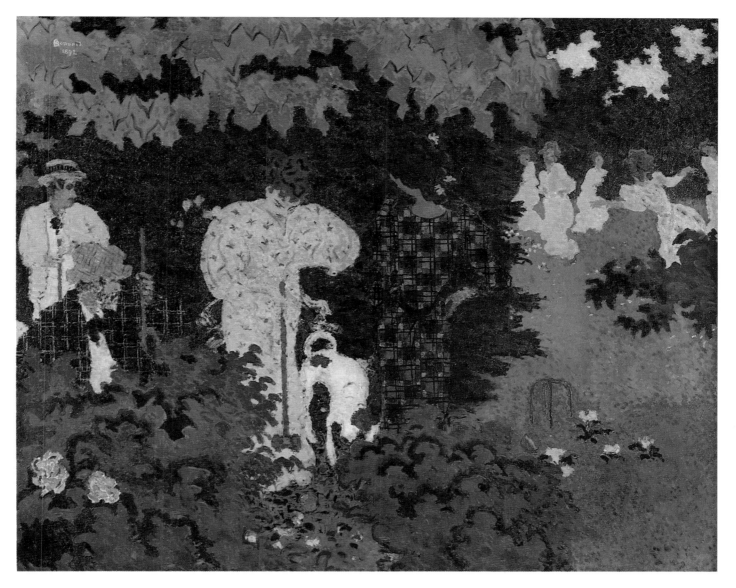

PIERRE BONNARD, Fontenay-aux-Roses 1867–Le Cannet 1947
Twilight (The Croquet Party), 1892 (Salon des Artistes Indépendants, 1892)
4′ 3¼″ x 5′ 3¾″ (130 x 162 cm) Gift of Daniel Wildenstein, 1985.
RF 1985-8

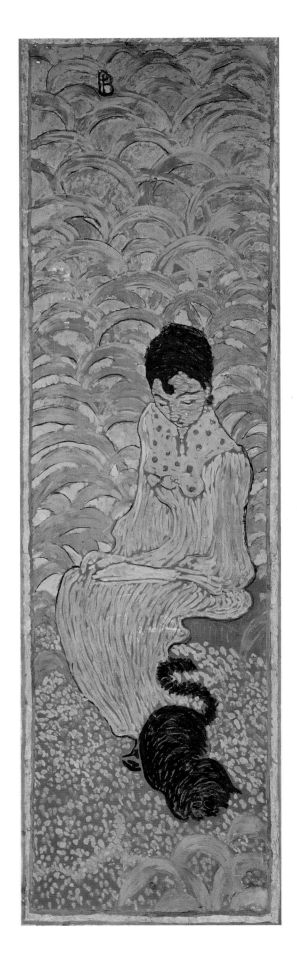

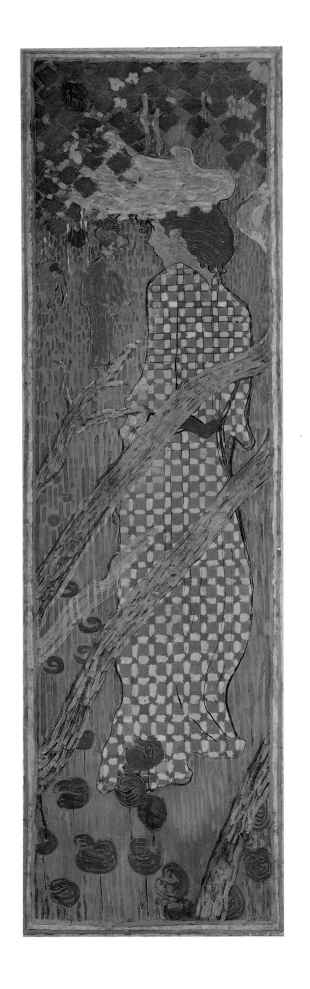

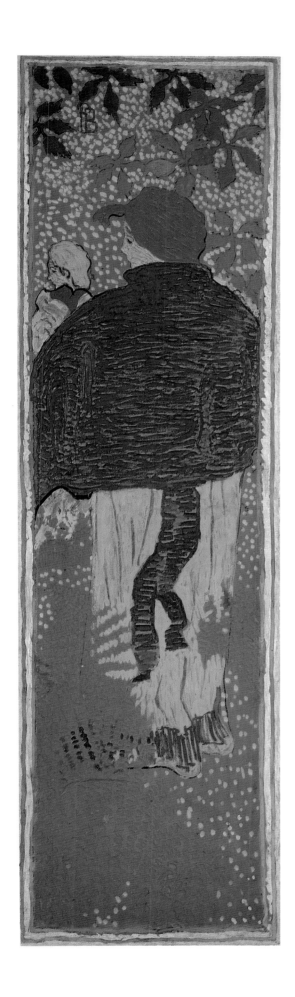

PIERRE BONNARD
Women in the Garden, 1891 (Salon des Indépendants, 1891)
Three of four panels, each 5′ 3″ x 1′ 7″ (160 x 48 cm)
RF 1984-159, 160, 161, 162

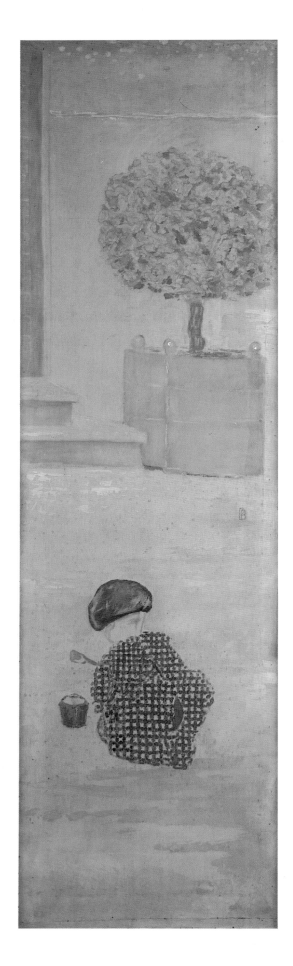

facing page, top

PIERRE BONNARD
By Lamplight, 1899
Oil on board, 1′ 1½″ x 1′ 5¼″ (34 x 44 cm) RF 1979-15

facing page, bottom

PIERRE BONNARD
Interior (Women and Children), 1899
Oil on board on panel, 1′ 9½″ x 1′ 10″ (54.5 x 56 cm) RF 1977-70

PIERRE BONNARD
Child with Sand Castle (section of screen), 1894–1895
5′ 5¾″ x 1′ 7¾″ (167 x 50 cm) RF 1982-69

PIERRE BONNARD
The White Cat, 1894
1′ 8″ x 1′ 1″ (51 x 33 cm) RF 1982-74

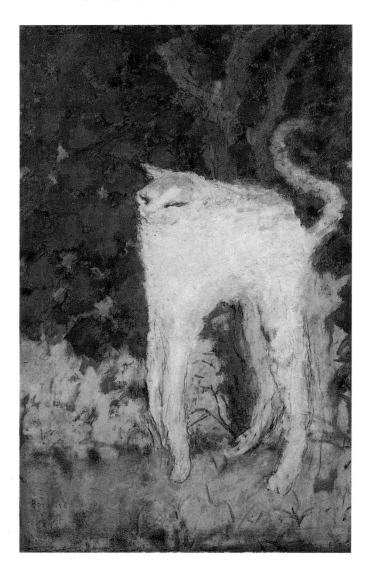

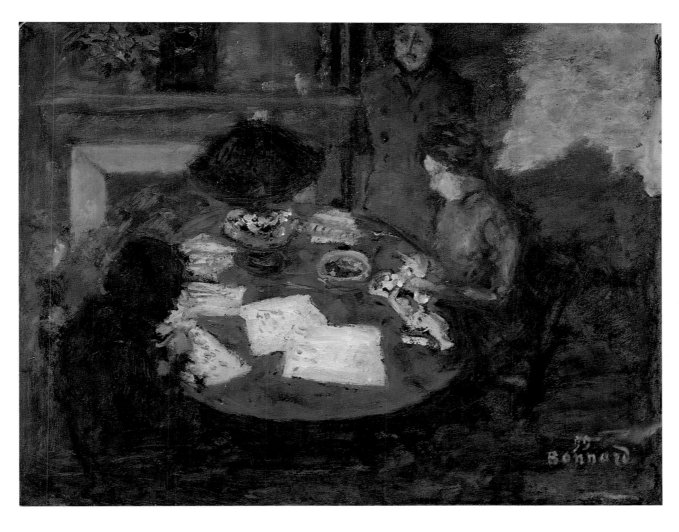

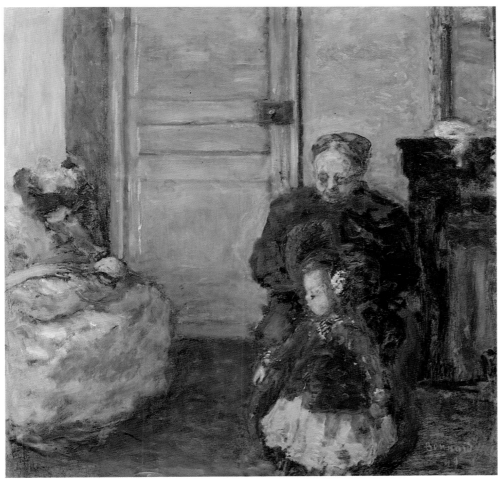

Pierre Bonnard
Man and Woman

*W*ithin Bonnard's long career, this large yet intimate painting comes as a surprise. Its forceful vertical divider, which turns out to be a folded screen crowned by the lower part of a chandelier, sets up an almost monumental duality of male and female, each confined by an axis of symmetry. The male nude (unique in Bonnard's work) has the kind of heroic frontality associated with those Symbolist nudes from the turn of the century which, in the hands of Munch or Hodler, reach far from contemporary reality to some transcendental statement about life, love, and death. Yet for all these lofty suggestions of elemental magnetism and sexuality, Bonnard's canvas immediately returns to more casual matters that locate it firmly in his usual milieu of middle-class domesticity. The scene is so matter-of-fact that it suggests an unposed snapshot of any married couple caught in a state of undress—or perhaps a glimpse of a more fleeting sexual encounter—although it undoubtedly mirrors the artist and his adored wife, Marthe.

The erotic charge, however, is diffused by the privacy seemingly afforded both the man and the woman: the would-be accident of the screen divides our view, if not their space. He looks off to the right, as he adjusts what appears to be a large cloth towel or robe, while she, in a more distant plane, curls up on the bed linens and toys with two pet cats. These traditional symbols of feminine sexuality resemble their mistress here much as Manet's staring black cat repeats Olympia's cool gaze. The woman's carnal, indeed kittenish, charm is the more discreet equal of the erotic abandon of *Woman Dozing on a Bed (The Indolent Woman)* of 1899, whose cropped, oblique view is more familiar to Bonnard, Toulouse-Lautrec, and Degas than is the heraldic symmetry of *Man and Woman*. Nevertheless, Bonnard undoes the obviousness of his bifocal structure by the comforting nonchalance of the bedroom, whose tumbled confusion radiates the warmth of flesh with an almost Venetian glow. Both the bed and the framed flower painting above it are cropped, as are the woman's right knee and the man's left arm and shoulder—a device that underlines the casualness of this fragmented slice of modern life. As for Bonnard's rendering of nudity, the pair have no relationship at all to ideal studio models, who would have taken poses of studied clarity to match this polarized symmetry. Instead, we are offered the refreshing, even startling candor of a keyhole view of a modern bedroom, revealing an Adam and Eve living in Paris, 1900.

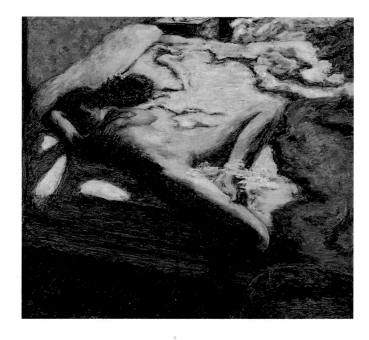

PIERRE BONNARD
Woman Dozing on a Bed (The Indolent Woman), 1899
3' 1¾" x 3' 5¾" (96 x 106 cm) RF 1977-75

facing page
PIERRE BONNARD
Man and Woman, 1900
3' 9¼" x 2' 4½" (115 x 72.5 cm) RF 1977-76

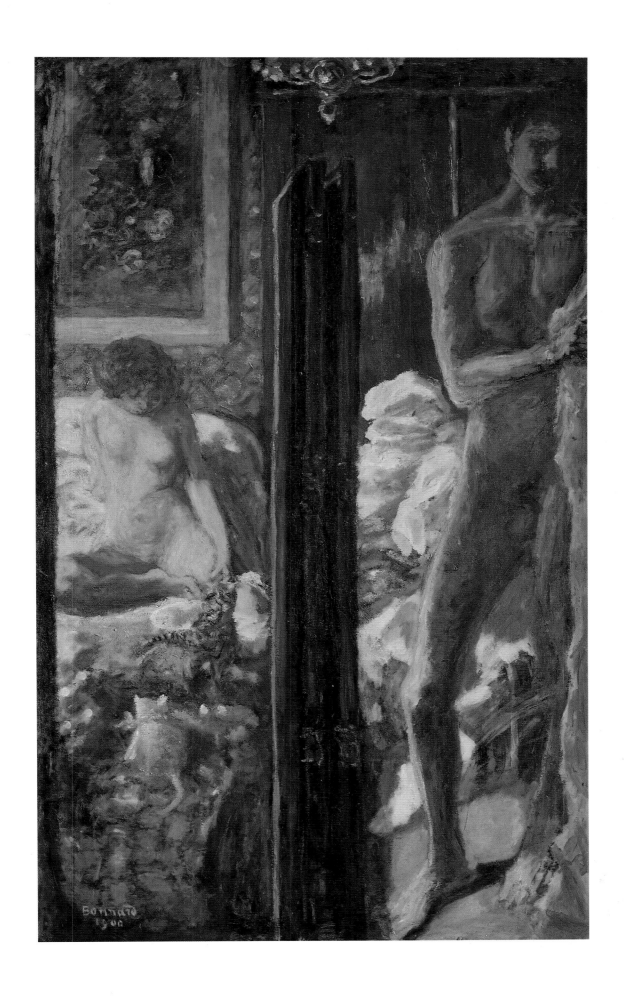

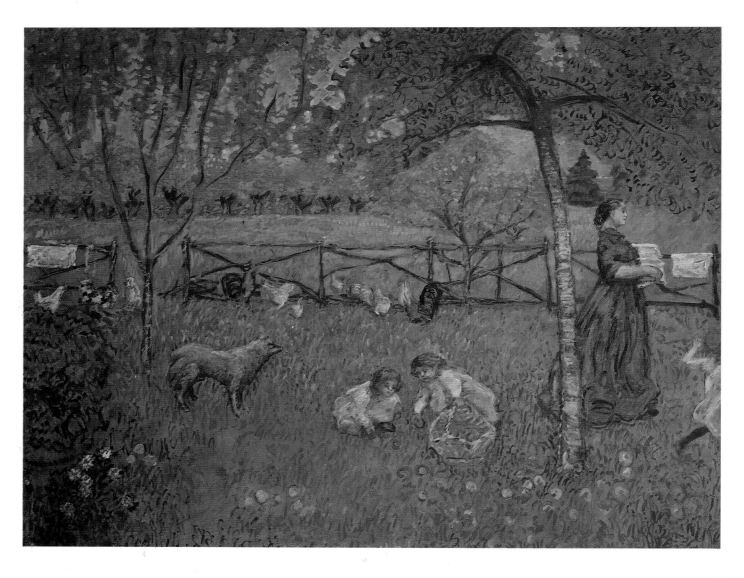

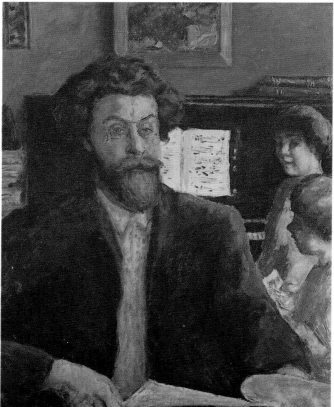

PIERRE BONNARD
The Large Garden, 1898
5' 6¼" x 7' 2½" (168 x 220 cm) Gift of Jean-Claude Bellier, 1982.
RF 1982-59

PIERRE BONNARD
The Composer Claude Terrasse and Two of His Sons, Jean and Charles
(Salon des Artistes Indépendants, 1903)
3' 1¼" x 2' 6½" (94.5 x 77.5 cm) Gift of Mr. and Mrs.
Charles Terrasse, 1978. RF 1980-2

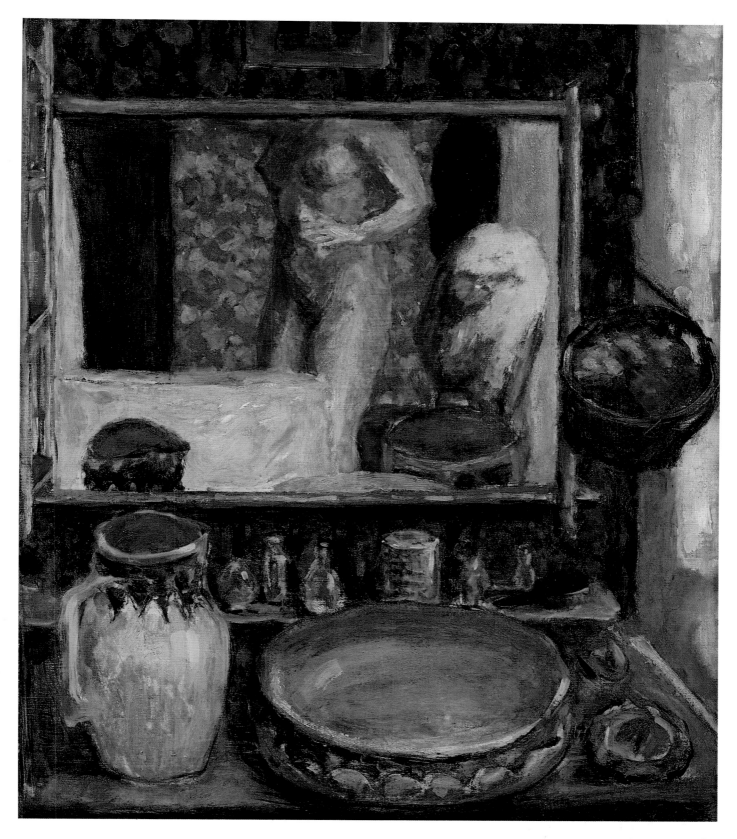

PIERRE BONNARD
The Dressing Table (The Mirror), 1908
1′ 8¾″ x 1′ 6″ (52.5 x 45.5 cm) Bequest of Mr. and Mrs.
Frédéric Lung, 1961. RF 1977-86

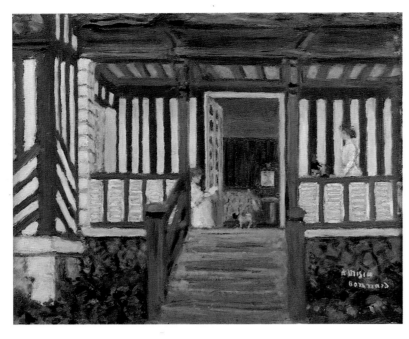

PIERRE BONNARD
Misia's House (The Verandah), ca. 1906
1′ 2¾″ x 1′ 6″ (37.5 x 46 cm) RF 1977-67

PIERRE BONNARD
In a Boat, ca. 1907
9′ 1½″ x 9′ 10½″ (278 x 301 cm) RF 1977-73

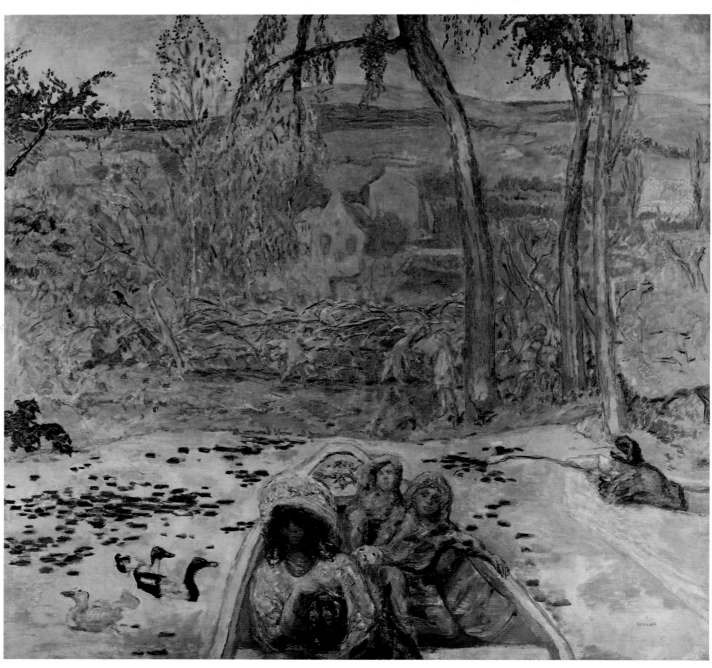

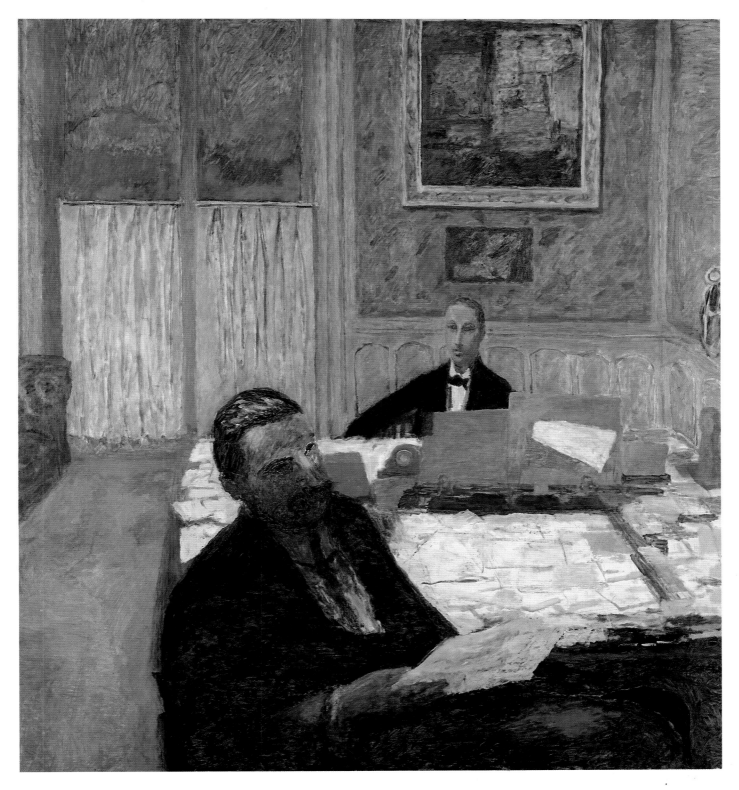

Portrait of the Brothers Bernheim de Villers, 1920
5' 5¼" x 5' 1¼" (165.5 x 155.5 cm) Gift of Mr. and Mrs. Bernheim
de Villers upon their fiftieth wedding anniversary. RF 1977-78

VUILLARD

After the Meal

For most nineteenth-century painters, whether a Seurat or a Bouguereau, ambition and success had to do, among other things, with dimensions. It was in the form of grand public orchestrations of their more private ideas that they hoped traditions would be upheld and their names preserved for posterity. But the reverse was also evident in a world of intimate journals rather than epic novels, of piano reveries rather than symphonies with organ and chorus.

Even in the 1860s, the young Impressionists were often more concerned with the glimpse than the epic view, and by the 1890s, this penchant had turned into a concerted effort to undermine the conventions of heroic canvases for vast audiences. By then, many painters pushed to other extremes, discovering, as if through a microscope of seeing and feeling, the precious wonders of comfortable middle-class apartments in Paris. In these family enclosures, flowered wallpaper, an open bottle of red wine, a few furry pets, bric-a-brac on wall and table, and a peek into perhaps a still cozier room behind a partly closed door create a soothing cocoon sealed off from whatever may lie outside. Among these artists—Bonnard, Vallotton, and Roussel—Vuillard was second to none in extracting whispered poetry from the prosaic facts of domestic life.

After the Meal is a perfect introduction to the diminutive miracles he wrought. Painted on cardboard, only about a foot wide, and seemingly unfinished to the point of illegibility, it looks as though it might have been retrieved from a wastebasket in Vuillard's Paris studio. But what a throwaway it would have been! Remembering that Vuillard's family had been immersed in a visual and commercial ambience of textiles—his uncle had designed cashmere shawls, and after his father's death in 1883, his mother, whose own father had been in the textile business, set up a dressmaker's shop in the family apartment—we may find the first of the painting's Lilliputian pleasures is a swatch of uncommonly refined fabric, seemingly woven from paint. Only to watch the minute dabs of red on a mottled yellow wall plane turn into a fragmentary pattern of stronger red and yellow stripes (or to see this same motif then varied, with green replacing red) is to have a glimmer of the muffled, hedonistic magic that Vuillard could conjure up with what appears to be an effortless touch.

But the magic involves another kind of sleight of hand, in this case the hide-and-seek mysteries Bonnard also explored in the 1890s in a painting like *Twilight (The Croquet Party)* (page 593). What begins as an almost abstract decoration of tapestry-like flatness begins to come alive in another way, as the identity of this or that object teasingly surfaces and then disappears. Although twentieth-century eyes are tempted to read the softened heraldry of stripes and rectangles at the right as a rehearsal for geometric abstraction, we also know that these patterns are probably literal responses to a sequence of near and far curtained doorways fusing and separating in a space whose layers also look backward in history. The ghosts of Chardin's interiors and those of seventeenth-century Holland hover here. More surprising still, the elusive foreground may suddenly move into partial focus, as quick dabs of white paint and an irregular variation in the speckled wallpaper metamorphose into a woman seated on a chair with a yellow-striped back that disappears into the yellow ground and concludes the quiet march of vertical stripes that begins with the curtains at the right. And if a few strokes of black above clearly evoke a frame around some image (is it a painting, a print,

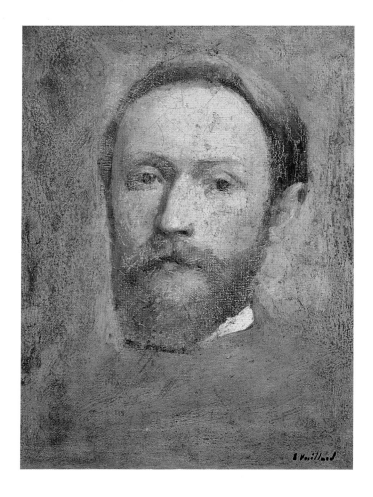

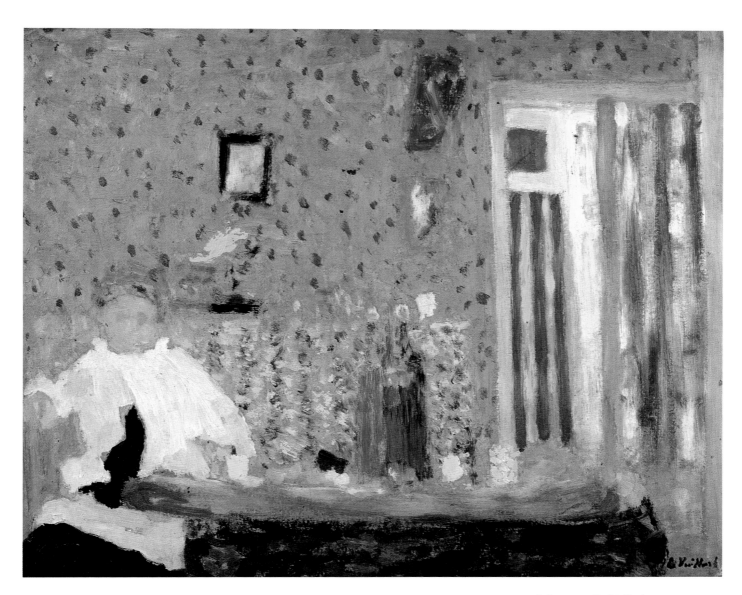

or perhaps one of the photographs Vuillard himself took of his beloved interiors?), their contagious black pigment reappearing in two places around the tabletop is more elusive, perhaps evoking the sly appearance of two black cats seeking food or family warmth.

Such visual alchemy, in which objects evaporate and congeal, parallels the no less dazzling verbal subtlety of Vuillard's friend, the Symbolist poet Stéphane Mallarmé, who could dissolve and merge commonplace words and syntax into a language where all is fluid suggestion. Vuillard's description of things seen becomes more like a description of things loved and remembered, Proustian madeleines that trigger the sensuous recall of everyday pleasures. But if they have the character of miniature, fragile fragments rather than of sturdy, full-scale wholes, one should also remember that such modest paintings carried with them an abundance of ideas that other masters could amplify to mural dimensions. From such small but exquisite seeds, even the monumental domestic interiors of Matisse could grow.

ÉDOUARD VUILLARD, Cuiseaux 1868–La Baule 1940
After the Meal, ca. 1900
Oil on board, 11″ x 1′ 2¼″ (28 x 36 cm) RF 1977-370

facing page
ÉDOUARD VUILLARD
Self-Portrait, ca. 1889
9¾″ x 7½″ (24.5 x 19 cm) Gift of Jos Hessel, 1942. RF 1977-384

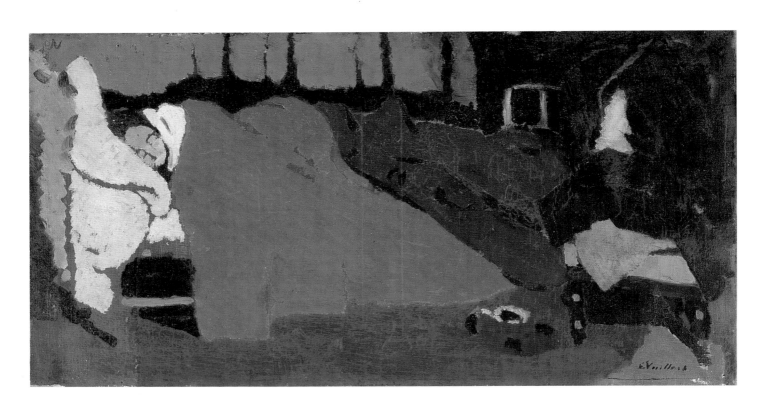

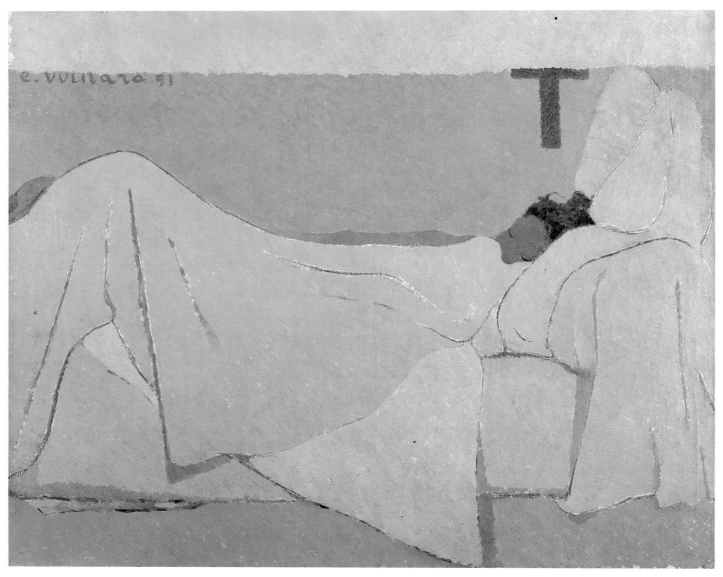

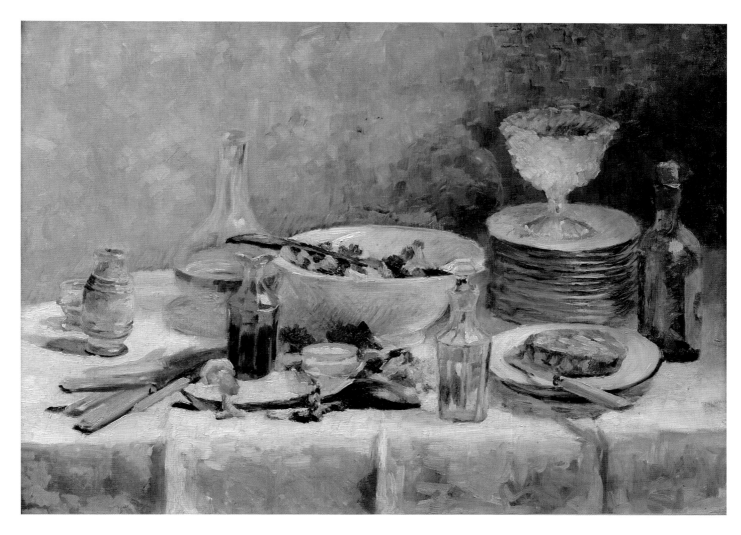

ÉDOUARD VUILLARD
Still Life with Salad Greens, ca. 1887–1888
1′ 6″ x 2′ 1½″ (46 x 65 cm) Bequest of the artist, 1941. RF 1977-382

facing page, top
ÉDOUARD VUILLARD
Sleep, ca. 1891
1′ 1″ x 2′ 1½″ (33 x 64.5 cm) RF 1977-369

facing page, bottom
ÉDOUARD VUILLARD
In Bed, 1891
2′ 4¾″ x 3′ (73 x 92.5 cm) Bequest of the artist, 1941. RF 1977-374

Dr. Georges Viau in His Office
Treating Annette Roussel

*O*nly Vuillard could turn a visit to the dentist into a mysteriously warm and intimate experience. This vignette of focused medical scrutiny and spotlit patient is, to be sure, common enough in real life but startlingly unfamiliar in art. Odd, too, is the fact that this is also a double portrait. The dentist is Dr. Georges Viau, a good friend of the artist, who also loved and collected modern art; the patient is Annette Roussel, the daughter of the painter Ker-Xavier Roussel, with whose family Vuillard had long and close connections in life and in art.

Like most of Vuillard's work after the turn of the century, this canvas of 1914 lets in more air, light, and descriptive detail than he permitted in his muffled camouflages of the 1890s. Here the sharp beam of medical light cuts through the Vuillard fog, providing enough illumination to turn Dr. Viau's ruddy, strongly modeled head into a fully identifiable portrait. In an earlier portrait, that of Vallotton of 1900 (page 580), the facial features of his fellow artist are veiled behind a blur of pink paint that merges into the gray shadows of the wall planes. But most sitters would not commission a portrait in which they turned out to be an invisible ghost. In Vuillard's later years, when he became a master of aristocratic society portraiture, the faces of such chic and blue-blooded Parisiennes as the high-style couturiere Jeanne Lanvin (page 612) and her daughter, the Comtesse de Polignac (page 613), provide the clear and identifiable centers of their elegant domestic universes.

Legible though it is, Vuillard's view of Dr. Viau at work still vibrates with Vuillard's enchantment of the 1890s. Even if we recognize that doctors' and dentists' offices occasionally masquerade as upholstered and wallpapered private interiors rather than as clinically white surgical chambers, Dr. Viau's office has an uncommon comfort. The dental mirror he holds, the porcelain basin, and the adjustable chair for the patient are all magically absorbed in an ambience of intense focus and quietly luminous planes. Even in a literal way, art seems to triumph over medicine. Framed on the wall at the right are not medical-school diplomas but works from Dr. Viau's own collection, including, at the top, a recognizable Carrière.

Dr. Viau was hardly the only man of medicine painted by Vuillard. Among his other art-loving friends were a Dr. Gosset and a Dr. Vaquez, both of whom he painted at work in a hospital, operating on or comforting a patient. Even in these public domains of the medical profession, Vuillard continued to earn his familiar classification as an Intimiste. At his best, he could make one forget that a tooth was soon due for extraction.

ÉDOUARD VUILLARD
Thadée Natanson, 1907–1908
6' 6¾" x 6' 7" (200 x 200.5 cm) Vuillard and Roussel can be seen in the mirror. Bequest of Mrs. Thadée Natanson, 1953. RF 1977-395

facing page, top
ÉDOUARD VUILLARD
Dr. Georges Viau in His Office Treating Annette Roussel, 1914
3' 6¼" x 4' 6¼" (107.5 x 138 cm) RF 1977-396

facing page, bottom
ÉDOUARD VUILLARD
Claude Bernheim de Villers, ca. 1906 (Salon d'automne, 1906)
Oil on paper, 2' 2¾" x 3' 2¼" (68 x 97 cm) Gift of Mr. and Mrs. Gaston Bernheim de Villers, 1951. RF 1977-388

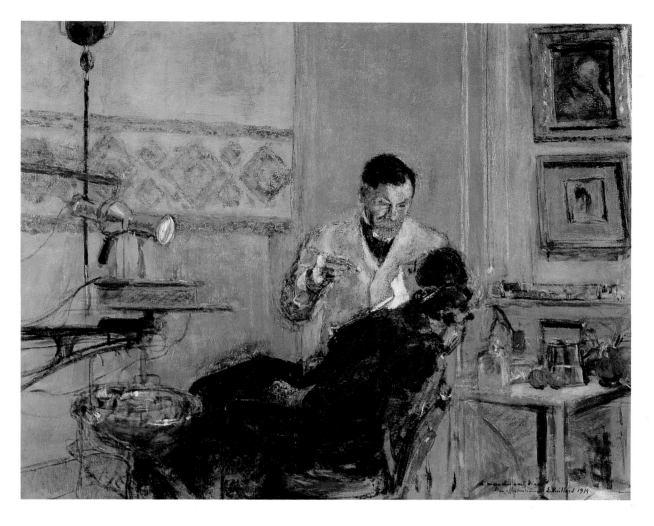

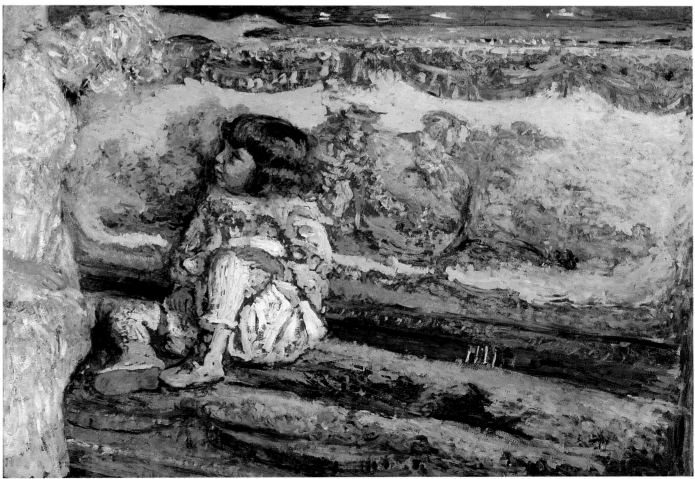

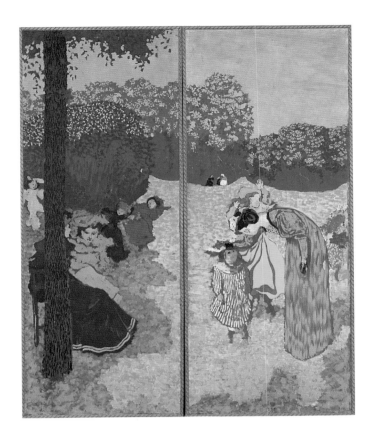

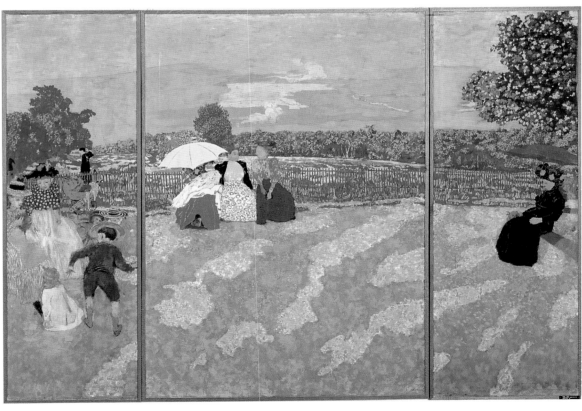

ÉDOUARD VUILLARD
Public Gardens. Little Girls Playing and *The Examination*, 1894
Two panels: 7′ x 2′ 10¾″ and 7′ x 3′ (214.5 x 88 cm and
214.5 x 92 cm) Bequest of Mrs. Alexandre Radot, 1978.
RF 1978-46, 47

ÉDOUARD VUILLARD
Public Gardens. The Conversation; The Nursemaids;
The Red Parasol, 1894
Three panels: 6′ 11¾″ x 5′ 1″, 7′ x 2′ 4¾″, 7′ x 2′ 8″
(213 x 154 cm, 213.5 x 73 cm, and 214 x 81 cm) RF 1977-365

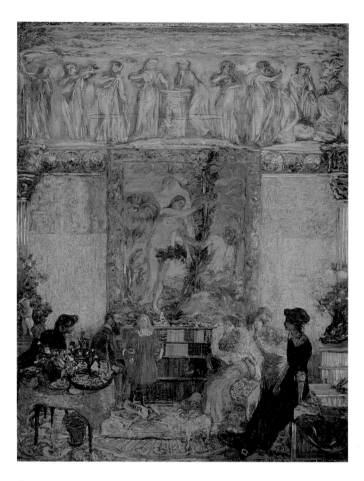

ÉDOUARD VUILLARD
The Library, 1911 (decoration for Princess Bassiano's library)
13′ 1½″ x 9′ 10″ (400 x 300 cm) RF 1977-368

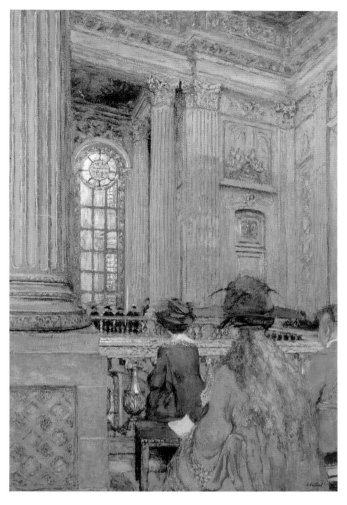

ÉDOUARD VUILLARD
The Chapel at the Château of Versailles, 1917–1919, reworked in 1928
Oil on paper on canvas, 3′ 1¾″ x 2′ 2″ (96 x 66 cm) Gift of Jacques
Laroche, 1947. RF 1947-33

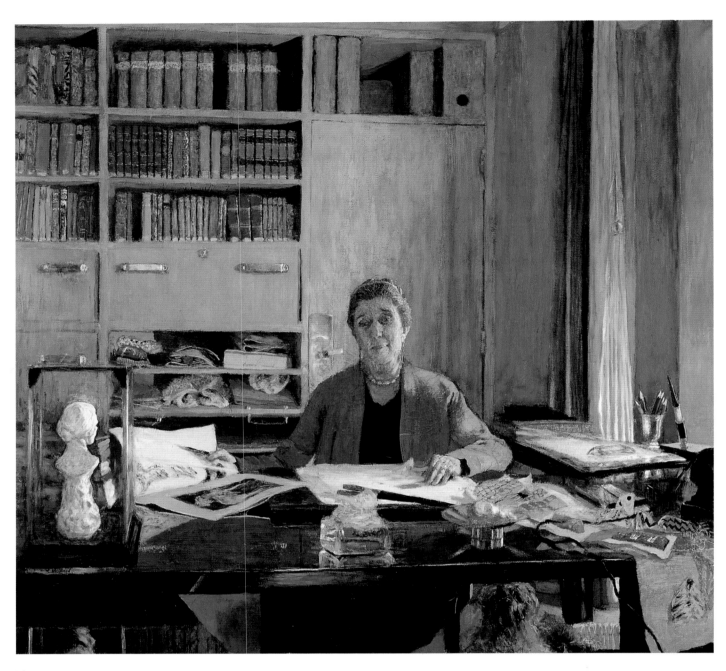

ÉDOUARD VUILLARD
Jeanne Lanvin, ca. 1935
4' 1" x 4' 5¾" (124.5 x 136.5 cm) Bequest of Countess
Jean de Polignac, 1958. RF 1977-399

facing page
ÉDOUARD VUILLARD
Countess Jean de Polignac, 1932
3' 9¾" x 2' 11¼" (116 x 89.5 cm) Bequest of Countess
Jean de Polignac, 1958. RF 1977-398

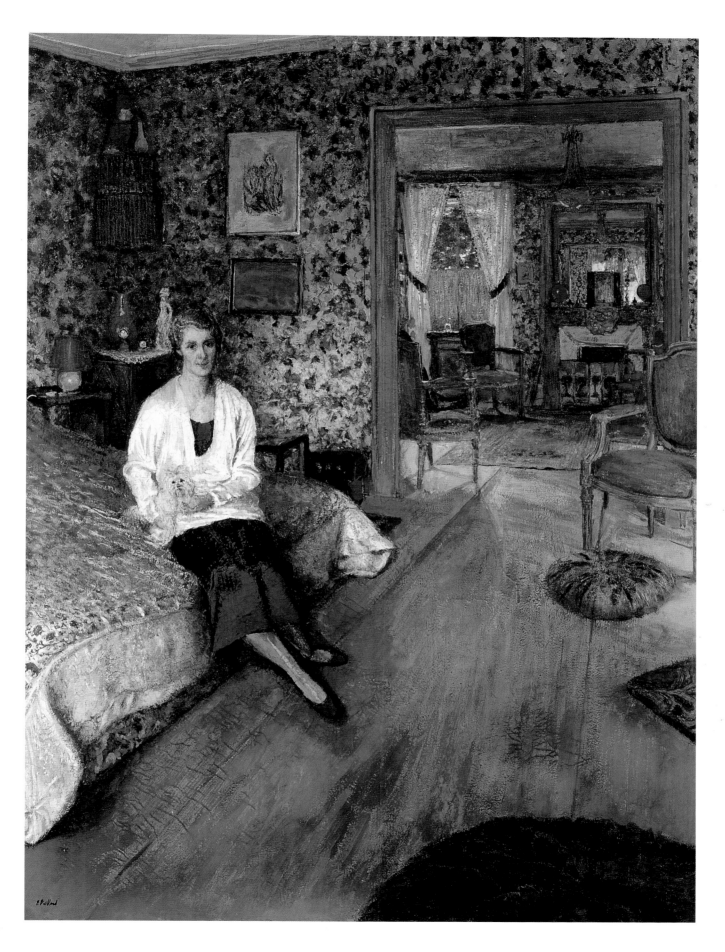

AN INTERNATIONAL ANTHOLOGY

A United Nations of Painters

*I*t goes without saying that for the period 1848 to 1905 the Musée d'Orsay provides the most glorious and comprehensive compilation of French painting in the world; but it is a tonic surprise to discover that, on its walls and down in its storerooms, there is also a virtual United Nations of painters, representing a dizzying variety of countries, from Finland to Australia. Paris, after all, was the sun in the artistic solar system of the nineteenth century and drew artists from every continent to its light. The Expositions Universelles (world's fairs) of 1855, 1867, 1878, 1889, and 1900 propagandized not only the commerce but the art of all nations; by the end of the century, Paris's museum of modern art, the Musée du Luxembourg, under the direction of Léonce Bénédite, was avidly acquiring the widest geographic range of artistic specimens for its encyclopedic permanent collection. Over the decades, then, an amazing number and diversity of paintings from both hemispheres found their way to Paris and stayed there.

Today, art historians and museum audiences seem eager to learn about the buried, unfamiliar histories of nineteenth-century art in nations other than France, as witnessed by recent exhibitions that have offered everything from Polish Symbolist painting to a cross section of Scandinavian painting, 1880–1910. The Orsay collection should turn out to be a treasure trove for scholars on the hunt for the missing-link canvas, as well as for spectators with open eyes and open minds who are willing to enjoy a painting by an artist whose name they couldn't think of trying to pronounce or, as is the case with a Victorian painting of three little girls who would have charmed Lewis Carroll, by an artist still eluding identification. The Orsay's inventory is,

in fact, like a combination gazetteer and Olympic stadium, where new reputations from far and wide remain to be made, and old ones can be freshly examined. Among the American entries, for example, there are such national and international stars as Whistler (page 154), Cassatt (page 304), Homer, Eakins, and Sargent. But there is also a broad selection of less well known painters such as Cecilia Beaux, John White Alexander, Lionel Walden, and Walter Gay that may even surprise specialists in American painting. At Orsay, almost anything can turn up.

If one wants a glimpse of work by one of the more famous Australian painters whose stars have been rising, such as E. Phillips Fox, it can be had at Orsay before traveling to Sydney. If one wants to see a few examples of Canada's finest pictorial sensibility at the turn of the century, James Wilson Morrice is there, too. If one wonders whether such popular French painters of rural labor as Breton and Bastien-Lepage left their mark in, say, faraway Portugal, there is a canvas by José-Julia de Souza-Pinto to prove it. The impact of Impressionism across both the Rhine and the Channel can be discerned in paintings by Max Liebermann and Sir William Orpen. And moving on to Eastern Europe, one can see the pride of Hungary, Mihály Munkácsy, who honored his country throughout the nineteenth-century world (there is even an example in the New York Public Library). He is represented at Orsay by a study for a characteristically operatic religious drama in Budapest, *Christ before Pilate*. Arriving farther east, one can even catch a swift survey of Russian painting, including Leonid Pasternak's intimate little portrait of Leo Tolstoy and Alexeievitch Borissov's travelogue of glacier territory.

This sweeping internationalism, viewed in a palace of French art, helps not only to define national flavors—the equivalent of local cuisines—but establishes dialogues across seas and borders that break down chauvinistic boundaries. The cosmopolitan portrait painter from Ferrara, Giovanni Boldini, gives us unforgettable images of famous Frenchmen like the Comte Robert de Montesquiou. Raimundo de Madrazo y Garreta, a globe-trotting Spaniard born in Rome, offers a preposterously pretentious allegorical portrait of the haughtiest example of French aristocracy, the Marquise d'Hervey Saint-Denys, as none other than the goddess Diana. A no less internationalized German, Franz Xaver Winterhalter, famous for his official images of the court of Napoleon III, is represented by a portrait of the wife of the Russian composer Rimsky-Korsakov. Should we venture to Norway, there is, among others, Frits Thaulow. Renowned in Paris in his day, he is represented by a snow scene from his homeland that was seen at the 1889 Exposition Universelle and that previews, in its white-on-whiteness, the Norwegian landscapes of Monet. And if we want to know what this prosperous, much-feted artist looked like, we can see him and his family recorded by the fashionable French portraitist Jacques-Émile Blanche.

But we can also seek out here the more pungent taste of differing national traditions: the intensely Spanish asceticism and grotesquerie of Ignacio Zuloaga's paintings of an anchorite and of a dwarf; the oddly belated extensions of Pre-Raphaelite preciosity and piety in offbeat British paintings by Maxwell Armfield and Marianne Stokes; the nineteenth-century variants of seventeenth-century Dutch paintings of church interiors and seascapes in works by Jacob Maris, Hendrik Mesdag, and Anton Mauve. The Musée d'Orsay reminds us again that art may speak an international language, but often does so with strong accents.

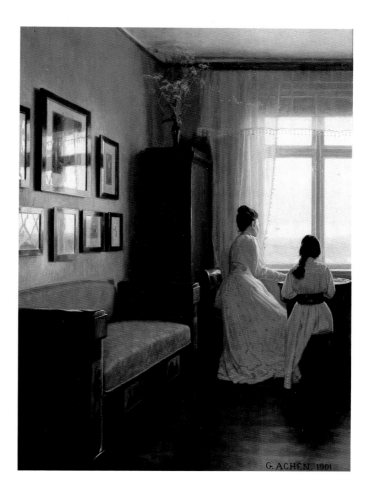

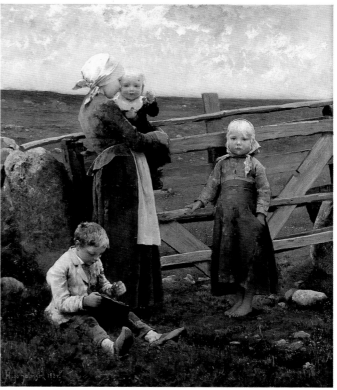

GEORG NICOLAJ ACHEN, Frederiksund 1860–Copenhagen 1912
Interior, 1901
2′ 1¾″ x 1′ 7″ (65.5 x 48.5 cm) RF 1980-54

HUGO FRÉDÉRICK SALMSON, Stockholm 1843–Lund 1894
Gateway to Dalby at Skane, 1884 (Salon of 1884)
2′ 3¾″ x 2′ (91 x 81 cm) RF 407

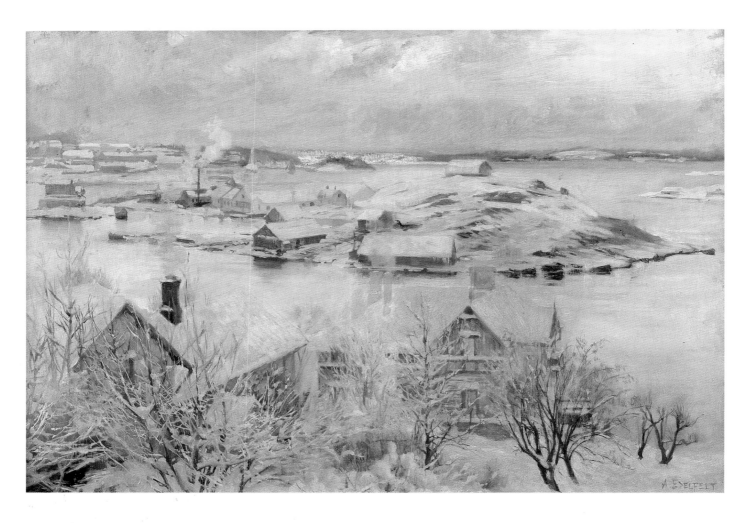

ALBERT EDELFELT, Helsinki 1855–Borgaen 1905
December Day (Salon de la Société Nationale des Beaux-Arts, 1893)
1′ 8½″ x 2′ 10¼″ (52 x 87 cm) RF 849

FRITS THAULOW, Oslo 1847–Volendam 1906
A Winter Day in Norway, 1886 (1889 Exposition Universelle)
3′ 2½″ x 5′ 2½″ (98 x 159 cm) RF 565

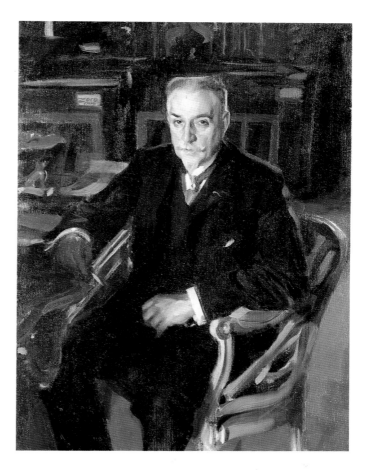

NILS GUSTAV WENTZEL, Oslo 1859–Lom 1927
Sailor's Funeral in the Country, Norway, 1896
4′ 11″ x 7′ 7¼″ (150 x 232) RF 1215

ANDERS ZORN, Mora 1860–Mora 1920
Alfred Beurdeley (1847–1919), 1906
5′ 5″ x 2′ 11¼″ (165 x 89.7 cm) Bequest of Marcel Beurdeley, 1979.
RF 1979-48

BRUNO ANDREAS LILJEFORS, Uppsala 1860–Uppsala 1939
The Curlews, 1913 (Salon of 1913)
3′ 11″ x 7′ 2½″ (119.5 x 220 cm) RF 1980-132

Winslow Homer
A Summer Night

For Americans at least, no artist could better represent a kind of tough Yankee insularity than Winslow Homer, and to see a painting of his, especially one of the Maine coast, in the midst of a vast collection of modern French painting is always a jolt. But there is also the fact that Homer had already been to Paris in 1866–67, when he exhibited two Civil War paintings at the 1867 World's Fair. Moreover, this much later painting of 1890 was also an international ambassador, having been exhibited in Paris at the 1900 World's Fair, where it received a gold medal that Homer was to cherish even on his deathbed, and was then bought by the state for the collections of the Musée du Luxembourg, Paris's museum of modern art. Seen within a European rather than an American context, Homer's ominous nocturne may, in fact, seem surprisingly at home, revealing international dimensions.

The scene of nominally simple, almost folkloric genre is real enough, apparently inspired by Homer's observation one summer night at Prouts Neck of two young women waltzing together on a front porch, dramatically lit by the lamps from within a house that would lie on the spectator's side of the canvas. But this prosaic event is strangely fraught, an initially chaste entertainment charged with a mood of sexual longing akin to that of works by Edvard Munch and other European Symbolists of the 1890s. The men in the painting, their backs turned to the women, are disembodied black silhouettes, phantoms that almost merge with the shadows on the sea. In contrast, the coupled women are fleshy and sensual, especially by late Victorian standards, combining in a close physical interlocking a frontal view of an enrapt pink face and a rear view that surprisingly discloses, beneath the long gown, a ripe roundness of waist and buttocks. Most potently, there is the awesome vista of moonlit ocean, the rough breakers, so wildly flecked with white pigment, finally receding to an almost uninterrupted horizon line that stretches out to infinity. With this, Homer provides an engulfing nocturnal drama that seems to animate and overpower these virginal dancers.

Homer's willful remoteness from Europe, and even from New York or Boston, during his last decades might suggest that his art should be clocked by his own time alone. In fact, despite its strongly regional American accent, *A Summer Night*, with its aching image of sexual awakening, fits quite comfortably into any international repertory of Symbolist art in which men and women, like those in Munch's *Dance of Life*, are pitted against overwhelming natural forces beyond their control.

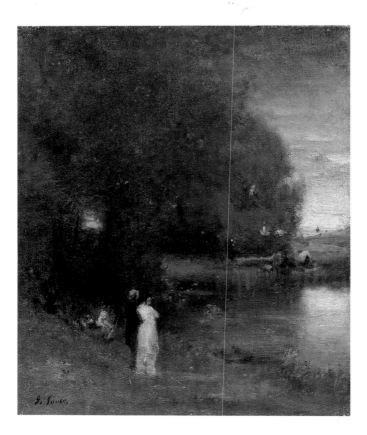

GEORGE INNESS
Newburgh (New York) 1825–Bridge of Allan (Scotland) 1894
Over the River
1′ 2″ x 1′ (35.7 x 30.7 cm) Gift of Mr. and Mrs. Atherton Curtis, 1938. RF 1938-52

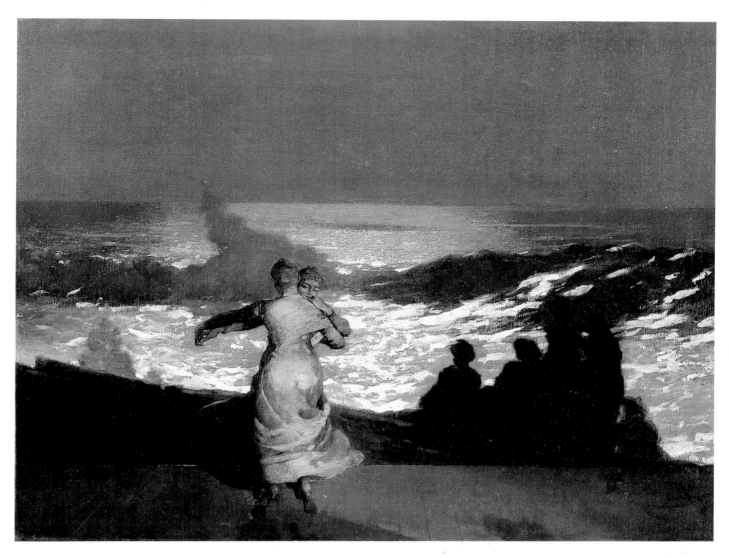

WINSLOW HOMER, Boston 1836–Prouts Neck (Maine) 1910
A Summer Night, 1890
2′ 6¼″ x 3′ 4¼″ (76.7 x 102 cm) RF 1977-427

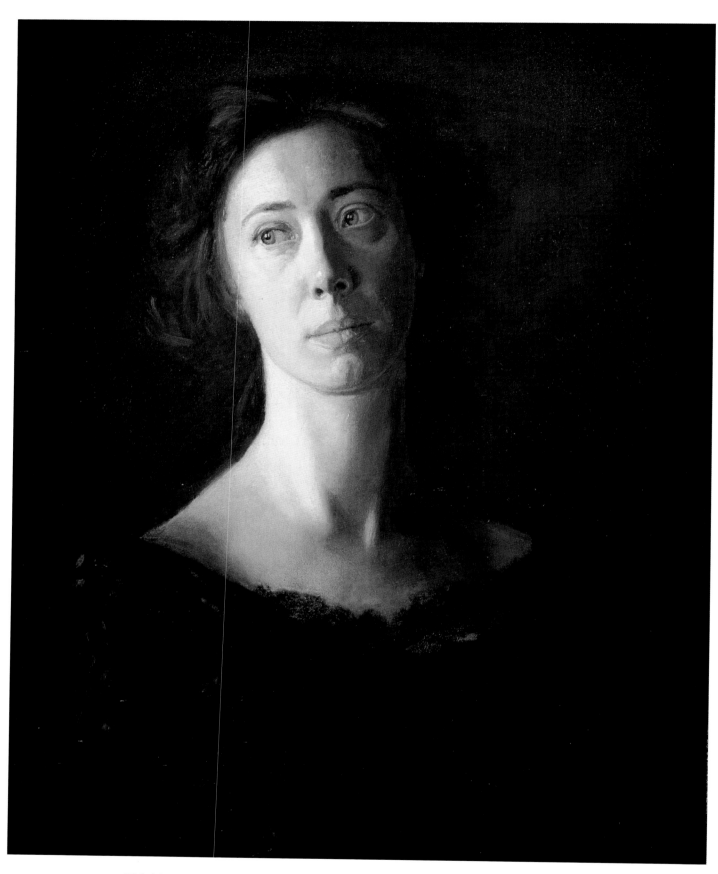

THOMAS EAKINS, Philadelphia 1844–Philadelphia 1916
Clara (Clara J. Mather), ca. 1900
2' x 1' 8" (61 x 51 cm) Gift of Mrs. Eakins, 1930. RF 3641

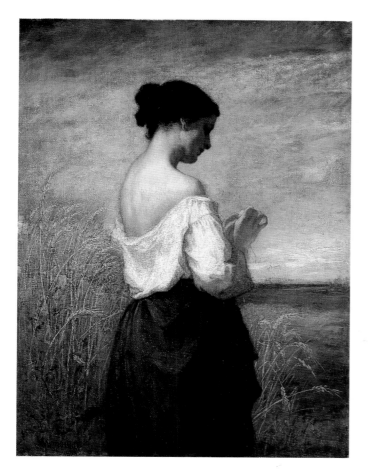

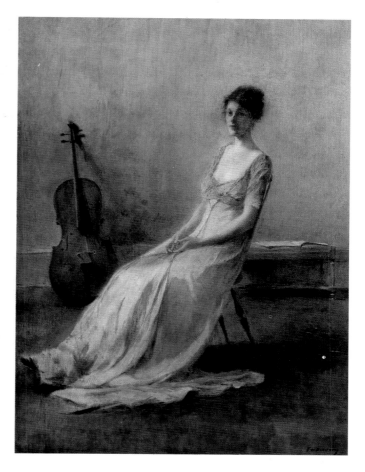

WILLIAM MORRIS HUNT, 1824–1879
Peasant Girl, 1852 (possibly Salon of 1852)
3′ 9¾″ x 2′ 11¼″ (116.2 x 89.7 cm) Gift of Mrs. Roland C. Lincoln, 1927. RF 2618

THOMAS DEWING, Boston 1851–New York 1938
The Musician
2′ x 1′ 6″ (61.5 x 46 cm) Gift of John Gellatly, 1921. RF 1980-96

page 622
JOHN SINGER SARGENT, Florence 1856–London 1925
La Carmencita (Salon de la Société Nationale des Beaux-Arts, 1892)
7′ 7¼″ x 4′ 8″ (232 x 142 cm) RF 746

page 623, clockwise from top left
WILLIAM MERRITT CHASE
Franklin Township (Ind.) 1849–New York 1916
Girl in White
4′ 6¼″ x 3′ (137.5 x 92 cm) Gift of Roland Knoedler, 1921.
RF 1980-81

CECILIA BEAUX, Philadelphia 1863–New York 1942
Sita and Sarita (Girl with a Cat) (Salon de la Société Nationale des Beaux-Arts, 1896)
3′ 1″ x 2′ 1″ (94 x 63.5 cm) Gift of the artist, 1921. RF 1980-60

JOHN WHITE ALEXANDER, Pittsburgh 1856–New York 1915
Gray Portrait (The Lady in Gray) (Salon of 1893)
6′ 2¾″ x 2′ 11½″ (190 x 90 cm) RF 1151

JOHN SINGER SARGENT, Florence 1856–London 1925
Edouard Pailleron, 1879
4′ 2½″ x 3′ 1¾″ (128 x 96 cm) Gift of Mme. Pailleron, 1950.
DO 1986-17

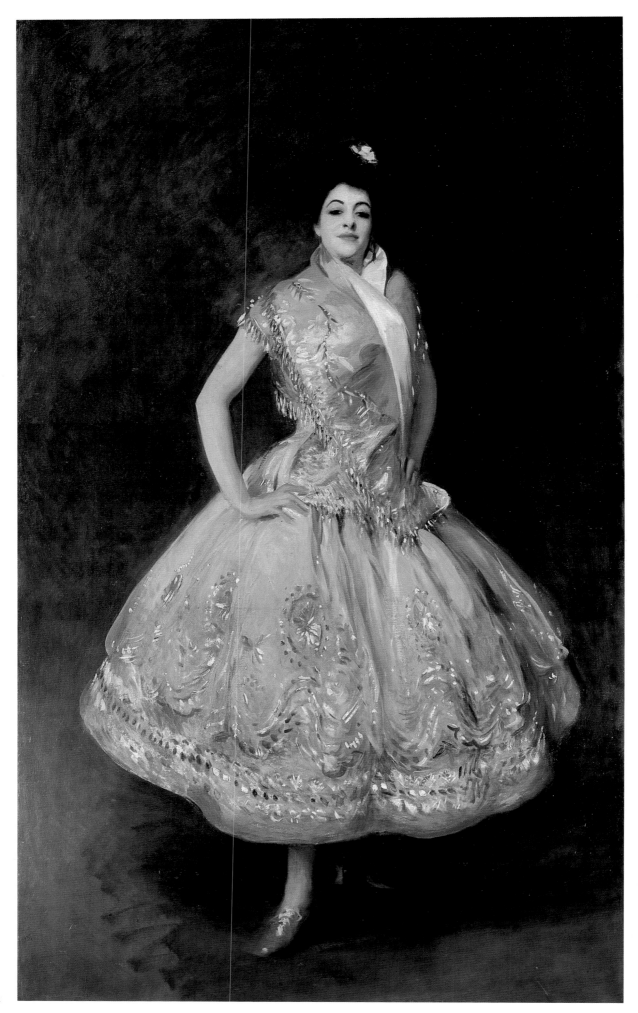

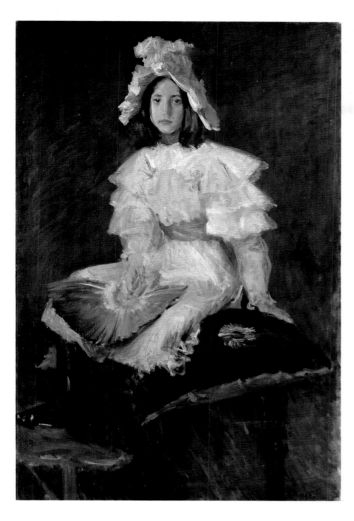

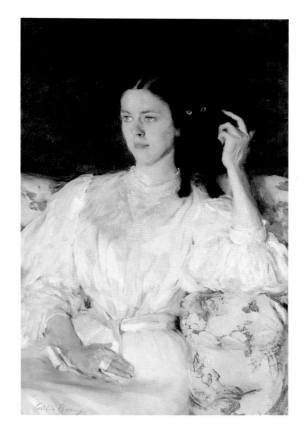

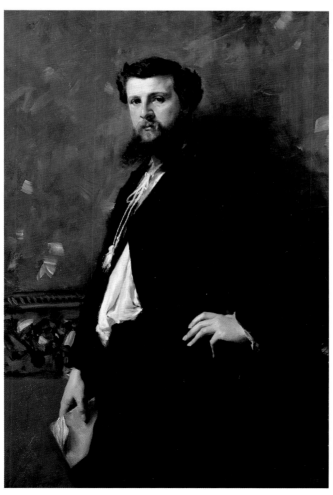

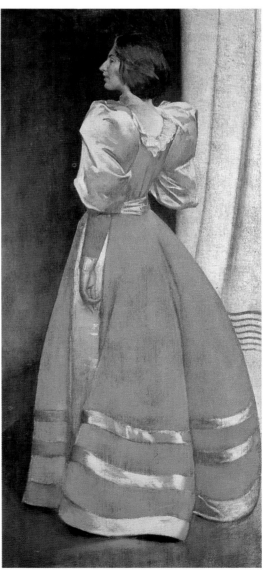

Lionel Walden
The Docks at Cardiff

*O*bscure even in the annals of American art, Lionel Walden, when categorized by nationality, looms large in the Orsay collections, where, with his compatriots, including the illustrious Whistler, Cassatt, Homer, Eakins, and Sargent, he must represent his country. Like them, he had studied in Paris (with Carolus-Duran) and was often included in exhibitions there that placed his work in a cosmopolitan milieu. His gloomy view of the Cardiff docks was painted in 1894 and exhibited in Paris two years later at the Salon. It belongs to an international category of later nineteenth-century painting that, almost as if in self-defense, would translate into the language of aesthetic sensibility what for many was the ever-more-conspicuously ugly world of industrial growth and modern transportation. Monet, in his views of the Gare Saint-Lazare (page 271), had already performed this alchemy in the heart of Paris. Here in the most depressing reaches of Wales's major shipyards, Walden manages to juggle such conventionally anti-aesthetic facts as railroad tracks, factories, steam engines, cargo ships, and railway signals into a foggy nocturnal poetry of a sort earlier explored by Whistler in his London views. The hard and grubby truths of maritime commerce are here submerged under a strangely irregular inventory of nearly abstract patterns: the disembodied glow of red, green, and whitish-yellow lights, both near and far; the metallic lashes of railway tracks that disappear at all sides; the ghostly rigging of the fogbound ships behind; the puffs of smoke from engines and factories that create an artificial cloudscape. Here the crepuscular vision of landscape, so common in the moody reveries of nineteenth-century painting, has been metamorphosed into a more modern kind of mystery, one of veiled mechanical energies, at once a pipe dream and a gritty document of the shipping industry.

facing page, top
LIONEL WALDEN, Norwich (Ct.) 1861–Paris 1933
The Docks at Cardiff, 1894 (Salon of 1896)
4' 2" x 6' 4" (127 x 193 cm) RF 1052

facing page, bottom
ROBERT HENRI, Cincinnati 1865–New York 1929
Snow, 1899 (Salon de la Société Nationale des Beaux-Arts, 1899)
2' 1¾" x 2' 8" (65.5 x 81.5 cm) RF 1336

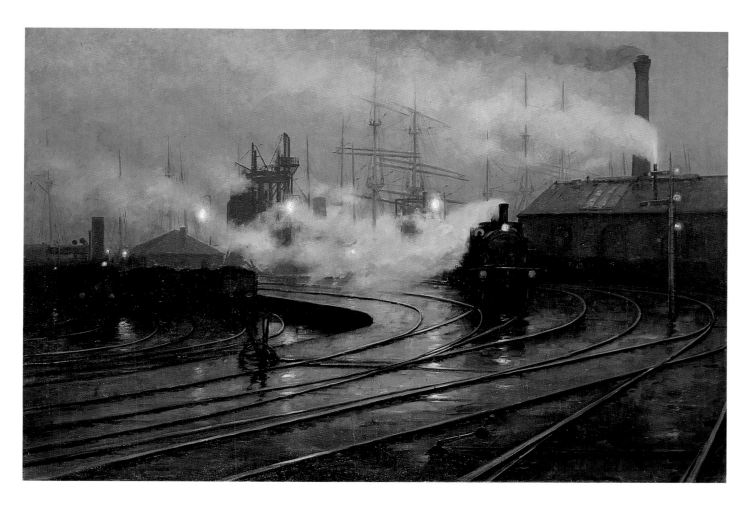

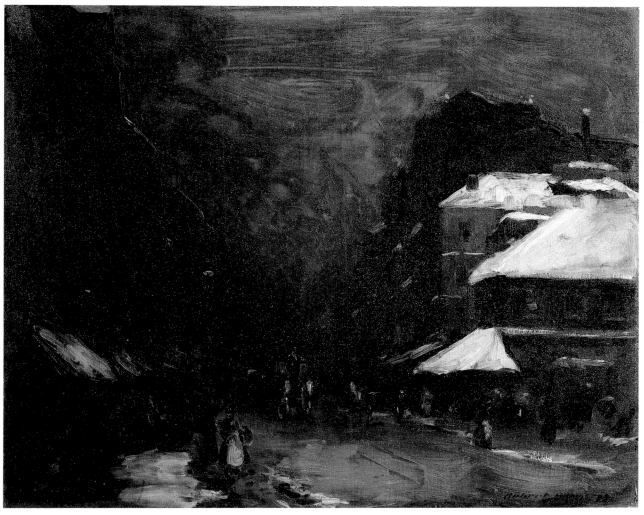

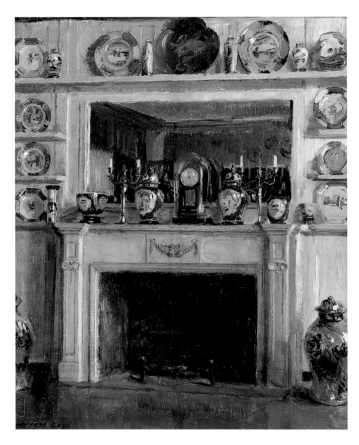

WALTER GAY, Hingham (Mass.) 1856–Bréau 1937
"*Blue and White*" (before 1904)
1′ 11″ x 1′ 6¾″ (58.5 x 47.5 cm) RF 1977-440

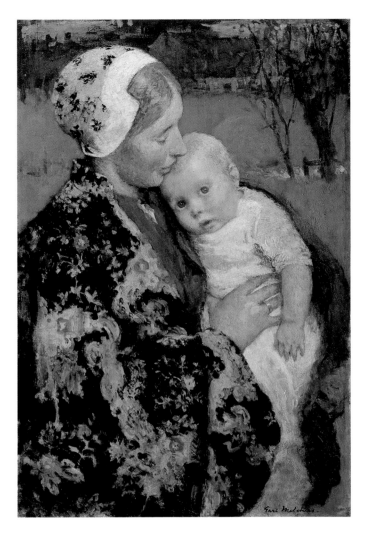

GARI-JULIUS MELCHERS, Detroit 1860–Falmouth (Va.) 1932
Motherhood (Salon de la Société Nationale des Beaux-Arts, 1895)
2′ 3¼″ x 1′ 6¼″ (69 x 46.5 cm) RF 944

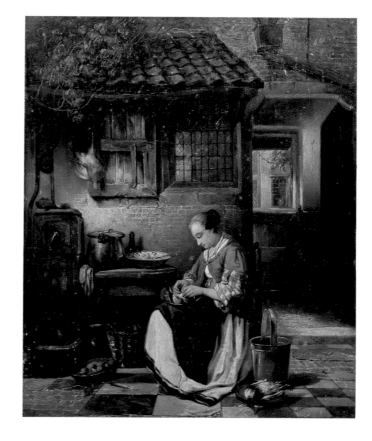

HENRI LEYS, Antwerp 1815–Antwerp 1869
Woman Plucking a Chicken in a Courtyard
1′ 7½″ x 1′ 4″ (49.5 x 40.4 cm) RF 1977-226

HENRI DE BRAEKELEER, Antwerp 1840–Antwerp 1888
Old Curios (before 1900)
1′ 3″ x 1′ 10″ (38 x 56 cm) RF 1196

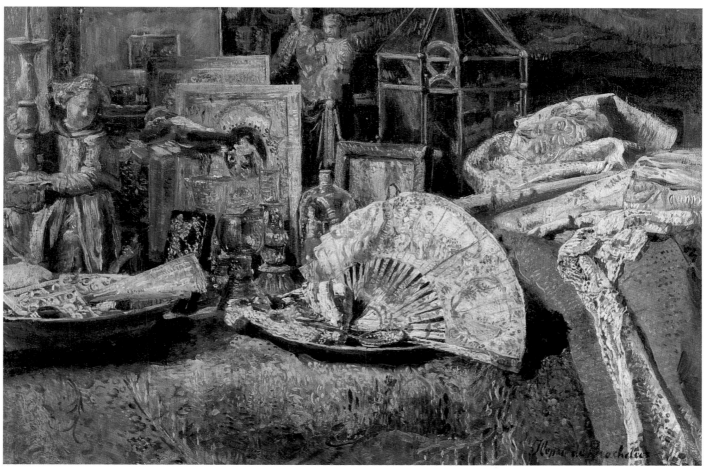

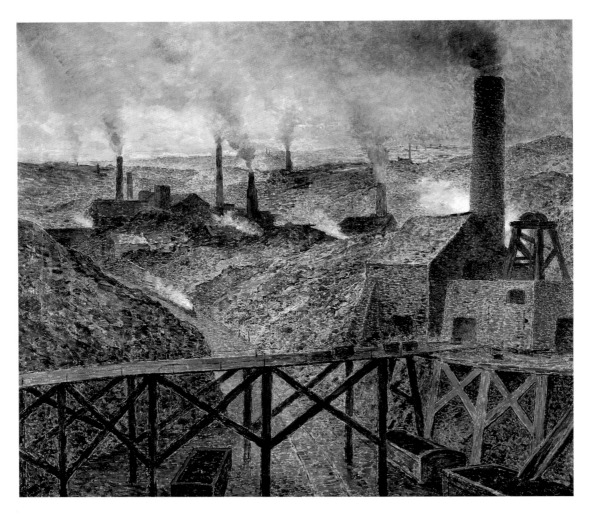

CONSTANTIN MEUNIER, Brussels 1831–Brussels 1905
In the Black Country, 1893
2′ 8″ x 3′ 1″ (81 x 93 cm) RF 1986-81

HENRI EVENEPOEL, Nice 1872–Paris 1899
Charles Milcendeau, 1899
3′ 11¼″ x 2′ 4¾″ (120 x 73 cm) Gift of Charles Milcendeau, 1901.
RF 1977-169

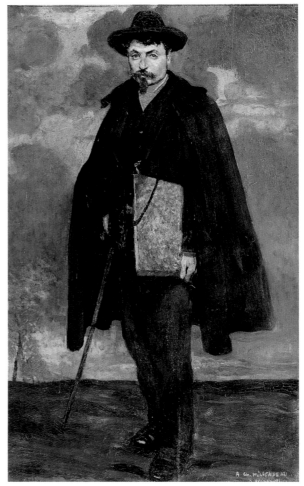

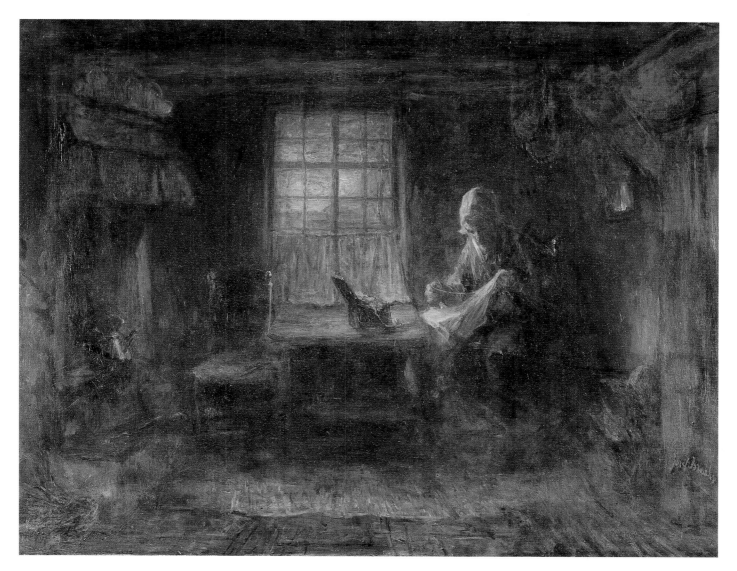

JOZEF ISRAËLS, Groningen 1824–The Hague 1911
Interior of a Hut
3' 5" x 4' 4¾" (104 x 134 cm) Gift of Abraham Preyer, 1926. RF 2550

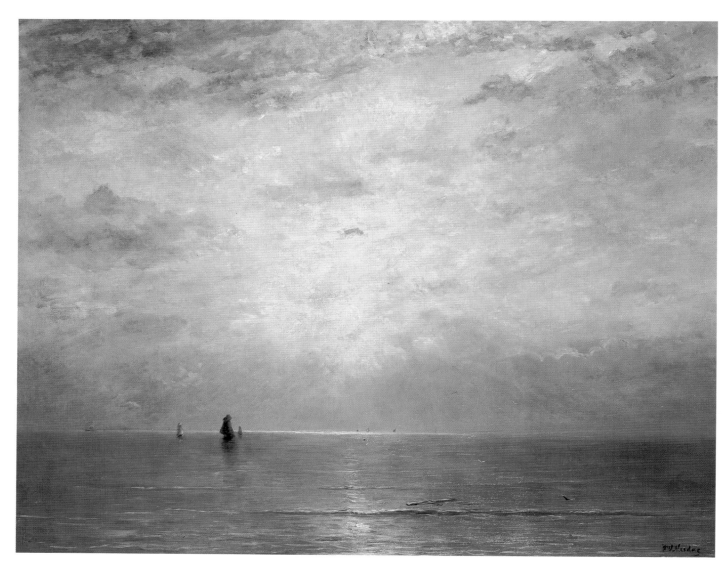

HENDRIK MESDAG, Groningen 1831–The Hague 1915
Setting Sun (Salon of 1887)
4′ 7″ x 5′ 10¾″ (140 x 180 cm) RF 497

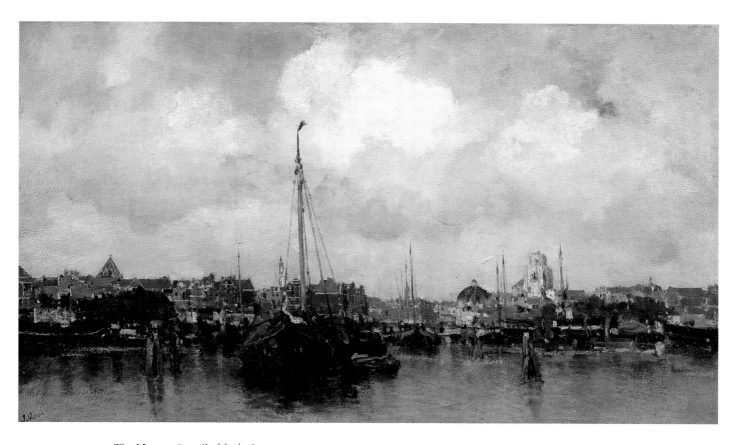

JACOB MARIS, The Hague 1837–Carlsbad 1899
Dutch Town on the Edge of the Sea, 1883
2′ 4¾″ x 4′ 2″ (73 x 127 cm) Gift of Abraham Preyer, 1926. RF 2551

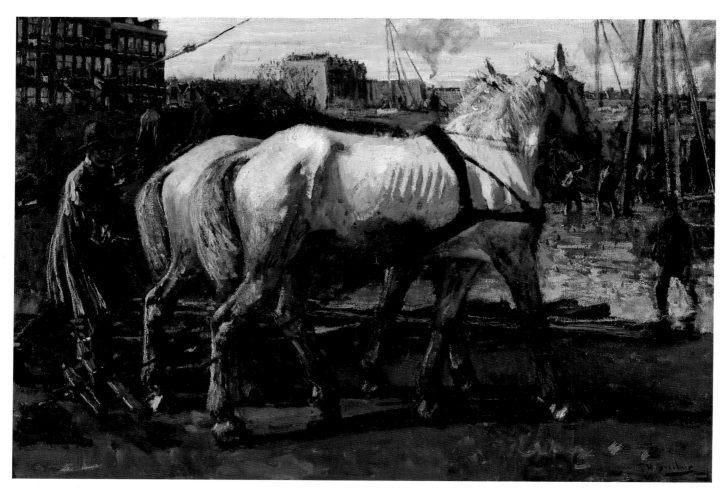

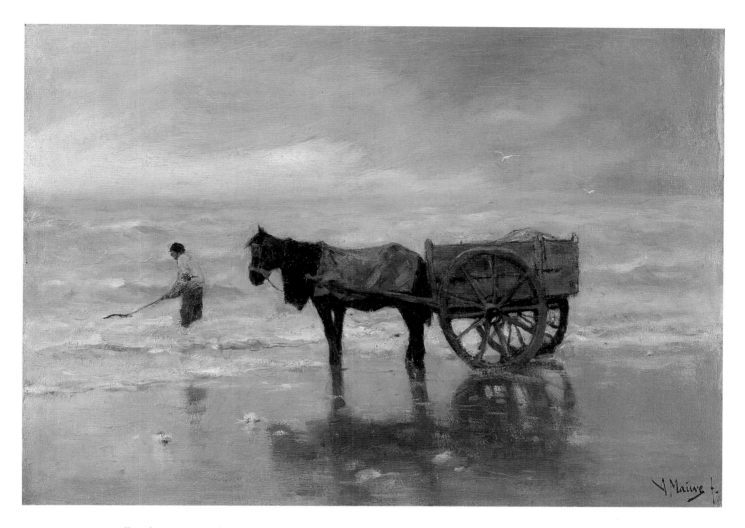

ANTON MAUVE, Zaandam 1838–Arnheim 1888
Gathering Seaweed
1′ 8″ x 2′ 4″ (51 x 71 cm) Gift of Abraham Preyer, 1926. RF 2552

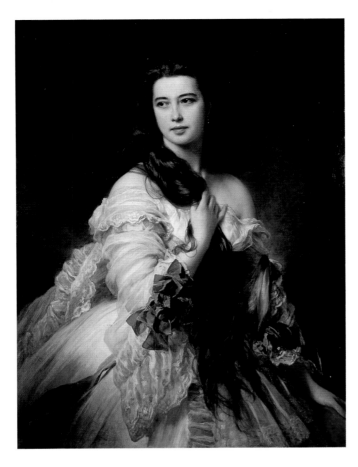

FRANZ XAVER WINTERHALTER
Menzelschwand 1806–Frankfurt 1873
Portrait of Mme. Rimsky-Korsakov, 1864
3′ 10″ x 2′ 11½″ (117 x 90 cm) Gift of her son, Mr. Rimsky-Korsakov.
RF 235

HANS MAKART, Salzburg 1840–Vienna 1884
Abundantia; the Gifts of the Sea, 1870
5′ 4″ x 14′ 8″ (162.5 x 447 cm) RF 1973-51

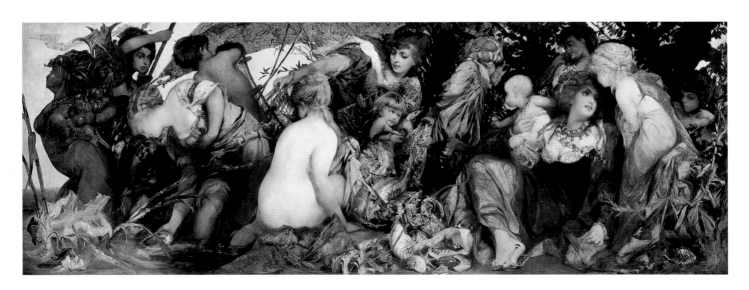

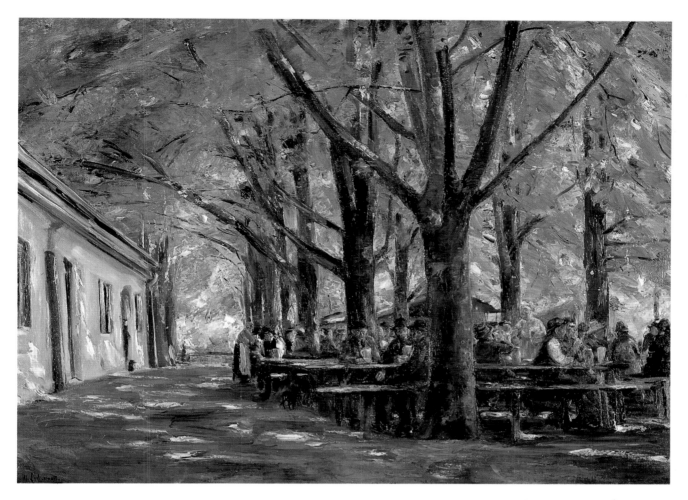

MAX LIEBERMANN, Berlin 1847–Berlin 1935
Country Tavern at Brunnenburg, 1893 (Société Nationale des Beaux-Arts,
1894)
2′ 3½″ x 3′ 3¼″ (70 x 100 cm) RF 1977-227

HANS MAKART
Abundantia; the Gifts of the Earth, 1870
5′ 4″ x 14′ 8″ (162.5 x 447 cm) RF 1973-50

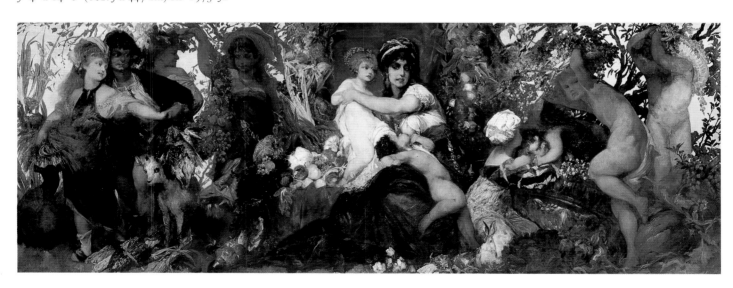

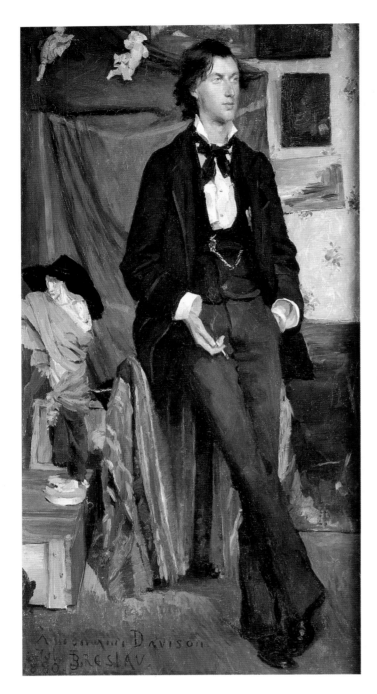

LOUISE BRESLAU, Munich 1856–Neuilly-sur-Seine 1927
Henry Davison, English Poet, 1880
2′ 10″ x 1′ 5¾″ (86.5 x 45.2 cm) Gift of Miss Zillhardt, 1929.
RF 1977-424

facing page, top
ALBERT GOS, Geneva 1852–Geneva 1942
The Breithorn, Seen from Zermatt, before 1909
1′ 3″ x 1′ 9¾″ (38 x 55 cm) RF 1980-107

facing page, bottom
EUGÈNE BURNAND, Moudon (Switzerland) 1850–Paris 1921
The Disciples Peter and John Rushing to the Sepulcher the Morning of the Resurrection, 1898 (Salon of 1898)
2′ 8¼″ x 4′ 4¾″ (82 x 134 cm) RF 1153

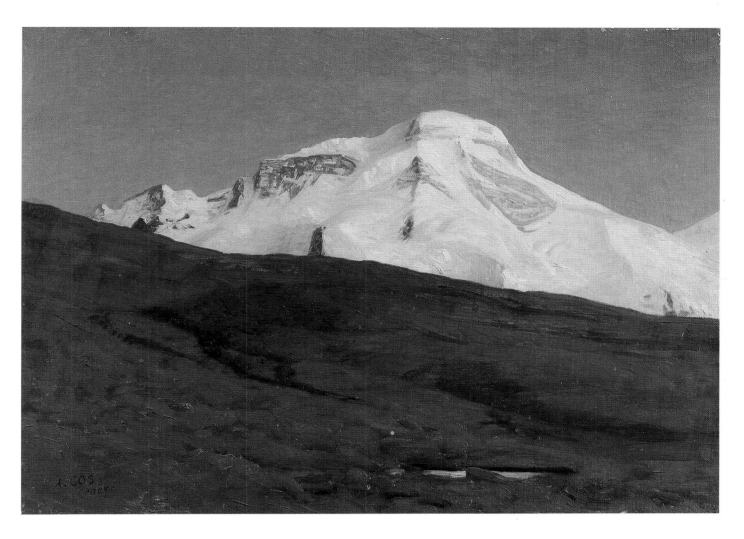

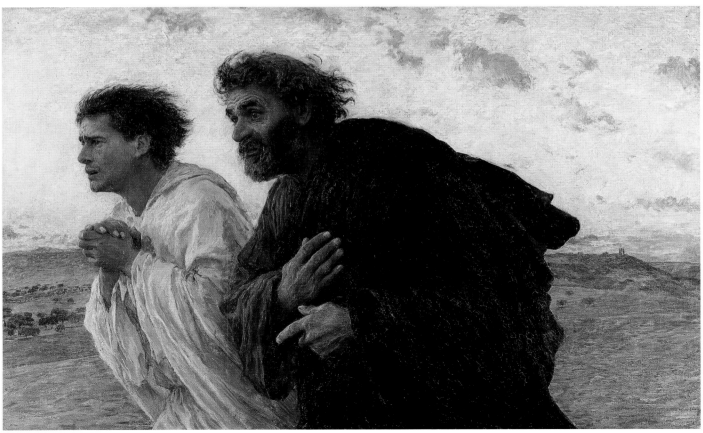

Giovanni Boldini
Henri Rochefort;
Madame Charles Max;
Count Robert de Montesquiou;
The Melon

A member of the most affluent cosmopolitan society, the Italian-born Giovanni Boldini finally settled in Paris in 1872. There, like another expatriate, the American John Singer Sargent (page 620), he became the post-Revolutionary equivalent of a court painter, reporting on and recording, with virtuoso speed, the life-styles of the rich and famous. As represented at Orsay, however, his earliest portrait (page 640) is of a more sober kind in terms of both sitter and facture. The newsworthy subject is Henri Rochefort, a journalist who had loudly opposed the Second Empire, had been a major protagonist in supporting the Commune, and had then, in 1873, been exiled by the Third Republic to a penal colony in New Caledonia, only to escape the following year by sea, together with his fellow fugitives. After Rochefort's return to Paris in 1880, following a general amnesty, his dramatic adventure was painted by Manet in two versions, of which one is at Orsay (page 266). Soon afterward, his portrait, if not his hair-raising escape, was painted by Boldini with a firmness of touch and seriousness of expression relatively rare in his more familiar depictions of Parisian social butterflies.

Few of these flew higher than Madame Charles Max, captured by Boldini in 1896, who in her portrait seems to reach at once for the heights of cool elegance and coquettish daring (Boldini initially prepared for this painting with a nude study). One shoulder strap dropped entirely, one hand holding her long skirt as she catches her balance, Madame Max seems to have just tripped elegantly into our presence at a fashionable soiree. Typically for Boldini and for 1890s ideals of feminine perfection, she resembles in bearing and proportion the borzoi hound so favored as a pet in her circles. The points of her silver shoes, glistening and spiky, tell all, controlling even the angle at which she extends her preternaturally lean arms. Matching this breezy and risqué posture, Boldini pinpoints her with calculated dash. The corner of the room, with its haughty perpendicular skeleton, holds her for a moment, but the brushwork is such a torrent of feathery white strokes that we feel she might blow away. But there is elegant measure here, too; within this slapdash swiftness, all is contained

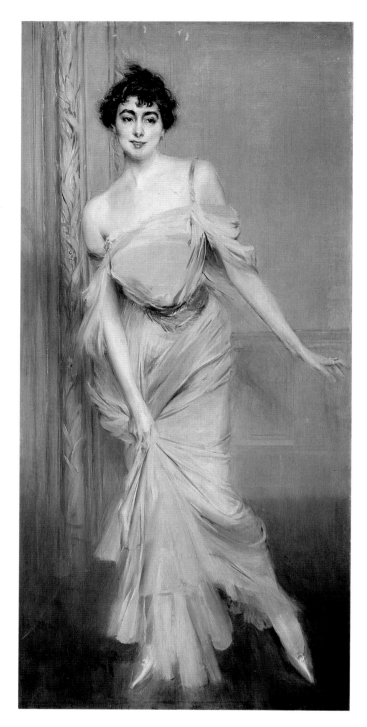

GIOVANNI BOLDINI, Ferrara 1842–Paris 1931
Madame Charles Max, 1896
6′ 8¾″ x 3′ 3¼″ (205 x 100 cm) Gift of Mrs. Charles Max, 1904.

GIOVANNI BOLDINI
Count Robert de Montesquiou, 1897 (Salon of 1897)
5' 5¼" x 2' 8½" (166 x 82.5 cm) Gift of Henri Pinard, 1922.
RF 1977-56

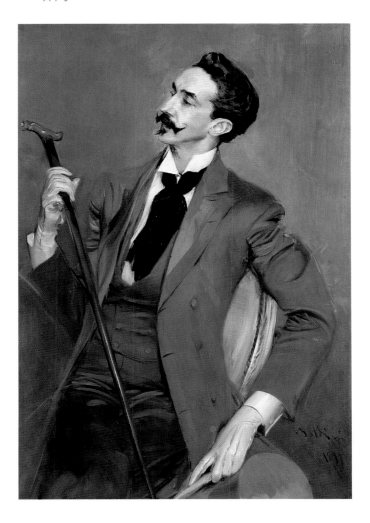

within a Whistlerian range of nuanced whites, a monochrome palette familiar to the fin de siècle as a vehicle of unnameable emotional mysteries and a mark of elite aesthetic discrimination that would counter a vulgar preference for "more is more."

Such whispered flamboyance of costume, tonality, and bearing reaches an attenuated peak in Boldini's portrait, the following year, of one of the most renowned aesthetes and dandies of this period, Count Robert de Montesquiou. The count's posthumous fame was secured through his friendship with the novelist Marcel Proust, who was to re-create him in the role of the Baron Charlus. Earlier, both Joris-Karl Huysmans and Oscar Wilde apparently took him as the inspiration for the heroes of their famous novels of decadence, *A Rebours* and *The Picture of Dorian Gray.* Boldini, it must be said, offers only the outer shell of Montesquiou's legendary heights of refinement, which rivaled the fantasies of Ludwig II of Bavaria. (Montesquiou's fabled dwellings included rooms dedicated to the moon, a chimera-shaped bed, and a sled on a white bearskin that might prompt imaginary voyages.) As tapered and pointed as Madame Max, the count is a creature of silvery-gray sheen, his head and mustache cocked at an angle of perfect aloofness and arrogance, his delicately sinuous torso propped up by the attenuated geometries of a top hat, an oval chairback, and the thinnest of canes. Again, the subdued white-gray tonality recalls Whistler, who, in fact, had earlier painted Montesquiou's portrait. As a characteristic note of exquisite refinement, the almost monochrome palette is discreetly set off by two turquoise touches: the handle of the cane and the cuff link just visible above the white-gloved left hand. Wilde's pithy definition of art as being "at once surface and symbol" might sum up this portrait, were it not that Boldini's almost exclusive concern with surface tends to outshine the symbol half of the equation.

Such a concern is particularly apparent when Boldini turns to inanimate subjects. A small still life of a melon (page 640) seizes this single piece of cut fruit on the run, so to speak. The tilt of the tabletop underlines the angled speed of execution, which has the flourish of the most expert, aristocratic calligraphy, the personal signature that Boldini's international audience would recognize as having an old-master pedigree. Today this bravura brushwork has mainly a strong period flavor typical of high-society portraiture, ca. 1900; but it also looks forward to the more decorative modes of abstract action painting that emerged in the 1950s, of which Georges Mathieu's chic signorial scribbles are closest in kin.

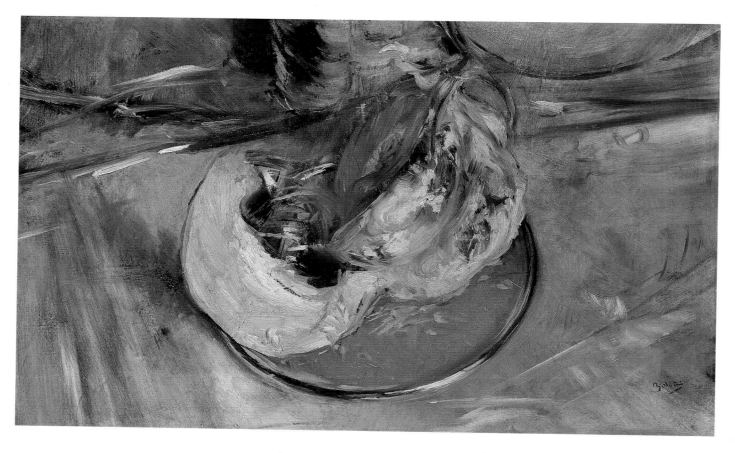

GIOVANNI BOLDINI
Henri Rochefort, ca. 1882
2′ x 1′ 7¾″ (61 x 50 cm) RF 1977-57

GIOVANNI BOLDINI
The Melon, ca. 1905
1′ 2¼″ x 1′ 11½″ (36.5 x 60 cm) Bequest of Carle Dreyfus, 1953.

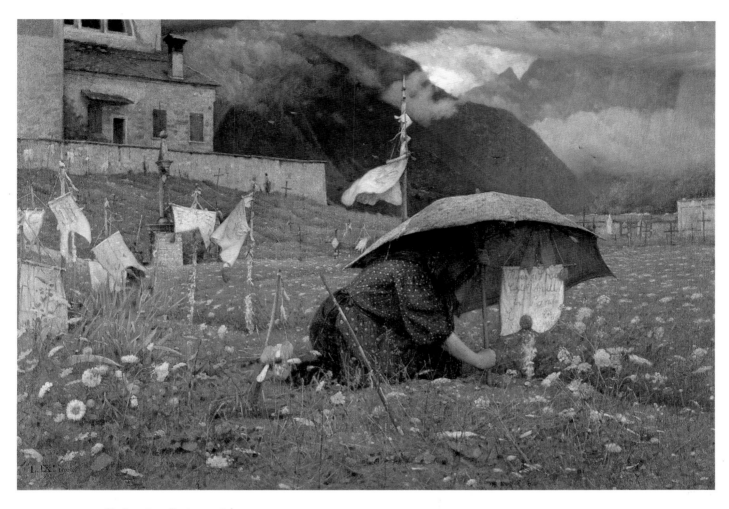

LUIGI NONO, Venice 1850–Venice 1918
First Rain, 1909
4′ 6″ x 6′ 7½″ (137 x 202 cm) RF 1977-277

Angelo Morbelli
Feast Day at the Hospice Trivulzio in Milan

*I*n every Western nation, the broadest spectrum of late nineteenth-century artists (from Degas and Van Gogh to such honored Victorians as Herkomer) would pay tribute to the grim lives of the poor in paintings that, at their best, offered an odd combination of poignant social indictment and triumphant visual and narrative order. Seen, as they were, in the context of art, these paintings could both prick and soothe the spectator's conscience.

In Italy, such a master was the Milan-based Angelo Morbelli, who documented the facts of modern life as he knew them, from the urban excitement of the city's new railway station and the nearby peasants working for starvation wages to the pathetic plight of the poor, lonely old men, as depicted in the canvas at Orsay, who were forced to pass their final years in a Milan hospice waiting to die. The setting is grimly utilitarian and dramatically succinct. The feast day of the title finds only a few feeble inmates indoors, seated with hands clasped as if in prayer on long wooden benches before long wooden tables, one of which bears, as if incised in the grain, the artist's name and the date. Within this bleak and colorless austerity, one of the residents has quietly collapsed and died, apparently unnoticed by his companions. As the only release in this vignette of secular misery, brilliant sunlight is reflected from the windows on the far walls, the workhouse counterpart to the effect of stained glass in a church. In this naturalist context of an unheralded passing from life to death, these disembodied squares of radiant light take on an almost subliminal suggestion of the supernatural, the faint promise of salvation in a scene of regimented, earthbound grief and inertia.

Art-historical time in the nineteenth century is usually clocked by avant-garde developments in France. As such, Morbelli's painting, first seen in Paris at the 1900 World's Fair, may seem laggard in terms of both its nationality and date. Nevertheless, it is also a painting that would not look alien in the milieu of Caillebotte and Degas. From such masters, Morbelli must have learned how to handle the exciting monotony of an insistently repeated, rhythmic beat; the surprise of obliquely angled views; the audacity of unexpected croppings of people and things; the precarious but perfect balance of empty spaces against a human presence. Indeed, Caillebotte's floor-scrapers and Degas's dancers of the 1870s (pages 323 and 338) might well have ended their days in a quiet spatial drama directed by Morbelli.

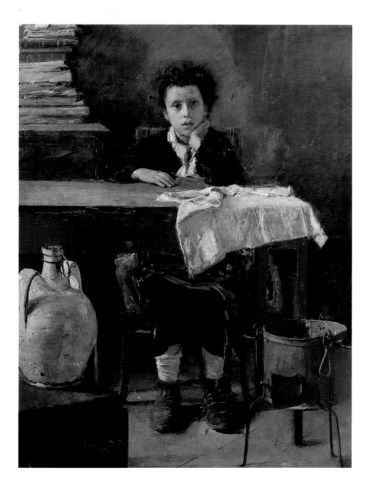

ANTONIO MANCINI, Rome 1852–Rome 1930
The Poor Schoolboy (Salon of 1876)
4′ 3¼″ x 3′ 2¼″ (130 x 97 cm) Gift of Charles Landelle, 1906.
RF 1980-135

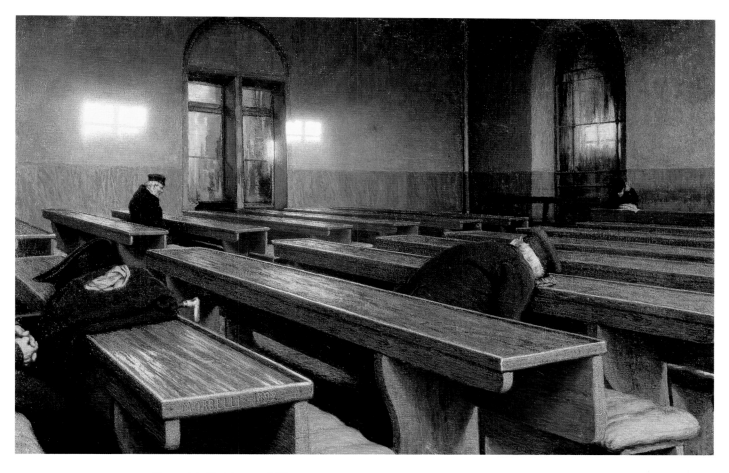

ANGELO MORBELLI, Alessandria (Italy) 1853–Milan 1919
Feast Day at the Hospice Trivulzio in Milan, 1892
2′ 6¾″ x 4′ (78 x 122 cm) RF 1193

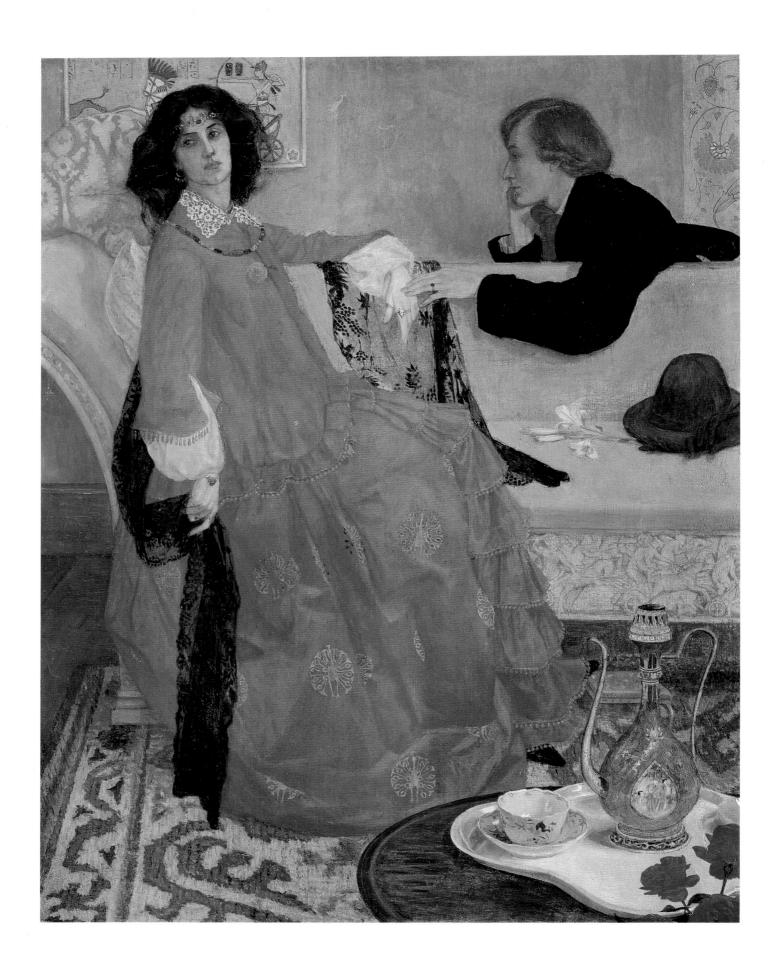

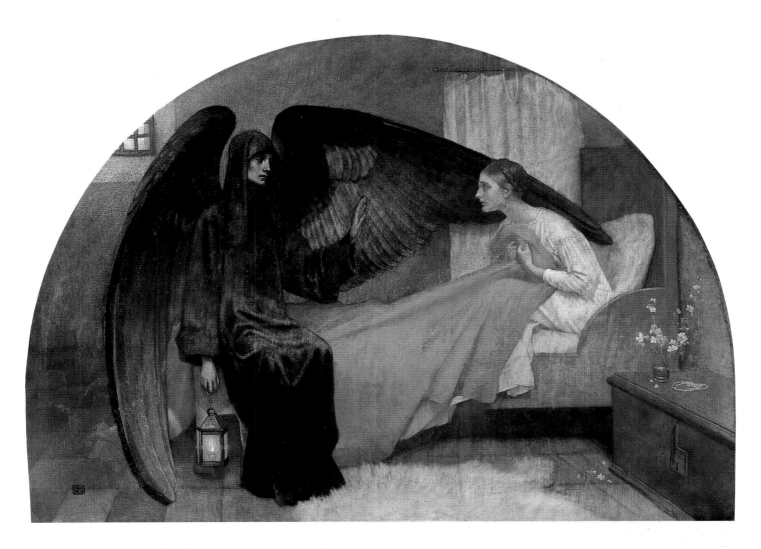

MARIANNE STOKES (NÉE PREINDLSBERGER),
Graz (Austria) 1855–London 1927
Death and the Maiden
3′ 1½″ x 4′ 5¼″ (95 x 135 cm) RF 1978-36

facing page

MAXWELL ARMFIELD, Ringwood (England) 1882–Dorset 1972
Faustine (Salon d'Automne, 1904)
2′ 1″ x 1′ 8″ (63.5 x 51 cm) Gift of Jules Blanck, 1904. RF 1977-26

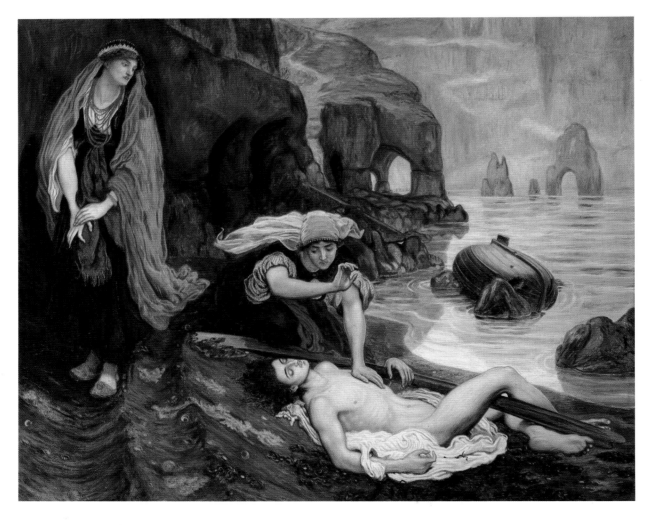

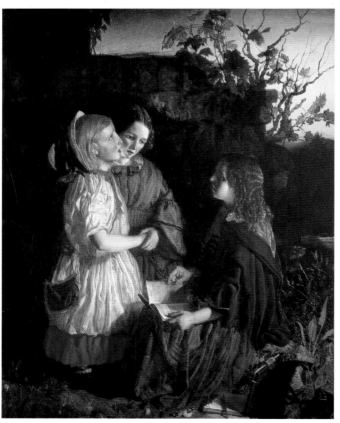

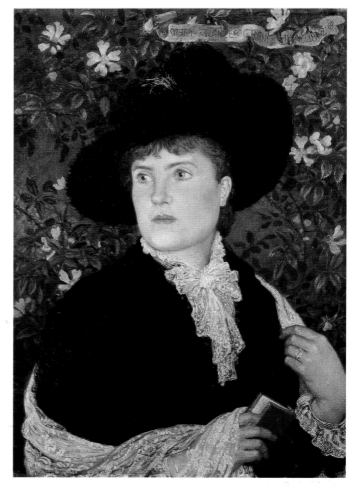

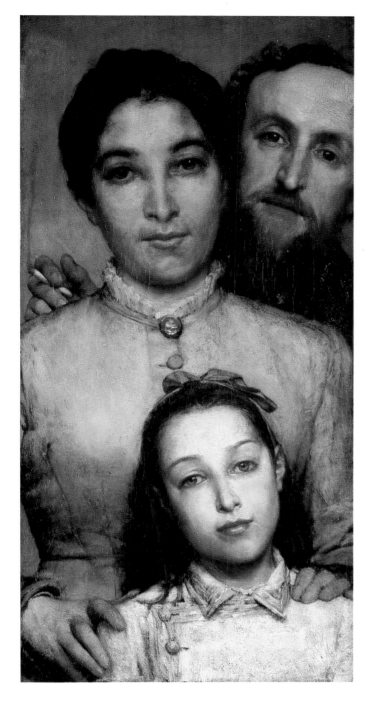

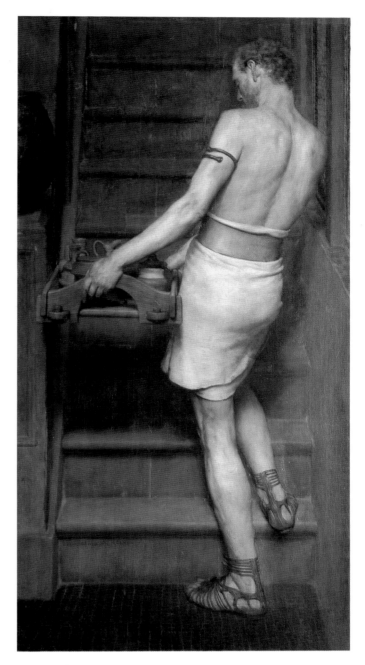

SIR LAWRENCE ALMA-TADEMA
Dronrijp 1836–Weisbaden 1912
Dalou, His Wife and His Daughter, 1876
2′ x 11¾″ (61 x 30 cm) RF 1977-18

facing page, top
FORD MADOX BROWN, Calais 1821–London 1893
Don Juan Discovered by Haydée, 1869–1878
3′ 9¾″ x 4′ 9″ (116 x 145 cm) Bequest of Miss Mathilde Blind, 1897.
RF 1133

facing page, bottom left
ANONYMOUS (ENGLISH SCHOOL)
Three Girls in a Landscape, ca. 1867
2′ 2″ x 1′ 8″ (65 x 51 cm) Gift of M. and Mme. Robert Walker, 1982.
RF 1982-56

facing page, bottom right
WALTER CRANE, Liverpool 1845–Horsham (England) 1915
Mrs. Walter Crane, 1882
2′ 7″ x 1′ 10″ (79 x 56 cm) RF 3642

SIR LAWRENCE ALMA-TADEMA
Roman Potter, 1884 (reworked 1910)
5′ x 2′ 7½″ (153 x 80 cm) Gift of the artist, 1910. RF 1977-17

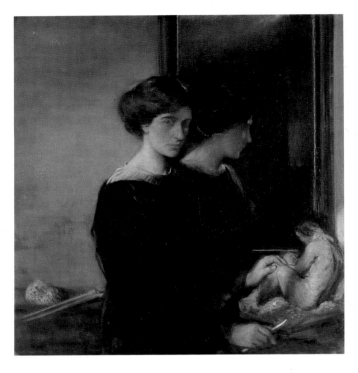

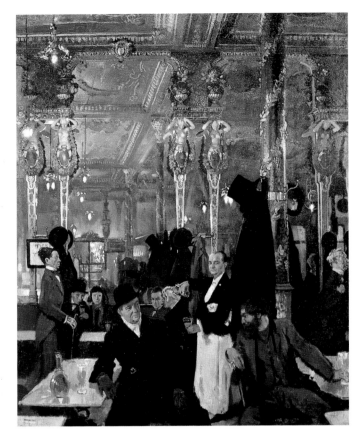

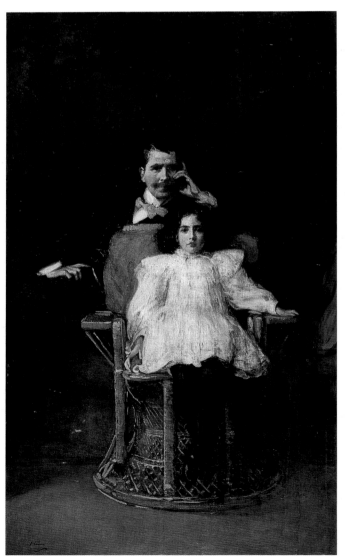

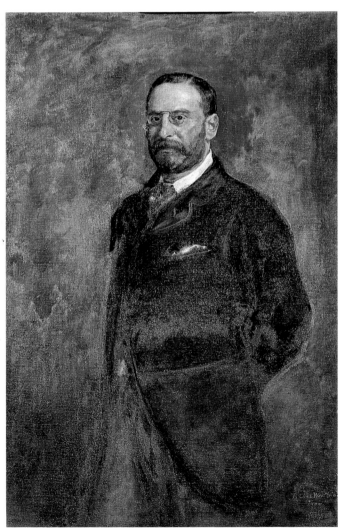

648

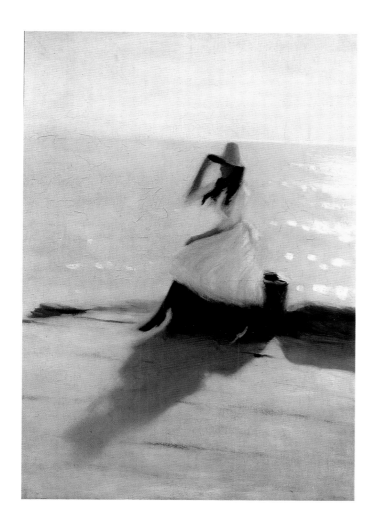

PHILIP WILSON STEER,
Birkenhead (England) 1860–London 1942
Young Woman on the Beach, ca. 1886
4′ 1½″ x 3′ (125.5 x 91.5 cm) Gift of Paul Rosenberg, 1927.
RF 1980-16

WILLIAM MCTAGGART
Aros (Scotland) 1835–Broomieknowe (Scotland) 1910
Bathing Girls, "White Bay," Cantire (Scotland), 1890
3′ x 4′ 8″ (91.2 x 142.5 cm) RF 1980-134

facing page, clockwise from top left
CHARLES SHANNON, Quarrington (England) 1863–Kew 1937
A Sculptress, Miss Bruce, 1907 (Salon de la Société Nationale des
Beaux-Arts, 1909)
3′ 9¼″ x 3′ 7¼″ (115 x 110 cm) RF 1980-166

SIR WILLIAM ORPEN, Stillorgen (Ireland) 1878–London 1931
The Café Royal, London, 1912
4′ 6¼″ x 3′ 8¾″ (137.5 x 113.5 cm) Gift of Edmund Davis, 1915.
RF 1977-278

SIR JOHN EVERETT MILLAIS
Southampton (England) 1829–London 1896
Charles J. Wertheimer, Esq., 1888
4′ 2½″ x 2′ 9″ (128 x 84 cm) Gift of Mrs. Wertheimer, 1914.
RF 1980-140

SIR JOHN LAVERY, Belfast 1856–Kilmaganny 1941
Father and Daughter (Salon of 1900)
6′ 10¼″ x 4′ 1½″ (209 x 126 cm) RF 1318

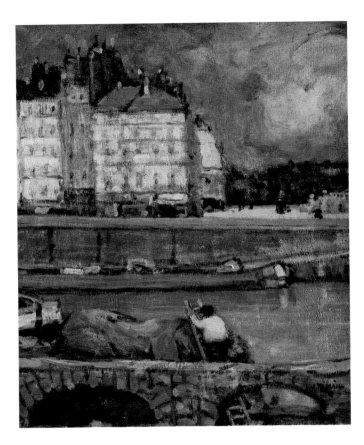

facing page, top

JAMES WILSON MORRICE, Montréal 1865–Tunis 1924

Quai des Grands-Augustins (Salon de la Société Nationale des Beaux-Arts, 1905)

2′ 1½″ x 2′ 7½″ (65 x 80 cm) RF 1980-146

facing page, bottom

EMANUEL PHILLIPS FOX, Melbourne 1865–Melbourne 1915

Reverie, 1903 (Salon of 1906)

1′ 10¾″ x 2′ 8¼″ (58 x 82 cm) Gift of the artist's widow, 1925. RF 1980-104

JAMES WILSON MORRICE

The Left Branch of the Seine before the Place Dauphine

1′ 6″ x 1′ 3″ (46 x 38 cm) Bequest of Paul Cosson, 1926. RF 2545

FRANK BRANGWYN, Brugge 1867–Ditching 1956

A Trade on the Beach, 1892 (Salon of 1895)

3′ 4¼″ x 4′ 2″ (102 x 127 cm) RF 931

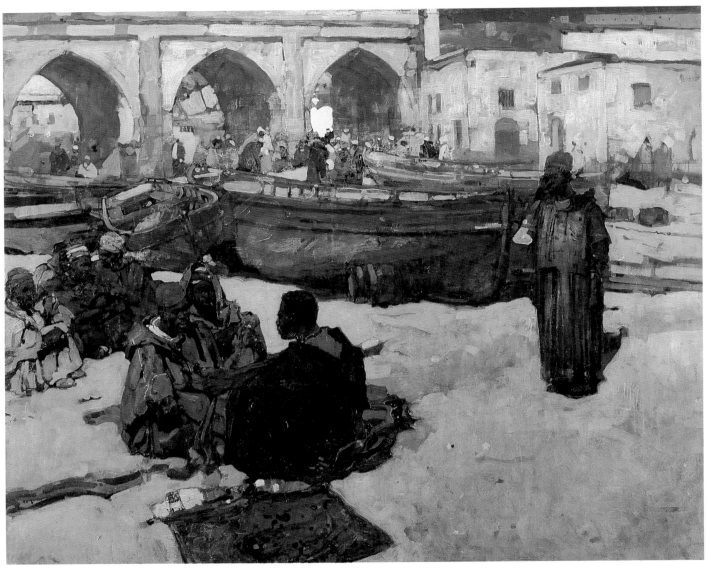

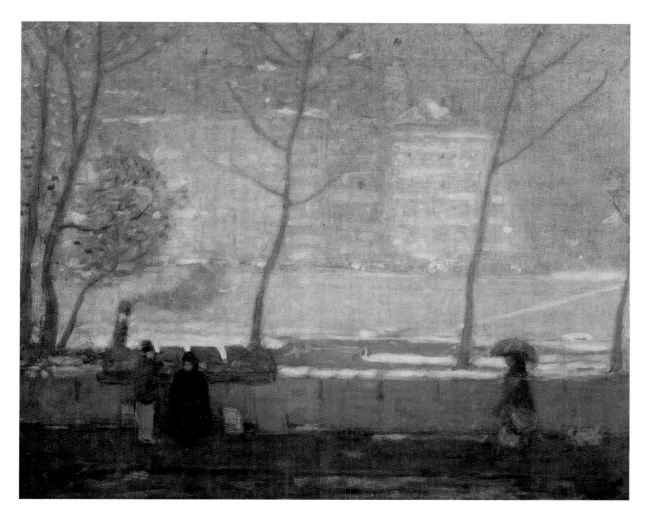

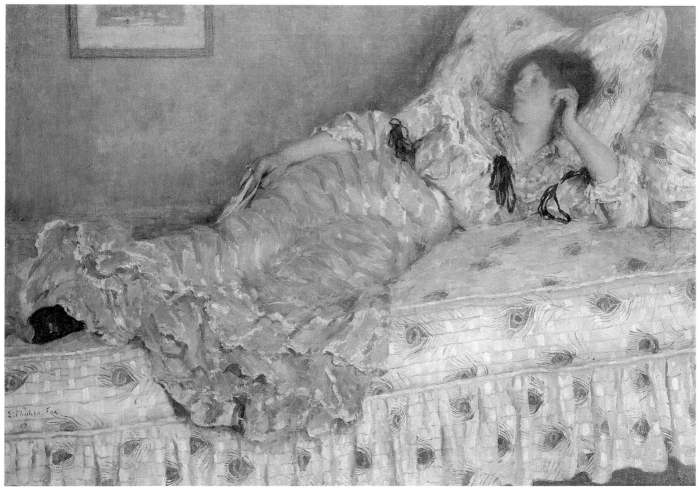

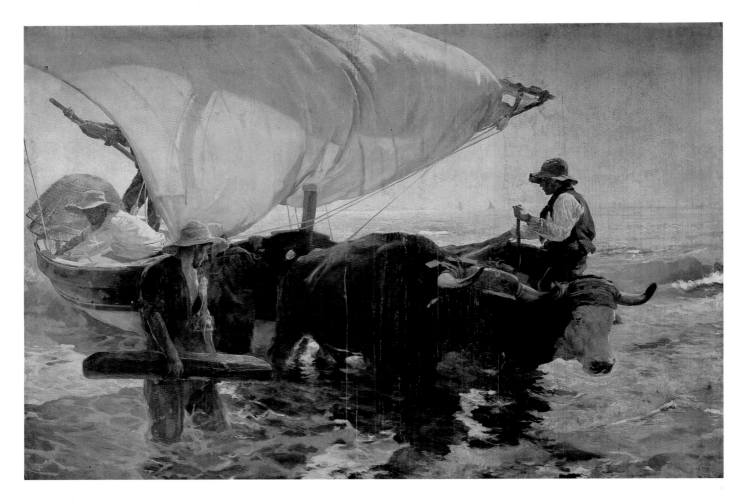

JOAQUÍN SOROLLA Y BASTIDA
Valencia 1862–Cercedillo (Spain) 1923
Return from Fishing; Towing the Bark (Salon of 1895)
8′ 8¼″ x 10′ 8″ (265 x 325 cm) RF 948

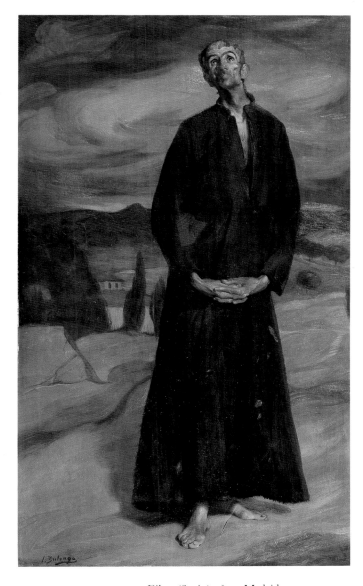

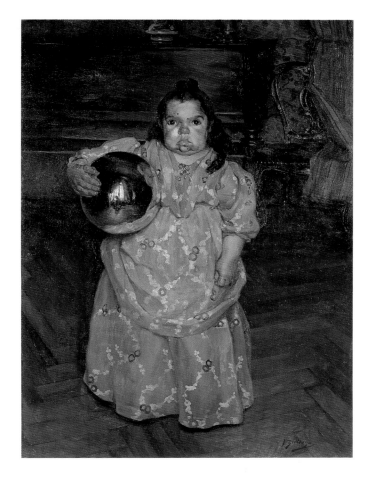

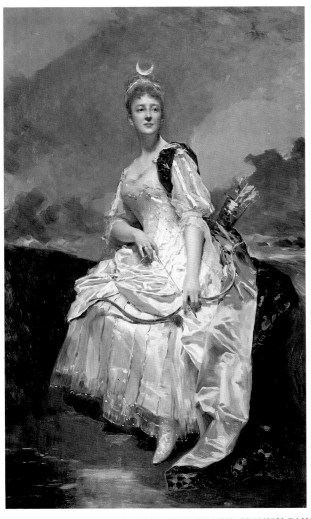

IGNACIO ZULOAGA, Eibar (Spain) 1870–Madrid 1945
The Anchorite, 1907
6′ 2″ x 3′ 9¼″ (188 x 115 cm) Bequest of Paul Cosson, 1926. RF 2540

top right
IGNACIO ZULOAGA
The Dwarf Doña Mercédes, 1899
4′ 3¼″ x 3′ 2½″ (130 x 97.5 cm) RF 1977-43

bottom right
RAIMUNDO DE MADRAZO Y GARRETA
Rome 1841–Versailles 1920
Marquise d'Hervey Saint-Denys, 1888
4′ 4¾″ x 2′ 8¾″ (134 x 83 cm) Bequest of Mrs. d'Adelsward-Pourtalès,
1934. INV 20417

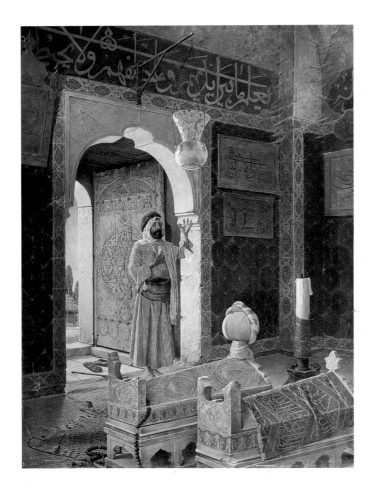

OSMAN HAMDY BEY, Istanbul 1842–Istanbul 1910
Old Man before Children's Tombs, 1903
2' 11¾" x 4' 11¼" (202 x 150.7 cm) INV 20736

MIHÁLY MUNKÁCSY
Moukatchevo (Hungary) 1844–Endenich 1900
Christ before Pilate, ca. 1881
2' 11" x 3' 9¾" (89 x 116 cm) RF 1979-63

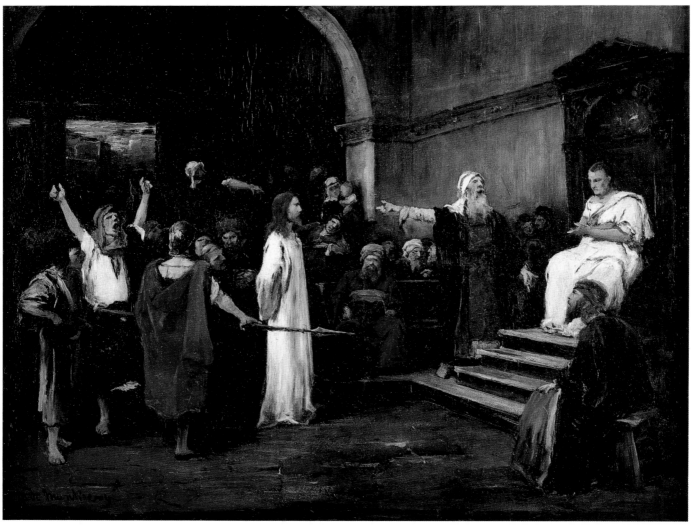

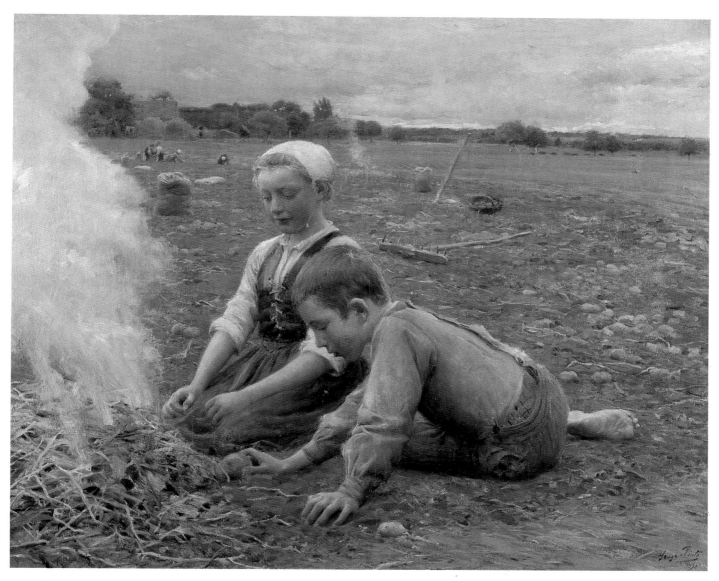

JOSÉ-JULIA DE SOUZA-PINTO
Terceira (The Azores) 1856–Quimperlé 1939
Potatoes, 1898 (Salon of 1899)
2′ 2¼″ x 2′ 8¼″ (66.5 x 81.7 cm) RF 1326

page 656, clockwise from top left
VALENTIN SEROV, St. Petersburg (Russia) 1865–Moscow 1911
Mme. Lwoff (1864–1955), 1895
2′ 11½″ x 1′ 11¼″ (90 x 59 cm) Gift of Messrs. André and Stéphane
Lwoff. RF 1980-8

ABRAM ARKHIPOV, Riazan (Russia) 1862–Moscow 1930
Sunset on a Winter Landscape
3′ 5¾″ x 2′ 11½″ (106 x 90 cm) RF 1981-15

LEONID PASTERNAK, Odessa 1862–Oxford 1945
The Night before the Examination, 1895 (Exposition Universelle, 1900)
1′ 3¼″ x 1′ 9¾″ (39 x 55.5 cm) RF 1193

page 657, top to bottom
ALEXEIEVITCH BORISSOV
Vologda (Russia) 1866–Krasnogorsk (Russia) 1934
Glaciers, Kara Sea, 1906
2′ 7″ x 4′ 1″ (79 x 124 cm) Gift of the artist, 1907. RF 1980-68

LEONID PASTERNAK
Leo Tolstoy, 1901
Sketch, 1′ 3″ x 1′ 6½″ (38 x 47 cm) Gift of Simon Belics, 1976.
RF 1976-76

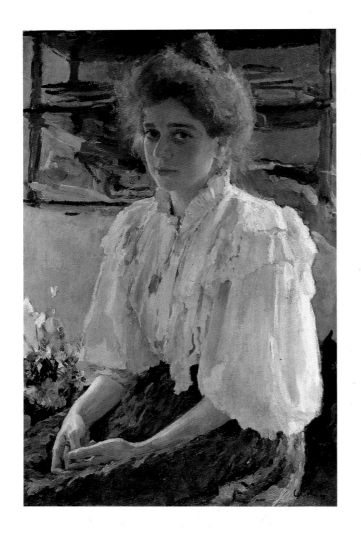

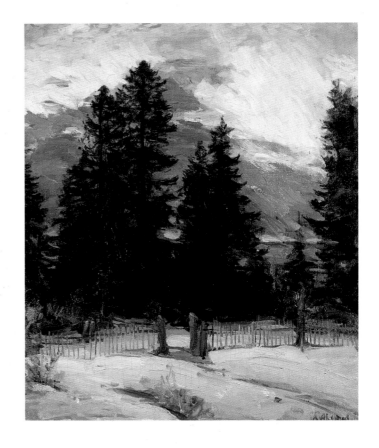

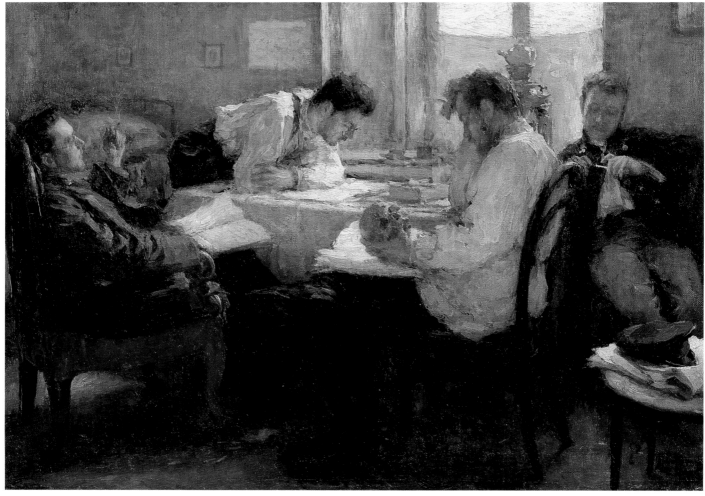

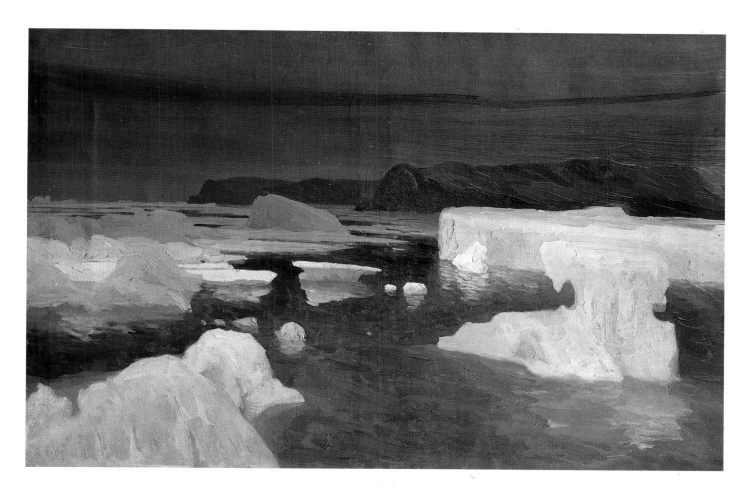

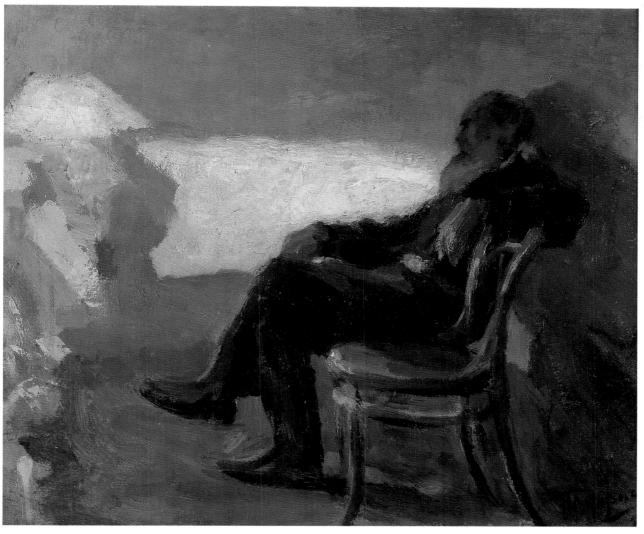

Henri Rousseau

Henri Rousseau
War (Cavalcade of Discord)

*L*ike the artist himself, who was adopted by the Parisian avant-garde as a simpleminded genius, Rousseau's first grand-scale allegory, *War*, seems to be both inside and outside the adventurous territory of turn-of-the-century art. Shown at the Salon des Indépendants in 1894, it was greeted there with both amused condescension toward its clumsiness and supportive praise for its totally freewheeling independence. To this day, it remains a painting that slips back and forth between a domain of untutored folk art and a major landmark in a pictorial evolution of stripping and flattening shapes and colors that belongs to the history of Post-Impressionism. Its theme could hardly be more universal, part of the repertory of countless nineteenth-century artists who, like Ernest Meissonier (page 252), might offer a documentary allegory of the siege of Paris during the Franco-Prussian War or, like Franz von Stuck (page 570), an imaginative excursion into a violent world of folklore, where a barbaric horseman gallops into an abyss of terror.

As for Rousseau's imagination, it was presumably triggered by youthful memories of the Franco-Prussian War, the traumatic event that, in a totally different, empirical way, was to reappear as late as 1905 in Maximilien Luce's journalistic reconstruction of May 1871, when corpses littered the streets of Paris (page 251). But in Rousseau's painting, nothing suggests the space-time coordinates of history. Indeed, the image feels closer to a Bible-inspired fantasy, a vision, say, of one of the four horsemen of the Apocalypse, in which now the figure of Bellona, the goddess of war, brandishing a saber and a smoking torch, thunders on a black steed across a landscape of devastation. Here the gray and black trees are blasted, naked and seminaked corpses are picked at by crows, and a visionary sunset rages against a limpid but cloud-filled blue sky over the panoramic sweep of the horizon.

Like the art of an inspired child, everything seems freshly invented, its imaginative leaps convincing. That the demon of war, with her tattered white robe, rides in an anatomically impossible sidesaddle; that the horse looks as though it were sired by a devil on a carousel; that the black crows, pecking on human carrion, are nightmares out of Edgar Allan Poe; that the corpses, with their wide-eyed stares, look like both toppled mannequins and agonized victims—such crazily private inventions nevertheless leave us convinced that we are immersed in a totally coherent universe of fantasy, both horrifyingly immediate and whimsically remote.

Rousseau's ability to compel us with a smile (and here a shudder) into his dreams and nightmares is everywhere enforced by his naive yet potent mastery of picture-making, which, almost by accident, intersects most of the sophisticated concerns of his day. Seurat himself might well have admired the almost Egyptian clarity of this lucid network of frozen, friezelike trees and figures; Gauguin might have marveled over the flat blue opacity of this visionary sky or the menace of the black silhouettes. And we know that Picasso, seeking out the most elemental, childlike building blocks of figure, landscape, and still life at the brink of Cubism, paid many subtle and overt homages to this strange master whose work seems both as timeless as a child's and as time-bound as the avant-garde decades, from 1890 to 1910, when he and his art flourished.

A later painting by Rousseau at Orsay, *The Snake Charmer* of 1907 (page 660), provides, almost as a pendant, the perfect antidote to *War*. This jungle excursion to a verdant Garden of Eden, with its total immersion in a primordial peaceable kingdom, can make even Gauguin's Tahitian scenes look more like documentary anthropology than a universal fantasy.

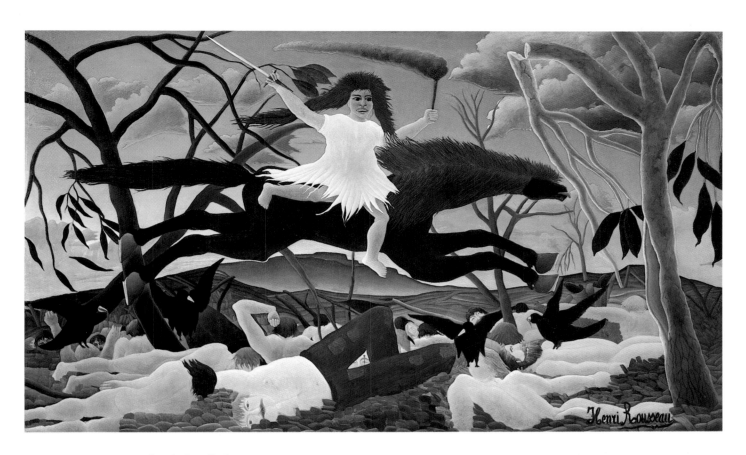

HENRI ROUSSEAU, Laval 1844–Paris 1910
War (Cavalcade of Discord), 1894 (Salon des Indépendants, 1894)
3′ 9″ x 6′ 4¾″ (114 x 195 cm) RF 1946-1

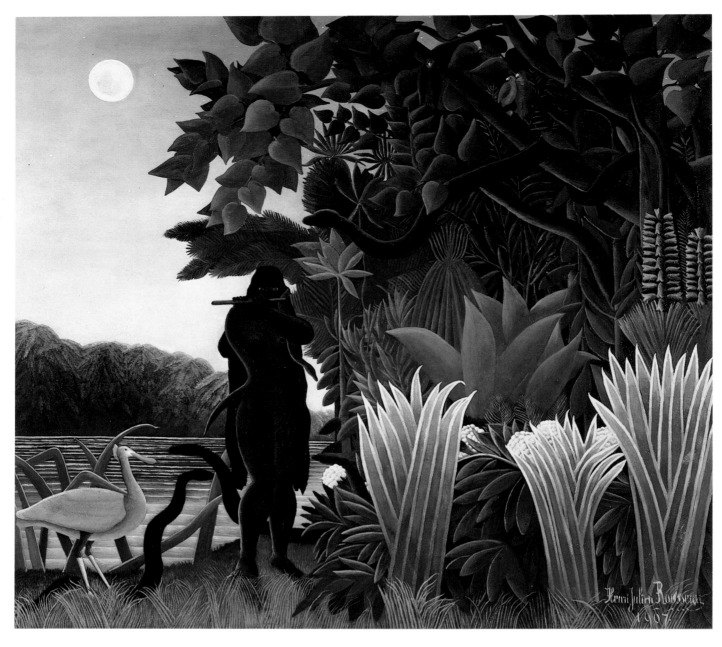

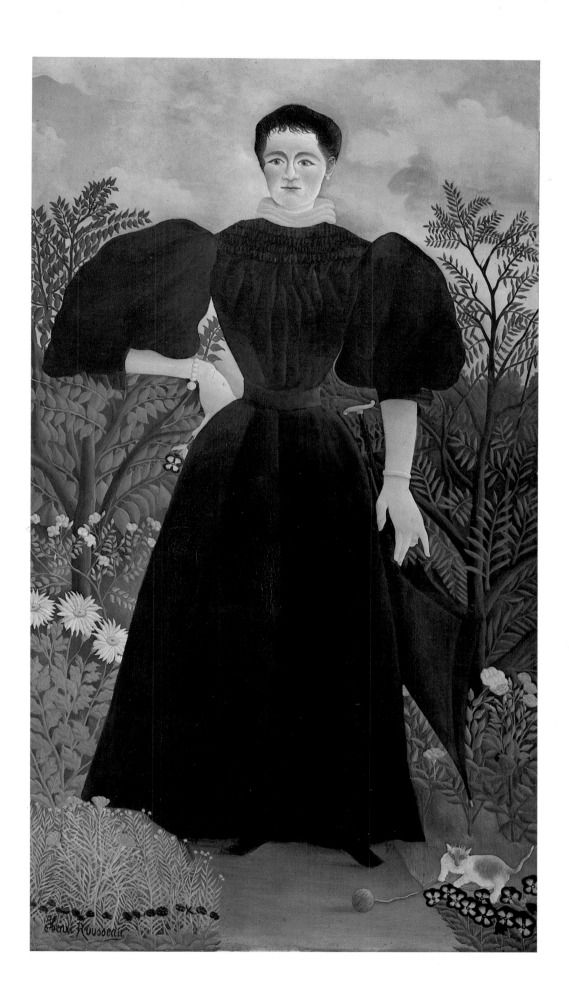

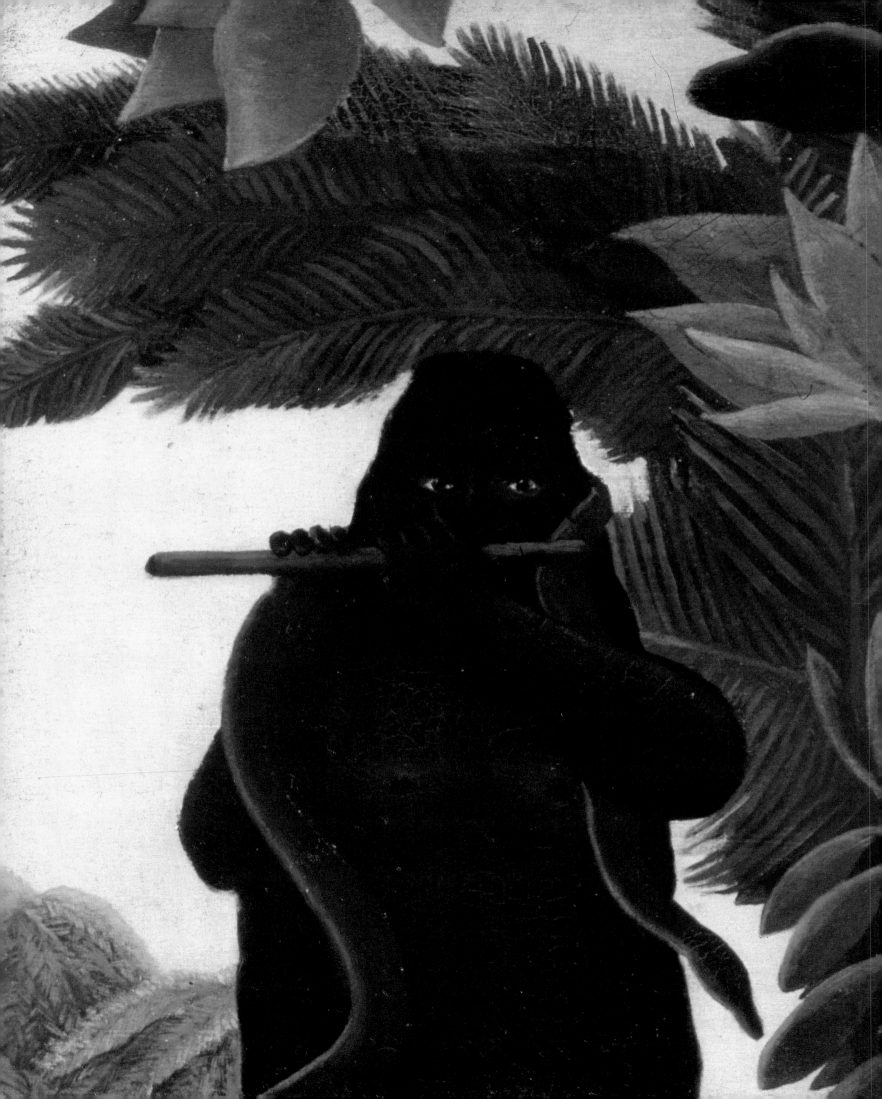

Into the Twentieth Century

Roger Fry
A Room in the Second Post-Impressionist Exhibition

Of the countless surprises in the huge Orsay collection, few are as unexpected as a modest little painting on wood by Roger Fry, the famous British evangelist of modern art. Himself a painter who tried to practice what he preached, he was second to none in promoting, through words and exhibitions in Britain, the cause of difficult new art from France, from Manet to Picasso. What we see in this painting is an extraordinary document: a view of the Matisse room in the second Post-Impressionist exhibition, organized by Fry at the Grafton Galleries in London, which opened on October 5, 1912. The identifiable works on view include two masterpieces, the second version of *Le Luxe* (1907) and the *Red Studio* (1911), whose transformation of ceiling, walls, and floor into floating seas of color obviously left its mark on Fry's own more discreet, British vision of a similar phenomenon in this London gallery interior. On a couch we see an art lover, perhaps Fry himself, who sits with legs crossed, immersed in this ultramodern pictorial world that announced a new century.

It is a world that can be glimpsed at the chronological finale of the Orsay collection, which offers a brief overview of a fresh terrain. (The museum contains works by Monet, Bonnard, Vuillard, and others that are later in date but not in spirit.) The Matisse of 1904—its untranslatable French title, *Luxe, calme et volupté*, taken from a poem by Baudelaire about escape into an Arcadian world—is, in fact, an early version of the painting seen at the left in Fry's gallery view. Like so many French painters at the turn of the century, Matisse both preserves a venerable academic theme—a Mediterranean idyll of pagan calm and sensuality beloved by Puvis de Chavannes, among others—and rejuvenates it with his startlingly original version of Signac's Neo-Impressionism. Matisse turns Signac's dabs of pure color—as in the older artist's 1900 view of the Papal Palace in Avignon (page 452)—into a rainbow brilliance whose sheer intensity makes one feel like a child discovering the undiluted pleasures of the spectrum. That this burst of joyous hedonism is wedded to a sinuous figural order of deeply traditional roots—for instance, the newborn Venus dressing her hair (page 43)—is a typically French marvel, in which old and new are perfectly fused.

Even more explosive chromatic fireworks are found in a group of related paintings by the so-called Fauves (Wild Beasts) who gathered around Matisse. Much younger than the master, whose maturity was gained with unusual slowness, these painters—Derain, Vlaminck, and Braque, among others—were even more reckless in 1905–1907, when they seemed to throw all caution to the winds. Generally choosing the innocuous subjects of Impressionism—suburban street scenes, summery woods, flower-covered meadows, London views earlier favored by Monet—they set them ablaze with pure colors that look poured, speckled, or swept on the canvas with such energy that the ground itself heaves with excitement. This eruptive moment was brief, and Vlaminck's still life, painted around 1910, already shows a reaching for calm after this exuberant storm (page 670), even if other, more adventurous painters like Kandinsky would go on to produce earthshakingly abstract deductions from these volcanic beginnings.

Other Orsay paintings of this vintage look for different sources of authentic vitality, such as the self-portrait of the Dutch painter Van Dongen (page 670). He was to become part of the Parisian Fauve group, but in 1895, when he was only eighteen and still in Holland, Van Dongen silhouetted himself against his studio window in a painting that is both chicly decorative and precociously daring in the bold distortions of head and shoulder that communicate the adolescent swagger of an artist about to take on the world. This brash glimpse into the psyche was one that got deeper in Northern European territory. Among other foreign surprises at Orsay is a portrait by the German Lovis Corinth of a man who might be called the German Roger Fry (page 672). Here we see Julius Meier-Graefe, who had staunchly defended the faith in modern painting on both sides of the Rhine. Yet his image radiates neither Cézanne's abiding structural order nor Matisse's pleasures of color and shape but, rather, an unstable world of anxiety. This was territory heralded by Van Gogh and plundered, after 1900, by a wide range of Expressionists on the eve of World War I. Corinth's psychoanalysis in paint may well symbolize the terminus of the Orsay collection, for it presses the foundations of nineteenth-century Realism to a point of rupture so violent that even the painting's recklessly brushed date is unclear. It has been read as 1912, 1914, and, most plausibly, 1917, a year that would plunge us into the shattering depths of another terminus in Western history, World War I.

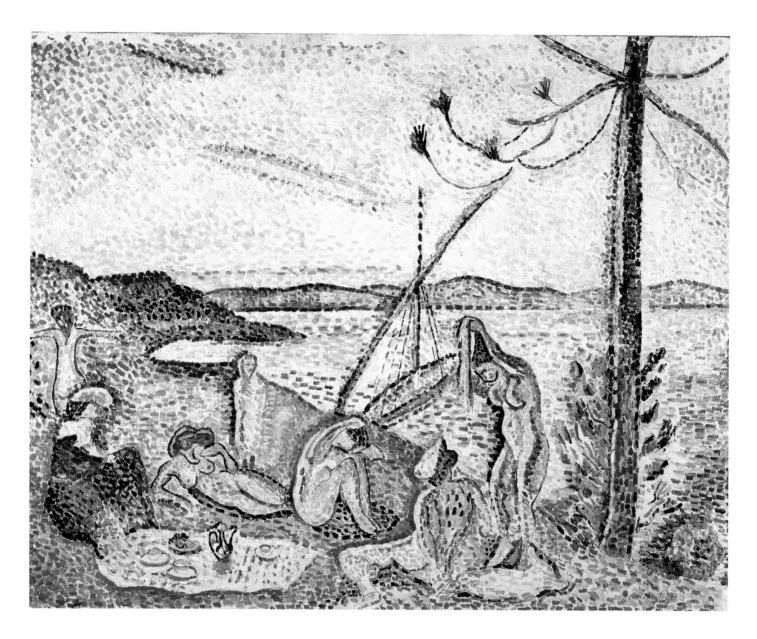

HENRI MATISSE, 1869–1954
Luxe, calme et volupté, 1904
3′ 2½″ x 3′ 10½″ (98 x 118 cm) DO 1985-1

ROGER FRY, London 1866–London 1934
A Room in the Second Post-Impressionist Exhibition (The Matisse Room),
1912
1′ 8¼″ x 2′ 1″ (51.3 x 62.9 cm) Gift of Mrs. Pamela Diamand, 1959.
RF 1977-179

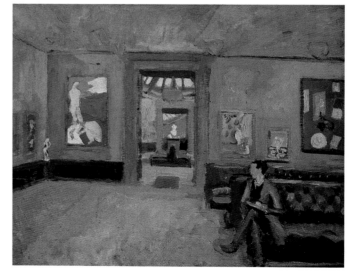

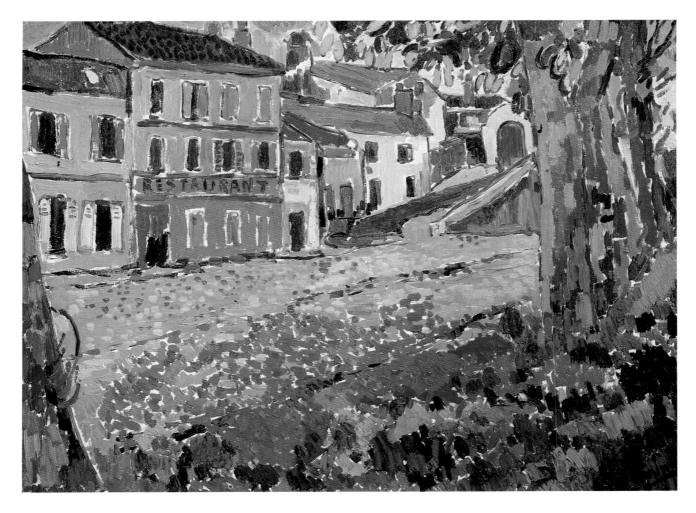

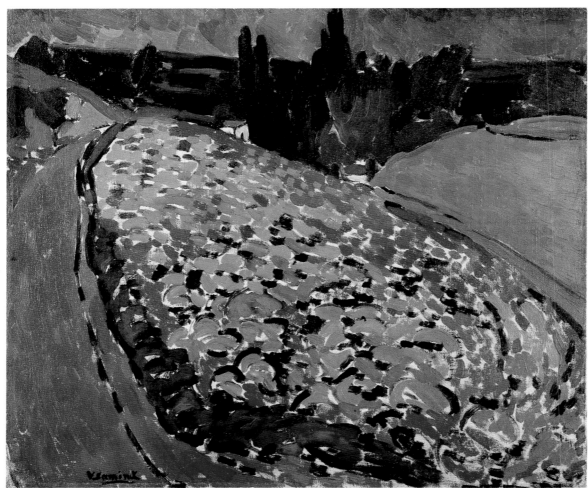

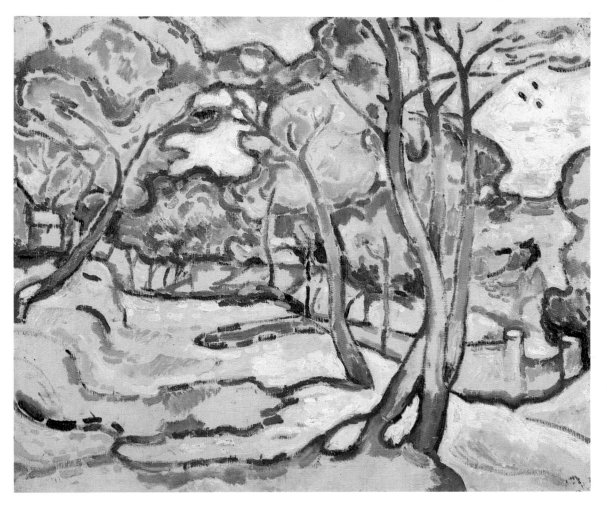

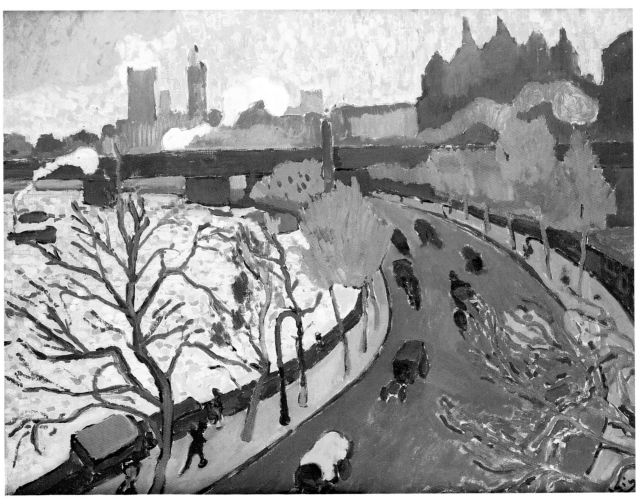

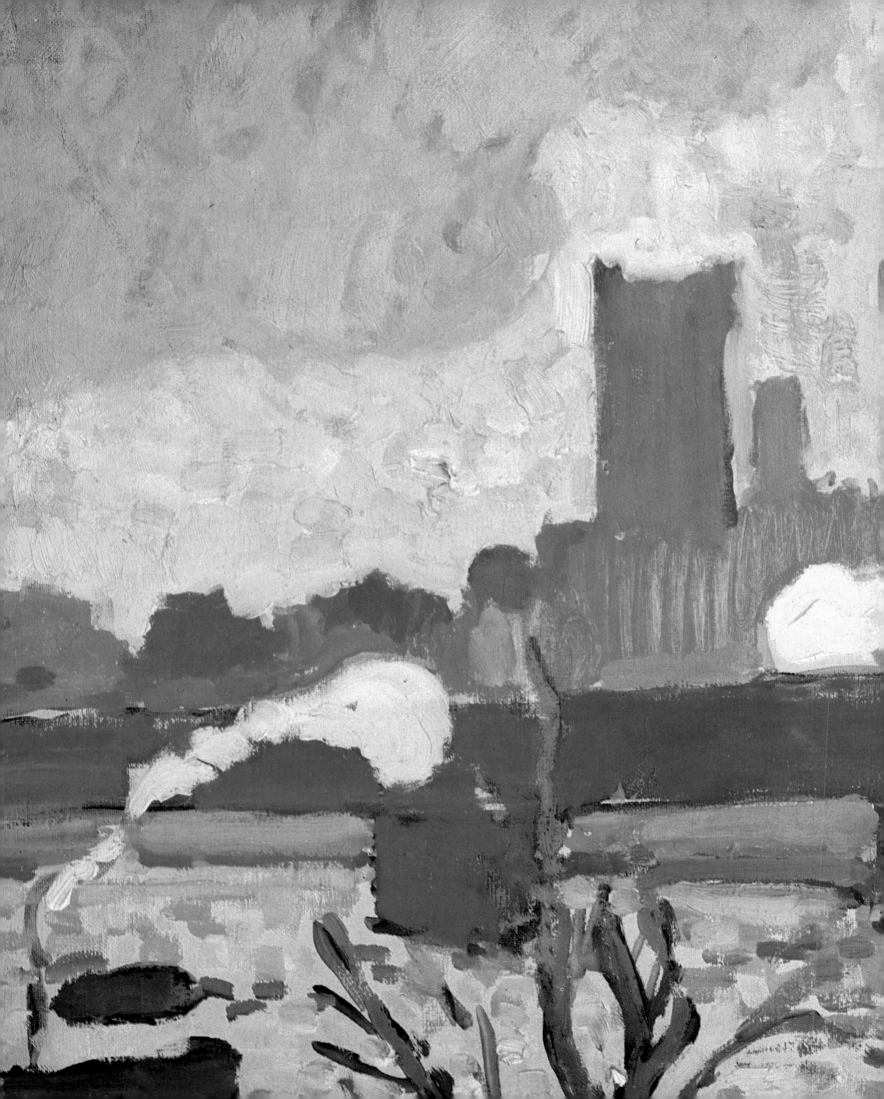

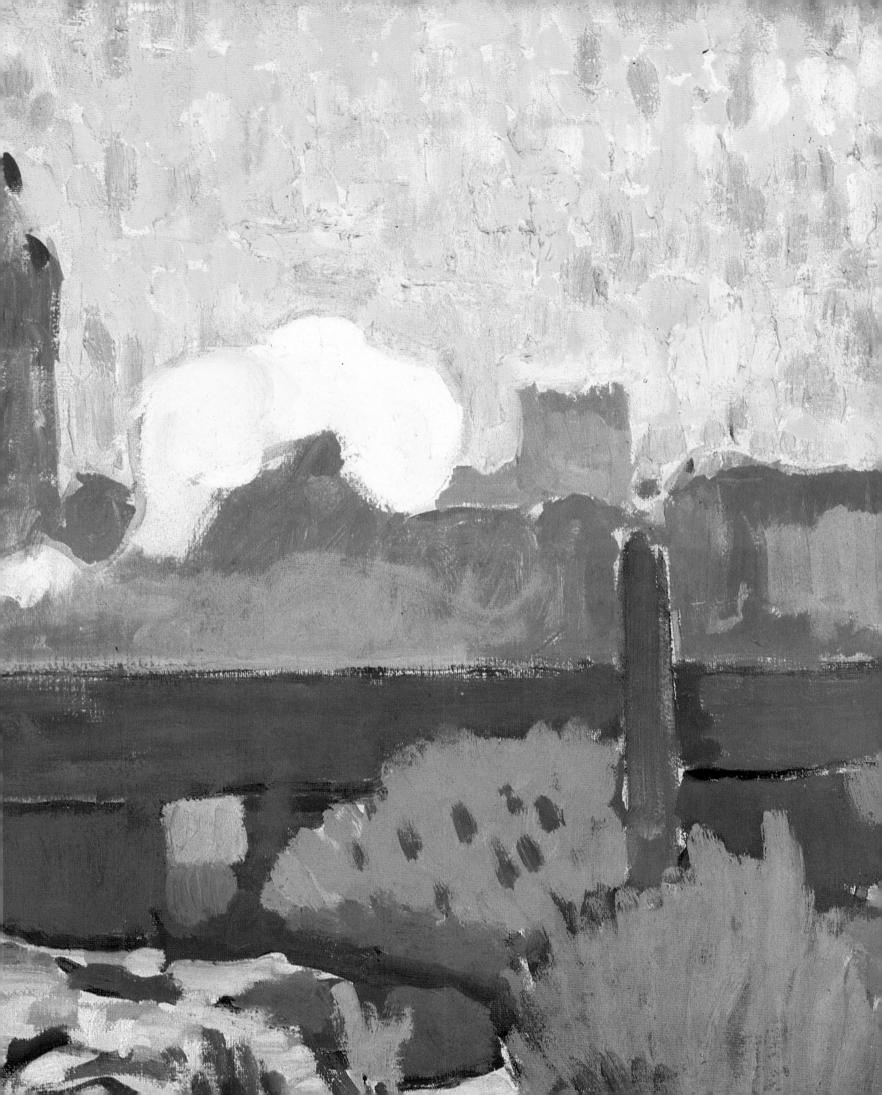

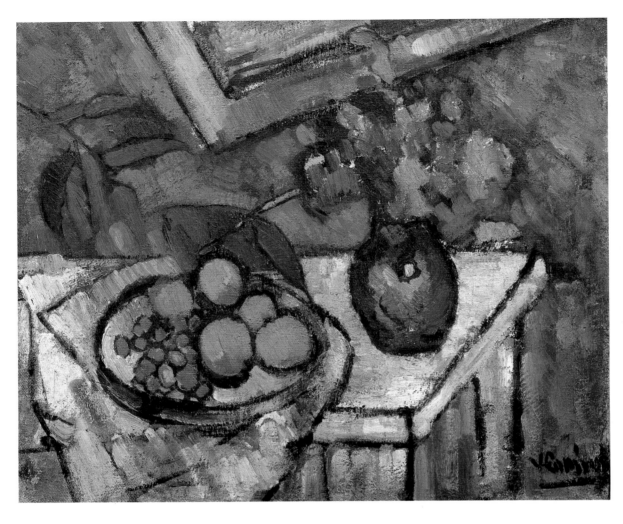

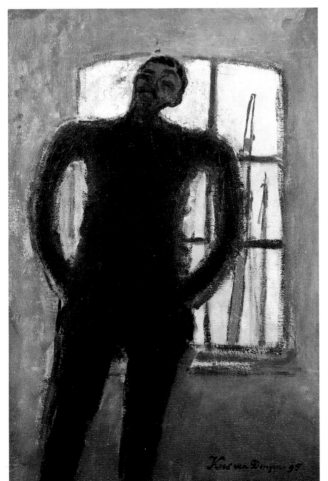

MAURICE DE VLAMINCK, Paris 1876–Rueil-la-Gadelière 1958
Still Life, ca. 1910
1' 9¼" x 2' 1½" (54 x 64.5 cm) Gift of Max and Rosy Kaganovitch,
1973. RF 1973-23

KEES VAN DONGEN
Self-Portrait, 1895
3' x 1' 11½" (92.5 x 59.8 cm) DO 1986-10

page 666, top to bottom
MAURICE DE VLAMINCK
Restaurant at Marly-le-Roi, ca. 1905
1' 11½" x 2' 8" (60 x 81.5 cm) Gift of Max and Rosy Kaganovitch,
1973. RF 1973-26

MAURICE DE VLAMINCK
The Hills at Rueil
1' 2⅔" x 1' 5" (48 x 56 cm) Deposit from the Musée National d'Art
Moderne. DO 1986-11

page 667, top to bottom
GEORGES BRAQUE, Argenteuil 1882–Paris 1963
Landscape at l'Estaque, 1906
1' 7¾" x 2' (50 x 61 cm) DO 1986-14

ANDRÉ DERAIN
Charing Cross Bridge, 1906
2' 8" x 3' 3¼" (81 x 100 cm) Gift of Max and Rosy Kaganovitch.
RF 1973-16

pages 668 and 669
ANDRÉ DERAIN
Charing Cross Bridge, detail

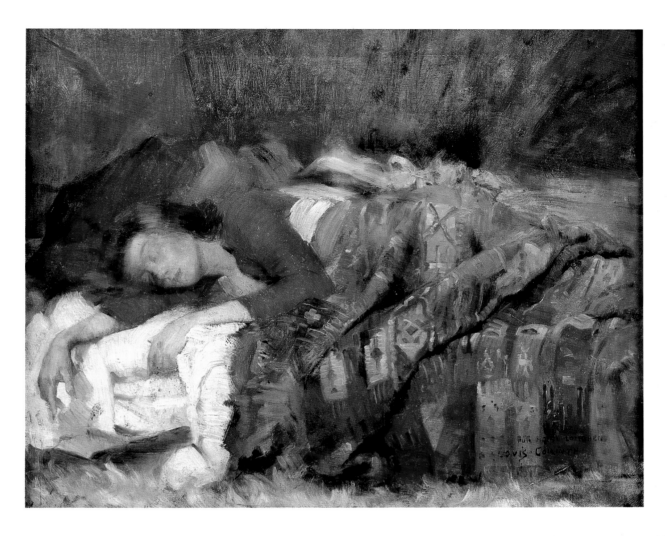

LOVIS CORINTH
Young Woman Sleeping
1′ 1″ x 1′ 3¾″ (32 x 40 cm) RF 1982-26

ALBERT MARQUET, 1875–1947
André Rouveyre, 1904
3′ x 2′ (92 x 61 cm)

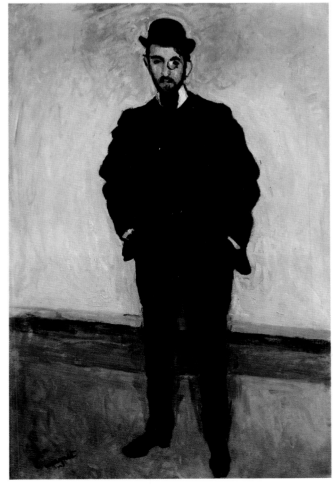

page 672
LOVIS CORINTH, Tapiau 1858–Zandwoort 1925
Julius Meier-Graefe, 1917
2′ 11½″ x 2′ 3¾″ (90.4 x 70.4 cm) Gift of E. J. Goeritz, 1936.
RF 1977-109

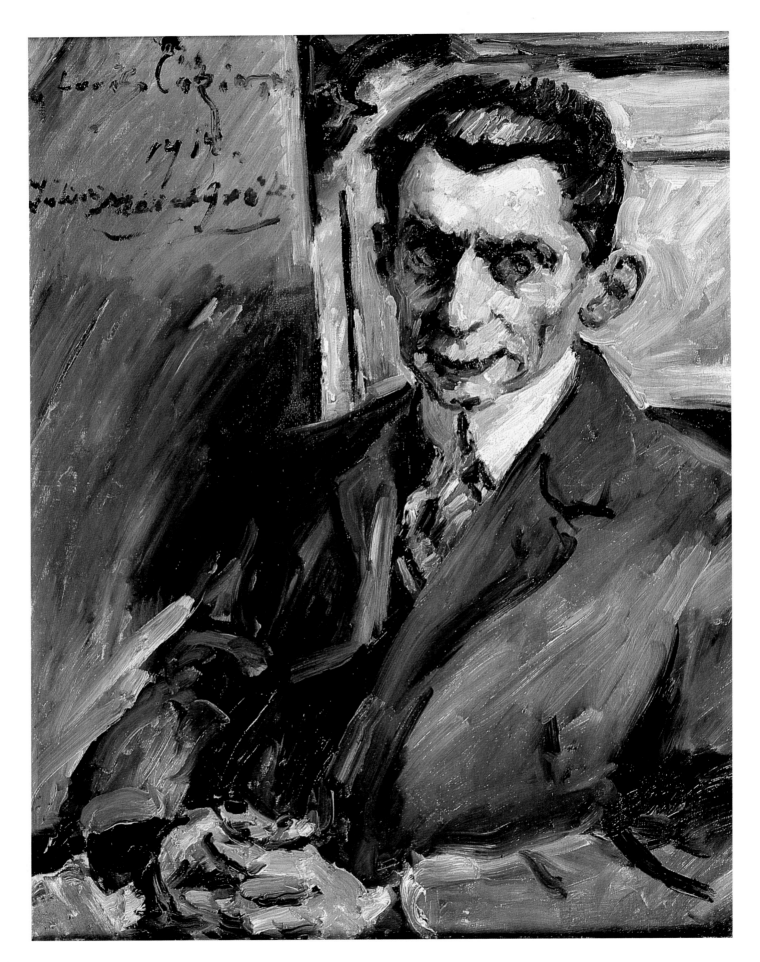

INDEXES

Design by J.C. Suarès and Paul Zakris.

The type was set
in Caslon Old Face
on the Mergenthaler Linotron 202
at Graphic Arts Composition, Inc.,
Philadelphia, Pennsylvania, USA.

The book was printed and bound
by Arnoldo Mondadori Editore S.p.A., Verona, Italy.